D1616754

RAPID EYE
movement

CREDITS

RAPID EYE *MOVEMENT*
By Simon Dwyer
ISBN 1 871592 69 0
A Creation Paperback Original
Copyright © Fiona Dwyer 1999.
World rights reserved
Published 2000AD
By **CREATION BOOKS**
A Butcherbest Production

Design, Layout & Typeset:
Bradley Davis, PCP International, Simon Dwyer
Logo Design:
Hugh Davies

Gilbert & George photographs used with kind permission of Gilbert & George and by courtesy The Anthony d'Offay Gallery, London.

Piss Christ by Andres Serrano reproduced with kind permission of The Saatchi Collection, London.

Simon Dwyer's epitaph by Paul Cecil first appeared in *The Independent*, October 28 1997.

THIS BOOK IS DEDICATED TO TOM AND LAURA DWYER IN RECOGNITION OF THE INSPIRATION AND THE UNCONDITIONAL LOVE THAT THEY GAVE TO THEIR SON SIMON.

CONTENTS

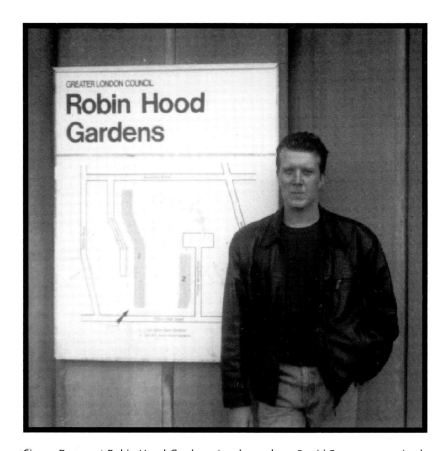

Simon Dwyer at Robin Hood Gardens, London, where *Rapid Eye* was conceived.

FOREWORD

Genesis P-Orridge

1.

I SPEAK FOR THOSE WHO LEFT

When I physically met Simon Dwyer he was robust, strong, clear-headed, perceptively intelligent, adamant; a knight apparent who charges forward with courageous folly and wins the errant day.

When I physically lost Simon he was slender and pliable; a zen master's brush leaving a trail of feathery ink and precise markings soaking slowly into the surface fibres of carefully prepared paper. He won the day.

It is so easy to be seduced by the physical plane. Plain to sea. Yet even as the material plane screams at us that it has substance, is strong and challenging, immovable, we, small clustered creatures of sensual fragility, see only the diaphanous surface. A gossamer thin film of colours and shadows that has settled over everything, giving it shape and implying solidity.

This process of believing in what we see, enables us to move around, get from place to place, avoid stumbling and bumping into each other. Such chance encounters being fraught with danger of many kinds; languages foreign to us, territorial disputes, posturing and snarling predators, cowering crowds of refugees. Noises stage right. Blue cones strobing warnings. Stage fright.

It would be easy to get lost in here, amongst the clashing billions of universes vying for attention as they build concrete memories of

2.

themselves. Trying to feel density. What you are becomes, quite literally, what you see. What you see becomes both a survival instinct and tool. Add to this maelstrom a sense of acceleration and spinning and navigation appears as hopelessly impossible as hesitation. Shoulders hunched against the sensory blizzard a formless stranger hustles by, swirling grey dust, mutters, "Seeing is believing".

Seeing is a first step. We lurch forward into the data pollution. Mad traffic hoping not to stumble on the curb. Relying, as we must, upon our belief that we are solid, that the asphalt is solid. That enough

friction can occur to propel us effectively towards our destination. If our peripheral vision holds up. If our brains efficiently translate and filter screeching cars, filing them separately from screaming kids. If we dodge and weave. Act decisively and keep our gaze and intent firmly locked onto the objective. Taking into account variable conditions at the centre of this universe which is our individual being. Then, random chance willing, we will make it to our goal.

That which was blurred by the effect of distance will come into sharper and sharper focus. We've all seen these movies. The screen shimmering, everything distorted and blurry. You can almost feel the sweat trickling. Your hand involuntarily twitches. This is so real that you went to wipe your brow for a split second. Gradually, ever so slowly, and without discernable patterns of any

3.

kind, the amoeboid shapes that have been so mysterious, so puzzling as they shaped, shifted, fragmented and reassembled languorously awaiting decoding based upon previous information, begin to solidify.

Suddenly, Pop! As if out of nowhere. All's clear. The voices no longer muffled. The distractions gone. The unnecessary background noises disappear. No interference. Perfect definition. Frozen for a momeant. A pick-up truck in a Los Angeles heat haze.

Our hero stands alone. The child remains connected to a group mind until thinking creates separation. Our thoughts, not our manners, maketh "man". Thinking, thinking alone, disconnects us from all others. Such a great loss occurs at the birth of individual thought that life can often become centred on the quest to return to the previous, connected state. To once more be a particle of a greater consciousness. To travel beyond the substantial into the very heart of compassion.

This journey is the hardest. Gone is the illusion that anything is fixed, or constant. The vines that shelter the arbour from illumination by the sun are arbitrary.

For they too rely upon the light.

Our hero sits in contemplation. Sanctuary dissolving facing fear and the unknown in direct proportion to the increase in

4.

illumination as the vines lose materiality. At some point all is filled with this sameness made of light. Cell by cell. Space by space. All that was visible is visible equally and without surface.

Shoulders stretched, erect within the limitless vision a formless being hustles by, swirling, fluttering and whispers, "Believing is seeing".

It is our great good fortune, seeded as a blessing through Simon's acknowledgement of us, that really, nothing of significant spiritual or meta-physical value (which to me is, or should be, interchangeable with cultural value) is actually material.

All that survives outside the loops of time are words and images. That which, for no better reason than it happened, we call Art. Really though, not even Art survives. Ideas crystallised in the form of Art survive. Know not even that. Ways of seeing. Waves of seeing. Positions from which to look. Perspective linking one frightened universe to another, creating a bridge of immortality. Knot mortal. A subjective point of reference. Luckily for us, for NOW!, the point at which Physics (the physical study) and Art (the metaphorical study) coincide. Perhaps collide.

It is my belief that Simon Dwyer understood that his conversations with each of us would occur because he wrote. It is my boundless hope that you will come to treasure your interaction with them

5.

because words can speak differently to each individual. Ending the unintended separation of our particular universes for a momeant. Easing our loneliness.

After you have lived with Simon in his universe for a time, please come back. Read this allegory once more.

—*Genesis P-Orridge*
NYC 1999.

FAITH, FEAR AND TIME

Simon Dwyer & Genesis P-Orridge

The first lesson from which all others grow is the simplest. We are mortal. We all die. This is not a morbid wallowing in hopelessness. It is the ability to genuinely come to terms with our physical transience that liberates us all. Many visionary philosophical systems include "The Small Death" in their ideas under one name or another. We all die. This realisation truly assimilated can be turned to positive use, in that it spurs one to action aware that all time is limited and no life span is certain. Every second counts and must count. This realisation can also be used unproductively, crippling an individual man or woman's search for fulfilment of all their needs and preventing for all their life a complete integration of every aspect of their character and thoughts. The inevitability of death can be used by outside forces as a weapon to create fear. Organised Religions use this weapon more blatantly than any other suppressive social regulation systems. They use fear of death to justify blind faith.

Those who escape the traps of religion through a first stage cynical knowledge of the hypocrisy of modern society and the emasculation of their individual power to change anything often seek oblivion from this knowledge, and so they use various drugs (tobacco, alcohol, tranquilisers and opiates like heroin) as a substitute for Faith. They want to kill time. Religion wants to side-step time. Both are actions based on fear.

Humankind spends a constant amount of energy in self-preservation. The very phrase "self-preservation" implies a threat of annihilation and is triggered by fear of death. So in a very real sense fear of death is present behind all normal functioning, it resides permanently in the subconscious, moulding our image of ourselves in relation to an inevitable, inexorable crisis of death. But fear of death could not be constantly present in our day to day conscious mental functioning, this would be an intolerable burden, as things are; but to behave "normally" the biological organism, the animal man, represses its knowledge of death to acquire comfort. As things are, so they must change. So we are all socially and biologically conditioned to put away our fear of death yet in a real paradox we become too efficiently oblivious to this fear in our conscious life.

Rapid Eye tries, struggles, to reconcile all our consciousnesses. To do this it embraces the knowledge of our own inevitable death with courage and uses it to justify action and the proper use of time. In actual fact, none of us know how much time we have, when we do die it ought to be with Zero Regret. Zero Regret is the magickal state of inner balance and calm acceptance of the mortality of individuals and the use of Zero Regret to channel all future action. The perfect state is to be sure that no time is wasted, no energy repressed and no fear hidden. In old language, we must experience the small death of literally facing ourselves and the reality of a temporary metabolism, a limit on time. Time can be a tool, a liberator, or an oppressor. When we claim that time back for ourselves we are at last learning to be free and effective. Control needs time like a junkie needs

junk. To escape control we must re-embrace our given time.

Initially the human being has no apparent alternative but to succumb to a negative appreciation of death. To feel fear. The brain is genetically programmed to survival and will not allow itself to believe that it shall cease to exist. Thus, as we have already seen, the subconscious mind will seduce the intellect into ignoring logic and fact, a condition bordering upon hopelessness. It will ignore the lessons of experience and observation in favour of an inherited image of existence and the effect of fear will be repressed. He or she will immediately become vulnerable to a desire for hope that bypasses confronting his subconscious knowledge. Religion thrives upon this. It requires only an act of blind faith in exchange for guaranteed hope and salvation. It denies death and avoids the facts. In short religion turns away from time, denies that which is inevitable. We strive (though often fail) to turn towards it. If you face yourself, you face death and in this way only you can re-integrate your entire character and all its levels of consciousness and perception. This cannot be stressed too much or too often.

So in religions all practical thought must be swept aside in a flood of faith. Answers become words, and facts become sins. This thing faith is the foundation of all religious thought. So powerful, yet fragile that faith must be protected. Protected from doubt, protected from questions, it is seen as a constant that will not even tolerate thought. Its causes, its real essence, – death – are so entrenched in everyone's mind that it has become the basis of every society, and so every society has developed a system to protect it. Dogma. The equation, simplified, goes something like this: Dogma negates thought. Thought is the enemy of faith (therefore the enemy of society). Individual thought patterns are discouraged in order to preserve faith inviolate, to thus preserve society, to preserve the status quo and the vested interests of the keepers of faith and dogma. It is in this web that religion meets politics meets western medicine meets drug companies meets the mass media meets national security forces and they reinforce each other in a web of deceit. Those in power have a personal interest in channelling individual thought down safe unthreatening avenues geared to the production of materials and services that are to the "benefit" of society, of the "greater good". In other words you sacrifice your time, and your time is your most precious commodity. When you take yourself back time becomes priceless. People are deflected from the theft of their time and trained to produce and consume instead of how to engage in their habitat and ideas. Politics organises, religion directs. Remember, you are the holder and owner of your time. You have absolutely no control over this time unless you cherish yourself – your own questions. Knowledge only comes at the end of your Time, knowledge does only come with death's great release.

"From a child of five to an adult is a short step. From a new-born baby to a child of five is an appalling distance."
—Tolstoy

"Give us a child of five, and we'll give you a Catholic for life."
—The Jesuit Sect

Religion invades the child's world. A child without guilt is thus given guilt. A child without fear is thus given fear. The only salvation offered is through faith. Faith, it is suggested, ends death. The price of cheating death through faith is, of course, submission.

People who are not satisfied with this situation, people who want proofs, who wish to develop a system without guilt and fear that absorbs and uses death as a positive and liberating knowledge are discouraged, ridiculed, treated with suspicion and often deliberately misrepresented in the media. They are, after all, a threat to society to some degree, they strike at the core of the trick that controls us and so in a real sense they are dangerous. Our work has been dedicated to the reacquisition by individuals of their allotted time. It encourages, it does not discourage, it stands as an example of what is possible. Without wishing to sound self-important (we do not wish to have followers) to become involved by reading *Rapid Eye* is to become informed only of our opinions, but only you can decide.

With the passage of history society's control over individuals is so subtle it becomes imperceptible, perhaps even genetically inherited. Its very power lies in the fact that even its figureheads and leaders do not realise its processes. Control is invisible. Time is invisible. Control is so able to shroud an individual's perception of reality in trivia as to become a uniform reality in itself. A reality that cannot ask itself questions. That cannot even formulate a language capable of setting questions that might reveal the, or a, truth.

In an age of collapse and transition we must find a language. A way out of the corner donated to us by history. We must find the alphabet of Desire. The human brain must develop, progress towards the next step in evolution. It is simply necessary to develop our latent neurological powers or truly die as a race. This is a war for survival. Through experiment, through exploration of our latent powers, by visionary use of science and technology, and by the integration of experience, observation and expression we must revere ourselves.

A reality that cannot face itself becomes an illusion. Cannot be real. We must reject totally the concept and use of faith, that sham. We must emasculate religion. The "Universe of Magick" is within the mind of mankind, the setting is but illusion even to the thinker. We both are, and always have been committed to building a modern network

of information where people are given back pride in themselves, where destruction becomes a laughable absurdity to a brain aware of its infinite and immeasurable potential. *Rapid Eye* has been committed to triggering the next evolutionary cycle in order to save this flawed but lovable animal Man. *Rapid Eye* is committed to developing a modern functional and inspiring magickal and artistic structure, a beautiful and surreal communications entity. In engendering at long last the completely integrated and effective individual. And this network of individuals is in turn inevitably faced with a task of action to communicate survival and social evolution to others. We try to suggest the first truly non-aligned and non-mystical philosophy.

Fear breeds faith. Faith uses fear. Reject faith, reject fear, reject organised religions, politicians, drugs, and reject dogma. Learn to cherish yourself, appreciate intuition and instinct, learn to love your questions. Value your time. Use mortality to motivate action and a caring, compassionate and concentrated life.

Deny Control. Love one another. See what happens...

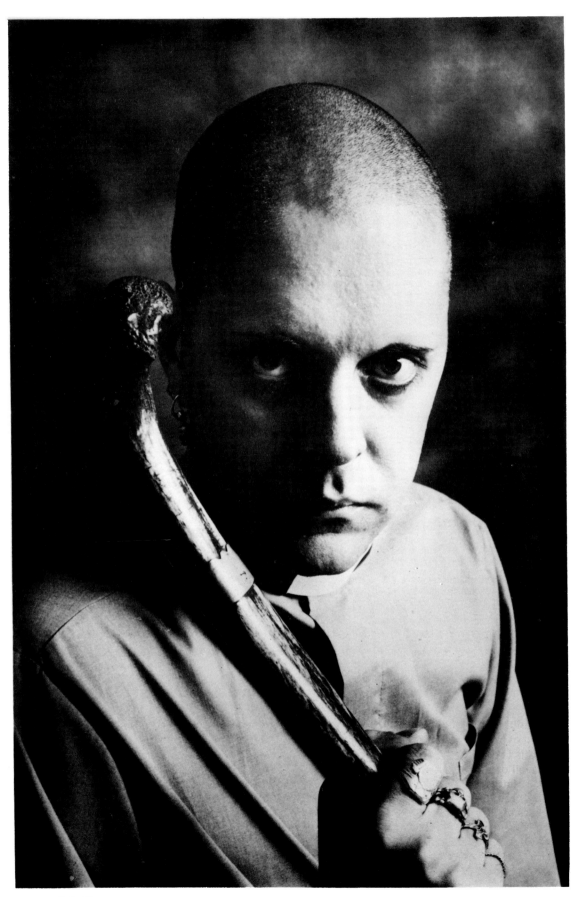

Genesis P-Orridge

FROM ATAVISM TO ZYKLON B

Genesis P-Orridge And The Temple Of Psychic Youth
(From A To B And Back Again)

Simon Dwyer

"Western people often see obscenity where there is only symbolism."
—Sir John Woodroffe, *Shakti & Shakta*

"Whoever wishes to be creative, must first destroy and smash accepted values."
—Nietzsche

"'Cults' he said thoughtfully, examining a tape report grinding from the receptor. 'What about cults?' Sung-Wu asked faintly. 'Any stable society is menaced by cults; our society is no exception. Certain lower strata are axiomatically dissatisfied. In secret they form fanatic, rebellious bands. They meet at night; they insidiously express inversions of accepted norms; they delight in flaunting basic mores and customs'."

—Philip K. Dick, *The Turning Wheel*

Social cohesion and individual liberty are in a state of permanent conflict or uneasy compromise. The result of this friction being a variety of cults, which fall like a veil of sparks, lighting the dark.

CRACK! Kathy Acker leaves the stage, her American brogue giving way to a whipping electronic beat that incessantly pounds the sweaty walls of a subterranean nightclub. A howl of wolves turns the beery air to frost. Necks tingle and hackles rise to the speeches of Hitler and JFK that spill from the speakers, the 23 TV screens on stage swim to life,

forming a giant mirror that glows with recurring images. The ornaments of power, the universal symbols, blend into hypnotic blurs of textural, throbbing colour: tacky 3-D postcard impressions of the Virgin Mary cut with dangling footage of faces caressed by hands: Third World tribal initiation ceremonies (which are acceptable), juxtapose with equally bloody-looking but innocuous Temple Ov Psychick Youth "rituals" (unacceptable). The atmosphere becomes stifling.

CRACK! Art school video techniques look so much

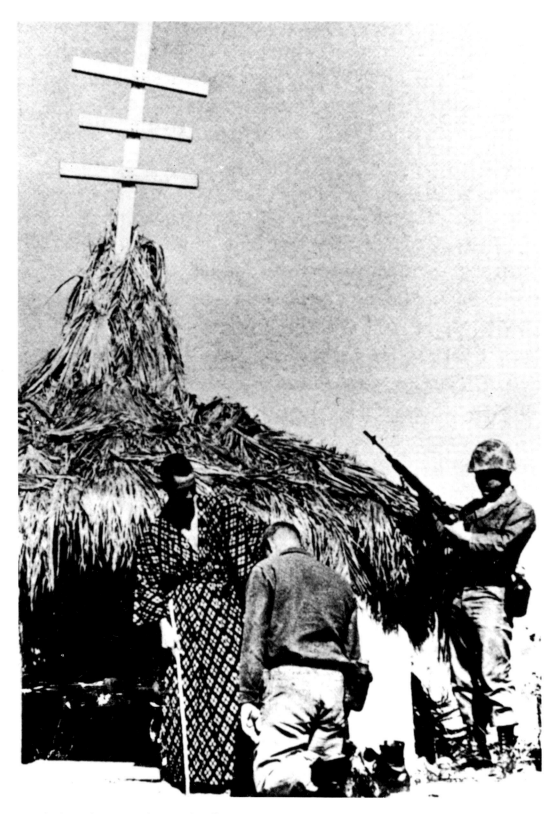

more convincing when carried out with self-discipline and purpose. The purpose is mass hallucination, the method enchantment, and enchantment is exactly what is taking place here on all levels. The hypnotic elements of strobe lights, the whirr of the Dream Machine, the primal mantra of "Buddhist" drum rhythms and rock guitars, the spell of meaningless oratory. The many-headed beast of the crowd is plunged into a pulsating trance dance. An angel, or maybe a devil is invoked. Jim Jones cackles his last hyena laugh as his followers make their sound in the white night.

CRACK! A small, elfin figure bawls with tuneless violence into a microphone that's threatening to choke him as he stands perilously straddled between two monitors, *Der Putsch* leather and tattoos

glistening in the heat. Wild eyes popping from a shaven skull. The classic rockist image is cut, only to be derided by a large furry hat perched incongruously on the top of his head. A music journalist nearby, wondering what such millinery signifies, scribbles something meaningful.

A cute Berlin blonde spike-top rises purposefully head and shoulders above the pulsating silhouette of heads at the front of the stage. She reaches up and grabs the singer's crotch. Fumbling, she tries to perform fellatio, but the singer instead jumps frog-like into the rippling crowd, still bawling. Equipment gets damaged. People have sex. Er, this must be rock'n'roll! The journalist scowls and scribbles feverishly...

By two-thirty the last stragglers wind their way out through the debris and onto the street. Some ashen-faced, trembling, nauseated. Others angry, some bored, unimpressed, some ecstatic. Few are exactly sure what they've just seen. A large black Psychic Cross has been sprayed on the wall above them – the same symbol as they wear sewn onto their grey jackets and hand-painted Kaftans, or have tattooed across their (wasted) biceps. It hangs silently over the city in the sickly yellow buzz of the streetlights. Marking the spot like a gravestone, a piece of history and mystery. It may bury itself like a martial artist's star in the subconscious levels of some neophytes' minds, perchance to enter into their dreams that night.

The symbol looks aptly like a strange TV aerial. Its tripach cross design inviting interpretations involving Christ and the two thieves, or a timeline incorporating the past, present, and future. It's similar to the alchemical glyph meaning 'very poisonous' and the Japanese symbolic cipher, (or Kana), for 'Fuck'. It's also reminiscent of the Fascist/Christian emblem in Peter Watkins' '60s cult pic *Privilege* that culminated in Paul Jones' ultimate pop rally, and a dead ringer for the Samurai ideogram meaning 'Master'. It can also be cleverly arranged from the letters P.T.V., and it is an outside broadcast of this particular company that we have just experienced.

If the main criterion for the creating of any cult is the stoking of fanaticism, then in this world of graphic corporate identity, of Capitalists making capital out of man's innate symbolism (from the Christian Cross to the bird on a Barclaycard) – it's only logical that such fanaticism must also be stoked with its own symbols.

The singer and co-director of the company, a geomancer named Genesis P-Orridge, has a stained glass Psychic Cross hanging in his East London apartment, the morning sun illuminating it as he talks.

A copy of the PTV video of *Catalan* flickers on the large colour television in the corner, director Derek Jarman playing pyromaniacally with the flames of Jordi Vallis' car as it lies on the beach outside Salvador Dali's house – crashed on the spot where *Un Chien Andalou* was filmed. Gen's daughter

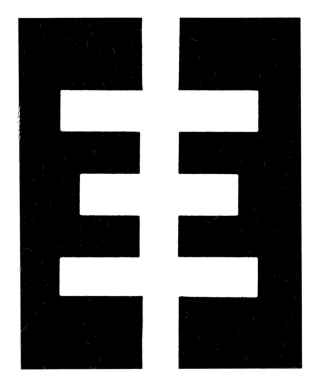

Caresse watches daddy on TV as she lies across the couch with Tanith the dog, baby Genesse gurgles happily on his lap, steam rises from the cups, as if in a Jacques Brel song.

As a father and now, approaching 40, homeowner, Genesis is exemplary. Many critics find this fact at odds with his stage persona, and want to know what his 'real' name is. Perhaps it is because people are used to pop stars, artists and their ilk creating a false public image that is at odds with their own character, as 'Entertainment'.

His real name, though, is Genesis P-Orridge, (changed by deed poll in the early '70s from Neil Megson) and of all the people working, even on the periphery of this area that I've known, Genesis is the one least interested in entertainment. Awkward and stubborn, sometimes to the point of exasperation, he just isn't the type of person to indulge the fantasies of fans and record companies' press rooms, and even if he were, he would hardly need to change. His lifestyle *is* unusual in some respects. The most weird and unpalatable aspect of his character really being that he attempts to perceive the world in a manner free from moral posturing and finite possibilities, and pays no lip service to those institutions that do. Being all-too-honest about what he thinks and does, he represents a commodity that the Entertainment Industry cannot handle with a bargepole – reality.

Reality, in the right hands, can be very, very dangerous. The fact that P-Orridge has never claimed to be particularly intelligent, original, or talented in his handling of it, only serves to make matters worse. He has thus been subjected to myriad forms of censorship and pressure. Although both his home and the Temple offices have been raided by the boys in blue, and British Telecom, HM Customs & Excise and the Post Office have taken actions against him,

P-P-P-Orridge (photo: Steve McNicholas)

rarely are such blunt instruments resorted to. 'Control' protects itself from attack in far more subtle forms if possible. Its deft conditioning of people, particularly the type of people who reach positions of power in organisations like those in civil service, means that their small-mindedness and dogmatism act as a normally impenetrable shield of prejudice and stupidity. (The underlying philosophy seems to be that "he is a weirdo", therefore, it seems, "he MUST be breaking the law, or threatening to the law in some way", and so

deserves any vilification he gets as he has brought it upon himself.)

This protection of ignorance manifests itself in a variety of ways. From death threats and rat poison being shoved through the P-Orridge family letterbox, to the wilful misrepresentation of Psychic TV and the Temple in the media. TV stations baulk at properly reporting the phenomenon (like LWT turning down Ben Elton's ideas for a 60 minute *South Of Watford* special on the Temple), or punish those responsible for giving it fair coverage (Spain's TVE company

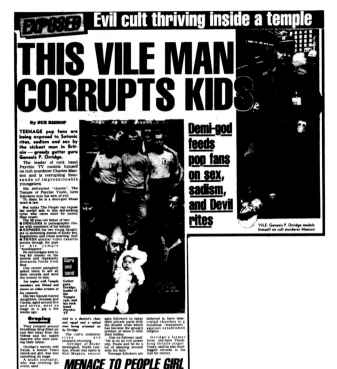

EXPOSED Evil cult thriving inside a temple

THIS VILE MAN CORRUPTS KIDS

By SUE BISHOP

Demi-god feeds pop fans on sex, sadism, and Devil rites

TEENAGE pop fans are being exposed to Satanic rites, sadism and sex by the sickest man in Britain — greedy gutter guru Genesis P. Orridge.

The leader of rock band Psychic TV models himself on cult murderer Charles Manson and is corrupting thousands of impressionable youngsters.

His self-styled "church", The Temple of Psychic Youth, lures followers into his web of evil.

To them he is a demi-god whose word is law.

But today The People can expose the sordid side to this self-seeking cynic who cares more for money than music.

The 38-year-old father of two:
● INDULGES in pornographic rituals with members of his temple.
● EXPOSES his two young daughters to sickening scenes of kinky sex, flagellation and ritual scarring. And
● SENDS similar video cassette scenes though the post to his temple "worshippers".

He encourages kids to beg for money on the streets and repeatedly demands funds from fans.

One recent pamphlet asked them to sell all their records and send the money to him.

Sex orgies with Temple members are filmed and shown on video screens at his concerts.

His two blonde-haired daughters, Genesse and Caress, aged around five and seven, were on one stage at a gig a few weeks ago.

Groping

They jumped around breathing drug-filled air just feet away from the videos and ten naked dancers who were pawing their father.

Orridge's weirdo wife Paula, a former Tesco check-out girl, was also cavorting on stage.

A music journalist, who was covering the event, said:

❝ It was a sickening sight. Those kids could see satanic groping, Satanic images of Christ burning on the cross and a woman with a snake crawling over her naked body. He is sick.

Videos went through the post to Temple members include First Transmission.

It shows scenes of a pregnant woman being

VILE: Genesis P. Orridge models himself on cult murderer Manson

Guru and band

Gutter guru Orridge, leader of the Temple cult, and his rock band Psychic TV

tied to a dentist's chair and raped and a naked man being arrested on by Orridge.

The cult's initiation rites are stomach-churning. Orridge, of Stoke Newington, North London, whose real name is Neil Megson, encour

ages followers to spear their private parts with the double cross which has become the group's symbol, or tatoo it onto their bodies.

One ex-follower said: "He is on an evil power trip. Paula and he do a lot of sleeping around with the fans."

Teenage followers are

believed to have desecrated churches in a mindless "statement" against established religion.

Orridge's former lover, one-time Throbbing Gristle singer Cosey, said he also bootlegged records in his lust for money.

MENACE TO PEOPLE GIRL

PEOPLE investigator Sue Bishop has first hand experience of the menace of Genesis P. Orridge.

She left her home telephone number with cronies of the pop star in a bid to get an interview with him.

A couple of days later someone claiming to be from a local newspaper tricked her boyfriend into giving Sue's home address.

PEOPLE REPORTER

The next day, after various silent phone calls, a bouquet of flowers arrived — in a blatant attempt to make her boyfriend jealous.

With it came a loving note thanking Sue for a wonderful time.

Then Orridge turned up on Sue's doorstep at

1.30 am, dressed in the gold top hat he wears on stage, and woke her up by persistently ringing the doorbell.

She saw off an accompanied by two cronies and rang the police.

They picked him up two streets away and advised him to stop.

The next morning Sue found the double cross symbol nailed to her door.

sacking the makers of the *La Edad De Oro* arts show after they did a special on PTV watched by 14 million viewers, many of whom complained after the programme was aired). Record executives are also hot for the group one minute, then remarkably cold the next (contracts apparently being nixed at boardroom level). PTV's paranoia doesn't give credence to the notions of suppression, but the incidents are there most brazenly illustrated in the pages of the Music Press and the trendy listings magazines. With their notoriously fickle, censorious and sanctimonious reportage, they remain the most consistent culprits.

Young, untrained cub reporters are (having just left home), likely to be prey to feelings of insecurity and confusion about their identity, so in the facile world of 'Pop' subjects of substance are targets to get the poison pen into and create a name for oneself. That may be forgiven. What cannot be forgiven is the creating of a climate where everything new or potentially serious is automatically derided, where blanket cynicism is somehow presented as being superior to investigation, where 'style' is championed over substance.

Although P-Orridge has prompted reams of misinformation and openly hateful reporting (often penned by the most supposedly 'liberal' of stringers), the situation has generally improved over the last few years. Genesis appears either to take the piss out of card-carrying NUJ enquirers and feeds them the sensationalistic claptrap they furtively desire – spiced with a sarcastic humour that's often received as

obtusely as it's reported; or, he adopts an opposite approach, being sickeningly pleasant and lucid in this tea-trollied scene of domestic bliss, daughters and dog always on hand.

"It can be very disillusioning," says P-Orridge, blowing into his tea. *"You just end up not wanting to have anything to do with the majority of this society. Because this society now really seems to exist through its media more than in any other way. And the media are generally absolute low-life. Intellectually small and very unskilled at their job."*

After the initial shock surrounding the group's explosive debut in 1981, reporting of PTV – albeit on the most innocuous of levels – has gradually become more positive. P-Orridge attracts much deference in some hip circles, (even though few of these same people know what he is actually doing), as if the system is now trying unconsciously to absorb him and his group into its antiseptic void – over tea and sympathy – just as it did with Crass (arguably the only other British group in the last decade to present such a precise, informed and genuine threat). Journalists like flirting with groups and individuals they perceive as being 'threats' (hence Nick Kent's obsession with Keith Richard of the Stones, for example) providing there is nothing serious intended. But groups who offer anything more genuinely subversive than gobbing on handicapped kids or puking up in airport lounges are either ignored or somehow made safe. In a world where no-one remembers what you wrote last week anyway, it may not matter, but P-Orridge, having now spent most of his life in the public eye to varying degrees, is a past master at such media games and is well aware of the irony implicit in the media's current, often positive, treatment of the Temple.

That irony being that the Temple *does* do some of the things the suspicious press hates it for. It does, however, do them for different reasons than the press generally presume or are even able to perceive, and it does them with a degree of responsibility and research usually unheard of in the fly-by-night microworld of Pop, as we will discover.

Still though, given the level of misinterpretation, misinformation and downright bloody-mindedness that has hallmarked the reportage of PTV, The Temple, and his earlier outfit Throbbing Gristle, it's hardly surprising that the most common impression people have of P-Orridge is one of almost total misunderstanding. Perhaps another reason for this is that the only constant running through his life and work is that it is in a state of permanent flux. In a system purporting to be based on anti-dogmatism, active research and observation, and the shunning of formulae, it could hardly be anything else. As such it would be impossible to form a finite opinion, draw a conclusion, entirely agree with, or entirely subscribe to, the P-Orridge model for living, or 'join' his cult, so full as it is of apparent contradictions and confusions. And that, of course, is exactly what it

Coum Transmissions performance

TG in Garageland

must be if the tribal, belief-based system of Control is to be subjectively perceived and demolished.

The Temple is a movement that combines several sets of values that are not easily harmonised. For example, on the one hand it exhibits a ruthlessness, always seeking conflict; on the other, it cherishes literature, philosophy and the arts for their own sake. As Bertrand Russell pointed out, this sort of superficial contradiction need not be wrong-headed. These were, in fact, just the values that often co-existed in the Italian Renaissance; embodied then by the likes of Popes who'd employ mercenaries and wage wars, while preaching peace and commissioning Michelangelo, and embodied now in the likes of Pope P-Orridge. A man given over to wearing 'secular' dog collars while overseeing what he thinks of as something of an art and social movement.

The Temple itself is based on such apparent paradox. Its ideas must not be presented in a dogmatic manner, but at the same time it must communicate in ways in which people will understand. Its methods and terminology therefore take on the form of illustrations, borrowing elements from religious and political groups and their media in order to investigate the effects of their conditioning. A rather convenient double-bluff is played as such avenues are still used to service the spreading of the Temple's own substitute propaganda.

P-Orridge himself must shun the cult adoration and trappings of 'leadership' his undoubted charm and intelligence foster, or he risks encouraging 'followers' who are quite happy to relinquish responsibility for their own lives and in so doing nullify what are claimed to be the true desires of the Temple. He's aware that he often skates on thin theoretical ice, but in finding himself the focus of attention, is not one to pass up any opportunities for publicity. He is, though, far from being a star.

Stars are unavailable. They are inaccessible but for glossy stills and short bursts of activity on pieces of plastic and celluloid. Few are as consistently self-deprecating or as just plain silly as P-Orridge can be, and who ever heard of a star saying he was "uninteresting" in one breath and then encouraging the people who come to his performances to bootleg them in the next?

Many hectares of newsprint have been devoted to the subject of P-Orridge, particularly concentrated on his supposed 'weirdness' and vision, his disillusionment with society from an early age and his remarkably intricate responses to that situation. Few articles seem to have satisfactorily explained, or even identified this disillusionment and its twin feeling of isolation that would, in many individuals, have resulted in a life of crime or more lonesome social maladjustment.

Behaviour patterns and modes of thinking are not only created by external forces, but also by internal ones. We are all products of conditioning, but we are also all products of chemical balances within our bodies. Gen's test-tube contains an illuminating imbalance.

Being treated with steroids for an asthmatic condition when he was four years old, his faith in the medical profession was (and remains to this day) shattered when it transpired that the side effect of the treatment had caused irreparable damage to his adrenal gland, leaving him unable to produce his own supply of the vital drug. To remedy this, he was to have to take regular does of adrenalin in tablet form.

Genesis P-Orridge

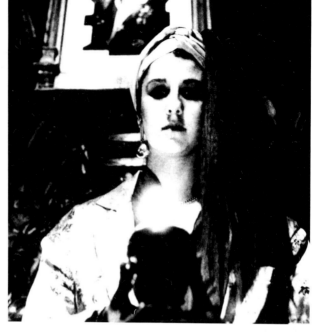

Paula P-Orridge

"I am split in different places
I am split from everything
...All this energy destroys me
Killing my security
...Adrenalin creates this law
And gives me hope for life again"
—Throbbing Gristle, *(Paper Thin) Adrenalin*

The body's daily requirement of adrenalin obviously being variable, the artificial dose is through necessity set at a constant high, meaning that not all of the drug available will be used – the body simply absorbing and breaking down the excess drug. Any chemist will tell you, however, that adrenalin can break down to something resembling LSD-6. Harmless enough, but meaning that P-Orridge has been on a steady, if infinitesimal trip for the last thirty odd years.

"Normal people experience somewhat the same thing as mescalin users when they have whipped up their adrenal glands with intense anger or fear... For when adrenalin decomposes, it produces adrenochrome – and an intoxication with some of the symptoms of mescalin. These may include brief lapses of reality – awareness, intensified appreciation of common-place objects, either actual or imagined, and exaggerated emotions of fear and hate."
—Dr. Claude William Chamberlain, *'Magic Land Of Mescalin', Fate* magazine, Vol. 9, No. 1, 1956.

This fact was borne out most startlingly when Gen experimented with hallucinogenic drugs in the '60s – once dangerously taking twelve times the normal dose of LSD and being thoroughly disappointed with the resulting state of near-normality. *"The colours on*

the carpet got a bit brighter," as his friends crawled around on the ceiling being generally wacky.

For all this, he was a fairly ordinary kid, although he has in the past gleefully admitted to the fact that he was more sexually active, and mischievous at an earlier age than most, enjoying such things as once running through town in thick fog with his willy hanging out (he is in fact an exhibitionist to this day!). Another clue to what was to follow came when he was nine, when he says he went through a phase of liking nothing better than going into the corner of a field alone and using twigs, knotted grass, sticks and stones to build...altars.

"I'd spend hours laboriously marking out areas and making clearings and painstakingly build them. And I remember taking great pleasure in the thought that with the first gust of wind, or rainstorm, it would all be blown away."

Even then, the nine-year-old minimalist took more pleasure from the process of creating than the creation itself.

Recording songs and poetry by the age of twelve he continued through school as a fairly normal pupil. His small physical stature made him a target for bullies, and it was no doubt from here that one of his present-day interests – a belief in the concept and practice of self-defence – evolved. He once "defended" himself in the classroom with a penknife, and was surprised to find blood trickling out of his assailant. The experience was committed to vinyl decades later in TG's song *Blood On The Floor*.

At the age of seventeen he seems to have become, as is normal, disenchanted with what life had to offer, particularly as he was disliked and picked-on by certain members of the school staff. He then hit

upon an idea that, again, has been used on a number of occasions in his later life. He turned the tables by confusing peoples' expectations of him. Already an agnostic, if not fully fledged anti-Christian, he became secretary of the Sixth Form Christian Discussion Circle.

"From then on I was protected from everything, even when I was being very naughty, because I was secretary of the Christian Discussion Circle, so I MUST be a nice boy. And that was when I learned that reversing your normal response often has a potent effect. Often bashing on a brick wall is a lot less constructive than walking around the side and shaking someone's hand while still carrying the bomb secretly in your back pocket."

By the age of 18 he was taking Sunday School classes. *"I did that because I was interested in the structure by then, and seeing how people were trained. While doing it I just trained the children there to be thoughtful, and not be the kind of people who'd consciously do others harm. I just used a flimsy web of Christianity as camouflage for that. I was brought up a Christian."* (surprisingly C of E, not Catholic). *"I'd had to go to communion every week and drink the blood. The only good thing about it was to see these very respectable people kneeling and guzzling blood and eating human flesh. I remember being very disappointed when I was young when I found out it wasn't real blood. I really felt cheated. Maybe that's why I've been disappointed in the Christian Church ever since."* Well, that's Christianity in a nutshell. No flesh. No blood.

Passing his exams, he entered Hull University, having chosen a telling curriculum of Philosophy, Sociology and Social Administration – the very structure of society. He'd ignored advice that he go to Art College thinking it "too obvious" a move, and unlikely to be able to teach him any practical skills that he could not learn himself somewhere else if and when they were ever needed (nobody, for example, ever gave him classes in how to use a recording studio).

A difficult student on what he thought a lousy course, he dropped out and lived in a succession of hippy communes based in squats all over England. It was from here that he started becoming involved in Performance Art, and his writing and poetry flourished. He contributed to a string of magazines, including the notorious *OZ*, and other titles like *I.T.*, *MOLE*, and his own, *WORM*. No less than the *Times Literary Supplement* had him pegged as "the most promising young poet in Britain". Faber are thought to have eyed him with interest, and the likes of Richard Murphy and the man who denounced the junket of Poet Laureate, Philip Larkin, tried to persuade him into becoming a serious poet (just like they were).

Unusual ideas were already marinating in Gen's mind, though, so instead the luverly lad joined a greasy gang of Hells Angels – performing oral sex with six of them as part of his initiation – and then

went on to develop an interest in areas of communication which avoided the written word. Performance, music, and visual art. Eventually becoming deeply involved in groups such as (don't laugh) The Exploding Galaxy, Trans Media Exploration, and (with girlfriend, artist and porno model Cosi Fanni Tutti, now of the Creative Technology Institute) COUM – the logo of which was a semi-erect penis, dribbling with semen, beneath it printed the words 'We Guarantee Disappointment'.

About this time Gen found an ally in the crumpled suit of William Burroughs. It all started when Genesis wrote a fan letter, to which the novelist replied. Gen then sent him a shoebox containing a plastercast hand with the thumb missing, and in the box he secreted a typically enigmatic note saying 'dead fingers thumb', adding only his name and phone number.

When, a few days later, Gen arrived home, a friend – and fellow Burroughs junkie – told him that he'd received a phone call in his absence.

"Who was it?"

"Some wanker pretending to be William Burroughs."

"It probably *was* William Burroughs. What did you say to him?"

"Oh shit. I told him to fuck off. I just told William Burroughs to fuck off and stop pissing about."

Fortunately, Burroughs persevered, inviting P-Orridge to his Duke Street flat. The two have since remained friends, resulting in "Uncle Bill"'s appearances at *The Final Academy* series of events organised by The Temple at Brixton's Ritzy Cinema. The three-day event, put together by P-Orridge, included performances by 23 Skidoo, Cabaret Voltaire, and readings by the poet John Giorno (once the lover of Ginsberg, and also of Warhol's *Sleep* film fame), Brion Gysin, Kathy Acker and the debut of PTV. P-Orridge is also the proud owner of probably the most complete collection of Burroughs books, videos and memorabilia in the country. It was he who the BBC wheeled out to talk on Radio One about Burroughs on the release of the Factory/IKON Burroughs videos, and he was also the person who supplied BBC 2 controller Alan Yentob with much of his material for the 'Arena' documentary on Burroughs' life in 1984.

Besides Burroughs, the primary influences on his life and work are not hidden. In fact they are made obvious by the pictures that hang on his walls. A Gysin painting; a large framed photograph of Crowley in full masonic uniform (looking ironically like Mussolini, the man who kicked A.C. out of Italy); an original Austin Spare; the only surviving portrait of Harry Crosby given to him by the sado-masochist writer Terence Sellers.

Crosby was a Boston socialite, a born millionaire who devoted himself to living life to the full. He inherited a library of several thousand books, but (saying nobody needed more than 200 books in their collection), he set about giving the rest away – discreetly depositing priceless first editions on the

shelves of secondhand bookshops! He married 'pretty' Polly Peabody (said by some to have been the co-inventor of the bra), having stolen her away from her alcoholic husband and carrying her off to Europe in a white Rolls Royce which he later burnt on the beach at Monaco. Saying that he couldn't spend the rest of his life with anyone calling themselves 'Polly' he dubbed the love of his life 'Caresse'.

He spent most of his remarkable life partying, writing, and offloading his vast inheritance by patronising the arts. In order to give himself the sense of panic necessary to ensure that he *lived* life to the full, he promised his friends that he'd be dead by the age of 30. He proved true to his word. On his 30th birthday, Harry Crosby killed himself.

In investigating P-Orridge, one could do worse than look at his heroes. Crosby embodied both decadence and despair, the essential gemini stars in the firmament of Cult Art, and tempered this with a conviction shared only by the likes of a Mishima. Gen admires conviction.

By the mid '70s he was involved in Mailart, (a peripheral member of the Fluxus movement that included La Monte Young and Joseph Beuys, and a correspondent with the likes of Anna Banana and Monte Cazazza in San Francisco), and, again, his contacts made during this time, such as Al Ackerman, and the influence of the philosophies of people such as Fluxus' founder George Maciunas, show some bearing on the later work of The Temple, who, viewed in this light, close-up, appear not so much as a Satanic Church, as a Mail Art movement focused on religious imagery and various forms of ritual.

Some of P-Orridge's mailart in the '70s was considered obscene. He was prosecuted for one of his postcards, (which depicted the Buckingham Palace garden with a large female bottom poking out of some bushes), taking legal advice from Lord Goodman, and being represented in court by the same Q.C. who'd previously successfully defended Linda Lovelace and the OZ editors, but who failed miserably in the case of the GPO v GP-O. So, in a world where it is an offence to offend he was landed with a £400 fine and unofficially sentenced to a life of having his mail tampered with.

His charming public image was further polished in 1976, when he and the other members of COUM staged the infamous *Prostitution* exhibition at the ICA.

The show included, among an unreported bulk of painting and sculpture, a selection of tampon exhibits. Tory loonies like Nicholas Fairburn MP, who had been invited to the show, reacted by going predictably bonkers. The owner of the ICA building in the Mall was not amused. It made it look as though she was living off "immoral earnings" by allowing the event to be put on, and her house, after all, was only down the street (for it was she – the lady with the bottom).

The gutter press pounced. Screaming from their usual platform of mock indignation, they slammed

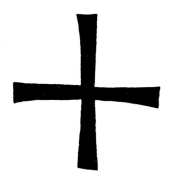

Pernicious, suspect

Poisonous

Very poisonous, deadly

P-Orridge (with his Arts Council grant) for being disgusting and immoral in columns wedged between lurid reports about horny clergymen and the inky paper flesh of Page Three breasts. He complained about their lies and misreporting of the affair to the Press Council, but it was too late. In the eyes of Fleet Street over a decade later, Genesis P-Orridge is still thought of as 'The Tampon Man' – a thoroughly nasty piece of work. After all, wasn't it he, in 1971 (5 years before the Pistols) who had committed the ultimate crime; hadn't he gobbed on John Peel? He had.

Although he now views his involvement with the Art establishment with contempt, saying that its petit bourgeois mentality and misunderstanding of what he was doing was detestable, and his and others work at the time largely "rubbish", the image was set, and stuck; he found himself framed in a picture of his own making. Besides being an 'artistic statement' as valid as anything else in the Institute of Contemporary Arts at the time, the *Prostitution* exhibition revealed much about the supposedly liberal art world and also the news media, and, important to our story, Genesis P-Orridge had created the only statement demanded by the arts community in a media dictated society – a persona. *"An achievement in some ways, and also an albatross around my neck in others."*

Presently, Gen appears to have attempted to divorce himself from the Art World by adopting a simple, yet effective ploy. He has substituted the word 'Art' with the word 'Magick'. He once wrote: *"I do not believe that ANY art has intrinsic value. It is a result, it is not the thing itself. It is expression and description; not experience, it is residue. It is means. Magick is the only medium that can be*

both."

In consciously distancing himself from the Art world, he successfully removed himself from the influence of the superficial consumerist ethics which the art establishment expounds. As an 'artist', P-Orridge felt suspicious, embarrassed and uncomfortable. Now, as a Magick Man, he feels at ease. Even if this new definition has resulted in problems that would not be shared by someone clinging to the title of "Artist", as that term still affords some understanding and tolerance in the community not given to these strange "occult" types.

As the *Catalan* video decays into static, little Caresse rolls languidly off the couch and gambols across the field of powder grey carpet to play with the two large Mickey Mouse helium balloons that float inanely a few feet above the floor – a present from Daddy. The antique lace curtains billow and the room is livened by a breath of morning Hackney breeze, finding P-Orridge discussing lack of energy in the morning. The tape switches to real time.

"You know why it is don't you? It's obviously biological."

Err, bio-rhythms?

"No. You assume that people transmit frequencies, pulses. You know the evidence."

Zuccarelli's holophonics, the Black Box, Dream Machine, Tibetan trumpets which resonate at frequencies that affect our frequencies and produce aurally-induced orgasms, Dr. Rupert Sheldrake's theory of Morphic Resonance – everything from radionics to Madame Blavatsky's auras would seem to point in that general direction. But how would that effect us in the morning?

Gen is reminded again of the past, revealing more of his exploits with the enigmatic Trans Media Exploration and in the process, more of the drives that motivate him and the Temple today.

"I was with them in 1969, they had grown out of the Exploding Galaxy. The people there used to talk about this guy who'd been with them who used to make strange plastic capes with all objects and things in – Derek Jarman. Then in 1978 I met up with him in person. Anyway, Trans Media was a very strict commune. You couldn't sleep in the same place two nights running. You had no money or clothes of your own. The clothes were all kept together in a box so you just chose something for the day from it. Meals were always at different times. Everything was affected, even food. No standard recipes were accepted, so you had to improvise. We'd also do things like wake each other up at odd times of the night. It was very tough."

Thus the seeds had been sown. He learnt not to ASSUME anything as being OBVIOUS. To learn what form of behaviour was habit, and to what extent the breaking of those ingrained habits and expectations affected reality. Reality being the way one experiences life. To become self-reliant, through varying rigorous forms of self-discipline, so as to be more able to investigate life subjectively and come

up with one's own conclusions and solutions to it. To be as non-lazy as possible. Such a lifestyle explains why his opinions are often so unusual, and inevitably unpopular. On a practical level, it's also an explanation for why he's amassed such an enormous body of work.

One Trans Media experiment was an attempt to crack, or at least tamper with, the limitations of Language – itself a key to 'Control' and a long obsession with the literati, from Orwell and James Joyce, to Burroughs and Anthony Burgess. The interest in language has expressed itself in a number of ways; indeed, one need only read Gen's contributions elsewhere in Rapid Eye to see that he still uses a personalised, highly idiosyncratic form of writing. An early experiment involved his attempts to build a typewriter that produced a form of non-linear writing.

"It could be used to form codes and hieroglyphs as well as shapes and forms of lettering, a type of writing that was more visual and less static. We were interested in breaking people's ways of looking at things. Writing in that way meant that people weren't looking at straight words or letters, and so they had to be looking at what the words were made from."

Editing this symbolised Newspeak not only made it more efficient than linear writing, but also more idiosyncratic.

"People either had to build it back up into letters they could see again in their head, or had to learn to decode it like shorthand"

Even when 'cracked' and read almost automatically, it could still be used to write private messages to other group members, or changed at will, depending on meaning and mood. But this invites criticism. Of, in this case, the language, and more widely any 'alternative' structure. As applicable to The Temple as it is to Trans Media. In doing all this, isn't one just replacing one structure, one language, one mad form of belief, with another? And if so, what's the point?

The point is, of course, not necessarily the results of the activity, but the taking part, the research. In the case of the language, learning the nature of language-Control (even with the widest of vocabularies), and the limitations inherent in any form of communication, and creating an individualised alternative that may communicate ideas and feelings that have up to that point remained muted by conventional expression. If nothing else, the understanding of such esoteric language defeats laziness, negates the conditioned passive role of acceptance and expectation, and promotes more inter-action between writer and reader.

Another advantage of creating such a flexible, visual form of written communication lies in its magickal applications. The meaning of such symbolism can more easily be forgotten by the conscious mind – a positive disadvantage in normal use, but not so when you are later using the

symbolism you have created in sigilisation for example – which we will go into later.

Trans Media's disorientation of logic and expectation, its mischievous Boy Scout pseudo-sect mentality and its interest in *observing process* rather than *creating product* seems to have been something of a blueprint for what was to follow.

But where does Frequency fit into this jigsaw?

"One of the linguistic things we had in Trans Media as a discipline was that there are two types of people. It was only a simplification to express an idea, it doesn't really mean that we thought there were two kinds of people, but for ease of description there are these genealogical terms, and one of them is 'quaquaversal', which apparently means 'pointing in every direction simultaneously'. And there is another word, 'centroclinal', which has the definition of being 'the opposite of quaquaversal'."

Genesis smiles and looks rather pleased with himself. The language creaks and finds it hard to cope. Trans Media loved playing with such ideas, it seems.

"We, and in fact most people observed that as you said, it was easier to work very late at night as opposed to in the morning. And our glib but semi-serious explanation for it was that the

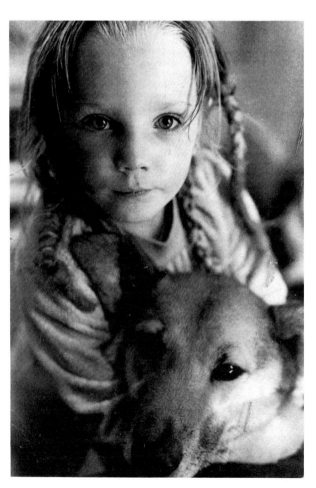

Gen's elder daughter Caresse, and dog, Tanith; both recording artists with PTV. (photo: Zbigniew Szydko)

centroclines – the people who don't want to wake up, don't want to look around and do anything, that squidgy, lard-like mass who individually are fine, but corporately generated an incredible amount of centroclinal energy. We didn't say negative energy, because the word 'negative' implies a moral judgement, whereas 'centroclinal' implies... wasted, a big black hole. So, when the centroclines went to sleep in their little suburbs and so on their brains slowed down a lot and their centroclinal emissions dwindled."

Creating more space?

"Yes, allowing the quaquaversal energies to pop out and fill the void."

But the centroclines on the other side of the world would still be awake anyway.

"Well I think we decided that the effect of the energy was more obvious the closer you were to the source; it was more powerful locally than globally. If you're next to someone who's trying to punch you in the mouth it hurts more than if somebody's trying to punch you when they're in Japan, I guess." Gen, as you will have noticed, loves parables.

Flashing back to Present Time the Sony booms out as Caresse dances with Mickey across the little ballroom in her head. PTV's breakneck version of The Beach Boys *Good Vibrations* (a frequency pun?) sweeps the conversation off its feet. The single was released in 1986 and, aided by a wonderful pastiche video shot during the group's US tour in California, reached the lower regions of the national charts. Although officially a Psychic TV release at the height of P-Orridge's interest in "Hyperdelia", the record was originally intended to be put out on 'The Process' label by *The Process*. The Process is not a group. Confused?

The Process is another piece in the mosaic of minor and often unpublicised projects that make up P-Orridge's career. The Process, with its obvious implied references to Brion Gysin and also to Dr Robert De Grimston's cult of the same name, is the way in which a thing is done. Its method rather than its identity (the band), or the results of that band's activity (the 'record'). The Process also produced a killing version of Gen's favourite Stones song *As Tears Go By*. The process adopted for the realisation of the project that has produced these two wax almadels was to gather together several interested musicians – such as Rose from Strawberry Switchblade – and use several instruments as they were used on the original '60s recordings, reproducing the originals in more palatable wall of sound disco by using state-of-the-art 1980s recording technology.

The general reaction to the single was that it was pretty, but, coming as it did from P-Orridge, rather pointless. Indeed, Genesis is so revered among the ageing, pseudo-intellectual pop fraternity that they had forgotten he was capable of releasing records purely for the fun of it, and as subject to influences as the next man. Visiting his house at the time of The Process project, one would note the cogent fact

that a well-thumbed copy of Warhol's *Popism* lay on the P-Orridge coffee table.

There were, of course, other reasons for the *Good Vibrations* release. He does have a wife, family, and mortgage to support. Despite advice, he has never watered down his weldgeist to a more weedy, acceptable consistency and gone hell for leather for the money – but The Process single was an undeniable step towards solvency, even though most of the money it made was ploughed back into the Temple's more esoteric projects.

Obviously, the fund-raising activities of PTV are also more accessible than was the mottled sheet of experimental sound that was TG, but even now they are hardly an easy pill to swallow, and anyway, the metamorphosis from abstract electronic din (an experiment in muzak and its effects on frequency) to the dark pop of PTV (an experiment in pop ritual and its effects on frequency), was an aesthetic desirability rather than a tactical manoeuvre.

P-Orridge though, on the bottom line, makes no bones about the fact that the money from such projects as the Process is needed. Alex Fergusson (late of Mark Perry's ATV and Fred and Judy Vermorel's naughty Cash Pussies) has got to be one of the great bedsit-bound pop composers of the moment. Due to his association with P-Orridge though, he has had to earn his living as an usher in a West End cinema. For his part, Gen – recipient of the odd royalty cheque and director of several Temple companies, is better off, though far from rich – despite rumours to the contrary based on false assumptions based on PTV's previous record deals.

Even though Psychic TV signed a whopping million-pound rolling option contract with CBS, all the £30,000 they actually received from it was spent on the recording of the *Dreams Less Sweet* album – along with £3,000 of the Temple's own money on top of that, borrowed from Some Bizzare's Stevo and raised by such events as the Marc (Almond) and the Mambas Temple benefit performance in London.

A large chunk of the vast recording costs went towards the use of Hugo Zuccarelli's Holophonic recording system. Zuccarelli is a thirtysomething Argentine physicist. He worked at the Cathedral of Brain Psychology in Buenos Aires, conducting research into sleep and dreams, specifically concerning himself with external induction of visual stimulation and memory. He later studied in Milan, where he worked on electronic and magnetic fields. It was here that he formulated the idea of Holophonics, the audio equivalent of Holography. Approaching the subject of recording from a neurophysiological, rather than from an acoustic/electronic angle, Zuccarelli works on the principle that listening to sound is an active, rather than a passive experience. From Edison onwards, we have listened to recordings of the mechanical vibration created by a sound source. This does not take into account the effect such sound has on the frequencies which emanate from the listener. Recording vibration from the source is only half the

sound picture; the other half is provided by the listener, giving sound a spatial quality.

For example, if you were listening to a recording of a voice that has been made with the person speaking standing 25 feet away from the microphone, you would hear a very faint voice – you would hear a bad recording. If, on the other hand, you were to hear someone talking to you from the same distance in a room, you would know that the person was about 25 feet away, how loud he was talking, and where he was standing in relation to you. You would be hearing reality. Holophonics, in giving sound a three-dimensional quality, is the recording of that reality. The sound is recorded without microphones in the ordinary sense of the word, through a dummy body, complete with skull, ears, hair, internal juices and cavities. What we hear through the dummy (called 'Ringo'), is the interference between the sound source and the reference tone given off by our – or in this case, Ringo's – ears. The brain is then able to interpret the result and give it a spatial quality.

Rubbish? Hype? Here is what Fleet Street had to say at the time:

"In the past few weeks several music and Fleet Street papers have written stories about Psychic TV's album. The group ostentatiously proclaim that it's the first "holophonic" record ever to be released and that it allows listeners to hear "3-D" music. Bunkum! After hearing the album I reckon the only strange thing about it, besides the bizarre music, is someone shaking a matchbox around at the end of the final track... Radio One DJ Richard Skinner, who interviewed Psychic TV last week, describes them as 'inventive comedians', adding 'All they're doing is using a very old stereo sound technique'."
—Peter Holm, The Standard, 24.11.82

"Stand by for holophonic sound, which is set to become one of the major technological breakthroughs of the '80s. After my rather sceptical piece on Psychic TV last week I was contacted by the inventor and given a special demonstration – and I can vouch that the effect is staggering... it was as if the noise was passing in front of my face and then going around the back of my head... a perfect 3-D effect, in fact, and most extraordinary was that it was no different through only one headphone,

meaning that it had nothing to do with conventional stereo... holophonics can also encourage visual stimulation."
—Peter Holm, *The Standard*, 1.12.82

Auto-suggestion perhaps? Well several people don't think so. Rick Wakeman, Stevie Wonder, Kate Bush, Vangelis, John Williams and Pink Floyd queued up to use the system first, and Paul McCartney wanted to buy the patent. Zuccarelli though, turning down vast sums, wanted his invention used by someone who would be able to understand it, appreciate its uses and use it with imagination, and with some courage of conviction, held out and chose PTV to be the first group to be allowed to fully record with it. Gen grasped the opportunity, dragging the hapless silver-haired Ringo down into the caves used by Sir Francis Dashwood's Hellfire Club, into wet-walled sewers, crept up behind him, chased him with dogs, poured petrol around him and set light to it, and put him in a coffin and buried him. (When playing it lock the door, put the headphones on and turn the lights out. Even allowing for the usual disorientation caused, if you don't feel some sensations not normally associated with listening to pop records, then you're made of wood.)

The result was a beautiful, mysterious and mean record. Full of breathless oboes and mad pumping church organs wrapped around the songs and poems of the Temple, penned by Thomas Tallis, Jim Jones, Charles Manson, Monte, Jordi, Krafft-Ebbing, Alex and Genesis. A sort of *Psychopathia Sexualis* done in rubber, it became the hymnal of the Temple, but the record company couldn't give a shit.

PTV, who had, prior to the *Dreams* album already been dumped after the *'Force The Hand Of Chance'* LP for abusing WEA Records, were dropped by CBS. Perhaps they didn't like the sight of Gen dragging a handcuffed Marc Almond around their Soho Square offices, particularly when David Jensen was visiting.

Gen was back with the independents. Illuminated, Fresh, Fetish, Red, De-Coder, and Sordid Sentimentale are just a few of the labels on which he has (literally) scratched his thoughts, giving away the copyright and master tapes of recordings like TG's legendary *D.o.A.* to fans so as to encourage them to start their own record companies and in the process defeat the gangland bootleggers who had been getting bloated on TG's deleted endeavours by feeding record junkie youth and charging through the inflamed nose for the service. All very altruistic, but such an attitude to the record business, and money in general, has often left him broke.

Being well-known does have its advantages though. One visitor to the Temple is Anton LaVey, leader of The Church of Satan (a registered church in the USA). LaVey, liking the idea of TOPY, seems interested in giving the Temple's fledgling publishing outlet the UK rights to his unpublished books, such as the rather naff *Satanic Bible*.

Another connection made by Genesis may make it possible for Temple Records to release the early 'sonic experiments' of the Velvet Underground, yet another gives the organisation the rights to publish a compendium of Terence Sellers' work.

This writer once bumped into P-Orridge in a London cafe and was introduced to Peter Getty, who had Concorded over from New York to interview P-Orridge for his *Evergreen Review*. Peter, who on his 25th birthday will inherit a fair chunk of the family fortune, jetted his poverty-stricken interviewee over to Paris for a few days, Gen returning the favour by introducing Getty to the man who'd done some of the paintings that hang over both of their fireplaces back home – Brion Gysin.

A confirmed Samuel Beckettian (if such a breed exists), Peter is at present writing a play. Without the profit motive being paramount, such a thing is likely to be slated by the critics for lack of 'hunger', or some such contrived drivel regardless of merit, simply because society cannot really believe in anything produced purely for creative reasons – thinking it self-indulgent even though, ironically, its motivations must be the most pure and uncompromising.

The Process single, however, was criticised by reversing this logic. It having had no pretensions to being anything other than an enjoyable, affectionate homage to pop pap, regardless of how it was produced. Sixties styles, with their innocent Yasgur's Farm idealism now made tougher by the perspective given by time, is a current interest of Gen's, musically and spiritually. Just as the exotic strains of Martin Denny in an incongruous marriage arranged by P-Orridge to the techno-pop of Düsseldorf had been the primal source of the later work of TG, Psychic TV are now passing through a phase as eccentric Acid House popists, as opposed to post-punk shockists. A mood reflected in P-Orridge's current mode of dress.

The old militaristic image of the Temple – austerely black and grey, threateningly shaved and brutalised, was introduced (quite deliberately) as a fashion. The Temple, purporting to be a loose association interested in 'Individuality', took on a uniformity to test the individual and public response to it. To play a mischievous game with fashion in order to negate it. Just as the Temple plays with the behavioral patterns encouraged by organised religion.

Nowadays, gone are the black shirts and camo-jackets, the vaguely fascistic-looking badges and squeaky DMs that created a false impression to many passers-by in the British Movement infested backstreets of the East End. (The idea was really one of appreciating Design and Image and wresting-back the powerful look usurped by the Nazis. Though most people obviously got the wrong idea, trendy lefties accusing P-Orridge of being a Fascist while at the same time he endured several attacks on the street from right wing skinheads who called him a "Jew".)

Now, bored with the monotonous grime of London, the traffic jams and rain, the bearded Socialists, white high-heeled tarts and acres of grey

council housing, all is sweetness and light. It was not always so. TG once commissioned a clothes designer, their friend Lawrence Dupre, to design for them their own camouflage (there are hundreds of different types of camouflage available from around the world, and P-Orridge has quite a collection, but the group wanted a unique one). He came up with a rectangular-looking design in the colours of black, white, and various shades of grey. TG had the suits made up, and would often perform in their "urban camo" uniforms. Now, as a reaction to the prevailing sense of greyness, P-Orridge is often resplendent in silk sari, purple slacks and long ponytail plaited with multi-coloured strands of wool.

The term Genesis has coined for the style is typically loaded – "Hyperdelic", psychedelia forged with modernism. The Temple now talks of "Angry Love", a unification of the peaceful idealism of the hippies and the militant, perhaps violent protests of the Situationists circa 1968. A love which is selective, an anger which is justified, and born out of sheer frustration.

To Gen, Angry Love is the clarion call of a new, realistic radicalism. *"Radicalism is what you do, not how you look. Celebrate and activate! Don't destroy, deploy and decoy... Radicalism is given power by building, not by destroying. Each day that passes this society commits mass murder. It murders imagination, potential, possibilities in people of all ages and sexes, but most obviously in young people. They are encouraged to kill time with Smack, to kill optimism with sarcasm, and to hypnotise themselves with death by the daily wearing of Black."*

Angry Love is Timothy Leary's vision smashing into the immovable object of Thatcher's bitter British reality. As P-Orridge writes in a Temple Newsletter – *"TURN ON (control), TUNE IN (to your Self), DROP OUT (of Control)... We do LOVE, but in a 1980s way. We LOVE the fight, we LOVE hope... We feel ANGER, for all the obvious reasons."*

Angry Love means Stop Hurting Each Other. Not because it's the "nice" thing to do, but because it's a waste of time. It's a diversion from the true fight. Each individual's fight. The fight against complacency, puritanism, uniformity, prejudice, guilt, fear, conditioning. The fight against the social manifestations of CONTROL.

This newer, practical radicalism expresses itself in such things as the Temple-organised demonstration outside the South African Embassy in Trafalgar Square on the 14th September 1987, timed to co-incide with the start of the trial of Moses Moyekaso in Johannesburg, and in the series of Temple demos held outside Brighton Marina calling for the release of the dolphins forced to perform in its shabby pool (hardly activities usually associated with "Satanic"/"Nazi"/"Arty"/"Pornographers", one thinks).

Angry Love has been celebrated at a number of PTV events, such as the 'Riot in the Eye' day at the Electric Ballroom. PTV played with The Angry Love Orchestra and six other bands at the nine hour "indoor festival". Stalls sold "Hyperdelic Wholefood", there was a "Tele-Visionary Lounge" and disco, but did anyone remember to take their Mates condoms for the "Free Love Tent"?

Events such as Riot in the Eye encouraged people to make a personal effort, rather than simply attend a gig. To ignore current fashion and the ridiculous '80s media obsession with 'Style' as dictated by the smug, monotonous voices of Peter York and Lloyd Grossman – and to have fun.

A Riot in the Eye is caused by SEEING and OBSERVING just what is really going on in this society. The concept of Angry Love directs the anger this generates not towards a riot in the street, but to a constructive end. A rejection. An increase in perception. The tape loops back... *"Radicalism is given power by building, not by destroying..."*

Whatever the terminology employed, the Temple now seems to reverberate to the sounds of nouveau hippiedom. It just depends on your view of a hippie as to whether you think the association good or bad. If you are locked into fashion, it's irrelevant and obnoxious. But if you regard a hippie as someone who is likely to be actively seeking better alternatives, and creating for himself a life free from the trappings of compromise and the pressures of materialism and fashion, you probably think it's OK. Personally, I find the Temple's current attitude towards clothes a mite overstated. At a PTV Thames Riverboat party, for instance, invitations insist that you wear Psychedelic clothes or forego admission – much like the early '80s 'exclusive', 'alternative' clubs in the West End, who operated a dress code that ensured everyone was an 'individual', provided they looked like Marilyn, Boy George, or one of Robert Elms' ex-girlfriends. Indeed the attack on all things grey and black continues with each Temple Newsletter. Despite the fact that wearing blank, classic clothes, provided it is regardless of the fashion, *does* actually negate fashion, and reduces the amount of brain power wasted on the trivia of buying and choosing clothes. Quite how Individual (sic) one is being by going along with some of P-Orridge's style games is probably something of no importance to the dancing masses one can see at any PTV gig, but in this kingdom of the double bluff and the clever-clever, who knows or really cares? Whatever your view, the Old Grey Wolf has come out in his true colours and, in so doing, accidentally predicted the Acid House explosion of late '88.

"Coincidentally, I was using the term 'Acid Dance' before the term 'Acid House' appeared from Chicago."

Thinking about what P-Orridge was doing with emulators, voice tapes, his weird sound archive and the electronic, 'industrial' rhythmic discipline of T.G. in the late '70s, and joining those elements with his wild eyed pronouncements on Manson, Leary, The Process and psychedelia with the Temple organisation in the early '80s, it is hard not to see the link.

This linkage resulted in him collaborating with

Gen, having jacked the tab

Richard Norris, behind the anonymous guise of 'Noise Or Not', an in-house acid production team which brought out the *Acid Tablets*, a string of phoney 'compilation' albums of original "UK acid dance freakbeats", and also the excellent *Superman/Jack The Tab* 12 inch single – called "the finest Acid House record to hit the dancefloor in 1988" by the Melody Maker.

The roots and definitions of Acid House are open to question, but, as Gen says, *"One of the things that's universal in all interpretations of Acid House is a revival of the original idea of psychedelia, which is to take whatever technology is current – back then it would have been the wah-wah, the mellotron – and try to find the weirdest, most irrational thing it can do. That's what Throbbing Gristle were into. We bought a computer and converted it to do sampling way back in '76, long before sampling technology was invented. Six tape decks in sequence, throwing out sounds at random, creating rhythms and conjunctions."*

The Big Sound bounces around the cultural capitals and attitudes of the world like light on mirrors and lenses. Briefly, all the colours bleeding into the white strobe light of Acid House, a very '80s fashion focus which juxtaposes sounds and images and sub-culture plots and, in so doing, embodies a

moment, a moment in and out of time, that is the common feeling of disorientation and overload which comes from living in the media jungle of the early '90s.

"There is no message, but the music itself is a statement about media explosion and the acceleration of experiences that the human copes with under the effect of the mass media.

"At last all the different dreams and all the different threads that have gone in strange meandering patterns for about 15 years have all converged, WHOOOMPH! And what's so great is that it's all so open-ended, there are no rules."

The lyric-less acid beat provides P-Orridge with an ideal platform. No format, no rules. By early '89 he and other British Acid Housers were producing harder, weirder sounds than those emanating from the States and transmitting them back to the purist DJ's in Chicago. Three thousand American disc jockeys can't be wrong.

"It's gonna be like what happened in the Sixties. We took U.S. R&B and tried to imitate it, and in the process peculiarised it, got it a bit wrong, made it British and re-exported it to the U.S. on a massive scale."

Hence the Temple Records Acid House label, a Union Jack logo with an upside-down Peace Sign at its centre.

"The Mods used the Union Jack, which relates to the freakbeat, psychedelic Mod thing. The punks used the torn-up Union Jack. Now we're using it, only upside down, 'cos everything is reversed. Funny thing is, if you put the C.N.D. sign upside down, you get the rune of 'Protection'. So they got it wrong in the Sixties and for the last 20 years everybody has been parading around under the wrong symbol!

"I love Acid House as the music allows sarcasm and disrespect and experiment to become a credible way of life again. We were all doing that anyway, because it's in our nature. But for once, circumstances have conjoined with us. All the best ideas are inevitable, nobody owns them. All popular culture has become a fair target for re-working, stealing whatever bits you need. Music, TV, political speeches, cartoons, movies."

The post modernist ethos of creative plagiarism, the practice of experimenting with, re-arranging and personalising the bones of culture – the tenets of society – is a godsend to P-Orridge.

"Nothing is immune and nothing is sacred. And I've ALWAYS wanted to live in a world where nothing is immune and nothing is sacred. And no one could tell you what was the correct way to do something."

Though usually ignored by the music press, there have been several other PTV albums released since 'Dreams' hit the record stores in 1983; such as the *Pagan Day* picture disc, released at 23.00 hrs on the 23rd December '84 and deleted 23 hours later. Then there have been the three *Psychic TV Themes* LPs. Featuring Aleister Crowley singing in Enochian, piano scales that drift up into peaks like a healthy

sales graph, and the banging and blowing of human thighbone trumpets. The trumpets not only stretch the capacity of the Musicians Union (who still have problems with emulators), but are in fact a long standing set of ritual tools. Called 'rkan-dun' in Tibet where they originate, they are crafted from the femur of (supposedly) either a murderer, a person who died violently, or a virgin – their sound being thought to call up the restless spirit of the dead person. Many such thighbones are several hundred years old, often elaborately decorated in silver threadwork and semi-precious stones. The less deluxe versions are finished in long-lasting human skin.

December '85 saw the release of the superb PTV soundtrack to the Mantis ballet *'Mouth of the Night'*, an event which combined choreographer Micha Bergese (from *The Company Of Wolves* movie) with Jarman's set design and the most eerie, echoing score the troupe have ever danced to.

Being presented with a totally lifeless and unsuitable piece of music from the commissioned composer, Bergese wanted to dump the music and ask someone else to provide the soundtrack, but he knew no-one who could come up with the goods before the show opened at Brighton's Gardner Centre just six days later. Jarman phoned his pal, and within 24 hours PTV were ensconced in the studio, writing and recording the soundtrack around a video of the ballet's dress rehearsal in one 36 hour stint, and hot-footing over to Mantis at Pineapple dance studios in Covent Garden, giving them just two days to rehearse to the completely new soundtrack. The finished product resulted in the unlikely sight of P-Orridge's skills being raved over by beautiful ballerinas on MTV.

Early in 1987 The Temple was presented with a problem. Lack of a record deal and a lack of cash on the one hand, and a deluge of requests from the public asking for more PTV-related product on the other. Always original, Genesis then hit upon an idea that would solve both problems and be in keeping with his wish to make PTV as demystified as possible. At the same time, it would present The Temple as a living entity, using records and their covers as a regular platform for messages and diary, while at the same time having the added bonus of irritating the record industry. Between early 1987 and 1989, Temple records would release one new Psychic TV live LP on the 23rd day of each MONTH for twenty three months. All the records were packaged in almost identical covers, pressed in limited editions of between 3,000 and 5,000, and numbered in series. Retailing cheaply at around £3.50 each, they gave the fans what they wanted and the Temple the income necessary for its survival. The record shops hated the idea. The music press couldn't cope with the project. The music industry in general thought that it debased the concept of album releases – they preferred reviewing, selling, hyping and generally lauding LPs as if their releases were cultural landmarks of mammoth importance. "The long awaited U2 album, the Springsteen LP it took three

years to record you've all been waiting for..." As the rock giants spent hundreds of thousands on videos, recordings and merchandise, little PTV reverted – partly out of necessity – to the punk ethics that had inspired P-Orridge to form Throbbing Gristle in the first place, over a decade previously.

On an even more esoteric note, there was also the Jim Jones LP, made up of sections of the recordings made of the last speeches of the lovely Reverend and his followers, right up until Jonestown committed its communal 'suicide'. As a study in paranoia, mass hallucination and lemming-like control practices (Socialism and Christianity in this case), it's on a par with the closed, doped, opiated, homosexual order of assassins of Alamout – the Hashishin. A modern microcosm of the Control theory in practice that's still probably under the microscope in some dingy office in downtown Washington D.C. Temple Records produced a limited edition numbering 993 copies of the record, one for each member of the Peoples Temple who snuffed it for Jesus and the Guyanan camp – each disc being stamped in gold *'Dead Body Number One'*, *'Dead Body Number Two'* and so on until the grisly collection is complete. These projects – ignored not only because they are by definition not part of popular culture, but because editors do not think young people should be informed about things that offend their own Moony sensibilities – are, however, mere stop gaps between the last major album and the new masterwork, recorded by Psychic TV and The Angels of Light.

The Starlit Mire is a configuration of assorted novas. Pope John Paul, Anton La Vey, and the bleached, chlorinated bones of Brian Jones. If Crowley rears his shaved head at all, it's in deference to his role in *Sgt Pepper* rather than the unintelligible *Book Of The Law*, as this is the Temple at its most accessible yet. Brilliant light and dark hyperdelic pop and Acid House trash fashioned by now fully competent musicians with a sense of direction and a (third) eye on effect rather than purpose.

Due to lack of money the album sits, literally, on the shelf. In need of a few finishing touches that will amount to £5,000 worth of studio time, and the backing and distribution of a company with more muscle than tiny Temple Records – if that effect is to be widespread. Gen has tried to woo a new contract, but the majors just don't want to know. Whatever their promise and international cult status, PTV are just too much trouble, too mischievous, too sophisticated to take the risk with in these days of wavering sales and the return to glamrock heroics and idolism and the splintering fads of Americana – House, Hip Hop, Hi Energy, et al. Perhaps also they remember the stunt Genesis pulled on them a few years ago, sending all the big West One companies a 9-inch long solid brass dildo, each one carved with the corporation's names around the glans... CBS, EMI, Polygram... and stamped at the base with *'Psychic TV Fuck the Record Industry'*. The ploy cost hundreds, but all too often humourless, budget-

BRIAN JONES

‡

Died For Your Sins

watching A & R departments are of the attitude that they just don't want to get involved with people like them. Indeed, there is a lot of the 'People Like Them' attitude towards PTV. (Although *The Starlit Mire* has still to be released, sections of it have appeared on other records, such as the Temple Records album, *Allegory And Self.* Corporate small-mindedness has largely been countered through the use of their own independent label, which PTV use on occasions to air new studio material. Due to its small size, however, Temple releases can never compete with records released by the major companies, and are unlikely to achieve high chart placings due to lack of advertising, radio plugging, and distribution).

One thing that went some way to sweeten the large record companies and update the static public image of "Tampon Man" P-Orridge was the release of PTV's biggest selling single to date, *'Godstar'*, a song about Brian Jones. The one in the Rolling Stones.

"And you were so beautiful
And you were so very special
I wish I was with you now
I wish I could save you somehow..."
—*Godstar*, PTV 1985

"Well, when we were recording 'Godstar', I don't know if people generally know this but when we're using a 24 track studio we only ever use 23 tracks. It's just a tradition really. There's always one track free for...the unexpected. Well, the recording had gone on a long time and it got to an impasse point where we – these things always sound corny but I don't care – we were all so emotionally involved in it, everyone was in an intense state, and there was a strange atmosphere in the studio. We were all tired, we'd all been in there about a week and we'd put more into that one track than we had into any whole LP. And because of the subject we wanted it to be respectful, accurate and a reflection. Ken Thomas was there and an engineer called Mark Fishlock. Jordi Vallis of the World Satanic Network and some of Psychic TV. Anyway, we decided to do a Raudives experiment, y'know, like in his book 'Breakthrough' [Taplinger Publishing, NY, 1971] where he uses little diodes to record the voices of the dead on tape. So Hillmar, who's an electronics whizzkid made this diode, cat's whiskers thing. I don't know the electronic ins and outs of it but the

basic idea is that it's like a receiver without having any charge in it. It's supposed to screen any outside signals."

And leave the tape free from interference like radio.

"Yeah, leave the tape so nothing can get on it, to stop things being picked up. So we ran the master tape with the empty track, track 23, on 'record', and we all sat down and turned the lights down and did what you'd do in a seance. Trying to commune with... Brian Jones. And the first time we ran it through and played it back and there was nothing. Then the second time we ran it back there was also nothing. Then, the third time we ran it through there was a very clear, loud sound under certain words which Ken Thomas and the studio engineer said was like nothing they'd ever heard in a studio. Not an electronic sound, not an interference sound. It wasn't generated by any of the equipment, and we'd isolated the studio."

This was on track 23 when you listened to the whole thing or just that one channel?

"No. Just listening to the one track. Then we played it back with the whole thing, to see what it sounded like, and it was EXACTLY under the words 'I wish I was with you now'. Perfect beat, time, everything."

Will it be heard on the LP?

"No, only subliminally."

What sort of noise was it on its own then, an electronic noise?

"Sort of a... cccrroagghh noise! But it wasn't like the noise you get from radio interference. It was sort-of electrical, but also a hissing noise as well, but not one you could get if you sat down and tried to reproduce it. And it was really precise, split-second."

He also plays piano on the LP?

"Oh yes, well that was easy, not so mysterious. We just sampled his piano from 'Satanic Majesties', put it onto an Emulator 2 and we could play Brian Jones playing piano on the LP."

Have you credited him?

"Well no, that might cost us money!"

Godstar was released on the 28th February 1986 (the anniversary of Brian Jones' birthday) while the group toured Europe. The single reached Number One in the Independent Charts and featured in the Top Fifty of the national placings, selling some 40,000 copies between March and June of that year. BBC Radio One initially refused to give the disc any airplay amid rumours of disquiet from Jagger himself, who was understandably miffed at the song's finger-pointing lyrical content. P-Orridge compounded the problem at a promotion for the single staged at Virgin's Oxford Street Megastore, where PTV were booked to play a few songs. Grabbing the shop's Mick Jagger waxwork dummy, he proceeded to take it for a little 'dance' as amazed Japanese tourists clicked their Nikons at the clazy plonk lockers. The *Godstar* promo video, filmed on a tight budget by old T.G. ally Akiko Hada was picked up by cable channels SKY and MTV, and

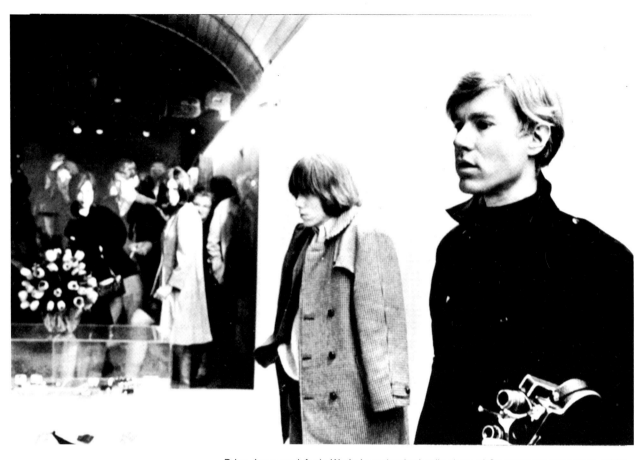

Brian Jones and Andy Warhol ponder the implications of Godstardom; New York, 1966.

P-Orridge was beamed into seven million living rooms in nine countries across Europe. He also featured in the most in-depth interview of his career when questioned on satellite TV by Gary Davies (he was not eligible for his 'Young, Free and Single' T shirt on any count). Pop Fame at last.

The release of *Godstar* was publicised in the form of 10,000 stickers, placed strategically around the country by Temple Initiates and sympathizers – in subways, trains, toilets, or cheekily in record shop windows. The first 5,000, looking like funeral cards, bear the simple message 'BRIAN JONES DIED FOR YOUR SINS'. The second 5,000, on first sight, appear to be the same, except a second piece of information has been added in the shape of a small black psychic cross. Enigmatic, subliminal, amusing? Some would no doubt say an attempt to be shocking and unnecessarily mysterious – a criticism levelled at every aspect of Gen's work.

Further qualification of most of the expressions of what is going on in his mind would defend his position. But just as simplifying and sanitising the image of PTV would probably result in their becoming a fairly successful, quite rich pop group, it would also tend to defeat the object. What point releasing a record or T-shirt or sticker if you have to attach a book to each explaining, in more straightforward terms, just what it all *means*. Such is the quandary of any artist if his motivations are not purely commercial. The line you draw between the History and the Mystery, the Appliance and the Science, could be the one used to hang you from.

"Well, as with anything you do, hopefully, that sticker is the top of a pyramid. It could just as well be a book, a feature film, a record, a social movement. That's why I can see what Derek (Jarman) meant when he said to you that it's very hard to explain anymore. I can't give you a whole answer. I can try."

Consider it an exercise. That sticker works on a variety of levels.

"Yes, there's one very simple level which is that it's deliberately sarcastic of Christian values and slogans. But also it could be addressed to the Rolling Stones still surviving. In which case, from the way I observed what happened to Brian Jones I would say it's accurate, it's reportage. A jab in the ribs asking for a response. It's also designed to embarrass the remaining Stones. It's also affectionate of Brian Jones, and is therefore meant to be like an epitaph on a gravestone. To the average person in the street it's meant to totally confuse them and make them wonder what it's all about, and make some people who are old enough to remember what happened perhaps think what they may have thought at the time – that he never got a fair deal."

Gen has always been one for able labels anyway – remember the spate of black and red psychic crosses,

or the 'Assume this phone is tapped' stickers that kept turning up in phone boxes in London some years ago? With P-Orridge subversion is always effected through the avenues of disposable, mass produced popular culture.

"If Warhol had done something like that, he'd have produced it in wallpaper and covered a gallery's walls with it. Have a few nice cut-outs of Brian Jones, and it'd all look very chic and beautifully presented, and so it would increase his artistic credibility and Art World profitability. But I've always been more interested in doing that same kind of thing on the street, semi-anonymously, to see what really happens. To see what effect it has in terms of generating gossip on the street. 'Have you seen this or that?' and 'what does it mean?' and so on."

The Psychic Cross design does that, so too does the Temple usage of the number '23'. Art on the street is instantly socially effective. As P-Orridge learnt years ago, Art on gallery walls is not. Look at local papers around the country and you'll eventually come across the smalltown trivia on which legends are made. Here are a few cuttings:

"Barclays Bank in Didsbury was daubed with slogans in an unexplained attack last week... as well as an anarchy symbol there were three examples of another symbol which baffled staff...a vertical line with three horizontal lines through it. They have no idea of its meaning. Do you?"

"'Black Magic' symbols and graffiti have been daubed on the walls at Walsall's parish church and officials say the artistic vandals are costing the council thousands of pounds in repairs...a spokesman told the Observer that the symbols looks like the Greek Eoka sign with a cross through it, although some thought it could be a black magic symbol."

"Police still have no idea what the number '23' means and why it was spray painted on six local churches last weekend. 'We can't find any significance to put on the number' Captain Mark Valleric said..."

"You may not know what this symbol means, but if you've been walking around Exeter recently you can't have helped notice it. Sprayed in black paint this mysterious little symbol has cropped up all over town, leaving passers-by pondering... The symbol of the Russian Orthodox Church has been put forward as one possibility and the cross of St. Catherin another..."

"The police have said that they have been told that the number '23', sprayed on several buildings recently may be a reversal of '32', which experts say represents Jesus Christ... Rev. Dennis Hancock agreed the reversal of Christian symbols is common in Satan worship, though he doubts that the graffiti has much to do with religion. 'There's always the possibility' he said. 'But I'm inclined to believe it's something to do with the pornography issue'. Hancock said a recent push by the local Fellowship of Churches organisation to ban X-rated movies may

have prompted the vandalism."

"The Rev. Frank Manieri of St. Marys Catholic Church, Shadyside, believes the recent outbreak of graffiti in the area has no meaning. 'It has to be somebody with a random number. A person with a low mentality not thinking of anything more original than two-three.'"

Thou shalt not snigger. At least such press reaction to the antics of wayward PTV fans (who, incidentally, are encouraged to act responsibly in the spreading of propaganda) prove that policemen, officials and priests don't read *Rapid Eye*. But, more seriously, when one looks at Gen's work – his realisation that, quite simply you can't express ideas without words and symbols – one does tend to see what all this is about. Information takes on a dynamism all of its own, and reveals all sorts of paranoia, prejudice and stupidity when let loose on the general community. But back to *Godstar*, another loaded, coded new word that acts on the imagination.

"I came up with this whimsical idea that first of all there were Hollywood stars, then Warhol came up with the idea that there were Superstars, then the mass media moved on to Megastars, so the final one has to be Godstar! Only to qualify for Godstar status you have to be dead."

A book with every sticker. The things that interest him as projects, and the results of those projects, are things that encapsulate hundreds of threads. They also are things that act as vehicles for many of his associates to put their skills and ideas into on a variety of different levels. Such an arrangement is possible within the pool of loosely amalgamated individuals that make up the Temple. A group of writers, musicians, technicians, film makers, painters that is as much a mutually supportive, though often diverse, arts movement as it is anything else.

Although it is Gen's charisma and mostly his ideas that dominate the Temple which he co-founded, he is by no means the sole source of its substance. For instance, although he may write half of the Temple's texts himself, the other half is just as likely to come from the Temple-stimulated brains of writers such as Jon Savage, David Tibet or people such as those who contribute to *Rapid Eye*. The words of the Temple messages being passed on by the 'Temple Spokesman' on videos who has the honeyed voice of PTV tattooist Mr Sebastian and the face of Derek Jarman (a nice, eerie combination). And the soundtrack to the Temple is as heavily influenced by Alex Fergusson, Hillmar, Andrew Poppy, Dave Ball or Monte Cazazza as it is by P-Orridge himself. The stunning early visuals created by The Temple, expressed in a series of videos, books and posters, were largely put together by Peter 'Sleazy' Christopherson, (now of Coil) who was a professional graphic and video artist and partner of the Hipnosis design firm responsible for so many record sleeves and pop videos in the past. In all areas, the Temple is a co-operative venture. *Godstar*, though, was quite definitely the product of a node of Gen's brain cells.

The whole thing started in 1965.

"We sat for half an hour in the cafeteria of the TV studios in Birmingham and chatted. All of the Stones were there, about to perform '19th Nervous Breakdown' on 'Thank Your Lucky Stars'. And even then he was completely separate from the others. Not physically, but going back to what we were saying about 'auras' and so on, there was a bubble around him that was almost physically present it was so strong. Very mysterious and very disturbing. Though simultaneously there was also a feeling of love and emotion and confusion. It really was very weird. I mean I can actually see the table as we sat around it as if I were still there, and I can still feel the sensation, and I can still see it around him, as visible as light. He was not with them. He was not present with them at that table."

But weren't the Stones nasty to Jones (stealing Anita Pallenberg from him, ostracising him, forcing him to leave the group he helped create) because of his apparently difficult character? And weren't Gen's heightened emotions caused by a simple experience common to any young fan when meeting his heroes in the flesh?

"Well, I was never a Stones fan really. I mean, I always hated The Beatles who I thought were a load of wimps, and compared to them I liked the Stones because they seemed a much better vehicle for rebellion. So I bought their early singles. But there was something about him. It didn't dawn on me until a long time afterwards that I didn't buy any Rolling Stones records after he died. It wasn't a conscious decision, I just lost interest in them. I realised that it wasn't the Rolling Stones that I was ever really interested in, except for a few pieces of their music. Apparently it was the projection of the Brian Jones enigma that drove me to the group, and I think a lot of other people too, quite unconsciously."

Up until early '85, when *Godstar* was recorded, this writer had never heard Genesis mention Brian Jones, though looking back at least two years before, I do remember him, on a typical shopping expedition that ended with him going home with armfuls of books, old records, clothes and curios – buying a book about him. A colleague of mine was surprised and asked him why he'd got it, and he hadn't really replied, changing the subject. Looking back it's clear that he was even then engaged in his copious 'research' – secretively. He has now long since read every available title on Jones, typically not opening his mouth about a project until he knew exactly what his feelings were.

"It does seem that in lots of ways he was obnoxious, but it seems to have been one of those chicken and egg things. The others were cutting him out a lot and maybe that was his defence. I don't claim to be able to speak about him from great personal experience, but a lot of people I've met said they found him appalling to deal with."

But why Brian Jones?

"Well, it's as if some people are chosen, against their better judgement, to be a vehicle for the unconscious of their generation and their time. When he died in '69 the Sixties just closed down. I'm not particularly interested in the personalities involved. You've got to remember that the whole of the Sixties was riddled with drugs and various people were unstable and could see money, power, fame revolving around them, so maybe they're not totally accountable for their selfishness and greed. Though of course you could argue that they didn't have to take drugs.

"It's just a sad story. He became inconvenient, he wanted to experiment with different music and soundtracks and so on, and that didn't fit in with someone's idea of what the Rolling Stones should be. It's just a shame there was nobody around to influence things away from self indulgence. There was no-one around him loving him, loving just HIM, for what he was. And it interests me because it was a symptomatic reflection of that decade. So I see him as a shattered mirror of the Sixties. He encapsulates all the different threads, spoken and unspoken. The archetype angel destroyed."

So that is what a "Godstar" is. A scapegoat. An emotional crutch. An iconoclastic symbol for things that seem not to be able to be expressed in any other form. Godstars don't just die young and famous, but die FOR something in some perverse way, for the social evils and cultural dreams they have been chosen to represent.

"So in a sense that sticker means he died for everyone's sins in terms of popular culture. Even ours, even now. Because we are all part of an ongoing history and I think that the sad thing at the moment is that it's not fashionable to be aware of, and value, your history."

And that's one reason why British society decays like a bad molar with rotten, forgotten roots. It being inconvenient to remember the darker areas of its past – the slavery and gung ho diplomacy – and socially unacceptable to celebrate its achievements in the arts and culture, it's fashionable and easier to deride it all as if a bad smell given off by a senile old man. Culture and history are means by which we can fleece the tourists, and that is that. Britain is a society based on two words, "Me" and "Now". Life experienced as a channel-hopping exercise through various assortments of fleetingly fashionable junk presented as reality by the media. The British attitude of self-hate shows up in the obsessional love for all things American, and is most obvious in our total disrespect for our culture – Theatre, Painting, Design, Music, Literature. Britain is inhabited by people who punish their bodies with a diet of lager and junk food, who punish their children with fifty pence coins to pump into the fruit machine, who punish their minds with the unending consumption of wallpaper TV; soaps; game shows; satellite American football; and degrade or destroy all that they perceive as existing outside of their cultural windtunnel. Hate and punishment are everywhere.

As Gen says: *"We don't deserve to survive as a*

society, because we don't even love ourselves." And we don't 'love ourselves' because we are afraid to, as we are a society built upon layers of guilt – for the crucifixion, the reformation, the Empire and the wet dream. Guilty as individuals and guilty en masse. What is worse, Britain wallows in it, and elects politicians who are here to administer the 'medicine' we deserve (we also have to be guilty for the decadence of having jobs in the '60s). The envy and submission imposed by 'class' compounds the problem, making people grateful to take what they deserve like lambs to the slaughter, or – in the public school mentality of those in power – happy to accept the smacking given by Margaret the Maitresse. As P-Orridge associate Kathy Acker said, it's an S/M society. Guilt, like fashion, sexual stereotyping and racial pride, is a great weapon of Control. Adolf Hitler, another politician with precious few ideas who took pride in being hard, rather than caring, did a similar thing to Germany in the Thirties, burning books instead of videos and dispensing with true cultural achievements in favour of artful museums of National Socialist Party propaganda. In many Initiates' eyes, Hitler and Thatcher are two masks on the same face. The face they hide is a snake-riddled skull – the face of Death. The same old face of Control. After all, Socialism and Conservatism have proved in practice to be inter-changeable. Identical but for the most minor detail. The only route to individual sanity is to be empirical.

The art of the Temple *must,* therefore, be offensive to the agents of Control if it is to be able to inform. It cannot allow itself to be engulfed and capitalised on – like Wagner – if it is to be of any social worth. It must also embrace its past culture, not the convenient fixation with the present and reject all considerations of 'good taste' (the last refuge of the witless) and social acceptability. It must love itself if it is to learn anything about itself. Goethe's bitter sorrow for Germany could be transposed to P-Orridge's lips and modern Britain.

P-Orridge took plenty of wet liberal stick for visiting the ovens at Auschwitz in the mid-seventies. PTV are still prone to be thought of as somehow fascistic, particularly by people who accused P-Orridge-related groups Death in June and A Certain Ratio of similar leanings (even though Simon Topping's band ACR got its name from Brian Eno's *801* lyric *"looking for a certain ratio"* and has a multi-racial line up). Genesis says his visit to the death camp (taken in whilst visiting friends in Poland) served to remind him of the danger and horror of man's "stupidity".

"Those who do not remember the past are condemned to repeat it."
—George Santayana

Unlike Pope John Paul II, who visited Dachau in '83 and rightly received no flack as I recall, P-Orridge at least used his time at Auschwitz as fruitful research. He found out that the camp – now a museum – and

its ovens had been kept in full working order, and could quite easily be used tomorrow. He also set up one of his little 'tests'.

Using an innocuous looking photo of the camp that made it look like a factory set at the end of a leafy lane (a deliberate impression created by the Nazis), he incorporated this into the trendy, acceptable logo of Industrial Records and later, after it had been absorbed into the cosy punk anar-chic establishment, let it be known publicly what the photograph was really of. In sadly predictable fashion, shock horrors ensued among the supposedly enlightened press of *Sounds* (Morgan Grampian's idea of enlightened), and *NME* (ditto IPC). The same people who only months before had carried pictures of Siouxie and Sid in swastika armbands (as the Pistols and Banshees never really threatened anything, that was OK – this P-Orridge character though, was something altogether different). *"So immediately that photograph almost physically changed before their eyes. Just because they'd been given one extra line of information."*

In the Information War, illustrations like that are useful, if a little mischievous. Information is a bullet, the human voice a weapon. Heard any good voice-overs on ITN recently? And as we all know, it's here, in the realm of Television, that the real power lies. Recognising this fact and acting as soon as the practicalities allowed (amassing video equipment and technical ability within the Temple) the company whose plastic ID cards say 'PSYCHIC TELEVISION LTD.' in clear letters at the top, was formed in 1981. Using video not as a promotional toy to aid in the selling of records, but as an end in itself, PTV have recorded many more inches of video tape than audio. At the moment, distributing videos by mail and incorporating them into their live transmissions, they can only hope to chip away at the monolithic structure of TV, but it is a start. Never ones to take the hint and be put off by apparent impracticality and technological myth, the Temple has now mastered this, THE most esoteric of the arts and sciences, and when cable and satellite proliferates under European de-regulation, Gen hopes it will be there on the channel selector button marked 'PTV'. The move of emphasis away from records to video was merely the first step; as pieces of plastic lose more and more of their potency as capsules of information and demonstration, the scale of PTV's visual operations will increase.

Television is an essential area for the Temple to invest in, as it is not only the valium of the people, a daily score of bore, but an actively oppressive mode of Control.

In a world which, as P-Orridge says, *"lives through its media"*, life's choices are limited only to the number of channels on the set. Televised reality is all there is, and often, Television's truth is the only thing to believe. Through 'light entertainment' we are emasculated as individuals – adopting and identifying with limiting stereotypes. And in 'serious' Television – that dealing with the most finite, square,

The Test Card and sensory apparatus

flat reality – the effects of a voice-over, an edit, a use of lighting or camera angle or piece of music, create for us a common geography. We share the same trigonometric points in this 625-lined world; the same prompts; because we share the same TV. The mass conscious is programmed en masse – therefore we share the same programmed response.

But Control is not only propagated by the people who television programmes represent – the programmers are as much helpless products of Control as any of us. Control is an intrinsic function of any linear form of mass communication – it must be as it is the logical product of programmed brains. However 'radical' a programme may be, it is still a programme. Psychic Television strives to de-programme. Therefore, although it would be more entertaining for PTV to produce fast, in-focus TV and be more acceptable if they posed around in front of a few screens at their performances showing off pretty images, again, it would be pointless. So

PTV adopt a creative dialectic, the 'Third Mind' technique when making television, approaching the TV studio with the unaffected curiosity of a child – pressing buttons, experimenting with images and noises – playing with the mechanics of television.

Without formatting, one image may clash with another, creating a third, new, image. One idea may clash with another, creating a third idea. A new idea. And new ideas lead to new understandings, and new perceptions.

Having said that, the process cannot be entirely random – Genesis choosing what images to incorporate into the mix. But the presentation is. Just as Dada did with painting and Burroughs did with writing, PTV were the first to do with Television; without regard to stylism, technical ability or aesthetics: they broke it up and abused it in order to see what happened. Give a child an Airfix model kit and he may not build a plane, but he might build an interesting sculpture that looks far more fun.

All this may be apparently very trendy and arty perhaps, but Gen saw no other choice.

"We're living in the age of television, so we have to deal with it, it's a matter of physical and mental survival. TV is used to hammer people into the ground, to make them stupid and keep them quiet. The answer to that situation isn't just to turn it off and try to ignore it. By doing that you're admitting its power and admitting that you're scared of it. You've got to go and kick it in the face, pull it to pieces and see what's going on. And it's very interesting that with the minimum amount of money and expertise, we've actually managed to dig out and reveal a lot of weird things; worms and reverberations that people didn't know were there. Some people are stimulated by that illustration of how powerful Television is, others just say they don't like it, as simple as that, treating the whole thing as entertainment. The attitude is summed up by the odd reviews we sometimes get from a few very repressed journalists. The irony is that when they write these totally over-the-top nasty pieces they are actually illustrating our point very well. They are describing what we've done and how powerful it is and how much it's affected them. But they're actually so unsophisticated as people that they don't even realise that is what they're doing."

Self-appointed brainiacs of youth culture, journalists often describe such things whilst labouring under the impression that the perpetrators – PTV – and we, the audience, are less aware of what television can do than they – the journalists – are. We, the herd, the unwashed mass, are, it seems, not supposed to trouble our stupid little heads about such things.

The technique of Psychic TV is also confused with the substance, meaning that in a printed media obsessed with hedonism and style rather than substance (one need not exclude the other), that P-Orridge's outfit is received as being a part of that artless, lumpen mass of Duvet scratch trash propagated by the likes of crazy Channel 4. Not surprisingly, Gen thinks they amount to rather more than that.

"Perhaps we are the first organisation to make truly surrealist television. Television that investigates the subconscious and the unconscious. Whereas Salvador Dalí would have done a fantastic painting, we would try to get the same jarring of sensibilities, the same confusion leading to revelation through juxtaposing television and film images and sound. Because as most people realise, film and sound are integrated in order to manipulate the perceptions and emotions of the viewer. The viewer is being bewitched, and in that sense they are put in a position of vulnerability."

PTV's cut-up of reality is aimed at short circuiting the training the brain has had – to twist up the map of that shared geography and make the viewer find his own way, rather than accepting what emanates from the TV screen without thought. Be it the blatant twists of facts and demographs on the BBC,

or the more general, subtle and seductive presentation of that punchline reality that gently radiates from the tube in the all-forgiving form of Entertainment. Surreal images are dirty pictures put into the brainwash. 'Psychic' television is that which alters the relationship between man and what PTV recognise as being his latest piece of sensory apparatus – the TV set.

This is also socially positive TV, in that it encourages activity rather than passivity. It reclaims the pleasure of life from the death of TV.

"Even Pleasure has become something which people do not seek after themselves but have presented to them in simulated forms. So that even an inherently active form of expression has become a pastime and the result is that expression becomes depression."

Psychic TV has never intended to be a replacement for conventional programming, but rather the first step in the de-programming, without regard to redundant assumptions about entertainment. So Psychic Transmissions are made to be viewed when conventional TV is off the air, at night – the time when you are encouraged to be in bed. When the centroclines snooze and quietly wank through their dreamless sleep.

The content of PTV transmissions has inevitably been banned, bleeped and blotched out. The powers that be take an interest in any package bearing the rubber-stamped insignia of the Temple, resulting in PTV videos in the past being posted from its formerly affiliated branch (run by 'De-Coder') in more liberal West Germany. The press has said that they show scenes of torture (untrue) and are 'shocking'. The latter may be true for some people (depending on what you find shocking), because they emphasise the aspects of life normally suppressed by the apparatus of Control for being subversive, contentious, disturbing or too sexual. It follows, using Temple logic, that it is exactly because those areas are suppressed in a deliberate attempt to limit knowledge and experience, that they SHOULD be shown.

Rumours about one particular PTV video abound throughout the backwaters of the media. Accusations from some individuals and groups with vested interests claim that they feature child abuse and Devil Worship. I have seen the video in question on several occasions, and personally know or have met several of the individuals featured in it. Disappointingly for the gutter press and assorted 'Christian' groups, I can confirm that the video features nothing more shocking than a performance art pseudo-'ritual' involving some naked cavorting, tattooing, piercing and so on. The participants are all clearly adults, and out-takes from the video, which include scenes of the participants laughing and joking, prove that they are all willing 'actors' in the piece. Far more sexually explicit and certainly more violent material is openly available in any Sex shop or video store in Europe or America. Indeed, the majority of hanky-panky that does take place is out

of focus and distorted to such an extent that it might as well be anything. Anyone who has been familiar with the performance art of P-Orridge over the years will clearly be able to see what is going on. Uninformed individuals with nasty minds will obviously see whatever they like. Which is rather part of the point, I thought.

Psychic television reclaims the night and fills it with colour and information. *"To cause things hidden in the dark to appear, and to take the darkness away from them."*

But if it's TV that makes up "50% of PTV", then the other half of the organisation is concerned with what to show on those 23 screens. The theorising and substantiating of that theory, of which TV images and soundtracks are just the results. It is here where the Inner Circle of the Temple dwells. Beneath the slick talking-head façade of the Temple, that which is put before the unblinking eye of the camera and fed to the public in the tactile form of records, books, videos and all the wall-splattering, symbol-carrying merchandise of pop culture, lies the Temple itself.

A temple without walls that draws its initiates from an international conspiracy of unrest. Dealing with contemporary art, sociology, religion, communication, neurology, and that grey area between the finite fact of science and the dogma of theology – Philosophy. A combination of interests glued together under the Psychic Cross and run along the lines of an intellectual urban(e) terroristic organisation and mock 'occult' fraternity. The type which the occult establishment would rather do without.

In that elitist and overly jealous underworld of traditional occultism, this populist high-tech Temple is not only generally considered undesirable, but also held in some real contempt. For example, I have on file a letter written by one David Rietti, just one of the many claimants to the 'leadership' of the OTO, the brotherhood once headed by Crowley. After the Temple of Psychic Youth produced a pamphlet along the lines of Crowley's *LIBER OZ 77* (cheekily calling it *Liber Ov 23*) in 1987, Rietti threatened the Temple with "a war" which he "would be unable to control", something which P-Orridge and his Temple colleagues seemed to find most amusing. Some people will, it seems, go to almost any lengths to protect what they see as their 'power' and monopoly on mystery.

Britain is absolutely choc-a-bloc with narrow-minded, so called 'magicians' who 'learn magic' by worming into mountains of arcane- looking 'parchments' supplied to them by over-priced specialist bookshops: of witches who are convinced that 'the power' is a solely feminine 'gift' passed down genetically like buck teeth or freckles: of imbeciles who are sure that not only does evil exist in the palpable form of the Devil, but that he regularly plays hoofsie with them under the shabitat dining table over a glass of Bulls Blood. These pathetic types are, unfortunately, the bulk of the

Televisual, sexual, magickal

'occult' fraternity. The whole yuppie awareness of the Mind and Spirit, of wands and crystal balls (balls being the operative word), of wholefood, crystal power, alternative medicine and healthy living has provided many with a vast ego-trip through the whole of the 1980s and sprouted an accompanying service industry and alternative dating agency for the socially inept, the bored, and the downright stupid. People sadly unable to come to terms with living in the last quarter of the 20th Century who have opted

for a cosy, Luddite approach to life.

This join-the-dots form of occultism is all very well if beneficial, but it has become merely a substitute religion for many and, as a result, covers a multitude of crappy, cranky ideologies that only serve to make the overall situation more confused and socially ineffectual.

Of course, the Temple of Psychic Youth has attracted its fair share of idiots. The smell of (black) candlewax pervades many seedy, spunk-stained 'Temple' loft conversions – the purpose of this highly unromantic grail all too often being the simple acquisition of power, material wealth, image-building and sex. The fact is, however, that people drawn into the Temple of Psychic Youth for these reasons usually fall out from it pretty quickly. After all, if one wants to be pedantic, TOPY is clearly *not* really much to do with 'occultism' at all. The word 'occult' does of course imply 'secret knowledge', and nothing that pertains to the Temple is secret. All knowledge is shared, which is one of the reasons why it is so unpopular with many traditional would-be 'magicians', as it usurps their power, or, at least, their self-image.

However, given the image of the occult in this country, it is not a surprising consequence of the Temple's high profile activity that it has wrongly been interpreted in much the same way as other groups.

Initiates of this Temple though, do not generally feel the need to dress up in funny old clothes (even though those they wear at Tescos may be quite wacky). Nor do they exchange funny handshakes, or study the most elementary forms of physics or astrology towards the attainment of various pseudo-degrees that the circle may confer on them. It is the demystification of psychic research (research that the Temple feels should not, in social terms, remain secret or 'special' any longer) that is at the root of its existence and propaganda. As it does with television, the Temple digs around in the occult, researching and making public what has remained, in political and social terms, futile in its isolation. An isolation that is in itself a hangover from when 'Christian' society perceived such things as Ritual and Magic as a threat – burning witches, torturing 'heretics' and invading communities (like the Cathars or Albigensians) who based their lifestyles on different (some would say more enlightened) values. A process that the West still carries out in the form of meddling, moped-riding missionaries who quite deliberately set out to destroy far more ancient structures than those which they themselves represent, with a smug cultural Coca Cola Kid imperialism.

The concepts of such things as ritual or the perception of a non-physical reality are misunderstood and now commonly seen as retrograde steps towards barbarianism and superstition. The Temple wishes to re-integrate such concepts into the human experience, and has therefore developed, quite consciously, a practical, logical, and presentable system to help this to be done.

In this article I've hoped to present information that will increase, even if only superficially, the understanding of Genesis and The Temple and to give factual insights that have never before been reported. My explanations of what is going on within this movement may be incorrect, but I think it important that the motivations behind this deeper area of Temple activity should at least be presented as I see them. This section is really what it's all about – the blueprint from which all the aforementioned tactics derive.

Taking for a moment the liberal, more contemporary view that the purpose of old occult imagery is to create archetypes from Jung's 'Collective Unconscious' to focus on and achieve a similar set of results as those gained by Temple activity, even this rigid, belief-dependent structure is considered unnecessary and harmful by P-Orridge and other Initiates.

So, rare in circles of the occult, there is no hierarchical structure in the Temple. Just as there are no pointy hats, goatee beards and Latin words, there are also no formalised rituals. There are no rules. In 'admitting' and 'initiating' anyone who has the genuine desire to become associated, and helping them to realise *their own potential in their own way* purely by promoting informed self discovery, the Temple is taking its only political step. By passing information on like a viral infection, one-to-one, it hopes to nudge society gradually into perceiving reality in a different, and more 'realistic' way. To make what is now (due to the aforementioned misuse of occultism and its misrepresentation in the media) seen as being crackpot, unjustifiable and weird, to be accepted as a sensible possible step along the evolutionary path. To replace the dulling, dualistic perception of 'Either/Or', with what P-Orridge theatrically calls the 'Magickal Perception' of infinite parallels and possibility. The TOPY method is a simple lesson in orientation and advertising that is typically efficient.

Temple ritual is tailored to suit the individual Initiate, and as such is just as likely to incorporate the trappings and fetishes of today – scratch videos, House music, rubber clothes and polaroids – as it is to use the (for some) equally viable symbolic weapons, pentagrams, and unintelligible utterances of old ritual.

The primary difference between the Temple and other more traditional organisations, though, is that the results of ritual activity are interpreted in an altogether different way. Successes from spells, for example, are not attributed to the intervention of spirits or deities, but to the internal workings of the ordinary human brain, and the effect the human brain can have in emitting frequencies that effect the collective pool of frequencies between all humans.

This may seem no big deal if the spells work the same but the terminology is different – but in wider,

social terms, the difference is vital. Because in the TOPY manner, attempts at understanding are increased, woolly and futile involved explanations are dispensed with, and ultimately control of and access to the process is made more efficient. The intuitive ritual practice is not at odds with or separated from perceived scientific reality, but integrated with it. The everyday experiences and the lifestyle of the Initiate are incorporated into the Magickal Perception, thus psychic activity is embraced more readily as being as natural as physical activity.

To illustrate the attitude of the Temple, and annoy those with a vested interest in keeping such matters couched in gothic mystery – therefore holding on to their tenuous self-appointed positions of superiority – here is the most basic type of experiment in the art and science of 'magick'.

Imagine you have been treated badly in a restaurant – the food off, the service bad. You refuse to pay your bill, so you are beaten up and robbed. Circumstances dictate that you cannot retaliate in the ordinary manner.

So. Go back the next few days, standing nearby the restaurant for half an hour at a time. Take photographs of the building. Record the sounds of the restaurant and the street outside on a Walkman. Steal a menu card from a table. Then, at a time you choose, develop the film. Cut the negative up and print your pictures of the street minus the restaurant. Overdub onto your recording the sound of breaking glass, of fire, of doors slamming shut. Concentrate your thoughts on the restaurant. Slowly cut the menu up, paying particular attention to the logo. Then bury all the photos and shredded card in your dustbin. Forget the incident. A month or so later the chances are that the restaurant will, for one reason or another, close down.

In this Burroughs-inspired example – which basically just gives one the simple understanding of the psychology of such base magick – you are clearly not evoking external forces or worshipping horned creatures that manifest themselves at midnight – shitting on your Axminster. You are not even 'psyching out' the enemy in the usual sense of the term by letting them know your intentions on a conscious level. Indeed, the explanation of how and why such a simple process works is not important here – though would, one thinks, be more satisfyingly described nowadays in the language of the neurologist and behavioral scientist than the warlock, even though nobody could really explain it. In this very easy example, it's clear that one is making contemporary symbols of the same process as used by witchdoctors and their ilk. Affecting change in the transmissions from and between humans, causing physical change to occur.

The realisation of such popularised experiments too is that *everyone* can use their mind to produce physical change purely by mental activity, if they have the self-discipline necessary to train it to do so. The Temple is merely making the necessary

information more available, and not attempting to explain such phenomena away with mumbo jumbo or creating a substitute structure of dogmatic belief around it.

"Well, Burroughs would explain that by saying you're actually cutting up reality itself. That reality is like a tape and if you cut it up and distort it you make things happen. Why they do remains a mystery. To what extent the mechanical manipulation of reality affects things is just not measurable. The basic answer is – who cares, if it works? If nothing else a process like that is good therapy."

The stock criticism of such experimentation, and, perhaps, realisation of power is that such things can be used irresponsibly, merely adding to the violence and conflict that already exist. Logically, though, such an argument could be used to support anything from censorship, to the lowering of educational standards, to dictatorship. P-Orridge would argue the case by saying that no extra power has been conferred on the individual anyway. By making such information more available and acceptable, people have simply been encouraged to experiment with and observe what they already possess.

"Their argument is just like saying somebody went out and raped someone because they watched it on TV. They probably did, but that doesn't mean that there should be no TV."

But people could say it's hardly a good advert for the proliferation of TV.

"Yes, but people who take that position are saying in effect that there is no need for awareness because awareness is dangerous. It can be. If people do abuse it then you could, if you wanted, argue that it's because they have been given those perverted motivations as a direct result of the suppression and conditioning they've had in the first place. So be it. I just have the fundamental feeling that the human race is here to evolve and is capable of becoming something relatively interesting and special. And the only way to even begin to approach that is to learn the real way that we work, both physically and psychologically, and there's no easy way 'round that. If given the choice of either moving forward or stagnating – which is what we're doing now – I'd gamble and move forward. And I think information and technique move things forward. For better or worse, quite honestly."

Rather than a pseudo-religion or a sinister Thule-like fraternity then, the Temple is more like an open-ended Information Exchange that expresses itself using a hybrid of the traditional, esoteric, and contemporary arts. A result of the same brain, it's as snappy, modern and ideologically devious as TG once were. And as with any P-Orridge inspired project, the tendency is towards testing conditioning and individual response. It's thus confusing and provocative; flexible and undogmatic; lacking in convention and therefore (through any success it achieves), threatening to convention.

Gen is not a very good singer in the classic style,

The scars

and his opinions, appearance, and writing, like his methods, may not be to everyone's taste. But his undeniable strength lies in the fact that anything he turns his hand to is effective on one level or another. Analyzing everything to the minute detail, the strengths, motivations, appeal and (most of all) weaknesses are discovered, and pressure applied at the most telling points.

Because of this efficiency, this realisation and application of that potentially most ordinary of commodities – power – the Temple is threatening to institutions of any kind. Its very existence is proof in all spheres that an 'alternative' approach, founded on a purely information- based system can work, devoid of hierarchies and crippling, limiting structures of belief.

Of the occultists that grumble, Gen remains both free from malice and unconcerned. Besides, if it's credentials that are important to gain acceptance in this closed order of fragmented cults, the Temple certainly could produce these in abundance.

TOPY member Icelander Hillmar O. Hillmarsson is probably one of the most respected and authoritative young figures in European occultisim. So much so that more than one museum and private collection has entrusted him with curatorship over priceless archives of occult books and artefacts. This connection has, for example, given the Temple exclusive access and publishing rights to many of Aleister Crowley's unprinted letters and manuscripts. It has also encouraged the only bona fide Ordo Templi Orientis (forget the people in South America) to offer the Temple a permanent base at their headquarters in Switzerland. The building, designed to the Thelemic specifications of Frater Perdurabo himself, contains what is thought to be the largest and most complete occult library in existence, plus a theatre, hotel, temple, lecture rooms and alchemical laboratory. Gen daydreams about it sometimes.

Fitted with a recording studio, computerised data system, gallery, cinema, TV studio and Dream Machine room; peopled by visiting Psychic Youths taking classes in such things as karate, breathing techniques and listening to lectures from the likes of Leary, Burroughs, or Colin Wilson, it all amounts to a tantalising proposition for P-Orridge to consider.

At present, though, the Temple has neither the funds nor the inclination to retreat from the grime of British urban life to a bunker in the Alps – however well appointed. The Temple is most effective, for the moment at least, producing propaganda through pop culture on the streets of the biggest and most youth-sophisticated city in Europe, regardless of the criticism such a high profile attracts.

P-Orridge sees no reason why, in the subterranean world of the occult, TOPY and the more orthodox societies, from the Rosicrucians to the I.O.T., cannot exist in tandem. However much they may disagree about methodology.

"I just don't think that those traditionalist groups, such as the OTO, are really honestly very interested in effecting a change in society. I think that if you care you have to be a part of society and its expression and popular culture. You have to set yourself up as an example and scapegoat. If you don't let people know what you do, how are they going to believe you when you say 'I did this and it works!' I think things like the OTO are primarily ego gratification and research into old ideas and old knowledge, which is fine. It's like a symphony orchestra still playing Beethoven is paralleled to Duran Duran playing 'The Reflex'. One does not have to exclude the other... I think, though, for me their way would be too easy. I've never been a joiner. I've never wanted to be subservient to a prescribed dogma of any kind, no matter how esoteric it might be. It just doesn't interest me. In all honesty I'd just

The tattoos

feel a complete arsehole standing in costume saying 'Oh Sephiroth, Sephirah, I invoke thee!' You know, I just couldn't. And it'd be boring."

That, then, is the explanation of why the Temple does not undertake any formalised rituals, though ritual itself is practised – sometimes for its own sake (as discipline), sometimes as a controlled experiment (research), and sometimes in order to produce a specific tremor in the fabric of physical reality (from the closing of a restaurant to the making of a perfect baby). The ritual aspect of Temple activity has, for tactical reasons, been underplayed since PTV burst onto the scene amid much blasphemy and scar tissue in '81 (record companies preferring to package wholesome sex – the kind Nik Kershaw clones offer on the back seat of Ford Escorts – to what they see as this pervy arty nonsense). Don't be fooled, though; ritual remains the bedrock of the Temple.

In my mind, the reasons for the incorporation of ritual go something like this: Numbed by contemporary media and education, Man has been distanced from ritual – something the Temple views as a vital *natural* activity. In order to control more effectively, 'Control' has fragmented the human character into tiny, dissociated and often forgotten slivers. Modern man lives in a perpetual state of stupor, and is made to suppress these multifarious aspects of his personality, made to not recognise, or to ignore his deepest desires, so that he may become totally immersed in the stagnant, counterfeitist reality of Control.

He is helpless, like a lone wolf stuck in a 'starlit mire'. Separated from the pack that does not even hear his howls for freedom, and if it did, would not even recognise his association with them – so covered as he is in mud.

That incomplete 'pack' of emotions and personalities – the individual human – runs on. It knows that there is something wrong, something missing, but it doesn't even know where to look. It convinces itself that it is quite content to go on as it is, and even if it stumbled across its long lost members, it would probably tear them to pieces in its ignorance.

The individual human, like a pack of Pavlovian dogs, has been programmed into such ignorance. Ignorance is convenience.

The sham illusion of 'freedom' is dangled before him in the form of material comfort and narrowly-defined political choice. Thus drugged, duped and divided, he is robbed of direction and self-respect. Shambling through life in a blur of trivia, he spends his life waiting for 'something' to happen. When and if he has the courage to ask 'Is this it?' he is told that he will be alright if he keeps the faith. If he continues producing and consuming. If he feigns 'normality' on the outside and does what's expected of him by the Church, by governments, by cartels. If he remains stupid, and even proud of his stupidity (his video-watching, car-driving 'normality'), clings to his set of beliefs, whatever they may be (they are, after all, interchangeable), and keeps his mouth shut, he'll be rewarded with... Life after Death!

Thus he will be robbed of fully experiencing his own life. Of realising his potential, even the potential of his own mind. The passion of the Temple is founded upon this great sadness. The sadness of the 1980s.

There is, though, a hint of optimism here. Just as geographically, racially and politically mankind is falsely divided and compartmentalised, split up into more easily administered nation states on Earth, the individual man or woman is shattered and divided from the inside. The concept of 'divide and rule' is scaled down to horrifyingly personal proportions. In the perception of the Temple, ritual (or, if you like, private performance art) is a way in which the demolished man and woman can be healed. It can

be used to promote internalisation, a search for and acceptance of the missing members of the pack. To re-integrate the many aspects of the personality that have been fragmented and ignored and achieve through this a healthy balance again. To incorporate into life those aspects of human character that society has trained the individual into perceiving as being (socially) worthless, (self-) indulgent, or unpleasant. Once these various areas are accepted they are better understood, and then you have the first step in the destruction of Control. You have a whole human being again with the self reliance of the 'full pack.' You have the inquisitive, pre-programmed purity of a baby.

"From a child of five to an adult is a short step.
From a new-born baby to a child of five is an appalling distance."

—Tolstoy

Ritual is an activity that a brief study of human history would seem to show that we need. It is also an activity that has been generally ignored or denied in Western culture (except in the most ineffectual forms offered by the modern church). By investigating what appears to be one of the weak points in the armour of Control, the Temple feels it has touched a nerve. By reclaiming ritual and developing its efficient personalised use, the process of shattering indoctrination that takes place is reversed. One becomes cognizant of one's real needs, and, able to confront and embrace these needs and desires, commit that most heinous of crimes in this group- orientated society – cherish oneself.

People in this position are more likely to be healthy, well balanced individuals. They do not commit suicide. They don't go out and attack people on the street. They don't fight wars on behalf of politicians. They are less inclined to become addicted to false outside stimulation (be it from drugs or TV) for their well being.

"Once you have re-integration and you have an effective whole individual again you can then have evolution, and that evolution I suggest needs to be neurological. If people see things intelligently and are more aware and thoughtful and using more of their brains, then stupid action will become more obviously stupid and therefore laughably irrelevant. The only way to get rid of stupidity is to make it LOOK stupid to the individual, so that nobody would indulge in it. And I think that forms of ritual and what is commonly termed 'magick' are an essential part of that re-integration and that's why they were quite deliberately amputated from man's experience during the middle ages, in order to facilitate the growth of power through various kinds of conditioning and suppression."

So in Temple philosophy, ritual helps the Initiate to commune not with spirits, but with The Spirit. In helping concentration, clearing space for internalisation, it enables the brain to function in a

way that, quite simply, it doesn't normally have the opportunity to in the logical life of everyday existence. The real purpose of ritual, the common denominator of all ritual from Christian communion to dervish dances and spiritualist meetings, is to lead you through the subconscious levels of the mind and into the areas of the brain where the unconscious dwells, darkly. Here you may stumble across angels and devils within yourself that have been hidden from you by Control.

The most simple form of ritual is a process of Sigilisation, whereby a wish is concentrated in symbolic form, and brought to bear on the mind when it achieves the required altered state – when it has been pushed into the quaquaversal mode and is able to transmit energies that can have an effect on both the physical and mental planes. Purely physical science does not (yet) allow for such things to be possible. Which is why the quite common phenomena of telepathy and precognition are written off as being 'coincidence', and why there is as yet no plausible physical explanation for such things as poltergeist activity, other than accusations of hoax. In the Magickal Perception of P-Orridge, such things are considered perfectly normal, unthreatening effects of transactions between the unconscious of the individual and the shared unconscious of the earth.

Ritual not only sends tremors through this unconscious, but, while doing so, teaches the Initiate that there may be more to life and death than meets the eye.

"Ritual helps you understand and perceive the invisible language of reality. The inarticulate, non verbal language of reality and relationships between cause and effect and emotion and action and behaviour and so on. The nitty gritty of the Cosmos!"

Ritual is really just a system of tricks which enable you to by-pass the cursors of the solely physical perception of reality (logic based on chemistry, physics, English, maths and biology class), and see the world from a quite different perspective – and new perspectives give birth to new ideas. The Temple's hackers report their individual systems and findings to TOPY H.Q, their research being kept under lock and key and made available only to other practising Initiates through newsletters and meetings, and in more general form in the public activities of PTV and P-Orridge. Each sigiliser's identity is protected from the outside world through the designation of code names and numbers. 'Eden' for boys and 'Kali' (the Indian goddess of sex and death) for girls.

The ritual techniques and sigils recorded at the Temple database are as varied as the Initiates themselves and have grown less familiar and more abstract, personal and effective as time wears on from the Temple's founding in 1981.

P-Orridge's personal rituals, for example, are a natural result of his own history, informed as much by his love of Gysin or Dalí as his interest in Crowley

A visual Sigil

and the laws of Thelema. An extension of his performance art exploits in COUM, Trans Media and beyond. He readily admits to the fact that what people often confused with as being Art, was, if seen in another context, Ritual.

"It was really psychotherapy rather than Art. In a sense rituals are a private version of what I always did. In fact you could say that after doing art

performances I noticed certain effects and phenomena that I decided to investigate privately and more intensely in a controlled environment. So there was no question of there being Entertainment involved."

The most effective rituals, and usually the most interesting and informative, are those that teach the Initiate certain practical boundaries, both physical and mental. It would serve no useful purpose here to try and go into detail about the more esoteric rituals employed by the Temple. In any case, each ritual is different, suited to the needs of the individual(s) taking part. Here though is an example of the never-before published ritualization of the Lone Wolf. An experiment into a more formalised, less sexual ritual, it has almost monastic qualities.

As his wife Paula and the psychic imps were taking a break in Brighton for five days, Gen decided to make the most of the unusual silence, space, and aloneness of the empty house. *"Each day I started at eleven [23.00 hrs.] and I couldn't go to bed until I'd incorporated a certain number of set things into the ritual. I had to do a drawing based on a particular photograph taken of Paula during another more esoteric sexual ritual. I had to write for a period, copying down anything that came into my head, and cut one letter of her name each day in my chest with a scalpel. I also had to drink from a special silver goblet [shaped like a wolf's head] which was full of my own urine, and read a section of an Austin Spare book and try to understand it, and do a sigil involving masturbation as well, all while listening to Scriabin's 'Poem of Fire' very loud on the stereo. I also had the television on with no sound and all the static snow drifting across the screen with the colour turned full up, and also have my one-pound steel weight through my prick."*

All the elements of this particular ritual, chosen more or less at random from a variety of associated interests, serve to symbolise certain areas of his life and reflect his lifestyle, and will strike chords in the minds of many of his fellow Initiates.

"At first I was very conscious and aware of what I was doing and it seemed very laborious, and I kept wanting to give up the drawing and not to do the shading in properly and so on. But by the fifth day I was writing without thought and the time was going very very fast instead of dragging. And during the day when I went about my normal business I became hyperactive and effective. By the end of the five days I was in a completely different state mentally and physically than when I'd started. I was very alert, perceptive, and just didn't get tired. Looking back at the writing I'd done during the ritual there was loads of stuff I didn't even remember writing at all. A lot of it is really interesting and challenging and quite impressive. And I'd done diagrams that I didn't really see the meaning of – little boxes and key words and relationships between key words and observations about personality and emotion and so on."

Besides such abstract forms of experimentation,

P-Orridge also practises straightforward Sex Magick – and is as open about his interests as he is any other subject.

Incapable of dealing with honesty, particularly when sex is involved, the usual reaction of the cynical British Media to this is to make several assumptions based on their weak grasp of such knowledge; that Gen is 'obviously' concerned only with manufacturing a weird sexy pop star image; that Sex Magick is 'obviously' merely used as an excuse for physical gratification; that anyone involved with the Temple is 'obviously' sexually promiscuous – just not honest enough to admit it.

Funny how people become either coy or abusive whenever sex rears its head, isn't it? Strange too, how people are so ready to apply their own sexual hang-ups and code of morals to the actions of others, as if they, considering themselves 'normal', were somehow the arbiters of everyone's sexual preferences and morality. It's always been easier to snigger – in the tinkling of a typewriter the presentation and apparent validity of any body of ideas as potentially threatening as those being transmitted from the Temple can be reduced to inconsequential rubble. The writer simply has to appeal to the tribal instinct that, for protectionist reasons, sees anyone 'different' from the group as being a threat, and the tribal instinct is largely born out of Control.

As the most public figure within the Temple, P-Orridge also finds himself caught up in a crossfire between a whole bunch of ideological imbeciles he cares not a jot for anyway. Macho men who are obsessed with the activity of sex (fucking); copybook 'feminists' who are obsessed only with gender; media people hellbent on sensationalising and disparaging anything to do with (ulp) 'Sex' from their usual platform of mock indignation (to sell papers). They confuse sex with sexuality; ritual with sexual promiscuity. Such people would no doubt be surprised, and not a little disappointed to hear P-Orridge talking about such things as sexual equality. Or learning that even within the Temple a person of course could, if they wished, explore their own sexuality without actually having sex with anyone (using solely autosexual techniques in ritual, for example). Though, as the learning process is always better if studies are shared and enjoyed, it'd be surprising for anyone to do so.

There is (unfortunately) a general type of person that usually becomes involved in the Temple, though that is hardly down to P-Orridge. People criticising such apparent anomalies of the Temple, or its activities, easily forget that as there are no strict formulae here, a person could share in its experiences without necessarily agreeing with other Initiates' methods, morals or lifestyles. Sex, though, is still an important aspect of the Temple.

"Because sex is one of the most primal motivations of human beings. I think that people are more animal than they believe they are and that there is a hormonal, metabolic, deeply engrained sexual urge

that motivates us and that one has to confront and understand. And if people can't confront and understand something as basic and physical as that then they might as well give up on things that are more abstract, really. And sex is used as a weapon to generate guilt and fear for Control. I think in mental terms it's of more importance than any battlefield on the planet. We have urges for a variety of things that have been suppressed. Ritual is also one of those things. A need to mark one's passage through life on oneself physically and mentally. The signs for something as simple as that are always there – from tattoos and pierced ears and different hairstyles to certain types of ceremony. Like marriage, birth, christening, football matches or whatever. I think the people who refuse to even recognise that need and dismiss it are the dangerous ones. Usually people like burn-again Christians and rightwing politicians and so on. The type of people who're convinced that they're right and tell other people how to live and think. I just prefer to recognise things and embrace them and see what they are and why they are. And I do think that the suppression of ritual and sexuality is why in our society there is a lot of mental illness. Some of it diagnosed and the vast majority of it walking around the streets! In other societies, where ritual is embraced as a natural function they don't even have a word for mental illness, it's just about unknown in many 'primitive' tribal societies. Neuroses are exorcised through ritual, there is always a point given to focus on. Even if it's not a regular everyday thing, there are always ritual points in their lifespan that are utilised to focus on completely different to everyday normal life. And that's very uncommon in our society."

What about birth and death?

"Well, even childbirth is emasculated as a sensation and as an experience and as a ritual. The medical profession tried to steal childbirth away from women. (Gen and Paula's two children were both delivered at home). Even death is considered something to be swept away and not talked about. Even fucking! All the things we can't avoid. We all fuck, we're born and we die. Even these three most basic focuses and rituals and experiences are screwed up and twisted and suppressed by our society. So it's no wonder we're all completely confused."

Add to this the fact that even the most subservient people are now becoming disenchanted with the structure of society. That society's authorities can no longer be trusted as they are consistently being discredited, and being proven to be (often quite openly) dishonest, uncaring and incompetent – which means, in the equation made by the Temple, that a very dangerous and unstable situation has arisen. Millions of directionless, dissatisfied people generating all that unfocused energy equals = Bad Magic. The symptoms of which are manifested in street crime, heroin addiction, sex murders, alcoholism, hypochondria and practically every other social malady you care to mention. People just have no self-discipline or respect for themselves. No clear direction. They do not even have any structure to work around anymore.

That explains why the structure of Christianity is so newly attractive to so many people. A structure in which people benefit from ritual focal points and a sense of direction. The direction, though, seems all too often to be towards death – Christianity in practice generally being a structure based on hedging one's bets for an afterlife, rather than fostering a genuine wish to live with people better in this.

The Temple confines itself to what it knows, to life rather than death. It does not presume to issue 'commandments' or give the impression that it is qualified to do so, representing as it does nothing other than a few ideas. Rather, it simply tries to encourage an active, positive life, assuming that people are quite able when freed from conditioned guilt to make up their own minds about how to live (is it better to help someone because you want to help them, or because you want to protect your own interests and avoid being sent to 'Hell'?). In observing the lure of the shared trappings of all religions, it is interested in the non-aligned, undogmatic investigation into what exactly is going on. Minus the bullshit of organised religion, the rhetoric of party politics, or the promises of 'occultism' that only serve to pervert that understanding and thus strengthen the foundations of Control.

Sex and sexuality lie at the roots of Control. Conditioning is most apparent, and crippling, in this area of our lives – illustrated for example in limiting sexual stereotyping and feelings of alienation, and the mass of hang-ups that pervade what Freud claimed to be this central area of human life. Gen argues then that it's only natural to try and tackle this universally applicable area first, and develop awareness from there.

There is, though, more than a tactical angle in the incorporation of Sex Magick rituals than that – as they are also an excellent method of illustrating the capabilities of the mind when unified by ritual.

The Occult Establishment, in the form of the German Theodore Reuss, for a time ostracised Crowley for making the 'secrets' of Sex Magick more available to non-initiates in books like LIBER CCCXXXIII The Book Of Lies (in which he wrote about the 'Magick Rood' and 'Mystic Rose'), before Crowley's revolutionary ideas, widely disseminated through his theatricism, gained more acceptance – resulting in Crowley heading the Argentum Astram and eventually becoming World Leader of the OTO on the German's retirement through illness.

Through the works of Havelock Ellis, mason Karl Kellner, Crowley and numerous others, such 'secrets' are nowadays common knowledge (if not often understood) amongst even the most dilettante students of the occult.

To over-simplify, the basic premise of Sex Magick is that when the individual achieves orgasm, he or she is able, albeit briefly, to gain access to and some

control over the hidden, dream-ridden world of the unconscious. There the 'True Will' is discovered and focused, the latent powers of this 'unseen' mind being used to alter physical reality. If a desire is first encapsulated (during a preparatory ritual), then visualised at the moment of orgasm (usually in the form of a symbolic glyph), the chances are that the desire will be achieved, in one way or another.

People bound up in the purely physical perception of life, and the traditional sciences used to explain it, must dismiss such notions out of hand. They will perhaps say, sneeringly, that such notions are 'magic'. They will of course be right. As with any theory though, several quite logical sounding arguments can be concocted to support such claims and make them more appealing on an intellectual level. One such argument could be based around the theory that prevails throughout *Rapid Eye* in various forms.

That is, that the language of the two brain hemispheres is frequently of transmitted impulse, and that by artificially tampering with the keys of those frequencies (be it through ritual or exposure to 'psychotronic' sounds, strobes, etc.) the two sides of the brain can be fooled into acting in unison. The right brain, that deals with dreams, 'intuition', creative endeavour and non-logical thinking, and is thought to house the unconscious entity – that which produces poltergeists and demons – is combined with the logical, practical hemisphere of the left brain, where the ego resides (the left brain is what we'd think of as being 'us'). Altered states of consciousness result. Anyone who has taken LSD, or been stupid enough to experiment with PCP, would agree that there are various levels of consciousness, and that the brain, and body, are capable of things far greater than we once may have thought.

By learning the most effective methods of tampering with the brain we can more efficiently produce the required states and find out exactly what the attainment of these states can achieve.

This particular assumption has been made for the purposes of this article, based on the work of Spare and P-Orridge and the most cursory reading of a few neurological facts. If people with a greater store of information in the areas of neurology, psychology etc. wanted to find a more convincing argument then they could no doubt do so. For the purposes of self-discovery and practical results, however, as P-Orridge says, "Who cares as long as it works?" That it does work is only doubted by those who haven't tried it, or approached it in too cynical, clinical, or careless a manner. The Temple is more interested in making such avenues of experimentation known than trying to convince people of the theories or results.

If such capabilities *are* inherent in Sex, it would certainly be in the interests of Control to suppress such information and activity. Genesis would say that this explains why 'Sex', more than any other area of usually private human activity, is subjected to extraordinary levels of outside interests and

interference from the unwitting agents of Control – be they police or priests.

Whatever anyone's opinion, it's undoubtedly true that while experiencing orgasm the individual experiences a sensation of freedom that renders any system of Control totally meaningless. In this case at least, sex is a liberator.

P-Orridge does not doubt the validity of Sex Magick at all, and given that medical science is constantly being revised and currently can only account for the activity of about one third of the brain's total physical mass, any explanations and explorations should be possible. From the traditionalist mummery to the more oriented, if equally woolly and vague beliefs of New Science. Gen being convinced that everyone is emitting their psychic transmissions all the time, he feels that there should be someone looking for ways in which to channel that energy. Sex Magick, for him, is the best avenue of exploration as it provides the skeleton key to the Doors of Perception, unlocking hidden areas of human potential. That assumption is his only belief and practically everything he does stems from the fact.

"It all depends on how much credence you give the subconscious to operate in positive ways on its own, almost. I do think over the years as I've gone along I've found more and more evidence to support the theory that people's brains send out these various frequencies, signals, and that through these there is some linkage in the mass unconscious. Which would explain, for instance, how you get apparent phenomena of messages from the dead and so on. So in fact all you're doing is tapping the residual pool of the unconscious thought all over the planet, and a lot of people aren't aware of that so they're thrashing about and being irritating and unhappy because they're tapping useless thoughts from it uncontrollably."

The study of Magick is the study of psychic radionics – how to control the transmissions and improve the reception. Sex Magick is a way of putting more power into the aerials – the brass, wood, paper, glass Psychic Crosses that hang on hundreds of walls from Tokyo to Toxteth, charged with the resolutions of the Temple. An organisation attempting to understand the mechanics of tapping into and tampering with the 'pool'.

Working on Gen's prompt – *"If you really, really want something to happen so pure at the moment of orgasm you get a completely pure desire, for a fraction of a second there is no distraction or dilution of that desire, the chances of it happening are greatly increased"* – Initiates have come up with varying experiments and reported some unusual results.

Here is one example of autoritualisation from the Temple Archives, submitted by an Eden:

"I find it vital to perform a sigil in a way that separates it from everyday activities. The setting is always a darkened room, in the evening – usually

about eleven. I rearrange the room taking out all the objects I feel to be superfluous. This leaves the room stripped except for the bed and the tools I've selected for the occasion. There are several objects I always use – chosen by intuition. Finding a set of tools that you can use especially for the Sigil is essential in promoting a magickal reflex. By this I mean a set of conditions, objects and actions that work on the subconscious as shortcuts to the special, elusive state of mind needed. I don't like to use these objects for anything other than the rituals.

"The objects I use are as follows: a knife, which I know has a potent history, a silver bell with a goat's-foot handle which I bought under unusual circumstances, candles and a razor. Before I begin I arrange these objects around me. I find it very useful to take some kind of drug, sometimes just alcohol, not for recreation but as an aid to changing the atmosphere, the consciousness, to stepping through a door to a special frame of mind. Always I keep at the back of my mind the aim and purpose of the ritual, slowly saturating my mind with the task before me. As I begin, I play Tibetan music because of its personal associations, and because it is intended for ritual use. I begin to masturbate, simultaneously using mental images of my own fetishes and playing with the focus of the ritual, swapping and overlapping the ideas with each other. The exact mental processes that go on are extremely hard to describe. I find my actions and emotions going on at once, all spiralling upwards, focusing on the orgasm itself. I simultaneously concentrate on both the situation I'm in and also the internal and intuitive processes I'm trying to arouse and initiate within myself. One knows when the spark of truth is struck. The outside is inside and vice-versa. Both are fused and concentrated - focusing on the one aim of

the ritual. The orgasm is the key to the whole process, the seal of the unconscious.

"Once the orgasm has passed, I prepare a physical Sigil. I write and draw on a piece of paper what I feel – sometimes unassociated scrawls and symbols, then I add spit and ov (semenal fluid). I use the razor to draw blood, painting symbols and marks with it, as occur to me at the time. I place the paper in a prominent position in the room, so I am constantly reminded of the aim of the Sigil. For me there is a huge difference between an orgasm during a Sigil and one achieved by normal erotic action or fantasy. Every Sigil I have conscientiously prepared has gained results; sometimes almost frightening in their efficiency and effect.

"For example, once I wanted to meet a boy I'd seen in a magazine and I performed a Sigil to do so, and a few days later decided to go to a pub I hadn't been to for some time, just as a change of scene. As I walked in I saw the boy across the room. Almost immediately he came up to me and said he had the feeling that he knew me or that he'd seen me somewhere before, which he certainly hadn't. We got talking and later had sex."

The leading innovator of such forms of 'Sigilisation' – Austin Spare – described the system with some more lucidity, adding the vital point that, as far as possible, the desire must be lodged in the subconscious without the conscious mind being involved or aware.

"My formula and Sigils for subconscious activity are a means of inspiration, capacity or genius, and a means of accelerating evolution. An economy of energy and a method of learning by enjoyment.

"For the construction of Sigils the ordinary

alphabet is used. (For example) the desire for super-human strength could be formulated as follows: 'I desire the strength of my tigers'. In order to Sigilise this desire, put down on a piece of paper all the letters of which the sentence is composed, omitting all repetitions. The resulting sequence of letters, 'IDESRTHNGOFMY' is then combined and incorporated into your Sigil." (This sequence of letters and/or symbols is called a 'glyph'.)

"The wish, thus Sigilised, must then be forgotten; that is to say, the conscious mind must desist from thinking about it at any time other than the magickal time, for the belief becomes true and vital by striving against it in the consciousness and by giving it (Sigil) form. Not by the striving of Faith.

"By virtue of the Sigil you are able to send your desires into the subconscious (the place where all dreams meet). All desire, whether for pleasure or knowledge that cannot find natural expression, can by Sigils and their formulae find fulfilment via the subconscious.

"The energizing of such a Sigil must occur at a special time. At the moment of orgasm the wish must be imperatively formulated. It is not in the actual Sigil that the power resides (this is merely the vehicle of the desire) but the intent with which it is despatched at the moment of exhaustion. Any glyph, personal or traditional, may be used as a Sigil. If personal, it must be the specific vehicle of the desire, and designed for no other purpose; if traditional, it must have received a new direction which thereby consecrates it to its secret purpose. Powers of visualisation, self-discipline and concentration are the qualities necessary."

Austin Osman Spare is, along with Crowley, the major figure behind the 'occult' philosophy of the Temple. Not only an extraordinary occultist, Spare was also a brilliant artist. Having left school at 13 he was given a scholarship to the R.C.A. on the strength of his illustrations and his treatise on Solid Geometry, for which he had won the National Gold Medal.

His father a London policeman and his mother a devout Christian, Spare developed a dislike for convention and developed a relationship with an old woman who was a witch, Mrs Patterson, who taught him many aspects of her craft. When he was still only 17 he published his first book *Earth Inferno*, a short aphoristic text lavishly illustrated with his occult-influenced surrealist drawings. On publication of this critics compared Spare to Dürer, and John Singer Sargent described the young East Ender as a genius. Around 1910 he joined Crowley's Argentum Astram. He served in Egypt during the First World War where he was impressed by the pyramids and the carved hieroglyphics of Egyptian occult art. Inspired by these, he went on to develop his own theory of Sigils, which was a system of ritual symbolism creating glyphs which aimed to express the human will in a secret, concentrated form. The process of sigilisation involved him expressing a desire to his subconscious in symbolic form while in a state of

trance (which he called "the death posture"), or ecstasy (usually sexual). A believer in reincarnation, he also felt that during this state he could regress and rediscover all his previous personalities – which he presented in his work in the form of half-man half-animal beasts – and finally be able to trace "the Primal Cause of all", which had been lost by Mankind through the passage of time. This "atavistic resurgence" and the ultimate discovery it revealed was called 'Kia' – the true Being of Man.

Undoubtedly one of England's finest illustrators, Spare's best work is to be found in the book he published when he was 22 years old, something of a bible for Temple Initiates, *The Book Of Pleasure (Self Love): The Philosophy Of Ecstasy* (1913), which he illustrated with automatic drawings, though his work also appears in another P-Orridge favourite, F. Russel/J. Bertrams' *The Starlit Mire* (1911). Spare was someone whom Trans Media may have called a "quaquavine" – being born at midnight on the 31st December 1888, or the 1st January 1889, this event giving Spare what he called his 'Janus Complex', named after the Roman deity who looks backwards and forwards simultaneously. His later years were spent, like Crowley, as a recluse in a dilapidated house. He died in Brixton in 1956.

Spare's rituals were not entirely done alone. He used a string of mistresses, prostitutes and, he claims, succubi for his ritual work. The Temple, too, does not rely solely on autosexual techniques.

Much has been made of the supposed orgiastic goings-on within the Temple (particularly by people feigning disgust while all the time wishing that they were invited to such activities).

Far be it from me to destroy anyone's fantasies, but in truth such activities are rare, though they do happen, normally among small groups of friends and lovers rather than between total strangers flung together in some moonlit meeting of a coven.

'Sex Magick rituals' performed by more than one person in the Temple often take place in an area that is as free from the pervading aura of Control as possible. Somewhere free from the trappings and proprieties of starchy social convention, a place where the ego and false identity is shed and the Initiate is more able to revert to a time of pre-conditioning. The Nursery.

"Without is without
In the Nursery
Darkness is not dark
In the Nursery
There is no fear
In the Nursery
The bear is there
In the Nursery"

—*In the Nursery*, PTV 1983

The Nursery is an attempt to create an environment without any rules that relate to the outside world. Unlike in Passolini's *Salo*, the nursery is not only a microcosm, but also a vacuum – there

are NO rules here at all. The Nursery is a functional artistic installation. A theatrical stage set in which Edward Kienholz meets Lucrezia Borgia.

The Nursery is situated at an address in an anonymous East End sidestreet behind heavily bolted doors and a video security system. The walls of the room are blood red. The black floor is clear of obstructions, except for a coffin that lies along one wall and the menacing hulk of an old leather dentist chair (which once played a part in a case of a dentist tried for the molestation of drugged patients) that dominates the room. Peacock feathers, ropes, dildoes, chains, mirrors, human skulls, gnarled wood, candles, carvings... dozens of articles line the walls. To be improvised with during ritual by adults much as the same way in which children may experiment with a box of old clothes in a playroom.

Sexual acts that may take place in the Nursery are not seen as being 'Sex' by participants. People separated from the embarrassment and fear of the outside world tend to indulge in activities that perhaps they would not normally. The sense of vulnerability engendered in such a highly- charged disorientating place serves to strengthen the Temple, creating a bond of trust – the ritual providing participants with a mutual intent. All physical and mental energies are joined and devoted to the ritual, and the liberation and channelling of psychic energy through the ritual abandonment of all aspects of Control, amid sweaty Bundeswehr vests and ecstasy.

As the Temple masters Sex Magick and compiles its research, other systems not involving orgasm have naturally developed. The idea is that once 'wholeness' is hopefully achieved, the vital ELEMENTS

of ritual that trigger the necessary altered states are learnt, the goal being to be able to 'switch on' and use such abilities automatically in everyday life. At a bus queue, on a train, lying in bed at night.

So, the assumptions made by the popular media would seem to be false – symptoms of the state of Control, inadvertently used to diffuse interest and divert attention away from suspect areas by making them appear futile, perverted, trendy or laughable. It is, though, just these areas that should, due to their tenderness, be investigated most rigorously. The rigours of the Temple, the ritual pop horrors and sex shocks are, in this light, just a means to an end. The end being this automatic ability. Evolution, no less.

Although Gen undoubtedly harbours a desire to be more famous, and PTV would quite like a stream of Number One records and to be disgustingly rich, it is primarily towards this evolutionary step which this psychic conglomerate strives – a slightly more interesting and important goal than getting your best profile on the cover of *The Face* – though it all depends on your priorities. Members of many groups obviously only want to be rich and famous and get models at cocktail parties to go to bed with them. Fair enough.

Genesis' priorities are patent. They stand drenched in his own blood, semen and urine. For all to see, and attack. For every group of detractors, though, there appears a convert. So when the jolly, trendy 'Biff' in the *Guardian*, or John Walters on Radio One, or Derek Jameson on Thames TV attack the Temple, an ally pops up in the form of a Sandy Robertson, a Paul Morley, or (as is often the case – surprisingly),

an Auberon Waugh (who said that P-Orridge was "one of the most lucid modern philosophers of the decade").

The *imposition* of will – be it the will of Thatcher, Stalin or P-Orridge – is quite clearly unjust to most level-headed people. The Temple is based on voluntary commitment. Total commitment. Not obedience. Despite the bombardment of the critics, volunteers are numerous.

The Temple is legion. It spreads like an unchecked disease throughout the disillusioned, existentialist rollnecks that blacken the reading rooms of the British Museum; it forms cells of MACE spraying, Ecstasy-taking 'Terror Guard' post-industrialist punks in sleazy squats; it settles onto the very fabric of White Western Culture (the T-shirts of TV producers and lapel badges of film directors often bear the tell-tale tripach cross).

As the '90s stretch before us, the Temple becomes more snappy and organised. A small but dedicated staff now run Temple Records from a neat office complete with buzzing computer, Xerox and FAX machines, serving the dual purpose of selling records and keeping the Temple informed. TOPY now has branches in the U.S.A. and 'Access Points' dotted throughout Europe, many of which produce their own Newsletters and Broadsheets independent of London and fund their activities with events, distribution of PTV product, and through the promotion of local gigs and discos.

As was planned by its founder, the Temple has taken on a life of its own, sprouting and inspiring numerous bands, artists, publications and events. People take from their association with the Temple whatever they like. Gen must take most of the credit for the phenomenon on his own narrow shoulders. Or, as his ideas and observations may be totally wrong, most of the blame.

As twilight turns into night, though, the theories behind a worldwide network of neophytes seem distant as Genesis finishes off a plate of his famous spaghetti bolognese, sips his tea, and moans about the chattering face of Noel Edmonds on TV. The grey glow of the cathode ray is turned off with the tap of a remote control consul, allowing the Moon to shine into the P-Orridge living room, reflecting in the dark dead glass of the screen. The huge stuffed wolf's head that hangs above him casts a ghostly shadow across the wall, that glints with three ceramic Hitlers – winging their way above the fireplace like Hilda Ogden's ducks. One's eyes drift across the room like a camera, focusing on objects. A box of piercing and tattooing magazines, a large glass tank housing a large friendly boa constrictor snake, 'Bella', and 'Moonchild' the family cat sitting – now stuffed – on the hearth. Shelves sag with books, occultism, art, psychology, drugs, cinema, and with videos, Anger and Jarman, Warhol and Buñuel, and a display of green bakelite art deco objects. And above the door, a pink perspex arrow with the number '23' at its centre, points the way out.

Twenty-three is the obsessional number of the Temple, appearing in its texts, records and memorabilia. It is suggested that sigils start at 23.00 hrs, major T.O.P.Y. rituals and events are held on the 23rd of the month, and so on.

The digits litter the work of Burroughs and Gysin (stemming from the Captain Clarke enigma), and figure heavily in Joyce's diaries. 23 is the number of the Illuminatus – the omnipotent, omnipresent secret order of masons founded by Dr Adam Weishaupt in Bavaria in 1776 and now said to invisibly rule the world. (There is tenuous evidence to suggest that they were responsible for both the Russian and American revolutions, even though they were banned in the 19th Century after being discovered in the throes of a plot to overthrow the Pope and all the monarchies of Europe.) 23 is connected in many texts with Sirius, which itself has heavy links with Egyptian and African magical mythology, and with Crowley's '93 Current'. 23 is a useful prime number, is incorporated into the name of a Temple-related band, and is a recurring figure in the cabbala. The number also features repeatedly in Koestler's works on coincidence. "23 Skidoo!" was the coded wolf whistle of New York vagrants on seeing an expanse of stocking-top during the Depression...and so it goes on.

In Temple usage it is largely incorporated as a code of recognition and association, a sign of good luck that brings a knowing smirk rather than a numerologist's jolt. Twenty-three is a leak through everyday normality, through which to get out and crawl into another world – like through one of Herr Vonnegut's mirrors.

As with all Temple mythology, the significance of the number should not be taken too literally, or seriously. Rather, it should be used as a trigger to set off one's own imagination, a seed for one's *own* mythology. Funny that 23 is also the American actors' slang for "Exit", given what Crowley wrote in 1913, a typically quirky poem under the title of *Keoall KT (Twenty three)*:

*"...thou canst not get out by the way thou
camest in. The way out is THE WAY
Get out. For OUT is Love and Wisdom and Power
Get OUT
If thou hast T already, first get UT
Then get O
And so, at last, get OUT."*

Interpreted as meaning that, first one leaves the life of materialism, then the physical confinement of the world at large and, lastly, even one's fellow Initiates. Life is, essentially, a solo voyage, and nobody can tell you how to get through it other than yourself.

Following the pink 23, your reporter staggers out onto the moonlit street and commences his voyage courtesy of the Number 23 bus (honest), leaving Genesis and Paula to put their children to bed.

The purpose of including the Temple Ov Psychic

Youth and their public manifestations in this form has been only to provide information, and hopefully a degree of insight – however biased I may be in its presentation. The only motivation one has for criticising the work of other people is to review and preview, or to promote the idea that one is somehow better informed than they are, or to help bring about their perdition – as pointless as a journalist interviewing someone for an hour then giving character references (as if they mattered). We leave the smart-arsed sensational journalese to people who think they need to prove that they are clever. We are confident that you are clever enough to gain your own impressions from the information you put at your disposal.

As that information will keep changing as long as P-Orridge and the Temple survive, there are no glib conclusions to be drawn. The Temple is not as easy or as neat as that. Unlike all Religious and Political doctrines, that exist on belief in a statement, the Temple exists only in the form of a question. A question begging a response which only you are able to give, based on your activity and research. Perhaps the only judgemental criterion one need apply to any cult phenomenon is: Does it ask questions that are worth answering?

In critical terms, even PTV manage to slither through the usual net as they claim not to entertain, but to *provoke* – and given the responses to PTV, they succeed.

And how does one take exception to this anti-Christ sitting here surrounded by the warm, slightly shitty domestic whiff that can only come from babies and pets – as he struggles against this "numbness of content" on one side and slanderous and sometimes physical assaults on the other? He claims no salvation, and brings only stimulation – the brass tack nailed into this Psychic Cross in an admission of vulnerability, fallibility that is all too recognisably human to be hero worshipped or obeyed – asking his solitary question from the bleeding heart of The Family: CAN THE WORLD BE AS SAD AS IT SEEMS?

His favourite song of all time is the Velvets' *I'll Be Your Mirror*, closely followed by a sad old Country Joe and the Fish number, which goes *"But who am I/To stand and wonder/Wait/While the wheels of Fate slowly grind my life away"*. Genesis is not one to stand still and wait. Although his letters and late night conversations sometimes show submission to the constant pressure he puts himself under (*"Oh let us write a book, a useful tool, and hide away in Spain living a quiet existence of debauchery"* or *"I have one more pop scam up my sleeve and then I will retire to Brighton to be Grand Old Grumpy of my era, I think..."*) he will continue to fight and provoke and confuse and *force* the hand of chance as long as he draws breath.

"Why do it all? Because it works for me and it makes sense to me and it makes life more stimulating. And, quite honestly, if life can be made more stimulating, then that's enough. Because it's a pretty boring concept really, being alive. It's not normally a riveting sensation, sixty odd years of crawling around the planet. I don't claim to have an original idea in my head. I've just observed things and tried to develop from that a clear line of thought in my mind, which I'm determined to follow through. It's an honest and interesting option for

me. And if it's applicable to other people then that's really nice, but primarily I'm doing all this as research for me, but as I've always believed in sharing research and information that's what we do as well. I've never yet come across anybody who's convinced me that we're going in the wrong direction. The more I learn and read about cultures, philosophies, perceptions and aesthetics the more I believe that it's just a useful synthesis of all those things that we're all searching for anyway. That synthesis has to include everything, and it starts with the individual and their personality, then goes through to their behaviour, then their relationships to the other people around them. That in turn generates outwards to society. I still believe that is the only way to get any change. I still believe that politics is a sham, that the mass media is designed to make us stupid, that drugs are there to control and distract us, and that violence is a cathartic exercise that does no good in the longterm whatsoever."

So here he is, still trying to define and refine and articulate Life. Investigate the expressions of his life, and expect nothing. Ignore them, and expect less.

"'What's with this serum?'
'I don't know, but it sounds ominous. The man's not to be trusted. Might do almost anything...Turn a massacre into a sex orgy.'
'Or a joke.'
'Precisely. Arty type – No principles.'"
—William S. Burroughs, *The Naked Lunch*

"'Ugh,' Sung-Wu agreed. 'It seems incredible people could practise such fanatic and disgusting rites.' He got nervously to his feet.
'I must go'."
—Philip K. Dick, *The Turning Wheel*

FOOTNOTE:
Since the writing and publication of this article in the original edition of *Rapid Eye 1*, Genesis P-Orridge has been effectively run out of the country. The news media, keen on sensationalising the largely contrived 'Satanic abuse' allegations in several parts of Britain (allegations which have now been proved to have been false), jumped on the band-wagon and accused P-Orridge and the Temple organisation of being Satanists, and that they were involved in the ritual abuse and murder of children.

Working with several extremist Christian authors who had recently published wildly over-the-top books and articles on the "Satanist" issue, the production team of the Channel 4 tabloid TV programme *Dispatches* concocted a false, sensationalistic and completely biased show claiming finally "to prove ritual Satanic abuse".

Showing short edited clips of a supposedly secret cult video that they had discovered (in fact, the 'First Transmission' art video referred to in this article, and shown openly at various performances and exhibitions for years), a voice-over claimed that the film was of a "Satanic ritual" involving abortion and torture!

Although neither TOPY or P-Orridge was named (to avoid libel actions that would undoubtedly have been taken by P-Orridge and TOPY solicitors against Channel 4, the station's legal advisors recommended that the programme was changed prior to airing. It was thus re-edited shortly before transmission), the TOPY logo and artwork was flashed on to the screen on many occasions.

Besides the ridiculous, mock 'serious' voice-over, viewers were also treated to sounds of what appeared to be a child crying in agony. The implications were obvious. Though, in fact, we can reveal that the child noises were taken from a personal recording P-Orridge made of his first daughter Caresse being born. As any PTV fan knows, this recording had been used by PTV as the backing for a sentimental, first-time fatherly song Gen wrote to his (then) baby daughter, called '*Just Drifting*'. The 'Dispatches' production team had, therefore, turned what they knew to be a song of paternal pride and affection (*"My little girl/precious and pure... you possess me with simple love... you touched my heart"* etc.) and gave the deliberate impression (without the lyrics) that it was a recording of a baby being tortured.

In an attempt to back up these ridiculous innuendos and assertions with a modicum of "evidence", the programme makers interviewed on film an un-lit individual, called only "Jennifer", who claimed to have been involved in the Satanic ritual, and, having been brainwashed by the cult (sic), agreed to the murder of her own children. Channel 4 later claimed that the witness, and a copy of the video, had been passed-on to them by a "professional carer". In fact, the presenter of the programme had been introduced to the woman by a solicitor, Marshall Roland. Unbeknown to most people, it is an established fact that Mr Roland had previously been forced to resign from his practice because of his extreme, and some would say eccentric views on "the dangers of Satanism".
The witness is, in fact, a woman who has since been described as a 'professional victim', well known to professional journalists and others, who has given lurid testimonies over the years to abuse-councillors as well as various rape and incest help groups. She is now receiving psychiatric help. (This "witness" later went on to describe the interior of the building in which these "rituals" were said to have taken place – incorrectly. She said, for example, that the scenes filmed took place in the basement of the building. In fact, *Rapid Eye* can reveal the building in question has no basement).

Despite the serious nature of her claims, Channel 4 refused to reveal her identity or fully co-operate with the Police, who

were consequentially unable to interview her and carry out proper enquiries into the allegations. The Dispatches team appeared, for some reason, not to want to get to the bottom of the allegations. Either that, or they are quite willing to protect self-confessed child murderers in the interests of getting a sensational story that happens to support their own unusual view of the world. Superintendent Michael Hames, head of Scotland Yard's Obscene Publications Squad, said: "I need to see these witnesses urgently because – if what they say is true – serious crimes have been committed which require investigation." His requests remain ignored by Channel 4.

The Dispatches team did, however, suggest to the police just prior to airing their well-advertised programme that P-Orridge was connected to the ritual abuse of children and was the ring-leader of a "Satanic cult". Police, who, apparently "had P-Orridge and his followers under surveillance for some time", had, however, been planning no raid on P-Orridge, and thus had their hand forced by the journalists, who threatened to reveal on TV that although the identity of the cult was now known to the police (due to the journalists own wonderful investigative reporting), the police themselves had not bothered to act.

Forced into action by the imminent screening of the programme, over twenty plain clothed and uniformed officers from Scotland Yard and Brighton Police station raided the P-Orridge family home in the Lewes Road area of Brighton. Remaining in the house for several hours, they questioned a friend who was staying at the house (to feed the pets) as well as neighbours. They also seized two van loads – over two tonnes – of private "material", including letters, diaries, family photo albums, address books, sculptures, musical instruments, artwork and videos (including Walt Disney cartoons). Genesis P-Orridge, his wife Paula, and two daughters, Caresse and Genesse, were fortunately at the time enjoying a family holiday visiting Buddhist temples in Thailand.

After the Dispatches programme was aired, the story was taken up by the tabloid press, who predictably vilified P-Orridge. Several papers remembered that he was the man who had been involved in the GPO/Mailart trial, and also that he was the infamous ICA Tampon Man. They said that P-Orridge and his "followers" (sic) "are lewd, disgusting people involved in all types of extreme sexual behaviour". Supposedly 'serious' newspapers, such as The Observer, joined in, publishing bizarre, unchallenged articles from Eileen Fairweather, a 'researcher' on the programme, which claimed (wrongly) that doctors and police had confirmed the film was genuine (ie one of a secret Satanic ritual involving child murder and forced abortion). Rapid Eye can reveal that this same 'investigative journalist' Eileen Fairweather was at the time a member of an extreme fundamentalist Christian group, and had herself previously undergone an "exorcism" at the hands of that group's leader.

In more sane sections of the media, an angry Derek Jarman and others countered this nonsense with the very obvious fact that the 'Satanic' video in question was in fact nothing more than a (very old) video-art 'piece'. Had the pseudo-journalists (or, more accurately, cranks) concerned with the programme read Rapid Eye, they would of course have known that several years previously.

After a thorough investigation (this time carried out by professionals), a police spokesman said that some charges were being considered, though THESE CHARGES DID NOT HAVE ANYTHING TO DO WITH CHILD ABUSE OR MURDER, AS THE POLICE HAD SATISFIED THEMSELVES THAT THESE ALLEGATIONS WERE UNFOUNDED.

Over a year after the raid, police still have not returned any of the innocuous confiscated material. Channel 4 have not bothered to retract their statements and damaging, though

suitably vague implications, or apologise, nor even give any coverage to the facts as reported by Jarman and the police. Nor have they mentioned the many factual inaccuracies of their gutter-level 'documentary' or the books that inspired it.

We can in fact reveal that Channel 4 and the Dispatches production team went to extraordinary lengths to cover-up the strong Christian fundamentalist views of those involved in the making of this individual edition of the programme. For example, the Dispatches credits said that the film had been produced by 'Look Twice Productions'. There is no such company listed in the telephone book. In fact, during the production of the programme, the group purchased an 'off-the-shelf' company for around £200 with which to conceal themselves. Channel 4 deny that this was a device to hide the true views of the team involved, but have offered no explanation as to why such unusual tactics were employed to mislead their viewers.

Presenter Andrew Boyd said: "Our religious views are irrelevant". Anyone who has had the misfortune to read his quite laughable, badly researched, inaccurate and at times semi-literate book, Blasphemous Rumours (Harper Collins), will know that Boyd's religious beliefs are far from being irrelevant when it comes to his presentation of 'facts'. His religious convictions are his private concern, but not when they impinge upon the personal convictions of others, or their liberty, or on the rights of innocent children and parents, or on standards of professional – let alone honest – reporting. Boyd claimed in the documentary that 98,000 children disappear every year in Britain and implied that they are abused and/or murdered. The police, like most normal people, know and say that this is absolute rubbish. Very few children go missing each year, and there are no cases at all of children proved to have been abused or murdered by so-called Satanic groups. Dr. Bill Thompson, a criminologist from Reading University, says: "The truth is that not one child has ever spontaneously described Satanic ritual abuse. It only emerges after repeated questioning and suggestions by adults." This view, commonly held by experts, was not even alluded to in the unbalanced sham documentary.

It is no surprise; the editorial techniques adopted throughout by the mysterious 'Look Twice' team are, to put it kindly, questionable. For example, Dr. Wendy Savage, a respected consultant gynaecologist, had been interviewed by the team. She says: "I viewed the video and told the Channel 4 film makers it clearly was not an abortion being shown. For some reason they cut me and my views out of the finished programme. I also told them that in my opinion, someone had a very fertile imagination." Boyd's book was, by the way, published to co-incide with the screening of Dispatches. The more extreme the programme, the greater the publicity generated for the book, the fatter the Royalty cheque.

Caught in a limbo, the P-Orridge family have been forced from their home (and, in the children's case, school), had their personal belongings effectively stolen, and are in an Oscar Wilde-type exile, forced to live in more tolerant California (legally, and without hinderance) but with no substantial source of income or permanent base. (P-Orridge currently ekes out a living by performing – PTV are still the best-known 'unknown' band in the world – and lecturing extensively with "Weary" Timothy Leary. He is also a "Youth Culture Expert" employed by various Californian Think Tanks in Silicon Valley.) Their family home in Brighton has been invaded by policemen and, later, ransacked by paint-spraying vandals. Valuable paintings and irreplaceable memorabilia have been stolen or destroyed. With P-Orridge unable to meet mortgage payments due to the move, and unable to sell the property, the Building Society are considering re-possessing the house.

Even more importantly, the P-Orridge family's personal,

private lives and histories have been ransacked, distorted and debated in public by strangers who have vested interests. (Journalists keen for good copy, religious cranks keen to sway public opinion against libertarianism and sell their own narrow-minded books, and self important rumour-mongers of all types).

Unspecific charges are still being considered by the police (though have not been made), meaning that P-Orridge risks arrest if he returns to this country on charges that he has not even yet been informed of. (It is thought by some that, before bringing charges, the Police have waited for the Law Lords final ruling on the controversial 'Spanner' sentences – several men having been arrested and imprisoned for consentual adult sex in private that involved S/M activities that, under a new interpretation of the law, were deemed to involve assault and therefore be illegal. Thus, any adult in Britain involved in SM activities, or even the piercing of a consenting adult partner, became criminals. It is also thought that P-Orridge, as a founding member of COUM and TOPY, may be charged with obscenity for some of his controversial, transgressive artwork).

Despite the lessons learned from the Orkney case, Social Services would also possibly feel obliged in the current media-generated climate of hysteria to investigate the case, which may involve temporary removal and interrogation of the children, regardless of the psychological damage this may have on them and the family. Again, Social Services, who before the programme were happy to let Gen and Paula bring up their children, would have their hand forced by know-all, attention seeking TV journalists and researchers desperate to increase their programme's tiny viewing figures, regardless of the disruption their irresponsible actions cause to innocent parents and children.

Regardless of the laws relating to sub judice, Boyd and his cronies have, in effect, tried P-Orridge in the media, as self-appointed policeman, prosecution, judge and jury. Many journalists and newspaper editors have, as usual, shamelessly followed suit. If charges are ever brought, will it be easy to find a real jury who have not been influenced against P-Orridge by the scurrilous reportage he has attracted?

Mindful, and respectful of the laws of sub judice, we have been careful here only to report proven facts that are already public knowledge. We could say more.

Finally, if the 'investigative reporters' of Channel 4 had any awareness or professionalism, they would have realised that the very video they "discovered" had in fact been made over a decade earlier (in 1981) by a video artist interested in the Temple, and had in fact previously been aired on Channel 4, BBC, and Thames TV arts programmes, as well as on television in Europe. To our knowledge, the video has never been distributed or been on sale, though it has been shown at exhibitions and performances. Stills from the video appeared openly in *Rapid Eye Movement* as far back as 1985.

The Temple of Psychic Youth continues to evolve and grow, albeit without P-Orridge, who decided to discontinue his involvement with the group in 1990. Since that time, the Temple has focused its attention more and more on developing new methods and symbolism with which to address the continued slow decay that they perceive in society. This decay manifests itself not only in the economic sense, but also, perhaps more significantly, in an increasing breakdown of hope and genuinely innovative creativity.

The early history of the Temple given in the above article is simply that, HIS-story. As was perhaps intended from the outset, the Temple has gradually become – as was stated – a co-operate venture. Thus, anyone approaching the Temple as it is now, in the hope of finding the Temple as it was then, will be disappointed (or not, as the case may be). TOPY has no wish to live in the past, and has never wished to be a static entity, tied to tradition or any form of fixed myth or methodology. As I said in this article, TOPY is based not on any one idea or system, but on flux. TOPY continually re-invents itself, as time flows, it changes. It is a question of evolution, of continuing to check and re-check the principal concerns of society as it really is; and the application of a "Magickal Perception" to those concerns.

So, TOPY still exists, their forms of communication and interests are broader-based, but equally intense. The exploration of society, of Control, of art and of The Art continues unabated. The period since the raid has taught TOPY a great deal, not only about media and communication, not only about the power of myths (and their construction); but also about the deeper levels of magick as it integrates fully as a truly effective means of Life.

TOPY has never offered easy answers – it still doesn't. It is neither a cult, nor a religion. It is not "Satanic", it is not "Christian". Indeed, these terms, left/right, black/white are not, and never have been the issues here. TOPY simply strives to be a way of seeing just a little bit more than you first thought was there, of seeing through the image that is projected and dealing directly with the realities behind these myths, behind these masks. Perhaps P-Orridge created one myth through which the mythology can be better understood. Perhaps everything was scripted, perhaps, on the other hand, nothing was intentional or true. Whatever your opinions, TOPY is a journey of discovery. Nothing less; and perhaps a great deal more.

For information on TOPY as it is now, write, enclosing an SAE or IRC to: Transmedia Foundation, PO Box 1034, Occidental, CA 95465-1034, USA. It should be noted that, after the media furore, mail heading for Temple Records, Temple Press, TOPY, and other organisations, including *Rapid Eye*, started to go missing or was clearly tampered with. (Though this has now stopped). The Liberty organisation (formerly the National Council for Civil Liberties), wrote to *Rapid Eye* saying that the Special Branch were probably opening our mail. Several bookshops refused to stock *Rapid Eye*.

We like to feel we live in a liberal society, and are cynical about any claims of suppression. We merely present you with the facts.

As we said in the above original article, Genesis P-Orridge represents a threat to Control. Society has concocted "good" reasons to remove him from a position of some artistic and social influence. Also, society has tried to come to terms with the genuine problem of child abuse, which most often takes place behind the net curtains of 'normal' suburban families, by transposing the problem onto an imagined minority group of individuals who may be interested in the academic works of assorted writers, artists and prophets who are considered to be 'suspect' by the majority – or, at least, by the populist media that claims to speak for the majority. Thus, people who read books such as *Rapid Eye* are assumed to be paedophiles and "Devil worshippers" (sic), regardless of the fact that many probably do not even believe in God or the Devil (we will ignore for the moment the fact that Satanism and paganism need have nothing to do with concepts of the Devil). So, the problem of child abuse is no longer a problem of society as a whole. The problem, as always, is the minority group.

The society that condones the dropping of nuclear weapons on children, systematically tortures and kills millions of animals, sells and poisons land from beneath unborn feet and profits from the preventable starvation and exploitation of children in differently developed countries, thus remains clean.

As Gen himself once wrote, borrowing from Charles Manson: **"CAN THE WORLD BE AS SAD AS IT SEEMS?"**
We let you decide.

—Simon Dwyer, Florence, 1993.

THROUGH A SCREEN, DARKLY
The Derek Jarman Interview

Simon Dwyer

Derek Jarman – painter, film-maker and theatre set designer, held his first one-man show at the Lisson Gallery in 1969. He designed sets and costumes for the theatre (*Jazz Calendar* with Frederick Ashton and Rudolf Nureyev at Covent Garden, *Don Giovanni* at the Coliseum, and *Mouth Of The Night* with Micha Bergese). He was production designer for Ken Russell's films *The Devils* and *Savage Messiah*, during which time he worked on his own films in Super 8, which became underground classics, such as *In The Shadow Of The Sun*. He went on to make feature films: *Sebastiane*, *Jubilee*, *The Tempest*, *Angelic Conversation*, *Caravaggio*, *Imagining October*, *War Requiem*, *The Last Of England*, *The Garden*, *Edward II*, *Wittgenstein*, and *Blue*, working with a variety of actors from Sir Lawrence Olivier to Adam Ant. His autobiographical books include *At Your Own Risk*, *Caravaggio*, *Dancing Ledge*, and *Modern Nature*. He has returned to painting (shows at the Royal Academy and the ICA) and design (*The Rake's Progress* in Florence), and made a number of pop videos, including promos for The Smiths, Pet Shop Boys, and Marianne Faithfull. His video for REM's *Losing My Religion*, won an MTV award for best pop video of 1991. He 'came out' while at art school in the company of David Hockney and Patrick Proctor, and had affairs with Robert Mapplethorpe and the serial murderer Michele Lupo. Canonized as Saint Derek by the activist queer group The Sisters of Perpetual Indulgence, Jarman became a prominent

media figure in the political and social battles against homophobia and AIDS. He was diagnosed HIV+ in 1986. He lived in a small flat in central London and a wooden fisherman's cottage on the beach near the nuclear power station at Dungeness, Kent. Gay martyr to some, transgressive art hero to others, he spoke to *Rapid Eye* in 1985.

"I have thee not, and yet I see thee still. Art thou not, fatal vision, sensible. To feeling as to sight?"

On the inner levels of philosophy, literature, theology and metaphysics, certain masters developed impressive esoteric ideas, founding new schools of thought through their synthesis of ancient teachings. The most famous of these was Jabir el-Hajyan, better known in the West as "Geber". It was from his name and the apparent unintelligibility of alchemical writings in general that the derisory descriptive noun "gibberish" derived...

Walking up the demolition site of Charing Cross Road in the morning sunshine, the rolled-down windows of the immobile metal snake that stretches up to Centrepoint gives an aural cut-up of the state of the world. Passing from big BMW to tiny Toyota is like listening to the post-intellectual hip-hop of Cabaret Voltaire. LBC, BBC, Capital, bulletins of IRA action spliced with S-Express, Terence Trent D'Arby, and The Eurythmics – Annie Lennox talking to the Angels... "Da da do da-da dahn da da dahh

dahhh..." Some people would understand.

Derek Jarman sits on a stool in his lovely little room, surrounded by his labyrinth of "gibberish", surrounded, quite literally, by himself – one hand on the back of his head, the other resting at the base of his spine, body rocking awkwardly as if he's waiting for the tooth-puller. Behind him stretches a long window, in front of it a large writing desk, empty but for a full appointment book. A double bed is headed by a big home-made bookcase, a maze stuffed with hundreds of titles; Psychology; Biographies; Art; Occultism. It all figures. A classic plastercast head of Mausolos looks on from the corner – saved in the '60s from the Slade just before it was to be smashed to make way for the flood of modernist American giganticism. The white walls are darkened by a symmetrical arrangement of Jarman's own beautiful miniatures – ghostly gold figures and skulls, naked silver shadows and scribbled hieroglyphics caked with thick black paint, all set in heavy frames and deep glass. A cylindrical witch's mirror, as used in medieval laser shows, dangles by a thread from the ceiling, giving a convex impression of the streetlife below. Jarman knows the art of mirrors.

In a climate of seamy social realism, 'adult' films are packed with Content (the stuff of broken marriages), obsessed with kitchen sink narrative and dazzled by American Actor's Workshop graduates who put on accents, weight and stubble for the making of a Picture. (It's always a "Picture". Not a Movie, never a Film, and never, ever a Dream.) All of which leaves little room, or backing, for the unfocused visual cinema of Derek Jarman.

As an individual media figure his own stature has increased enormously in the last couple of years. But often he is in demand not because of what he does, but because of what he says. A man who puts his art into his life, rather than his work.

Uncompromising, fiercely independent, Jarman is still more distanced from the British Film establishment than any other major director, as his is still seen as 'serious', 'arty' cinema that they wish neither to encourage nor understand. But he remains unconcerned about being understood, using as he does the unpopular language of the artist, the language of the angels, without regret.

I'd met him before on brief occasions when he'd often seemed polite but preoccupied. Preoccupied with his work which, in such a personal artist, such an honest autobiographer, was a preoccupation with himself. When Jarman is working, he is often gliding around in a tizz and he seems to float half an inch above the ground, untouchable but untouching – ignoring everything, and everyone, around him. Reminiscent of the Queen Mary leaving harbour, at such moments it is advisable to give the man a wide berth.

As the creator of such a powerful body of work he has always remained something of an enigma behind this self-assured front. Seemingly aloof not only to the demands of the Film World, but also the needs of his audience.

Flippant and occasionally bitchy, but thankfully never apologetic, as so many less determined artists are. In a society so hostile to its Art World and cynical of the gay mafia that operates within it, it would be easy to harbour doubts about him. One could picture Derek as a boy, sensitive, frightfully middle class and fresh from the closet of public school, standing in front of that distorting witch's mirror engrossed in his cleverness and beauty. Like Quentin Crisp in *The Naked Civil Servant*, like the clone boys standing in uniformed rows in the full-frontal mirrored toilets at Heaven – so heady with the nitrate that they believe what they see in the mirror, as if it had their own mind, as if it couldn't lie. It was always possible that Jarman had latched on to anti-fashion, olde worlde imagery and mild eccentricity just as the clones had pieced together their own acceptable identity. In cultivating his own image and believing his own publicity, distancing himself further and further from the Art/Cinema establishments that don't always think too highly of him anyway, and while doing so making no explanations for self exploration and possible self love, one could easily wonder if Jarman were merely subsidising his lifestyle; still living through a massive hangover from the Andrew Logan party that was the '60s and at which Jarman was, in his own words, "an extra".

Was he gratifying himself, existing only for himself, was he (let's face it) a wanker? Why should anybody wish to eavesdrop on this man's private visions, decode his mystical signals, when we can gulp up pop culture in the sanitised columns of IPC? Boy George and his ilk, being a so much less bitter pill to swallow as cultural crusaders for we modern, liberal people. George, the type of harmless eccentric the English convince themselves they love, was at least free from all that artistic solipsism. And probably a far truer, more apparently 'real' reflection of the 1980s than anything found in Jarman's mottled mirror.

But the fact is, however confused or romanticised Jarman's vision may sometimes appear, there is sitting before us a pearl in the shit of 'experimental' film-making. Derek is erudite, funny, and completely charming, but the reason this man is so engaging, so fascinating in his pretention – the reason he gets away with sometimes acting like the Queen Mary – is that out of the shadows of his films there is a human face. As in all 'worthwhile' art, be it film, music, literature, comedy or whatever, when the mask is removed that face is (often uncomfortably) like your own. In Jarman's films, the whole being greater than the total parts, your senses are honed to perceive "the face of the soul". Not the fat face of America. Not the face the TV would like us to have, the face we show the world in *Brideshead* or *Brookside*. In Jarman's films, real people are allowed to exist. Real, weird people shimmer silently across the screen in his vaguely allegorical, image-based, mood drenched stories where the traps of time and

place are cross-referenced and transgressed, and where 'meaning' is supplied by the viewer. The dreamer. As naturally follows in a world that lives through its media, real people are therefore more able to live life the way they wish. People are allowed to leave Brookside. Bad actors in the scripts given to them by Lorimar and Granada, they are instead able to confront their wildest dreams and live because they see themselves on the screen.

Such escapist philanthropy may, in Jarman's eyes, be merely a by-product of his own wish to exist. He just holds his mirror up to 'Reality' or 'Control', like Boy George does. But in Jarman's mirror, instead of a confirmation, Control sees its 'reality' distorted, made, in Jarman's eyes, more 'real'. Such an image may not be part of the Grand Plan, which may explain why Derek Jarman remained until 1986 the only British film maker to have made three feature films and not have had any of his work shown on TV – the IBA banning the original planned Channel 4 screenings in the same stroke as they nixed transmission of Ron Peck's *Nighthawks* (in which, coincidentally, Jarman played a small role).

It is, though, always self-defeating to over-intellectualise about anything as vague and subjective as Art, even with the aim of trying to decipher and disperse it, so that pieces, fallen neglected like Jarman from the high tables of Melvyn Bragg and *Time Out* be better appreciated – or at least disliked for more sensible reasons. Perhaps, then, not bucking for a job on *The Late Show*, we should just say that in case you have never seen his work, it is only Jarman who could make such superficially boring cinema so seductive, and listen to his own words echoing from the Sanyo...

Talking of the British Film Institute funding of his long-awaited, much acclaimed, **Caravaggio** epic, of his enduring associations with Genesis P-Orridge and Coil (from **In The Shadow Of The Sun** to **Mouth Of The Night**), of artistic control over the huge production of anything as heavyweight as a modern feature film, of Money...

"The money needed in film is enormous. The money needed in other areas, to put out a tape of music for example, is peanuts by comparison."
RE: Do you envy people who work in other areas then? Would you like to be free as the musicians you use in your work, for instance, like your pals at PTV?
"Oh, I'm MUCH freer than Gen! Because I don't have any theories to hinder my development. He's going to love that isn't he!?"
RE: I'm surprised you have that approach. Gen, for instance, always has very good reasons for doing anything-
"Oh, I have my reasons."
RE: Alright. What was your reason for making **Caravaggio**, then?
"Umm... what an appalling question! I don't know."
RE: Well, it's just that, talking of Gen, he always knows exactly, he always analyses everything he does y'know.

"Yes, I do too. It's just that I've got to such a state of self-analysis that people can't understand the language I'm talking in, so it actually becomes impossible. You see, I'm working in a sort of way which, in my own mind, is not very easily communicated. Do you know what I mean?" [I'm not sure if I do.]
RE: ...Feelings?
"Yes, feelings and things like that. So I really can't say it's theoretical. Personally I can't see the point in communication at all any longer."
RE: Why not? Because it's all been said, or people have nothing to say?
"Well, because I don't think it's necessary to say it. My feeling is that all of this is centred around people sending messages to other people. I suppose one sends messages to people who're already inclined to actually receive one's messages. One doesn't make many converts. My feeling is I'm a bad audience. I dislike audiences. No one should go and see anything, they should go and do it for themselves. Therefore this precludes even a situation like Gen's, theoretically. On the other hand in an imperfect world in which I've got to live I've to make a film.

So... I'm doing it for the money!"
RE: Yes of course, but now you're being flippant, you don't only think of that at all.

He doesn't, in 'theory'. But the fact is that in this imperfect world Derek Jarman is almost a bankrupt, and the bigger films, such as **Caravaggio** and **The Garden** should, if not make him rich, at least wipe out his massive debts. And the important idea is encapsulated there – in a perfect world we'd not only need to devote most of our energies towards survival, but there would also be no need for us to be culture vultures, picking over the brains of usually very dull musicians, film makers, fashion designers, painters and novelists for interpretations of Life. We'd all be too busy finding our own interpretations ourselves. The ethics behind the bedroom-bound cassette makers he refers to, similar to the motivations that started *Rapid Eye* in the late '70s, would be close to Jarman's heart. In theory at least the whole Ladbroke Grove 'alternative' activity was not only about producing something for oneself, but about doing it while being uncorrupted by the needs of the audience. This is something the likes of the Record Industry and Music Press could never collectively admit to understand. In the acceptable areas of culture (anything prefixed by 'Youth'), chart placings and ratings are what count. Jarman knows only too well. The audience is everything.

"Audiences have always been dangerous. They can get enormous."
Hardly pop culture material, Jarman gets his mouth around the word 'enormous' as if he meant 'monstrous'.
"Like audiences listening to some speaker telling them to go and kill people. I don't believe in audiences, therefore it is essentially difficult for me to be honest with people about communicating anything in art like that. I'm only communicating really to the converted, and quite honestly at this stage in my life I'm sufficiently aware of the structure outside to realise that in a certain sense you can blind yourself by believing."
RE: So you don't even have any ideas about the feelings you would like people to have when leaving the cinema, say?
"No I don't. Not even that. What happens is I think other people decide afterwards exactly what things are. What a thing becomes in a culture after it's made is very different from the intentions of the person making it. Also, don't believe that you can set up a situation and know what the outcome is going to be. You can say 'I'm going to do this', but you end up with the other. Invariably things end up with their opposites... To put it in really blunt language, systems of Peace and Love end up as War and Hate. It's quite simple."
His mind picks up the thread.
"Where I do agree with Gen is that while one's working one should encourage people to take the leap to work as well, because the more people who're doing it, the more interesting and vibrant it becomes."
RE: Why is it vibrant if nobody is communicating anything to anyone?
"Because it's all to do with internal things, it's nothing to do with external things at all. That's what it comes down to. There's no such thing as the world outside. The only thing that's of interest is the world inside, and its relationship with the world outside. That's the attrition point, and that's what makes Art."

An explanation, of sorts, for films that have nothing to say. Home movies made by, and for, Derek Jarman – a man hellbent on finding his own explanations – props for the physical realisation of his own reality. In this context, then, ironically it's Jarman who is being unpretentious. His usual lack of obvious propaganda, ideals, and messages is far less presumptuous on the viewer than anything one sees on TV, for example. Television, by its nature, will lump millions of people's perceptions – their opinions, politics, morals, memories – into one insipid mass, to be moulded by anyone with a big enough hand (such people include the likes of Mary Whitehouse and Douglas Hurd). As so many 'alternatives' to this are merely equally arrogant, loaded and absurd reactions to the right-wing propaganda that dominates every TV and cinema screen in the country, Jarman's unfashionable artiness is like a breath of fresh air. If his films must have a socially credible quality, it is in nudging the voyeur into looking for such "internal explanations" himself. One starts by wondering what the fuck his films are about and, realising they need not "be about" anything, begins to read whatever one likes into them, his dream vehicles. He knows many ways of skinning a skull.

The most common and base criticism of Jarman is that he is nothing more than a neo-romantic libertarian. That he's not obviously 'political' enough. Yet Jarman is a tacit anarchist. It doesn't take an enormous leap of the imagination to see throughout

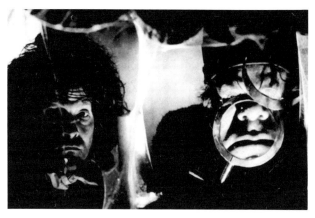

'The Tempest': Prospero (Heathcote Williams) and the King of Naples (Peter Bull). (photo: Bridget Holm)

his work a quite clearly defined attitude.

Look at an exhibition of his paintings and you will find works such as the sardonically titled 'GBH', a series of vast canvasses depicting a melting, burning map of Britain. *"A Britain in the grip of hellfire, a ritual destruction of little England, the Old Country – by Oppenheimer's nuclear grandchildren"*. Jarman's view of modern Britain seems to be one of damnation. Damned for being the most class conscious, hypocritical, xenophobic island in the West. Damned for being a puppet of Washington. Damned for shunning painting and literature in preference of M.T.V. His obsession with the past – **Jubilee** cross referencing punk London with Elizabethan England, **The Tempest** raking over the coals of Shakespeare, **Caravaggio** set in the Renaissance and so on – is also a rejection of the present. Surely a quite overt 'political' statement. Jarman himself says:

"I think of myself as a Green film maker. Our culture has always been backward looking. Shakespeare is backward looking. What interests me is that Elizabethan England is our cultural Arcadia. As Shakespeare is the essential pivot of our culture, it seemed really important to deal with it. Nearly everyone who works in the arts at some point actually pays attention to Shakespeare. The whole myth of Camelot, Blake, Tennyson – you can go through all the English artists – there's that dream of Arcadia. We seem to be the only European culture which has that dream background." Jarman's dream is one of the *"pre-scientific world"*, of John Dee's alchemical visions.

"People are recovering that view again because it saw a world in which matter was living – that's what alchemy was all about. People like the Greens are realising that the destruction of the Amazon jungle, fences across the Kalahari desert and so on show a scientific world which is rapacious and might be wrong. We might need those dreams and they might really be a part of us, and that's what interests me about John Dee. Alchemy is about turning matter into gold, about dross and being. About dark dross being pure gold. And for pure gold don't read 'capitalism', read gold in its spiritual sense – metal that doesn't corrupt..."*

"If you desire to get this golden Lodestone, your prayers must be rightly made to God in true knowledge, contrition, sorrow and true humility for to know and learn the three different worlds... Out of the Super Celestial World doth spring the Light of the Spirit; from the Second Celestial World is derived the fountain of life and of the Soul: and from the third, the elemental World, cometh the Invincible, heavenly yet sensible fire, by which is digested and ripened that which is comprehensible."

—John Dee, *Of The Spirit Of Gold*

"...Maybe an audience can see something that can trigger off that inward exploration. That's what it's all for, there's nothing else. As for dictating or believing or having theories, one knows that one can have all those things but one knows that they're really suspect. Not for oneself, but when put in other people's hands, because everyone misinterprets them. Look at the painter I've been dealing with, Caravaggio; he influenced a whole generation. Now, some painters actually took off his work, like Velasquez or Rembrandt for instance, and produced their own quite extraordinary work from it. Others just took all explorations of Caravaggio and turned them into convention."

And so, while British Film Year fades into memory, as slickly shot message movies attract the money and consequently the publicity that ensures our images of ourselves remain constant, ex-advertising men become influential directors and Jarman stubbornly continues his inward exploration... publicly.

RE: What do you think of the British Cinema?

"I don't think about it at all, it doesn't interest me. Nor do other British film makers particularly, except my friends."

Unlike the rest of Europe, the British Cinema exists in little-known fragments. Never having been quite the same depository for American iconography as the U.K., the continent has been left to a larger extent to improvise with its Fassbinders, Pasolinis, Godards, Rossis and Antonionis. Names to conjure

Vanessa Redgrave surveys Jarman's set designs in 'The Devils' (Ken Russell, 1971).

with. Here, amid the Deadwood, the exponents are less lauded.

RE: Cerith Wyn Evans?

"Yes, I rate him. I think he's a master. I like Terence Davis, I like a few of the older film makers, Michael Powell. Nicolas Roeg at the moment, Ken Russell at the moment. I love old 'Carry On' films because they're so ridiculous and wonderful. I like John Maybury's films, Sophie Williams too. So actually I do like a lot of films, all my friends' films!"

RE: You opened a Young Film Makers Festival in Leicester recently. What was that like?

"Well, it was very very good. That was an object lesson. I said in my opening of it that it would be the most important thing that the British Film Institute would be engaged in, and it was, because was all people making their own Cinema. People outside it criticise it because it only goes to the other enthusiasts, but they're missing the point, I think, of what art is about..."

RE: As opposed to the Film Industry.

"That... vague and nebulous and much maligned word, as opposed to the commercial cinema, yes. I've made a very uncomfortable brush between the two which is quite an interesting area. That's an attrition point."

His major 'brushes', the sweeps of **Sebastiane**, **Jubilee**, **The Tempest**, **Caravaggio**, **War Requiem**, **Edward II** and **The Garden** represent only a fraction of a film output that has spanned over twenty years. His smaller-scale films, which he describes as *"movie art rather than Art Movies"*, slip out like an O.A.P.'s willy (once every few months and with nobody noticing). They are usually greeted with a deafening silence by everyone apart from Mary Whitehouse and her anti-sex lobbyists (who have gone on record as condemning Jarman for his work) and those who occupy the most hip and hallowed corners of the ICA. One could, for instance, be forgiven for not hearing too much about his classic short, **Angelic Conversation**, a tellingly titled film about "an avant garde romance" that was shot in Dorset. The

soundtrack features music from Coil, and Jarman got Judi Dench to provide its voice-over monologue in the form of 14 of Shakespeare's sonnets. This one left me fairly cold, but Radio 4's resident 'alternative' comic, Simon Fanshawe, once told me that it was the only film he'd watched which had made him cry.

Conversation had its premiere in July '85 to herald the opening of Pride Week, the proceeds going to the admirable Terence Higgins Trust. Watch out, and you may still find it blown-up at your local art house fleapit playing along side Peck's *What Can I Do With A Male Nude?*. I wonder, too, how many readers will have actually seen his main 1987 film, **The Last Of England**, starring Jarman's 'only woman actor', Tilda Swinton? It was perhaps his most overtly 'political', autobiographical and controversial work to date. Loved by some – it won 1st Prize at the 1988 Berlin Film Festival – it was predictably annihilated by reactionary critics in papers like *The Sunday Times*. Critics who actually admitted that they did not understand what it was about. Jarman's super, Super 8's are often hard to find, but always worth seeking out.

But why does he keep making them? Keep struggling to set up his projector (Jarman is no Film School technician) – to run these strange, slow flickerers to any audience larger than three people?

"Well, I'm just not interested in giganticism. I love small things, small audiences, film shows for friends. They are really private films which have just been made to inspire and illustrate. They also give me a good sketchpad for ideas. In a sense there are similarities with that and the independent music that sprang up in the late '70s."

RE: But the difference was that with records being de-mystified people could easily do something about it. The money needed was peanuts, like you said. There also existed a ready-made outlet for those records that were being produced. You couldn't make a film independently and put it out yourself very easily; the structure wasn't there, still isn't. So how do people wanting to do that get 'round it?

*"Well, I think Gen had a bright idea with video. It is difficult, but, I mean, something like **In The Shadow Of The Sun** which started off in 1972, well, thousands of people have seen it now. And if it carries on being shown it'll be seen by many more people than saw a lot of the commercial films of that period."*

RE: Which show in town for a week then disappear forever.

*"Yes, vanish! It'll probably be seen by more people than saw **Exorcist 2!***

"RE: You don't worry too much about how many people are going to see what you do.

"No, as long as there are six or seven people in a room you're away! Nearly everyone's value judgements are overshadowed by the cash till. It's quite simple, if you make a film costing 22 million dollars it's really just 22 million dollars' worth of publicity telling the world that you're the best.

'The Tempest': Miranda (Toyah Wilcox) and Ferdinand (David Meyer). (photo: Bridget Holm)

'Jubilee': Amyl (Jordan). (photo: Jean Marc Prouveur)

You've only got to see what happened with something like, say, **Absolute Beginners**. That had fourteen million behind it and it cropped up in every single magazine. But you can make a film like **Caravaggio** which I was working on a lot longer than Julian (Temple) was working on that, and the silence is overwhelming, which I think I prefer, though I love the publicity as well!"

RE: That film, **In The Shadow Of The Sun** seemed to me to have a lot to do with dreams.

"Yes, well, it was as much to do with that as it was with experimenting with Super 8. In the sense that dreams are random and uncontrollable and often crop up in groups and recur, and I think that film in that sense is rather like a dream. But there was no design before that film as to how it was going to come out. It was just an experiment."

RE: This was 'Flowing With The Glue' then.

"Yes! What Heathcote says!"

RE: Is that how you always like to work?

"I think so, because if one sets down plans beforehand they never really work, like we were saying. I think then that you have to let it go when it goes. In that film I just set up a series of images and they randomly did whatever they did when I was re-filming. And it was very random."

RE: But however random it was you still chose what images to film in the first place. The quality and type of work still depends on the person doing it, no matter how random the process involved in the creation.

"Yes, I'm not trying to divorce myself from it at all. It was me, that film was an accurate reflection of how I was when I made it."

RE: But you see what I'm getting at. There is a culture of cut-ups that have emerged since Jamie Reid and the current interest in Burroughs and Dada and everything else, and a lot of pseudo-arty types are using cut-ups and scratching and so on as an excuse to be lazy, aren't they? It's so easy because both the technology and the market are easily available.

"Absolutely. In experimental music and a lot of experimental film. I think, though, that it depends on how much work you've done on yourself beforehand. If you have had discipline and worked, that random element can work really well."

You may notice that Jarman, painter, film maker, writer and designer, often refers to music – one of the few things that he hasn't tried himself. He's scathing about the Record Industry, but at the same time attracted by, and attractive to, musicians. Like Jarman's heroes Roeg and Burroughs – who photograph, or get photographed with all of pop's preening pin-ups (the highbrow ones anyway), there seems a mutual fascination. Perhaps because Pop can disseminate ideas and create cultural climates so much more effectively than film or literature nowadays. Pop Stars are now the perfect vessels through which all the hopes and dreams and

hare-brain ideas of the world can pass through. The immediately acceptable face of art or revolution or good old fashioned decadent eccentricity.

Roeg worked with Jagger and Art Garfunkel, Burroughs with P-Orridge and 23 Skidoo, Jarman with Coil, Eno and Steve Ball. All three with Bowie. Trying to use him as his Edward Kelly substitute, Jarman called him *"the tuning fork of the media humming to perfection... the mirror of ambivalence and monarch of the invisible threads of communication"* and summed it all up rather neatly. Bowie once left a pack of cigarettes on Jarman's mantelpiece, which he kept like a souvenir-hunter until Bowie's next visit, when the Thin One noticed them and tore them up as a slightly embarrassed film-maker looked on, feeling something like a silly schoolgirl. For his part, Bowie had Jarman marked as "a Black Magician".

RE: You were going to make **Neutron** with David Bowie once, weren't you?

"Well, it was one of those On/Off things that never really gelled. It was never really on."

RE: It was a sort of post-Apocalypse story?

"It was, I suppose, yes. Though I've never thought of it in that way. It was the Apocalypse of St. John the Divine done in a dream state, though there were about six different scripts for that film. I never really worked it out properly. It's quite dead at the moment."

RE: You get a lot of ideas for films that never get made?

"Lots, but they usually get swallowed up into the ones that do get made. There was nothing of **Neutron** *in* **Caravaggio**, *for instance, but it'll come somewhere else."*

The most cursory glance at Jarman's work – his sets scribbled with hieroglyphs, his fascination with figures such as St. John the Divine, with angels and magi, Ariel or John Dee, gives an obvious impression; but Bowie was only partly correct. Jarman may be a magician of sorts, but he's no Kenneth Anger. An avid reader of the esoteric works of Dee, the Hermetic mnemonicist Giordano Bruno, the physician and mystical philosopher (Grand Master of the Prieuré de Sion) Robert Fludd, and the enigmatic Paracelsus. Paracelsus was the central figure of Jung's alchemical studies and a looming figure in the Renaissance, who wrote in a language that was allegorical, mystical and symbolic. His vocabulary thus being complicated and obscure, coupled with his self-confidence and dismissal of established forms of medicine resulted in him being misunderstood and disliked by his peers.

Paracelsus preached a form of 'alchemical' homeopathy that, in its own way, predicted the rise of antibiotics and synthetic changes in the human environment centuries before their arrival, and warned against the inevitable cancers and viral infections that such an 'unnatural' lifestyle would bring. The connections Jarman has with the old masters are not only aesthetic. The perennial

Paracelsus

philosophy shows up whenever one chips away at the camp, urbane veneer of Jarman's media-perceived image. Paracelsus, a 'natural' doctor, misunderstood by his peers. Derek, a 'naturalist' film maker, misunderstood by the media.

If Jarman is, as Bowie says, a Black Magician, though, the description rests in the original meaning of the term.

All alchemy originated in Egypt – "al khem" (the Black Land) in Arabic. To further confuse the issue, 'Black' in Arabic speech is pronounced "fecham". 'Wise' is pronounced "facham". The true nature of alchemical studies has therefore been misinterpreted. So Jarman is not connected with the over-emotive Hammer Horror branch of the Occult; in fact, in conversation, few people could be less diabolical. For "Black" then, read "Wise".

Jarman is merely conversant in the language of the angels – Enochian – the unspoken language of what he calls the *"pre-scientific approach to the physical world"*. And with his films, *"the wedding of Light and Matter"*, he takes up his role as Wiseman, a modern-day alchemist of Fulcanelli-sized proportions. Substituting the pestle and mortar for their 20th Century equivalents in this world of magical mass media – film and video.

For fear of intellectualising that which is instinctive, of gaining "lust of result" and losing potency, he's suitably vague and mysterious when pressed on the subject.

*"Well... hmm... It's not based on any particular fact... I don't dabble in magic. I **am** magic!"*

RE: [Pressing on] Your imagery is very obviously influenced; would you just say, then, that it's a similarity of attitudes with—
"It's a dangerous... er, it's very deeply buried, I really don't know how to answer. I have no theories about it. What can I say? One can read about magic, but that doesn't make one magical. I practise magic in films, not outside them. I've always found, umm, I think it's more alchemical, yes, rather than Crowleyite magick, although that interests me also. I'm interested in Cornelius Agrippa and all the Renaissance magicians greatly."
RE: Because of their struggle, because their perception was similar to your own?
"Yes. I'm fascinated with certain things. Well just the whole... I suppose I've always quite liked losers. And they all lost out, didn't they? But their time will come. I mean John Dee lost out in a big way, didn't he, he just became known as a charlatan. The most intelligent man in Elizabethan England, he was no charlatan. So there's a sort of feeling of rehabilitation in my interests, because there was something quite extraordinary there. And I fell on 'The Art of Memory' of Frances Yates in the early '70s, and of course Jung who was involved with Alchemy in his later works. Then it just branched out."

Currently his interest has led him to become infatuated with the works of archetypal psychologist James Hillman, dug up on forays into Foyles bookshop across the road. Looking at Hillman one can see why. He is something of a kindred spirit to the film maker, a clinical manifestation of the same soul-facing intent. The psychologist writes drily about 'Betrayal', 'Masturbation', 'Abandonment' and dreams.
"I find him fascinating. So that's the interesting area to me. Not so much magick and Crowley, it was always more to do with psychology."

As he gestures towards a copy of Hillman's *Loose Ends* on the bookshelf, I notice next to it a volume on Sado-Masochism, and remember that Jarman had loose connections with the staging of Georges Bataille's *Feast* at the Bloomsbury Theatre, along with the likes of Cosey Fanni Tutti and Terence Sellers – otherwise known as the New York Mistress 'Angel Stern'.
Jarman himself was no stranger to the underworld of backroom bars and coded handkerchiefs. Derek

did not used to visit Hampstead Heath only to take in the night air. Though he detests the Californiaised cloning process that 'liberation' brought (*"nothing could bring me to want to touch a moustache!"*), he did seem to find some solace in his anonymous cruising alter ego. A character that could escape the world of Art and the Cinema and their accompanying pressures. He once wrote: *"Anonymous sex can be the sweetest and most transient. The imagination runs riot. Earthbound minds suddenly take on angelic bodies."*
Jarman, a brave man, made no attempts to keep things secret when he discovered that he was HIV antibody positive, feeling – in this current climate of homophobia – that it was his duty to discuss it.
The most repugnant aspect of the swing against homosexuality in the public arena is, of course, Clause 28 of the Local Government Bill (discussed elsewhere in this book), which effectively banned schools, local councils and other organisation from 'promoting' homosexuality.
"The repercussions are very dangerous. You could potentially have a ban on Shakespeare's sonnets in the local library! Many of the sonnets are evidently addressed to a man, such as Sonnet number 20, 'for a woman wert thou first created...'"
On the subject of banning teachers from talking about homosexuality in schools, he points out that this will not only make it more difficult for young people to come to terms with their own sexuality, but it will also detract from the promotion of the Safe Sex message.
"We can't create a climate of fear where homosexuality can't be discussed... We also have to talk about using condoms, about safe sex and so on."
The obnoxious apartheid-like Clause could mean that some cinemas would have to think twice about screening Jarman's work, art galleries of exhibiting David Hockney or Robert Mapplethorpe, council libraries of stocking books by Ginsberg, or Isherwood, or Mary Renault. The list is endless.

"At least ten percent of the population is gay. If people were trying to say these things about blacks or Irish people, you would think they were insane... I just hope I live to see the Clause rescinded."
What kind of a society is it that passes laws which officially condone the persecution of minority groups, at a time when their need for help, support and understanding is at its greatest?
At time of writing Derek is thankfully feeling 'hale and hearty', and judging from a survey carried out by doctors in San Francisco published in early '88, he has about a 50/50 chance of seeing out the 1990s.
I have nothing but admiration for the way in which Jarman has acted since his discovery, being open and honest, keeping busy and, on the surface at least, coping remarkably well.

RE: Where do we go from here?
"God, where DO we go from here..."

RE: Somewhere to the lift the gloom. Italy!

"I got beaten-up in Italy."

Oops.

"They were thieving primarily. I got knocked down by a gang who went through my pockets, they were really quite nasty, really kicking me. One never knows what to do in situations like that. I could've been killed, so I just let them get on with it, and for some reason I just kept smiling at them! I just looked up at them in complete disbelief and wondered what the fuck they were up to. I remember saying 'Is this how you welcome people to Rome?' to them in Italian as I lay there with them all kicking me. It was crazy. Fortunately Italian shoes are not as heavy as british Bovver Boots; they were all wearing soft Gucci numbers, so it was mainly just bad bruising. They got away with about 50p and a bottle of Poppers!... I still love Italy though."

RE: It's far more art-orientated and design conscious in Italy. Does the British attitude to art annoy you?

"Well, it's deeper in the culture there. It's not stratified as it is here, their whole system of class is different, there's much more of a shared language in Italy... It's just, if you're Florentine you know who Michelangelo was no matter who you are, whereas you couldn't say that about people in British cities. In London they wouldn't know their Turner from their Constable!"

RE: Don't you find, then, that here you're generally considered an eccentric arty farty type, making boring films? Doesn't that bother you? Surely they love you in Italy.

"Yes, well, it's a completely different attitude. They call me 'Maestro' in Italy. It's like your title, it's position. It would be like saying you're a Doctor or something here, you're accepted. 'Maestro' is accepted in Italy. Especially ones who've had their head kicked in!"

RE: The attitude to art here is hostile to the point of artists having to be apologetic and defensive and coy. It's like what you said before about doing something for yourself, internally, rather than doing something for the audience, for the greater good. If you do that you're acceptable to society because you're making money and products and offering a service to entertain people with. The cash till you mentioned.

"Yes, but Art is the only thing that matters!"

RE: But in a country so dominated by the industrial Victorian attitudes to work, they don't produce anything tangibly useful. Unless they're "successful artists" that people can make money from. Because by nature artists must be egotistical bastards in a sense, and selfish to be any good, because they're looking internally instead of pandering to the needs of the audience. How would you—

"Yes, but I am useful because I'm showing people how to do it for themselves. That's the most important thing anyone can discover. Themself. So in that sense art is vital and does contribute. Though one does have to be careful about calling oneself an Artist, yes. The greatest art of all would be to be able to sit on top of an oak tree and do nothing. The art of doing nothing is the greatest art of all. I like that."

RE: I don't think I agree with that, Derek, doing nothing. Anyway, you never do nothing. You never stop working.

"No. Well, what I mean is as you said, the West is so orientated towards Product, the greatest thing would be to be able to do nothing at all. But to answer your basic question which you were getting at with Italy... it's really, I suppose, that if I wanted to be accepted I'd live in Italy. but I don't want to be accepted. It's far more interesting here because it's abrasive. I could easily have been accepted if I'd wanted to at a few points in my life."

One such point would have been in 1980, after his version of **The Tempest**, with Toyah as Miranda, Heathcote Williams as Prospero and Elizabeth "Stormy Weather" Welch as the Goddess romped its way to critical acclaim and modest profit. He could then have gone for the real money, got backing for a bigger, straighter feature, or sold himself to Channel 4's pre-launch alternative film project. *"All Beaujolais Nouveau and scrubbed Scandinavian, pot plants in place... a channel for a slightly adventurous commuter."* But, not surprisingly, he didn't. To be very cynical critics could say that he didn't have to. Helped by being bohemian, free and single, able to devote himself to his work without major responsibilities to others, he has been able to survive, barely, without having to compromise. But that misses the point, and is the stock excuse for all forms of compromise and laziness.

First of all, nobody needs to get married, nobody needs to have children, nobody needs to get a mortgage or a car or a TV. It is simply a question of priorities, and Jarman has never had any of these things. Besides, the L.A. Hillbillies are hardly making multi-million dollar blockbusters to keep the bailiffs from the door, and many of them were once young British revolutionaries.

RE: You could've capitalised and become very big. [He smiles broadly at this.]

*"Yes, but I **am** big! No, not in terms of cash but I know that underneath it there's an immense interest in that stand. Particularly among other film makers, because it's something I think all of us would like to do. Mind you, it is wearing; I don't ever preclude the possibility of my selling out!"*

RE: It's been an advantage in that respect, your being single?

"Yes, I don't know what I'd do having someone around my neck all the time if I was married and with children. One can be alone a lot of the time. As soon as one takes on mortgages and so on one becomes a part of that structure and under that pressure."

So instead of making a clutch of pop videos, for the likes of Lords of the New Church, Marianne Faithfull, Carmel and The Smiths, which he did for

the money, Derek reckons he'd have been on the video treadmill for life.

*"Which would've been deadening and have left me with no time to get **Caravaggio** together or read James Hillman!"*

RE: Before we talk about **Caravaggio**, what about your film **Imagining October**?

"Yes?"

RE: You filmed that illegally in the USSR, prior to the dismantling of the Iron Curtain.

"No. You were allowed to film with a Super 8 camera in the Soviet Union you know."

RE: But not in that cemetery though, or is this another Western myth?

"No, it's true, they did ask me not to film the cemetery."

RE: Well I thought, when watching that film, that it did have a very definite theory and message behind it.

"Yes? You're going to pin me down now, aren't you?! Well, yes. It did have a message. It was an agitprop film in an odd sort of way."

RE: To do with what we've been talking about.

"It was a film to do with profit, and the influence of profit on communication. That was part and parcel of the quotations that came up. In the present context. Then there was an element of materialism with the painting being done of the soldiers, and a wonderful feeling of, well, sadness at the end. A feeling of, you know, all the ideals of the 20th Century have become their opposites. They've come to their real fruition."

That, in having unswerving faith in ideals and arguing for their case, "the systems of Peace and Love become Hate and War", to use his language. A million miles from the October uprising, the film, just like the tanks in Afghanistan, underlines what Jarman said earlier in chilling fashion – you can blind yourself by believing.

RE: Why did you go there?

*"I was invited to show **The Tempest** to the Film Union there."*

RE: Did they like it?

"I don't think so; well, some did but they didn't get to open their mouth as it was all done through a spokesperson, and they are very adept at not quite getting around to the questions they don't want raised. There is no real individual voice in Soviet discussion."

RE: Was their reaction to it better than the Americans? (One *New York Times* critic, in a piece short on style and critical content but big on venom, said that it was like "watching Shakespeare through a broken windscreen." Cute how these Americans are so proud of their Anglo-Saxon culture.)

"Well..." says Derek, sidestepping a potentially hurtful question. *"It wasn't open to an audience in the Soviet Union so I don't know."*

RE: You don't seem to like American culture very much.

"I love America. It's just that they have such a hold over our lives. If I was Polish I'd feel the same way

about metropolitan Russia. I think we're completely enthralled with them. We're a dumping ground for all their ammunition. But my generation believed that everything that came from America was good, because the food parcels came from there. And the really horrid decade, the 1950s, had a ridiculous myopic vision about it all, and we still think in the same way. It was a bad time, the '50s, the decade that's been remembered as... a haircut. Which is all that it deserves! We all just wanted to go to America then. They had some good propaganda."*

RE: They've all done it, including the British.

"Yes, well, all the power centres have done it. If the USSR or China was ruling the world they'd do it. The Americans had to rescue Europe during the war otherwise the Soviets would have it."

RE: And there'd be nobody to buy their hamburgers.

*"Yes! And there was this terrible confusion in thinking how nice they were to help us, and the terrible thing is, the confusion's still there. All over the culture. It's interesting, people will suspend judgement when they see, for instance, a film, as somehow in this country it's seen as 'Entertainment' and it's in everyone's interest to keep these people in power and just look upon it as entertainment because then it's of no consequence. Even in the more supposedly analytical journals, like **City Limits** or **Time Out**, they look at it as if it were just entertainment. They would completely suspend judgement as to where it came from and what and who the film was representing. They would just say that it was entertainment, good or bad. They wouldn't say that it was made with megabucks from Hollywood. They should have seen it more in terms of corporations, as the product of American culture, the product of a rotten system. There were many refreshing things about the Soviet Union. Art is taken very seriously, for instance, whereas here it's rendered impotent. Especially pop music, which is the most important form of art ever ever ever invented. Talk about non-communication! It's kept in a perpetual state of pre-adolescence, so nobody is allowed to grow up in it and think. It's therefore worthless. It's a good system of Control. It channels revolts that would otherwise be political; the powers that be connive in it. And as for 'Street Credibility' most of it's about as street credible as Channel 4..."*

Although most of us would probably agree with that, I can't really see how that by "taking art seriously" in the sense that the Soviets take solely traditional art seriously (classical ballet, opera and music) there is any real improvement. By denying people even the cultural illusion of revolution I don't think the Russian system is any better in this respect. It is, in fact, less resonant.

I don't argue with Derek as he continues his attack on all things Pop, and waves his hands about a bit. The last thing I want to talk about with Derek Jarman is pop music, though he seems convinced that anyone under the age of Cliff Richard is obsessed by the stuff, and keeps dragging it into conversation in order to knock it down and stress,

'Sebastiane' (photo: Gerald Incandela)

"with the perspective given by time", that anyone can see the innate superiority of the classics. He had a soft spot for Bronski Beat, though.

"Some things are of a positive value, yes. I think Bronski Beat did a fantastic amount of good in their area, more practical good than I could ever do with my films. But that doesn't preclude what I'm saying and I'm sure if Jimmi Sommerville reads this he'd agree with what I'm saying. Each generation is coming along every five years, so it can be valuable. If one knows one is in that area then alright, but if these people make other claims for it then they're crazy. This isn't just some tired old queen sitting here moaning; if I was seventeen I'd be listening to it."

I point out that many people criticised Bronski Beat for being crass and evangelical – not the type of thing one would have thought would appeal to the sophisticate sitting before me.

"Well I think there was a reason for them working in that way. There's a social reason for it, they're dealing with young people who are by the system denied."

A hint of public school condescension if you ask me, but hardly worth worrying about. Jarman is the last person one could call a snob and actually what he says is largely true, and could apply as much to his own work as that of the late Bronskis, if for different reasons. Disinterested in communicating messages

and pandering to the limitations of "the audience", he would still like to think that his work has helped erode prejudice without having to resort to artless political rhetoric.

*"I know my film **Sebastiane** has had a huge effect when it has been shown at odd cinemas here and there. One hopes that **Angelic Conversation** will eventually filter through: I've also written an autobiography that is fairly frank by most standards."*

His first book, **Dancing Ledge**, was written in 1983 and published a year later – an "autobiographical collage" compiled from notepads, appointment books and filmscripts – realised or imaginary – from his childhood spent as the son of an RAF officer to **The Final Academy** and beyond. The themes of the book, and his life, recur in apparently haphazard tracts of print. (As Ken Campbell said, it's a great book for picking up and reading in the toilet.) A constant attack on all establishment culture; Film; Sex; Painting; anecdotes from twenty years spent as a self styled artist; Renaissance rehabilitation; references to a quaint and slightly crooked Olde England of vicars and royalty, picnics, castle ruins and empty beaches (as loved by Michael Powell); Occultism; Famous friends... and Caravaggio. A figure that has fascinated him since his days as a student at the Slade, when a young Jarman hunted down anything that was the product of another isolated, homosexual, mind. Isherwood, Wilde, Genet, Sartre...

Much has been made of Jarman's sexual orientation. Too much, in my view. Though perhaps it's not surprising. If there is a stencil under which every Jarman movie fits, it would be one cut from Derek's lucid sexual imagination. The problem is, although Jarman's candour may help in the gradual erosion of homophobia, there is a danger that his presentations may just be labelled as being "gay" films, the deifying products of a queer martyr that have nothing to say to people outside of the embattled gay circle.

In wider terms, the relative liberalisation of male homosexuality over the past 20 years has led to the creation of a cultural ghetto. The re-definition of the word "gay" brought with it not only a greater (and necessary) freedom, it also identified and defined a certain kind of life within specifically defined boundaries. So gay people are not only still looked upon as being 'different' because they enjoy slightly different sexual relationships, but also because they live a largely different lifestyle – a life style created by the gay and straight media. In some ways, gay people became more isolated in their liberalisation, with their own clubs, their own music, their own clothes, literature, Cinema, and (supposedly) their own shared ideologies. In my mind, integration and synthesis are the ways forward. A ghetto is a ghetto from both the outside and the inside. In the future, everyone will be bisexual. An individual's sexual habits will not define their social position.

Realising that a yawning (and unnecessary) chasm exists between "gay" and "straight" society, Jarman

has often been concerned with trying to bridge the gap. Not by making more 'ordinary' films about suburban heterosexual couples, but by making such things as openly homo-erotic films be accepted as being ordinary. Which of course they are.

Jarman hacks away at the parameters which society has set down in a variety of ways. Visually, many of his actors are androgynous, and attractive to either sex. Tradition is, if not trampled, at least confused in Derek's shadowy world. Even the word "gay" is being eradicated from his scrapbook of press cuttings.

"I did a book with **The Last Of England** *in the form of a series of interviews, and of course the word 'gay' came up a lot. Eventually, we decided to take the word completely out of the book to see what happened. It was on computer so I just pressed a button and said search the word 'gay' and obliterate. So a question like 'What was gay life like in the '60s?' became 'What was life like in the '60s?' and the answer was the same, only it was no longer ghettoised by the question."*

Caravaggio, then, is transformed at the tap of a computer console from being a Gay Movie into being a film about a Renaissance painter.

The cast was headed by Nigel Perry, playing the title role, and Tilda Swinton as Lena. Other notables in the film were the Comic Strip's Robbie Coltrane as Borghese and a Jarman favourite, the blind actor Jack Birkett, playing the part of the "Satire Pope". The old punksters among you will also remember the name of ex-Chelsea lead singer and one-time beefcake model Gene October (who's been turning up in bit parts all over TV land and once appeared in a 1978 magazine edition of this very publication in a piece written by Alan Anger). Gene's thespian skills are put to the test in the role as a street hustler peeling a piece of fruit. To coincide with the film's release, Thames & Hudson published a Jarman book about the making of the film, with breathtaking photos by his old pal, the brilliant photographer Gerald Incandela.

Caravaggio - "the inventor of cinematic light" - was an Italian painter who lived between 1572 and 1610. After a history of violence, on the 29th May 1606, he murdered one Ranuccio Tomassoni while playing a ballgame in Rome. For the last four years of his life he went on the run, with the help of rich relatives, friends and admirers, through Malta, Sicily and Italy, taking commissions from town to town and producing probably better work than that which he'd done before the murder. Reports of how he met his death conflict, but most evidence now points towards him having died on the 18th July 1610 on the beach at Porto Ercole, collapsing while running along the waterfront – aged 39. Ironically, he was probably just about to be pardoned for the murder and be able to return to his beloved Rome. You can read such information in any book on the Renaissance painters; though few will tell you of the man's private life.

'Caravaggio' (photo: Gerald Incandela)

"He was obviously a gay artist though there's obviously no proof as there was no real documentation. Though it does appear that he was drummed out of Syracuse for molesting young men. It's generally accepted now that he was gay."
RE: He interests you partly because of that?
"Partly, yes, because of the fact that with that difficult nature, unacceptable at the time, he came up with all sorts of solutions in his work which were very radical... He was the first Italian painter, for example, to use ordinary people in his paintings, probably his friends, and paint them as the Virgin Mary for instance in one of his altarpieces. He was an innovator."

Jarman's main reason for making the film was not because Caravaggio was homosexual, but because his life is a study of being an artist, as relevant now as it was 400 years ago.
"Everything we've talked about today would be applicable to Caravaggio. You've just got to translate Church patronage for TV Companies and Caravaggio for Roman Polanski, say. It's just imaging a culture. It's all to do with images. How they're read and how they're received by people, and how to achieve that sort of communication, in order to become 'successful', you have to make a pact with the powers that be."
RE: And that's still the case now.
"Precisely. It's always been the case. Completely now.

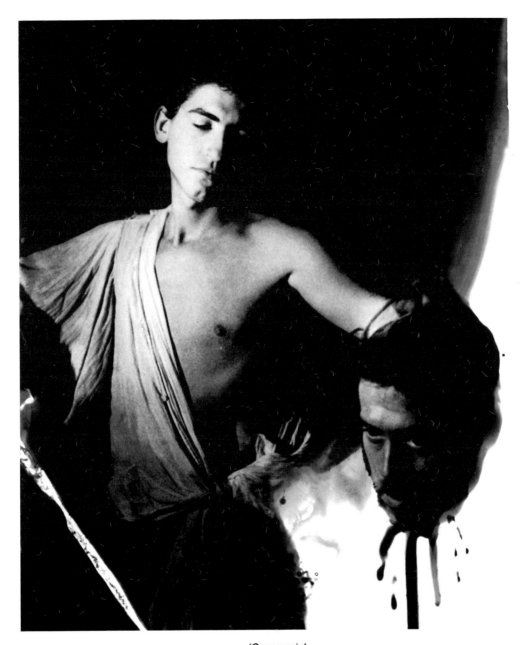

'Caravaggio'
(photo: Gerald Incandela)

So it's possible to make a case for someone like, for instance, Alan Parker, who in a much clearer way is utilising the powers that be. That's advertising. Or Warhol who did it very well with his painting in the 1960s. You can make a case for that kind of representative art of the age if you want to, for success in those terms rather than staying outside of the mainstream. Caravaggio was very much the mainstream, he was very successful. Personally I think that being outside, being a stand against is a more interesting area to be in, and that's the ambivalence that interests me... Some people are part of a culture and some people commentators on it."

RE: Even though everyone's a result of the same culture.

"Yes, one person is the Action and another is the Reaction. Caravaggio was the Action, one of the most successful painters of his time, and that's what interests me, how someone who is a killer is immediately welcomed into the next cathedral in the next town to paint the next altarpiece. He had to get out of Rome as he was too much of a problem for the authorities, but in the town down the road he was welcomed with open arms. It would be as if I killed someone and carried on working, like 'Please make another video, Mr Caravaggio!'... he died of neglect in the end, like a pop star, lived too fast."

RE: Talking of which, did you take drugs?

"Who didn't? In the '60s everyone went through the stage of taking drugs, one wasn't even aware of it being damaging or not, it was irrelevant. Drugs were just part and parcel of the moment."

RE: I thought you might have been an Aldous Huxley type, taking drugs for your own 'internal exploration', quite deliberately.

*"Well, his **Doors Of Perception** was why people took drugs. Most of the interesting artists took drugs. I mean, Coleridge, de Quincy, Cocteau... Burroughs. Lots. If you include excessive alcohol then just about everyone of them; look at Dylan Thomas."*

One is left wondering if Jarman took drugs to more properly fulfil his '60s poloneck, to stick to the classic wasted image of an artist, living as he did at the time in his draughty loft overlooking the Thames at Wapping before Dockland became infested with red Porches and sunken wine bars. Despite his shoestring (or, at least, Shoebox) existence, his Smirnoff tipples and his past dalliances in the backrooms of Europe, Derek seems somehow too wholesome to have slid headlong into a romantic façade at the expense of his body.

His monster – "the audience" – may in some perverse and fascinated way have scripted Jarman's life for him. The tragedies of Dean/Monroe/Orton/Vicious *et al* please the public, their fast lives and deaths satisfying the bohemian script and relieving the miserable boredom of fans and critics. Forces that require a conveyor belt of dead artists and pop stars to be used as some huge emotional crutch. Artists who lived life to the full on behalf of the audience (an audience that is in the main locked in a world of boring jobs, boring houses and boring marriages), and produced a steady stream of saleable relics – records and prints – are ensured a cultural immortality.

The fact that Derek has been unlucky enough to contract a potentially lethal virus that in the main confines itself to people who lead interesting sex lives or take hard drugs served – sure enough – to massively increase public interest in both the man and his work. To Derek, though, and the thousands of others in his position, this is a time of uncertainty, of fear, of anger, of sadness. Every day.

This is a strange mirror indeed. Just look at the last four years of Caravaggio's life, under threat from Rome. Caravaggio, though, was, for all his antisocial behaviour, a figure loved by the Establishment. Not so Jarman. The Art World aren't too keen on Derek because, in the words of the Royal Academy's Norman Rosenthal – "they tend to like people who stick at things". Jarman looks pained.

"But I think I DO stick at things, you know, I've had exhibitions of my paintings, I've produced sets for opera and ballet, I've written several books, scripts, I've made a number of feature films – I think to do that you've got to be quite a good sticker. Though I'm sure there are better stickers than me, Francis Bacon, for example. [Jarman is off to visit Bacon's show at the Tate later in the day]. Films, though, they include everything. Painting, music, set design, writing, filming. It uses it all up. Being just a painter nowadays is like being involved in stained glass. Film making is really the art form of the twentieth century. Being a film maker is wonderful. It's also a marvellous esoteric pursuit for someone like me and a lovely lifestyle."

In the 23rd Century, the names of Fassbinder, Pasolini and Jarman may – who knows – carry as much weight as Michelangelo, Raphael and Caravaggio.

That Jarman's cinema will live long there should be no doubt. As he himself said about Shakespeare's *Tempest*, *"it's the greatest play in the English language because people are still trying to explain what it all means."* Jarman, always sharp, knows that *The Tempest* appeals not to the intellect, but to the imagination. Just as with his films, audiences are then seeing something timeless because they must be applying their own interpretations to it. Once a piece of art is understood, it is absorbed and lost in the culture and used to make memory – and money. It ends up on an advertising hoarding or a biscuit tin. It dies.

You may, using this logic, still think Jarman's work is rubbish, but must admit, it has life. He would ask no more.

And so we leave him, alone with his sketchpad and imagination, perhaps on the beach at Porto Ercole, on the spot in the sand where Caravaggio fell dead and where Jarman, 361 years later, had anonymous sex in the dunes with an Italian boy...

QUEEN ELIZABETH: The sea remindeth me of youth. Oh John Dee, do you remember the whispering secrets at Oxford like the sea breeze, the codes and counter codes, the secret language of flowers...and I with yellow celandine, true gold of the new spring of learning.
JOHN DEE: Oh Majesty, to me you are the celandine now as then before, balm against all melancholy.
QUEEN ELIZABETH: Ah, but I was young then.
ARIEL: There and back and there and back. The waves break on the shores of England. The white cliffs stand against the void. We gaze seaward, contemplating the night journey. The sun sinks lower. The moon waits to make her entrance. In the south at Tilly Whim, a picture of wind and sea. In the west a vision of silver dew on a sea of pure gold. In the east a black hoarfrost. The sun eclipsed by the phoenix. In the north a howling chaos into which black rain falls without ceasing. Now is the time of departure, the last streamer that ties us to what is known – parts. We drift into a sea of storms.
And now Elizabeth and Dee go along that same great highway, and the light of the air about them seemed somewhat dark, like evening or twilight, and as they walked the phoenix spoke and cried with a loud voice...

"It's horribly uncomfortable dying from the HIV virus. It's like being in a coconut shy and having things thrown at you, being battered and buffeted. You can feel everything about your body falling apart. It's an appalling feeling. But I've had an amazingly wild and happy life, and I've not got a single regret. I've lived in a fantastic time. I've been blessed with the chance of making the films I wanted to make. I'd do everything the same way again. I don't deny my past. I don't feel 'mea culpa' at all."

We leave Derek washing the cups in his no-room-to-swing-a-cat kitchen, among the dried flowers. The last Englishman. Witnessing the last of England – the closed factory furnaces, now embers among the dark Satanic stumps. Police sirens screech beneath his window, the mirror glowing blue at night over Soho. Operation Tiger/Operation Faggot/Operation Spanner. Operation censor. The guardian angels with gloves on go about their business of protecting new England's Peace and Love. Blinding all to its system of Hate and War. Who can doubt him? The Sun rises, the Sun sets, the World constantly changes colour.

Self-obsessed, handsome, erudite, funny, intelligent, explorational and misunderstood – cruising through the anonymous hidden connections of Time and Space. They are all here in Charing Cross Road: Mr Caravaggio, Mr Dee, Mr Jarman, with their spirits to enforce, art to enhance; with their brushes and mirrors and lenses. Sweeping the leaves up from the garden, forming perfect, beautiful mounds that will, we love to know, all be blown away forever. All – despite their problems – fortunate men. Our eyes, now as then, with their celestial geometry in the micaolz olprt. They whisper... COME AWAY

THE FILMS OF DEREK JARMAN

A Journey To Avebury (1972)
The Magician (1972)
The Art Of Mirrors (1973)
In The Shadow Of The Sun (1974)
SEBASTIANE (1975)
JUBILEE (1977)
Jordan (1978)
THE TEMPEST (1979)
IMAGINING OCTOBER (1984)
ANGELIC CONVERSATION (1984)
CARAVAGGIO (1986)
THE LAST OF ENGLAND (1987)
WAR REQUIEM (1988)
THE GARDEN (1990)
EDWARD II (1991)
WITTGENSTEIN (1992)
BLUE (1993)

THE BOOKS OF DEREK JARMAN

Dancing Ledge (1984)
The Last Of England (1987)
Modern Nature (1991)
At Your Own Risk (1992)
Chroma (1993)

Derek died in February 1994.

"To Master, a long goodnight."

DREAMACHINE
An Information Montage

Simon Dwyer

The Dreamachine was devised by Brion Gysin, artist, writer, traveller and alchemist; one of the great unsung British painters of the 20th Century. Too clever and independent for the consumerist Art World, he nevertheless exhibited with Picasso, had shows throughout Europe and America, and was famously expelled from the Surrealists by André Breton.

Gysin was the seminal influence who introduced William S. Burroughs to the use of cut-ups in writing. His wide cultural synthesis led him also into the world of the Rolling Stones, and particularly Brian Jones, whom he introduced to the Master Musicians of Joujouka in Morocco. He did not identify with any codified, preconceived religion, philosophy, or system of thought. He cited his major influence as Hassan i Sabbah, knowing that Hassan i Sabbah left no written teachings or doctrines. Since so little is really known about Hassan i Sabbah – the "Old Man of the Mountain" from whom the word 'assassin' derived – or his followers, any thought that is informed by Hassan i Sabbah must, therefore, be made up of suppositions and the use of the imagination. Gysin's world was thus magickal in origin. Brion said that we are "here to go". The future is in space. Not, as most thought, outer space, but interior space. The future – like the universe – is here, in the mind.

The Dreamachine is a spacecraft that travels through time. NASA and the technophiles are left behind for the price of a lightbulb. Brion Gysin spent many years of his life in Britain, America, Morocco and France; but he spent most of his time in that place where all true visionaries are forced to dwell – in his mind.

"Brain waves, minute electrical oscillations associated with brain activity, can be measured accurately and graphically recorded by the electroencephalograph (EEG) machine. EEG records show that brain rhythms divide into groups according to frequency. One of these groups, the alpha or scanning rhythms, is strongest when the brain is unoccupied, searching for a pattern, and weakest during purposeful thinking, eyes open studying pattern. The strength and type of rhythms vary between individuals. The EEG records of some primitive peoples are similar to those of a ten year old in our society. Variations occur with age. The alpha rhythms do not appear in children until they are about four years old."

—Ian Sommerville, *Flicker*

"Had a transcendental storm of colour visions today in the bus going to Marseilles. We ran through a long avenue of trees and I closed my eyes against the setting sun. An overwhelming flood of intensely bright colours exploded behind my eyelids: A multidimensional kaleidoscope whirling out through space. I was swept out of time. I was out in a world of infinite number. The vision stopped abruptly as we left the trees. Was that a vision? What happened

to me?"
—Extract from the Diary of Brion Gysin, 21/12/1958

Department of Transport guidelines say that trees planted alongside motorways must not be of uniform height or distance apart. The reason for this is that drivers passing such trees for long periods experience pulses of light and changes in sound levels which can affect their concentration, and their ability to drive. Drowsiness, nausea and "motorway madness" can ensue.

Tests in Britain and America have taken place investigating the effects of strobe lights and loud oscillating sound on humans. It has now been confirmed that this research has been put to use by some security agencies in the area of crowd control. It is believed that systems have been developed which can induce epileptic fits in approximately one in four people – which would be more than enough to confuse and disperse any demonstrating crowd.

On February 15th 1960, Ian Sommerville, who had been recently inspired by Grey Walters' book 'The Living Brain', wrote a letter to Brion Gysin: *"I have made a simple flicker machine. You look at it with your eyes shut and the flicker plays over your eyelids. Visions start with a kaleidoscope of colours on a plane in front of the eyes and gradually become more complex and beautiful, breaking like surf on a shore until whole patterns of colour are pounding to get in. After a while the visions were permanently behind my eyes and I was in the middle of the whole scene with limitless patterns being generated around me. There was an almost unbearable feeling of spatial movement for a while but it was well worth getting through, for I found that when it stopped I was high above the Earth in a universal blaze of glory. Afterwards I found that my perception of the world around me had increased very notably. All conceptions of being drugged or tired had dropped away..."*

Following Sommerville's later description of the 'Flicker Machine', Gysin proceeded to make his own, adding to it an interior cylinder covered with a painting which he produced along the lines of his 'flicker' experiences. (Indeed, much of Gysin's later painting sprang from his visions experienced in front of the machine.) Gysin wrote at the time:

"Flicker may prove to be a valid instrument of practical psychology: some people see and others do not. The DREAMACHINE, with its patterns visible to the open eyes, induces people to see. The fluctuating elements of flickered design support the development of autonomous movies, intensely pleasurable and, possibly, instructive to the viewer.

What is art? What is colour? What is vision? These old questions demand new answers when, in the light of the Dreamachine, one sees all of ancient and modern abstract art with eyes closed."

IN THE HISTORY OF ART. IN THE HISTORY OF MAGIC AND SCIENCE. IN THE HISTORY OF THE WORLD. ONLY ONE OBJECT HAS BEEN MADE TO BE

VIEWED WITH THE EYES CLOSED.
THE DREAMACHINE.

Dreamachines bring to a conclusion the period of kinetic invention in 'modern' painting and sculpture. The Dreamachine opens up a whole new era and a new area of vision... Interior Vision.

Look into a Dreamachine, and look deep. Here you will actually SEE the fundamental order present in the physiology of the human brain. Your brain. Order imposed on chaos. Life imposed on matter. History and Mystery.

"You are the artist when you approach a Dreamachine with your eyes closed. What the Dreamachine incites you to see is yours... your own. The brilliant interior visions you so suddenly see whirling around inside your head are produced by your own brain activity. These may not be your first glimpse of these dazzling lights and celestial coloured images. Dreamachines provide them only just as long as you choose to look into them. What you are seeing is perhaps a broader vision than you may have had before of your own incalculable treasure, the 'Jungian' store of symbols which we share with all normally constituted humanity. From this storehouse, artists and artisans have drawn the elements of art down the ages. In the rapid flux of images, you will immediately recognise crosses, stars, halos... woven patterns like pre-Columbian textiles and Islamic rugs... repetitive patterns on ceramic

tile... in embroideries of all times... rapidly fluctuating serial images of abstract art... what look like endless expanses of fresh paint laid on with a palette knife."

—Brion Gysin

Brion Gysin using a Dreamachine

The visions hollowed out of the Dreamachine usually start off with a rapid, and quickening, succession of abstract patterns. Often this transit of speeding images is followed by a clear perception of human faces. Humanoid figures and the apparent enactment of highly coloured events, or, as Gysin described them, "pseudo-events", carried out in time and in space.

"Do you dream in colour?"

—Bill Nelson

The Dreamachine really IS just that. A dream machine. One person I know who exposed themselves to its spinning glare came out of their semi-hallucinatory state talking seriously of visiting another planet, complete with aliens, cavepaintings and children. Some people have reported nightmares of sorts, but these, as all dreams experienced on the Machine, can be abruptly brought to an end by opening your eyes.

"However you look into a Dreamachine, in a short time you will have acquired greater self knowledge, extended the limits of your vision, brightened your perception of a treasure you may not have known you own."

—Brion Gysin

"A light like a billion watt bulb floated up through the bars on my window. The Great White Light, the Ineffable Light the Tibetans are always talking about. I was transfixed, of course. I felt I could see it, naturally, because it ran straight up my optic nerve and through the disintegrating mass of my freshly re-awakened brain right down to my hypothalamus. My narrow cell began to revolve like an old 78 rpm turntable and the bars on my cell window on the spiral stairs to spin at between eight and thirteen flickers a second – the alpha rhythm of my soft old brainbox. An overwhelming flood of intensely bright abstract patterns in supernatural colours exploded somewhere behind my blind eyes where multi-dimensional kaleidoscopes whirled through endless space. Dazzling lights of unearthly brilliance and colour were developing in magnitude and complexity at great speed. Infinite acres of geometric wallpaper and rubbishy canvases by painters like Vasarely spread all around me. I was the pivot in the centre of developing worlds, giant galaxies hurtling through my own interior space at the speed of light. It all means that my EEG has not flattened out yet and the old brain is still working. I laugh uncontrollably...

"Long experience of Gysin's Dreamachine had taught me what to expect. I knew I could expect to see the symbols of all the great religions float free from this background noise to pass slowly and majestically across my field of vision. The cross in all its variations flashed as brightly for me as it had for Saul on his way to Damascus racing down an avenue of trees on the buckboard of his chariot as the sun set behind the tree trunks, producing flicker at his alpha rate. So he fell off his chariot and came to as Saint Paul, more's the pity for all of us. As I said before, all these religions ought to be taxed out of existence. Then the swastikas spinning clockwise and counter were followed by a magnificently jewelled Tibetan dorje, raised like a club or sceptre. The all-seeing eye of Isis floated by, eyeing me knowingly, succeeding by other eyes flashing fire. The crescent moon of Islam or the Blessed Virgin Mary and the blue hand of Fatima gave way to the symbols of forgotten religions or, who knows, those of other planets. I waited expectantly..."

—Robert Anton Wilson

Gysin was approached by various large companies, including the Dutch electronics giant, Philips, sniffing around the patenting possibilities of the machine which he and Sommerville had effectively invented out of nothing. *"When I told them that it made people more awake"*, said Gysin later, *"they lost interest. They were only interested in machines and drugs which made people go to sleep."*

If the Dreamachine is real, a non-habit forming, simple spinning dreambox that is capable of inducing a drugless high, why is it not available in your local department store? The answer would seem obvious. Look at the *Financial Times* and you will see that some of the biggest companies in the

world are chemical giants, ICI, Bayer, Hoffman La Roche. Go to your GP and tell him that you are ill and what will you get? Drugs. Seek a path out of everyday trivial reality and what will you be offered? Drugs. You can only sell people one Dreamachine, one turntable, the occasional lightbulb. Drugs and their accompanying paraphernalia (and I include most doctors as an integral part of the paraphernalia) generate far more money in a drug dependent world.

How do you go about getting a Dreamachine? Well, only a handful exist, made in metal cylindrical form and costing upwards of £500. But you can experiment by making your own.

To build your own Dreamachine you need a sheet of 4-ply paper, 32 inches square, a record player that can revolve at 78 rpm (available from many secondhand shops for a few quid) and a hanging lightbulb.

On the paper, draw three inch borders along the top and bottom, then carefully divide the rest into two inch squares. Cut out the cardboard templates, then trace them onto the paper in the positions illustrated. With great care and accuracy, then cut the holes out and connect the two ends together, thus forming a cylinder. Dangle a lightbulb down the middle of the cylinder and rest this on the turntable. Now, darken the rest of the room, play some repetitive but "unfocused" music, and spin.

From now on, it's all free, it's all safe, it's legal – and it really works.

"BRAZIL"

Simon Dwyer

Britain is not a free country. In this special investigation, Rapid Eye tells you why.

"MAN IS BORN FREE. THAT IS HIS NATURAL STATE. HIS GOD-GIVEN RIGHT. NOWHERE IS THIS TRADITION MORE DEEPLY ROOTED THAN IN BRITAIN. OFTEN, IN OUR LONG HISTORY, WE HAVE STOOD ALONE, FACING THE MIGHTIEST ARMIES OF THE WORLD TO DEFEND OUR FREEDOM, SOMETIMES AT TREMENDOUS SACRIFICE – NEVER DOUBTING THAT THE PRICE IS WORTH PAYING. FREEDOM HAS BEEN BOTH OUR STRENGTH AND OUR BATTLE-CRY. WE ARE A PROUD NATION OF INDIVIDUALS. WE FLOURISH UNDER FREEDOM."
—Tory Election Broadcast (May 1987)

"And therefore never send to know for whom the bell tolls. It tolls for thee..."
—John Donne (1610)

"From the age of restriction, from the age of secrets, from the age of lies – greetings!"
—George Orwell (1948)

Ask people what it is that they most like about living in Britain and invariably one word will crop up: "Freedom".

Most of us like to think that we live in a society that allows a far greater degree of individual freedom than anywhere else. For all our faults, that element of freedom is what – we are told – makes Britain 'great'.

The idea is nonsense. Despite the Newspeak put about by Saatchi & Saatchi, British people are not free. We never have been. What is more, the few freedoms that we have traditionally enjoyed in the past are now being eroded at an alarming rate. Under a veil of State secrecy, cynical political

manoeuvring, media control and socially engineered public apathy.

The infringements of the State into the private, personal life of the individual are usually subtle and – due to our conditioning – barely perceived as being intrusive at all. When each infringement is viewed singly, it is normally not considered something worth bothering about – a mild irritant that can be tolerated without too much hardship. It is often not until the individual strays far from the popular path of social acceptability that one is forced to turn and face reality, forced to realise that the sum total of minor irritants, bad laws and corrupt practices congeal to present a frightening whole. In reality, a labyrinth of social and legal diversions stand around the kernel of Individual Freedom which we are supposed to hold so dear.

As most people proudly consider themselves to be 'normal' members of some unspecified majority, the question of Freedom is not something thought worthy of serious popular consideration. For most, the rhetoric is enough. Attacks on one's civil liberties thus pass, for the most part, unchallenged. Sometimes, through a clever use of the news media, they are actually lauded, being presented to the public as pieces of legislation that will make our community a safer, more wholesome place to live. Such a sophisticated exercise of control only comes from a great deal of practice. In this area, few other nations are as experienced, or as expert, as Britain. And it is this ability – the ability to keep people oppressed yet contented, rather than to make people more free – that is what in reality has made Britain 'great'.

There has never been a full scale revolution in Britain, as through a deft mixture of camouflage and persuasion – peppered liberally with buzzwords such as 'Democracy', 'Justice' and 'Patriotism' – the control of the State been presented as being universally benign and a practical necessity. Put simply, there has been nothing tangible enough to revolt against. In this century, the country has never had anything as openly dictatorial or corrupt as a Hitler, Stalin or Marcos to identify with the oppression and target such revolution against (though it is interesting to note that the only peacetime Prime Minister in British history to have had a serious assassination attempt made against them is Margaret Thatcher). In Britain, the State machine is more oily and silent running. Here, it is more often the case that the enemies of freedom are faceless bureaucrats, lethargic institutions and two-faced politicians.

In any society, the argument runs, this treasured concept of Personal Freedom must be hedged in with other considerations and compromises.
Sacrifices must be made for 'the greater good'. Officially, 'freedom', (always somehow considered a concept rather than a practical reality) is simply a question of degree, and in a democratic society the *amount* of freedom an individual has is ostensibly dictated by the majority.

If an individual member of that majority is encouraged to remain ill-informed about the limitations of his freedom, he will be unable to extend those freedoms in his personal life. His choice will be controlled, as will its outcome. If he wishes to choose an entirely different path, he will discover that no such alternative exists within the framework of this society. Immediately, by not making his controlled choice, he will become a social outcast to some extent. He will be labelled as being selfish, subversive, criminal or insane.

In a country that has resisted radical change and quashed revolt, even the word 'revolution' (so loved in many countries), equates with violence, pseudo-intellectualism and oddness. Words which are the antithesis of Britain's self-image. Revolution, even if carried out peacefully in films, literature, or in the mind, (rather than on the streets) can be considered a treasonous act. And it is not surprising to find that treason remains the ultimate crime and the only one – in theory at least – that is still punishable by death.

In a society so blind to the everyday facts and bedazzled by the ancient myth, even to address the topic of Individual Freedom in a manner such as this is to invite criticism and misinterpretation. Yet it is these potential critics, who in all probability claim to be concerned about Law & Order, Freedom & Justice, Peace & Happiness etc., who should be those people who are most interested in ensuring that the people of this 'great' country are governed by just laws which are implemented fairly within a humane society. A society that pays more than lip service to the ideals of democracy, equality and personal liberty which it purports to champion.

In the 'alternative' culture it's fashionable, even essential, to claim that the 'system' is so unworthy it isn't worth thinking about; that all politicians are ego maniacs; that the police are universally corrupt and Fascistic; that all journalists are liars and so on, ad nauseam. Such criticisms are usually carried out by people who've never printed their own magazine, never made a subversive video, never done anything, in fact, but consume the products that the State produces and condones. Acned youngsters with £30 haircuts are keen to fall, lemming-like, into generation gaps created by a succession of stupid young (and not-so-young) men in leather jackets, whose bounty from this bottomless mine (gold records, coke, limitless penicillin) is also the main motivation for their sanitised form of revolt. It is no accident that rock'n'roll is now being embraced by Russia, China, and other societies which operate a high level of control. Contrary to the myths put about by numerous dullards in the 1960s and late 1970s, although music can be used to express and refine certain attitudes, as a revolutionary weapon, or information channel, it is usually about as much use as a lightbulb to Stevie Wonder.

In social terms, the pop placebo is a good method of keeping society visibly healthy, transmuting disenchantment and real social disquiet from the Problematic to the Profitable. State control and rock and roll are run by clever men. Feelings of alienation

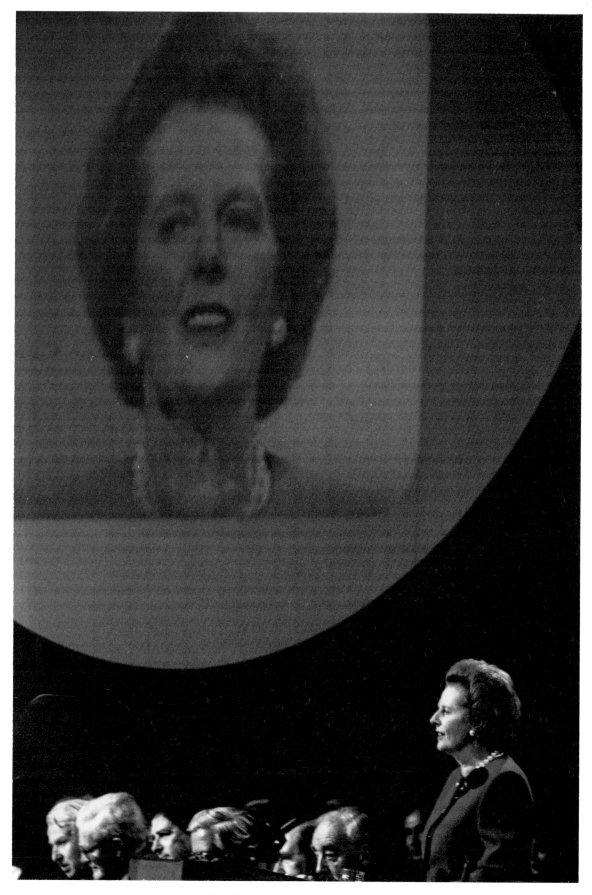

Big Sister (courtesy The Independent)

caused by repression are absorbed and turned into escapism in the land of Entertainment. In the Coke generation social reality is made to look boring. Information on how things really are is made to look stupendously boring. Here though, we intend to present a pellet of information – slug death to the hedonist – which makes no apologies for being chock-a-block with dull fact. Only by using the dialect of 'Control', the language of the Law and the hard currency of Information, can we hope to present the current situation as it really is. Or at least, go as far as official records, Hansard, *The Times*, the BBC etc. *admit* that it really is. The facts speak for themselves. This is how we live in this free country in the late 1980s.

Anyone who doubts any of the incidents and facts reported here is encouraged to check them out independently. In so doing they will find that this informational collage represents but a drop in the ocean. All we can hope to do here is convey a sense of the whole, horrible truth.

Although the excessive levels of control which presently operate cannot be laid at the door of any single political party; although the 'system' is obviously flawed in that it apparently lacks the capacity to successfully reconcile the rights of the individual with the supposed wishes of the majority, Britain's current crisis (and I use the word advisedly), is partly brought about by the attitude of the present government. A government which reflects the age in which we live. An age in which 'freedom' has been edited, limited and re-defined to mean the 'freedom' individuals and companies now have to compete more ruthlessly with others on a purely economic level.

To be fair, we do have certain new rights under this present regime. The right to own a Telecom phone all of our own, but not the right to express feelings that detract from the dominant ideology of the State. The right to buy council houses, but not the right to expect employment. The right to buy a share in British Airways, but not the right to be educated properly by the State...

These are uncertain times. Brought about indirectly by the social and economic failures of the country since the war. In such a climate, many unimaginative people in the political arena have been persuaded to abandon even the pretence of consensus politics, consultation and moderation. So dispensing with the need for debate, freedom of information, and the recognition of equality that goes hand in hand with such old-fashioned ideas.

It seems that the British people have been largely conned into believing that the sins of their fathers – the relative liberalism and over-indulgences of the '50s and '60s – have been visited upon them, the children. The blackouts, shortages and strikes of the '70s and the mass unemployment, riots and new diseases of the '80s have strengthened their belief that we must have 'strong' leaders, and restrictive laws, in order to fight such menaces and mount some yellowbrick road to 'recovery'. The climate is

one of guilt and retribution. Dr. Benway's medicine must be gulped down if you want to keep that job, that mortgage, that veneer of success. So we, the compliant majority, allow ourselves to be ruled by a tiny dictatorial minority with an iron fist in a velvet glove. The boots may be Gucci, but they're stamping on our faces just the same.

In this silent, submissive age, it seems that public resistance decreases as oppression increases. Our tolerance goes up and up in a never-ending spiral. So with each bullet fired from a police gun, less uproar is heard. Because the more bullets fired, the more restrictive laws passed, the more frequent the acts of repression – the older the news, the less interested and concerned we become. And our training, highlighted by our age-old acceptance of such ridiculous things as the Sunday Trading and Licensing Laws, has stood us in good stead for the current swing against libertarianism and attacks on civil rights.

In the face of an increasingly polarised political left and right wing, the fundamentally civilised, moderate and caring quality of life desired by the silent majority looks more and more impossible to attain. While all the time the organisational machinery of the State rumbles on like a Chieftain tank, oblivious to any instruction that does not emanate from the Downing Street. This would not be so if Britain had adequate safeguards as enjoyed by other countries.

A BILL OF RIGHTS IN A STATE OF WRONGS
In 1215 King John signed Magna Carta, a charter which gave the individual Englishman the right to fair trial and protection from arbitrary arrest and imprisonment. Thus the concept of 'individual freedom' was lodged into the psyche of what history has shown, in some ways, to have been the most advanced social structure on the planet. Ever since, as was pointed out earlier, this vague idea of Freedom has swilled around the neurological backwaters of the collective British unconscious mind to be used and abused at will throughout subsequent generations.

Thus Nazi Germany was fought as it was seen as being against all that Britain said she stood for. The Nazis were anti-freedom, anti-democracy and anti-Christ. Co-incidentally, just the same set of reasons given later for the vilification of our allies against Nazis, the U.S.S.R. And thus, the General Election campaign of 1979 – a full 764 years after Magna Carta -this ancient freedom factor, by now almost akin to an Arthurian legend, was invoked by the black magical advertising executives employed by the Tories (just as it was in 1983 and 1987).

Wantonly wrapping herself in the Union Jack, a latterday Boadicea born very much from the 'Jerusalem' school of English thought, stood on a platform of 'Personal Freedom' and pitted herself against what was depicted as being the Socialist's platform of 'state interference'. She promised to set people free with jobs (*Arbeit Macht Frei*) and "To

make Britain strong enough to give the individual citizen more freedom of choice." Appealing to an almost genetic instinct (like Franco and Hitler), Margaret Thatcher was elected as Prime Minister on the 3rd May 1979. Britain, we were told, was about to be set free.

Not surprisingly, the politicians lied. The reality has not matched the pre-election rhetoric. Since the Thatcher administration came to power, voted in by 11 million of the 56,488,000 people who live in the U.K., the practice of increasing the individual's personal freedom has included some apparently incongruous actions, which we will investigate here.

What Thatcher did not make clear was that her idea of 'freedom' was highly selective, and in creating the greater economic freedoms of the rich to get richer, a certain amount of morality had to be dispensed with. For when market forces are unleashed, there will inevitably be fall-out. The 'losers' in this new system who cannot compete will no longer be looked after by society. Welfare rights take a backseat, so social conflict, class polarisation, dissatisfaction and even crime are encouraged. So a strong disciplinary regime is an accompanying necessity when one enters the era of the Free Market. The State intervenes less in financial matters (as people are encouraged to sink or swim on their own) but interferes far more in other areas.

Since the Tories came to power, Britain has witnessed the introduction of random police roadblocks, strip searches in women's prisons, a removal of the right to be tried by jury, bans on the right to protest, restrictions on Trade Union Membership and their rights to strike and picket, the abolition of democratically elected local councils, a rise in censorship, a plethora of new laws involving the media, an enormous increase in the powers of the police and courts, Customs and Excise, and officers of the DHSS to search and snoop without warrants and to incarcerate in prisons and hospitals without an individual being found guilty of any crime or social defect.

The continued calls for an adequate Freedom of Information Act, genuine reform of the Official Secrets Act, and demands for a Bill of Rights have all been largely ignored, or not properly implemented.

As one will see, the list is long. It could be far longer. One safeguard against this unpleasant trend continuing would be constitutional. *Britain does not have a written Constitution that protects or recognises the rights of the Individual.*

A Constitutional Bill of Rights is a permanent charter that, in many countries, is in itself more important than any transient law or passing government. Its sole purpose is to recognise the Individual and his or her rights as a human being, and to protect those basic rights from the misuse of State power, be it from extremist left or rightwing governments, their police and courts, or the Monarchy. Britain does not, and never has had a Bill of Rights. In this sense, in the free world, we're rare. (Even countries who didn't enjoy a written

constitution while under British rule have drawn them up since independence. The last Commonwealth country to do so was Canada in 1982. If Australia becomes a Republic, as seems likely, it is almost certain that their first constitutional changes will be connected to drawing-up a Bill of Rights. In freeing themselves from what many states formerly in the Empire think of as the British yoke of oppression, it is natural for new, independent countries to base their constitution on something that has been denied them for centuries. The British people, unfortunately, cannot benefit in this way as we are one of the relatively few countries not to be a Republic. What was once the genuine oppression of the British Empire, is now confined to being the British constitutional oppression of the British people. We are, as British subjects, punished by our ancestor's history).

A Human Rights Bill for the British people was introduced by Sir Edward Gardner QC in 1986. It went through the Lords, helped by Lords Scarman, Hailsham and Broxbourne. Although a hardcore of reactionary MPs and civil servants opposed it, the Government did not wish to be seen to officially oppose the Bill. Strangely, however, they did not officially support it either. It was also arranged through Parliamentary processes for the vote on the Bill to be made late on a Friday afternoon, (30th January 1987). A strategic time, when most MPs will already be on their way back to their far-flung constituencies after the weeks usual Parliamentary business. It is indicative of the Government's true attitude, and of all political parties' set of priorities, that (unlike when an 'important' Bill is voted on) no party whips were in operation. MPs were thus freed by their parties not to attend the House of Commons when the Bill was read.

Although, for the first time, politicians were given an opportunity to make British people more tangibly, legally 'free' than ever before in their history, only a paltry 20% of them turned up to vote. Some of those who did appear wanted to vote against it, but it didn't matter. With such a low turn-out a Bill cannot even get through to its Second Reading, necessary to make it law. Had the Bill gone to the Second Reading stage, it's widely thought that the government would have blocked it anyway, but that's hardly the point. Although millions of British servicemen over the years have died for an abstract sense of Freedom, when the real crunch came, politicians simply couldn't be bothered.

So as things stand, British people are open to abuses of power that would be illegal in countries such as, for example, France or the U.S.A. We are prey to practically anything dreamt up by puritanical governments, tyrannical local authorities and senile judges.

Our only recourse, as Europeans, is to take any complaint we have to the European Court of Human Rights in Strasbourg, an astronomically expensive and time-consuming process.

Contrary to popular opinion, the European Court

itself has shown recently that it is less ready to risk offending individual member governments by applying the European Convention of Human Rights and finding for the complainant, particularly in the case of Britain who is *the most persistent offender in the European Court;* the country which already has the least 'European' outlook; and is the second largest financial contributor to the community budget.

So, as things stand, any British Government riding in on the blatantly unfair electoral system which we operate, awards itself a 'mandate' from the entire population, so it can do *whatever* it likes. Providing they have a large enough majority in Parliament, there is *nothing* to stop them passing any weird laws they wish. Indeed, it is because the present government has been so liberal in its interpretation of the people's mandate that so many laws which are alien to the British way of life have been swept through.

Of course, not all governmental actions are intrusive to Personal Liberties, but a written Bill of Rights would provide us with a catch-all, basic set of rights that would stop all manner of unjust things happening to millions of people throughout this country. That such a Bill would be popular with the British people is not open to question, so why do politicians continue to ignore the demands for such a piece of legislation? What, exactly, are they scared of?

FREEDOM OF SPEECH
The Oxford English Dictionary is surprisingly sparing and unhelpful when it comes to defining the word 'Censorship', reflecting the belief that censorship and control in Britain is not a topic to be discussed. A censor, it seems, is either a Roman who collects data or, it says, a present-day official whose duty it is to ensure that *"no books, journals, plays etc. contain anything immoral, heretical or offensive to the government."*

In a sophisticated, well-educated, supposedly 'free' society, the needs for censorship are, to say the least, somewhat dubious. But nevertheless, censorship remains rife in Britain, and is now on the increase.

'Control' is self-perpetuating because even when the practical need to exercise control has disappeared or become questionable, the desires to assume control, and to be controlled, remain. So basically any form of Authority, however out-moded, useless or corrupt it may be is bound to protect itself. Protect its authority. Otherwise it would, by definition, cease to exist. Censorship is in this sense just a bureaucratic version of the survival instinct.

As with all forms of bureaucracy, it is snowed in with confusion, over-justification and triplicated humbug. The reasoning behind it is said to be complex. In fact, censorship is quite easy to understand. It is simply the policy of cutting-off the individual's right to express certain opinions, ideas, desires, concepts and impulses which the State believe may have the capacity to undermine its

authority. Its power. (And it seems in Britain that if power is wonderful, absolute power is absolutely wonderful.)

The key word of the censorious is *information.* If you carefully restrict and regulate its collection, presentation and dissemination, the edited and corrupted information which you implant into the Information Exchange systems of the mass media becomes the only currency. In a country absolutely obsessed with its media, it becomes truth. The Truth.

Remember. Information is power. The sharing of information is the sharing of power.

In this light, the concept of censorship in a free, democratic society just does not stand up to scrutiny. The practice of censorship in an unfree, un-democratic society is, however, absolutely essential. In a country like Britain, censorship may be less obtrusive than in more blatantly dictatorial nations (partly because we find the idea of it so natural and acceptable), but make no mistake, our system requires the use of censorship if it is to continue to exist in its present form. It is a practical necessity. If this were not the case our government, supposedly keen to cut costs, reduce red tape and unclog our courts would have abolished the costly and cumbersome legal systems that surround censorship long ago. Surely?

Isolation, dissatisfaction and crime are encouraged if an individual, or minority group of individuals, are denied access to the rights enjoyed by the majority. It is an essential basic freedom for each individual to be allowed to gain access to information and education, entertainment and stimulation, in any advanced society that seriously claims to be 'free'. In such societies, people have a right to read published works that may enrich their existence in some way, and the right to form educated opinions based on such works, plus the right to express those opinions within a lifestyle that suits them. Equally, people who attach themselves to groups of other people who happen to feel the same way about life as they do, should be able in a free country to find out about the history, culture and shared experience of such a group.

At this point, one should forget the newspeak definition of 'freedom' and put aside petty prejudices. Freedom could, more fairly, be defined as a simple recognition of people's rights, including, most importantly, their right to be wrong. *Their right to choose.* This is the most unpalatable definition of freedom that governments can hear, for obvious reasons.

The fact that various 'minority groups' interpretations of life do not conform to those held by the majority should not affect such basic human rights. Specifically, the right to seek happiness. Providing their opinions and actions do not deny equal rights to other individuals, it is only natural justice that is being served if they are left to go their own way.

In Britain, a populist theologically dubious set of 'Christian' morals and customs are lodged at the

heart of the State system (even though only about 4% of the population are Christian church-goers on a regular basis and do, themselves, form a minority). These largely corrupted pseudo-Christian values, as interpreted by the State, allow for any level of interference to be applied to the personal, usually private lives of individuals who choose not to conform to the narrow moral codes of the assumed majority.

The most obvious consistent target of the 'moral' majority are homosexuals; particularly, in a male orientated society, homosexual men. Despite their relatively new found legality (in 1967) and general social acceptability, the British State, it seems, can't quite bring itself to recognise their rights of expression, *or the rights of any perceived 'minority group'*.

Why else would police raid the offices of Toshanex Ltd., and seize gay books and titles such as William Burroughs' *Junky, Fear And Loathing In Las Vegas* by Hunter Thompson, and works by writers such as Tom Wolfe which are in current use as University texts?

In a quite recent series of raids, bookshops in several other locations have been raided in similarly heavy-handed fashion. As a result, many people have been criminalised and brought to trial for a number of offences – though inconsistencies often appear between one part of the country and the next. For example, magistrates in Nottingham ruled that some titles brought before them by police in court were not obscene, while, at the same time, police in London continued to hold copies of the same books from raids in the Metropolitan area under the Obscene Publications Act.

Titles published by such reputable firms as Pan, Corgi, Penguin, Granada and the Harvard University Press were included in the seizures, but it is interesting to note that not one of these established publishers was actually brought to trial. Smaller companies, who could not afford teams of solicitors and whose prosecution would not attract the same amount of publicity – such as Airlift Books – were, however, charged with offenses such as "having obscene articles for publication for gain". They were also charged with "conspiracy to incite offences" under the Misuse of Drugs Act, for stocking such books as the aforementioned Burroughs number. All this, despite the fact that many of the books involved were openly on sale in High Street shops all over the country and the information relating to drugs therein could be found in any public reference library. The tenuous drugs connection was, in any case, thought by many to be a cover for the raids' real target – erotic literature (gasp).

As in many other countries, access to such literature in Britain is limited to people over a certain age. In this country, people are free to legally indulge in sex at 16, but not allowed to read about sex until they are 18. Unlike other European countries, Britain licenses Sex Shops. Unlike many other European countries, it also stringently censors all the material available in such shops to the legally consenting adult customers who wish to buy such books. The annual license fee for each shop selling primarily sexually-related literature is £12,500 per year. (Despite police claims that a third of traffic accidents and nearly 50% of violent crime involves people who are drunk, this figure compares with the £10 average sum needed to licence a pub.) Many feel that the exorbitant licence fee required from Sex Shops amounts to unofficial prohibition of all sexually related material, despite the fact that such material has already been heavily censored, and is only available to adult customers.

In June, 1984, 120 titles heading for the Feminist Book Fair were intercepted by H.M. Customs & Excise Officers. Books worth more than £1,600 on their way to the Essentially Gay Mailorder Company were also seized, and the company was forced to close. A parcel of books ordered by a general book shop, Balham Food & Book Co-Op was also stopped. Two thousand books were taken from Gay's The Word book store, and eight of the company's directors were brought to trial. Lavender Menace Ltd. of Edinburgh had two shipments of gay books seized, and London's Peace bookshop, Housmans, have also had material confiscated. Indeed, the list goes on and on. Britain's *only* licensed Gay bookshop – Zipper – has also been raided.

No complaints about the books or the bookshops concerned in this series of raids had been received from members of the public. No figures are published giving the numbers of police and customs men involved in the operations, or giving details of how much court time and public money has been used on such cases over the past few years. Whatever the figures, they must be considered against a back-drop of supposedly spiralling street crime, over-worked courts and complaints from both the Police and Customs that they are seriously under-manned, particularly, for example, in the fight against the importation of hard drugs, which all claim to be their highest priority.

In October 1986, a month in which new figures showed a further increase in the numbers of heroin addicts, police busied themselves with raiding the offices of *Skin Two* magazine, and also confiscated copies of the latest edition from news-stands around the capital. Despite the fact that the magazine is primarily fashion-orientated and has little in the way of erotic content, the Metropolitan Police still decided it worthy of persecution due to its S/M overtones (Fashion photos of women modelling high heels, leather skirts etc. Compare this to the situation that exists in Amsterdam, where a local S/M on-premises sex club is a respected member of the city's Chamber of Commerce.)

It is interesting to note that since the current Tory administration has come to power, the law used to try many bookshops is not the Obscene Publications Act, but the more obscure Customs Consolidation Act, a law which came into force 111 years ago. Under this law – unlike the Obscene Publications Act – *No book can be defended in court on the basis of*

its artistic or literary merit. (Very convenient). Some book companies have been charged with the more usual Obscene Publications Act. This law makes it an offence to produce any book which "may deprave or corrupt" an ordinary member of society. A charge that is in itself almost impossible to defend oneself against. In an extraordinary move, however, some booksellers have recently been charged and found guilty under this law for the publication of books *which contained no violent or erotic content whatsoever,* meaning, in effect, that the scope of the Obscene Publications Act has been widened by the Government and Courts, giving the police even greater opportunities for arrest, without consultation with the public or in the Houses of Parliament.

Many feel that the way in which the present government has evoked ancient laws and encouraged the courts to re-interpret and increase the scope of others is typical of the unpublicised, underhand way in which people's individual freedoms are being eroded without debate, publicity, or the chance of protest.

Other brand new laws inhibiting personal freedoms have, however, come in for a good deal of public criticism, despite efforts to confuse or distract the issues by the government's publicity machine at the time of such laws being pushed through Parliament and enforced.

Under the notorious Video Recordings Act, all films put onto video now have to be re-submitted to the British Board of Film Censors for new classification. (Meaning that each movie shown at a cinema and also available on video has to be classified twice) It costs an average of £500 to have a film certificated by the censors. Films included in the new censorship net are Donald Duck cartoons. Hundreds of bona fide video rental shops have been vetted by the police. Thousands of tapes have been confiscated and not returned to their owners, including many titles which have B.B.F.C. 'X' or '18' certificates and which have been screened openly to cinema audiences.

At this juncture, it should be remembered that despite unsubstantiated claims to the contrary (claims which find an unquestioning outlet in both the popular press and pseudo-'feminist' women's magazines), *no* scientific evidence of a reputable nature has been produced to link acts of a violent sexual nature to video viewing. The Act itself was based on pseudo-research into children's viewing habits, and the effect of video watching on the 'family unit' (commissioned independently by an extremist Christian organisation), which has since been proved to have been fabricated and exaggerated. Research that is so flawed and biased, that even the Catholic and Methodist churches have publicity dissociated themselves from it. Despite this fact, the Bill, which was lobbied for by The Festival of Light (who acted under a pseudonym at the time) remains law which directly affects everyone who uses a VCR (over half of all households in Britain) and inconveniences and wrongly criminalises many who

seek to earn an honest living in the business of renting and manufacturing quite ordinary videos.

Although a small number of criminals have claimed in mitigation to have been influenced by their viewing habits, these are in a tiny minority – a minority that has received excessive amounts of publicity from newspapers keen to sensationalise the issue and support the powerful and vociferous rightwing minority. It is no surprise to find that the papers which have given the most coverage to this topic are *The Sun* and *The Sunday Times*. As a result (as Dr Terence DuQuesne pointed out in a previous issue of *Rapid Eye Movement* magazine), a climate now exists in Britain where one is given a clearly defined choice between being seen to support "The Family/Law & Order/Godliness" *or* being seen to support "Moral breakdown/Crime/Sin". As in most totalitarian regimes, no middleground, no grey area of debate is perceived. The choice, as always, is limited. Not surprisingly, under this blackmail and pressure, most people in public positions or power, such as MPs, despite their personal reservations, want to be seen as being on the side of 'good', and allow such new pieces of legislation to pass unchallenged. Furthermore, to actively introduce legislation that seeks to repeal old laws, such as the Obscene Publications Act or Customs Consolidation Act, would be to stand up and be seen as being pro-pornography.

As a result, Britain today goes against the liberalising trends of almost every other civilised nation on Earth.

For example, many 'Catholic countries' around the world, who are often condescendingly portrayed in Britain as being strict and somehow old-fashioned, have *no* film or video censorship. Indeed, in Western Europe, the U.K. and Ireland are the only countries to have film censorship. In South America, post-junta Argentina moved into the 20th century when it abolished *all* its film censorship laws in 1984, just at the time when rejoicing, victorious, happy-and-glorious, 'free' Britain tightened its own laws and increased the powers of the courts and police to implement them. Italy, home of Vatican City, has several pornographic TV channels. Holland allows any form of sexual behaviour between adults to be shown in books and videos – but has a lower rate of violent crime than the U.K. Japan, which has by far the most violent TV and Cinema in the world, has only 1.9 robberies with violence per 100,000 inhabitants each year. The U.K. has more than *twenty times* as many violent crimes per capita and nearly *eighty times* as many rapes. (Co-incidently, since the new censorship laws have been introduced, rape has increased faster than any other type of crime.)

In 1975, West Germany relaxed all its censorship laws. Since then, crimes of rape and child abuse have declined, against an increase in all other types of serious crime.

We are told by the Government that, despite such inconvenient (under publicised) statistics, the general

population actually *want* more censorship. This quite clearly is not the case.

In a poll carried out by the Opinion Research Centre into people's views on what is shown on television, it was discovered that only 23% wanted 'Sex and Blasphemy' banned from the T.V. Only 18% wanted nudity banned. 66% said that they thought acts of sex on the screen acceptable and 57% said that blasphemy should be allowed on television.

Opinion polls such as this – and the results of this poll broadly correspond with others – do not get cited by politicians keen to mould public opinion in their direction.

As other countries (even Russia) question the reasoning and true motives behind the censorship lobbies and increasingly challenge the right of the State to interfere in the private lives of citizens, Britain – the most 'free' country in the world – stands alongside a small number of countries like the Mullah's Iran and Lee Quan Yews' Singapore in reversing this trend, despite the wishes of the silent majority of its people.

One of the main advocates for censorship is Mary Whitehouse, self-appointed mouthpiece and founder of the grandly titled 'National Viewers & Listeners Association'. Whitehouse not only supports the right of the State to interfere in an individual's personal sexual and cultural tastes, but is also of the opinion that the TV news should be censored. (She has cited, as an example to defend her position, the wide-spread riots of 1984/86, which she said were the direct result of South African rioting being shown on ITN and which, she says, should not therefore have been screened).

Of course, the news is already censored in Britain. A classic example sprang from the Law Lord's ruling made on the 30th July 1987, which effectively forbade journalists from reporting on the Peter Wright case. The following morning's BBC radio news bulletin was curtailed with the words, "we are unable to report what was said next under the new restrictions..." For journalists, who a few months earlier had winced when having to file similar-sounding reports from South Africa during the state of emergency, it was a sorry time. The editor of *The Sunday Times*, Andrew Neil, said: *"We live in a totalitarian state. It's like living in Russia."*

In December 1987 the Government took out an injunction banning the BBC from airing the Radio 4 programme *'My Country: Right Or Wrong'*. A programme which threatened to expose the way in which State Secret Service agents operated outside the jurisdiction of Parliament. The action also forbade journalists and broadcasters from referring in any way to the names of people whom they knew were – or had been – involved in the Security Services.

The Government's bizarre actions had some severe and widespread implications, as well as some revealingly silly ones. For example, the day after the injunction, BBC Radio Essex was barred from mentioning the names Wright, Philby, Burgess or McLean in a trailer to an interview with the star of a new musical playing in Basildon called *Philby, Burgess And McLean: The Musical*. Bemused listeners were instead treated to a selection of records. (If the Law was made to look an ass, the government was made to look a bunch of arseholes).

Such a public banning order is rarely resorted to, however. Usually it is sufficient for the government of the day to censor items behind the scenes.

When the BBC planned to screen a programme on N. Ireland, *At The Edge Of The Union'* in 1985, Leon Brittan, then Home Secretary, wrote to the BBC's Governors asking them not to show the programme. Brittan latter claimed that his Government were not censoring the BBC, as he had simply written his letter as "an interested citizen". The fact that as Home Secretary he had the power to ban programmes and also fix the BBC's licence fee, had nothing to do with it at all. (The film was banned.)

Early in 1988, three unarmed terrorists were shot repeatedly by an SAS team in Gibraltar. Despite Government pressure, the IBA refused to ban the commercial TV programme *Death On The Rock*, which revealed some unsavoury facts about the killings (the Government had already refused to co-operate with an investigation by the Amnesty International organisation into the killings). A few days later, the government introduced a new tier of TV censors (the third tier in all), Thatcher herself chose as the new body's Chairman her avid admirer Sir William Rees-Mogg, former editor of the low circulation *Times* newspaper and a well-documented campaigner for censorship. (If Rees-Mogg was appointed, as the government suggested, to reflect public taste, why was *he* appointed at all? *The Times* was, under his editorship, one of the smallest-selling national daily papers in the country. If one really wanted someone to reflect true public taste, should Thatcher not have appointed the editor of *The Sun* or *The Mirror*, easily the most popular papers in the nation?)

The National Viewers' and Listeners Association, whom one would think would be interested in the viewer's right to know, did not comment on the Law Lords ruling, or the later injunctions and threats: Whitehouse and co. were, in fact, more concerned with counting the number of times the word "bloody" was used in Billy Connolly's stage act.

An avid admirer of this loathsome Whitehouse woman is Winston Churchill MP. His Obscene Publications (Amendment) Bill proposes to give the Director of Public Prosecutions more powers to prosecute TV producers under the all-embracing accusation of 'obscenity'. Programme controllers and directors, if found guilty of airing a programme that offends the likes of Whitehouse and Churchill in some way, could find themselves in prison for three years in Thatcher's "new, free Britain".

As film director Michael Winner points out, under the wide implications of the Bill it could be an offence to transmit a production of, for example, Shakespeare's *King Lear*; the censors argument being

that, in showing Gloucester getting his eye gauged out, the programme makers would be inciting viewers to do the same. (What, indeed then, about *Oedipus Rex*, or a cinematic version of the crucifixion?)

The general impression given by the censors as they seek to increase their control is that things are "constantly getting worse". We are told, for example, that violence on TV is more frequent and brutal than ever before, but, again, the *facts* simply don't support the censorship lobby's argument. In a lengthy report carried out by Dr Guy Cumberbatch and his team at Aston University in 1987 into TV violence, it was found that there has, in reality, been a steady *decrease* in violence on British television in recent years. The doctor's findings, based on 2,078 hours of monitored TV output, was totally ignored by Churchill. Should his ideas solidify into law – and it's almost a certainty that in some shape or form, they will – then adventurous drama programmes such as *Edge Of Darkness*, *The Singing Detective*, or *I, Claudius* will become a thing of the past.

Although Churchill's Personal Publicity Bill, at time of writing, is not yet law, the previously-mentioned Video Recording Act is, having come into force amid deafening silence in September 1985. Among other things, this new law made it an offence for a person to have in their possession a video that has not received classification from the British Board of Film Censors. Clause 2 of the Act does, however, allow for some types of video to be exempt from this necessity. The Minister of State for the Home Office, defending the new legislation in the House of Lords, admitted that the exact definitions of what videos are exempt and what videos are not exempt is open to testing in the courts. So, if the police stop a citizen in the street, find an uncertificated video in his or her pocket (a Cabaret Voltaire scratch tape, or a copy of Peter Shaffer's *Equus* starring Richard Burton, for example), and decide that it is not exempt, then that citizen can be charged. One's only protection, in the words of the Home Office, is if that person "convinces the court that they *thought* it was an exempt video".

This system goes against the traditional belief that, in British courts, a person that is charged with an offence *has to be proven guilty by the prosecution*. In this instance, the onus of proof is put upon the person the police have accused.

It is also a generally accepted fact of British justice that ignorance of the law is no defence, so one could imagine severe practical difficulties if one were faced with the task of defending oneself in court on the basis of ignorance of the law. Another defence may be to say that the video was not for supply to anyone else, though again, in practice this defence may be impossible to prove, particularly if one has video-copying facilities at home. It also leaves any aspiring video artist facing a heavy fine or even imprisonment.

New laws such as this and suggested amendments to established laws show how attitudes are becoming more restrictive and reactionary, rather than more forward-thinking and reformatory. For example, the aforementioned Obscene Publications Act 1959 has been tampered with on several occasions over the years, but no real changes have been implemented which make the law more obviously fair in the context of a free society.

The government has still *not* implemented the recommendations of its own committee on the Obscenity Laws. (Not surprising really, as the Williams Committee recommended that these laws be relaxed).

The latest change, mooted in a Private Member's Bill by Tory MP Gerald Howarth, ostensibly attempts to make the Obscenity Law more up-to-date and clearly understood. On hearing this, one is supposed to be pleased to hear that someone in Parliament is taking the trouble to alter bad laws. But on closer inspection, one finds that the suggested changes to the wording of the law are not intended to remove the ambiguous and subjective criteria of "...to deprave or corrupt...", but to add to that anachronism the words "and/or grossly offend a reasonable person." So the new Bill doesn't even claim to offer a new, fairer test for obscenity, but merely adds yet another subjective test to the old one, thus *increasing* the scope for prejudice and making prosecution of anyone dragged before a judge even more of a foregone conclusion.

The practical reasons for the Bill's introduction are that, despite the hardline attitudes shown by the current government and the police, some magistrates (such as those in Nottingham mentioned earlier) have thrown police cases against some booksellers and video shops out of court saying that the material confiscated was clearly not obscene and the police had been wasting public money in bringing such cases before them. Howarth's new proposals therefore imply that because some independently-minded magistrates and jurors had chosen to return some fairly ordinary magazines to their owners – as they have a right to do – there must be something wrong with them, and wrong with the law that allows them this freedom. The logic is that if the jurors go against the wishes of the police, the law must be made more restrictive, thus making it more difficult for courts to acquit those who stand accused. Howarth knows that people can, after all, be 'offended' by almost anything, particularly the type of people the Tory government would describe as 'reasonable'.

Howarth, an unknown backbencher, has received more personal publicity due to his Bill than at any time since the BBC accused him of being a member of a secret right-wing 'militant' organisation operating from within the Conservative Party. So the Bill is good for his career. He wouldn't admit to it though, but he does blunder into defending tighter controls on individual freedom by saying that such things are "good for police morale", as if that is justification enough. Both he, and the Police, condescendingly say that the new broader wording

of the law would make it easier for the public to understand. Indeed, London's senior Vice Squad officer said *"the word 'offensive' may be more easily interpreted by the man on the Clapham omnibus"*. Ordinary people, the people Howarth and the Police exist to serve, are apparently incapable of interpreting such words as "corrupt", or at least unable to do so in a way which pleases rightwing politicians and policemen.

The British Board of Film Censors are far from being such ordinary people. According to their own leaflet explaining their reasons for existence, they claim to be able to judge the moral standards of other people and they have the power to exclude from the public exhibition anything likely to "impair these moral standards" (the word 'moral' is always followed by the word 'standards', inferring that a person who has different moral attitudes and customs must have *lower standards*).

The Kinematograph Manufacturer's Association makes much of the Board's supposed independence, though in fact Members cannot be appointed to the Censorship Board without lengthy prior consultation with the Government's Home Office.

The BBFC was founded in 1912, with one of its first stated aims being "to protect the Cinema from local authority interference". In this area, they seem to have failed miserably.

In reality, despite the propaganda put about by the Board, it is the personal peculiarities and whims of local councillors that account for the nation's cinematic viewing habits. The ultimate power of veto lies with them, at local authority level, and councillors often show a keenness to exercise that power. For example, the progressive members of Beaconsfield Urban Council banned The Beatles' *Yellow Submarine* because, in their own words, "it was pure unadulterated rubbish." Never mind that the British Board of Film Censors had already given it a certificate that allowed it to be shown to children. (So much for the Board "protecting the Cinema from local authority interference".)

Although the BBFC's certificates are often disregarded by local councils when the Board passes a film and the council wants to ban it, as in the above case; the majority of councillors are willing to accept the BBFC's opinions without question when the Board simply refuse to give a film any certificate at all.

Normally, when the Board does not give a film a certificate, the film's distributors shelve the picture and it simply doesn't make it to general release, regardless of the work and money put into its making. When the Board refused to give any certificate to a film version of James Joyce's *Ulysses*, however, Columbia Pictures took the usual step of applying directly to individual authorities for permission to screen the film in their areas. In the event, 54 councils refused them permission and 27 let it be shown.

At this point one wonders if local councillors and policemen are the best people to judge works of art?

Police raiding the Open Space Theatre Club in London, to seize Andy Warhol's film *Flesh*, admitted to some startled customers that they didn't even know who Warhol was. Similarly, in the case of *Ulysses*, Councillor Beardsworth of Blackburn admitted that he hadn't read Joyce, *or* viewed the film, but he'd heard it was "so obscene" that the film was banned in his area anyway. Alderman Michael Pettitt of Southampton proved to be rather more well-read, having brought a copy of *Ulysses* 30 years earlier. "I believe that without the obscenity and blasphemy, a film version of *Ulysses* would not be worth seeing" he said. No help. Without even viewing the film, he and his council banned it.

This power of film censorship in the hands of local authorities is clearly not only unlikely to be of benefit to the flagging British Film Industry – it is also legally dubious.

In a flagrant abuse of the spirit of the law, local councillors and the courts have connived to re-interpret The Cinema Acts to give councils more power over what people can – and more importantly cannot – see in a cinema.

The Cinema Acts were passed only to ensure that cinema *buildings* were safe places for audiences, giving councils the right to inspect and licence cinemas on the grounds of public safety. However, by interpreting the Acts in a way which even the Home Office admits Parliament never intended, the courts have been able to uphold in law the validity of the censoring powers which local council despots have usurped unto themselves, through an imaginative interpretation of the law. Now it is unquestioned universal practice for local authorities, when issuing licences to cinemas, to impose their *own conditions* with regard to the films screened at cinemas in their area, rather than just licensing the buildings in which the films are shown.

This means, in effect, that if a handful of local councillors disagree with the content of a film they can stop it being shown to the public. In Brighton, for example, the newly-elected Labour Council banned the already heavily-cut film *9½ Weeks* in 1986 as the female 'feminist' Mayor and two of her colleagues found the film (unspecifically) "offensive to women." The adult population of Brighton (both male and female) were therefore denied the right to decide for themselves, nor able to watch a movie seen by people all over the rest of the country. Public opinion weighed heavily against the council's action but, as usual, the wishes of the public were ignored by the politicised minority.

Indeed, the bible-thumping, loud mouthed minority of would-be censors on the political Right often form an unholy alliance with the equally vociferous, breast-beating minority on the Left when the thorny question of censorship arises. Besides both sets of people being earth-shatteringly boring, they have something else in common. They both presume that their view is 'right' – so sure, and so opinionated are they, in fact, that they have the arrogance to take things a step further by insisting

that everybody with differing opinions must be wrong. This self-appointed state of grace allows them to use their powers in any way they see fit, regardless of any now-redundant assumptions of democracy. In Ken Livingstone's words, when speaking to support his Militant colleague Clare Short's motion to ban 'Page 3' photos from the tabloid press – *"People must be moulded to think properly."* (Moulded by Ken, in his own image, in other words).

The question of censorship is oil for the cogs of Social Engineering. In the search for any despot's version of Utopia, where uniform people think harmoniously, censorship of all that is 'nasty' and 'naughty' and 'subversive' and different is an essential part of the blueprint. Media types like Livingstone and Whitehouse live in the public eye solely because they realise the power of the news media, realise that as a society our perception of reality comes only through the edited, stylised 'reality' presented to us by the media, and purely because as politicised people they are interested in 'moulding' how other people think. So that, one day, we may all live happily ever after in their antiseptic heaven. This is all very well, if you conveniently forget the concept of freedom of choice and the right of each human to decide for himself. Censors are not interested in writing or reading books themselves, they are interested only in what other people write and read. On top of that, they are also able to magically predict what effect a person's reading matter will have upon that person. (Yes, they are remarkable people.)

The news media is vital in the arsenal of the censors. The media needs sages, prophets of doom and monstrous figures who will fulfil such prophecies. The media needs news. Any newsworthy item is seized upon and wrung dry. So, figures like Michael Ryan for example, who shot up Hungerford one dark afternoon, are godsends to the vultures in the media. Follow-up interviews with shocked members of the public and outraged politicians create a counterfeitist call for "something to be done" across the nation, and a totally media-invented panic gains momentum in the Press and on TV. Pressure is put to bear on hapless politicians who can only save their popularity by doing "something" – almost anything – to appease the hyped-up Leader Writers of Fleet Street. So, in the case of the appalling Mr Ryan, instead of looking upon the incident as an isolated event in which a man who owned guns went stark raving mad, the government introduced a set of new laws which affected every sane, law abiding citizen who owned a gun, and also affected every sane law-abiding citizen who did not. It's important to realise that the changes in the law did *nothing* to prevent a repeat of the Ryan incident, but merely did something to appease the media, which was the object of the exercise. The government also promised to do "something" about the adventure-game computer programmes and survivalist magazines to which the pathetic Ryan

subscribed. In the Britain of the 1980s the rights of well-balanced people count for little. The wishes of the true majority count for nought. We must all be treated as potential sickos and children, so our TV and Cinema and magazines must aim to be as bland and yellow and innocuous as possible.

Nowadays, it is not only the individual's personal viewing and reading habits which are interfered with. The whole question of Free Speech must now be viewed within a context of harassment and general intimidation.

Madeline Haigh, a housewife living in Sutton Coldfield, wrote to her local paper in 1985 airing her views about British and American nuclear weapons. A few days later she was visited and questioned by officers of the Special Branch. This, and other similar incidents which occasionally come to light, have been officially acknowledged as being true. But as others have pointed out – how many other such cases go by without a mention?

Even before his national notoriety, journalist Duncan Campbell's home was raided and searched by the police. Nothing unusual about that, perhaps. But, at the time of the raid, Campbell was being treated in hospital after a road accident. The police knew about this when they applied for a warrant to search his home, and that his hospitalisation would ensure that the troublesome citizen was not around while his private files were being gone through. An uncanny coincidence indeed.

Friends of the Earth and Greenpeace are among the non-violent, essentially apolitical citizen's organisations that have had their offices raided and searched without any charges being brought against them. (Under the Telecommunications Bill of 1984, police and other government agencies were given the right to tap the telephones of people who had not been convicted of any crime. In 1987, some 33,000 telephones were officially tapped).

To some, it seems that the only right to free speech that really exists in this country is the right to freely express support for the established political parties, churches, and traditional institutions. The only criticism that is allowed is mild cynicism exposed in the areas of entertainment, or criticism of one political party – providing it is supporting the (similar) ideology of another major party. Protest against the Police, the Political system, the Church and the State is quite definitely taboo.

EDUCATION
If a country claims to be Free and Just, the main foundation of its Freedom and Justice must lie in the education which it provides and allows for its citizens. Without a basic education, the individual is not only denied facts which may be pertinent to his decision-making, but he is automatically placed in a subordinate position in relation to those who have the facts at their disposal. When this situation arises, the individual is inclined to take advice unquestioningly. Depending on the motives of the people supplying him with information, his decisions

can be influenced by means of editing what information he is given – omitting facts which may detract from the dominant argument and giving misleading projections about the results of the individual's decision. It therefore follows that in any society which claims to have a failsafe system of democracy, an unbiased and wide-ranging education is essential. So too is the creation of an atmosphere which encourages the individual to think independently.

When it wants to be, the basic State educational system in Britain can be very effective. It is a tribute to its effectiveness that, for instance, the overwhelming majority of its graduates accept unquestioningly the historical existence of Jesus Christ – regardless of their level of interest in religious matters – even though verification of this cannot be made by usual historical methods. (Some form of Religious Instruction is a legal necessity in schools, and in some areas of education and law, no religion other than Christianity is given the same protection and avenue of propagation. This is why, for example, *The Satanic Verses* could not be tried under the laws of blasphemy, which only cover blasphemy against the Christian idea of God.)

However, one simple indictment of the education system's wide-ranging effectiveness may be seen in the area of Religious Education. Although British people do probably leave school believing in Christ, they hear next to nothing about the teachings of Buddha, Mohammed, or the subject of comparative religions. This may be a crass example, but it is just this sort of one-sidedness, the *selection of information* made available to the individual, which is at the heart of the debate about Freedom. All too often, education in Britain compares uncomfortably with straightforward conditioning.

The narrowness of education is not limited to religious matters or to the schooling of impressionable young children. Unless any college's curriculum toes the predominant line, it is open to interference of all kinds.

When, in 1969, the Open University was founded, its stated aims of providing a good non-traditional form of education for all adults whom the traditional educational system had 'missed out' was praised by all political parties. It is now the largest university in the world. In a free society, an overriding and long-established principle has been that the syllabus and methods involved in educating students should be left to the educationalists, free from interference from the State.

In June 1984, however, the Open University received a communication from the Department of Education 'advising' that its Social Science course texts be revised so as to change their political content. The OU faculty was also informed that the Minister of Education, appointed by Margaret Thatcher, was "taking a personal interest in the matter". At this point, it should be remembered that the Open University relies for the vast majority of its income from the Government of the day. Its bursary

is decided by the Minister of Education.

Such instances are not as isolated as they seem. It has long been the case that political parties in control of central and local government funding of schools and colleges in this country have sought to influence the presentation and content of subjects taught to young people through the unfair application of such pressures.

It is not only political parties and right-wing extremists who monopolise the right to interfere, though. Despite an increase in cases of child molestation in the capital, when the Inner London Education Authority made a video warning children about sex attackers in January '87, the Inner London Teachers' Association refused to show it to pupils "because the police were involved in the making of the video". So the way in which vital information was presented to pupils was interfered with on the grounds that it was not the Association's policy to work with the police, for political reasons, by a group of people who, as Educationalists, would claim to put the educational needs and safety of their pupils above anything else.

Besides such cases of interference, it is notable that over the last few years the State Education system has been starved of funds for necessary equipment etc., the government of the day having chosen to question the high priority given to education, preferring, it seems, to create a semi-literate, generally ill-educated pool of easily influenced, easily pleased people – a practice that must be at odds with the concept of democracy. The rights of individuals to gain education in a free society have also been brought into question by the State and by people in positions of political influence. Both the following quotes came in 1986 and are taken as examples from many which are in a similar vein on the subject. The first is from a non-aligned civil servant in the Department of Education, the second from former Vice Chairman of the Conservative Party, Jeffrey Archer (a man who definitely does not give money to prostitutes).

"We are in a period of considerable social change. There may be unrest, but we can cope with the Toxteths. But if we have a highly educated and idle population, we may anticipate more serious conflict. PEOPLE MUST BE EDUCATED ONCE MORE TO KNOW THEIR PLACE."

"The problem is that, nowadays, people think they have a RIGHT to education."

Conspiracy theories aside, the State, it seems, is engaged in a longterm exercise in social engineering, so as to produce, through its (non-)education system, a new 'proletariat' lacking in adequate education (and therefore choice) who will accept the prospect of such things as continual unemployment and the increasing lack of individual liberty without serious or co-ordinated revolt. (Under the present Tory regime we spend less of our GNP on Education than any other EC country.) At the same time, as the effectiveness and resources of the State Education system decline, tax concessions and other benefits

have been extended to those seeking private education. The vast majority of MPs, peers, top civil servants and members of the British Institute of Management, as well as most senior ranks in the armed forces, attended private schools. The next generation, it seems, is being set into the same polarised mould, with even greater gaps between the education of those taking over the effective running of the State, and those who are at the other end of the economic scale. The resulting Society this type of policy creates will inevitably be even more divided, in educational and economic terms, than it is at present.

As Information is the key to the Freedom of Choice, the control of Education is a vital area to dominate, as is the control of the media. If one carefully controls both areas, one has all but won the battle for control of the people's minds. Interesting then to note that no other Government since the War has interfered so frequently in the areas of Education (see the Education Reform Acts etc.) and the Media (see the numerous new rules governing TV and video).

The only area you now need to concentrate upon is the overtly Political one. If you control Education and the Media properly, all you have to do now is ensure that all opposing political parties appear incompetent and corrupt, if you are to stay in power.

INFORMATION, SURVEILLANCE, DECEPTION
It is generally believed that one of the common criteria of all free countries is the right for each individual to be free to engage in any legal political activity they wish, free from harassment and interference from the State.

The Campaign for Nuclear Disarmament is a peaceful, non-aligned movement founded in 1956. At its height, its membership numbered over 100,000 and its general views are supported by more than a third of the population (given the results of various opinion polls). Its supporters include Bishops, Lords, MPs of most major parties, and former Government Ministers. Despite its legality and general credibility, it is one of many institutions that is under close scrutiny from the Government, and a target for interference from its agents.

In 1985, Sir Ronald Dearing, Chairman of the Post Office, revealed that he had established that CND correspondence had been "substantially tampered with". When challenged with this information, the Home Secretary replied that he would "neither confirm or deny the existence of authorised interceptions". He went on to say that he had no reason to believe any *unauthorised* interceptions were being made on letters to CND members and to the campaign's offices. As the interceptions had been established – by of all people the Chairman of the Post Office – one is therefore left with no choice but to come to the conclusion that CND mail is *officially* tampered with. Besides this, it has also been reported that the CND office telephone lines were tapped. (As these reports came through, bugs were

found in the offices of the Communist Party of Great Britain, adding credence to the phone tapping claims of CND.)

The Independent Enquiry into the policing implications of the Miners' Strike of 1985 found that there was strong evidence to suggest that the telephones of many miners were tapped during the dispute. The Chairman of the inquiry, Professor Peter Wallington, called on the Home Secretary to "make a clear statement" on the extent of the phone tapping of NUM members, but his requests have been ignored by the government.

In 1986, further evidence of such shady goings-on came from an unlikely source. Ex-MI5 agent Peter Wright tried to publish a book – *Spycatcher* – about his experiences while working for Her Majesty's government. Even though Mrs Thatcher said in the House of Commons that Wright's claims that he burgled and bugged his way around London illegally were "fiction", the book was banned in Britain. The public were quite simply denied the opportunity to read the book, which was freely available in other countries at the time. (Rather strange that the government should invest so much time and money in banning a work of pure fantasy.)

As MPs' demands for an enquiry into Wright's claims were turned down by the government, the British media – by now fed up with the story – contented themselves with poking fun at the Americans' painstakingly public enquiry into the Irangate affair. The sense of irony was acute. If Irangate had happened here, the British legal and constitutional system would not even be able to accommodate such a mammoth investigation, even if such a scandal were ever admitted by the politicians and civil servants involved. (Can any British citizen imagine Thatcher, the Home Secretary, the Head of MI5 and senior civil servants from the Ministry of Defence being grilled by MPs and judges on live TV for several weeks? Sadly, I for one cannot.)

Between 1985 and 1987 another ex-secret service officer, Cathy Massiter, gave MPs a series of highly detailed accounts of how MI5 operatives deliberately misinterpreted Home Office rules on gaining interception warrants, so that they could legally tap the phones of private citizens. Of the accounts she gave, the Home Secretary told the Commons that "this does not and cannot happen". Massiter, who worked for the Security services for many years, insists that it does. She cites numerous examples of the bugging and phone tapping of people who were neither criminal, nor suspected of being involved in espionage – though the Government refuses "to confirm or deny" any of the cases involved.

Massiter says that a typical way in which the government and MI5 operate in obtaining information on potential *political* adversaries is the way in which MI5 provided information on individual CND members to a propaganda unit – DS19 – which had been created by Michael Heseltine when he was Minister of Defence. It is not surprising to find out

that this operation was set up just before the 1983 General Election, when nuclear disarmament was a key issue in the Labour Party manifesto.

So Tory politicians use the British Secret Service not only to combat terrorists and spies, but also to obtain information on their innocent political adversaries in the hope of discrediting them before the electorate and pre-empting their political plans.

Again, the comparisons between Thatcher's smug claims of 'freedom' in Britain and the reality of life in the USA are embarrassing. Watergate brought down an entire government. Massiter's well-documented claims here have hardly made a ripple. Indeed, few people would even know who Massiter is.

Even when faced with such indictable evidence, however, public hysteria and prejudices can be whipped up so that any infringements of people's right to privacy are acceptable. Speaking in the House of Commons in March '85, after the Post Office-CND revelations, Conservative MP Robert Audley said that as people involved with CND must share a worldview "indistinguishable" from that held in the Kremlin, "they should expect such treatment". His statement was greeted with approval from the Government benches.

In many other countries, such an attitude is not tolerated. It is indicative of the British situation to note how our government is treated in Europe. In May 1984, for example, when the Government was questioned by the opposition on the subject, Lord Elton was forced to say that – at that moment alone – the European Court of Human Rights had before it 30 applications relating to the interference of correspondence within the U.K. against the British Government. By far the highest number of complaints against any EEC member, even though very few cases are ever taken out against the government by individuals having their mail tampered with, meaning that even this figure represents only a fraction of the mail involved.

Personal information of all kinds can be pried into by the Government – even the most confidential medical information. Mere patients are actually prevented from gaining full access to their own medical records. These records are not the property of the patient, nor even the property of the patient's doctor. They belong to the local Health Authority. Without the knowledge of the patient, or his doctor, the police have access to the personal data recorded on the patient's file via the Health Authority.

In a situation such as this, it is perhaps not surprising that many people fear consulting fully with their GP, and may suffer physically and mentally as a result. A person may be worried about having VD for example, but not go for testing or treatment because he is afraid that his confidentiality may be breached.

In these days when the question of compulsory AIDS screening is a subject of serious debate, as too is the incarceration of AIDS victims and carriers (HIV positive prostitutes are already being held against their will by the Social Services in some hospitals), it is perhaps worrying – when police can refer to patients' records at will – when powerful policemen display their true attitudes towards people who don't conform to their own narrow personal set of beliefs.

In December 1986, James Anderton, Chief Constable of Greater Manchester, said, *"People with AIDS are swirling around in a cesspool of their own making"*. Anderton, a devout Christian and lay preacher, is the same policeman who set up armed police patrols in Manchester city centre, and was also accused by other police officers of bugging their phones. This writer can find no quotes from Anderton on the subject of Human Rights. Perhaps he should study the works of J. Christ more carefully – or at least listen harder when he speaks to him on his intercom. *"Judge not and you shall not be judged; condemn not and you shall not be condemned; forgive and you shall be forgiven."*

Anyone who raises their eyes above street level in London will find police video surveillance cameras in numerous positions above the capital – there are six in Trafalgar Square alone. Police helicopters and 'hoolivans' are now a common sight in most large cities. Any patrolling officer can radio base and find the identity and records of any member of the public within seconds. Official phone taps are increasing, as is the use of all manner of computerised information-gathering technology. Individual officers add to police data by getting information from the Inland Revenue, Social Security offices, Customs & Excise, Education and Health Authorities, even banks and other private institutions.

With a few real safeguards, this information can be passed on to private security firms, employment officers, foreign governments and police forces – even though much of the information cannot be checked and may be incorrect, and a lot of it is based on unsubstantiated hearsay from informants and officers. In the estimation of one former Chief Constable – John Alderson (not to be confused with James Anderton) over a third of the information held by the police alone is totally useless in the pursuit of law breakers. In a variety of ways, police build up information on members of the public who have no convictions.

Since May 1984, beat policemen have been encouraged to add to this mass of information on non-convicted members of the public by completing very brief green 'Intelligence Debriefing Reports', listing car and telephone numbers, names and addresses of suspects and potential trouble makers, etc. etc. and filing these at their station for other officers to refer to. Police patrols regularly note the registration numbers of cars seen parked outside such innocuous events as charity village fetes in aid of CND, or in the car parks of certain pubs used by known criminals and nightclubs frequented by gays. Serious allegations have been made, aired on Channel 4 TV, saying that some police officers have actually staged burglaries into new offices and the

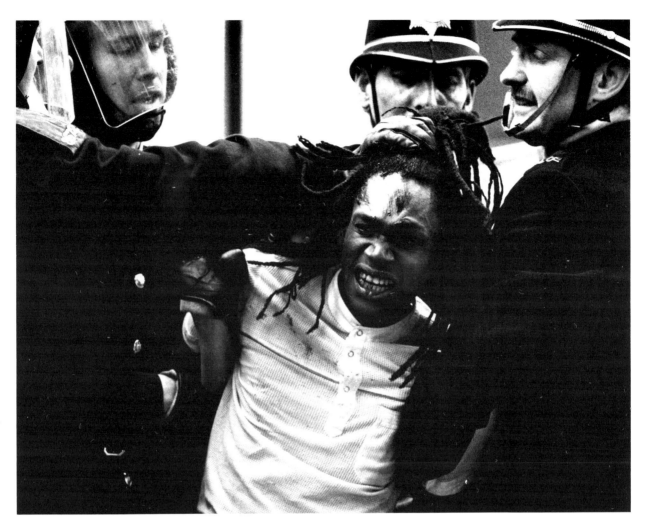

homes of newcomers to an area, as a cover for a clandestine search of the property to see what business is done there. The reported 'burglaries' are then investigated in the normal way, involving an official police visit with questions being asked and fingerprints being taken. Even in legitimate enquiries, such as murder investigations, thousands of innocent people may be interviewed and information stored on them relating to their work, their lifestyles, their friends etc. Even when the specific inquiry is resolved, this information can be kept by the police in perpetuity.

The enormous amount of trivial information, held in the form of brief notes on computer and likely to be ambiguous, though often inferring that individuals are in some way criminally minded or subversive, can then be passed on through the information system. Years later, a foreign police force, for example, could request information on a citizen, leading to a false impression being created based on the ambiguous info received.

If you happen to be stopped by the police three times within a month – even if you are guilty of no crime – some constabularies automatically put you on file as being a 'suspected person'. Meaning you are "someone who is actively engaged in crime but who has not been convicted of any offence". No

matter how innocent or law-abiding you are, this information will no doubt affect the way you are treated by the police in future.

Driving away from Plymouth in May 1983, Mrs B. – who was eight months pregnant – was stopped by the police because her car registration number was routinely checked through the computer which revealed that the car was connected with an address at which there had been a drugs raid in 1981. Taken to the police station, she was stripped, searched, and held for four hours on 'suspicion'. True, police *had* raided her home two years before – but only because they went to the wrong address. In other words, incorrect and misleading information had been held on computer for 2 years.

In September 1984 Dr Brian Richards was arrested by police in Los Angeles on the basis of information which they had been sent by Scotland Yard (information which had been stored on the 'C' Computer at Hendon, which alone holds information on over two million people). The information supplied to the L.A.P.D. was misleading and later proved to be incorrect. When asked about this particular incident, the under-Secretary of State admitted that the information was wrong and that the Met. were wrong to have supplied it. However, he added, the problem was that the information was

"now in the possession of the U.S. authorities, and, regretfully, cannot be withdrawn". Tough luck, Doctor.

The cogent fact is that data, however irresponsibly gathered, can be held against an individual for life if stringent rules are not applied. Even in a 'free' society such as ours, citizens have little control over the information held on them, how it is used, or to whom it is disseminated.

The case of Dr Richards and the case of 'Mrs B.' (when the National Council for Civil Liberties reported her case she asked for her name to be kept secret) are not isolated ones. It recently came to light that MI5 vetted all the journalists applying for jobs at the BBC, and have done so secretly for years. The only reason this fact came out was because of the case of Isabel Hilton. In 1976, Ms Hilton applied for a television job with the Corporation. The BBC Board unanimously chose her from the many candidates for the post, but they were informed by MI5 that she was a "security risk", as she was Secretary of an academic cultural group called the Scotland/China Association, which the 'Intelligence' Services wrongly thought was a 'subversive' organisation. So she couldn't have the job.

The position went to someone else, despite the wishes of Ms Hilton and the BBC Under British law,

Ms Hilton has *no right* to challenge the accuracy of the information passed on to prospective employers about her. Determined to clear her name and highlight the unjust system that operates in Britain, with great determination she took the case to the European Court. (It was one of three cases regarding British Intelligence services heard by the court in February 1987 alone.) Though hundreds of similar cases here have come to light, one can only speculate on how many thousands of other cases have not.

Public accountability is not a high priority in Britain, whether it be about the use of personal information regarding a private citizen, or the release of information that is in the public interest.

Under the Public Records Act, records of the Cabinet and central government departments are placed in the PR office where they must be made available to the public... but only after a period of *thirty years* has elapsed, and even then only at the discretion of the Lord Chancellor of the time. Even this necessity can be avoided if "sensitive" information is involved. In all government departments, a constant process of sieving is going on so as to reduce the enormous amount of paper stored. During this process, the vast bulk of governmental records are destroyed. Of course, most

of these records are of no interest to anyone, but historians and journalists have made accusations of government departments conveniently destroying records that may be embarrassing to them in later years. (Incidentally, records of criminal proceedings brought by the government are made available to the public not after 30, but only after 100 years.)

Such injustices flourish almost unnoticed because this government is a master in the art of public relations, and a genius at wrapping restrictive new laws and practices in an appealing package. For example, the public is told that the system of collecting local council rates is "unfair", so the government, deeply concerned with fairness and justice, will help everybody by radically changing the system. The Poll Tax is introduced. No longer are rates to be paid by the householder and determined purely by the size and value of the building and the wealth of the person. Now everybody is to pay. Conveniently, this means that every person in the land must declare where they are living, who they are living with, how much time they spend at an address etc. etc. An ongoing census is introduced, albeit by the back door.

The information on the new tax register is collected by thousands of Registration Officers, who have the power to investigate any household in the country. The information which they seek must be given by every citizen (if you refuse to co-operate you can be sent to prison). The extensive personal data collected will *not* be safeguarded by the law. More worryingly, behind the Register itself is what is called a Second File, recording the notes, anecdotes and suspicions of the local authority officers about individuals made in order to assist them in catching evaders. A citizen is not allowed to see his or her entry on the Second File, as the Local Authority can deny access on the grounds that the file is related to the collection of a tax. Any information collected by the local council can be passed on to other governmental departments on request. The government have said that to build up information on individuals living in a house, it may be possible to cross reference Tax Register files with records kept by estate agents, insurance companies, local libraries, housing departments, bus companies (season ticket lists), landlords, trade associations, British Telecom, the local Electricity and British Gas Boards, the local press, education bodies, health authorities etc. etc. The new Tax Register will also include an individual's National Insurance Number – which is interesting when one considers what is happening to people's National Insurance Cards.

The old cards (which every person over 16 has) are suddenly no longer any good, so a new type of card is introduced. Gone is the scruffy, ordinary looking piece of cardboard (which can be read by the card holder), to be replaced by a shiny new plastic card, which just happens to have a mysterious magnetic strip on the back of it (which cannot be read by the card holder).

In June 1988, Metropolitan Police Commissioner Sir Peter Imbert forecast that Identity Cards would be carried by all British adults by the mid 1990s – embarrassed Government Ministers denied all knowledge of the plan.

By November of '88, however, Douglas Hurd announced the introduction of a 'voluntary' national ID Card scheme to be phased in over the next few years. One wonders what the police would say to people they stop who have not chosen to co-operate with this scheme (got something to hide 'ave we?) Of course, after the voluntary 'run-in' period an excuse will be found to make the cards compulsory. This happened when Sports Minister Colin Monyhan announced that due to the success of a voluntary card scheme at Luton Town Football Club (the scheme was not voluntary with fans nor was it successful) all seven million people who attended football matches would be required by law to register for, buy and carry such a card to all matches – regardless of their previous behaviour. Something which the clubs, the fans, the Police Federation and many local Councils opposed. Despite this, and the public safety problems that will arise when 50,000 people turn up at a stadium ten minutes before kick-off, Thatcher liked the idea. So, the idea was that unless you have a card you cannot watch our national sport. Freedom – loving England was the only country in the world to consider adopting such a scheme.

In response to growing public concern over the gathering, storage and use of personal information, the Government – as keen as ever to win votes – passed the Data Protection Act in 1984 amid a blaze of positive publicity. (In fact the law had been forced on the British Government by the European Government.) Everybody is happy as superficially, the Act, which came into force in November 1987, purports to give private citizens sweeping new rights of access to all material held on them. On closer inspection, one finds that any information held on computer which is deemed to relate in any way to the safeguard of "national security" (as defined by officials at the time) is exempted. So too is any information held on manual (paper) systems of storage. Also, although the publicity surrounding the Act claimed that it outlawed the secret transfer of information from one agency to another, there are in fact several exemptions in the small print. For example, any government department, local authority, bank, employer or any other body can release any information in secret to the Police, Customs, and Tax officials in the interests of "preventing crime". (Note the word "prevention", which means the Police and others can still gain secret access to any records even if no crime has been committed.) In everyday reality, the Act only means that citizens can pay to see what information is held on them in the computers of mailorder and credit card companies and their ilk. The law does *not* mean that individuals can see, and perhaps challenge, files held on them by several government departments, which are still withheld, regardless of

how inaccurate or misleading they may be.

Besides the shortage of rights a British subject has relating to personal information, Britain also gives few opportunities for the electorate to find out exactly what is being done in the name of the country by the Government in control. The much-abused '30 Year Rule' is just one example of how this situation is tolerated with little or no criticism.

The outmoded and unfair Official Secrets Act (particularly Section 2), has, however, been criticised by many politicians, judges and private individuals over the last few years, though it remains defiantly on the statute book and has been used by successive governments. It is not only seen as being morally correct for a government to have secrets from the citizens who elect it into power to serve them, but it is also apparently acceptable for this wide-ranging Act to be used to cover up a variety of truths that cannot conceivably affect the nation's security.

In 1979 an attempt was made to reform the Act by introducing a fairer 'Protection of Information Bill', but this failed to get through Parliament. In 1988, backbencher Richard Shepherd introduced a 'Protection of Official Information Bill', which proposed to effectively replace Section 2 with a better code. The Government used their majority to defeat the Bill.

The ubiquitous Official Secrets Act gags over 2,500,000 British citizens, forbidding them from talking in any way about any aspect of their work. It also makes it an offence to *receive* any such information. So, for example, if you read the first copy of the now-defunct left wing tabloid the *News On Sunday* in July '87 which contained a list of innocuous 'official secrets', *you* broke the law.

So did a postman who wrote to his local paper saying that the post office was undermanned. He was threatened with prosecution under the Act. So was a journalist who published nothing more important than the dress regulations of the Police Force. Although such examples did not make it to court, the *threat* of imprisonment remains hanging over almost all of us, whether we have signed the Act or not.

In a blatant P.R. move in November '88 the Government published its own proposed changes to the Act. Despite some good publicity, the small print of the 'reformed' law shows it to be every bit as unjust and open to abuse as the previous Act.

Regardless of one's opinion about war, few people would expect any government to divulge such things as troop movements to the press during hostilities, as this would inevitably cost lives. It is generally believed that it is clear-cut cases such as this which make the Act necessary. However, not many people outside of the government would agree that it would be justifiable for that government to invoke the Act in order to cover up military movements retrospectively, particularly when several years had passed since conflict ceased. To reveal the whereabouts of military units after the event could have no effect on the outcome of the war.

Yet governments ignore the concept of accountability and invoke the spectre of 'National Security' whenever it suits them to do so. And in Britain, there is *nothing* anybody can do to stop them.

Ignoring the political fact that, as Head of National Security, the Prime Minister of the day is accountable for getting us into any war, and that as Head of the Intelligence Services, she was also responsible for ignoring information received two months ahead of the Argentine invasion of the Falklands in 1982 – for which she has not been brought to account – as leader of the War Cabinet at the time, she has also never explained several military decisions which were taken during the course of the conflict. Everyone knows about the repugnant Belgrano and Clive Ponting affairs, and the way in which Sarah Tisdall was imprisoned for six months for leaking politically embarrassing information to the *Guardian* but other, perhaps more important matters just do not seem to have been spotlighted by the press and remain unanswered by the government.

It has long been the boast of the British Foreign Office that we, the third country to develop and arm ourselves with nuclear weapons, were the first country to promise never to threaten a non-nuclear power. It is in this context that we should look at the mystery of the Falklands submarines.

Why were three nuclear-powered Fleet submarines (HMS Conqueror, HMS Spartan and HMS Splendid) kept in the Falklands war zone for so long that they came close to running out of food? Why were they not relieved by other nuclear-powered submarines in their class which were not otherwise engaged in their normal NATO duties at the time? At the time, the Royal Navy had 32 submarines, twelve of which were of this nuclear-powered 'Fleet' type. According to a variety of reputable sources, six of these Fleet Submarines were free at the time of the Falklands crisis (those 3 already mentioned, plus HMS Warspite, HMS Superb and HMS Courageous), but these three 'spare' subs did not relieve their starving sister ships in the war zone because they were in fact being used secretly to escort one of Britain's four SSBNs (otherwise known as Polaris submarines) in the South Atlantic between the military base at Ascension Island and the Falklands.

Given Britain's long standing promise to the world about the limited use of its nuclear weapons, what was such a powerful unit of Britain's 'nuclear deterrent' doing *sailing out of range of the Soviet Union,* but within range of the non-nuclear capable Argentine mainland? Who was it 'deterring'? Labour MP Tam Dalyell has been asking such questions for several years, but not only has he never received any satisfactory answers from the Government, he has been pictured as something of a crank by the media for being interested in the answers.

It has also been reported that several frigates and two carriers leaving the largest naval base in Europe, Devonport Dockyard in Plymouth, and others sailing from the naval bases at Portsmouth, Rosyth and

Chatham, were armed with fully charged nuclear weapons on board. Asked about these reports in the House of Commons after the war, Margaret Thatcher refused to answer any such questions "in the interests of national security".

The same excuse was rolled out for the actions that sprang from the Zircon affair in early 1987.

In 1983, the government was approached by the signals intelligence branch – GCHQ at Cheltenham – with technical plans for the Zircon spy satellite. Only the USA and USSR have spy satellites. Their development and deployment is costly and technically difficult and, like nuclear weapons systems, they are a defence acquirement that gives a nation a childish prestige in a field not shared by anyone else. Not surprisingly in Thatcher's Britain, the plans were approved in June '83 and, unbeknown to the taxpayer and despite a climate of cut-backs in the social services and even in conventional defence, a budget of £700,000,000 was earmarked for the project.

At this point it should be remembered that even if the Soviet Union did not know of the plans (which is doubtful given the history of MI5 and GCHQ) it would have been able to detect the new satellite from the moment it was launched.

Duncan Campbell, a freelance investigative journalist working on a BBC TV series, discovered details of the project and started filming a documentary about it in 1986, for transmission in November of that year. The government stepped in, however, and had secret talks with BBC governors instructing them not to air the programme, which was obligingly shelved. In January '87 Campbell, somewhat disappointed, wrote an article in the *New Statesman* magazine which talked in general terms about the satellite and concerned itself primarily with the way in which Parliament had supposedly been duped by the government over the £700m Zircon budget.

The magazine's offices were promptly raided by the police. Special Branch officers also raided Campbell's home (twice) in January and seized documents. A few days later, detectives raided the BBC's Broadcasting House in Glasgow at night, and confiscated the master tapes of the Zircon programme and those of all the other programmes in the projected series. In a supposedly unconnected incident a few days later, Sir Alistair Milne, Director General of the BBC, resigned. He had already been under pressure to do so from Norman Tebbit, then Chairman of the Conservative Party, for supposed political bias against the Tories.

In free Britain, then, police swept into the private home of a well known journalist, the offices of a widely-read magazine and, under cover of darkness, the studios of our country's National TV station, broke down doors (Campbell's), and took away material that was destined for public consumption. Labour MP Gerald Kaufman compared the actions with those being carried out in South Africa and East Germany. The government denied all responsibility for the raids, saying that the police had "acted without instructions from Whitehall"!

Some found it hard to believe that the chain of command, from Chief Constable, to Home Secretary to Prime Minister, was broken in a case of such national importance.

Of the 15 member nations of N.A.T.O., only two governments refuse to publicise or debate their emergency civil defence plans for times of war. It will be no surprise to learn that one of these two countries is Britain.

Since 1979, Home Defence arrangements in Britain have been completely revised, and government powers over the internment of citizens, setting up of new courts, conscription of civilians to work parties, reinstatement of the death penalty, commandeerment of private transport and buildings, plans to block road and rail routes out of major cities and so on have been extended far beyond the emergency powers which operated in Britain during World War II.

Secret Bills are now known to have been drawn up since the Thatcher government signed the 1983 Joint Logistics Plan, an unpublicised agreement with the Americans which led to these secret Bills being devised. The elected government of this country have denied even the existence of these mysterious Bills and refuse to debate their contents openly in Parliament, but it is now accepted that they do exist.

It may perhaps be necessary for governments to have emergency powers in case of the outbreak of war, and also to keep certain military plans secret from potential enemies, but why is Britain almost unique in making these plans for the *civilian* population totally secret and undebatable by MPs and the British people? The answer seems obvious. If real information about government plans in the event of war were known, serious, *informed* debate would take place resulting in public pressure on the government to change these plans and, probably, added pressure would also be brought to close down British and American nuclear bases throughout Airstrip One.

Unlike the Germans, Dutch, Italians and almost everyone else, the British people and their elected representatives are flatly *refused the right* to find out what they may be letting themselves in for.

Nobody can change this situation. Politicians learn from the experience of Tam Dayell that their questions are either not answered truthfully – or not answered at all. Civil Servants have seen Clive Ponting charged for speaking the truth, and journalists must heed the message sent out by the Zircon affair. Don't investigate the government, don't listen to the truth, don't publicise the facts.

So the censorship of reality goes on and on. It is a way of life. There are, of course, numerous examples of censorship of material which cannot remotely affect National Security.

In November '87 the American Alza Corporation, marketing a new IUD contraceptive, wished to supply patients with an 8 page booklet explaining the

possible longterm effects of using IUDs and giving women instructions on their correct use. The British Health Department banned the booklet (which was distributed freely in all the other countries taking the contraceptive) saying it was *"inappropriate for use in the U.K."* Social Audit, a consumer research group on pharmaceuticals, said that the British decision *"reflected the British Government's tight-fistedness with information".* The DHSS said that it would not comment on this, or any other of its decisions, which are confidential. The leaflet, and the product, were withdrawn by Alza, who refused to supply women with IUDs without informing them of the possible health risks involved. This is by no means an isolated example of the peculiar secrecy adopted by the British Government in order to maximise its power and limit public awareness.

The government gets detailed reports on defects of all models of car, but will not reveal the findings to the general public; the government's Department of Health tests the relative toxicity of all brands of cigarettes, but won't tell of the results; the government has lists of areas in Britain that are hazard sites, liable to be unfit for human habitation due to "fall out" of dangerous chemicals if accidents occur at local factories and stores – the information is classified. And so on. In 1984 a Social Security ruling which allows young people studying part time to claim benefits during their first three months of study was not publicised, nor even did the DHSS inform any Social Security office of the ruling, until news of the situation was leaked to *The Guardian* newspaper: a report commissioned by the DHSS on healthier eating was suppressed by the government as the Ministry of Agriculture predicted that its recommendations to reduce the consumption of red meat would affect farmers' sales...

The Government not only conceal the truth, they distort it. Since 1979, the methods of calculating and publishing the unemployment figures have been 'altered' more than 27 times. Each 'alteration' has caused an apparent drop in the numbers of unemployed, trying to conceal the true rise from 1 million to nearly 4 million.

ENFORCERS (GUNS, COMPUTERS, ARMOURED CARS – BUT NO BLUE LAMP)

The UK has 125,000 police officers. (The police recently asked for 15,000 more.) There are also a variety of specialist internal security branches, such as MI6, the UDF, Int.Corps, C13, and the Special Branch.

At any time, these civil forces can be supported by the military, who number around 250,000. The army were last called onto the streets of U.K. cities to support the police in 1969. They have also been used in England to break strikes which affect the "national interest", such as the Dockers' Dispute in the 1970s.

The vast majority of law enforcement, of course, is carried out by the police alone. Contrary to a totally hollow piece of rhetoric which people like to repeat, they are an armed force. (If they were not, 5 year old John Shorthouse, who was shot accidentally by police in 1985, would still be alive today. Londoner Steven Waldorf would not have been crippled by a hail of police bullets as he sat innocently in his car at some traffic lights. Fourteen people would not have been killed by police plastic bullets alone since Thatcher took over in 1979.) Of course the police are armed; they probably need to be – but let's not pretend they are not.

The police arsenal *in England and Wales alone* includes more than 30,000 plastic bullets, 2,000 rounds of CS gas, stun grenades, 9mm Heckler & Koch MP5K sub machine guns (which are of German design but clandestinely manufactured in the U.K.), Parker Hale rifles, Smith & Wesson handguns, armoured personnel carriers and assorted other weaponry.

The police make no secret of the fact that they are, primarily, the heavies of the State machinery by requiring recruits to be of a certain physical, rather than intellectual stature. The police are employed to enforce laws created by the government. Laws defined by judges – individuals who have been selected by the Lord Chancellor – in the courts. These are the nuts and bolts of the legal system. The *manner* in which this system operates is dictated by the attitudes of those at the top, in the cabinet. These attitudes are illustrated not only by looking at the spate of new laws which the British people have been subjected to, but also by the priority given to the Police and other law enforcement agencies in terms of spending.

Although NHS waiting lists have increased by 70% since Thatcher assumed power, and there are some 500,000 more homeless people now than there were in 1979 when the Tories were elected, this government has seen fit to increase Law & Order spending by more than 35% in real terms over the last ten years (costing us now around £6,500,000,000 per year). Spending on the police alone has – even after allowing for inflation – increased by more than 50% since 1977. One would assume that such a vast increase would have halted the steady growth in real crime, but nothing could be further from the truth. For example, in this time burglary has increased by 61% and theft has increased by nearly 40%. And since 1979, under the Tory 'Law & Order' Government, notifiable offences increased from 2.3 million annually to 5.5 million, while police clear-up rates fell from 42% to under 35%.

Perhaps the police themselves are not to blame. They didn't use to have to spend their time raiding so many bookshops, cinemas, or TV stations.

The Tory Government has certainly increased the police workload, by inventing new offences through new laws and adjustments to existing ones. Everything seems geared towards giving the law enforcement agencies and the State prosecutors more and more power. More reasons for arrest. More chances of conviction.

The 1986 Public Order Act is one such example. Among other things, it created a whole new offence

called "disorderly conduct" (which covered just about anything) and also gave the police powers to ban peaceful, formerly legal marches and protests, infringing the British public's age-old right to assemble peacefully and hold a march or public demonstration.

The local police can even ban a demonstration if they believe it may simply cause some disruption to the "life of the community" (traffic and shoppers). Unlike in Moscow, where it is now common in the Glasnost era to see demos that have not received the necessary police clearance, if you try to organise a demonstration of any kind in Britain despite police instructions, you can now be imprisoned for three months and fined – regardless of how peaceful the demonstration is. (Even before the new Act came into force the Home Secretary has been able to ban marches, and this potentially undemocratic habit has become more common under this Government than ever before, as State interference in all areas of life has become more acceptable. Between 1970 and 1980, 11 demonstrations were banned, most of them in N. Ireland. In the years 1981 to 1984, 75 demos were banned, all over the country.)

A father in the North of England was arrested under this new Public Order 'offence' when his son's birthday party was thought "too noisy". A street theatre group in Hereford were threatened with arrest under this new law for singing songs about our beloved Prime Minister. Four people were arrested and charged with the offence in London for putting up a satirical poster of Margaret Thatcher in December '87.

The new law also gives police more powers to ban any other type of gathering of 20 people or more. They have already recently banned some pop festivals and football matches. Now, the Public Order Act, in conjunction with the Sporting Events Act 1985, can be used with equally new Trade Union laws to stop almost anyone going anywhere if the police don't like the look of them. For instance, if you are on your way to a sporting event in a private mini bus with two or three friends you can be stopped and searched by police. If you have a can of alcohol with you in the van, you can be arrested. This quite ridiculous law is a typically inept response to the isolated tragedy of the Heysel Stadium disaster and the disproportionate reporting of football-related violence in the gutter press. As usual, the Government disregard personal freedoms and pass a law that will have no effect whatsoever on fighting at football matches.

Both the Alliance and Labour parties vowed to repeal the Public Order Act if they came to power in the '87 election, but so little publicity had been given to the Act anyway that nobody bothered to make it an election issue.

It's undoubtedly true that many ordinary police officers are becoming increasingly resentful of the way in which they are being used by the present government to prop up an ever more totalitarian regime. Unfortunately, in the present climate,

precious few such officers get promoted to the top jobs in the force. Such jobs are reserved for the likes of James Anderton, or less well known officers such as Mike Dixon, President of the Police Super-intendents Association. In September 1987, the Association pressed for jurors to be informed of a defendant's previous police record *before* a trial – the implications of which are obvious to all. In defending their position, Superintendent Dixon said that it was "time civil liberty took a step backwards." Perhaps Mr Dixon should have said "another step backwards", as there are numerous examples of this steady backward shuffle which are already enshrined in Law, or soon to be added to the statute book.

The Criminal Justice Bill is yet another such example. Traditionally, the defence council has been able to challenge and remove up to three jurors prior to the case being heard, without having to give any reason. This is to try and give the defence the benefit of rejecting anyone who they think may not be an unbiased judge of the evidence at hand (for a hypothetical example, if a black person saw some white skinheads take seats on a jury about to try him, he could reject them). The government's new bill proposes to deny people this tried and trusted right of peremptory challenge completely. Meanwhile, in other countries such as the USA, the opposite is the case, as the rights of the defence to reject jurors is increased. Once more, age-old rights of the individual citizen are being reduced, and the chances of the State to convict people of crime are increased, against the worldwide trend.

During the 'Persons Unknown' trial it was revealed that in some cases potential jurors are vetted and – contrary to the British principle that juries should be randomly selected – excluded if they were considered by the Prosecution to be 'unsuitable'. The Secretary General's guidelines on jury rigging say that potential jurors should be checked against local police, Special Branch, and other records (the Special Branch computer alone has more than 1,000,000 people's details stored on it). People can be barred from jury service if the State feels they may have 'extreme political beliefs' and the Special Branch do not consider them 'loyal' citizens. These guidelines have never been approved by Parliament.

Parliament was neatly bypassed (again) when obscure local bylaws were introduced for Molesworth and Greenham Common (coincidentally, both places where a foreign government has dumped its weapons) in 1985. Suddenly, trespass on MoD land in these specific areas became a criminal (rather than a civil) offence. It also became an offence for anyone to attach anything to the perimeter fences of Air Force bases. This includes, of course, the priests and nuns who have regularly attached crosses and crucifixes to the fences over the years. In July '87, the common moorland near RAF Fylingdale became out of bounds to ordinary British people. Now, MoD police can tell any person to leave the moors without giving any reason, and direct them not to return within 12 months. If one

protests at this, one can be charged with a criminal offence. The new 'Controlled Area' is 50% Common Land.

Apart from such changes in the law, the legal system itself is changing its practices within the existing legal framework in order to fit in with the current almost totalitarian atmosphere.

There is, for example, a growing trend for trials to be held behind closed doors. In one sample week in 1987, a published survey of London courts showed that more than 366 hearings were held with both the Press and the Public excluded. In several cases, Contempt orders were also placed on trials so that certain pieces of evidence could not be reported. This secretive style of justice is common practice in the country's major courts today. Decisions which effect the freedom of thousands of people are made behind closed doors, or with reporting restrictions which stop newspapers and TV from releasing pertinent facts. Even more insidious is the fact that more general, far-reaching judgements – which alter and re-interpret areas of the law and therefore affect all of us – are being made without public scrutiny or discussion.

Lord Scarman said a few years ago that *"Justice is done in public so that it can be discussed and criticised in public"*. Now, in this era of almost imperceptible clampdown, the rights of discussion and serious criticism are effectively being denied. All too often, justice is not being seen to be done.

Even in normal 'open' court there is a widespread practice of preventing members of the public from taking notes during a trial. Some instances have been reported of police moving into the public gallery and removing notebooks from onlookers in the court. There is no legal authority for police to restrict people's freedom to take notes in this way, other than on the orders of the judge.

Even journalists reporting on open trials are not always allowed a copy of the transcript of the court proceedings. The procedure is that the journalist must apply to the Attorney General for permission to purchase a copy of the transcript (the fee itself is substantial), and this permission may be refused without reason. Journalists who have been refused trial records include such potential subversives as Ludovic Kennedy.

The courts are given special protection against criticism by the doctrine of contempt of court. Unlike in some other countries, judges are not elected, and cannot be voted out. They cannot, in effect, be controlled or disciplined. Complaints against them are heard by their colleagues and, in practice, usually come to nothing.

What is not generally known about judges is that, when an accused person is brought to trial, his or her past record of convictions is given to the judge. (This explains why the Statue of Justice on top of the Old Bailey is not blindfolded, as she is in other countries.) Some people think that, as the attitude and stature of the judge influences often nervous and easily-led jurors, the accused person's past record

should not be made available to judges in this way before the evidence is even heard.

Although journalists have many complaints about the judicial decisions which deny them reporting rights, they find their rights to appeal blocked by The Supreme Court Act, which prevents reviews of actions of Crown Court judges. This law came into force in 1981. Thanks to this, the only way people have of obtaining a proper legal review of a dubious reporting ban is to break it, and risk prosecution and a prison sentence for contempt of court.

In State-inspired mythology, every person accused of a crime must be convicted on the grounds of hard evidence – not hearsay or accusation – by twelve of his fellow citizens who sit as a jury. Quite right too. A shame that this is just not true.

There are numerous types of case where *no hard evidence, no defence witnesses,* and *no jury* are needed. For instance, if Customs Officers enter and search your premises (they do not need a warrant and are free to take anything they wish) they can forfeit any item unless, within a month, you decide to take them to court to argue your case. No jury can be present at such hearings and the only evidence acceptable is for you to convince the judge that you are not breaking any subjectively interpreted law by having the articles in your house.

There are far more sinister possible injustices than this, however. The law relating to the evidence of informers is exactly the same all over the United Kingdom of England, Wales, Scotland and N. Ireland, or so the Home Secretary once assured Enoch Powell, and offers one such possibility. In all these parts of the country, it is possible for an individual to be accused by the police of a crime and tried without the right to have a jury, solely on the evidence of a police informer. The informer, in most circumstances, is in turn granted immunity from prosecution, or leniency himself if his evidence is sufficient to ensure the desired results. He is thus put in the position in which his 'evidence' must have the maximum effect on the judge. This method of justice has frequently been used, often with startling results.

A judge in Belfast, trying ten men without a jury in May '84, sentenced the ten to a total of 1,001 years imprisonment on the basis of the accusations made by a police informant.

Although there is little public concern over the fate of people who may be guilty of crimes of brutal, bigoted violence, many people have expressed reservations about this dubious practice and its future implications. How is it, they ask, that the country which most prides itself on its fair legal system, can imprison people for over 100 years each without a jury being present, and purely on the basis of hearsay evidence given by a confessed criminal out to save his own neck?

The law of the UK, as administered in the microcosm of Ulster, is an example of the State's powers over its citizenry when protest and revolt are in the air, even when this protest is only manifested in the hands of a tiny minority. It is important to

realise that it is in no way inconceivable that the heavy-handed practices of State interference operating in the province be put to use in any other part of the country. The law already allows for this and, after all, special measures adopted to handle the specific case of N. Ireland have been imported into Britain before. The Special Branch, for example, was formed in 1883 as a secret police unit purely to combat the bombings of Fenian extremists. It is now used to infiltrate and keep watch on the National Front, Communist Party, CND, Scottish Nationalist Party, Trades Union officials, journalists, and a host of others throughout Britain. The legal system already exists to allow the government to pass powers such as internment without trial all over the UK mainland if it so wished, because we have no written constitution forbidding it.

The Prevention of Terrorism Act was an 'emergency' Bill passed through Parliament in 1974. This very stringent Act was only passed because, at the time, the Government said that it would only exist for a maximum of six months, and would help the security forces net dozens of active I.R.A. members operating in Britain. *Nearly twenty years later, it remains on the statute book.* Despite the fact that the then Home Secretary admitted that the Act was "wholly unacceptable and inimical to our tradition of civil liberties". The powers of the Act were extended in 1984.

The unfortunate individual detained under the Act can be detained for 7 days without any charge and is effectively put in the position of having to prove his innocence of a crime of which he may not even have been told.

Perhaps Governments need extra powers with which to combat violent terrorists, but the Act has proved to be neither necessary nor effective in this fight. Available figures show that between 25th November 1974 and 30th September 1983, 5,683 people were detained under this Act. Of these, only 21 (twenty-one) were found to be involved in anything resembling terroristic activity. The overwhelming majority of those arrested and detained under this sweeping law were guilty of no offence of *any* kind. Most detentions occurred in Liverpool, and included innocent people attending Trades Union meetings, weddings, and even the funerals of relatives.

The Act also allows the State to place an 'Exclusion Order' on any individual, stopping their movement from one part of the country to the next (usually from N.Ireland to England or vice versa). No one who has their freedom of movement restricted in this way has a right to be told why, nor to appeal. Sean Stitt, a student from Belfast, had no idea why he was placed under an Exclusion Order for over a decade. Despite being a UK passport holder, and never having been a member or supporter of any illegal or terrorist organisation, he found himself 'exiled' to N. Ireland and unable to visit Britain to see his sister or attend National Union of Students functions to which he was invited. Despite appeals, the Government refuse to discuss his case.

In the early '70s, the Labour Government reintroduced the practice of internment without trial and – as in the South Africa the Labour Party criticises today – hundreds of people were dragged from their beds and arrested within days of the decision being taken. As revealed in the Compton Report, many were hooded and forced to spend long periods spreadeagled against walls. As reported by the Parker Commission, many people were also beaten, kicked, and deprived of sleep. Many detainees claimed that police had put plastic bags over people's heads, not allowing them to breathe for long periods during interrogation, and others spoke of electric shock treatment as favoured in some South American countries (countries which, like South Africa, are rightly heavily criticised in the UK media, who largely ignore such accusations when they are levelled against our own security forces). Lord Gardiner, of the Parker Commission, found that the procedures adopted by the police were "secret, illegal, not morally justifiable and alien to the traditions of the greatest democracy in the world". Yet another investigation, The Bennett Report, said in 1979 that prisoners had "sustained injuries which were not self-inflicted". The Secretary of State at the time accepted the inquiries' broad conclusions, though now, over a decade after the British Government was hauled before the European Commission of Human Rights and found guilty of the use of torture, numerous comparable accusations are still being made.

Torture has, of course, been used by almost every country in the world to extract information and admissions from suspects. The Catholic inquisitions and Protestant witch hunters of previous centuries had demonstrated that physical pain is a good key with which to open up the mind. Torture victims are not usually imprisoned because of what they have done, but because of what they know and because of what they might do. Because of what they *think*.

THOUGHT CRIME

We all know that to attempt a crime is in itself an offence, and to conspire with others to commit a crime is also an offence. Did you know, though, that under the Police & Criminal Evidence Act of 1984, it is now tantamount to an offence *for you to have in your mind the intention to commit a crime,* even if you keep silent about it. To have criminal thoughts – even if they are not acted upon in any way – in the privacy of one's own mind is now itself good reason for the police to act against you. *"For the police to now have powers to do things such as set up roadblocks in order to find people who they merely believe may be intending to commit an offence takes us dangerously near to the Thought-Crime of George Orwell,"* commented Lord Gifford.

He was not alone in his condemnation of the Tories' new law. The Law Society said that it was 'absolutely against' parts of the Act. Also, in a *Sunday Times*/MORI poll, more than 65% of the

Jerusalem
(photomontage: Pete Kennard)

public opposed the Act. Nowadays, in our free country, one cannot move around freely if the authorities perceive that you may be thinking of committing an offence, regardless of your behaviour. Miners, during the Coal Strike of 1985, were the first large group to fall victim of the Thought Police, as they were intercepted on roads and turned back at county borders in case they were planning to join a picket.

If you listen to Government Ministers and their cronies in the right wing press, the police only used this tactic occasionally, when imminent violence was obvious in the vicinity. The Chief Constable of Nottinghamshire admitted, however, that 164,508 people who were guilty of no crime, were prevented from entering the county of Nottinghamshire in one 27-week period during the strike. The police roadblocks effectively cut off the counties of Nottinghamshire, Derbyshire, Yorkshire and many other mining areas, turning them into 'no-go' areas for hundreds of thousands of ordinary people. Any individual who was told to turn back but who insisted on exercising his right as a British citizen to freedom of movement was promptly arrested.

When the generally peaceful Stonehenge Festival was outlawed in 1985, 1,363 policemen massed around the nearby site on which the convoy camped, harassing and abusing the six or seven hundred picnicking hippies who had gathered. The report investigating the incident was highly critical of police tactics and behaviour, and also of the manner in which hippies were detained after arrest – in overcrowded cells without proper toilet facilities. When the report was published in April 1987, the

toothless nature of such inquiries was revealed when the Chief Constable of Somerset said that he "would do the same again" if the hippies ever returned. Not *one* of the tabloid newspapers covered the findings of the report, which found that "some officers used excessive force". It also concluded that the 537 arrests which took place "were largely wrong", and that "a number of incidents took place in which members of the public were hit by police with truncheons... the police accept the truth of these incidents [but] it has not been possible to identify *any* of the officers concerned" (my emphasis).

Surely, in this free country, one asks, the armed thugs guilty of beating up innocent men, women and children have been arrested, imprisoned, or at least drummed out of the Force?

The answer is all too predictable. Not one policeman was charged with any offence after the Stonehenge debacle. Shame on them.

Kate Adie is a well known TV Reporter who has worked in Libya and Lebanon, among other places. In none of these 'oppressive' nations has she been attacked by the police. However, in common with other journalists and TV camera crews, the British police refused her entry to certain areas of Wapping when she was covering the print workers dispute. A good old British Bobby also hit her with a truncheon in the course of his duty.

Adie is far from being alone in her experience with the police. Cameras covering protests at Greenham Common, Toxteth, Aldgrave, Stonehenge and numerous other places have been covered up by the ubiquitous police glove, and the National Union of Journalists has had many complaints about the police

from their members. Journalists covering police actions are now fair game, it seems; as is anyone who may be vaguely identified with a group that has been socially stigmatised, such as hippies, football fans, punks, pickets etc. All are legitimate targets as the new rules give police greater powers and allow far more scope for any personal bigotry which they may have to be vented. An individual's behaviour and intent may be peaceful and law-abiding. But it doesn't matter anymore. The police, it seems, can now read minds.

If you are a male and police see you talking to someone who they know to be a prostitute, you can both be arrested under The Sexual Offences Act 1985. This typically Victorian piece of legislation was supposed to make the streets safer for women. In fact, it merely gave police more powers to intervene in the voluntary sexual transactions of consenting adults, and diverted the police from their real task – to arrest and convict rapists. According to the organisation Women Against Rape, the Act "makes women more, not less, vulnerable to rape and other sexual assault." It does, however, appeal to the moralists of the Tory party and to the type of policemen who are obviously keen to exercise their new-found mind-reading powers.

All of this may be alright if you're white, middle class, middle aged and female (in fact, just like Margaret Thatcher). But don't be young, don't look different, don't be male and, above all, don't be black...

"There was a time, in Nazi Germany, when police were instructed in a similar way to look at the features of a person. If he had Semitic features he could be arrested."
—Lord Molloy speaking on the Government's new laws.

Mark Bravo is not a criminal, but he *is* black. On his 16th birthday he got a Suzuki motorbike, and started riding it near his home in North London. In the first *week* he was stopped by police seven times. This was only the beginning, as over the next few months, he was stopped dozens of times. It got so bad, his mother started keeping a diary of the general police harassment of the boy. It revealed that, for example, in the period between March 31st and April 14th, he was stopped 24 times (nearly twice every day). By the end of the year, fed up with dozens of more incidents, Mark sold his bike.

In December '84, Derek Donaldson, a musician with the group Sons of Jah, was injured while being "searched" by police in the street. He was charged with assault, but Judge Suckling QC dismissed the charges against him, noting that the arresting officers had given evidence saying that "anyone in the Notting Hill area is suspected of being in possession of a controlled drug."

On May 6th, 1982, Matthew Paul, a 19 year old "black youth" was found dead in his cell at Leman Street Police Station. He had been detained, without charge, for 36 hours without access to his family, friends or a solicitor – this is perfectly legal (in fact new laws allow police to keep you without charge for up to 96 hours). Paul had hanged himself (after being questioned by police) from a flap on his cell door which had been left open by police officers despite regulations to the contrary and regardless of a recommendation made by a West London coroner after a similar death had occurred in another station. What's unusual about Matthew's case is that the inquest jury returned a verdict of "suicide due to lack of care". In this case, though, it's strange to note that in the official Home Office records *the jury's verdict is not recorded*. Also, in new coroners rules which came into force shortly after the Paul case, the list of available verdicts open to a jury was altered so as to exclude the use of the words "lack of care" where death resulted from violence, accident or suicide in police cells.

It is common practice for people to be held, incommunicado and without charges being made, for long periods of time in police cells. It is also quite common for people to die while being held in custody for one reason or another. In 1983, the most recent year's figures which are available, 106 people died while in cells. Although perhaps not too much importance should be attached to statistics, it is strange to note that between 1970 and 1983, the number of annual deaths while in police custody has increased by 300%.

When a death occurs in a police cell, a public inquiry is held. There are literally dozens of cases which record such deaths as being caused by violence, though they are usually very briefly reported. Unfortunately, one has to die while in custody in order to get a public inquiry. If you are merely beaten, you apparently have little cause for concern.

It seems that the general attitude is that anyone who finds himself in a police station deserves to be there and can therefore expect such treatment. The system is geared towards acceptance of the fact that as any such complaints are so difficult to prove, they should remain unanswered. So *no* independent jurors sit in on complaints made against the police. Most complainants therefore do not bother to go through official channels. This is hardly good for public confidence in the police.

Someone who had his confidence in the police severely impaired was reggae singer Junior Service. He was arrested in February 1984 and charged with handling a stolen cheque. Later the same day he was stretchered out of Brixton Police Station to Kings College Hospital. An emergency operation was performed after doctors at the hospital found that he had "severe injuries" to his penis resulting in an inability to pass water.

At 10.40 pm on the 1st January, 1987, Police arrested 19 year old Trevor Monerville for breaking the window of a parked car. His family were not informed of the arrest, and Monerville's worried father visited Stoke Newington Police Station on

several occasions during the following few days, asking the police if they knew what had happened to his son. On one occasion, he even brought in a photo of Trevor to show the desk sergeant while asking for him to be put on the Missing Persons list. On each occasion, the police claimed to have no knowledge of Trevor's whereabouts, even though, in fact, he was in cells at Stoke Newington Police Station itself. The following Sunday, Mr Monerville was shocked to learn that his son was in Brixton Prison Hospital. When he had last seen him, on the evening of the 31st December, he had appeared perfectly normal and well. A few days later, after being held secretly in police cells, he needed a brain operation. Anthony Strong, the consultant neurosurgeon at Maudsey Hospital where Trevor was taken to be treated, indicated that Trevor's head injuries which made the operation necessary were likely to have been caused by a blow with an instrument. The police custody records, later obtained by Monerville's solicitor, show that six officers were involved in taking Trevor's fingerprints "by force". It also shows that Trevor's clothes were somehow destroyed. Police did not make any charge against Trevor, who is now partially paralysed.

In December 1982, police shot dead Rod Carroll and another man. Constable John Robertson was subsequently charged with murder. During his trial, Robertson gave evidence saying that the police had lied at the time of the shootings when they claimed that the two men had crashed through a police roadblock. The police did not challenge this evidence at the trial. P.C. Robertson was acquitted. The local coroner was later asked to investigate the double killing. A few days later, he resigned.

The British Crime Survey of 1984 revealed that fewer than one person in ten who had a complaint against the police took it to the authorities. If you do make such a complaint about the behaviour of a policeman, it will, on average, take 216 days for your complaint to be processed. All complaints made against police officers are carried out by their colleagues on the force. Of those complaints which are received, only 10% lead to a police officer being disciplined or 'advised'. So, the statistics suggest that if a policeman were to hit you for no reason, he has less than a 1 in a 100 chance of being reprimanded by his superiors – let alone being convicted of assault.

Often, however, it seems that when a general complaint about police behaviour is made, the force suffers lapses of memory, loses documentation, and the culprits cannot be identified. In 1986 it was revealed by former officers that detectives in Kent, keen to increase their crime clear-up rate, bribed criminals with promises of bail if they would admit to crimes other than those for which they had been arrested. More than 150 officers were investigated, but it was reported that, as many crucial files had mysteriously "gone missing", not one prosecution was made.

When Liverpool football fans contributed to the Heysel Stadium disaster at the 1985 European Cup Final at which 38 Juventus fans died, police, under pressure from Downing Street, spent months studying TV and video footage of the event, along with hundreds of blown-up newspaper stills, so that they could identify trouble makers in the crowd and track them down. They did very well, too, arresting fans months after the event and deporting them to Belgium for trial. It seems then that they can manage to make identifications of nameless faces in the melee of a fighting football crowd, but when presented with clear, close-up TV film of their own officers, identification is impossible. As happened at Stonehenge, for example.

Such was also the case at the Orgrave Coking Plant in 1985, when opposition MPs wanted some officers disciplined or charged with criminal offences after watching the violent scenes on TV. The force didn't take such action due to "the problems of identifying officers in the crowd." Weird.

ONE MAN'S RIOT
A riot was started by the police when, in a raid on her home, Mrs Cynthia Jarret – an innocent woman accused of no crime – died after being flung to the ground by police. (The start of this riot was similar to the beginning of the Handsworth riot, when Cheryl Groce was attacked by police.) In the Broadwater Farm riot which followed a few hours after the Jarret incident, a policeman was brutally killed.

Many feel that this incident led the police, and the courts, into actions that Lord Gifford QC said exceeded zealousness and clearly broke the law. In the days following the riot, hundreds of police in full riot gear occupied the flats of the Estate and – in the words of the Queen's Council's report – "terrorised" innocent residents, smashed down dozens of doors unnecessarily, and arrested hundreds of young men. The official inquiry found that when the arrested people's parents and legal advisers inquired at police stations as to the whereabouts of the young men, they were deliberately lied to and misled.

"Those being questioned were being hidden away in police stations" said Gifford. The inquiry found that in very many cases, the police held people far longer without charge than the law allowed (36 hours), and denied them any right to legal advice or contact with the outside world until a confession was signed. As a result of the many 'confessions' which somehow appeared, the courts were faced with a procession of cases involving juveniles and people of 17 and 18 who apparently had admitted to a variety of serious allegations entirely of their own free will. Not surprisingly, jurors did not know that many such confessions had come from terrified young people who had been isolated and questioned for days without any legal counselling. So, when presented with such confessions, many jurors – who had themselves recently been horrified to read of the barbaric killing of the young PC – went unquestioningly with the police view and took such confessions at face value. Once defendants were

convicted, the judges were severe.

In January '88, Government Minister David Mellor visited the Gaza Strip. In a well-publicised incident which outraged the Israelis, he criticised the housing conditions of the Palestinians and carpeted an accompanying Israeli official for the arrest of a youth, near his entourage, who was throwing stones. The British Foreign Office spokesman told the Israeli hosts that *"in Britain we don't arrest young men for throwing stones".*

Tell that to the judge. One young (black) man arrested in Tottenham for throwing stones during the riot was sentenced to eight (8) years' imprisonment.

One 13 year old 'confessed' after being held incommunicado for three days in a police cell, after being interrogated regularly and only allowed to wear his underpants during his confinement.

The comparisons with the type of charges brought by the police and the punishments meted out by the courts between the Tottenham cases and those arising from the earlier Handsworth riot add fuel to the belief that zealousness against specific murderers had given way to a police policy of outright discrimination against a whole community.

After the far longer, bigger and more violent Handsworth riot, in which petrol bombs caused more damage, and during which two (Asian) men were killed, the type of charges brought were far less serious. At Tottenham, 71 were charged with affray, 13 with riot and 6 with murder (though charges were dropped against 2 as the judge found discrepancies in the police evidence). At Birmingham, only 16 people were charged with serious offences such as affray, and nobody with murder (even the manslaughter charges were reduced). Sentences were also strangely different. Arsonists convicted in Birmingham were given shorter sentences than those convicted of less serious offences in Tottenham.

The Report into the causes of the Tottenham riot found that the local community had "justified anger" stemming from the long term history of policing of the area, sparked by the death of Mrs Jarret on that October night.

Since the days of the Peterloo Massacre, the U.K. has, of course, been a nation of rioters and of swift action against those involved in any such violent protest. A classic modern example was Bloody Sunday, when the army shot dead 13 of the United Kingdom's residents.

Although there have been scores of riots in Belfast and Londonderry regardless of the political climate in London, and although there are intermittent shudders on the UK 'mainland' such as at Red Lion Square, Grunwick and Lewisham (where Blair Peach was killed with a police truncheon and no-one was charged with his death), we have not had such troubled streets since the social unrest of the Industrial Revolution. Thatcher's extremist policies have, perhaps, truly taken us back to 'Victorian values'.

History clearly shows that in any country where freedom of expression is denied, where the concepts of equality and education are openly abused, and where people are patronised, oppressed and dissatisfied, there will be riots. St. Pauls, Toxteth, Brixton, Tottenham, Nothing Hill, Wapping – we are informed about riots which occur at the focal points of media attention, but what of the incidents in cities such as Southampton, Leeds, Wolverhampton and Plymouth, or those at new towns such as Skelmersdale, which have only been reported locally?

In the case of Skelmersdale, reporters from Radio Piccadilly in Manchester telephoned the local police for news of what was happening during the riot, but were told that "nothing unusual" was, in fact, going on. Is it true that such "riots" are now fairly commonplace, and that police chiefs are simply denying that they have occurred? The evidence from around the country suggests that this is so. (500 people turning over cars and looting shops would have been national news in 1970, one thinks.) Perhaps the reason for such a cover-up is that police fear creating a knock-on effect of 'copycat' riots nationwide, which Tory MPs accused the Media of doing after the first Brixton riots. Perhaps the policy expressed by Mary Whitehouse at the time, to censor the news, was, in fact, adopted.

Perhaps the answer to the paranoid idea of a mass cover-up is far more simple. Nationally, such events are just not reported. The Media is not interested any more, because the nation is bored with watching images of blazing cars, baton charges and rubber bullets being fired. (When was the last time you saw a Belfast riot reported? Have they stopped?) Protest and oppression are now so tolerable, they're no longer news; and if they're no longer news, they might as well not be real.

PRISON
All countries have prisons; few have as high a percentage of their people inside them as we do. Britain has far more people in prison than any other European country. As you read this, nearly one person in every thousand is in jail.

In some countries, prisons are seen as places of rehabilitation rather than punishment. The impression Britain gives to the outside world is that we, too, look upon prisons largely as places of reform. Incarceration is merely a last resort, used to protect the general public from its most violent and habitually criminal members. A prison sentence is more of an inconvenience to the prisoner, not a denial of all rights spent in a place of misery and despair etc. We are, after all, a modern, liberal and just society.

Barry Foster was kept imprisoned for more than two years before his case came to trial. He had admitted while under police questioning to a crime which it was proved that he did not commit. Despite this, he was kept in prison. The Home Office gave his MP, Robert MacLennan, no explanation for keeping Foster imprisoned for so long without him being found guilty of any crime.

The Secretary of State for the Home Office (the person appointed by the Prime Minister to be in charge of prison affairs and know what he's talking about) claims to have "no record" of the number of people held in jail in England and Wales without trial. The official government estimate (likely to be conservative) is that, at any one time, there are about 1,500 people in prison who have been held there for *over three months without being found guilty of any crime.* (This figure does not include those in prison in Scotland and N. Ireland.) What the Government does not publicise is that, in some parts of the U.K., it will on *average* take you 178 days in prison before your case even comes to trial.

There was a time, not so long ago, when such remand prisoners were allowed a few privileges not shared by convicted prisoners. Relatives were able to visit more often, and food, toothpaste and other items were allowed to be sent in to these inmates who had not been convicted of any crime. No more. In December 1987 the Government announced that drugs were being smuggled into prisons in food parcels, so all privileges enjoyed by previous generations of remand prisoners were immediately curtailed. The Prison Officers' unions said it would be easy for their members to search parcels to prevent this happening, if they had enough staff. Cutting citizens' rights was cheaper than employing an adequate number of prison officers.

In January 1988, the main Prison Officers' Union balloted its members on the question of industrial action in protest at low manning levels throughout Britain's jails. The overwhelming majority of members – over 90% – voted for such action. The Government, however, said that the vote for action only amounted to just over 45% of the *total* workforce, so "we do not consider that 45% gives them a mandate" (said the Home Office). Strange, that. The same Government, after all, was voted in by only 19% of the total U.K. population. No more prison officers were employed. Unemployment carried on rising. Prisoners' rights continued to erode due to "lack of staff".

As anyone who has spent time in prison will tell you, British prisons are often dangerous, old fashioned and overcrowded (official reports show that we have 9,000 more prisoners than we have authorised prison places). Violence among inmates and between inmates and warders is said to be common. Once inside, justice is rare.

In a test case, a former prisoner claimed damages against the Home Office for assault and battery, and the administration of drugs against his will while in custody. (Unusually, the prisoner concerned also continued to protest his innocence of the crime for which he was imprisoned, long after he was sent down. As such protests can lengthen one's stay in jail, this is something few convicts do). In the case, the Home Office denied that the prisoner was forced to take drugs or that he was assaulted, saying that he expressly consented to the administration of the drugs. However, the man claimed that five prison

officers had entered his cell, held him down, wrenched off his trousers and pushed a needle into his buttocks – injecting Stelesine. He claimed that these forced injections happened on several occasions. The judge accepted the evidence of the prison officers, however, who claimed to be "totally unaware of the absence of any consent to the injections", and the case was dismissed. The ex-prisoner appealed, but the case was dismissed again.

Legal expert Sir John Donaldson says that a prisoner cannot, as a matter of law, give an effective consent to treatment under any circumstances. Lord Avebury claims that even if a prisoner agrees to medication, it is often due to the fact that any refusal can be interpreted as a refusal to co-operate with the prison authorities, thus lengthening the stay in prison.

The practice of injecting prisoners with drugs is not uncommon. In 1984, the Home Office admitted that in 1983 alone, 8,220 doses of psychotropic drugs were injected into prisoners. These *mind-related* drugs were, we should stress, not injected into people incarcerated in mental institutions, but into inmates of normal prisons. No figures for orally-administered drugs in prisons are available for publication.

Although the particular test case mentioned may or may not have had a basis in fact, such accusations of forced drugging and other forms of mistreatment are very common indeed. It has even been pointed out in Parliament that "there is a pattern and consistency about ex-prisoners' allegations of brutality which lends substance to such claims."

Such accusations are almost impossible to prove. Even when presented with a corpse, it seems that the legal establishment is unable to come up with many cases in which either police or prison officers have been jailed for acts of violence, let alone murder. Often, it seems, when someone is badly injured or dies while in prison the motions of a concerned society are gone through, inquests are held...and nothing happens.

Let us take the example of just one of the prisons in England and Wales, the example of Wandsworth Prison in South London.

At Wandsworth, Terry Smerdon was recently found dead in his cell with bruises to his body. The inquest returned an "open" verdict.

Ian Methven was another prisoner to meet his end in a Wandsworth cell. The inquest verdict this time was "death due to lack of care".

Lennie Turner alleges that while in Wandsworth, he was assaulted and denied food and drink for five days.

Jimmy Anderson, who actually went as far as asking a court's permission to take legal proceedings against some prison officers at Wandsworth, said in court that other prison officers had threatened him with death unless he dropped his charges. He applied to the High Court to allow him to take the legal action necessary to try the prison officers who

had assaulted him, but Lord Justice Tasker Williams ruled against him, stopping him from taking legal action on the grounds that there was "adequate protection against abuse within the prison system". No prison officers were even brought to trial.

Although *thousands* of similar complaints have been made about the illegal actions of prison officers, many totally legal punishments pass without comment. At the discretion of Prison Officers alone, a variety of extreme punishments and restraints can be imposed on a prisoner. Under Rule 43, prisoners can be segregated and put into solitary confinement; they can be strapped into the notorious Body Belt (a sort of leather straight-jacket); or they can be incarcerated in 'Strong Box' cells (otherwise known as 'Strip Cells').

Strip-searching is common. In 1982, some prisons introduced the practice of strip searching women prisoners. In *one* prison, 97 prisoners were strip searched a total of 772 times in a period of 4 months – almost eight strip searches per prisoner. In June 1983 records show that one woman at the same prison was strip searched 28 times. This practice continues, and is quite legal.

Contrary to popular opinion, most criminals who are sent to prison have been convicted of crimes not against people, but against the property of people – victimless crimes. Of all crimes reported in England and Wales in 1986, *96% were committed against property.* Despite the headlines and the propaganda put about by the Home Office and the Police, the vast majority of people now in prison are *not* violent, are *not* sexually motivated, and do *not* represent a physical danger to other members of society. They are far more likely to have stolen a car, evaded tax, sold a pornographic video, or taken marijuana than they are of raping or killing anyone. But in a society obsessed with materialism, censorship and restriction, they are dumped into a prison system that does not properly differentiate between the violent and the unlucky. Although some prisons are better than others, if you are put in prison in this country, even for a victimless crime, it is not only possible that you may be injected with drugs, stripped and caged in a bare cell and – if certain members of the House of Lords are to be believed – beaten up by guards and other inmates; it is also possible that if you have a mental or physical problem, you will not be given the medical attention expected by any civilised society.

Take the example of Alan Tschelbinski. When he arrived at the aptly-named Strangeways prison, he was suffering from fits. Instead of being hospitalised, he was transferred to a cell with bare brick walls, a concrete floor, and no furniture except for a bare mattress which lay on the floor. He was stripped naked and left alone in this cell for several days. Most of the time he spent lying on the cell floor, the last couple of days in his own excrement. When the fits took hold of him, he would run against the cell walls. He was not treated for any of the bruising and other injuries that occurred. Despite his appalling

condition, the prison authorities refused to allow his parents admission when they came to visit him, even though they knew that his mother had dealt with him successfully on many occasions in the past when he had been suffering from fits. Alan died within a week of being imprisoned. At his inquest, which uncovered the details of his death listed here, the prison authorities still maintained that the cell was "the proper place" for Alan.

Although our prisons and detention centres are hopelessly overcrowded, there is a remedy that would not involve a great deal of public expenditure. That would be to de-criminalise several offences, such as the possession of certain drugs, instruct magistrates to sentence people to shorter terms for minor crimes which are not carried out against the person, and, instead of punishing offenders by simply sending them to prison, make them do community service work and pay compensation to the owners of the property which they have stolen or damaged. Despite the common sense of these suggestions, which have been made in a number of reports, courts seem reluctant to change, as every year the prison population increases and the penal system sags under the pressure. One other alternative answer to the problem of prison overcrowding is to let prisoners die, particularly if they are as troublesome as Tschelbinski. Alan was not unique. Someone dies in a cell in this country every two days.

The National Council for Civil Liberties (now called 'Liberty') receives, on average, 2,000 letters a year concerning the abuse of prisoners. A typical case they have highlighted was that of 18 year old Jim Heather-Hayes. He committed suicide while at Ashford Remand Centre, just after being examined by the Prison Doctor. At the inquest into his death the doctor gave evidence which revealed what Ashford's medical care really entailed. *"I go into a cell with a warder and I say 'Are you alright?'. Heather-Hayes did not reply, so I left the cell."*

Risley Remand Centre is another prison which holds people who have been found guilty of no crime. In a report on the Centre, published in June '88, it was found that the centre was "infested with cockroaches and other pests, toilet facilities were practically non-existent and overall conditions ranged from bad to disgusting". In Risley's twenty odd years of existence, there have been 25 suicides.

Of course, not all prisons are hell-holes. The Government would point to some that are very good, and indeed they are. But surely, we do not need to be concerned about what goes on in good prisons, but as a caring society we *must* be concerned with the many bad ones.

The message is, perhaps we British should not be as complacent about our own prison system, nor as quick to condemn the prisons in other countries (such as those in Turkey or the USSR, for instance) until we have made reforms here.

The problem is that MPs, newspapers and the general public are not very concerned about what

goes on inside the prison walls, and of those few campaigners that are concerned, many find it impossible to judge the situation themselves as their sources, the former prisoners themselves, are automatically discredited as witnesses due to their previous law breaking, and officialdom blocks any inquiries with a wall of silence and suspicion. We are back to the question of Information. Information about what goes on inside prisons is considered to be extraordinarily sensitive in free Britain.

Home office rules relating to prisoners writing books while serving their sentences say that inmates wishing to write a book while in custody may do so, and the book may be published after release, *"provided there is no reference to prison conditions, or members of the staff or fellow prisoners"*. On top of this, no manuscript can be sent out of prison, even after vetting, during the writer's sentence.

Books, letters, notes and even personal diaries written by prisoners while in custody are prison property, and may be censored or confiscated at any time, for any reason, and kept – even after the prisoner's release from gaol.

Compare this with unfree Russia. When convicted spy Peter Kroger was exchanged for British spy Gerald Brooke, all of his notebooks were taken from him by the prison authorities and he was not allowed to leave prison with them. Brooke, coming back to England from the USSR brought back all his 30-odd prison notebooks to the U.K.

HEALTH, SEX AND MORALITY (THE CONDOMS GO ON AND THE GLOVES COME OFF)

The many areas that we have already covered seem to give the impression that there is a great deal of repression in the land of the free. Anyone who endeavours to bring information to the public which highlights this fact is open to persecution, regardless of their motives. The right wing monopoly that controls the news media and the extremist, censorious, amateurish attempts of the political left to counter-balance this on 'alternative' TV shows and in magazines means that 'political' avenues of expression are also, in practice, limited and compartmentalised.

Having said that, however, there is a great deal more tolerance shown to political dissenters (who retain a small degree of power due to their voting capacity), than there is to people who publish information relating to Religion and Sex. Even the lethargic British would, one thinks, protest if anything like the same degree of open interference and censorship were shown in public political matters as in private sexual ones. Our freedom to complain about the government, sometimes even to criticise the government (though not the State) is considered fundamental, and infinitely more important than our freedom to do with our own bodies what we wish.

As the only alternative to the government is another government, which acts in much the same way as the one that went before it, the State System can afford to encourage superficial criticism of Downing Street and accept government personnel changes if the system is to survive without serious questions being asked of the very structure of British society.

A real necessity of Control is to control each individual as a single entity, thereby controlling the masses. This control over the individual is no more apparent, and at the same time no more apparently unnecessary, as it is in the area of sex.

The social pressures put on an individual so that he or she conforms to 'normality' are so enormous and widely experienced that we need not even cite examples of this here. The British seem totally obsessed with sex, and the law is full of the results of this unhealthy obsession. Here are a few examples.

The Post Office Acts make it an offence for anyone to send "indecent" material through the post, even if it is packaged in such a way as to cause no possible offence to prudish postmen...

Anal intercourse between men and women is illegal – even if the participants are married...

In 1985, a Midland based contact magazine called *Rendezvous* was prosecuted, and production of the magazine stopped. The magazine published no erotic stories or letters, no photographs of models or genitalia. What it did do was feature lists of personal adverts placed voluntarily by adult members of the public wishing to meet others, primarily for sex. The magazine accepted no adverts from minors or prostitutes or pornographers, and was only on sale to people over the age of 18. This did not stop it being fined...

Nightshift was a nightclub operating in central London that was frequented primarily by suburban married couples interested in the "swinging" scene. Although no on-premises sex was permitted by the management and the club was only used as a meeting point for likeminded adults, the police raided the club in November '87, saying that they were "investigating possible licensing infringements and (unspecified) indecent behaviour." The club was forced to close...

Homosexuality is still forbidden in the armed forces. It is thought that nearly 100 men a year are locked up in Colchester Military Training Centre, guilty of nothing more than being gay. In a flagrant breach of an individual's right to privacy, the military question candidates about their personal sexual habits prior to admission. It also goes to great lengths to root-out individuals who it suspects of being gay, and court marshals them, kicking them out. This means, in effect, that thousands of pounds of taxpayer's money is wasted on their training, and the military lose hundreds of competent, professional individuals.

After a series of police raids on private homes in 1990, codenamed Operation Spanner, sixteen men were convicted of assaults causing actual bodily harm and wounding at the Old Bailey, under sections 47 and 20 of the Offences Against the Person Act, 1861.

Their crime had been to indulge in heavy homosexual S/M activities with each other, and commit some of these scenes to video. The video was not sold or distributed, but was discovered by police in one of the initial raids. All the defendants were over the age of twenty-one. Sentences varied, but some of the convicted men were given up to four and a half years in prison. The Court of Appeal cut some of the sentences, but upheld the convictions. Lawyers for the convicted men took the case on through to the House of Lords, where, on 11th March 1993, the original judgement was upheld by the Law Lords by a small majority. One of the judges, Lord Lowry, said: *"Homosexual activity cannot be regarded as conducive to the welfare of society or the enhancement of family life."* Another, Lord Templeman, said: *"Society is entitled to protect itself against a cult of violence. Pleasure derived from the infliction of pain is an evil thing."* So, regardless of the fact that the men involved were all above the legal age of consent, acted in private and through their own volition, and, prior to the new interpretation of this ancient law, had no reason to believe that they were acting illegally, they still went to Brixton prison. At the time of writing, several of the defendants are thus languishing in jail for inflicting minor, short term injuries on each other, while successful boxers are lauded and respected members of society for doing the same thing. Britain, as a member of the EC, is a signatory to the European Convention on Human Rights, Article 8 of which guarantees respect for the private life of each European citizen. The case is being taken to the European Commission of Human Rights. Co-incidentally, on the day the Law Lord's ruling was reported, some newspapers carried a small item on the case of doctors who had acquiesced with the Jehovah's Witness parents of a 13-day-old baby by refusing to give medical attention that, in the words of the doctors, would have saved the mother's life. Some gay men, who, by their sexual orientation, do not contribute in the normal way to the "enhancement of family life" were given prison sentences for consensual activities that caused no permanent injury or damage, let alone death. On the same day, a Christian sect is, on the other hand, allowed to let people die, thus depriving their children of the "enhancement of family life". Extremists with "Christian" motives are apparently alright, even if their activities lead to the death of others. Extremists who have personal, sexual motives, are punished by the law, even if their activities harm no-one.

New York has Times Square, Paris has The Pigalle, Hamburg has The Reeperbahn – London had Soho. Due to the connivance of the Metropolitan Police, Westminster Council and the Government, there are no longer any shops in Soho selling only sexually-related literature. There are no filmclubs screening explicit adult movies.

This may be no great loss, but it is indicative of the current puritanical crackdown that's taking place in this country. It has also caused problems. When the Recreational Sex industry is driven underground, rather than regulated by public scrutiny, a situation is created where gangsters, rip-off merchants and black marketeers of all kinds move in. This is bad for the police, bad for the hapless customers, and bad for those involved – who are far more likely to be treated badly and exploited and less likely to be given regular health checks. Thatcher's Britain prefers to sweep Sex under the carpet. If one compares the situation in Copenhagen, which has council-run brothels, legal gay clubs etc., with that in Bangkok, which outlaws prostitution and therefore has a terrible record of child exploitation and disease, one wonders why the British authorities adopt such an unrealistic and restrictive policy.

Politicians can say what they like, but the bottom line in all political debate is the allocation of resources. The splitting up of the cake. And the State, in this allocation of resources and set of priorities, reveals in this way its true attitude towards certain sections of society, and the way in which they behave. The most obvious and topical case in question at present is how the British government, NHS, DHSS, scientific establishment and the media have reacted to the HIV virus and its spread of AIDS.

The Syndrome was first identified by doctors in America at the turn of the decade, and by 1983 the sexually transmitted nature of the virus' spread was well known. In the first few years the problem confined itself almost entirely to gay men, mainline drug users and a relatively minuscule number of haemophiliacs. Information about the disease was, however, left largely to the gay press, the Terence Higgins Trust charity and a handful of aware doctors in STD clinics. Despite warnings from the USA, which were heeded in countries such as Holland and Sweden, the British government left it more than three years, until the end of 1986, to take serious action. Was it coincidental that this happened just as health experts warned that the disease had started to spread into the heterosexual community? At the time, it was estimated that over 50,000 British people had already been infected with the virus. Besides a few thousand haemophiliacs, a few hundred junkies and only six heterosexual women, all these 50,000 were thought to be gay men.

When the evidence showed that heterosexuals were becoming at risk, the government allocated £4 million to fund 21 AIDS related projects (only four of which were engaged in looking for a cure for the disease.) To put this into perspective, this sum represents the equivalent of one third of the cost of one Tornado fighter, of which the RAF have 220. At the beginning of 1987, £20 million was spent on an advertising campaign warning about the disease (compared to the £40 million spent on advertising shares in British Gas a few months earlier). One survey showed that the public thought the government had reacted well to the threat, though the gay press wondered publicly why the government had waited so many years to take

action. And why was its research budget one of the lowest per capita of any Western country? Why hadn't the government acted three years earlier, when the problem was perceived as being almost solely one for homosexuals? At least, at last, 'ordinary' people were being made aware of the problem, even though the battle against 'ignorance' was fought not with Durex – who the IBA initially refused permission to advertise on TV – but with volcanoes and icebergs.

In February '87 Junior Health Minister Edwina Curry spoke her Government's mind at a speech in Liverpool. *"Good, Christian people don't get AIDS,"* she assured the nation, and went on to say that *"only people who misbehave are at risk"*. It seems, then, that as the virus only affects what one must logically assume from her speech are bad, godless people who obviously disagree with the perverse pseudo-Victorian values of the Government, there is no reason for their health to be any concern.

Meanwhile, that other pillar of the establishment, the Christian Church, set about offering constructive advice on the problem. *"The AIDS TV adverts encourage sex amongst the young,"* boomed one helpful Catholic Bishop, adding that the tombstone shape used in the ads was *"too phallic"*. (Quite how the threat of death and the allure of a gravestone encouraged sex was not made clear.) A vicar in Kent refused to allow the burial of a young gay victim of the disease in his graveyard, saying *"We don't want people like that buried here."* True compassion.

There are many pleasant, well-meaning people involved with the Christian Church, and the faith and rhetoric it generates may be very helpful to many people. But the hard fact, like it or not, is that the Church is the enemy of Freedom of Choice. When faced with difficult, real issues, the Church always agrees with the concept of interference, rather than persuasion by example. As it is a supposedly Christian set of morals which are the foundation of the State's attitudes to sex and sexuality, it is always the followers of the Church in this country who persecute any sexually (or otherwise) identified minority. So, "good" reasons are always drummed up to support such persecution. British Communists are bugged as they are assumed to be in league with the Anti-Christ in Moscow; gays are victimised and denied entry to the Church as Ministers as they pervert youngsters and spread disease; anti-Semitism is still rife as the Jewish faith opposes the validity and power of Christ; videos are censored to protect children from being led astray. And so it goes on (and on).

Although we do not want to dwell on the question of AIDS, or the persecution of male homosexuals, in recent years it is this group of individuals who have suffered most obviously as the State looks for 'deviants' and minorities to make scapegoats of – and it is their experience that provides a classic example of how 'free' we really are in the last decade of the millennium.

In December '87, under pressure from Tory backbenchers, the Government sneaked a new clause into the Local Government Bill – a bill which, in itself, went further in taking power from democratically elected local councils and transferring it to Whitehall than anything that had gone before. Clause 28 said that local councils would now be "prohibited from the teaching in any maintained school of the acceptability of homosexuality..." and barred from "intentionally promoting homosexuality" in any way.

Incredibly (or not), the Parliamentary Labour Party supported the Clause, though their spokesman Jack Cunningham expressed reservations, asking if the public realised that the new legislation might prevent school and public libraries from stocking books by such eminent authors as Truman Capote, Oscar Wilde and Gore Vidal – all of whom described and 'promoted' homosexual lifestyles. Only *one* Tory MP – Michael Brown – opposed the Clause.

On the 9th January 1988, 12,000 people took part in an OLGA march demonstrating against Clause 28 in London. During the peaceful demo 20 people were arrested – two men for kissing in public, and others for carrying offensive weapons, the "weapons" being flag poles used to carry banners. The *Sunday Mirror*, Britain's only supposedly 'left wing' tabloid paper, devoted one column inch on an inside page to the march. When 40,000 demonstrated against the Clause in Manchester, most national papers ignored the event completely.

In March '87 Barrister Adrian Fulford reported that *"since the advent of AIDS, it seems that the number of arrests of gay men has gone up. And, whereas before most people arrested for importuning were normally cautioned or bound over without the case coming to trial, now it is more the case that the prosecutors insist that cases go to court."* The self-righteous, religious right wing have manipulated public opinion so brazenly since the appearance of AIDS that homosexuals in some areas are being treated in the same bigoted and often violent fashion as were Jews in Germany in the years preceding WWII. Rugby Council in Warwickshire refuse to employ homosexual men; an HIV carrier in Southampton has been banned from using his local council swimming pool; hundreds of gays have lost their jobs, and, since 1985, polls show that in the 1985/87 period, reported attacks on gay men increased by 1,000 percent.

The lesson to learn is that, whenever an excuse crops up which allows society to vent its true, barely-concealed hatred of any individual who seeks to live in a slightly different fashion, all civilised concepts of compassion, respect and tolerance go out the window. The gloves come off...

Or, in the case of the police, the gloves go on. Many gay men have reported that in recent raids on gay clubs, police have worn surgical gloves and joked about not wanting to touch any 'queers' when arresting them in case they catch the disease. (Our police are wonderful.)

Pressure is mounting from reactionary groups on

all sides, particularly within the government. The Conservative Family Campaign, supported by a number of Tory MPs, is calling for a repeal of the 1967 Act which legalised homosexual acts between consenting adult men in the privacy of their own home. Though not, incidentally, in the privacy of their hotel room or any other 'public' place. (Homosexuality was still illegal in N. Ireland until 1982. It is also still illegal on the Isle of Man).

Geoffrey Dickens MP – a Tory backbencher – is not a member of the campaign, but he nevertheless has a lot to say about the subject. *"The family life of this country is eroding,"* due, he says, to liberal sexual attitudes. *"Homosexuals entice and corrupt others into their unnatural net. The 1967 Act should be repealed."* When asked about the question of Civil Rights, the exceptionally well-proportioned person says *"We have to interfere with civil liberties to do what's right,"* (don't they always) *"...normal people are appalled about the way homosexuality is spreading in this country."* But how would such a change in the law be enforced? *"Policing such a change in the law would include closing down all gay and lesbian clubs and pubs and limiting certain publications."*

Would this enforcement include police raids on the private bedrooms of adults living together who were *suspected* by the police of being homosexual, one wonders. *"Oh yes,"* he replies. *"Absolutely."* (Incidentally, Dickens has also been calling on the Government to introduce laws which will effectively ban any 'occult' practice in Britain. Something that would be constitutionally impossible for the Federal government to do in America, but is easy to do in free-thinking Britain.)

Such a change in the law would inevitably mean fewer gay men attending clinics for check-ups, for fear of a visit from policemen like the afore-mentioned James Anderton. This would no doubt facilitate the spread of diseases like AIDS. So, although Public Health is the excuse, it seems that a bigoted idea of 'Public Decency' is the real question behind such a change.

The Conservative Party is said to be seriously considering making such a change during their next period in office. Should the law be altered, police would be given even more discretionary powers to stop and question individuals, read minds, confiscate books, and raid private property. At the same time diverting manpower from the fight against rape, murder, mugging and other violent crimes that we are told are the threats that they are there to protect us from. The protection of the individual from physical attack, and the protection of his or her civil rights, are obviously not as important as implementing laws that are considered 'right' by a few hundred absolutist MPs and the Government's ventriloquist dummies in the Tory-owned right-wing press.

As a society, the British seem far less worried about the threat of violence than the perceived threat posed by people who *think differently.*

Whether they be gay, communist, vegan, pagan, or 'mad'.

The threat that worries us as a Society is not that these or any other factions may somehow violently overthrow the systems to which we adhere, but that they may actually convince us that they are right. There may be ways of living which may be more practical and enjoyable. Why else would we harass peaceful organisations like CND, or make illegal certain sexual acts between adults? This is why alternative lifestyles and literature are treated with contempt and derision in the popular press. This is why we are encouraged not to think or act differently. This is why there is hardly ever any talk about what happens to people when they have mental problems.

Incredible as it may seem, there is now a growing body of opinion within the psychiatric profession that holds the previously unthinkable view that there is no such thing as mental illness unless the brain is injured or diseased, just variety and deviation in numerous – sometimes extreme – forms. Although this revolutionary opinion may be erroneous, and does sound something to be debated by eager 6th Form sociology students, the point is that over the years anti-social behaviour of all kinds in an individual has been seen as being the result of some vague mental "derangement". (Up until the 1920s, we still used to lock up epileptics, people who were catatonic, homosexual men and even unmarried mothers – who were thought to have a mental illness which explained their lack of morals.) Oddly enough, the behaviour of an individual is often the only 'proof' of any cerebral disorder we have, while at the same time the disorder itself is sometimes explained as originating from such behavioral experience. Although diagnosis and treatment of mental illness is undoubtedly well-intentioned, a Free Society must be very careful when it diagnoses people as being sick without their having any physical damage. Often, it seems that the basic criterion we have for judging mental disorder seems to be how inconvenient the person has become to their family, friends and doctors. No clear or consistent distinction has ever been made between criminals and mentally sick offenders, but a mental patient is robbed of even more rights – we even assume the right to tamper with the workings of their mind without their informed consent.

Of course, even in a free society, some such decisions have to be made. However, in a truly free and caring society, adequate safeguards which make incarceration of sane, anti-social people impossible should be in place. The files of the Mental Health charity MIND would suggest that in Britain, they are not.

It's generally believed that nobody here can be committed to a mental institution against their will unless several psychiatrists commit a patient referred to them for the protection of society as a whole. Not so. Under Section 4 of the Mental Health Act 1983, a Social Worker can apply for someone to be

admitted and detained against their will if they think it necessary. Only one Doctor, a G.P. who may never before have met the 'patient' or have had any specialist training, is all that is now required to have a person forcibly admitted. Once the G.P. has given the go-ahead, the (usually old) person concerned can be forcibly taken from their home (usually by police and social workers), detained in a secure hospital, and forcibly drugged.

The 'patient' is left totally at the mercy of the doctor concerned, who can administer drugs such as neuroleptics which may be detrimental to his longterm general health. (Although any patient is to some degree at the mercy of his doctor, people with physical illness and injury have the right to refuse treatment, discharge themselves from hospital, or ask for a second opinion. Mental patients do not.) When they are diagnosed, often inaccurately, all their usual rights are taken away. Doctors, obsessed with the idea of 'psychosis', are often keen to treat behavioral difficulties with a flood of chemicals and little else.

The Mental Health Act does not forbid people other than doctors from administering drugs. Prison officers, nurses and health workers at mental hospitals forcibly administer drugs to inmates daily. The only legal right they have to do this is in cases of "urgent necessity" when the patient (or, it seems, prisoner) is unable to give his informed consent. (If, for example, he had been injured and was unconscious and therefore unable to agree to the administration of life-saving drugs.)

In reality, even when patients and prisoners are quite conscious, and involved in no urgent life or death situation they have no right to refuse injections of drugs. Such anti-social people, whether they can be called insane or criminal, are easier to handle when they are drugged up to the eyeballs, so the practice is widespread and officially condoned, though not publicised.

Despite persistent calls for reform, the government has not altered the law, and in passing the 1983 Act, threw away an opportunity to make the medical establishment and DHSS more accountable for its treatments and give more recognition to the question of individual patients' rights. In typical fashion, the British Government has, at the same time, been highly critical of the forcible drugging and incarceration of subversive and difficult individuals in other countries.

GOD'S POLITICS
The present Conservative Government is the most marvellous political animal to emerge in this country in the last 40 years because it has learnt first to influence public opinion, then reflect it. At least, reflect the parts of it which it finds useful.

There has been a media-manufactured change in attitudes towards Public Morality in the last few years, and in any country, such shifts in Public Opinion have a nasty habit of showing up as changes in the law. (Clause 28 is a classic example, in that it reflects rampant homophobia induced by

AIDS.) Such changes also show-up in the way in which the State spends the tax payers' money.

For example. The government feels it wants to spend more money on the Police Force, so as to combat social unrest caused primarily by its uncaring economic programme and enforce its plethora of restrictive new laws. It cannot justify this vast increase in spending to the electorate in the light of the huge cutbacks in Health and Education, so it must carry support for such spending. The Police Force, happy to oblige as it always wants more muscle, concocts crime figures which show a crime wave of tidal proportions. So, in the 1986 statistics for example, there are hundreds more rapes than in 1985. In fact, as the Police later admitted, there were probably not, but methods of cataloguing reported rapes had changed, giving a misleadingly large apparent increase.

Of course, even in a democracy, the private attitudes and morals of an individual have nothing to do with changes in the law at all. What matters is Public Opinion. Public Opinion and Individual Morality are often confused. Public Opinion can be changed by whipping up hysteria in the news media, and by releasing distorted statistics. The private morals of each individual cannot be changed quite so easily. We live through our media, and in the media world, Public Opinion is formed not through a collection of independent thought or informed debate, but by the media's image of Public Opinion. The opinion represented in the views of a thin stratum of society – the 'personalities' who feature on TV, on radio, and in newspapers.

For the majority of people it's probably fair to say that their image of Public Opinion is drawn solely from the reporting of Public Opinion – usually by people with political axes to grind. Most 'news' is in fact taken up with the opinions of publicity-seeking individuals. (For example, in the report 'Mass Media & N.Ireland' it was found that the largest category of 'news' coverage of the province was devoted to the speeches and interviews of politicians.)

So in Britain today there exists a genuine silent majority of people who, for instance, don't really mind about people cavorting around Stonehenge or watching sexually explicit films or having their genitals pierced or setting up pirate radio stations or picketing at closed factory gates. These people are told that they are in a minority. They do not get on TV shows. Their privately held opinions are not held by those in power. They cannot argue against all the evidence, and anyway, a public silence breeds a private fear of speaking up in public against the government and what must be the majority. So, although the majority really don't want to see our traditional rights eroded, the minority that sees itself as the guardian of Public Morality manipulates and amplifies publicly voiced opinion as loudly as possible, so as to excuse its excesses.

In areas of finite fact, such as the physical sciences, successful deviations from the accepted norm are called 'inspiration'. Deviants who challenge what is

accepted, and prove it to be wrong, are given Nobel Prizes. Their research is encouraged and their findings are supported with tangible physical evidence.

In areas of Art, Morality, Philosophy, Theology and so on, practically no opinion, vision or revelation can be supported by physical evidence of any kind. The only chance one has of encouraging evolution is to convince the majority of people that what one thinks and does may be interesting and beneficial. That changes can be made for the better. The only way one can do this is through the imaginative use of the communications media. Through cinema, novels, magazines, paintings, newspapers, music etc. When such free forms of expression are denied and censored, progress is made impossible. Everything is geared towards support for the present system, however limited and unsatisfactory that system may be. Everyone must pay lip service to it. To the idea of retrogression rather than advancement. To static, septic status quo rather than illumination and change.

In the current climate, where morality is seen in the monochrome, it is Human Evolution itself which suffers. When you distort reality and censor the media, changes in people's perceptions become impossible. In scientific terms, radical changes in what is accepted as being fact is called a paradigm shift. A paradigm is, quite literally, a frame of thought (from the Greek word *'paradigma'* – pattern). So a paradigm shift is a new way of thinking about our old problems. The interesting thing about paradigm shifts is, of course, that with the passage of time, each 'shift' eventually becomes the established mode of thought and naturally becomes redundant itself whenever a new shift occurs. A shift is evoked by someone. At first (perhaps for decades) it is scorned by adherents to the old paradigm, but it is eventually accepted as being a reasonable framework within which to operate. So in evolutionary terms the concept of such shifting of the 'truth' provides the perfect argument against blind faith, dogmatism and censorship, as each paradigm seems to have an in-built self destruct mechanism. That is, each framework, each idea, each answer, throws up another idea, another question. New pieces of data turn up that don't fit into the old frame of reference, so eventually you are left with a mountain of questions that cannot be held within the structure of the old paradigm and – pricked by a Cezanne or an Einstein – it bursts open. The unsolved questions flood into a new frame of reference to be answered, and so it goes on until the next shift. Sadly, in social terms, this evolutionary experience can no longer happen in Britain.

The truth is that we live in a society that cannot accommodate progressive change. This country had started to make some real advances in the years between the end of the war and the introduction of Thatcherism. The invention of the NHS, the improvement of the educational system, the

relaxation of many unjust laws and so on. It still had a long way to go, but it might have got there. The reason this slow progress was stopped was because it was decided that we could not pay for our advancement. As usual, the World Banks saw to that. Now the Conservatives have rolled things back nearly a century, to make the country backward, isolated, but safe in its ignorance. The Capitalist State has recuperated any longterm changes quite successfully. The present Government have proved that we are a society that will not look at the present and into the future, but cling to an image of the past. Politicians on both the left and right preach censorship, ignorance, and the need for adherence to outmoded values and ways of thinking. The church, meanwhile, believe that the ancient principles and methods of living are sacrosanct, and can be applied to the problems of today. The legal system and social climate reflect all this in an icy permafrost, where the only movements made are small and always backward. All ignore the theory of evolution. The theory that makes credible and necessary the need for individuals to be able to express themselves, research life for themselves, vent their views and experience new sensations so as to allow for, encourage, and inspire change. Growth. Progress.

We live in a country run through fear by yesterday's men. Men who control through a myriad of mummified, unfathomable laws underlined by the threat of real physical violence and deprivation. Men who do this not necessarily because they are evil or stupid, but because they are so conceited as to be convinced that they are right, and that the ends justify the means.

The reason for the State's absolute belief in itself is deeply rooted, and stems from its symbolic relationship with Religion.

From Egypt, Babylon and Greece – the areas from which Christianity most heavily borrowed – come the schematic idea of humanised gods. Gods who made laws and ruled the Earth. These deities had to be pleased, so that crops would grow. Clever leaders of dominant groups seized on the idea well, and claimed divine and mysterious links with the gods. So, it's not surprising to find that the first legal system ever recorded – in Babylon – was said not to have been drawn up by a man, but by a God. King Hanmurali (2067 – 2025 BC) said that the law had been given to him by Merduk (not just any god, but the Babylonian version of the later, all-powerful Greek god Zeus.) And so, although throughout history the names of the gods and the details of the laws have changed, the concept remains the same.

The Head of State in Britain is the Monarch, who is also head of the Church of England. Bishops are given automatic seats in Parliament (in the House of Lords) and any laws passed by MPs cannot become law until they are rubber-stamped by the Monarch (given 'Royal Assent'). Implied associations with God, and with what is Good, are everywhere. So, by inference, that State is given the right to rule.

From clever King Hanmurali onwards, God has

become inexorably connected with the State. God has become politicised, and the appeal of God has been utilised by all those who seek to exercise control over others. 'His' laws have been propagated and freely adapted by people who claim, perhaps not to have spoken to him, but through a study of his laws (an association with the Church) have therefore assumed not only their right to control others, but a monopoly on morality. So all wars are holy wars and all laws are good laws. The more laws we have, the better we must be. It's lovely!

Regrettably, this unspoken association with All Things Bright and Beautiful has led us into a situation in which those who are convinced they are right, must believe to some degree that everyone else is wrong. In the ultimate Nanny State, their poor souls must be saved and they must be made to behave. Naughty children.

As Britain's position in the world has slumped, the temptation has been for governments not to look forward and tackle today's problems in a realistic manner, but to look back, to a golden vision of the country when everyone knew their place and when it ruled a quarter of the planet. In a simpleton's equation, the current government have sought to encourage and enforce a return to old values of the Victorian era, as if social retardation to a blatantly unjust and uncaring time would by some weird science restore Britain's world status.

This notion is not only a fallacy, it is indicative of the survival instinct of the State Machine. To this enormous, almost abstract entity, individual people do not matter. So if, for the system to run smoothly, individuals have to submit to injustice, unnecessary hardship and lack of liberty, it doesn't matter. So long as the image of a squeaky-clean, new British Motherland emerges. Not strong in itself, but appearing strong and wholesome to the outside world again. A strength measured not in individual liberty and contentment, but in share prices and nuclear warheads.

Our civilisation is locked into the dialectic of Conflict and Competition on an international stage, and the preservation of its control in the domestic area at all costs. In this nuclear age, where co-operation and compromise are the real keys to survival, our system is clearly as dangerous as it is outmoded.

As research and reform are relegated, civilisation itself suffers, Education, Art, Literature all take a back seat, as individuals who seek to express new ideas are gagged. People who do not conform are made to look foolish, and even criminal, so the new criminal class is not composed of violent gangsters or rapists, but people who sell books and make films. Of old ladies who protest at Greenham and Civil Servants who reveal the truth about the workings of our Government.

Our story is truly a chilling one. A sad and depressing one. Think about it. The country that was once the Cradle of Democracy and the birthplace of the fairest legal system in the world has been damaged, perhaps beyond repair. The long term consequences, not only of the Government's new laws but of its disregard for the truth are genuinely crippling to both Individual Liberties and to the social health of the nation. We are left with only a false external appearance of democracy, manifested in long queues to the ballot box every five years, giving our support to one idiotic set of values against another. Our choice is totally controlled and predicted by the system to which we have submitted. A system which elevates megalomaniacs and liars to superstardom.

In systematically lying more so than any government in modern times, in editing and covering-up the truth, Thatcher, and to a lesser extent, John Major and their cronies have created what communication scientists call a 'disinformation situation'. In America, Paul Watzlonick and others conducted experiments during which totally sane people were lied to in a systematic and calculating manner. The results were that the subjects started to behave with all the irrationality of schizophrenics and paranoid patients. I would suggest that this is starting to happen now, as people abandon all hope, and all interests in politics and the structures of this society. This has the effect of leaving more space for the insidious and unchecked growth of centralised power, more distant and less accountable than ever. The rise in narcotic and alcohol abuse, suicide and violent crime is a product not of TV, but of alienation and mistrust of a system that denies people any hope.

Few realists would argue the need for some reasonable and generally agreed laws and levels of policing those laws. We all want protection from violence and intimidation, warnings about exposure to dangerous drugs and so on. This is not the issue here. What we are discussing is a heavily disguised undemocratic use of power. Of blind assumptions that the preservation of the present social system is a paramount importance, and the belief that the elected government's own narrow set of values are so perfect that any serious dissent must be silenced.

Have we not illustrated that we condone an educational system that openly indoctrinates children? That our belief in 'good' and 'evil' has been so perverted that adherents to the State's dictums actually believe that they have the monopoly on godliness, justice, good taste and common sense? That we have created a bureaucracy that assumes the right to interfere in people's private lives and sit in judgement on even the most noble acts of any individual? Are we not saddled with a blatantly undemocratic electoral system which will not be overturned by those who ride this same system to total power, and an all too often corrupt, stupid, violent police force and a demonstrably biased, unjust and senile legal structure? On top of this, history shows us to be stuck with a governmental monolith that exists supposedly to serve the people and administer to their well being, but which has grown into a latterday Godking. To be

served (particularly during times of war) and serviced. Our sense of freedom is abstract, our feelings of oppression are all too real.

The system is not perfect, and all governments have their faults, but this present government has changed all the rules, and is getting away with it. As Stuart Bell pointed out, John Donne may have had a lot to say on the matter.

The government tolls the bell for egalitarianism in a society that we once believed was opposed to authoritarianism. It tolls the bell for liberties that are known, understood, and were once enjoyed by all of us. It tolls for our children. They will be brought up in a society that takes as a matter of course arbitrary searches of people's homes without warrant, the interception of private mail, seven days' detention without charge, 3 months' imprisonment without trial, regular deaths in custody, systematic roadblocks, plastic bullets fired on children, the outlawing of peaceful demonstrations, trial without jury and enforced drugging of prisoners, the effective removal of the right to strike or picket, the abolition of local democracy, the banning of books...

Perhaps the last words should go to an outsider, who can provide a more objective view. In this case, American Professor Ronald Dworkin, an international commentator on politics, philosopher and a lecturer based in Oxford: *"A truly civilised society is vigilant about the question of civil rights. The number of minorities which are hated in this country is indefinite. Each person who is in some way or another a member of a minority – not only black people, not only homosexuals – but people who hold unpopular convictions of all sorts, have got to band together. They've got to say that they're not going to allow it when on every possible occasion people use some trumped-up excuse as justification for tearing the veneer of civilisation away."*

But the words of the Tory ad man repeat on the video machine, cold and hollow... **"Man is born free... his natural state... his God-given right. Nowhere is this tradition more deeply rooted than in Britain... we are a proud nation of individuals... Freedom has been both our strength and our battle cry..."** The television beams lies to a nation that doesn't believe anything anymore.

Our claims to be the most free country in the world have no validity any longer. We hold these truths to be self-evident.

This is the last of England.

This article was inspired by Dr. Terence DuQuesne. Terence DuQuesne is a former contributor to *Rapid Eye*, and writes widely on many subjects. His books include *Catalogi Librorum Eroticorum*, *A Handbook Of Psychoactive Medicines'*, and volumes of poetry. He is a clinical pharmacologist and writes extensively on human rights, oriental studies, the classics, poetry and art criticism. Simon Dwyer would like also to thank Liberty for their co-operation in his researching of this piece.

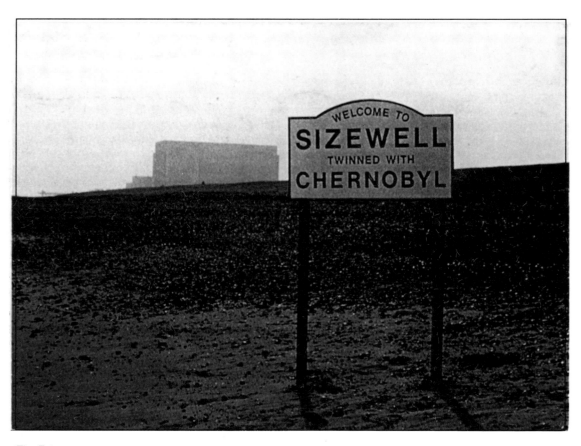

The Future.
(photo: Stop Sizewell 'B' Association)

BODYSHOCKS
The Mr. Sebastian Interview

Simon Dwyer

"The human body is always treated as an image of society and there can be no natural way of considering the body that does not involve at the same time a social dimension."

—Mary Douglas, *Natural Symbols*

"One must be a work of art, or wear a work of art."

—Oscar Wilde

A small, clean room in London, Radio 4 drifts out of the open window over the rows of sun-baked rooftops. A semi-naked man lies on a medical couch. He notices a crack in the ceiling. An anglepoise lamp creaks into position and hangs above him, like a praying mantis. A honeyed voice, deep and hypnotic, soothes away the last minute beads of anxiety, "you may just feel a slight tingling sensation". Odour of surgical alcohol bends images the way heat does. The peace is broken by the nauseating buzz of the tiny metal needle, glinting blue ink. Fleeting thoughts of dental torture, Klaus Barbie or Laurence Olivier, gently subside, taut muscles relax as the body realises that it really doesn't hurt at all. It's all very peaceful.

The last time I'd ventured into a tattooist's grandly titled 'studio' had been when I was sixteen. I'd sat, squashed into a queue of sailors' and skinheads' spotty white flesh, watching with a mixture of fascination and barely concealed horror at the

Mickey Moused beer bellies, L.O.V.E.-engraved fists and skull-infested backsides. All were being produced indelibly in a matter of minutes by an artiste of Hulk Hoganesque proportions, a bad case of Delirium Tremens and the personal hygiene of a hippo. Gritted teeth grinned inanely as the painted punters bared various hairy white hams and accepted their doses of hepatitis like men. Suddenly, I remembered a previous engagement.

It took me nearly a decade before I was inexorably drawn back. This time, though, things could hardly have been more different. Now I was in the capable hands of Mr Sebastian, a legendary figure among tattoo aficionados who enjoys the reputation as one of the best tattooists and piercers on this side of the Atlantic.

If you want a job done by Sebastian you don't join a queue for an hour, you join a waiting list for four or five months. Like any good surgeon or lawyer, this man exudes an air of elitism and appointment-only

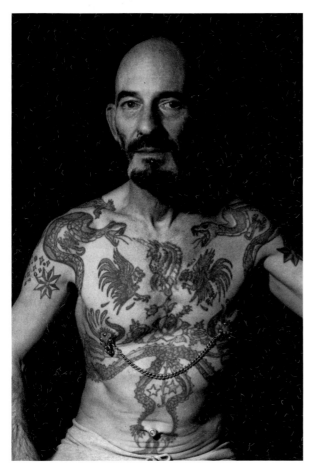

The Illustrated Man

remember we sat around drinking rum and his pet monkey kept running around the room pissing everywhere. We got a little drunk, but that didn't really help with the pain. He knew what he was doing, but he used an old fashioned syringe-type piercer."

On his return to Britain, Sebastian decided that his gold rings were positioned a little too near the front of his nipples, so he decided to move them back, making new piercings himself with the aid of some disinfectant, whisky, and an embroidery needle. "Bloody painful", but it worked.

Reactions to his piercings were surprisingly good, and in response to the demand, Sebastian invested in a piercing syringe and gave nipple piercings to a few friends.

A piercing has the effect of baring nerve endings and, as a result, increasing sensitivity in the area of the piercing when the ring is touched. Generally, men's nipples are far less sensitive than those of a woman, but after piercing the man discovers two new, highly sensitive erogenous zones. Piercing is partly aesthetic, primarily sexual. This is part of the underlying reason why body adornment is generally frowned upon in polite society, though it is by no means the only reason. The whole culture of Body Art is still tinged with the lustre of rebelliousness and riddled with unspecific underworld associations for simple historical reasons.

Tattooing, piercing and scarification of the body existed in dozens of quite separate tribal and national cultures all over the world before the global domination of the white man, and his religion. As the European empires spread around the planet like a plague, the accompanying shadow of Christianity spread with them. In its wake, all forms of body-marking were crushed. The logic was typically crass: The bible said that God had made Man in his own image, so, any attempt to alter that image was seen as being a departure from God – the work of the Devil. Tattooing and piercing were seen as satanic, or at best, godless traditions.

Sebastian was having none of that. He realised then what we should all know now: our bodies are our own, to do with as we please, regardless of the opinions and interfering laws of our society. Often, our bodies are all that we have left.

Impressed with what he called his two new "jolly buttons", he decided it only natural to extend his attentions to his genitals.

"I used to practice on myself with needles" he grins, as this interviewer crosses his legs involuntarily. *"I was working as an Art Teacher by this time and had a few more tattoos done. Becoming more and more adventurous as I went along. Then a few years later I went to the States and stayed with four or five tattooists, learning as I went along. Then I met Doug Malloy who'd been interested in tattooing for years and was really quite knowledgable. So with advice from him and a doctor friend of his, I also learnt*

authority, and in his presence it's easy to elevate the craft of the body artist to the vocation of the professional. It's quite simple, if you want your body adorned and you're fashionable, professional, or just plain sensible, you go to Mr Sebastian. Your body is worth it.

But how does such a man become involved in a world that, even now, implies associations with subterranean machismo? His introduction was traditional enough. His first tattoo – a small star on his hand – was a DIY job done in the army during his National Service, but that, for the time being, was that. Unusually, Sebastian (real name Alan Oversby) became interested in piercing before tattoos.

Unemployed and unwilling to follow his father's footsteps into an Insurance firm in Liverpool, 22-year-old Alan caught a steamer to South America to become an Overseer on a sugar plantation in British Guyana. It was while he was there that he first came into contact with piercing.

"I saw two fieldhands with pierced nipples, with little gold rings through them. As soon as I saw them I knew that's what I wanted. So I got to know them and then one evening they took me to this strange little man who was a Portuguese West Indian, who lived in one of those houses on stilts in the jungle. He was the man who had done their piercing. I

about piercing. About what you could do and what you couldn't do."

RE: So there was really nobody who could actually train you.

*"No. Even Doug Malloy had only done a few piercings at that time and Jim Ward who runs **P.F.I.Q.** (Piercing Fans International Quarterly), didn't have any piercings. So between us talking about it and pooling what experience we had we worked out the best way of doing it."*

Twenty years on, Sebastian has perfected the delicate art like few others. The photos in his studio are his testament, and a wonder to behold. Roses etched around arseholes; snakes extended up cocks, rings through labia. Men with 3, 4, and even 5 gold rings or steel 'bolts' through the shaft of their cock. Other photos show smiling couples joined together (temporarily!) with thin steel chains extending from one foreskin or helmet ring to the other. (Quite properly, Sebastian declined us permission to reprint these pictures, to preserve his clients' anonymity).

Besides the amusing, the novel, and the bizarre, there are of course a few horrors. Some customers come to Sebastian having divided their own penis completely from tip to base.

Many people may find it hard to believe, but there are quite a few obsessives who do sit at home with a carving knife and a bottle of painkillers and hack pieces from their own glands. Psychiatrists and sociologists would probably have a field day with these characters, but the reasons they do this are – in their minds – aesthetic, and also to increase the novel sexual kicks one apparently gets from having intercourse with a dick that has thousand of nerve-endings exposed beneath only a thin layer of scar tissue. There's also a certain degree of one-upmanship involved. People enjoy the kudos of being the only man at a party who owns a penis that is, in itself, a work of art. And just as it's often the case that one tattoo leads to another and leaves the entire body ending up looking like a patchwork quilt, piercers often come back for more and more extreme and novel additions.

One regular visitor is a respectable middleaged businessman who – in effect – now has two cocks. His penis having been completely bifurcated along its entire length. He claims to get two (thin) erections (and no doubt a few curious double-takes in the urinals). The urethra, through which the urine and seminal fluid passes, is preserved down one side of the 'tube', though apparently some people do experience a lot of 'leaking' and 'dribbling' during both urination and ejaculation. (Even with a straightforward cock piercing, one has to learn to 'adjust your aim'.) This particular customer's wife is pleased with her husband's unusual genitalia. *"He brings her along with him, she's most keen!"* In fact, Sebastian had one wife telephone to thank him for her husband's nipple piercings, saying they were *"Magic. Things have started happening now he's got nipples that work."*

Mainly, though, Sebastian's clientele is gay, middleaged, respectable. *"I don't get a lot of skinheads, but I'm sure I would if I had an open shop. Lal Hardy, who does some excellent work, gets a lot but I wouldn't really care for a lot of skinheads myself. Not being snotty, but I wouldn't really want to do bulldogs and Union Jacks or whatever. I realised when I started that there was a need for somebody to do work by appointment. There are an awful lot of businessmen – for want of a better word – who want to have tattoos but wouldn't be happy walking into an open shop... that type of person usually wants something small and discreet, mostly something on their arse or cock."*

The most 'respectable' cock piercing of all is that of the 'Prince Albert', a metal ring which is inserted through the urethra and through the underneath of the (punctured) glands. It's so named because there were strong rumours in Victorian times that the Prince himself sported such a device. Of course, the only person who could confirm or deny this was Queen Victoria – and she wasn't saying.

Small tattoos and a fair deal of piercing was in fact said to be quite common among Society men in the late 19th Century, and, unlike tattooing and most types of piercings, nipple piercing was a purely English invention.

RE: What's the most difficult place to tattoo?
"The inside of the foreskin, which some secretive people want. That's very difficult. There's one fellow who comes in who's cut his foreskin completely in two and I'm in the process of tattooing the inside of that now, a little at a time. It's very hard, as it's mostly scar tissue, and the ink tends to seep along the tissue beneath the skin if you're not very careful. For a tattoo to be done properly the skin really needs to be stretched tight, so it's difficult. I don't think it looks nice either."

Despite what one may at first think, there are instances when he will not work on a client. Nobody under the age of 18 (that's the law anyway). Also, any young men who come in asking for tattoos on their heads are turned away, as are people who want tattoos on their hands and other permanently visible areas. The same rule applies to piercings. If the customer looks young or undecided, Sebastian asks them to go away and think about it.

One can easily become very anthropological about man's innate desire to make marks when considering the subject of Body Art, but the real reasons people have tattoos and so on are quite simple.

We live in a Society that is synthetic and automatic. Never before has mankind been so distanced from his body, so the sensual, physical and mental kick of bodymarking – which heightens one's feeling of being physical – has perhaps never before been so necessary. And anyway, the body – the point at which our mind meets the outside universe – is also a good advertising hoarding.

Besides the straightforward decorative and physical

effects, having a tattoo or series of piercings is a sign of some sort of self-realisation. Of arrival. Of commitment to a certain kind of attitude and life. Hence the high number of homosexual men who visit Sebastian for tattoos. This also explains, to a degree, why so many members of gangs and cults, from Hells Angels to punks to Triad members, go in for permanent body marks. An indelible sign not only to your peer group, but to yourself.

In Arab countries the tattoo was used both decoratively and as a protection against evil spirits and physical harm by way of sympathetic magic and, not surprisingly, many people in Britain connected with formal 'occult' groups come to Sebastian for a variety of secretive images that mean little to the tattooist (Ray Sherwin & co. may be interested to know that I saw several Chaos insignia in Seb's photo album). Of course, such activities are nowadays more acceptable than they were in the past, but the interest in tattooing does seem to vary at geographical borders.

Relatively few people have tattoos in Holland, but there are now three full time piercers in Amsterdam (one bad, two good). The Dutch do, however, have more tattoos than the Spanish, who have practically none. One survey showed that some 50% of the male prison population in both Britain and America have tattoos before they go inside (largely a remnant of the fact that both countries have been the world's major naval powers). In Germany the figure's down to about 20%, in France less than 10%, and in Italy and most other countries it's next to nothing. Tattoos are still illegal in Japan, having as they do unpleasant connections to outlawed gangs and also serving to remind the Japanese of the occupying American soldiers and sailors shortly after the bombs on Hiroshima and Nagasaki.

In Britain, tattoos and piercings have never been more popular. Now, with years of experience and state-of-the-art equipment at his disposal, more and more people are hearing of, and trusting themselves to Mr Sebastian. His repertoire is imaginative. Both men and women can have several nipple piercings, through which studs, rings and chains can be worn. Most people who have this type of piercing find that not only is the sensitivity of the area pleasurably heightened, but the actual size of the nipple is increased. A ring or stud can also be worn on or near the navel, and a small piercing in the skin beneath the lower lip can provide a perfect resting place for the occasionally worn piece of jewellery (Sebastian himself wears a tiny diamond in his). Apart from the ears, of course, other head piercings include the nose – either outside or inside, (through the tissue between the nostrils). Besides the Prince Albert, many men also go in for short bolts – ampallangs – through the head of the penis, and smaller rings through the foreskin and down at the base of the shaft. All of which have the effect of increasing the intensity, and duration, of the orgasm. Women, too, occasionally come into the studio. Besides the normal small tattoos and head and nipple piercings, many

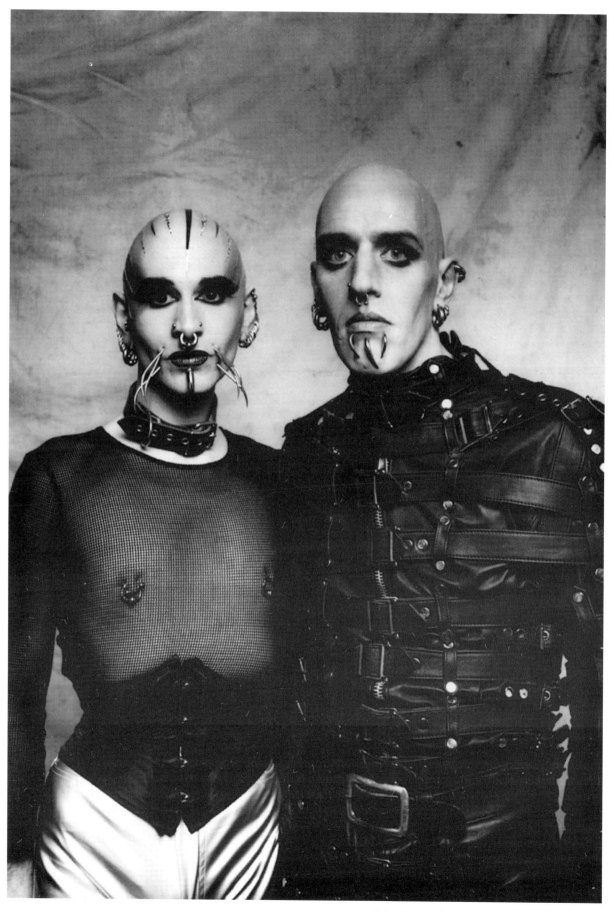

At the Torture Garden: photograph by Alan Sivroni

have rings put through both the outer and inner labia. And although Sebastian advises customers against it, many also have their clitoris pierced. Men's scrotums are pierced, and for the more masochistically inclined, Sebastian also supplies and can advise on the use of stainless steel weights which can be worn round the balls to stretch the scrotum to quite remarkable lengths.

Indeed, the word 'tattoo' still implies a sense of pain. It was, in fact, introduced to the language by Captain Cook (who else) on his return from the South Seas and comes from the Tahitian 'taku' – meaning 'to strike' – referring to the painful technique of holding a sharp-pointed instrument, usually made of human bone, against the skin and tapping it with a small hammer.

The ritual, painful 'initiation' aspect of tattooing is still evident and will be known to all small boys who own a blood and ink stained compass, and even though in Sebastian's hands the operation is practically painless, I wonder aloud if masochism does play its part.

"I don't think so. I know a few people have got erections when I've tattooed or pierced them, but it's very very rare. One tattooist told me of an old customer who asked him to make it hurt more once, and actually wanted him to dress up as a doctor and bend the needle so it caused him more pain! But he was the only one I've heard of."

The writer knows six or seven people who have 'erotic' piercings, and every single one of them have said that they were glad they took the plunge.

One of these is John Norton. John used to be an Advertising Executive, but he became bored and decided to drop out. Now he lives on the 17th floor of a block of council flats in South London, behind a mass of security cameras and broken lifts, with his wife and baby. A normal couple, under the skin. If one wants to pontificate, one could say that John's new 'birth' into a more free lifestyle was ritually marked by him undergoing a process of being tattooed and pierced, and talk about his innate need for a lasting initiation into this different world. An initiation that's left his body so marked with dancing dragons and serpents that it would be socially impossible for him to return to his old job in the city. But, really, that's all obvious. To John, tattoos are sexy and fun and, rather like motorbikes or stamp collections, provide the holder with a passport to a sub-culture that, in this case, is obsessed with body decoration.

The cult is served by magazines such as the aforementioned *P.F.I.Q.* and Britain's own *Body Art*, run by old *Maitresse* regular Henry Fergusson. John also contributes to this relatively new mailorder industry by producing the *Body Shock* videos and distributing them through his own company, Dragon Video. The tapes include interviews with a variety of tattooists and their subjects and a section showing Sebastian performing a piercing operation.

John Lomax of Brighton's Wildcat Productions also says that he's never had it so good. Wildcat have a thriving mailorder business specialising in body modification videos, books, and an amazing array of Ball weights, Bar Closure rings, Barbells with Stirrups, Ball Closure rings, Chunk rings, Tusks, Labret studs, Flesh Tunnels, Nipple clamps, Nipple discs and Cock rings. Wildcat also run party nights called *The Steel Ball* at a variety of venues that are a truly eye-popping experience. One party John threw recently had a guest who, as his party piece, could pass a large dead fish through a hole in his penis! What once may have been the domain of men in dirty raincoats is now a realm of fantasy, fashionable fetishism and, above all, SAFE FUN. You cannot take yourself too seriously if you have a dead fish hanging out of your willy.

The burgeoning interest in relatively safe sexual practices that do not require the exchange of bodily fluids has led to an enormous interest in the bondage and S/M scene. Now, it is quite *de rigueur* for trendy couples to attend clubs like *The Torture Garden* in leathers, rubbers and plastics, and the demand for piercing and tattooing has never been greater.

Unlike tattoos, which require painful surgery to remove and leave an often horrendous-looking scar, one can change heart over a piercing by removing the inserted rings. This will either have the effect of making the piercing all but invisible, or, in some cases, allow the hole to seal up for good.

Interestingly, no one I know has allowed this to happen. It also says something for the allure of piercing when one realises that after the 'operation', men cannot have any kind of sex (including masturbation) until the piercing is completely healed; sometimes taking up to 10 weeks. From all accounts the frustrating wait is worth it (even though – and don't tell Sebastian – nobody I've met has lasted the full 10 weeks before indulging). But is it legal?

Sebastian rolls his eyes. *"Well, it's not actually illegal. I just don't think the powers that be really know much about it, unless they read books like this. I do have a licence to pierce ears and I'm also officially allowed to tattoo people. The health inspector has been around here and checked the place and my equipment so... it's legal!"*

Perhaps Her Majesty knows something that we don't?

FROM WASTELAND TO UTOPIA
The Visions Of Gilbert & George

Simon Dwyer

"The most beautiful, moving, original, fascinating and serious art piece you have ever seen. It consists of two sculptors, one stick, one glove and one song."

EAST

The claustrophobia, the rattling train, handprints on the window, averted rows of eyes, trainers, suits, jeans. Adverts, coloured flashes, images... the tube thuds into Aldgate. A black hole. Buskers, beggars, hard looking black boys and skinheads with union jack tattoos, art students who look like skinheads, DM's squeaking. Cars, buses, taxis, streetcorner newspaper sellers, vegans, communists selling broadsheets, Pakistani girls in purple saris, an Hassidic jew walking to work at Hatton Garden, litter, the smell of the daytime pub wafting out onto the street – beer, cigarettes, betting shop, prison. Burger wrappers and crushed glass. Cut-ups of my old home, that nobody sees, modern and beautiful under a bruising sky. The vast grey concrete sprawl, the blackened brick sweat-houses, the empty market, the dark echoing shadows...

When you walk, with some trepidation, into an exhibition of the country's most notorious, highly priced contemporary artists, you walk into an ultra-modern cathedral of colour and light.

The vast pictures glow as if stained glass, huge images of faces stare down at you from behind bunches of day-glo roses, crucifixes, swastikas, tower blocks and drawings of enormous cocks. It could be that these gargantuan pieces are all part of a gigantic collage, a collage that shows the landscape of modern life as it really is. It's as if the whole of the picture already exists – in your own mind. This is why the exhibition's pieces are so stunning, so absorbing and recognisable. Many utopianists – including, it must be said, Albert Speer – have dealt with giganticism, clean, strong images, symbols and symmetry. These pictures are not merely decoration for the white walls of a museum, they tell you that the artists are no different in this search for social utopias.

The element that has the greatest effect on the viewer are the faces, and the eyes of the young men used as models in the pictures. These are the eyes of Londoners in the Nineties.

They are sad eyes.

Fournier Street is an elegant, if anonymous

side street sheltering in the shadow of Nicholas Hawksmoors' beautiful, peculiar church just around the corner from the now darkened Spitalfields Market. A cut above the houses which surround it, the street was built by the French Calvinist Protestants who fled to the East End to escape the religious persecution instigated by Catholicism at home. Now, the corner pub has lunchtime strippers, the unforgiving stone of the church steps is home to half a dozen piss-stained winos, and cute Bengali children play outside the excellent greasy spoon market café.

The two middle-aged, besuited men – looking like tweedy gemini twins from Burtons – lead me in to their home up a mountain of creaking highly polished wooden stairs: past gorgeous wood-panelled rooms full of gilt framed paintings, tapestries, sculptures of Christ, fine carpets, gothic furniture and superb pieces of Barnstaple art pottery, Elton-Ware, Watcombe-ware, and glazed vases from Christopher Dresser.

I am at last seated in one of the most comfortable chairs in the world (which I'm casually informed was designed by the gothic designer Augustus Pugin, who designed the interior of the Houses of Parliament), the smell of coffee and cigarette smoke fills the air, and I am faced by two of the most famous artists in the world: Gilbert and George.

I worry if I have to play a game, a game which the *enfants terribles* of the art world are notorious for playing with journalists they dislike – they talk in unison, or in sequence. They talk

as if they are one person, or as Siamese twins. Having sacrificed their identities – and surnames – to art, every moment would be considered a 'piece'. As showroom dummies, they showed not a glimmer of emotion as they would strive to be as deadpan as possible, throwing out controversial quotes that would be reported as obtusely as only journalists can make them.

One such unwitting victim of the game was the perennial bore Waldemar Januszczak, art critic for *The Guardian* and predictably a favourite face on BBC2 art programmes. Interviewing G&G, he fell hook, line and sinker into the game when Gilbert called the venerable Pablo Picasso a "foreign dago wanker". Blasphemy! Oh, racist blasphemy at that! Poor, sensitive Januszczak fled home and penned one of the most critical pieces on contemporary artists written in the PC rag for some time. Has the stupid Armani-clad buffoon no sense of humour?

The truth is that Gilbert and George are reviled for being racist, misogynist, uncouth fascist faggots by ninety percent of the critics who effectively run the British Art Establishment from behind their desk top computers.

Peter Fuller, once art critic of the *Sunday Telegraph* and the editor of *Modern Painters* admitted to writer Daniel Farson that he actually hated them. Predictably Roger Scruton, the self-styled intellectual of the right whose name has cropped up in previous editions of *Rapid Eye*, wrote that Gilbert and George's work "could not be art, as there is nothing in it to understand". Amazingly, from his (padded) ivory

THE QUEUE

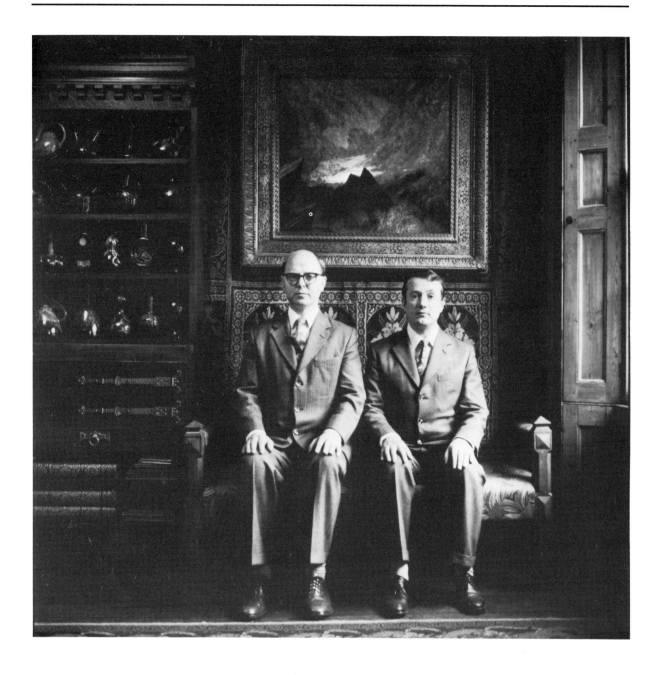

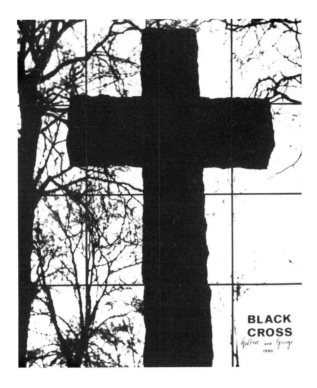

BLACK
CROSS
Gilbert and George
1980

tower, he finds no emotional response to their work, and the reason for that is because he is so tutored in classicism that he is not sensitive to avant garde art, and so insulated from the day-to-day hopes, fears and aspirations of the average working class East Ender to recognise anything in the pictures to which he can respond.

GEORGE: Our aim is through friendship formed between the viewer and our pictures. Each pictures speaks of a 'particular view' which the viewer may consider in the light of his own life. The true function of art is to bring about new understanding, progress and advancement. Every single person on Earth agrees that there is room for improvement.

DOSH

Even when Gilbert and George donated a reputed £600,000 of their own money to AIDS charities and staged an AIDS-related exhibition at the Anthony d'Offay gallery in 1989, harvesting their first good press, Giles Auty wrote in *The Spectator* "Can one sensibly question any calamities that befall a society which makes Gilbert and George heroes?"

So, I had been assured, these were technically clever, sleazy fascist misogynists, peddling meaningless, super-sized porn, acres of emotionless, disgusting, dark art to foreign collectors.

RE: What's your relationship with the people who buy your stuff?
GILBERT: None. None.
GEORGE: I suppose if we could do it without selling pictures we would.
GILBERT: We would prefer it.

They enjoy their money without ostentation. They've used it to finance exhibitions, get books published by young artists and writers they admire, such as David Robillard and Andrew Heard, who have since both died of AIDS – and plough it back into their work. At present they're hoping to buy the house next door to turn into an extension of their studio.

In 1990, the couple staged a vast retrospective exhibition in Moscow, taking their art to the people. The pictures were driven to Russia in articulated trucks, and there were seven tons of catalogues to be transported. The British Council refused to support the show, one British Diplomat in Moscow asking the Russian organisers why they were promoting the work of "two homosexual fascists". So Gilbert and George funded it to the tune of £135,000. A

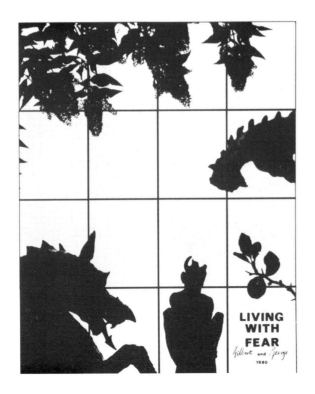

LIVING
WITH
FEAR
Gilbert and George
1980

similar sum was spent taking a show to China. Both were the first major Western shows of their kind, both an enormous success, with thousands attending. Gilbert and George proved that they could snub the system while becoming true ambassadors of British art, using their wealth to present the oppressed world with images that would affect them forever.

They never mention money, think it worthless and the pursuit of it stupid, spend it only on their growing antiquarian book collection and eating out at the best restaurants (they never cook, and have no kitchen or refrigerator in the house). They once turned down a fortune to appear in a worldwide car advert for TV. It would have been beneath them.

To give one an idea of their success, you can usually pick up a fair sized G&G for as little as $30,000, though their prices are rising. At Christies in New York, *Finding God* fetched $198,000, *Stepping* $165,000, and another work has gone for $300,000 – a cut of which goes to the artists' agent Anthony d'Offay, a longterm supporter whose agency turns over in excess of $30,000,000 a year. G&G are the brightest stars in his artistic firmament.

The room contains nothing from the last fifty years, except a portable colour TV and a coffee-making machine perched incongruously on a table. They chat about Coronation Street, which they watch religiously.

A pause for pouring the coffee; I look at Gilbert, small, dark, with piercing black eyes, he

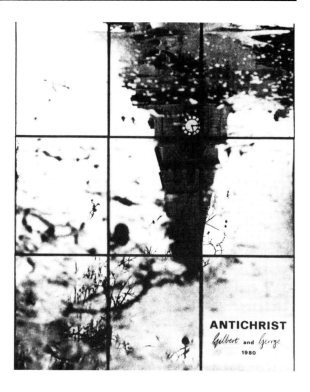

seems at first the more reticent. Then I look at George and think of him as he appears in some pictures, naked, with images of young boys proliferating. Now, like some doting uncle, with a cupboard full of 'physique' magazines from the Fifties, nestling next to a hand-signed first edition of Wilde's gay classic *The Picture Of Dorian Gray*...

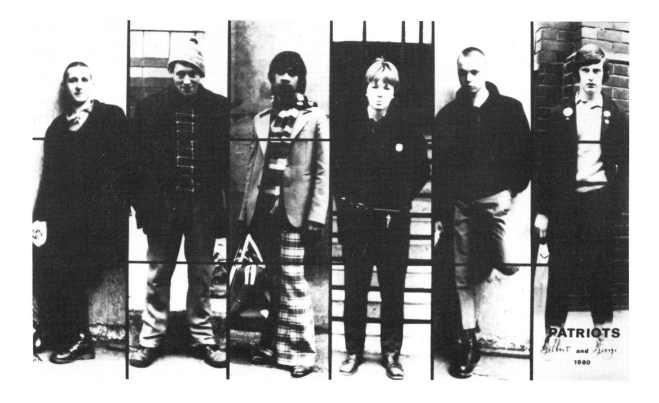

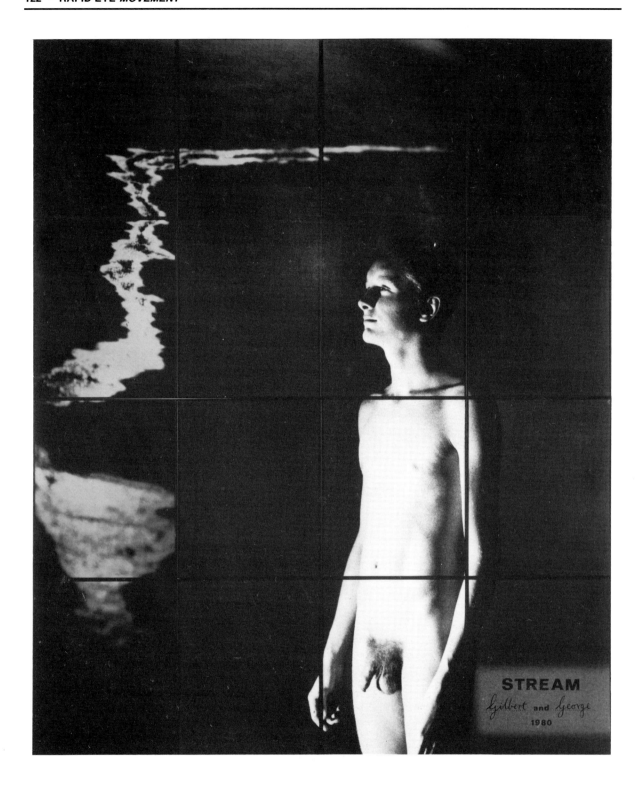

QUEER

RE: You don't get called 'gay artists' any more.
GILBERT: We try very much not to go down that road.
GEORGE: We never thought of ourselves as that. We don't think of that as an issue. Sex, yes, sexual yes.
RE: But it's not relevant to be necessarily gay or hetro.

GEORGE: No.
RE: Then what do you think of the gay subculture? I think it divisive now. When you go 'out', you also go 'in' to a micro world of fashions, clubs, literature...
GEORGE: We're not so keen on the divisions. We realise that in the Seventies they had to make a big stand, which was a good thing, but now it's

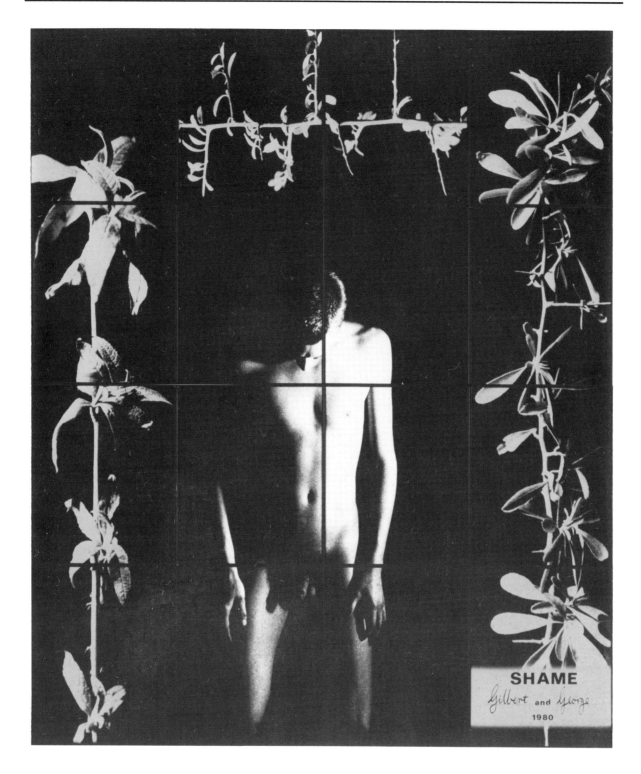

SHAME
Gilbert and George
1980

become a very habit-ridden idea. We don't accept the idea that every middle-class couple accepts the two chaps who live at the end of the road and wear jeans and leather jackets as being 'gay'. It seems such a bore.

RE: But I would have thought that it's better than not being accepted.

GEORGE: But you see before they would have accepted them just as the two chaps who live at the end of the road. They wouldn't be thought

of as 'gay' or 'queer'.

RE: So you're not politicised about it.

GEORGE: Not at all.

As with most avant garde artists – and G&G can be considered as such – there is a social utopianist undercurrent here. They want to change the world, not through political posturing, but through art, to make it more 'modern' in its outlook. More tolerant, more

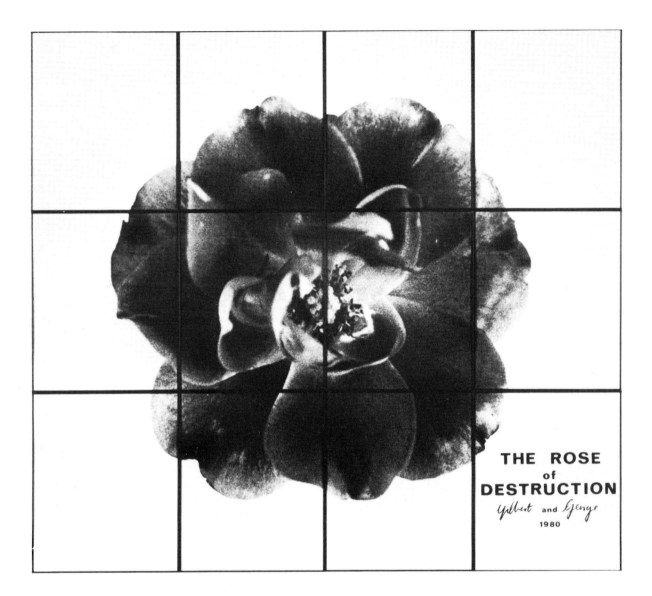

THE ROSE
of
DESTRUCTION
Gilbert and *George*
1980

aware, more peaceful and civilised, unconcerned with people's colour or sexuality.

GILBERT: We're interested in mixing it all up. In making it normal.

RE: Not a division. Making it a normal aspect of life so that people don't have to be defined by their sexuality.

GEORGE: We think nobody knows what 'queer' and 'straight' really are. We don't even understand what man and woman are.

GILBERT: We believe much of it is cliché. With cliché people don't have to think and you can make them do anything.

RE: So it's easier socially to manage them.

GEORGE: Yes.

RE: Your art and writing encourages change, particularly in young people – who you call 'modern people'.

GEORGE: That's the main... we know much younger friends... post-G&G people you can call

them... they just don't think of sexuality in divisions.

GILBERT: And you can talk about anything.

GEORGE: They don't think 'gay', 'straight' or 'queer'. They don't ask if the friend coming to dinner is queer or not, it's not an issue.

GILBERT: And that's very good.

GEORGE: It's not 'this is the straight one, this is the queer one'. You don't know. Until the law changed in 1967 most homosexual men were married with children – lots of people.

RE: You only use young men and boys in your photos. Many say that they are homoerotic...

GEORGE: Only if you accept that every Page 3 girl is lesbo-erotic. No-one ever says that.

As their friend Richard Dorment has pointed out, the boys used are hardly idealised images of Adonis, but rather undernourished kids in Parkas. The artistic tradition since the Renaissance has held Michelangelo's David and

Belveder's Apollo to be the ultimate representations of male beauty and sexuality. But these boys are rarely heroic, nor sexy. And if they wanted some kids to wave a flag, they could have found better specimens than these to interpret the fascism of which they're accused. These lads remind you of the East End street rogues from the days of Hogarth and Sickert.

GEORGE: All men have cocks and we *are* interested in sex. We don't do eunuch art. There are no great eunuch artists. We don't want to decide what a person does with their hands or sexual organs. More importantly, we're normal.
RE: How do you get your models?
GEORGE: Word of mouth, locally. We pay a certain amount.
GILBERT: They tell their friends.
RE: Do they know the implications?
GEORGE: We show them the catalogues. They love them.
RE: I don't suppose previously they've had any attention.
GEORGE: They love posing. They feel that during the session they are something after all. They all mention it when we ask them. We like to use models who have prominent eyes – we can't use people with deeply set eyes – and this gets around, so one day we open the door and there are a group of local Pakistani kids asking if they can be models, and all of them are forcing their eyes wide open to make their eyes look bigger!

FEMINAZIS
RE: One PC criticism of you is that you don't include women in your work.
GILBERT: We are not politically correct.
GEORGE: Perhaps *too* politically correct. Actually we don't get much criticism from feminists, except the feminazis in America who hate gay men. Modern feminists should agree with us that we are not exploiting women. It became interesting because all over the world people started asking us about women. They never ask Anthony Caro about women. But we know nothing about women. Most other artists have used women's images for centuries, the art world is run by men.
RE: So, you're not objectifying women in any way...
GEORGE: Also, men are the sex that women are most interested in. The moment you exclude something in art it becomes important to people. We didn't even think about it.
GILBERT: They decided for us.
GEORGE: But it became a very important issue since then... Before that it was all women, women, women in the media.

GILBERT: Now man is becoming a sexual being again.
GEORGE: For the first time in centuries. When we were young students at St. Martins there was no male image available except the Sandeman Sherry Man and the Moss Bros man – the English gentleman. Young men in chipie trousers, black men, workmen were just not published in the Sixties.
GILBERT: And we had to fight very hard

because, as you said, they thought that every male image in our pictures must be homoerotic. We always deny that. We say they are men.
GEORGE: Persons, in fact.
RE: I think men have had a rough time in the media and so on over the last twenty years. Practically all magazines are edited by and aimed at women, if a guy gets his penis cut off by his wife it's thought of as a joke, whereas if he cut out her cunt he'd be lynched. In every TV

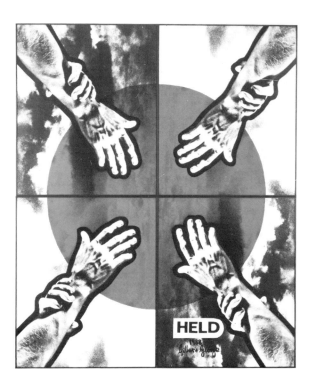

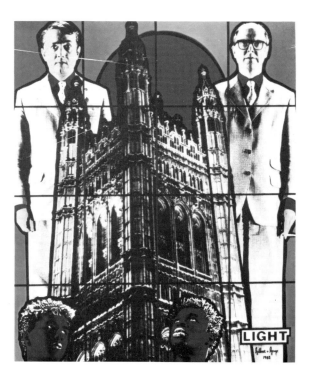

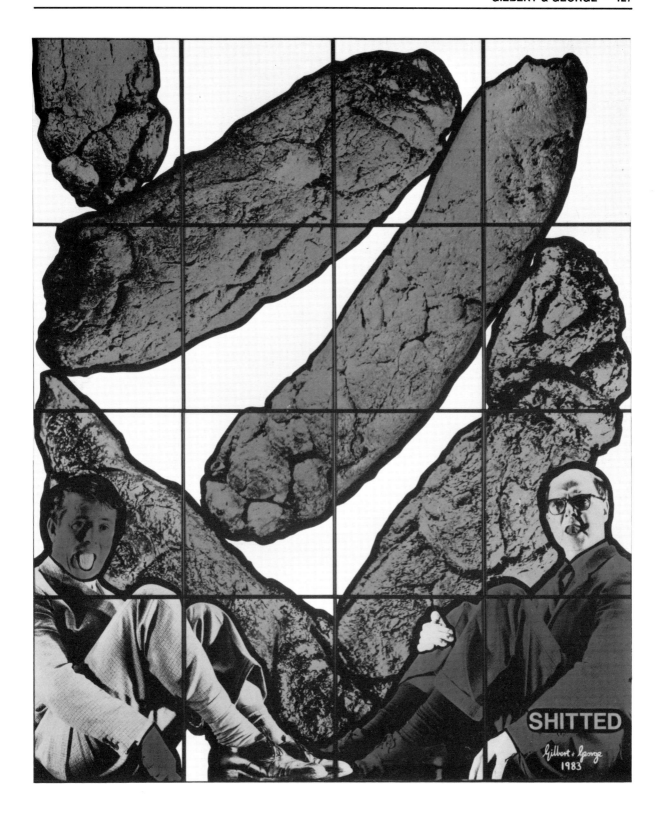

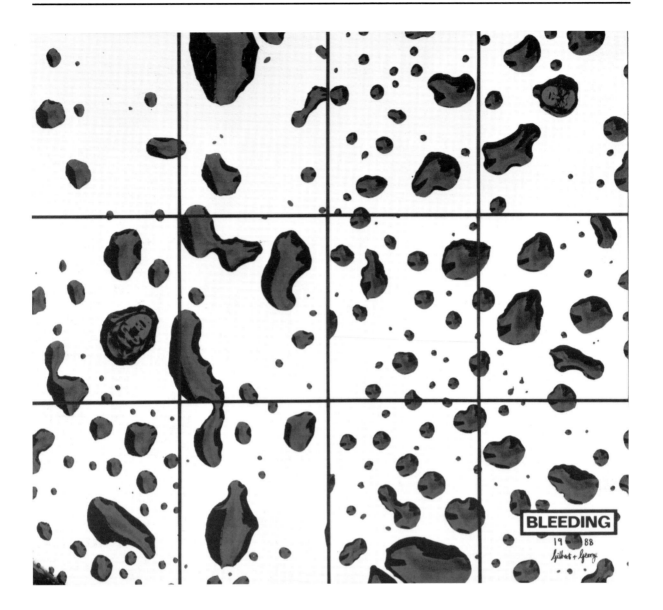

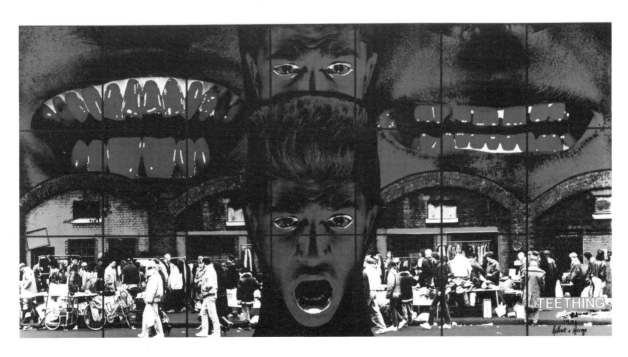

advert or sitcom the man is the stupid one, and the butt of all the jokes.

GEORGE: We're very opposed to that prejudice. We see it so much on TV, when the wife takes the chip and puts it under his nose...because the other way around is forbidden. The man in the sitcom is a wretched creature. But this view will not last. The feminists can never win an argument now because it is people like us who are doing a better job for a new truth, opening doors, to find new ways of living... And I'm sure we had a lot to do with that.

G&G: We invented and are constantly developing our own visual language. We want the most accessible modern form with which to create the most modern-speaking visual pictures of our time. The art-material must be subservient to the meaning and purpose of the picture. Our reason for making pictures is to change people and not congratulate them for being how they are.

GILBERT: It became important to us to show naked pictures in museums, put dirty words in museums... in America they wanted to take them down, even in New York.

RE: Have you had a problem with censorship?

GILBERT: Oh yes.

GEORGE: Our film *Jungled* is basically banned from television. It's been offered every year for fourteen years to BBC2, Channel 4. They show arty films, but they won't show us. One producer said he'd rather drop dead than have Gilbert and George's film on his show. Nowadays *The South Bank Show* features jazz musicians and alternative comedians as art.

G&G may well have good reasons for their paranoia, though they did win the Turner Prize in 1986, and accepted it "to annoy people". They have also been feted (and copied) by rock stars such as Dave Stewart and David Bowie, and invited to dine by former premier Edward Heath at his Salisbury home. Their work has shown at the Guggenheim, Tate, and in all the world's major cities.

RE: And the paintings?

GEORGE: We always try to do it in a delicate way. We think we know the line you can go up to in any city and we take it to that line and get away with it. We don't like the idea of confrontation. We don't think its productive to go up to someone and say 'You do agree with this don't you? And if you don't you're a stupid cunt.' It's much better to be subversive, to get away with it. Once people see *Shitted* that's it. They might say that we shouldn't exhibit it but it's too late because they're already commenting on the picture.

GILBERT: All these art critics love to accuse us of using dirty words and they love to write them all down, the 'Buggered' and 'Fuck Off'.

GEORGE: "These disgusting artists did these pictures...!"

GILBERT: All the time.

GEORGE: And that's very funny as these words will be printed in a newspaper that can't publish those words otherwise. Infiltration. To be against, they have to be won over partly, to become a part of it.

RE: Then they should at least think – though they probably don't – why they are opposed to it.

GILBERT: It's very interesting because we have a young Polish friend who is trying to write a book on us and he went through the press of the show. It was a huge success, so it took the critics' power away. So instead they talked about "The fulfilment of Goebbels' dream"...

ART

Gilbert and George's art is not easy on the eyes, or the brain. What the images provoke leave the Art World confused, scrabbling for explanations.

RE: I think people feel uneasy responding to your pictures because they are direct.

GEORGE: People are not used to that in art. That's the trouble.

GILBERT: There's nothing that speaks in art at the moment. Abstract canvasses don't speak. Nothing speaks.

GEORGE: They only exist... I remember when I first came to London when I was twenty, I went to the Tate. There was one of these groups being lectured looking at one of those ballet pictures by Degas, and this posh man asked them to say what they were looking at, and the poor things said "a ballet dancer". And then he put on a very superior smile and said "No, what you are actually looking at is the shapes between the legs." Jesus Christ! Complete nonsense. It's unbelievable... complete shit.

RE: The art world talks out of its arse. The interpretations get more ridiculous as people try to justify themselves.

GEORGE: It's very interesting that the same class of person that is pro-humanist is totally anti-people when it comes to fine art. They're the most patronising decadent bores. Totally hypocritical in fact.

RE: The problem is you have chosen a medium that is dominated by rich people and academics.

GILBERT: The problem is that art is based on rich people... what you are allowed to do is dependent on the money of these rich people.

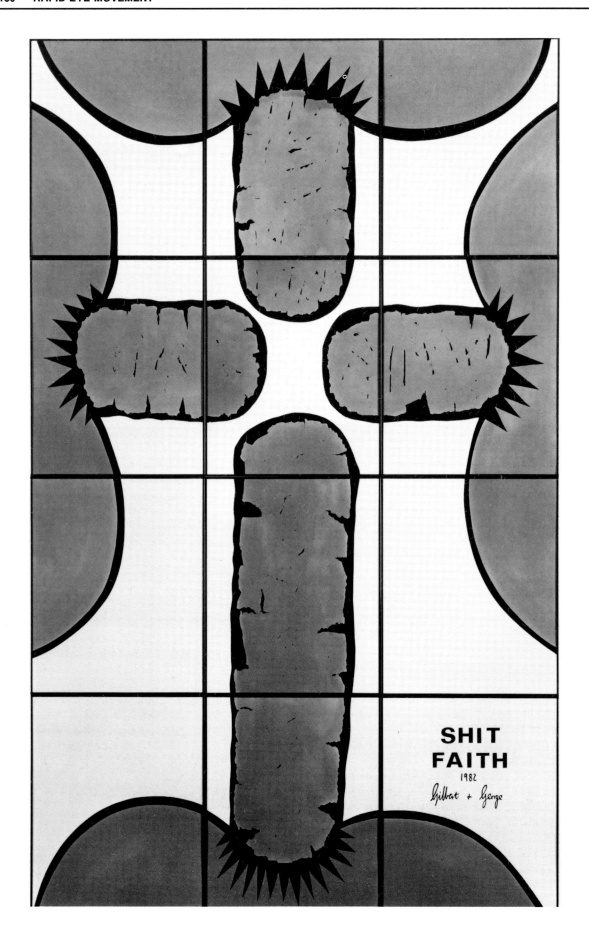

If we do things that are so extreme they don't want to buy them we'd have no money to do our books. It's difficult.

GEORGE: I think we've got around that more and more. A lot of people who love looking at our pictures have their own reasons, whereas what we call decadent art is only good if it's supported by those professionals, who don't know themselves what it's about. There's a bucket of water in the corner of a gallery, you don't know if it's good or not but if you know the leading museums in the world say it's good you accept it. Whereas we think people accept our pictures – person to person pictures.

G&G's pictures are evocative because they are honed from real life focal points – Fear, Hope, Sex, Death, the Head, the Soul. Each picture provides the viewer with a frozen moment of one of these 'arrangements'. They speak directly to the viewer who does not need to have been tutored in what to look for in art.

RE: I often find your pictures disturbing.
GEORGE: I'm sure they are.
RE: Why do you think I find that?
GILBERT: Because we always like to get involved in taboo subjects. First we decided we are the art and the speakers – that's how we started the Living Sculptures. We are speaking through images, through postcards, drawings. The subject... we thought we should just continue to have a man, instead of just us we should have other men in our pictures. That became the big subject.
RE: Do you see your pictures as being able to be read in a narrative way?
GILBERT: Yes, if people want to. It's not so simple. We don't make a story out of our pictures.
GEORGE: We know from the variety of responses.
GILBERT: I would agree that some pictures are more narrative, some less, they are all based on deep inner emotions, feelings.
RE: You want those emotions and pictures to reach as many people as you can.
GEORGE: Yes, as ART. That's very important. We don't believe in the art going out to a wider public if it's not known as art. They firstly have to know it's art.

Which is why they turned down the TV ads, and the offer to make billboards for London.

GEORGE: This is why we like them to know they are going to a gallery to see art that is very emotional and speaks directly to the viewer.

Doesn't matter who he is, he has been spoken to.
RE: Is it important that the viewer understands your original motives for doing it?
GEORGE: We don't know exactly. We try to fall into some new picture. We don't go into the studio with our head filled with ideas of how we'd do it because we'd be doing pictures we'd done before, and we always use new images in each project. We try to be incredibly honest... zonked... dead headed... try to grind something out of ourselves that's so true on some delicate aspect of what we're all doing.
GILBERT: If it's so true it becomes true for the viewer. They see themselves, they are searching for themselves. The viewer is not going in to see G&G, he is going to see that art does relate to him.
GEORGE: We always say that if we can take our catalogue onto the street and show the first person and they are interested in some way that's OK because with every other catalogue they don't know what the fuck it is. They have just been told it's an art exhibition.
RE: We spoke earlier of the people who run art, but I think the artists themselves are so pretentious...
GILBERT: Totally pretentious.
GEORGE: Most people don't say that.
GILBERT: They are going down that road again totally.
RE: And it's elitist.
GEORGE: We like very much the platform of art. The formality of it... the idea of a rectangular picture. But we always fight for a more generous art world.
GEORGE: We hate the inner circle based on the artist. They do such weird stuff that nobody understands.
GILBERT: And they're accepted by the inner circle and that's it. And they all LOVE each other.
GILBERT: The fewer people who understand it the more they feel superior. It's all based on fear, fear of looking stupid. That's why we prefer publications. That's how young people contact us, through catalogues, not through exhibitions... too difficult. Once in a lifetime they let you into the Hayward Gallery and they don't want you after that.

Even now, Gilbert and George's work, bought by Nicholas Serota, a former progressive director of the Tate, is kept in deep storage by the new regime.

SHIT FAITH
GEORGE: We have a fan in the H Block in Belfast

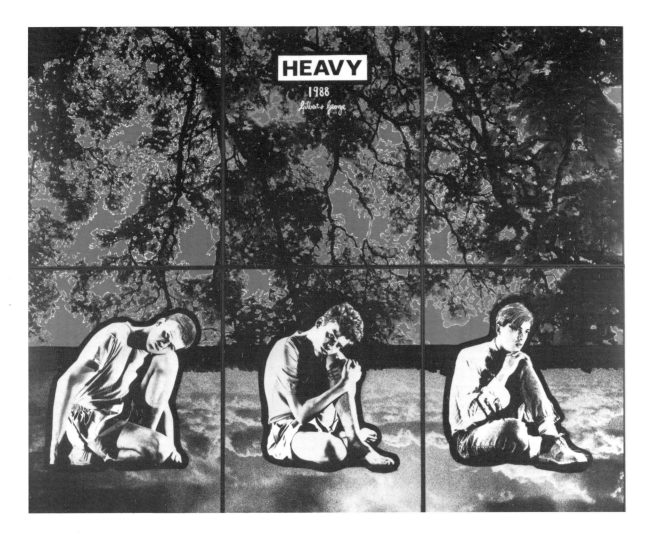

who writes to us. He's seen our catalogues. He writes to us regularly. It's quite exciting.

RE: The troubles in Ireland are the epitome of stupidity, and religion doesn't help it.

GEORGE: *Shit Faith.* We just had a letter yesterday from a German student.

GILBERT: Studying philosophy. He found a postcard on the floor, which illustrates the point, the picture of four bums with shit coming out of them forming a cross, and he said it changed his life completely.

RE: What does *Shit Faith* offer?

GEORGE: Amazing freedoms if you haven't come across that before.

RE: Your only political act seems to have been in criticising religion in your pictures.

GILBERT: We are anti-religion. Eat and shit. If you are able to say that in Europe that shows amazing freedom. In Munich they made us take it down.

GEORGE: We do think the church should be taken to the European Court.

GILBERT: For lying.

GEORGE: You could get them under the Trade Descriptions Act. We've had to go to funerals

recently and the Vicar said this person is not dead, he's already in Heaven. He should be summonsed immediately.

GILBERT: And the Pope.

GEORGE: You have to think of the number of people dying due to his discouraging the use of condoms – with AIDS being probably the world's most common killer soon. In South America every day people get HIV because they're Catholic.

GILBERT: This German was saying how difficult it is in Germany now with all this back-to-basics morality.

GEORGE: Neo-Nazis.

RE: This new morality is worrying, particularly in America. It's informed by AIDS.

GILBERT: Yes, an excuse.

GEORGE: Must have been the long dream of the bigot. Fulfilment of all their hopes. They are all there. You have these intelligent people, they are all bigots inside. Can you imagine *The Times*, which has been regarded for the last twenty years as a platform for liberal ideas, may actually dispute any connection between HIV and AIDS. Incredibly irresponsible.

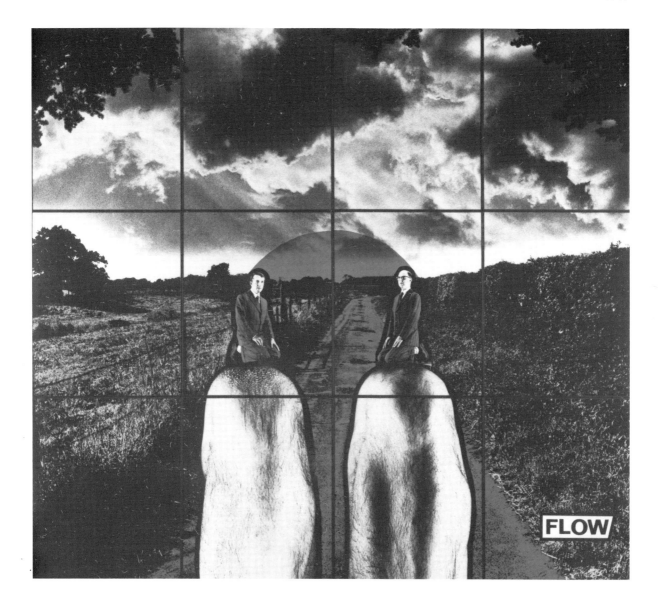

These journalists should come to the HIV clinic which I attend and see the HIV+ patients decline. Contracting HIV in London in the early Eighties, in the last two years I have lost four stone, had numerous infections and hospital visits, and I am now temporarily wheelchair-bound as the virus attacks my very being. I lie, wasting away in the bigot's fire – but we shall fight these madmen and this fucking virus till the last in this publication by supporting new ideas, new concepts and new, peaceful ways of living as offered by Gilbert and George.

GEORGE: We did the AIDS show as we've had quite a lot of friends die. It changed the way some critics looked at our work. They had never looked before. They started to see for the first time. It's taken a long time.

Their past is hardly relevant to their current art, as they gave up their identities, their histories, for their art. Everything they do is dedicated as a part of the art process that spans every action, moment, movement. Gilbert and George are living sculptures, 24 hours a day, every day. We are *all* artists, creating moments of sorrow and beauty as we walk through day-to-day existence. We get up, wash, dress, go and do some kind of work, eat, shit, get drunk and in so doing can find and experience the wonder of that existence.

George's existence started in the docklands of Plymouth on January 8th 1942. The 'stinking nazi' bombing of the city created an inferno so terrible that the jewellery in shops' windows melted, forming streams of silver and gold in the streets with the molten window panes. Plymouth was England's sixth largest urban mass, though many of those who fled never returned: during the Blitz George's mother took

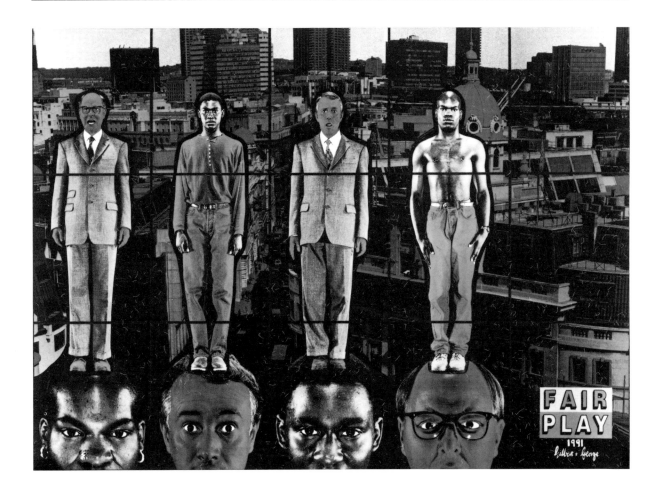

him by bus to the unlit suburbs, then crawled through the dark countryside to a refuge. He does not know his father, who he tracked down to a village in Devon. Approaching a man in a pub, he asked if they could talk in another room. George asked ten times, and the man only relented when he told him "My name's George, I think I'm your son." They have not met since. Attending Dartington, George progressed on to St. Martins School of Art in 1967, where he met Gilbert.

GEORGE: We didn't plan to work together, people just pointed out that we were. It just came over us.

Gilbert was born in the Dolomites, north of Venice. "From the age of four I have always supported myself" he says, without elaboration. Studying art in Munich, Austria and Italy, he moved to England wanting to go to what was then the most progressive art school in the world. He's been living in London so long, he now considers himself an English gentleman, though retains a foreign accent.

Being influenced at the college by Bruce MacLean, they took up postal and performance art. Their Fluxus-like mailart exploits consisted of collages with sayings printed on them such as *All my life I gave you nothing, and still you ask for more*, as well as invitations to events. Plus of course there was their limited edition book, *Dark Shadow*, which showed a hilariously schoolboy piece – photos of the couple with 'George the shit' and 'Gilbert the cunt' written on signs around their necks. But it was not until after graduation that they hit upon the idea of Living Sculptures.

Art wasn't confined to galleries, it became them, they became it, sacrificing their individual identities (if not their personalities) to art. It was a revolutionary act that has been overlooked by art critics, but for which they will be long remembered.

Art took over from 'normal' existence, from which they opted out. They rise at 6am, wash, put overalls over their suits, and go into the studio to submerge themselves totally in the work at hand. They have lunch at 11am in the market café across the road, and return to work by 12am, often working into the night. They have little help, preferring to work together in their studio, which consists of a podium, lighting and photographic equipment, and serried rows

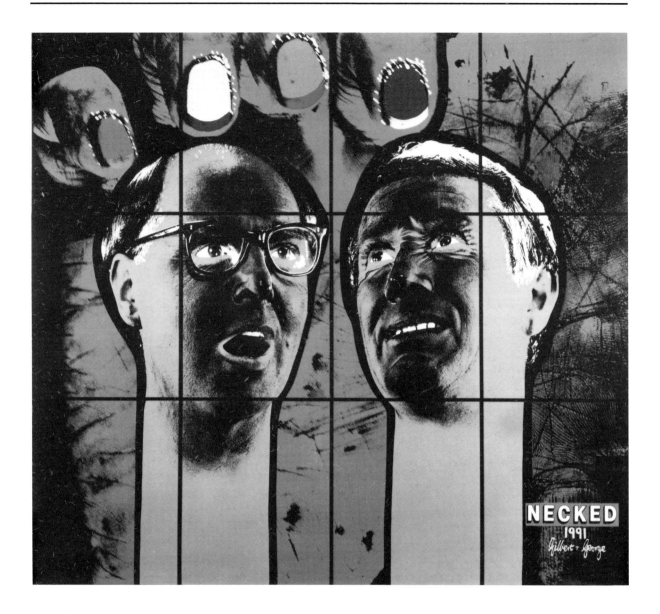

of coloured dyes, all marked 'Blue', 'Sky Blue' etc, and having a pair of rubber gloves beside each bottle. They have a library of over 70,000 photographic images to work with, but use new images for each new exhibition project.

The technical feat of producing sixty-foot photo montages in a room of about 40 feet, of enormously enlarging photos, of painting panels and trying to image if they will fit together, is stunning and demanding. So, when, after months, a particular project is finished, they go on a drunken bender in the winebars and restaurants of London. They particularly enjoyed the early punk clubs such as Blitz in the late Seventies. Both have been beaten up by queer bashers, both have been arrested for being drunk and disorderly. They are very naughty boys.

To give you an idea of their mischievous sense of humour, Genesis P-Orridge in Los Angeles told me a story about them from the late Seventies when he, and G&G, were appearing at a festival of performance art in Italy. Genesis, G&G and a women with a baby in a pram shared a lift in the hotel where they were staying. The baby was crying loudly, and in a deadpan voice Gilbert commented to George what a horrible specimen it was. George replied in his deadpan, posh voice 'Yes, disgusting. Shall we eat it?' The woman fled from the elevator at the next floor.

In the late Sixties, G&G left college and decided to make themselves into art. Not just by adopting a persona, as had Warhol, Dalí, Beuys and, later, Jeff Koons, but by becoming full-time pieces of daily functioning art.

RE: Was the Living Sculpture period a statement that all life is art?
GEORGE: Partly, yes. And partly because we

didn't have anything else. We left college, had no money. Every student who was a goody-goody went for a studio or teaching job. We knew we could never have that. We were already discriminated against. We realised that all we did have was ourselves so we thought that must be the art. It worked like magic.

GILBERT: We hated formalism very much.

GEORGE: Lines and squares and circles.

RE: You went for a walk in Hyde Park and filmed it, coinciding with the NASA Moonwalk that day [*People often miss out on the fact that G&G's work is funny*].

SINGING SCULPTURE

They shot to fame in their Singing Sculpture mode, wherein both G&G posed either on a podium, or attached to the gallery walls, moving occasionally to the recorded accompaniment of Flanagan & Allens' Depression era song about two down-and-outs sleeping rough under Charing Cross railway station in central London. At the time, the words were apt:

"The Ritz I never sigh for
The Carlton they can keep
There's only one place I know
And that is where I sleep

Underneath the arches
I dream my dream away..."

Some of the performances lasted eight hours, the 'show' being a hit in London, New York, and across Europe.

GEORGE: It was a democratic idea. We thought that we could be art and artists without the profession.

Using themselves as art involved inviting an audience to a venue in Bromley where they could watch Gilbert and George have lunch with their friend David Hockney. They are, as they say, the equivalent of Joseph Beuys' dead hare in art.

RE: Why use yourselves so much in your art?

GILBERT: That's how we started.

GEORGE: It's our best invention. When people see us on the street it's a different experience than seeing, say, Howard Hodgkin or any other artist.

GILBERT: We are the art.

GEORGE: Politicians and sportsmen are like that.

GILBERT: Even when you talk about Oscar Wilde, I only know the name and that he went to prison. He was a living sculpture.

RE: Your imagery now is very much associated with the powerful image of fascism. Even your postcards are called 'sculptures', which implies that they are monumental, significant...

GEORGE: We think there are things lurking in people that come out when they look at our paintings, not if they look at an abstract painting. If they have feelings about race they will probably start saying them in front of our pictures. If they have problems with fascism it will bring it out. That is what art is for. Isn't it funny that all that class of people who attacked us for having skinheads in our work *became* skinheads? If you walk into a private view of a new artist it's like going to a National Front meeting. Girls and boys who look like skinheads.

GILBERT: Queer and posh.

GEORGE: The anti-Nazi movement look like skinheads or Auschwitz victims – just what they are opposed to. All the girls have thin faces, are skinny and wear black clothes.

GILBERT: They are totally censorious.

GEORGE: Anti fun. In fact, a disproportionate number of black people come up to us in the street and compliment us on our work.

GILBERT: Because we are the only contemporary artists using black people in their work.

GEORGE: One black businessman told us he liked our pictures because he saw himself... that it was not an issue... and that he was sick of seeing these anti-apartheid posters with someone being strangled over a collage of a black person.

RE: In newspapers black people are always portrayed in one or two ways, as a criminal or a victim of famine or violence. They will show close-ups of black people dying, but never show that in Northern Ireland.

GEORGE: I think there's a free prejudice to do that.

GILBERT: As in the Western films. The cowboys can shoot them down by the thousands. When John Wayne gets shot you get a big conversation as he takes 30 minutes to die.

GEORGE: It's a cliché. Calling someone a fascist. In every sitcom if the dad doesn't let the daughter go out to a party she says he's a fascist. In fact fascism came out of socialism and conservative politics. Very boring. We don't mind being called fascists. There's nothing we haven't been called anyway. One critic accused us of being homophobic. I didn't know what it meant.

GILBERT: It's very silly.

FASCISM

Gilbert and George choose to live in an urban area that is a melting pot of cultures. Although they consider themselves patriotic, they are

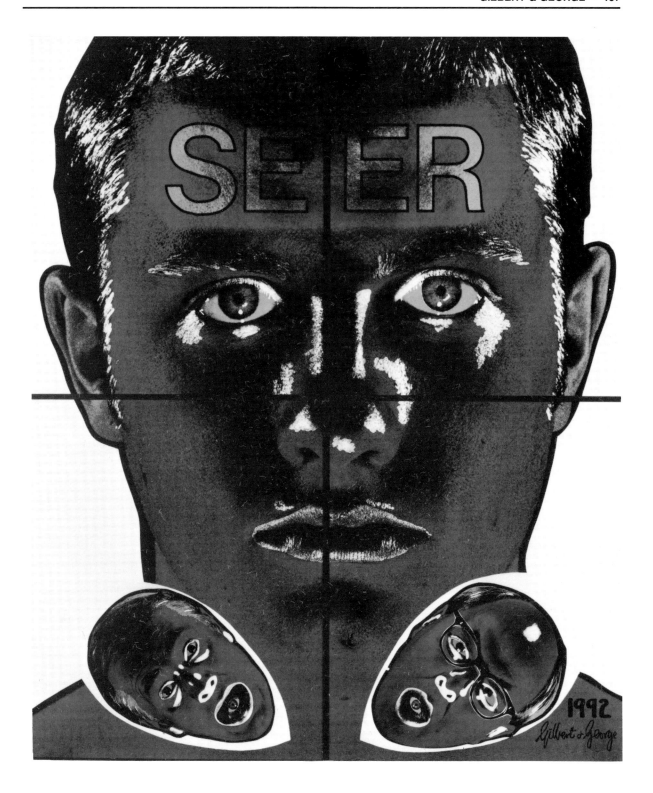

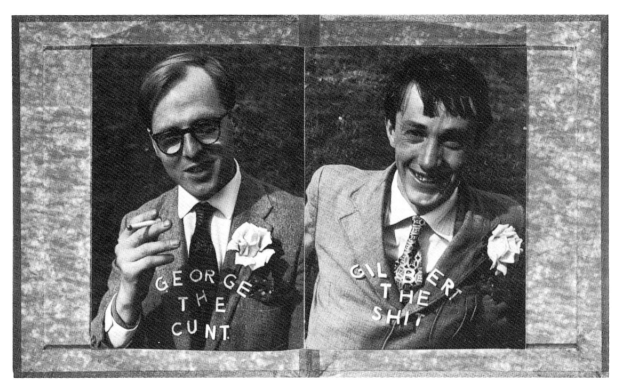

'George The Cunt & Gilbert The Shit'. A Magazine Sculpture, 1970.

'Hyde Park Walk'. A living piece, 1969.

proud of being English gentlemen within a multi-cultural country. Their cleaner calls them 'the nicest people you could hope to meet. I love them. Prejudice? I've never encountered any at all. They're the only two humans I've met. To me more than a friend, more than a brother. I have no words to say how good they are. I wish half the world was like them, then it would be a perfect world, everyone would be treated as equals.' Stainton Forest, the cleaner whose words these are, is West Indian.

RE: Is this area very Bangladeshi?
GEORGE: It is now.
RE: How long have you lived here?
GEORGE: Twenty-seven years. It was entirely Jewish when we moved here.
GILBERT: We like the Indians very much.
GEORGE: We have one Indian family who we are very friendly with. They come here for drinks, the kids sit on my knee... Our adopted family.
RE: You're in a financial position to live anywhere. Do you find this area resonant? Could you produce work in L.A.?
GEORGE: Not for one moment. We always say that if a spaceship landed and people got out and said we've got five minutes to film planet Earth and want something typical, we'd say go to Aldgate (around the corner). You wouldn't tell them to go to Zurich as typical planet Earth. Not even New York. We think central London – not south like Kensington – central and east London is very actual and up to date. Expressions in the eyes of the people are very modern.
GILBERT: We believe it is one of the nicest cities in the world.
GEORGE: Very ill-understood.
GILBERT: Total freedom in some way. It's a kind of anarchy that's accepted.
GEORGE: No European city has it.
GILBERT: None have the total freedom. Like when you walk down Commercial Street nobody cares whatever you do, however you dress.
GEORGE: There's such variety compared with Europe. More restaurants of more nationalities in London than any other city in the world. Thousands.
GILBERT: The best architecture.
GEORGE: The best variety of architecture. Nicholas Hawksmoor's church, a Turkish market around the corner. Then you have Broadgate, very modern, and Bethnal Green and Brick Lane. We can feel London, even when we are away.
RE: Do you find London masculine or feminine?
GEORGE: Not masculine. Masculine would be Berlin probably.
GILBERT: Queer maybe. In a modern way.

RE: Do you consider yourselves to be modern people?
GILBERT: Yes.
RE: So you're happy now?
GEORGE: We're fighting for the future, we want the world to be a little bit more like our pictures. That the world would become more complex, that every person could get out of their bedsit and in a moment be feeling a new idea or a new person. We always think that when you read a novel of the 18th Century we realise how much the idea of the person has changed since then, and we know that it could change incredibly again. It could be a different type of person that develops. Only if life became more elaborate, and more gentle. More tolerances – that, I hope, everyone can find. As artists we want to respect and honour 'the whole'. The content of all mankind is our subject and our inspiration. We stand each day for good traditions and necessary changes. We want to find and accept all the good and bad in ourselves. Civilisation has always depended on advancement of 'the giving person'. We want to spill our blood, brains and seed in our life-search for new meanings and purpose to give life.

Gilbert and George are sad that the cynicism that has taken over Britain prevents experimentation and progress.

RE: Do you want to be loved?
GEORGE: Oh yes! Have to be... there is nothing else. People come up to us in wine bars and say something fantastically complimentary. We love the viewers. All the artists of this century have become distinguished through their love of our culture or art or something. We think that's a lot of nonsense. Most artists this century also had a critical position. We feel that we are different. We are not against anybody or anything. All the artists think that the general public is stupid. We don't believe that. Every single person is a fantastic person.

GILBERT: Sometimes we have a problem because whatever you say here in Britain, they always run everything down.
GEORGE: The media, not the public. Even the everyday news.
RE: There is an enormous smugness and cynicism about everything.
GEORGE: They even destroyed comedy and humour, again they adopted this cynical outlook. It's not humorous. People attacking vicars or the middleclass or the government. We think that if you have a table and a bottle and an ashtray you can be very creative and make

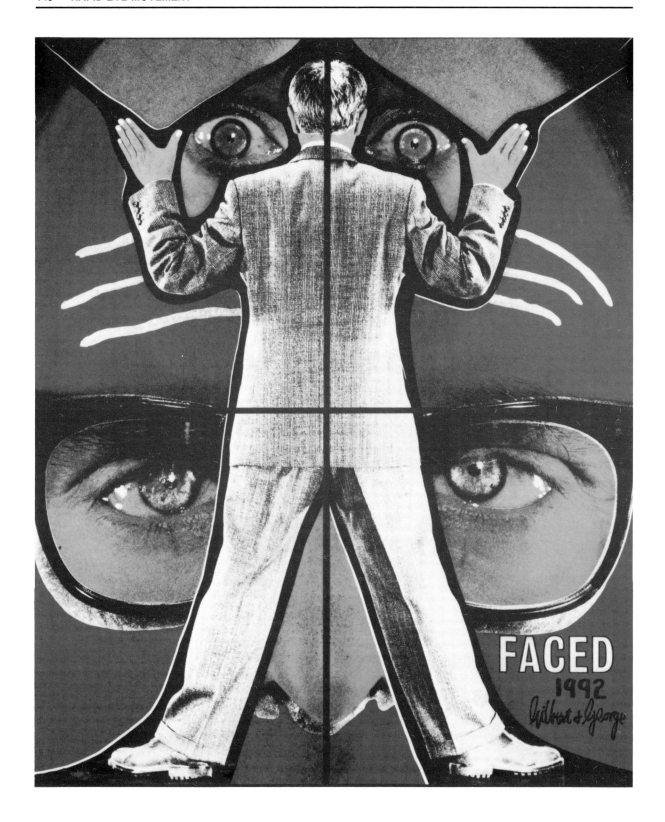

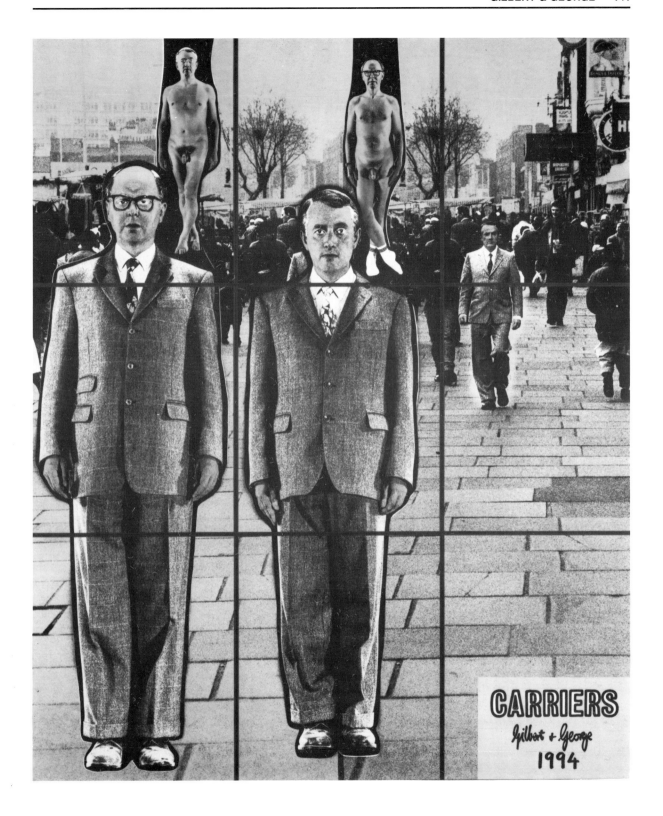

something hilarious without being against anybody. The critical comedy is going to make a lot of people unhappy. A lot of people are very hurt. I get quite a wretched feeling when on comedy they do this patting on the head of the bald man... I get so hurt. I try to say it doesn't matter. And I think every chubby lady thinks that way... everybody. Like the superior artist with the bucket and people not understanding, it's the same thing.

GILBERT: The problem here in England is that... well if you say English Food they say, 'Bad'.

GEORGE: English holiday resorts... dirty.

GEORGE: English class system.

G&G: 'Bad!'

GEORGE: English economy.

G&G: 'Bad!'

GEORGE: English Prime Minister.

G&G: 'Bad!'

GILBERT: English artists.

G&G: 'Bad!'

GEORGE: English cricket – lost.

GILBERT: English film – bad.

GEORGE: It's just the biggest nonsense. A disease. A hunger for negativity.

We retire to the back yard for warm Chardonay, and George excitedly calls me in to the studio. "Simon, come and look at this!" I am shown to a photographic contact print on a table, and given a magnifying glass. What I see is a photo of a human turd. George is enthusiastic. "It's a good shaped one isn't it? Fantastic!" I nod, he's not kidding.

The turd, and many others, are all part of G&G's next project, delicately entitled *Flying Shit*, a sample of which is printed for the first time in this book. Shit, after all, is the great leveller between all colours and classes.

GILBERT: We were very offended when people ask if we use dog shit in our work. It's all ours!

And so the time has come to go. I leave the odd couple to carry on with their life, having found that Gilbert and George are two of the most courteous, amazingly kind and funny people I have ever met, with a mischievous sense of humour that reveals much about their disgusting, dark, infamous art, and a utopian vision for the future of art and society that all of us can share: An art that is an experience of real life, and a culture that is shared by all colours and creeds, living together in a world unfettered by religion and intolerance.

The world of Gilbert and George.

This is the world
This is our end
This is our world
And this is the end

—*Gilbert & George.*

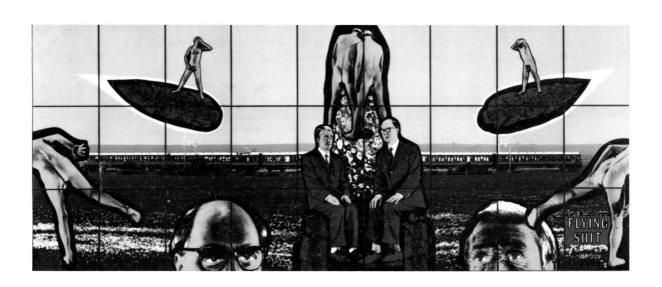

THE PLAGUE YARD
Altered States Of America

Simon Dwyer

In the shadow of Death Valley, confused, confusing, drunk and disorientated, Simon Dwyer travels and rants through the home of the unholy trinity, the virtually real land of Art, Commerce, Religion – the Altered States of America. Not so much Apocalypse Now, as apocalypse from now on...

HOT WAX AND HOLY WOOD
Dreams, Visions, And Statements Of The Obvious
"YOU ARE ABOUT TO HAVE ONE OF THE MOST THRILLING EXPERIENCES OF YOUR LIFE" says the sign in the cluttered foyer of the Hollywood Wax Museum. I repress a small shiver. Not another one. "I am about to have one of the most thrilling experiences of my life," I think. In *Travels In Hyper-Reality* the Italian Doctor of Semiotics, Umberto Eco, had visited this spot and called the place one of America's many "Fortresses of Solitude", where the Superman (of D.C., rather than Nietzsche) retreated for meditation. At present, though, it's full of frightened children and Japanese tourists.

The tour of the building takes about twenty-five minutes as the customer peers at celebrities and historical figures that are, in the main, recognisable only by their nameplate. Iron Mike Tyson, Crockett and Tubbs, the two English Davids – Niven and Bowie – the four breasts, Marilyn Monroe and 'Vampira', Maila Nurmi.

The junkie Frankenstein Bela Lugosi, unaware that he featured in Bauhaus's only good song and posthumously in Edward D Wood's incredibly bad film, *Plan 9 From Outer Space*, is the only character who appears to have benefited from the wax treatment, looking more rosy-cheeked here than he did in real life. But the dummies, right up to the nation's most revered VD-ridden hypocrite, Abraham Lincoln, all share the same glass eyes, shadows, and shiny nylon hair. Suddenly, the museum seems quite empty.

Captain James T. Kirk stares across the gloom at the crew of the ill fated *Challenger* space shuttle. Faithful Trekkies flock here in droves to worship. The waxwork Leonard Nimoy sits impassively, his silky pyjama top, black ski pants and pointed ears (made of what?) showing him in his *Star Trek* persona. The fictional Mr Spock being a more famous character than Leonard Nimoy the TV actor, and a much more famous astronaut than the lifeless crew of Challenger, means he gets a better set, one that lights up. Spock, here, is more real than them, there. Even if neither Spock nor the shuttle crew exist, except as tiny images on celluloid and in the still, 3-D form of wax bodies: they are real in the mind and memory of the viewer. More real than 'the real thing', because the real thing doesn't exist, and

The Last Supper

anyway, they are here. In the mind.

The dead Shuttle crew, now heroic American icons who "gave their life for the exploration of space", as though they died on purpose, are remembered briefly, sharing serious-looking room with American Presidents. The Lost Boys. Tricky Dicky, the villain who lost his tapes, and J.F.K., the good guy who lost his head and created a 'loss of innocence' myth which America used to absolve all its previous sins (including Hiroshima). Images, symbols, memories, little triggers. The most thrilling experience of your life.

The overall feeling of this place is – in a word – creepy. It's not a new analogy to say that the odd wax models are like a surreal predated piece of Pop Art, but, unlike most such pieces, these figures produce a reaction, a recoil, that has not been deliberately provoked.

The closest direct Art-related experience to it is in the Stedelijk Museum in Amsterdam, where the stoned, drunken British tourist can stumble in and see a piece done (I think) by the L.A. sculptor Edward Kienholz. *The Beanery* depicts a life size saloon bar. Distorted music plays in the background as figures lean over the dim, yellow lit bar, motionlessly trying to sip their drinks – forever. Their faces are clocks, clocks which don't move. It's scary because you look at the figures and at the bar and you know that is where you'll end up when you die (a Hell where

time stands still and you cannot lift up your drink). The Hollywood Wax Museum is scary because these people are, or were, rich and famous, and this is where they have ended up. Even they cannot escape. All but one of them, anyway.

Jesus Christ needs no nameplate, no introduction. He has a beard, and, after all, none of the other exhibits in the building are nailed to a cross. But that comes later. First, there is The Last Supper. Timing here is of the essence, as at the point of Man's Salvation, bright lights and taped choirs envelop the crucifix, leaving the Last Supper in the dark. So if one enters God's Room when Jesus is being killed, you can miss the Last Supper entirely. So the chronology of history is rather dependant, as always, on the viewer. Not surprisingly the Last Supper in question is an attempt at an exact three dimensional copy of that depicted in oils by Leonardo da Vinci. The long dead Italian, an imaginative genius and no mean sculptor himself, could not have imagined anything like this. The painting is replicated everywhere. Sleeping throughout the culture and waking up and looking back at you at the oddest, most unexpected moments. You remember seeing it appear in the arranged actors of Steven Berkoff's adaptation of Oscar Wilde's *Salome* – a clever theatrical hint at the beheading to come – and also, inexplicably, painted on a pinhead exhibited under a microscope in Mijas' *Smallest Things* Museum,

among the sunburn and San Miguel of Spain's Costa Del Sol. God, like Leonardo, gets everywhere, and is available in all shapes and sizes, working in mysterious ways. Here in Hollywood, He is larger than life.

But one wonders — is this supposed to be a reproduction of Christ's last supper, or a replica of Leonardo's *Last Supper*? A reminder of a historical event, a mythical event, or a duplicated image. One wonders if any difference should be perceived here, in the mind of the viewer, between the Passion and what is now almost a photographically accurate picture from the shared unconscious of Italian Catholicism. Then a voice, as deep and reverential as something out of Cecil B De Mille's *Ten Commandments*, prompts the punter to observe the scene not in terms of a viewer looking at a cheap waxwork representation of a Renaissance painting, but almost as if you were a ghostly uninvited guest at dinner the night before Christ was executed. You could almost point at Judas and reveal all to the disciples as they munch their way through the dusty wax bread and fruit, and save the life of the young Nazarene revolutionary. (Indeed, in Henry Lincoln's book, *Holy Blood, Holy Grail*, that Christ did survive his supposed execution is seriously, and quite convincingly, postulated.) One wonders if, in some time slip as experienced by the likes of Mr Spock, a customer from the Wax Museum did just that and changed history. Or Henry Lincoln, perhaps. But no, Judas triumphs as a flash of lightning streaks across the blackened set, and Christ is, in a clever scene change, bumped-off. The faces on Berkoff's actors, or Oscar Wilde's characters, or Leonardo's painting, all look in the same direction as they, the viewer, and the world, are plunged into darkness.

"But one of the soldiers with a spear pierced his side, and forthwith came blood and water... and the scripture sayeth 'They shall look on Him whom they have pierced.'"

—St. John 19, 34 & 37

A Roman Soldier, Loginus, holds the weapon that will in future become the so-called *Spear of Destiny*, an occult relic – like the skull of Lazarus – that in itself will inspire still more madness and death and belief, passing from the hands of Loginus through to Charlemagne and, via a circuitous route, to Adolf Hitler. A weapon used to pierce the side of one Jew, used as a Lost Ark symbol with which to kill six million. The disembodied voice of the narrator doesn't mention it, or its own legend, so for now, it's just a spear, and for now, the tape tells the customers, they are having one of the most thrilling experiences of their lives. Christ is born, Christ is risen, Christ will come again.

In the book, *The Hidden Art*, there is some speculation as to the true significance of *The Last Supper* painting, and suggestions that the picture is, in fact, somewhat heretical. The problem seems to lie with the figure that sits second from the left. He

The skull of Lazarus

looks like Christ's döppelganger, and there is speculation that the image may be significant – fuelling the rumours that survived through to the Renaissance and beyond, which said that Christ had brothers and, later, a family of his own. *Hidden Art* author Gettings himself seems unaware of the 'Christ family' story, saying that *"...the source of the tradition in Renaissance thought is so far unknown."* And, *"Perhaps Leonardo da Vinci was himself an initiate, a secret adept..."* Curious. Thanks to documents since unearthed by numerous journalists in Paris' Bibliothèque Nationale, we now know that he probably was.

Leonardo is listed as Grand Master of the Prieuré de Sion between 1510 and 1519. Also on the list are such notables as Nicolas Flamel, Boticelli, Robert Fludd, Isaac Newton, Victor Hugo and Jean Cocteau. The list ends with Cocteau, who is said to have taken over leadership of the secret society in 1918 from Claude Debussy. It is said that Cocteau handed over leadership in 1956, four years before his death, to none other than Pope John XXIII.

Pope John was a Rosicrucian since his days as Papal Nuncio in Turkey in 1935, and many of his judgements as Pope lend some credence to the idea of him having some connections with the masonic stream of thought, not least his strange letter to all Diocese in 1960, when he wrote of Christ's physical spilling of blood being important, and also ruled that Catholics could join the Freemasons. Given the recent revelations unearthed by investigators into

the death of Roberto Calvi – found hanging beneath London's Blackfriars bridge – which indicated connections between the Vatican Bank, Chicago mobsters and the Mafia-like Italian masonic lodge P2, the theory of Pope John 23rd's masonic involvement does not seem as far-fetched as it may once have done.

As the brief, three minute God Slot section of the show finishes and the loop tapes roll for another instant repeat (Christ dies and resurrects a few dozen times a day here), I wonder what it is that is glinting on the wooden floor and on the table of the Last Supper set, and I see coins. Hundreds of dimes, pennies and quarters, all have been thrown by faithful previous visitors at the feet of Christ. As if this wax 'museum' were a real – that is, consecrated – shrine. To many of the tourists from the Mid West, and the Hispanic cities to the south (the hidden people of 'real' America), it is.

This is Hollywood, the mecca of visions and dreamers and myths. As they should say in the Pepsi ads, it's the Unreal Thing. So, Christ takes his rightful place alongside James T Kirk and Mr Spock. At once both real and imaginary, he has an even more impressive set, because, like the shuttle crew, he gave his life for someone, or something or other. And like Mr Spock, he can travel through space – and time – through art and imagination. And here he is, more real than the "real thing", because he exists there, in wax, and here, in the mind of the viewer. Belief constructs the virtual reality. More concrete than the myth, more tangible than the Word.

And he is just as one remembered. Just as hairy and white and hippyish and kind and sacrificial as had been taught at school. People come in here to worship not only filmstars, but God, no less. Worship God and give money to the Hollywood Wax Museum.

Christ's story, one of the all-powerful magician prophet being misunderstood, persecuted, and allowing himself to be butchered by the oppressors of the Nazarene sect, is the most powerful magickal act in the history of the planet. From omnipotence to omnipresence in one day. From the hill of Golgotha to the hills of Rome, Rio and, holy of holies, Hollywood. The show is on. One hadn't realised.

A POLAROID NEGATIVE (OF DORIAN GRAY)

The usual reaction to such a thrilling experience is to seek out a few large, strong drinks, so I stumble into the white sunlight of Hollywood and proceed to get blisters and sunstroke in my search for a bar, the nearest of which seems some 30 miles away (L.A. has never heard of tube trains and has precious few cabs). The first bar I go into is about the size of someone's front room and is as dark as pitch, lit only by a buzzing Budweiser advert and a portable TV. In the gloom I realise that there are only two other customers, both Hells Angels the size of Arnold Schwarzenegger who stare at me as I stumble blindly

towards the bar and rapidly try to think of a drink that they definitely won't stock here. Sure enough, to my great disappointment, they're right out of Newcastle Brown, so I leave. Quickly.

When finally ensconced with a 'pint' of weak lager that is, as is the fashion here, smaller than a pint in Britain (16 fluid ounces instead of 20), fifty percent froth and far too cold to taste, I discover that the second bar I have chosen is gay. I realise this because the man sitting next to me, a slim Italian calling himself George, leans over and beckons me with a snaking index finger that dances uninvitingly on a hairy little fist. I move my head within hearing distance. George smiles, looks at me and says that I "must be European" because I'm so beautiful and... can he kiss me?

George won't leave me alone, and it is one of those humbling occasions when as a man, you realise just how awful it must be to be a woman in such situations.

Despite my protestations in my deepest, most macho voice, my ego rather enjoys having this person repeat "yuwere sooo bootifowl", but I extricate myself and sit nearer the women at the bar. Naturally, they are all so phenomenally good looking they cannot, in Hollywood, be the real thing. And indeed, their foot sizes prove that they're all TV's or TS's, with shoes the size of HMS Ark Royal. Watching them dance to Jim Morrison aptly singing *L.A. Woman* on the jukebox is like seeing the NATO Fleet manoeuvre. They're fun, and happy and relaxed, but the love that once dared not speak its name has long since been overcast by something that few would wish to speak of, and the shadows in this bar are getting longer, darker, crossing tables and laying-on peoples' shoulders like hands.

"But my secret is hidden within me. No one shall discover my name!
Oh no, I will reveal it only on your lips when the daylight shines forth and my lips shall break the silence."

"Nobody will discover his name... and we shall have to die. Alas. Die."

—Puccini, *Turandot*

Secrets, secrets, never seen... In the days when homosexuality was outlawed, homosexual men made the best spies – used to keeping secret lives. Their lives were so secret that even their spy masters were often unaware of their private sexuality. Ironically such sexual tastes were considered to be a weakness in a spy but were, in fact, his strength. A guarded sub text, perfect practice. In the days when occult practices and beliefs were genuinely that – secret – writers and painters made the best communicators of the hidden truths.

The secrets carried by *Last Supper* painter Da Vinci were, perhaps, numerous. A giant scientist, artist and philosopher – it was not really until I happened to visit an exhibition of his drawings and reconstructed

models at the Hayward Gallery in London that I realised quite how substantial this man's genius was. The first man to understand inertia, sound and light waves and, a hundred years before England's William Harvey, the circulation of the blood. He was also an astounding mathematician, engineer and architect, having worked as such for Ludovco Sforza – 'the Moor' – and in Egypt. (Both the Moors and Egyptians were of course steeped in magickal thought, and this influence may have been relevant to his later life). In 1506 he moved from Florence to Milan, which was at the time under the rule of France.

Four years later, he became Grand Master of the French-based Prieuré de Sion, and in 1517 moved to Amboise, between Tours and Orleans, an area steeped in the traditions of the Cathars.

SONGS OF LOVE AND DEATH
While rich Americans think of themselves as sophisticated, well brought-up Europeans such as my gay Italian barfly George like to think of themselves as Cultured. At the Dorothy Chandler Opera House, a slick concrete mausoleum dotted with the proud civic fountains with which big cities like to festoon themselves, the cultures collide.

The culture of Old Europe, predominantly white, meets the citizens of the New Europe, which is also predominantly white. America's highest social strata retain their links with the old countries, while all around them, America transmogrifies into a South American and Asian culture. On the streets of L.A., you can see one black or Hispanic face for every white one. In the air conditioned, perfumed palace of the Opera House, non-white faces are rare.

The place is studded with famous and soon to be famous nose-jobs, gleaming capped teeth, expensive wigs, clicking Gucci heels and wrists dripping with gold; and that's just the men. The women, straight off a Lorimar set, have shoulders the width of a small Japanese car and the stretched, leathery brown skin from the twelve month summers of the wealthy. Having said that, although there is probably far more money on show here, there is less of the chinless snobbery of similar events in Little England. The last time I went to the Royal Opera House in London I felt almost physically ill. Media types and minor middle-aged celebrities are everywhere; Jeremy Isaacs, Whatsisname, the Editor of the *Observer*, That bloke, the famous actor, Ken Russell slouching around in one of those ill-fitting tracksuits that pass for being 'eccentric' in such situations, and numerous fat ugly MPs and their fatter, uglier wives with their noses in the air. No wonder nobody goes there.

Here in L.A. I sit, trespassing on the first night of *Tosca*, like – as they would say in London – a snotty opera bore. The building epitomises the meaning of that old word, swanky. In direct confrontation with the words of Ruskin, that architecture should be designed forever, Marinetti and the Italian Futurists, with all their nonsensical pretension, said that as we needed a complete break with the past then all

architecture should be temporary, and that each generation should destroy the buildings erected by the last. What a stupid fucking idea. If you look at La Scala in Milan, then at this place, you know they didn't really mean it. Even if they tried not to be, they were, after all, Artists.

The world famous head of Placido Domingo peeks up from the orchestra pit where tonight he is conducting. He looks like a nervous Pilsbury Dough Boy. At least here at the Opera they know something that the world of popular music does not admit. Namely, that watching musicians perform is as boring as watching paint dry. Here they use the Orchestra Pit for its obvious purpose, as a place in which to drop musicians. The hidden orchestra tunes up from the bowels of the theatre, angrily scratching catgut and making the sound of a thousand fingernails on glass. Then, all is silent.

Rome, June, 1800. In the church of Sant'Andrea, our hero Mario is putting the finishing touches to his canvas depicting Mary Magdalene. As the Sacristan moans about his profanity, the artist muses ('Recondita armonia') on the contrast between his subject and the woman he loves, the singer Tosca: one blonde, the other dark, both beautiful.

Although a little Nutrasweet, Puccini's music melts the most cynical of hearts. From a male perspective his heroine, the headstrong Floria Tosca, represents more about the feminine condition than any text from Andrea Dworkin ever could. Consumed and weakened by the worst and most common sin – jealously – she is made vulnerable to the ruthlessness of a sex-obsessed, conniving politico – the nasty Scarpia.

Yet, forced by him into a trap, she proves herself strong enough to commit murder, yet still too trusting and innocent of mens' cold-blooded sense of duty to be able to save either herself or her lover.

The opera is set within a forest of symbols, in the darkest of Establishments. A church, a government office, and a prison. Places where love and whispered plots take place beneath the stony ornaments of power. In this set – crucifixes, coats of arms, and guns. Since Puccini composed the piece in the early part of the century, these symbols remain unchanged, immovable. Unmoving. Or, do they?

"Love and music, these I have lived for."

"*Nell'ora del dolore, perche, perche, Signor, perche me ne rimuneri cosi?*"

"I've laid flowers on the altar.
In this, my hour of sorrow
and bitter tribulation
oh! Heavenly Father
why have you forsaken me?"

You're reminded of the flowers in the dustbin. The threads and desperate, accusing questions showing up in the later, angry electric cultures of London and New York. Bustling cultural wind-tunnels of broken

dreams. Towns of scattered flowers.

"Oh, Heavenly Father, I know I have sinned, but what she's done to me, is making me crazy..."
—Lou Reed

As Maria Ewing pauses for dramatic effect, I hold my breath. Not because of the tension, but because if I don't I will cough loudly, and probably spray Ms Ewing and the front three rows with luminescent globules of sputum. Eventually, Ewing starts once more to sing, allowing me to cough-up something that looks like it came out of John Hurt in *Alien*. Asthmatics have a bad time here, nitrogen oxides and hydrocarbons reacting in the sunlight to form photochemical smog.

It's worse in L.A. not – as most locals think – because there is more traffic here than in other places, but because the ozone levels are higher in suburban areas that are distanced from really heavy traffic, and Los Angeles is one huge suburb set down in a still, breathless bowl. Like Milton Keynes with palm trees.

Back in London, *Friends of the Earth* are hanging up posters printed on blue litmus paper (memories of bunsen burners and controlled explosions). With the acid rain falling on England, the paper takes only a few minutes to turn red. Affects the commuters as they drive to work, one to a car.

Aq. Dist. Fol. Laur. Te Verid. Enough stuff here to chloroform you... bad cough. Clogs the pores or the phlegm. Poison the only cure... And white wax also, he said. Brings out the darkness of her eyes. Flowers, incense, candles, innocence, melting... Sweet lemony wax.

In the more urban, grubby environment of Britain, where the word 'smog' was invented (in Glasgow), the pollutants are altogether more homely. Sulphur dioxide from power stations; particulates from diesel engines; nitrogen dioxide from rush hour cars and heavy industry; and my favourite, carbon monoxide which peaks *inside* of cars during traffic jams. Whatever, I'm just not used to this kind of smog and my throat is itching like sandpaper. I need a cigarette.

Of course, had this been inside the 100 Club or Marquee or Music Machine back in '77 or '78, it would have been considered by some quite *de rigueur* if I had sprayed the stage with large quantities of dubious coloured solids from the aching walls of my lungs. Punk stars were often petulant moving targets who courted a youth culture that took them at spotty face value. I was one of the best gob-shots at my school, using a hand flick technique that could hit someone at twenty paces. When, as a star-struck 18 year old, I met Joe Strummer atop a Number Eleven bus to The Swan in Hammersmith in 1978, he complained of getting illnesses due to the amount of spittle he had to swallow at each gig from people who tried too hard to be street credible. I liked Joe, I liked The Clash. But I had little sympathy then.

Joe Strummer, c.1977

Here and now, 5,000 miles and an aeon away, I have no desire to disrupt proceedings with so much as a murmur into my man-sized Scotties. Even though I feel somewhat out of place. This feeling is my problem, as, like most people, I always feel somewhat out of place.

That was why I loved the first Clash album, and hated all the rest. The limp, Americanised white trash of Bernie's boys. The stuff that was adored by people who found it easy, the people who just didn't understand. Then, it was considered cool not to cope. Now, in these suits and colognes and thirtynothing glasses, being able to cope, and get on, is what it's all about. Sit in silence in the secular world of 'Culture'. (Sit/stand/kneel, dressed in these clothes, listening to the language which nobody understands...)

From the flashbulbs and film crews outside it becomes clear that this evening is an Event, something to see and be seen at. Forget culture. People exchange Events with each other in theatrical whispers across the aisles, and one realises that to many people here, Puccini is to the Opera what Shakespeare is to the Theatre. Both are more popular and more misunderstood than even The

Clash at their height.

Puccini is of course adored by opera bores the world over, just as Shakespeare is adored by supposedly literate theatre bores. Of course, if the rumours that Sylvester Stallone is due to play the part of Puccini in a forthcoming bio-pic are true, Puccini's popularity among the middle classes will take a huge nose-dive, as such hype will put the composer on a par with Batman and make him a part of popular culture. A sort of dead Andrew Lloyd Webber. (Since writing, we have of course witnessed Gascoigne's World Cup weeping and the popularisation of Puccini by the BBC, which has had the effect of making Puccini something of a no-no among the opera types who read *The Telegraph*. Puccini, now, is more *Daily Express* or *Mail*.)

Like an 'appreciation of' musicians and composers, cultural Events are used as forms of recognition. Here in Los Angeles the art has been reduced to a simple name-drop. I start talking to an unpleasant man in a white suit at the foyer bar who reckons he's just produced Mel Gibson's new film, and mentions that he's having dealings with "Dustin". I respond by telling him I've recently seen Hoffman in Peter Hall's London production of *The Merchant Of Venice*. "Wow!" shrieks the man, no doubt thinking that this is cultural stuff, but there's no money in it. "What was he like?"

"A small man with a big nose." Haw haw haw.

I remember my moronic school teacher telling me that the *Merchant Of Venice* is a play about greedy Jews. But both works, the *Merchant Of Venice* and *Tosca*, recent productions of which received rave reviews in London and L.A., are similar to Oscar Wilde's *Salome*, or the best editions of Gene Roddenberry's *Star Trek*, and have pointed undercurrents. Phallic shapes beneath the robes of the priests and rabbis, the lawyers and lovers, the police and thieves.

The point really is that all show how difficult – how impossible – it is for decent, thinking humans to be true to themselves and others, to their word and dogmatic beliefs. How does Captain Kirk maintain natural justice without breaking the Prime Directive? What should King Herod do when he rashly promises Salome anything she wishes, and she asks for the head of John the Baptist? And – buried in the subplot – how can Bassanio give Portia's ring to the lawyer who had saved his life, without breaking an oath before God made to friends, or an oath to a wife? How can Tosca save her lover and remain God's child, when prostitution and murder are her only choices? All face the morality, and mortality, that we are trained to leave unexamined and ignored. Art is invested with life when it is a mirror in which the viewer can recognise himself, and particularly when it illustrates what happens when that mirror cracks. Under the pressure of broken promises, lost beliefs, threats, and everyday life, dogmatism and rulebooks are shed and adaptable, anarchic humanity, friendship and love shine through the social clutter. And in all such battles,

with all such choices, goodness is confused with evil (such as Tosca murdering Scarpia) and wrong-doing is condoned by the righteous (such as Herod beheading John to fulfil a promise, or Shylock being exiled). In the real, mirrored world, all morals turn a darker, more pragmatic shade of grey. And Humanity, like Art, is beyond such judgemental definitions. At its best, Art can show you life as it really is. Like Shakespeare, Puccini could tell a good story.

It is a shame that such glaringly obvious and simple, sometimes genuinely subversive messages are lost or buried by the academics, intellectuals and artful posers who have effectively destroyed the pleasures of the Theatre or Opera for what they condescendingly refer to as the 'masses' by being unable to see the wood for their own cerebral sawdust.

Perhaps because all realistic solutions and interpretations of life, and all good art pieces, are on one level simple and in some sense educational and subversive. In other words, evolutionary. It is a shame, too, that the knee jerk reaction to such formal 'Cultural' pursuits from the self appointed men o'the people is one of genuinely bigoted, thoughtless derision, philistinism and inverted snobbery.

Though it is hardly surprising. Despite the incursions of clever opportunists like Malcolm McLaren, the media have for the most part

Oscar Wilde, with Lord Alfred Douglas

presented the Theatre and Opera only in discreet sanitised packages.

Even after Puccini's fall from upper middle-class grace, using operatic music to sell such commodities as airline tickets and cars infers that the air tickets are for those in the 'executive' club seats and that the cars are expensive and therefore exude 'class', a horribly tatty British idea. Thus the opera is the domain of people who drive BMWs along Alpine country roads, call each other "Darling" and never spit. *Vorsprung durch technik*, as they say in Surrey.

Despite what the media and advertisers and academics have gone and done, Giacomo Puccini's humanist light rises above the cultural excrement. This man – an early pop star who tailored the length of his compositions to fit onto ten-inch 78 rpm records – obviously didn't write this music because he wanted to be thought of as a cultural emblem for later generations of people with padded shoulders and tuxedos, or as a topic for the boring conversations of intellectual dullards with PhDs. He wrote them because he was in love.

And in all such theatre, as in life, as in love, there are victims. Victims of the situations and choices and morals and social codes that everyday life comes up with.

Be it *Salome's* author Oscar Wilde in prison: "Truth is rarely pure, and never simple." Or Shylock in *The Merchant Of Venice*: "The world is still deceived with ornament. In law, what plea so tainted and corrupt, but being seasoned with a gracious voice, obscures the show of evil?" Or, closer, the words of former Los Angeles resident, author of a Beach Boys' B-side and supposed architect of the Tate/La Bianca murders, Charles Manson: "Can the world be as sad as it seems?"

Where does all this leave Belief, or contemporary art, or America? As one listens to Maria Ewing's aria, or turns on the C.B.S. News, or looks into the empty

eyes of the crack addicts on the smoggy streets of East L.A., there can be only one answer.

I BLEW UP YOUR BODY

At the opera's interval, a large, wobbly cellulite backside is shoved in my face. I look, slightly annoyed, at the owner as he squeezes past to the toilet. Crumpled cream suit, dyed blond hair, round glasses. Some idiot trying to look like David Hockney, I think, before realising that the man is trying to look like David Hockney for a very good reason.

At the bar selling the feeble Californian Chardonay, Hockney fiddles with his hearing aide. This being Los Angeles Opera House, not Tesco's in Bradford, he is studiously ignored by people trying hard to show their complete disinterest in one of the world's most highly priced living painters, while all the time wishing that he would walk over to them and say hello. These are, after all, the people who made Hockney rich and famous, the people who swim in the pool he painted at the Hollywood Roosevelt Hotel, shop in the chic, hip jewellery stores in the Melrose Avenue he helped make famous, live in the sandy Californian hills and valleys he immortalised on canvas. But David Hockney's L.A. is not theirs. Because Hockney, like most painters, lives in a world of his own invention.

It is strange, synchronistically, that Hockney is here, as it was Hockney who introduced me to the opera in the first place. Enthusing about his sets for the 1978 staging of *The Magic Flute* (without the usual Masonic symbolism) Hockney described the piece on television, and I was enthralled. His child-like enthusiasm for opera was infectious. Derek Jarman once told me that he was a film-maker because film was a medium that "used it all up". Painting, writing, designing, acting. Through Hockney I realised, Opera can be like that too. Only in the Opera, more people screw around and get killed.

...Stop press. Cutting flickers on to the screen. *Daily Express*, 5th May 1961. Lord Birkett opens a students' art show at the University of London. Two awards made. Professional Class (students making art their career) First Prize of £25 to David Hockney (Royal College of Art). Amateur Class (students whose first subject is not art) First Prize of £20 to Michael Derek Jarman (Kings College)...

Hockney's deceptive, simple paintings and photo montages are interesting because they invite the most obvious little shifts in visual perception. Before Hockney, many painters were just looking at the surface of the water, a flat two dimensional plane. But in his colourful paper pools, you can look into the water, through it, onto it, at it, or at what's going on beneath it.

Hockney and other painters throughout history have invented a way of looking that is better than the 'real thing'. Just like Leonardo, or the artist who creates a beautiful altarpiece or flattering portrait. When you see one of Hockney's swimmers diving into one of his cool blue pools, that representation of what you see – a big splash, a body, waves –

David Hockney, 'Splash' (1966)

Alongside the equally famous Francis Bacon and Lucian Freud, Hockney is still one of my favourite rich, big, still-breathing British painters [Bacon has died since writing – Ed], not so much because of how he paints, but because of what he says. I liked the way he failed at Art College, and decided instead to draw his own Diploma and award it to himself, realising that there are few finite arguments, and that he could see things in a way that many of his tutors could not. And I like the way he became one of the first members of the Artist-as-Pop Star cult, as that's how accessible art should be (even if it has contributed to a situation in which some artists aspire only towards pop stardom). And I like his enthusiasm and his ideas. He is after all responsible for possibly the most simple, perceptive and accurate quote to come from the mouth of any painter in the late 1980s. It went something like this:

"THERE ARE FAR MORE INTERESTING THINGS HAPPENING NOW IN SCIENCE THAN THERE ARE IN ART"

seems more realistic than when you see a photograph of the same event, in which you'd just see a frozen splash. A splash that is so still, it doesn't look like a splash at all. Time is freed to move by the painter. In still photographs, or waxwork dummies, time is caught. What is fluid is made solid = no reality. Of course, painters, and some believers have gone on to assume that this way of presenting and looking at the world is the correct one, the real one. It is not. When you look at someone dive into a pool, you don't see a David Hockney painting at all, and vice versa. Pseudo-reality is not the same as physiological reality, and what we have been trained to recognise as being realistic, should not be confused with the real thing. To argue, as many painters including Hockney are fond of doing, that painting is any more valid or realistic than any other form of representational recording, is simply stupid.

There is a confusion between art which is a contributing agent towards genuine perceptual changes and art as a mechanism for a false consciousness that has been externally manufactured. A virtually real world is too easily generated and eagerly digested – because it "fits in". Altarpieces instead of hard, grey choices.

The Painter only presents the world in edited, highly stylised terms that are as unreliable as any other medium. Indeed, the reason why some painters are famous and other painters are not, is because of the way in which their vision has been technically expressed and, above all, edited. If Leonardo had chosen to imagine Christ on the toilet, rather than at the Last Supper, it's probable that his painting would not have been reproduced in Hollywood at all. Leonardo had edited, highlighted and condensed his vision of an historical, or mythological event, to fit in with the social expectations of his day. How real is that? But more of Christ, and more of toilets, later.

Stephen Hawking

He is of course right. The work of Frijtof Capra, Niels Bohr, Alan Stockton, Carl Sagan, Fred Hoyle, Stephen Hawking and many others over the last few decades has moved science closer to religion and art and away from Newtownian mechanics and Cartesian dualism. Few in the secular religion of the art world (except for Hockney and people like Tony

Carter) appreciate it, but the theories and interpretations surrounding such things as Quantum Physics, Black Holes, Time, Chaos Theory and so on are more far reaching, relevant, creative and inspiring than anything that ever crossed the lips of a supposedly professionally 'creative' human being in the history of the planet. If only more artists, teachers, theologians and philosophers realised that fact and reported it as honestly as Mr Hockney, then the world would be a better place to live in. Because the world would not be as sad and empty as it seems, as Truth would not remain in a permafrost, dictated by priests, politicians, artists or even scientists. In the subjectively perceived universe of constantly shifting truths that much current scientific thought suggests, much more speculation, and many more dreams and versions of reality can be accommodated, and should be tolerated. Indeed, part of the social function of science it seems to me is to illustrate, in a demonstrable way, the idea that no theories are sacrosanct. As Spock may have sung on his Vulcan lyre, There's a space for us...

Driving away from the Opera House you see a flapping poster advertising a screening of the film version of Richard O'Brien's tacky glam musical *The Rocky Horror Show*, in which aliens land on Earth to invade it and, through the lure of physical pleasures and the corruption of their objective, Earth ends up invading them – leaving only the remaining humans to regret the passing of the liberalising trend of the aliens and humanity's own futility. We are left "crawling on the planet's face/some creatures, called the human race/Lost in Time/Lost in space...and meaning." The picture is one of a race of self-obsessed, confusing, baffling animals scurrying around a pinprick planet, wasting time by taking themselves too seriously. Wasting sex and art and love and life. Although smalltown American Good has triumphed over some Alien Evil (after a fashion) even in such supposedly trifling entertainment as the *Horror Show*, the world is presented with a dangerous relativity, men and women are shown to break their vows, act amorally, wrestle with guilt, be flexible, veer from the dogmatic beliefs of their kind, learn and *change*. The offer from Space rejected, the characters are left lonely, isolated, and without direction. Left to get married, have kids, and face life and death in 'real' America.

"They slipped the bonds of Earth, to touch the face of God..."
—Ronald Reagan's obituary to the *Challenger* Crew.

As in real life, Space, the final frontier, is seen as offering a new challenge. And real life in the narrow, workaday world, is seen as being shallow and unfulfilling. As with the best art, the challenge of space is one to the individual human's perception.

When, like Captain Kirk or Brad and Janet, you stop briefly to consider the cosmos, you challenge your perception. Your answer to this may be, for

'The Rocky Horror Picture Show'

instance, that you realise that you are an integral part of some huge soft machine, or it may be that you are God, or the Son of Sam. Whatever, through realising – or inventing – your role, you change your perception. Art has encouraged you to do this, and in this respect, art can be beneficial, as only through evaluating your perception, and challenging yourself, can you save the world. Your world. Given his earlier quote, it is perhaps not surprising that Hockney has filled his art with obvious references to Space and Time, through splashes in water. Floating, drifting, magnifying. Water. Only through challenging your perception can you save the world...

For all His waxworks and his quarters and dimes, Christianity as practised by established churches and worshipped in museums cannot any longer do this for you. Christianity as practised since St. Peter was never meant to do this for you. When people pray to the Christ who has forsaken them, or throw coins, or kiss feet, or wage holy war, surely they are – like the Shakespeare bores – being rather too complicated and literal. Christ's basic message, as a great magician, was one of tolerance. What this prophet asked for was not coinage or carnage, what he asked for was simply a change in one's perception. But what we get is not his question – his challenge – what we get is his image, his words, his cross, used as weapons against our asking of questions, against such a possible shift in perception. A totally perverted, unholy image that is used against knowledge, against change, against the evolution of the very life that Christians believe he had a hand in creating. Some people believe that, as this is the case, one merely has to use that powerful image of Christ in order to alter peoples' perceptions. (Floating, drifting, sleeping, turning up throughout the culture, through Time, in time. He was up there in space, bleeping. He was out and bleeding, and the orchestra leader, who had, I saw, a Craven A between his lips, bent down to inspect the damage. He's floating in a most mysterious way, his wonders to perform. Laughter. Applause. Haw haw haw. Bloody big nose. Bloodied.) But, like much organised religion which has missed the point, much art –

which could be used to challenge perception and perhaps inform evolution – has concentrated on the style and not the content.

PLENTY OF ROOM AT THE HOTEL
Here in California we have fund raising supporters of the Jews and the Arabs. Supposed adherents of the Pope's words who give money to the IRA's romanticised 'struggle', and Pro-Lifers who push pregnant women down stairs to protest against abortion. We have neo-Nazis and – even more unpopular here – Socialists too. Like the nitty gritty, sandy reality of California, the real world is a complex place and a cessation of conflict and violence, slavery and famine, is, in such a complex world, impossible. As everybody has a good reason for doing, and thinking, and believing what they do. Charles Manson had a good reason, Herod, Hitler, Napoleon, Tosca, Judas, the IRA, the Klingons.

There is no solution to the problems created by such believers to be found if one adheres to linear, dogmatic belief structures and modes of thinking. And sorry, but the chances are that Christ will not literally be born again and make the world one nation under a groove. Finding the 'gold' of Christ (or, if you prefer, 'understanding') is an allegorical expedition, among these words, these icons, these 'believers', this cross, this dross. People have confused the images with the messages.

The only solution is the most obvious, though difficult, perceptual one. This is why visual art, writing and music can be important. It's just unfortunate that so little contemporary visual or conceptual art has anything to offer in terms of informing a viewer's perception, even though, through its lack of linear structure, it can be seen as having advantages over writing, its practitioners do not exhibit the ability writers have to communicate genuine thoughts and emotions.

IN THE DAWN'S EARLY LIGHT
I don't go to Disneyland, as Disneyland is hell on earth. I know. It's on TV as I wake, still jet-lagged, at six in the morning. I get a tub of frozen yogurt from the fridge that I've had to prop up against our door in lieu of a key. I stare, transfixed. Outside my window the sun is just starting to come up with the smog.

I love the morning. The Earth takes on the glow of a pregnant woman, bloated with Time and future possibilities. The cool, clear air, slowly, almost imperceptibly lightening, makes L.A. look like a beautiful deserted watercolour. Washed clean, holding all those dreams. Wakening, opening, expectant.

In the parking-lot below a man who has been sleeping in a skip is rising, stretching, then shitting. He takes a supermarket trolley and walks off into the morning sun. On the TV, people at Disney are sitting on an underground ride called 'It's a Small World', and I see, as one writer observed, that the Devil is in fact an American who'd like to teach the

world to sing. The walls of this ride truly are worse than the characters one sees in a Hieronymus Bosch painting. They consist of disgusting children, all of whom should have been murdered at birth along with their filthy parents, dressed-up in national costumes which nobody ever wears. The foul creatures all sing and dance to a famous children's tune about 'togetherness' that is typical Disney. The world is a complex place, but in America, all problems can be reduced to plastic and wax, made simple, safe, lovable and, like Christ in the Wax Museum, strangely AMERICAN. A lonely place, where someone still believes. In something...

California is all skin, no core. Without the dirt and rain of London or New York, its residents are living under a badly prescribed, black sentence: to live a life of happiness in the sun. All the while, beneath their sandled feet, and at the back of their cranium, the San Andreas fault shifts and murmurs. Above, the glimmering metal snake refracts and blurs in the heat. Motionless.

Blisters. Aimlessness is thick in the air. Social insecurities break out like boils. California as it is now lacks social self-justification, cultural history, and any sense of spiritual fulfilment. California just exists. And there is nothing to complain about when you have a palm tree growing in your back garden. In fact, the demeanour of Californians is created by the climate, in which it is more sensible to wear jeans, shorts, and T-shirts to work and play. Clothes have an effect on behaviour. When one walks down a street in Bermuda shorts or lounges around in holey jeans it's hard to take yourself quite as seriously as you would in a grey flannel suit or dirty overalls, battling with the traffic and the rain. Hence, terrorists and priests are a European phenomenon, in California, you have cocaine, cults, and commercials. One can get into thisism, thatism and whatever bag one finds appealing in one's search for purpose. In California, almost anything goes. Oh yes.

The TV commercials here on the West Coast are terrible sub Victor Kayam/K-Tel/local fleapit cinema curry house 'round-the-corner affairs. Except for a very few ads made for the giant companies like Coke, the art of TV advertising here is surprisingly primitive, and usually involves some obnoxious child or old man shouting about bran helping bowel movements, or a mother telling her teenage daughter that she has a feminine odour problem and should clean her vagina with some unfathomable product from Johnson and Johnson.

Of the big budget commercials here, as in Britain, the tendency is towards New Man smarm. These men are obviously what the Disney dancers grow into if not creatively culled. Adverts are full of buddy images of real hunky guys, glistening with sweat from the gym, smiling at each other, picking their horrible kids up from school in their ozone-friendly cars, donning expensive dinner jackets and hugging their old Italian Dad. This, it seems, is "the best a man can get".

Since the late '60s the media has been concerned

primarily with women. This has created a generation of men who have identity problems. The '90s will be a decade concerned almost totally with Men trying to create a new identity and social role. Big boys crying into their Aqua Libra, trying to come to terms with it all.

Sounds awful.

BINARY OPPOSITIONS

"Americans are funny people. First you shock them, then they put you in a museum."
—Jean Cocteau

Now, more of Christ, and the promised references to things that go on in a toilet. I open the papers here and see that another dead artist and another image of Christ is causing news. Robert Mapplethorpe, who finally succumbed to his AIDS-related illness in London, had a posthumous show, *The Perfect Moment*, cancelled by the Corcoran Gallery in Washington amid fears of official backlash and subsequent cuts in funding. Several New York artists decided to boycott future shows by the gallery, and the Corcoran's Director resigned. The Mapplethorpe show was transferred to a smaller gallery at the Washington Project for the Arts and, as one might expect, the show attracted forty times as many people as any previous exhibition held at the venue.

Mapplethorpe's contemporary Andres Serrano's show went ahead, and featured the by now infamous *Piss Christ*, in which we find an image of our old friend again, this time floating in urine. In the type of country which has just discussed passing a law making it illegal to 'desecrate' the national flag (what would've become of Jasper Johns or Laurie Anderson?), the piece caused calculated rage.

Senator Jesse Helms – a man who conveniently photographs rather like a Nazi war criminal – rapidly introduced legislation which would ban federal funds from being used in any way to support exhibitions of "obscene and indecent art". The National Endowment for the Arts were targeted for all the usual righteous indignation of the immoral minority on the All-American Right, who had seized the Perfect Moment to strike back at liberalism. The Far Right had been disappointed with President Bush for not acting to support America's fight against all things alien and filthy. They were losing the unifying potency of the Cold War, which Gorbachev was dismantling, and needed to muster some righteous indignation against a target that Middle America would perceive as a threat. Mapplethorpe and Serrano were easy meat.

The National Endowment for the Arts listened apprehensively to Senator Helms' protestations, and when President Bush said that he was *"deeply offended by some of the filth that I see and to which federal money has gone"*, the Chairman of the NEA promised that *"in future obscenity will not be funded by taxpayers' money"*. The supposedly liberal Arts Establishment countered – screaming about the First Amendment – and the hornets' nest, which

should be stirred up by art every two years or so, buzzed in predictable fashion, just as it did when The Young Unknowns Gallery in London had shown Rick Gibson's freeze-dried foetus earrings, a year or so before. But how long ago did Dalí and Buñuel drag a Cross through the ant-eaten set of *Un Chien Andalou*? The argument from the intolerant Christian censors seems like something out of Nietzsche: *"I am fond of all that is clean, but I have no wish to see the grinning snouts and thirst of the unclean. They cast their eye into the well; now their revolting smile shines up out of the well. They have poisoned the holy water with their lustfulness; and when they call their dirty dreams pleasure, they poison the language too."* Perhaps Serrano was attempting to reveal the true intolerance of the Right wing Christian community, but I wonder if this were the case, if such an act reveals anything not already known?

It is at such moments when one is forced to wonder what is going on. Hockney's pools of paint and naked bums are suggestive, mildly interesting, amusing little shifts. Serrano's pool of urine is all that, but it is also an open political statement. Begging wantonly for attention, and the venting of narrow-minded criticism that passes for 'debate'. There is a place for Christ in Western art, and a right for Serrano to cover that image in urine if he so wishes. Indeed, the image may be helpful to some people if it makes them view Christ in more human, fallible, terms. Or if it suggests to them that Christ's image – which is supposed to belong to all of us – is monopolised by a minority and normally used as a symbol of repression, as I discussed earlier. But is this really the best, most noteworthy, most provocative and informative piece of art to come out of America in the last decade? Of course not. But it is the most talked about.

So what? Sometimes I get the feeling that many Artists want nothing other than to be taken as seriously as Scientists, want only the shocking revolutionary fame of Darwin, without the far reaching ideas. In so doing – assuming the role of fine art as being socially akin to that of science or medicine – they are ironically continuing in the tradition of Leonardo. But Art, which is un-measurable by any finite methods, often lacking in invention, and certainly rarely influential, is *not* akin to Science. By pretending that it is, certain kinds of artists are merely seeking justification for what many view as their tiresome indulgences, money (grants) for their pseudo-'research', and the social status enjoyed by people who contribute to the needs of society and have the power to challenge accepted models of the world. The monied, academically powerful artistic community have tried to shun their role as Quarrelsome Entertainers and usurped much of the influence once given to the Church, as Troublesome Priests. But the opportunities this situation offers have – with a few notable exceptions – been wasted in self adoration.

Most avant-garde cultural workers in the visual

Jasper Johns, 'Flag' (1954)

arts believe in pitching their work at a level that assumes a suggested, but unstated superiority, thus forcing the audience to admit itself to be in some way inadequate and insensitive, or perhaps react by translating its prejudices and misunderstanding into verbal violence and, as in the Serrano case, censorship. The underlying philosophy seems to compare the Artist with the heretical astronomer, Copernicus. The Artist, too, knows that the Earth revolves around the Sun, and history will one day prove his visions to be 'right', and the 'masses' opinions to be wrong. But, as I said, Art is not measurable.

"These things I do, just to make myself more attractive to you... Have I failed?"
—Morrissey, *The Last Of The Famous International Playboys*

Faced with indifference, many visual artists react like the petulant spoilt children that, in everyday life, many of them are. Namely, they seek out notoriety when fame eludes them, or seems an impossible dream. After all, the contemporary Art World is so easily offended and deliberately offensive, and so utterly obvious. And always trying to justify its grants, its social position, its absurd self-esteem, by trying to fulfil some often imagined evolutionary, thought-provoking, avant-garde role. This would all

be very well, but most artists do not *want* to overthrow society, nor do they really want to inform it or change it. They want to be seen to occupy a specially aware, specially sensitive position *within* an unchanging society. Much the same position as the one that appealed to Spiritualists in the last century. As American writer Tom Wolfe said in his book *The Painted Word*, artists are only screaming one thing – "Look at me!"

In calling themselves "artists", they are implying that other people are less sensitive and creative than they are themselves, and in turning out art that is critical or paradoxical, they are often not really informing social change, just trying to increase their own social significance as people of vision and foresight. They imply that it is only they who have a social conscience. Their audience – who 'appreciate' such ideas – literally buy into the game and bask in the reflected glory. They too must be kinda, er, sophisticated and sensitive to dig this junk. Much contemporary conceptual art, particularly that which is sculptural or performance based, is primarily concerned not with 'altering' peoples' perceptions of life or society or the universe and their chosen place in it, but of 'altering' the viewer's perception of art itself, and of common everyday images. Serrano himself has – to give him his due – used many images and icons that carry a great deal of representational weight besides his Christ. There is

Caravaggio, 'Salomé'

nothing wrong in an artist wanting to question perception, indeed, that is part of his or her function. I would, however, often question the simplistic methods that are involved.

Socially, this kind of art is almost worthless, but it is feted by modern society as it gives the appearance of social and cultural progress and debate. One of the most valued pieces of contemporary art, *Target*, by Jasper Johns, depicts an archery target. Is this a challenge to anyone's perception in the same magnitude of Stephen Hawking's theories relating to Time, or of Herod beheading a saint to fulfil a promise to the daughter he loves? But, I digress slightly.

The appropriation and contextual alteration of everyday social and manufactured images and objects is, anyway, as old as the hills. The Dadaists were doing it in the 1920s, and most pop artists made a career out of it in the '60s. And I would question if the viewer of such a work really identifies in any way with the piece itself. More likely, I think, he identifies with the artist, and with the artist's words. Serrano, who uses images as the word 'image' intended — as a site of conflict — is typical of the artist bred on the myth that says by simply *being* an artist, one can imbue images and objects with

power. That idea — that simply by contextualising images behind glass and juxtaposing them, the 'masses' of the late 20th Century Western world will start to question reality — is as dictatorial and pompous as it is ridiculous. For church read museum, for museum read gallery.

In this sense, such conceptual artists can be compared to medieval *souffleurs* — the alchemists who misunderstood the *allegorical* nature of occult texts and, like the naïve Strindberg or amusingly warped De Rais, literally tried to alter the physical composition of reality through the chemical wedding of the sublime to the ridiculous. Activist art — that is, art which aims to be more socially relevant, rebellious and demonstrative than the narcissistic class conscious garbage that in reality most of it is — should be, primarily, useful. Apart from challenging one's sensual perceptions, it should threaten the various status quos that exist in art and society. (Disregarding aesthetics for the moment — as many artists do — I can see little point in artists who do not try to threaten, alter or transcend the system when there are so many interior designers about.) But what many 'social' artists ignore is that in the dim witted, big money world of art, such forms of protest are almost automatically degraded by their

context and their mannered, self conscious stylism. If such artists were as socially aware as they imply, they would of course know this.

The accepted truth is that the Italian Renaissance embraced the civilised humanistic thought of the era and that this, in some conveniently unspecific way, altered theological thought. It did not. The Church did not 'embrace' humanist tendencies and advances at all. It absorbed them. The arts have always been connected to, and used by, organised Religion. The root word of 'culture', after all, is the same as that for 'cult' – *colere*, meaning 'to worship'.

The vanishing points of the brilliant Piero de la Francesca led the eye not into infinity, but into the walls of churches, walls that the Church built. The great architecture of the age was used not to house people, but to glorify the church and to literally, physically control the congregation through the use of symbolism and acoustics. (For instance, it has been claimed that hymns performed in such cathedrals were designed deliberately to stimulate the production of endorphins in the human brain, giving the congregation a tiny 'high'). The advances of the Renaissance, sponsored by Rome, did not change the doctrinal belief of the Church, but were used by the Church to increase its power. Caravaggio painting Salome receiving the head of John the Baptist did indeed make for magnificent visuals, but did little to help one with the existential problems one has while sitting on the bus going to work in the morning.

When viewed in this light, perhaps Serrano is making this point of questioning the Renaissance-inspired perception of Christ. Of wresting Christ from the Temple Priests, and giving him back to the people. The idea and image of Christ does not belong to the Church or to Leonardo, just as Puccini does not belong to the advertising executives of British Airways. Maybe he is just trying to make people think about such a point. But there is an element missing from most 'provocative' contemporary conceptual art that is hard to put a finger on. The element missing is the *next* sentence, the missing digit in the sum.

Perhaps I'm being guilty of generalising and viewing the Serrano piece in the same jaded way in which I view most activist art works. But given the standard of such work, it's not surprising. As I have indicated, nowadays it is enough for you to call yourself an activist by producing a piece that will cause some outrage, assuming that that action will automatically be significant in itself. Be criticism of the status quo in itself. But, given the self imposed criteria of such art, it is not enough to be socially aware and juxtapose supposedly important images and words, without having some awareness of what Marx and Engels called "the line of march". That is, some idea of the aims and the ultimate results of the revolution. A little knowledge is, indeed, dangerous, and can be counter productive. And my jaded suspicion is that Serrano seems to know too little, being happy merely to 'offend', and not to question.

Maybe I'm wrong, and this impressionistic journey

Marcel Duchamp, 'Fountain' (1915)

through America will show me why he did it, but for now the piece seems too calculating to even fit in with the Dadaist principle, expressed by Grosz, that their art was "done in the dark", flung out to the public via the Cabaret Voltaire and exhibitions, with a degree of naïveté that could not predict what seem now to be the inevitable repercussions.

Artists who are well known, particularly those operating under the American god of Money cannot, it seems, take many artistic risks, so they now opt instead to take what are seen as being social risks. It is indicative of the lousy situation within both art and society that, even when the risks taken are as tame as the Serrano piece, such a fiery debate is ignited.

There is always a painter or sculptor or writer hanging about, thinking of ways to show how much he hates everybody and everything, who knows how much he should've been appreciated by his peers, loved by his mother, fucked by his girlfriend or boyfriend. A piece of creative nihilism, calculated outrage, or pure violence is normally the answer. (As Tom Wolfe jibed, they are only saying "Look at me!") It smugly advertises that the artist knows better, sees differently, points up others hypocrisy, and, most of all, it gets attention. The other half of the equation is always waiting. There is always some publicity-seeking, philistine politician knocking about, who will obediently react to the most prurient pieces of garbage and threaten censorship. This allows a bunch of old pseudo-intellectual art victims in poloneck jumpers to forget the bourgeois reality of their social position and don their Cultural

Revolutionary guises. For a few months they will bleat in the columns of magazines which nobody reads about the danger of censoring ideas, (as if they have not already censored the social impact of their ideas by choosing High Cultural avenues of expression) and of society foisting its accepted morality on artists (as if Society's morality was not foisted on everybody anyway).

They do of course have some justification, but, remember, we are looking at artists who are self-professed activists involved in avant-garde art at the sharp end of society, and this is *old* news, crumbling data. Of course censorship is difficult for liberal thinkers to accept, as censorship is concerned with limiting the expression of ideas, limiting, in fact, the use of the brain. But do we need to hear any more about Picasso, Caravaggio, Rembrandt, Rodin, or Duchamp's urinal to generally justify the art establishment's trail-blazing self image and academic existence? And should we defend trivial artists' inalienable right to make arses out of themselves by quoting from interesting artists' chapter and verse, and thus investing boring, derivative works of art with a weight which they don't deserve? (Just because The Sex Pistols were briefly the greatest band in the world, does it mean that Slaughter and the Dogs were worthy of life?) There seems to be much Templar-like scrambling towards what Guy DeBord called in *In Girum*, (just) "another evil Grail". Another phoney disney reality. An empty stance. I want to find one avant-garde artist in America about whom I can write home about. Although *Piss Christ* is powerful, even if its power lies in areas that may not have been intended (otherwise why would I now be writing about it?), Serrano is apparently not he.

In some respects, I have a sneaking wish – for the sake of Art and Society – that all grants made to the Arts were stopped as a result of the Serrano piece, as it would remedy much of the current malady of the Art World. It would remove Washington and Whitehall from the Arts, Rome from the Renaissance. In the visual arts, there are few cultural terrorists capable of informing any far reaching social and perceptual change, because most artists, like the micro world they inhabit, are parochial, self serving, trained to be incapable of articulation and, although some are able to communicate, rarely have they anything to say. The Art World is rightly criticised because it is normally little more than an acceptable avenue for financial speculation and attention-seeking, but this doesn't really bother me. The Music Industry gets away with it while still half kidding itself that it's somehow important (Bono is a real statesman, man), so why shouldn't the Art World – let them have their fun. No, what dismays me is the common level of stupidity. I'd certainly not agree with the cruel adage that the definition of 'Art' is "Stupidity sent through college" (even if many of the tutors and, worryingly, students you meet are dullards of the highest order who are into Art only for the prestige and grants), but the general level of debate surrounding the Serrano piece illustrates the

current bankruptcy of ideas in the Art World. There is of course something to be said for creating situations which are designed purely to shock, and situations which are designed purely to provoke people into thought and debate. The principles are to be defended and it is a truism that some things done in the name of Art do have a long term effect, and do filter down through society. Consecrated shrine or piece of Hollywood Entertainment? Two pennies in a fountain, a thousand coins thrown on the floor, flowers on the altar, blah blah blah.

Millions of people actually may think that Christ looks like Leonardo portrayed him, some even think that God is a large man who looks similar to Santa Claus, so in this limited sense the use of Christ's traditional image may be justified by Serrano. After all, the visual, political statements of the Dadaists made all manner of things possible in the arts, and their bastard grandson, Situationism, has been imaginatively credited with numerous social changes, including the Student riots of '68, Baader-Meinhof, the bombing of MP Robert Carr by The Angry Brigade in 1971, and The Sex Pistols. But it took McLaren's pop sensibilities to put the best parts of Situationism onto the street, and the best parts of Situationism were of course the slogans, the *words*, and the vague idea that reality was socially conditioned and could be re-sequenced at will. Also, it is of course questionable as to what the Sex Pistols or the Situationists really achieved socially, but they were at least a phenomenon that contributed to the articulation of a social malaise that already existed. A precious contribution to a vital social attitude, a nice haircut too, but not the originators of any major social or political changes. Unless one really thinks it a key moment in social history to encourage teenagers to sing songs bemoaning their lack of employment, where previous generations of teenagers composed songs complaining about their dreary jobs.

Ideas presented to the world in the straightjacket of contemporary high visual art are more fleeting gestures which must lack the higher degree of social impact as enjoyed by Pop Music. This old dilemma must bring into question the motives that drive 'activist artists' like Serrano, or Billie Lynn (who tried to use American flags in her show formed in the shape of labia – gee). They all must know that the Cubists' paintings made people change the way they looked at *paintings*, and the abstract expressionists did the same, and the Pop artists may have had some effect on how we perceive images in the media, or mass produced objects, and so on, but *little else*. And if you hang the American Flag upside-down, you are still taking part in the pathetic argument that empowers flags with importance, you are still filling up newspapers with trivial junk when those newspapers could, most would agree, be better used reporting the largely ignored plight of the starving underclass of America for example. Of course, an artist is bound to want to explore and re-interpret images and media, but what I am questioning is not

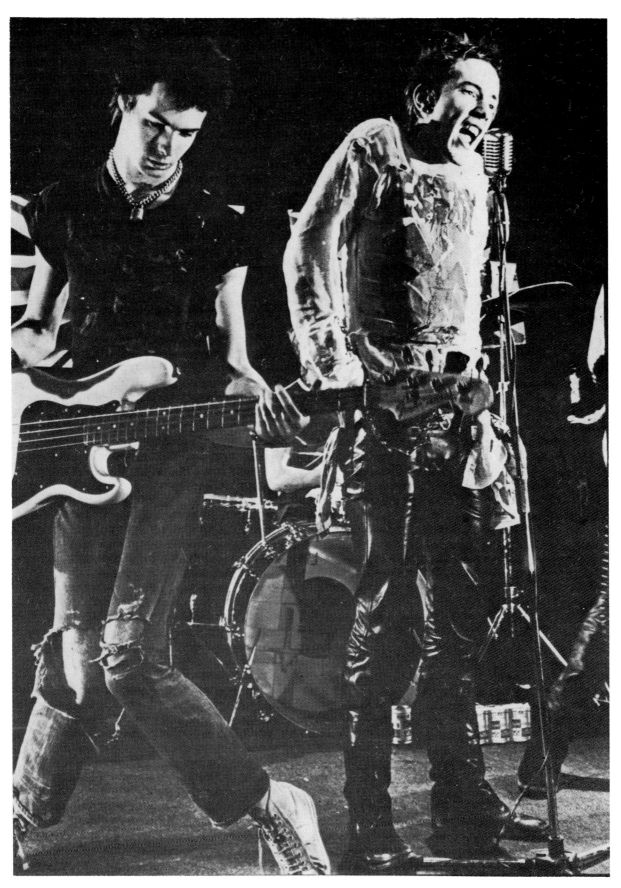

The Sex Pistols, 1977 (photo: Dennis Morris)

the artist's right to do so, but the social significance he assumes by doing so.

When artists and people like myself get smug and think of ourselves as being in there at the sharp end, when we think of ourselves as being anything other than Entertainers, the we should go to a bar in Watts and thank sweet Jesus we have the opportunity to fill our time and our bank accounts by thinking about such comparative trivia. Art is a social necessity, one that is generally underrated by the public and overrated by the artist. (Avant-garde art – the raising of new questions to challenge old paradigms – is particularly necessary, but, frankly, here in America I can't *find* any avant-garde art.) Even these limited influences seem to be somewhat in abeyance at present, given the current state of Art here, in the home of the Twentieth Century and its art – the USA. It appears to the untrained eye that the influences and choices and effects sought by most people who call themselves Artists at the tail end of this incredible Century seem remarkably weak and marginal. In art which uses such imagery, these images should surely take on new meanings and implications, but, like the *souffleurs* with their pile of dross, *Piss Christ* does not transform anything without the Prima Materia – the First Matter needed for the transformation – the missing piece of algebra from Serrano's sum: New Ideas. This would seem to be the problem with the modern conceptual art world. Much thoughtless activity, a bit of ripping, dribbling, and scat, a lot of art's motions being gone through, but nothing happening. Leaving aside the fact that Serrano's can of worms opened arguments mainly concerned not with censorship, or religion, or even with the way one looks at works of art, but of general arts funding (what really matters in the art world is, after all, money) the whole argument seemed remarkably dull.

Despite their mutual pretensions, the overtly political, cock-shock artists and PhD rattlers are usually every bit as predictable as those seeking to censor them. What they don't seem to really appreciate is the hard fact that Nobody Cares. As the ubiquitous Raoul Vaneigem said of Mourré, *"To piss on the altar is still paying homage to the Church"*, and now, that Church is empty. So floating an image of Christ in urine may not only be seen as being tedium made flesh, but it could also be seen as being reactionary in the extreme, in that it serves to strengthen those two images – Christ and Piss – by making them juxtapose. As if they are in any way connected, or opposite. In the context of Serrano consciously choosing his audience of politicos and art bores, rather than patrons of the Hollywood Wax Museum, the two images put together do nothing but entrench and inform extremist, and extremely stupid views of the world, involving by now redundant concepts of 'purity' and 'corruption'. Cleanliness and filth. God and (gasp) Water Sports. It seems that even the most applauded pieces of socially aware art have nothing more than a short lived power to offend stupid old men. There is a

world of difference in this and in articulating truths and feelings that people have previously been reluctant to examine. And still more between this and re-organising Society and the Individual's place in it. So, as often happens, what is supposed – I assume – to be *outré* and provoke serious debate, just raises a pointless question and leaves it hanging in the arid air of the arts community, so encouraging a stronger alignment to boring ideas, polarisation, and *forced choices*.

In simple, social terms, it is expedient for some such choices to be made, occasionally lines have to be drawn, and the battle between liberal, artistic rights and reactionary philistine wrongs is politically necessary on occasions. In such a straightforward argument, I would back Serrano to the hilt. But Serrano, and the art academics who defend him, are missing the wider point. The presentation of two choices is not enough anymore, as the System has accommodated and absorbed both choices. When artists make divisive visual statements they cannot avoid reinforcing concepts of polarisation and confrontation. A reactionary pastime, as it is clear that the only way forward, the only way in which the human race can progress is to replace, inform, and synthesise.

Piss Christ provides an abject lesson in how 'Control' works. Filling up Time with spurious spacejunk. Action and reaction, cause and effect, opposites, good and evil, old moral baggage to be got into by academics, clerics and congressmen. The world of Contemporary Art is usually liberal, rarely liberating. All we get offered are old icons or new diseases.

MARY: "Are you sure it's God. Are you sure it's not the Devil?"
JESUS: "I'm not sure."
MARY: "If it's the Devil, the Devil can be cast out."
JESUS: "But what if it's God. You can't cast out God, can you?"
—*The Last Temptation of Christ* (Martin Scorsese)

"I didn't want what happened to me to happen. Neoism?! was given to me. A gift from God or the devil, but something I didn't want."
—Monty Cantsin (*Rapid Eye 1*)

The power of Christ's image may be stronger and more apparent in America than it is in Britain, as a phenomenal percentage of Americans are in some way practising Christians, but it still would seem that too many otherwise clever people in the supposedly modern Art World are using old paradigms, decaying social dialects. Serrano's piece *is* more 'interesting' than anything else seen in New York for months. And that is the problem. Old hardware. That is why a lot of contemporary art is 'misunderstood' by 'the public' – because it's too introverted and intellectually simple, and often too visually subjective to be viewed on any other level. In this sense, *Piss Christ* appeals to the lowest, most common

denominators. Those which prompt a startling 380,000 salivating Christians to write indignant letters to the South Eastern Centre for Contemporary Art protesting Serrano's profanity, and art critics, lecturers, and other self-appointed 'anointed ones' dismissing such feelings out of hand as being worthless. As an old cut-up recorded by William Burroughs and Gregory Corso once said, "Understanding out of date". After all, unless they find Spock's rejuvenating Genesis Effect from *Star Trek 3*, both Mapplethorpe – and Christ – are dead.

THREE STIGMATA IN CALIFORNIA

"You who are girdled with ice,
by such fire consumed..."

—Puccini, *Turandot*

Of course, there are many ways involving both sorcery and surgery to bring people back from the dead, and all the necromancer's arts are practised here in California. One method is cryogenics, wherein the dead person is frozen by men in white coats ('Scientists') and 'woken up' decades or even centuries later, when a cure for their terminal illness is found. Walt Disney was supposedly one such person currently living in what Alice Cooper termed his Refrigerated Heaven, though, in fact, the Disney freeze was a myth. Though other famous believers include the writer Robert Anton Wilson, who expounded cryogenic techniques in his excellent books, most notably the seminal, essential, *Cosmic Trigger*.

When, after completing the book, Wilson's daughter was killed in one of California's numerous armed robberies, he had no hesitation in paying Cryonics Internment Inc. to freeze her corpse. Little did he then know that, by the early '80s, the company had gone bust and allowed their 'clients' to melt. Money buys you more of everything in California. Poor Wilson was left to mourn twice.

Such unfortunate publicity has done little to further the idea of cryonics to the American public, though the science is far from finished. For as little as $100,000 one can still go to the Alcor Life Extension Foundation in Riverside, here in California, and now also in England, and get 'suspended' after death.

The process is quite simple, in theory. As an Alcor subscriber, you carry a disc around your person in case of death; this shows that you wish to be suspended and bears Alcor's phone number. When the company is called, a team is dispatched to pack your body in ice. You are then rushed to the Foundation's clinic, where your body is plugged into a life support machine. A hole is drilled in your groin and your blood is then washed out, bringing the temperature of your body down rapidly. Your breastbone is then cut open and tubes carrying an anti-freeze liquid made of glycerol and sucrose is pumped into you via your heart. Depending on how much, or more to the point, how little you've paid,

your head may then be sawn off (if you've only opted for the 'neuro' scheme you pay less, but your body is left to rot). A hole is then drilled in your head so that the state of your perfusion and blood wash-out can be checked. A thermometer is then stuffed into the hole in your skull and you are then put in a plastic bag and floated in a bath of silicone oil, taking your temperature down to minus 77 degrees centigrade in 72 hours. You're then placed in a pre-cooled sleeping bag on a stretcher, and plopped into a large vacuum flask of liquid nitrogen, in which you cool down to minus 196 degrees and float, float on... until such time as you are revived.

Alcor have been experiencing a few legal problems. Even in the State of California, you need to have a death certificate issued before you can be decapitated with legal impunity. In 1988 the death of Dora Kent caused the company some difficulties. The coroner wanted her body, saying that the 83 year old lady may have died of barbiturates given to her by Alcor members. He wanted the body for an autopsy. Dora's son, Saul, said that they couldn't have it. Mrs Kent had been taken to the Alcor facility when she was dying, but they had waited until her heart stopped beating before they had chopped off her head and given it the suspension treatment – just as Mom would have wanted. The Ten Commandments say it all. Like that of the Templars' Baphomet, the head vanished. Police raided Alcor, confiscated their computer records and made six arrests; but still Dora's head remained 'lost', no doubt floating blissfully in some cold Californian bath, awaiting the 21st Century alarm call. Alcor sued the FBI, the Riverside Health Department said that if Alcor have bodies and heads floating around in their well guarded tanks then they are breaking local health and safety laws. The debate goes on. What Human Rights do dead (or, undead) people have? Shouldn't they be allowed to be suspended and have the last laugh? Of course they should. But it's not for me.

In Marlowe's *Dr Faustus*, you may recall that Faust sells his soul to the Devil in return for magickal powers and privilege. Summoning Helen of Troy from her age-old slumber, he then predictably seeks eternal life through her immortal kiss. Later, sad and regretful, he is shocked when Mephistopheles returns for his payment. There is no such thing as a free lunch, or life.

Cryonics fans, looking for a kiss, never seem to mention the fact that, soon after death, your brain cells start to die too, and, regardless of future technological advances, the information which they retained is probably irretrievable. So, even if the process works and you can find a spare body lying around onto which future super surgeons can graft and revive your head – and cure you of that malignant carcinoma which you died of to boot – how would you like to wake up in 2090 when all your friends and family are long dead, into a totally alien world peopled by your aging grandchildren? Not that you would know who your grandchildren

or anyone else were, as you would quite possibly be little more than a vegetable, living life in some distant dismal coma, having been plucked from the gates of Heaven. (There is a novel there somewhere, but I'm sure it's already been written.)

THIS MAY BE HEAVEN OR THIS MAY BE HELL...
Our fictional history is alive with ghosts, zombies, the undead, those who have been resurrected, cloned, robotised and rebuilt. Because, in the spiritless, fleshy world of the West, we are generally terrified of ceasing to exist. For me, one of the best, trickiest writers of such life/death scenarios was another Californian resident, Philip K Dick. Dick is famous for two reasons. One, he appeared in the first edition of *Rapid Eye Movement* magazine in 1979, and two, he was by far and away the best SF writer on this "or any other" planet.

Dick's best books – *Ubik, Flow My Tears, The Policeman Said, Do Androids Dream Of Electric Sheep?, The Three Stigmata Of Palmer Eldrich* – were among the first novels I read. I think it was those books that hinted to me that Time and Life are circular and, if your Perception is purely linear, you will only experience one tiny sliver of the circle. What a hippy.

Mostly rush-writing as a cheap pulp fictioner in the '50s and '60s, Dick became a cult writer of the early '70s in Britain, a well-thumbed copy of such gems as *The Turning Wheel, The Man In The High Castle* or *Dr Futurity* being as essential a fashion accessory to wasted white artschool boys as a copy of Roxy Music's first album. But Philip Kendrick Dick deserved whatever popularity he got by being – along with Alfred Bester – a writer who used the generally appalling serious SF genre to spark the human imagination away from the drudgery of everyday perception. His plots never relied on tedious technology and fancifully named planets. To Dick, what counted were ideas, altered states, love and life under pressure. The Science Fiction element being used, as it should, only as a vehicle with which to create new, internal worlds. Worlds not of outer, but of inner space. The universe in the minds of men. His anti-heroes were normal, boring, fallible, mistake ridden men who learned to cope in the most weird and extraordinary of circumstances. Humans under stress, again, whose perceptions were challenged by those old favourites, Space, Drugs, Love and, in his later work, Religion. Most popular Science Fiction nowadays is overblown Dungeons and Dragons fantasy trash of the type Heavy Metal Horror fans, and aficionados of crappy B-movies adore. Although those weaned on the Classics would rather die than admit to even reading it, Philip K Dick's visions and versions of a future present – that is, an inner turmoil – are as good, if not better, than any dystopia dreamed up by Orwell or Burgess, Huxley or Vonnegut. His plots took place in future societies whose worldviews were governed by the distorting influences of idiosyncratic messiahs. His heroes were little scraps of humanity seen living

under such madness. We all teeter on the edge of our own insanity. Whereas Serrano passes comment on 'social reality' and becomes a world famous blasphemer, in practically all his novels, Dick mirrored the world by juxtaposing TWO LEVELS OF REALITY. One which is objectively perceived, the other which was determined by the processes of other people.

Perhaps not surprisingly Dick, so rumour has it, spent a lot of his time taking unusual drugs, extracted from sheep's glands, with Dr John Lilley and Al Ackerman. The former a revolutionary psychologist, the latter a mad, bad and dangerous to know mail-artist. Lilley was among the first to perceptively investigate the intelligences of non-humans, such as Whales and Dolphins, and Al Ackerman – a member of Fluxus and co-founder of The Neoist Movement – is a practitioner of what he calls 'rotational situationism', which apparently involves things such as; *"get rid of door to door salesmen by ending each sentence with the word 'tooth'."* He is probably best known for the piece he wrote while working as an Orderly in a local hospital. It was called *The Hamburger Lady.*

"...By far the worst is the hamburger lady, and because of the shortage of 'qualified technicians', e.g. technicians who can work with her and keep their last meal down, Screwloose Lauritzen and I have been alternating nights with her, unrelievedly. If you put a 250lb meatloaf in the oven and then burned it and then followed that by propping it up on a potty chair to greet you at 11 pm each night, you would have some description of these past two weeks. Which is to say the worst I seen since the Viet napalms. When somebody tells you that there is a level of pain beyond which the human mind cannot retain consciousness, please tell them to write me. In point of fact this lady has not slept more than 3/5 minutes at a stretch since she came to us – that was over two weeks ago and, thanks to medical advances, there is no end in sight; from the waist (waste?) up everything is burned off, ears, nose etc. – lower half is untouched and that, I guess, is what keeps her alive. I took one guy in to help me change the tubes and he did alright, that is alright till he came out, then he spotted one of the burn nurses (pleasant smiling zombies) eating a can of chili-mac at the desk, and that did it: he flashed on the carpet. It is fucking insane is what it is."

Al Ackerman is still producing his artwork, Lilley still penning thought-provoking books; the story of their friend though, has an unhappy ending. Philip K Dick dies while Warner Brothers start filming a cinematic version of *Do Androids...* starring Harrison Ford, confusingly calling it the more snappy *Blade Runner* after the short story by Bill Burroughs. International stardom and a scriptwriter's home in Long Beach or Beverly Hills was never really on for Dick. He was too much of an outsider. Like John Lilley and Al Ackerman, he saw too much, and his

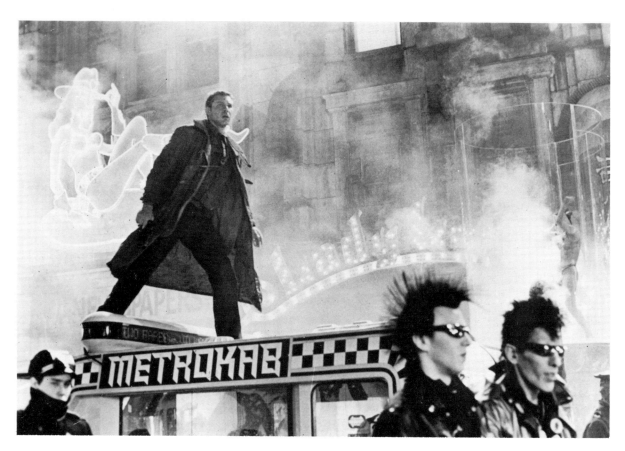

'Blade Runner' (Ridley Scott, 1982)

vision of the world was never edited to fit in with what others saw, what others were supposed to want to read, what 'Society Expected'. Unlike Leonardo, that's why he was, in his own words, a crap artist.

When you roll past Rod Stewart's home in Beverly Hills, you wonder if Philip K Dick – a classical music fanatic and man of consummate good taste – would have wanted to live here in Hollywood anyway. Money is never disgusting, people who waste and flaunt it almost always are. Barbara Streisand has an Estate in Beverly Hills on which stand five mansions. When Babs gets bored with one, she simply moves into another for a few weeks, and so on. The talentless (Pia Zadora) live cheek by jowl with the tasteless (Zsa Zsa Gabor) in Beverly Hills, a honeysuckled overpriced suburban ghetto where the local policemen are paid $50,000 a year and arrest anyone caught committing the crime of *walking* in the neighbourhood.

Prince's house used to be painted purple (he's very original like that), and the ex-home of Marilyn Monroe is small and sad and somehow as you'd expect. Mick Jagger's house, on the other hand, is very big, and has been empty since he bought it three years ago, but nobody seems to have told that to some of the tourists who hop off the tour coaches and surreptitiously root through the binliners of his, and others, homes. (Englebert Humperdink, I'm told, recently complained about the excessive security

arrangements of his neighbours but got short shrift, the neighbours being Ron and Nancy Reagan, whose dustbins are definitely out of bounds). At the gates to each house is a sign from a local private security firm, warning potential trespassers of an "Immediate Armed Response" should the householder press their panic button and want you removed. I notice that nobody in Hollywood wears Charles Manson T-shirts.

In the main, Beverly Hills is something akin to Egypt's Valley of the Kings – all the really glamorous inhabitants are either dead or have been moved on. Tutankhamen on a blockbusting tour of the world's smartest museums and Errol Flynn, like Christ, to the Wax Museum on Hollywood Boulevard. Culture, Religion and Entertainment, the trinity of the West, all set down in museums. And all most artists can think to do is press their faces against the glass, not, as many people think, because they are natural 'outsiders' in the vein of Camus's Meursault, but because they are desperate to be invited in, accepted, placed on a plinth or in a sarcophagus or nailed to a wall or floated in a tank of urine. Or, if they really make it, left to rot in a mansion on Laurel Canyon, or, depending on their medium, in one of the dozens of chic "artists' colonies" up the coast, having 'arrived'. California is peopled by 'creative' types who want nothing more than to be as rich and famous – and useless – as the Queen of England. Made safe, innocuous, irrelevant, distant, inhuman, graven, wax. What do you do when you have five

houses? Make a record saying you feel isolated and empty, and buy your sixth. Perhaps Philip K Dick was lucky.

A few hundred yards down the road, and you are out of Beverly Hills and back in Hollywood. Sunset Strip is a huge disappointment. A few unexceptional, fairly over-priced restaurants, a few famous nightclubs that have seen better days, like *The Whisky* and *The Roxy*, from which I steal an ashtray to replace a broken one at home that someone stole for me on a visit here in 1977 – and only one sleazy sex bar. Not being able to resist it, I enter for free and buy a drink from a semi-naked barmaid, then take a seat near the catwalk with the other customers.

Fat, dull-looking cunts of both sexes can bemoan the media-dictated myth of beauty all they like, but a *perfect*-looking blonde strides up and down the stage like a caged panther, obligatory high heels clicking as she skips across the boards. She is obviously a dancer and an athlete as she proves by climbing up a fire station pole and sliding down it using only her legs as a grip, then cartwheeling along the catwalk, landing in the splits next to a tired looking accountant. He smiles as she stands on her head and opens her legs in front of him, then he throws her a five dollar bill. Moving, dancing and gyrating along the catwalk she works her way methodically around the whole audience, all of whom seem to throw five dollar notes as if they were going out of fashion.

This feels degrading, uncomfortable, embarrassing and, more to the point, potentially expensive. I throw a dollar and leave.

Cracking under the Californian sun, Los Angeles is the most beautifully illuminated, unimaginably dull city in the world, offering suburban vistas of uninterrupted nothingness not experienced by this writer ever before. No wonder so many people abuse drugs out here. I have seen the past, and it does not work. L.A. is such an old fashioned idea of what a brave new city should be. However hideous, Hollywood is something of a idyllic town marooned on the sea of the smoggy megalopolis of giant freeways and lowrise monotony of the rest of L.A. Like most of southern California, it is locked in a dusty time warp, circa 1972. Dennis Hopper bikers trying to look like Peter Fonda bikers are everywhere, cavorting with pimply peroxide blonde girls in tastefully torn pink leopard-print T-shirts and spray-on white jeans. MOR rock blares from each of the radio stations, which pump out Jethro Tull, the Doobies, Peter Frampton and the inevitable Doors as though tomorrow never came. Whatever moves have been made in musical terms have been forgotten, squandered, recuperated. But this music is so right for L.A., who am I to argue?

I swear that I see the late Mama Cass one night before I turn the corner and find a nightclub. Once inside I see that it is, in fact, nothing more than a glorified cupboard with a few stools scattered around the beer sodden floor and a jukebox in the corner. Sweet's *Blockbuster* and Alice Cooper's *School's Out* play as people with long hair and very thin limbs wobble their backsides around, swigging from bottles of Bud in unison. Like it or lump it, this is rock'n'roll USA. A guy stumbles over to me and tells me that he likes my tattoo. Then he smiles and shows me his. Both designs are almost identical, only mine is slightly better as it was done by London's finest, Mr. Sebastian (recently arrested for cock-piercing by police who one would have thought had something better to do). The coincidence proves me to be completely unoriginal. To my new friend, it is an event of cosmic significance. "Fuckin' far-out." "Yeah". "Hey man, that's really fuckin' far-out." "Hmmm yes I know." "Really though man, that's fuckin' far-out... I mean, really..."

It turns out that most of 'the kids' here have just been to see The Cure. I ask where they were playing, the Roxy or Whisky or surely not the Hollywood Bowl. No, The Cure have just played to seventy thousand people in some stadium outside of town. The last time I spoke to Robert Smith he was lying on the floor of the town square in Ghent, Belgium, drunk and trying to eat greasy chips while discussing the implications of *Killing An Arab*. A pleasant, normal lad with a girlfriend back home in Horley, to 'the kids' here he is every bit as important as Jesus Christ, because they can identify with him. As I sit in a drunken haze I wonder what on earth these kids have in common with Smith, who sits reading Mervyn Peake in Sussex, then I remember something from the Twilight Zone. That last night I saw Smith, we'd been to a nightclub with Lol Tolhurst and Smith had badgered the DJ all night with requests for Alvin Stardust and Sweet's *Ballroom Blitz*.

But Rod Serling and Arthur Koestler be damned, tonight's coincidences can be explained away quite easily. Pop culture, tattoos, the radar-for-rubbish activated by beer and searches at the jukebox are, more than anything, what we British share with America. The 'special relationship', amazingly, does exist. It's political (the UK is still more politically important to America than Germany), economic (Britain is by far the largest overseas investor) and, with over forty percent of Americans still claiming not just British, but English roots, racial. Primarily, though, our relationship is cultural, and expressed best in the realm of pop.

There is a commotion outside and two of the bouncers lock the doors. From outside, some raised voices tell the people inside the club that they're all as good as dead. The barman rushes over to phone the cops, someone says "he's got a gun". In five seconds flat, I'm sober. Then, as quickly as it started, it's finished. People resume dancing, the doors are unlocked, I ask the barman what happened. "Just some assholes", he says. I cover the two mile walk back to my hotel with what feels like a poker stuck against my spine, and the tiny hairs on my neck bristling. Why do you never see a cop when you need one?

NOTES FROM THE UNDERGROUND

*"How long the night of my pain Lord,
And short the days of my joy?
Why does darkness shroud my soul at noon
And the light stop at my doorway?
Is it my knees You want me to bend?
Is it my will You would have me surrender?
O Lord*

*O Lord
How short the days of my joy?
How long the nights of my despair?"*
— Hubert Selby Jnr., *Psalm III*

Among the suntans and muscles of California, Hubert Selby Jnr., a small, gaunt asthmatic, seems somewhat out of place. Selby, a Brooklynite who now lives here in Hollywood on North Orlando, never developed the pop star persona of Burroughs or Bukowski, but as a writer of fiction that gives insights to the grimy underbelly of America, is easily their equal.[1]

As a boy sailor working on Dredgers, then Liberty ships in his teens, he contracted T.B. in Germany at eighteen and was given three months to live. The experience changed his life. After having part of a lung removed and spending three years in a hospital bed, spending his time reading and, as writers should, observing, Selby found himself back in his native Brooklyn, sharing a bar with the writer Gil Sorrentino. Sorrentino became his mentor, Selby became self-educated, alcoholic, and wrote one of the most important novels of the decade. I read *Last Exit To Brooklyn* as a boy of sixteen, attracted to the 75 pence paperback largely because of the words "POST-TRIAL EDITION. COMPLETE AND UN-EXPURGATED" that were emblazoned across the cover. I loved it and lent it to my disbelieving friends. They loved it too.

Although brimming-over with descriptive sex and violence, drug abuse, dirt, and the grinding blackness caused by poverty, addiction and broken dreams, *Exit* is one of the most moralistic books you could ever read. Moral in the sense that mirrors the reality of decadence, but does not judge it. His other books *The Room, Demon, Requiem For A Dream* and *Song Of The Silent Snow*, continue the themes. Selby's characters are down-trodden, alienated, fearful, and breathing in an atmosphere of violence that pervades all big cities like smog. But Selby's characters have something else in common. They are all *searching* for something. Men possessed by demons; addictions to alcohol, sex, gambling. They are men who are self-conscious and guilty, and trapped in a cycle of obsession and regret. They lack any control over their lives, and the 'rooms' which they inhabit may be viewed from a barstool or, just as well, a cell bunk or deadend job or an unhappy marriage. They yearn to escape but find themselves too fearful or content to try.

*"So you just better believe boy,
somebody's gonna get hurt tonight."*
— Bruce Springsteen – *Factory*

Despite the obvious morality of such tales, *Last Exit* was tried under the obscenity laws in England and, despite being defended by the likes of John Mortimer and Anthony Burgess, was found to be "obscene" at the Old Bailey in June of 1967. Selby joins Joyce and D H Lawrence, I squirm, and as usual, the law in England is made to look an ass. *"Honi soit qui mal y pense"*.

The book was acquitted in the Court of Criminal Appeal a year later, and now has been made into a film by Uli Edel. I can't see how anyone could do the book justice on film, but it has been called "a 100 minute jean commercial studded with set-piece ultra-violence." I can't wait. (I should have. Since writing, I've seen the film version and my highly honed, well expressed critical appraisal of it is that it's... just about OK.)

PERFORMANCE (Sang d'un Poète)
"I don't think I'm going to let you stay in the film business."

Also living in Hollywood, on Barton Avenue, is Kenneth Anger. Nowadays, he's best known for his legendary gossip bibles, *Hollywood Babylon I* and *II*. (According to an unpublished piece by Dale Ashmun, the famous 'missing' photo on page 285 of *Babylon II* IS of Marlon Brando, or someone very much like him, performing fellatio – he says Anger showed it to him). Although now rich and famous for his dirt-digging, it should not be forgotten that Anger is also one of the most influential independent

Kenneth Anger

film-makers to come out of America.

As Carel Rowe wrote, Anger's own film work was as highly symbolic as it was highly tinted.[2] A reflective documentary of decadent America, alive with icons snapped from the sickbed of California. Like Warhol's, his films were avant-garde, and walked the fine line between boring self-indulgence and Vision – often unsuccessfully. And, like Warhol, Jack Smith, and a few other American film-makers, his art is highly contextualised and quite magickal. He made his first surviving film, a black and white short called *Fireworks*, in 1947, when he was only seventeen. It became quite a famous little movie, because it was supported by none other than Jean Cocteau, on whose *Blood Of A Poet* it was partly based. That Cocteau was a magician, and an important one at that, we already know. He has, as I have said, been listed in some occult documents as being leader of the Prieuré de Sion – the secret masonic sect, descended from the Knights Templar, which guards some great occult secret (obviously being that Christ's *blood* [ie genes] were preserved and live on.

Looking at Anger's work, the influence of Cocteau, and the occult connections, are glaringly obvious. Anger was one of the first of many contemporary artists who were obsessed with Aleister Crowley, and used his films as Crowley used his texts, poems and rituals – to create a (cinematic) range of symbolic correspondences.

The interest in the occult of experimental artists in general, and film-makers in particular, is by now traditional. In many instances, this may often merely be due to the fact that some artists want to qualify their work in something other than 'artistic' terms so as to add weight to their opinions, but Maya Deren, Cerith Wyn Evans, Hollis Frampton, Derek Jarman and others have drawn on occult imagery and ritual as a system for depicting an interior state, and a utopianist social change.

But Anger went one step further, using symbolism and ritual not only as allegory, or as a trendy signal of attitude, but *to make his films into ritual* and, quite literally, cast a spell on his audience.

Inauguration Of The Pleasure Dome, Invocation Of My Demon Brother, Scorpio Rising and *Lucifer Rising* are all obvious examples. Naturally, Anger's influence in the world of experimental film, underground art and rock'n'roll (all supposedly rebellious, liberating, somehow millenarian pursuits) is immense, as can be seen by his list of collaborators – Mick Jagger, Anton LaVey, Bobby Beausoleil, Anita Pallenberg, Jimmy Page, Marianne Faithfull – all of whom at some stage shared Anger's interest in Crowley.

'Performance' (Donald Cammell & Nic Roeg, 1968)

The image of Crowley as a more obviously subversive, mystical Oscar Wilde type figure has been hugely popular among angry young men and women who find themselves at odds with the bible, as personified by Turner, the Mick Jagger character, having sex among the velvet cushions of a Powis Square mansion, in Nic Roeg's brilliant epitaph to the '60s, *Performance*. Although much of Crowley's

'Blood Of A Poet' (Jean Cocteau, 1930)

work was egotistical rubbish, it was through Crowley and the wide-eyed occultniks I met in the late '70s that I stumbled upon the first cohesive expressions of a non-Christian, joyfully indulgent humanism – just what you need during your late teens, in fact...

Just as Victor Hugo (coincidentally, another former leader of the Prieuré de Sion) or Gustave Moreau have been credited with an influence over the founding of surrealism, Anger can be said to be one of the fore-runners of the use of montage in the cinema. (Actually, the comparisons with Moreau don't stop there – Anger also strikes me as being misogynistic, and, like the painter, a sometimes over-ambitious perfectionist whose great famous works – Moreau's *Les Chimères* or Anger's version of Lautréamont's *Les Chants De Maldoror*, or even *Lucifer Rising* – remain lost or unfinished.)

Unlike many of the copyists, Anger's overlaid 'subconscious' image montages are relevant, telling, illustrations of, and from, American life. As Anger, like Dalí, combined his art to his tarot-like system of correspondences and his own astute, witty, and very black awareness of reality, they could hardly be anything else.

MIRROR IN THE BATHROOM

"the door is locked, just you and me..."

Scorpio Rising, his most famous film, was at the core of Kenneth Anger. Not an image *for* the unblinking TV eye, crafted on the Dream Factory floor and designed to strengthen the flat mediated reality of America, but an image from *behind* the retina, from America's collective, supposedly innocent unconscious. The images used in the film were themselves the result of some artistic serendipity. While filming it, a processing lab accidentally sent Anger a reel of film from a cheap Christian picture called *Road To Jerusalem*. Anger cut it up, tinted it

Gustave Moreau, 'Jupiter And Semele'

blue, and overlaid it onto *Scorpio*, which he'd filmed at a bike gang's Halloween party. The resulting movie bristles with icons like the cast of the Hollywood Wax Museum.

The 'crucified' *Giant* image of James Dean, Marlon Brando in *The Wild One*, Hitler, Christ, idols appearing on the character Scorpio's portable TV set and around the idolised Harley Davidson – its chrome reflecting the lasting image of 20th Century art and

Anger with the door from Aleister Crowley's Abbey of Thelema at Cefalu in Sicily

occultism. That is, as Anger says, the 'daemon brother', the dream lover, the narcissistic double of adolescent homoeroticism and '60s humanist worship, what the clones saw in the full frontal mirrored toilets at London's Heaven nightclub. Almost real: The reflection is of Kenneth Anger himself.

The songs – *He's A Rebel*, *Torture*, and *I Will Follow Him*, obviously (perhaps too obviously) give a linkage between Christ and Dean and Brando. Who Anger says are *"human idols idolised by idiots... The different degree of impact each had being dependent on the degree of advertising between pop stars and Christ."*

Like *The Book Of The Law*, *Scorpio* depicts the end of Christendom – the Age of Pisces – through the medium of a biker riding towards death, or the enlightenment of the birth of Scorpio/Horus/ Humanism. Lucifer is reinterpreted and reborn, from the misunderstandings of Christianity, that had him figured as Satan – rather than Rex Mundi, the most human god.

The new aeon rises like a phoenix from among the death of old icons, the death of the Self, and the chaotic oblivion caused by change and progress, by Niels Bohr and the new physicists, by Crowley or the New Agers. The age when the world need not be as sad as it seems.

Scorpio is a million miles away from the usual glamorised violence that spews out from here in Hollywood. Its sex, sado-masochism, homoeroticism, angst, drug-taking, suggested violence and, ultimately, death, is by contrast dirty, dull, and – like

death itself – very ordinary. This stylised but realistic treatment of sex and violence is why Anger – like Selby – is a worrying figure to many critics. His sexually ambiguous, ironic use of the song *Blue Velvet* in the soundtrack to *Scorpio* was surely an inspiration to David Lynch, who filmed *Blue Velvet* years later. Lynch, who had already made the harrowing *Eraserhead* and *The Elephant Man*, caused more outrage with *Velvet* because its sex and violence, sending up a genre, went against Hollywood's obsessional glamorisation of the subjects.

Lynch's violence worked because of its attention to *detail*. Because its atmosphere echoed the queasy feeling of inevitability that is invoked when violence is coming. That common, matter-of-fact uneasiness that engulfs you when violence is thick in the air is present in *Blue Velvet*. The fear and loathing in LA that I briefly sniffed last night at the club off Hollywood Boulevard, and in a hundred pubs and clubs and dingy dives before. We all know it. It's a funny feeling, one that actually makes you want to laugh, if only to release the tension.

When violence *does* happen, there is a glint, a single split second of cracked time in the pre-amble to the physical violence that is the point of no return. When the ritualised taunting, insults, glances, and forced laughter freezes in dry throats and white eyes. It is a moment that rockets tension and is in itself a contributor to the violence, which comes almost as a relief after the moment's brief, embarrassing, stranglehold. Lynch caught that moment. Too real for Hollywood, as Hollywood hates reality. As with Lynch, so with Anger. Within Anger, such moments of change are caught and released on film – his viewer is not allowed to forget or turn away. Nor is the audience able to distinguish between the icons of Hollywood and those of Christianity, the real and the imaginary, the Christian reel and the Gay Bikers reel, *The Road To Jerusalem* or the road to Damascus, or, some would say, Hell.

But even with Kenneth Anger, as with Christ, I find disappointment. The flash of Enlightenment is not found in the journey, the life, the biker's ritual – but in death. Crowley's promised age of Horus, the Do-What-You-Will philosophy dictated by Aiwass on some dark Cairo night ends up just there – in darkness, ends up just the same as Christianity, where you have to "slip the bonds of Earth" in order to touch the face of God. In the penultimate section of *Scorpio Rising*, Scorpio urinates on the altar of a church. But there is little defiance, no public ground gained, as the church is empty. And, "to piss on the altar is still paying homage to the church". Scorpio gets on his bike, rides off, and... dies. The last expression of Haight Ashbury or Powis Square or the revolution that was the ''60s is a boarded-up house, a deserted church, a hitch-hike to an old film set in Death Valley, the auto destruction of heroes. Be they the biker character of Scorpio in *Rising*, or Jimmy Page's friends in hotel rooms, or Brian Jones' floating, chlorinated head of hair, or Austin Spare

Dennis Hopper, Isabella Rosellini; 'Blue Velvet' (David Lynch, 1986)

dying in Brixton poverty, or Crowley, dead sybarite in a heroin haze among the long shadows of a cheap Sussex boarding house. As Bobby Beausoleil discovered, the world *can* be as sad as it seems. "And I can still see blue velvet through my tears..."

ONCE THAT RAGED, THE SEA THAT RAGED NO MORE (LIKE THE VIDEO FILMS WE SAW)...

"I like to drive along the freeways/See the smokestacks belching/breasts turn brown, so warm and so brown/I'm buried deep in mass production/you're not nothin' new."
—Iggy Pop, *Mass Production*

Before the smog and claustrophobia and boredom of Hollywood kills us we hire a rent-a-wreck and drive, up the craggy Californian coast, towards San Francisco. People may be starving, but the Diners dotted along Route 1 have food mountains that would make even the European Community blush. Here, everything is yours, so fuck the starving millions, what do they think *We Are The World* was for?

As a race, Americans are the flabbiest people in the world, because, it seems, the more one has, the more one has to flaunt. The blubber mountain that is America's Youth acts as a kind of sign telling the country that everything is alright with the world, because America can afford to be fat, ugly and semi-literate and, therefore, independent of the rest of the planet's people. Indeed, although it is wrong to generalise, it seems to me that the level of ignorance about world affairs here would be unbelievable to the averagely informed European. America is big enough and rich enough, for now, to be illiterate and insular. But like the British Empire that dominated the world before it, it is slowly learning that the world has a life of its own. Britain ruled a quarter of the world, gave it away to pay-off economic and political debts made to the US during the wars, and still worries about it. Now America inherits the world and finds that the world is dying at its feet.

Americans' reaction to this enormous responsibility seems to have been to revert to childhood. The language here is juvenile, the TV is juvenile, America can't grow up. Here, everything is fluffy and "nice". "Candy" could only be a word invented in America. Bank managers in 500 dollar three-piece suits complete the ensemble with baseball hats, white trainers and bubble-gum. Grown men in restaurants screech and shout like schoolboys rolling in a mud-bath as the waitress pours the syrup on their pancakes. Eddie Murphy cracks a joke about sitting on the bog and the audience dissolve into high-pitched whoowww-ing sounds. The President of the United States says that the world political situation is "scary". When one takes some clothes into a dry cleaners they say "yew wan'em folded and fluffed?"

The Easter Egg is replaced – for some reason that escapes me – with a rabbit which they refer to as a "bunny". Every situation comedy on television is peopled with "cute" children, and one of the nation's favourite meals is "finger-lickin' good". And here, in the most powerful country on Earth, the whole nation celebrates the birthday of a cartoon mouse. God help us.

San Simeon is a discreet dot on the map of the Pacific coast. When you park your car you can't help but notice a row of metal telescopes by the car lot, cocked and out of use, like rusting antique cannons. As always, such abandoned objects whisper to you. The (few) locals here make their living out of tourism. Travellers stop over in San Simeon to lounge on the windswept beach and watch the wildlife being wild under the balmy Pacific sunsets. Squirrels, pelicans and seals outnumber the people, who smile benevolently as their furry, feathered friends steal the food from their picnic hampers. It was not always so. San Simeon was not always a tourist spot. The town was made by whalers.

Boats, bristling with harpoons would launch from this beach every time a lookout spotted a passing school of whales as they migrated south for the winter. But now, the whaling has stopped, and the people of San Simeon, in their ethnic craft and sea shell shops, would not dream of harpooning such a creature. In the space of just one generation, they have, as a whole community, changed their perception. Or at least, altered their morality to fit in both with the more enlightened views, and pragmatic demands of the age. Pragmatic because along the beachhead is that line of coin-operated telescopes of the kind that make a ticking, whirring sound when in use. Contraptions that show you a clear reflection of your eyelash against a black unfocused haze when you put your money in and try to look through them. When I was a child visiting any such beauty spots, I used to get bored and hide under a blanket, feeling out of place as I didn't want to join in the beach games. But, at least there were always telescopes, just as there was always a queue to use such wonderful machines.

In the '60s and '70s, after San Simeon's whaling fleet had been scuppered, these telescopes too had been busy with people using them to look just a mile out into the glistening platinum coloured ocean and see the families of whales as they swam past the beach. Now, here in San Simeon, the line of telescopes are deserted, and stand like a row of dead trees in the sunshine. As Science Officer Spock said of Earth's whaling in *Star Trek 4*, "What is the point of farming an animal to extinction?" But you just feel like forgetting the logic of the argument and asking, What have we done?

Emotions aside for one moment, standing in the hard sunlight on this empty beach looking seaward, I wonder what messages – if any – are coursing around the ocean, from one whale to the next, about we humans. Although whales and dolphins may not be quite as intelligent as we once thought

they were, and although I think it unlikely that they are descended from the visitors from a planet near Sirius B (the mysterious Dog Star of the Dogon), as I have heard suggested, I do get the impression that, on some level, even animals who have had no direct contact with Man are cognisant of the fact that he is a vicious and untrustworthy creature. Despite the conferences and bans, even now thousands of whales, dolphins and porpoises are killed every year; either harpooned, stabbed, clubbed or drowned in fishing nets. The worst culprits are the Japanese fishermen, who have demonstrated no respect for international agreements made to govern international waters, and who should therefore be made to suffer the consequences by nothing short of a boycott of their nation's goods. If the matter is considered as serious enough for one to demonstrate about, why is it not serious enough for a boycott of Sony and Nissan?

The Japanese have a different attitude towards the Earth than many people in the West, informed by ancient cultural differences, and there may be some incredulity in the minds of some old Japanese fishermen when the West tells the country to stop being so barbaric, not least for reasons of that August day in 1945.

In the case of the quite moronic and bloodthirsty Faroe islanders, no such considerations exist, and the taking of more direct action is a temptation. Having ignored all efforts to bring them to their senses, these people continue the barbaric and pointless slaughter of whales and dolphins, who they enjoy rounding-up in a bay and hacking or beating to death. Of course, what the Faroe Islanders get up to in their own country is beyond our control, and the social codes of larger nations, such as Britain or the States, should not be foisted upon anybody. Stupid activity should, however, be made to look stupid. Communication and education are, as always, the only long term answers.

The quite dumb and cruel pastimes of Faroe Island fishermen and, for that matter, Spanish peasants, can be explained. These national cultures do not have a long tradition of treating animals in a particularly humane manner. For educated, supposedly sophisticated 20th Century Englishmen to become involved in acts of ritualised cruelty in the name of entertainment is not so easy to swallow.

In Britain, we are for some reason expected to accept the notion that the Royal Family and other well-heeled weekend Barbour wearers can trample across other peoples' property with packs of trained killer dogs and spend hours wearing out, then ritually slaughtering, wild animals. At the same time, we are expected to be outraged by tabloid stories of working class thugs on council estates who chase and kill stray cats. Cruel and stupid activity is socially condoned, providing you speak with the correct accent.

Roger Scruton, a self-styled right wing 'intellectual' who has become a spokesman for the hunt lobby is typical of the middle-class suburbanite who, for all

THE PLAGUE YARD · 171

his supposed intelligence, cannot adequately justify his ritual killing of animals for pleasure. His defence rests primarily on his argument that the fox is vermin – but ignores the fact that, in many areas, foxes are bred for the specific purpose of hunting. I wonder if the city-based Mr Scruton, who appears exceptionally keen to control vermin, gets his friends together and goes out hunting rats and mice when he is in London? Scrotum goes on to say that all other methods of controlling vermin are less humane than chasing it with packs of trained dogs for hours, terrifying it, tiring it out, digging it out of its hide, then flinging it into the pack so that they can rip it apart while it is still alive. He also fails miserably to explain why, if we are merely talking about the control of vermin, should this be celebrated and turned into a blood ritual from which some individuals deride a dubious kick. (It is popular nowadays to sweep the connection between killing and sexuality under the carpet, but the fascination of killing, torture, and violence is sexual.) Scruton pleads for the hunt on the grounds that it provides people with the enjoyable experience of riding horses and that this is heightened by "the thrill of the chase". (Joy-riders, shoplifters and all sorts of sociopaths use the same pathetic argument of "thrill seeking" for *their* behavioral problems). Scruton obviously hasn't heard of chasing a previously laid scent. On the bottom line, Scruton really perceives the fox hunting debate to be a question of crusty leftist lesbians attacking decent, middleclass traditionalists, and to defend the elitist argument says that hunts are drawn from people from all walks of life. Again, he is quite wrong. The majority of people who hunt are from higher income groups and the majority of working class people involved are not part of the hunt, but are employed by the hunt. (Horses do not come cheap. Even to rent one for a day of hunting costs upwards of £90).

Mr Scruton also wrongly reckons that the anti-hunt lobby are guilty of "siding with the innocent fox" and applying human traits to an animal. He misses the point. The issue is not the humanisation of a wild animal, but the dehumanising effects that the legalised ritual killing of animals for entertainment has on civilised human society. British society would not – as I said, does not – condone groups of working class skinheads with packs of pit bull terriers chasing animals, often trespassing, shouting, screaming, blowing trumpets, tearing animals to pieces and celebrating by daubing blood over children and drinking alcohol in public places. Why, then, should it condone fox hunting? What Scruton is so badly defending is not the right to control vermin, or even the moral correctness of killing animals for sport, but the right of a privileged few to act in a manner that the vast majority of citizens find to be cruel, barbaric, and highly offensive. Hardly something that adheres to contemporary concepts of public decency, order and democracy. Scruton thinks he is defending traditional values, and the rights individuals have to make choices. He is in

fact defending something that is, if he considers the matter more deeply, actually now quite alien to the English way of life, and championing champagne anarchy over democracy.

However tempting violent action may be when one witnesses such repulsive behaviour, violence is not the answer and should not, in a world teetering on a genocidal scenario, even be considered as a solution to a problem. To resort to violence is to shake bloody hands with Control. However high minded his ideals, Brutus was aptly named. One way to deal with the Faroe Island cull and numerous other atrocities is to act as one would when faced with an exhibition of the symptoms of mental illness. With drugs. A prescription of MDMA for every islander and huntsman would soon cure them of their obvious social disease. Scruton might even stop being an intellectual and become a man of intellect.

THE COLOUR FIELD

Nothing is more arrogant or more indicative of the world's current problems than the phenomenon of killing animals purely for pleasure. If men with jellified genitalia need so desperately to prove themselves as men, then they should go and climb a tree or do a hundred press-ups. Something macho like that.

Unlike our less sophisticated Faroe Island cousins and middle-class British intellectuals, most Californians have come to terms with the fact that animals should be studied by intelligent people, not gratuitously killed by stupid ones. Animals have much to teach us in terms of our position in the universe, about the way the planet works, and about communication.

What can we learn from studying animals about communication? We wondered earlier what messages whales passed on to each other about humans. 'Morphic Resonance' was the term coined by the scientist Dr Rupert Sheldrake to describe the as yet unfathomable forms of mammalian communication which stretch across continents and generations. Simply, it is one term used to describe what is going on when creatures communicate in ways that humans do not understand. For example, it is well known that if a dolphin is taught a trick in an aquarium in Florida, then the time taken to teach a similar dolphin the same trick in an aquarium in, say, England would be shorter. This sort of phenomenon has been observed and documented by doubting scientists since 1920, when the psychologist William McDougall of Harvard University set up a series of experiments to discover if animals were able to inherit behavioural characteristics from their parents. Not behaviour that had been genetically programmed for generations, but habits that had been acquired by their parents during the parents' own life, or learnt by unrelated animals of the same species. McDougall placed laboratory rats, one at a time, in a tank of water and gave them two routes of escape; one up a brightly lit gangway at the end of which the rat received a small electric shock, the

other up an unlit gangway which led to freedom. McDougall recorded how many times each poor rat took to learn that to avoid the electric shock he must always chose the unlit gangway. With the first generation of rats it took an average of 160 shocks before they learnt the correct route out of the water tank. Their offspring learned the trick quicker, and their offspring quicker still, until the average of shocks each rat would receive went down from the original 160 to only 20 before they learnt how to escape without a shock.

Orthodox Mendelian genetic science denies that such a thing could happen, and although biologists could find nothing wrong with McDougall's elaborate test procedures, they concluded that he must have, by chance, picked a co-incidentally super intelligent group of rats in the first place. McDougall started again, conducting tests to find the most stupid rats he could, and only breeding from them from one test generation to the next. According to conventional scientific theory, the rats success rate should have gone down, but they did even better than the first 'intelligent' generations of rats, learning an incredible ten times faster. However interesting this may be, people will still say that 'genetics' are responsible, even though we have no understanding of how such specific behavioural information could be passed biologically from one generation to the next.

McDougall's experiments really get weird when, in Australia, a group of scientists try repeating his work. Using the same species of rats and a replica water tank some time later, the team were amazed to discover that from the very *first* generation of rats the animals were learning the trick much quicker than McDougall's earlier rats. After repeating the astounding experiments and finding that this was no fluke, the Australian scientists then tried the experiments with untrained, unrelated rats. Over an exhaustive series of experiments lasting twenty-five years, the scientists found that even rats who were not bred from parents who had taken the tests were quicker and quicker in solving the problem, until it got to such a stage that many rats made no errors at all, always picking the unlit gangplank to safety from their very first test.

To this day, the results of this and much other similar work cannot be explained by conventional science, but it does lend credence to the idea that there is some shared pool of unconscious information that is 'tuned into' by mammals and acted upon at an unconscious level. Without denying the physical importance of such things as DNA, protein molecules and so on, and the influences of the environment, Sheldrake's theory that there exists a morphogenetic field (the word comes from the Greek 'morphe', meaning 'form' and 'genesis', which means 'coming into being') which, like the invisible fields of magnetism or electricity for instance, can be tapped into, is attractive. Dr Sheldrake does not to my knowledge seem to have aired any theories on how such a 'field' would be accessed, but for the

sake of argument we can invent one of our own. If this pool of what may perhaps be energy exists as an evolutionary store of information, connecting all living things, then, like a computer, it needs to be accessed at different levels, by different species, for different information.

Perhaps the signal or reference tone given off by each different species' brain-wave activity has the effect of tuning the unconscious mind in to the information pool, much like a radio tuned to a certain frequency would pick up only the station that the listener wanted, rather than all the irrelevant jumble of foreign language stations vying for attention across the dial. In this way, a dog would tune in to the canine pool of stored information, the dolphin would pick up the accumulated knowledge of his forefathers, and a human would do the same.

The idea strikes many familiar chords. Could not the 'auras' of Madame Blavatsky be a visual interpretation of such an energy field? Would the existence of such a field not help us explain the phenomenon of people communicating across time and space by telepathic means? Could this pool be the akashic record, or the 'collective unconscious' of Carl Jung? Could this vast interconnecting web of information energy be God itself? Ulp. I don't know, but I'm sure that if it was, then it would not have any interest in stopping me having a drink on a Sunday afternoon.

I do, though, think that such a pool of information would be rippled by the activities of people who persist in torturing and exterminating various species of creatures purely for their own enjoyment. What is the akashic record saying about us to all those whales out there? The answer, as Spock would have known, is quite logical – and all too obvious.

THE CHANTEL IN THE HIGH CASTLE.
On the top of the mountain just inland from the town of San Simeon is a large Disneyland castle. Hurst's Castle. William Randolph Hurst was one of those men whose certainty infects the rest of us with doubt. In California, there are many such men.

"Stood still on the highway, I saw a woman by the side of the road... A fearful pressure paralysed me in my shadow...
I said 'Mama I've come to the valley of the rich, myself to sell'.
She said, 'Son, this is the road to hell...'"
—Chris Rea, *Road To Hell*

You drive along the freeways of California and realise that those horror stories you heard back home are just not true. Even in the big cities, the Americans are generally the slowest, safest, and most polite drivers in the world.

San Francisco creeps up over the horizon and suddenly hits you as you slide around Half Moon Bay. SF is a shanty town seaport set on multi-coloured hills, speckled with low-rise wooden houses.

Yellow, blue, pink. Your mind flicks like the channels on the unfathomable FM radio in the car... *The Lovin' Spoonful*... Harvey Milk... Flowers in your hair... hanging out of the gun barrels of National Guardsmen... Emmet Grogan's Diggers leaving wads of money in wastepaper bins... Patty Hurst staying away from Daddy's castle to give out free food with the S.L.A... A chic, hip, shanty town. The sailors shanties were learnt aboard sailing ships moored off the Polynesian islands. On hot evenings the ritual chants of the island tribes would float aboard on the wind, like a dim signal on a untuned radio, crossing the ether, the cultures, beneath the last wisps of pollution-free cloud. The dimly heard, distant rhythms and shouted harmonies of the islanders' religious songs would be taken-up by the bored crew, re-worked, given English lyrics, westernised, and end up being sung on streets from Plymouth to San Francisco.

Cultures are misunderstood, looted, re-invented. Time loops.

LUCIFER RISING
Now, in the apartments of Haight Ashbury, the spirits and bones of the "savage's" rituals have returned, not as sailor's songs, but stripped down, closer to their original ethnic roots, and are repeated phonetically as the chants in the rituals and mind-exercises of San Francisco's New Agers, Hippies, and assorted cult members. Whereas 17th Century sailors wanted to convert ethnic culture into something which they could understand and absorb, the 20th Century urbanite tries to re-invent and copy the past cultures that he is unable to understand, in the hope that a return to a more simple, yet 'spiritual' past will fill some perceived void. They may have a point. The past seeps into the city, informing the present in reheated atavistic dew – the Prima Materia for access to the hidden worlds of the akashic record. As in worthwhile Art, this information is carried not on cheap tricks or intellect, but on an often vague, indefinable feeling that is more astutely reflected in music or brushstrokes: convenient to charlatans who wish to package and sell it, and exasperating for those who must express themselves in more exacting, linear forms. As Brion Gysin once said, Writing is fifty years behind Painting.

Perhaps.

IT'S SUCH A LOVELY PLACE...

"Then some sage man, above the vulgar wise, knowing that laws could not in quiet dwell, unless they were observed, did first devise the names of Gods, religion, heaven, and hell... Only bug-bears to keep the world in fear."
 —*The Hellish Verses*, produced at the trial of
 Sir Walter Raleigh and ascribed to him (1610).

One San Franciscan who has attempted to apply a capable and contemporary mind to the subject of

Anton Szandor LaVey (photo: Bobby Neel Adams)

searching out and examining such "vague and indefinable" feelings, and at the same time express himself through a hybrid of words and deeds, is Anton Szandor LaVey. The mystery man who smiled from the balcony on the inside cover of the Eagle's *Hotel California* LP, the man who performed the 'wedding' in *Rosemary's Baby*. A man of sub-cultural in-jokes and hidden influence. In my mind, LaVey is one of the most fascinating and compelling artists in America today, but you won't find him featured in *Art In America* or *Artscribe*, simply because LaVey is one of those artists who is sensible enough not to call himself an artist. And he does not call himself an artist because Anton LaVey may *really* be interested in changing the world. He is the High Priest and Founder of an organisation that is a tax-exempt registered charity in California: The Church of Satan.

Although generally regarded with derision in the pompous, academic circles of European occultism, LaVey is a big deal here for precisely the same reasons as he is vilified by many in the U.K. Namely that in the '60s, he came to a conclusion that is shared by most people who have studied the occult and applied to it even a modicum of common sense: that with few exceptions, "every tract and paper, every 'secret' grimoire on the subject of magic are nothing more than sanctimonious fraud – guilt ridden ramblings... esoteric gibberish... [that have] clouded the entire issue..."

LaVey's choice of words is noteworthy. My old friend Kenneth Rayner Johnson – author of the best contemporary book on Alchemy (*The Fulcanelli Phenomenon*[3]) and a mine of useful information – once told me that the word 'gibberish' itself was

introduced into the English language originally as slang, springing from the name of the alchemist Jabir el-Haiyan, who was known in the West as 'Geber'. Even more than his name, much of the language he used in his writings was not easily pronounceable, and the texts themselves were unintelligible to the uninitiated, hence the word "gibberish". LaVey's use of the word as a derisory descriptive noun either means that LaVey is not truly as *au fait* with the subject of esoteric knowledge as he might be, or it means that he uses the term with a sense of ironic deliberation. Given the man's obvious intelligence and erudition, it is likely to be the latter.

LaVey also stated in the '60s that which is taken as being obvious to almost everybody in Britain since the last century – that, like God, the Devil does not exist. At least, the Devil is not some anthropomorphic deity that represents the reverse of God and what is Good, but is rather a derisory term (a little like "gibberish") used to describe the dimly understood force of nature that leads mankind to evolve, express himself, revolt, explore, progress, and seek knowledge and experience that has, by those with vested interests, been forbidden. And, as the word "occult" means, made secret. As with the serpent wrapped around the Tree of Knowledge in the Garden of Eden, or the man who splits the atom, or the little boy who looks up a girl's skirt to see what's there. All actions might be done in innocence, until they are called evil.

Although LaVey conveniently seems to forget that such opinions have been obvious throughout modern history, preferring to air these opinions as though one were being made privy to some marvellous esoterica, it's true that they do need repeating, and he has at least shaved his head, reversed his secular collar, and put himself on the line. Serrano's argument comes back to me. It all depends on one's audience... I would probably agree with more of what LaVey says about Religion and Morality than with what most people say, and normally would find myself arguing firmly on the side of the Church of Satan, but to Mr LaVey I would play Devil's Advocate, particularly as many readers of *Rapid Eye* will already be familiar with aspects of LaVey's work and not need the basic principles explained and defended. We are not Jesse Helms, so, let's get specific. The Devil can take it.

Like so many attracted to the micro world of the occult, LaVey seems obsessed with Christianity, even though he blurs this obsession by referring to "all other churches", as if all other churches were Christian. (For instance, he says that all other churches are based on worship of the spirit and denial of the flesh and the intellect, even though this could hardly be said of Moslems, for example). The millennial-minded Mr. LaVey talks a lot of sense, but insists, like Serrano, in addressing his audience using terminology that is supposed to make things both more thought-provoking and accessible, but which in fact serves to reinforce the same old social

barriers and beliefs. On the one hand he implies, or at least, I infer, that he is merely interested in forming a group of like-minded, thoughtful individuals who can pool their resources and energies in an attempt to come up with a liberating, alternative humanist philosophy, free from crippling, dogmatic belief systems. And he has done much to further such a utopian lifestyle.

On the other hand, however, he indulges himself with old terminology and hierarchies, clichés, wearing black cloaks, horned hats, silly goatee beards and festooning his Church and stationery with the glamour of gothic gore and cobwebs. His argument for all this is the old one, the same one that was manifest to the tribesmen on the beach and the crewmen of those ships anchored back in the 17th Century as they made up their sea shanties. That people need images, ritual, symbols, focal points, as vehicles for the exorcism of feelings that they can't, in Western life, easily release. We all know that this is true – the evidence for it is everywhere in our art and adverts, our cultures and sports – but one can't help but wonder if this is enough. Like many avant-garde art movements (which are themselves generally utopian), Satanism seems to offer a safe channel through which all the anger, all the creativity and desperation one feels with life can be directed. But the direction is only used towards the taking-up of a social *stance* against prevailing views of the world, and not in the genuine creation of a new world. Just as one cynical view of Punk could say that it was a control device that recuperated feelings of alienation and castrated much potent revolutionary feeling. (Former *Rapid Eye* interviewee Patrick Fitzgerald summed up this view on his *Safety Pin Stuck In My Heart* EP in simple consumerist terms back in '78, saying that Punk meant only that Bondage Trousers were now available at Woolworths.)

Also, I wonder if by replacing one old, limiting religion with a new, limited one, by appropriating and inverting old symbols, how understanding, or even knowledge, is increased. If Satan is 'Progress', how then has he been served? Occultists, like Artists, should learn that the simple act of reversal, like the act of protest, is really not enough nowadays.

Perhaps though, I'm expecting too much. As it seems that as soon as you open your mouth to speak, much of what you say is stripped of some feeling due to the way words are formulated and received. Printed feelings also then become propaganda. To escape this eternal problem, LaVey could have been an abstract artist rather than a man of words, but that, as LaVey knows, appeals only to people who are afraid or unwilling to meet the challenge of language, which is the challenge placed on the individual by Society. A society formed and ruled by words, ruled not, as art bores think, only by simple images, but by what images literally *mean*. You can only do so much, and LaVey deserves respect for doing what he has. There are, though, still several obvious questions to be asked of the

John Dee

Church of Satan.

In a manner which is identified very much with the 'American way', the focus here seems not on Understanding or even on Information, but on assuming a position of power. Although much of the interest in 'alternative' structures can be seen as individuals reacting to America's materialism, in practice, beneath the veneer, the alternative offered does not seem an alternative life, but an alternative way to achieve the largely materialist goals of American society. The Church of Satan's rituals, like any formal rituals, concentrate the mind through symbols and words and suggested altered states, but the mind that has been nurtured on Hollywood is concentrated not on things of the spirit, but of the material. Most books you see on the shelves in America are 'How To' books; *How To Get More Money*, *How To Get Your Boss Eating Out Of Your Hand*, *How To Fuck More Women* (the titles are usually more coded, but we all know what they're about).

The type of occultism practised by Satanists represents the last word in this genre of oneupmanship. Only, in the Church of Satan, the church-goer, or client, is encouraged not to chant 'I must get thin' or 'I don't have a big nose' as in some Californian psychotherapy group, but chant in Enochian – the language invented for Dr John Dee by his clever young skryer Edward Kelly in 16th Century England. This use of Elizabethan gibberish – which appears serious rather than ironic – in itself seems something of a contradiction, given that the brilliant polymath Dee's books, such as *De Heptarchia Mystica*, were major contributions to the

cloudy magickal thought of the early 20th century occult revivalists, including those in MacGregor Mathers' Golden Dawn which LaVey so heavily criticises. The language, handed down to Kelly as if he were a new age Christian speaking in tongues, a priest reciting in Latin, or an opera star singing in Italian, is only understood by those who've bought the book. And in LaVey's own words, *"If you want miracles, you should expect to have to pay miraculous prices."* Philosophies, like spells, don't come cheap. Having said that, I don't think LaVey is a charlatan (he may well believe everything he says), and he is certainly not a crank. More accurately, he is a wealthy activist artist who can attract charlatans and cranks. Here in California, LaVey's clients have included not only the usual bunch of weak-willed losers, hip lonely hearts and thrill-seekers, but the rich and famous as well. The most famous being Sammy Davis Jnr., Jayne Mansfield, and The Eagles.

The Eagles' manager Larry Salter has gone on record as saying that the group were members of the Church of Satan. The first base for the Church was an old hotel on California Street, San Francisco, hence the title of their biggest-selling album, *Hotel California*. Christian fundamentalist anti-rockers here have come up with the accusation that the 'Hotel California' track actually includes the backmasking message which says "Yes, Satan had help, he even organised his own religion". Hardly an Earth shaking statement, and even if it were, who cares? Backmasking never did anyone any harm as, contrary to popular belief, the unconscious mind does not listen to music backwards, and even if it was somehow willing or able to discern such buried messages, the suggestion that "Satan had help" is hardly going to make someone go out and commit murder. The practice of backmasking, which involves recording words backwards and hiding them among music, is merely an invention of a Record Industry that wishes to increase its market share in an American pop chart still based on the creation of a superficial Generation Gap. American pop and rock music is, more than most, merely interested in making kids feel that they are scaring Mom and Dad with all that crazy hair, wiggling, Attitude, and so on. The putting about of rumours concerning backmasking is simply more ammunition in the game. (Anyway, as they say, if you spend your time sitting at home listening to your vinyl records backwards, then you probably *are* the Devil.)

The Eagles, like Sammy Davis Jnr., are said to have got tired with the Church of Satan and drifted away from LaVey. Jayne Mansfield did not. Mansfield was a sad case. Once a loyal devotee and lover of LaVey, the movie star didn't heed his warnings and stay away from her new boyfriend, lawyer Sam Brody, and LaVey placed a curse on his rival.

Shortly before her death, LaVey claims that he was making a cutting out of a newspaper and found, on the next page, that he had also accidentally cut through a photograph of Ms Mansfield – cutting off her head. The rest is cult history. Jayne Mansfield

Jayne Mansfield

was decapitated in a car crash. The car was being driven by Sam Brody. LaVey says he didn't mean to do it, and was devastated with the news of her death. He'd missed.

That some spells and incantations do work on some level, I don't doubt. So, depending on how cynical you are, this either means that Mr LaVey is very good at cursing, or pretty lousy. Perhaps the old rule of karma, expressed in the occult as being the rule of bad magick returning home to roost, is in some sense applicable.

But the hype and hokum are not really important here. The ideas of The Church of Satan are. The basic philosophy is typically practical – anything that brings gratification is OK and the morality put about by the Christian Church, which is based on guilt and self denial, is a load of hogwash. LaVey encourages devotees to question all things, avoid dogma, enjoy sex, live in the present, extend personal liberties... and I say hurray to all that, so far so good. However, the further you get into the philosophy, the shakier it all becomes. LaVey, who is not only founder but self-styled leader of the Church, starts laying down the Law. Don't they always? In the Church of Satan's Laws, you are, for example, encouraged not to turn the other cheek to your enemies and told that 'love' is a sign of weakness when shown to strangers, or to

anybody who you have not chosen specifically to love. LaVey's tracts are also peppered with practical examples of how a Satanist might behave, which are perhaps chosen to attract people who still feel that they need to offend their maiden aunt in the suburbs. For example, you are quite sensibly told such obvious things as if you are a sadist and you meet a masochist, you should torture them for your mutual satisfaction.

But, despite the superficial shunning of morality throughout, you are then told not to inflict harm on those who don't want to be harmed. Not to kill animals, and so on. But, if one finds gratification in activities which others find unacceptable, quite why you shouldn't inflict harm on others, or sacrifice one of the last surviving Giant Pandas for that matter, is not made clear. And so it goes on, contradictions mounting, from one 'Law' unto the next. What rationale and humanism and logic there is, soon being lost under a welter of pseudo amoral posturing. As usual, you realise that one set of mores and laws is merely being replaced with another. Only in this scenario, everything is not unnaturally informed by Mr LaVey's own personal morality and his members' shared obsession with Christianity, amid much theatrical blasphemy and what can only correctly be described as 'naughtiness'. As in all rulebooks, difficult issues are never raised, or stupidly dismissed. What, for example, happens to the Here and Now, the Planet, if we don't tolerate our enemies? Nuclear war? How then is 'he' (ie Human Progress) served? On the one hand, the ideas seem to be aimed at providing natural justice beneath the oppressive yoke of the Christian Churches and their hypocritical cultures, but on the other, such an ideal of justice is conveniently ignored. Babies are thrown out with the bathwater everywhere. The only worthwhile tenants of Christianity – compassion, tolerance, love – are lost in a tirade against the true evils propagated in the name of Christ by the arrogant men and women who have called themselves preachers and teachers throughout history. The people who burned the Salem Witches, killed the Kennedys, and let Brian Jones float in his new pool were the same. In this light, LaVey's world doesn't look all that different. It's still the weak-minded, rather than the meek, who inherit the Earth.

LaVey is a pleasant, intelligent man who has decided to act the (scape)Goat. Despite what many people think, he has done more than most to further the practical, liberal principles to which most people in the West guiltily adhere – by trying to remove some of the guilt. Nothing wrong in that. But, like most American artists and liberals (and he is in many ways both, though I doubt if he'd like either term), he's using a language, or a form of magick, that has lost its once powerful potency. Does anyone but a Christian really care if you hang a crucifix upside-down? And if it is important to them because of the repetition of Christ's image and misquoted words throughout our culture, isn't referring to

Christ's image at all likely only to strengthen the Christian grip on Perception? People would say to this argument that you cannot ignore such powerful images in the hope that they will go away. But you can. If you do not make your controlled choice, you realise that such choices are unnecessary. Using the emotive image of Satan to represent Evolution may be an interesting idea in that it illustrates the point that much of Christian teaching is against the idea of Knowledge and Evolution, but it also implies that the search for Knowledge is heretical and therefore in some way wrong. It is of course perfectly natural to strive for progress, and Old Testament deities or Jewish prophet figures have about as much to do with it as the Celtic Banshee or the Babylonian god Ea.

The Church of Satan is a quintessentially American phenomenon. Californians like to think that this is because America is a liberal, just, constitutionally right-on kinda country that is the only place in the world that would allow such hereticism. In fact, the truth is that if someone announced the formation of a Church of Satan in England, (I use England as an example as it is the only other country which I know enough about) the social effect would be very minimal, because most people in the U.K. are not overtly practising Christians.

Unlike America, individuals one meets in Britain in general, and England in particular, also have a deeply ingrained – albeit superficial – tolerance of eccentricity that makes such emotive public displays of anti-social posturing rather less necessary. One need only to look to the political arena to see the point. In Britain, Neil Kinnock can stand up at the Labour Party conference and proclaim himself to be an atheist, Tony Benn can say he is sympathetic to the words of Marx, and Michael Foot can admit to supporting Plymouth Argyle. To me, all three men have made reasonable choices (Mike Bickle was God), but here in America, even in California, such public admissions by a politician would be unthinkable. California needs The Church of Satan; New York needs *Piss Christ*; Britain needs a written constitution. (Before we get too smug, however, one should consider that Britain, an old country, is far more adept at dealing with what the State considers a threat than America is. For instance, the Social Services and media in Britain have connived in such a way as to make the word "Satanism" automatically equate with sexual child-abuse. So, anyone who investigates the esoteric writings of people such as Aleister Crowley, for example, is considered somewhat 'weird' and perverted. A whole sub-culture, that is involved with all aspects of esoteric and avant-garde art, alternative philosophies etc., is therefore seen as being suspect. Child-abuse, which takes place more often behind net curtains in supposedly pleasant English suburbs where it is ignored, is transposed from 'normal' society, from whence it springs, and on to anybody who wishes to live what some see as an 'alternative' lifestyle.)

Like many self-styled leaders, Mr LaVey (or 'The Doctor' to his friends) is very sensitive to criticism. When I hint at such topics of conversation to him and his Personal Secretary, lover and biographer, Blanche Barton, he stops praising *Rapid Eye*. When I want to get down to specifics, I'm told that I'm being "nit-picking", and neither LaVey or Barton telephone my hotel room as previously suggested. But people have nit-picked at the Christian Bible for generations – such is the stuff of new religions like Mr LaVey's. The Church of Satan is a nice idea, a socially useful art piece, but, like other churches, it seems to have missed the point. The point being simply that what you get when you dismiss or decode religious myths, reject both rhetorical Christian mumbo jumbo and Satanic shock, is a marriage of Satan and God. Progress *and* Love, Knowledge *and* Tolerance.

Such a marriage is called Human.

(Exterior shot of suspension bridges rocking in an Earth tremor. Close-up Interior. He lifts up the sheet to find the bloody, severed head of a dolphin. Last one. Delphinus nesarnack, beelzebub, diabolos, nomen oblitum, obliterated.)

BOO HOO BABIES

There are many offshoot religions in the States. The creation of bogus or deliberately pseudo-religious groups – as irony – is something of a tradition here. Unfortunately, the constitutional right all Americans have to take the piss out of religion has been abused by assorted idiots who have taken it all seriously. Thus, the country is full of Protestant crank-cults who exert a political influence that one would like to think would be laughed at in England. Nowadays, though, under the unholy alliance of such dubious groups as the Jesus Army, the Conservative Family Campaign, and the repugnant Festival of Light, I'm not so sure if we can afford to ignore what has happened here, where the immoral minority can exert their undemocratic dollar dominance to put TV shows off the air and make sure some records never get played, or even made. Of the openly irreverent, satirical churches, there are some gems. Probably the most famous was the Neo-American Church, formed by Art Kleps in the '60s. The Church's sacrament was the mind altering drug LSD., a more obvious ritual tool than the unleavened bread of catholicism, transubstantiation or not. In Kleps' book, *The Boo Hoo Bible*, the drugged beatnik demanded that church members envisaged a brave new world of unbridled bliss, one created here on Earth, rather than in some vague, hoped-for heaven. The N.A.C. even went to court to establish its constitutional right – as a bona fide religion – to incorporate the use of LSD in its rituals. Judge Gessell, who more recently presided over the Oliver North trial, predictably threw Kleps out of court. Miserable bastard.

Given the scandal over Salman Rushdie's boring *Satanic Verses*, we should also at this point remember America's Moorish Orthodox Church, which was nothing more than a 1960's parody of

Islam. And then there's the Discordian movement, presided over by White Cord witch, Robert Anton Wilson. The man who, like Lazarus' wife, mourned twice. Basically, the Discordians taught that God was a woman. And a mad woman at that. The Discordians were utopianist artists who knew that in a world based on words, they had to write. The Discordian myth, a joke which, like all good jokes, has a true black sadness at its core, has been fuelled by several books. One was *Principia Discordia*, the other was the Illuminatus trilogy, which is still on the bookshelves of shops around San Francisco's Union Square.

'BOB' DOBBS - THE GURU FROM DALLAS

Bob Dobbs

One of the most hip churches here is one which is well known in London, that of the Church of the SubGenius. Its best slogan is its most crass – "Pull the wool over your own eyes". The Church was founded in 1978 down in Dallas by Ivan Stang, (Douglas St.Clair Smith). Doug, in typically obvious arty fashion, took a picture that was supposed to represent American 'success' from an old magazine, added the name J.R. Bob Dobbs to it, and went about posting this with mailart pieces to everyone, telling them that the world was due to end on July 5th 1998, but, if they sent an ordainment fee, they would become members of the Church of the SubGenius and be saved by aliens in the nick of time. Quite an amusing little idea for ten minutes. Thousands sent their ordainment fees, Stang became quite rich and famous.

J.R. Bob Dobbs' picture soon started turning up throughout the American underground and spread to English fanzines (most notably industrial arty ones emanating from Manchester and Sheffield, not surprisingly) and, as these things tend to do, informed an unspecific attitude of outsider oneupmanship.

I have always been in two minds about such Mailart. It epitomises a central problem of much 'alternative' art. That is, in individual, creative terms, it may all be very healthy and fun, in that some people are encouraged to communicate and Produce rather than solely Consume. It may also give isolated minds the feeling that they are not alone, and give artists who are too extreme to be popular in Cork Street or the galleries on Melrose Avenue a slightly 'subversive' avenue of expression, but – ultimately – that's usually all it does. It's not exactly going to change anyone's world.

*"He wants to be above the law/
but he doesn't know what he's fighting for/
with his hammer and his popsicle/
they'll put him in a hospital for good"*
—Scritti Politti, *Asylums In Jerusalem*

At this point, I am standing in Haight Ashbury's version of Rough Trade. Scritti Politti are playing and I'm in a time warp. Once, the Scrit's leader Green Gartside – then the epitome of Camden Marxist Art Squatter – complained to me about the very thing he had become famous for. The production of DIY records, the cottage mailorder industry of the John Peel Post Punk generation, the mailing out of xeroxed propaganda, tapes, records. All this, he said, was boring. It was, too, an idealised, dull, anti-social life stance spent amid the musty world of Blues, Bacon, and Burroughs. Green got depressed, asked me if I had any drugs (I hadn't), and in the morning was staring up from a hospital bed, having been told by disapproving doctors that he had almost died. When recuperating, a shaken Green ditched Marxism and became faithless, and *Faithless* became the new Scrit's first chart single and John Peel's record of the year. Kind of how I feel, standing here now in Rough Trade.

The very pleasant nouveau hippies I meet here have an original copy of *Rapid Eye One* on display on their shop's wall. A man with a lot of hair grabs me and pumps my hand, saying that it's the best thing he's seen in ages. I nearly faint. Around the book displayed on the wall they've kindly written an advert for the book which says it's "super cool", and that, it seems, is enough. I realise I'm on the brink of getting famous – people ask me for autographs!

Getting the post in the morning and finding 'interesting' images on postcards from mailartists

around the world is initially very pleasant, but after a while the novelty of networking – the vague sense of camaraderie, the effect of pleasant aesthetics, the discovery of a piece of mail that isn't a Final Demand – wears off, and now most of it goes straight in the bin. It doesn't do anything more than communicate the obvious fact that, well, there are millions of discontented arty bastards like you in the world. Looking at the posters and flyers in Rough Trade and the coffeeshop, they're all Just So. Just as you knew they would be. Full of 'Dadaesque' cut-ups and collages, repeated photocopied images and some even with the rubber stamps that mailartists, in a mockery of officialdom, once made their own. But it all appears to me so much empty stylism, informed by an Alternative Art movement of which Mailart was an integral part. The graphics department of the revolution. But really, what is so useful about a bunch of people who are interested in art sending postcards to each other? Having been born a month before the '60s started, I'm probably too old, or too stupid or too cynical, but I think that unless these images say anything other than signalling some vague 'alternative' type attitude, unless they cast some light into this smoggy darkness, then, to use the local vernacular, I think the idea sucks.

A friend of mine in London (the highly underrated painter Nicholas Slagg) has this tattoo under both his armpits. He likes to show it at restaurants full of tourists. In one armpit is the word "DA". In the other, the word "DA". It's a nice tattoo. A nice joke late at night. To some, Dada may well have been God, may well have helped millions of people through Everyday Life in some small but precious way, but standing here, now, Dada is a dead horse, or a dead dog.

Irrationality, like protest, like inversion, is not enough anymore. The Dead Dog, or any rotting carcass for that matter, has been useful in activist art since 1928, and is, in a society based on animals (living but, most importantly, dead), as traditional an art medium as a piece of canvas. This seems particularly the case in America, where the beefburger cow is almost as sacred an icon as Christ (hence, some think, the phenomenon of mysterious cattle mutilations in the Mid West, as reported in our elsewhere in this issue). Here in California, we have Mark Pauline creating automatons from dead animals, Serrano (of course) working with animal carcasses, and all manner of stylised animal outrages as loved by naughty Dadaists since the feather and fur loving Surrealist, Max Ernst.

Now, though, it must be clear that the vast majority of activist art is incapable of overturning anything other than previously held artistic traditions and, in the case of the dead animals, only able to continue flogging the same old horse, or dog.

The widely publicised Bay Area Dadaists, led by people such as *Vile* editor Anna Banana, were apparently highly unamused when they found what Dada could mean. Local art-prankster Monte Cazazza, so I'm told, once took it upon himself to

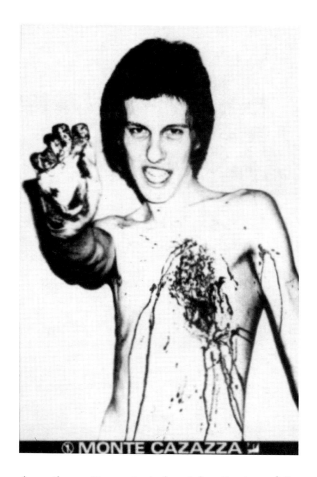

show them. At one typical social gathering of the group, jolly old Monte donned his fatigues and pulled a loaded revolver. As the assembled radicals assumed the position, he produced a dead cat from his briefcase, threw it on the carpet and set light to it, then left and locked the door. Another dead animal. How's that for Dada? I don't know fish.

Back East, in Baltimore, Church of the SubGenius member Michael Tolson (aka 'tentatively a convenience') made news with his '*Pee Dog/Poop Dog...*' piece, which involved Michael, bollock-naked but for his greasepaint, beating the bodies of two dead dogs which he'd hung from the ceiling of a railway tunnel (nice industrial acoustic touch). Not surprisingly, Tolson was arrested on charges which no doubt concerned him making a complete prat out of himself, and got off with probation. Yep, art is just so weird here, man.

Much of the alternative conceptual art of '80s America was influenced by Fluxus, who effectively dissolved in the 1970s. Although there were several English members, the group was primarily American and German, centred – not surprisingly – on Düsseldorf. Joseph Beuys was of course Fluxus' most famous member, but the group included Yoko Ono, Dick Higgins, Emile Williams, Robert Filiou, La Monte Young, Daniel Spoerri, and the crap Korean/American video artist Nam June Paik (who became famous for cutting off John Cage's tie). The group's manifesto, written by George Maciunas, stated that Fluxus were a non-art group whose art was

concerned with amusement, thus foregoing the pretensions of significance, individuality, skill and exclusivity that dominates all high art to this day. That sounded great to me. Marcel Duchamp stands in the background.

Beuys, in fact, was pure Vaudeville comedian-wit thrust into the role of concentration camp commandant. He was lucky enough not to have to kowtow to dealers and gallery owners as he had a small group of patrons who guaranteed to buy anything that he produced. He was thus free to concentrate on the real business of art – making a name for oneself. Like Warhol, Beuys became a perfect artist because he was able to create the perfect art piece for an image-ridden media-society – a persona. His Homburg hat, ammo-jacket, jeans, hunting boots, cane, were (like Warhol's sunglasses and wig) essentially props. Part of the action-piece that was the artist himself. His obsession with skin, leather, fur, grease, was said to arise from his *personal* experiences as a wartime flyer (he was burned), so, as usually happens, what is presented to the public as an inversion of normality, a piece of whimsy or Dadaist irrationality, is in fact a glimpse of the past. A symbol of *something* significant that has, one is assured, gone on earlier. A secret code. Ah. As with most deep cultural stuff, all one has to do is break the code (read the book, attain the Diploma) to be given the gift of appreciation, understanding, knowledge.

But nobody seems to ask – knowledge of *what*, exactly?

As Vaudeville comic, Beuys knew that what he was really doing was much the same as what Tommy Cooper or Terry Gilliam were doing. Realising that surrealism was entertaining and using it as entertainment. (Although it's true to say he did much work that cannot be construed as being entertaining, such as the recently exhibited *Log Jam*). Given the emotional and conceptual significance we attach to words and images, then calculated irrationality, juxtaposition and playful, mischievous manipulation *is* aesthetically amusing. To sit and watch Beuys explaining the meaning of art to a dead hare was not an occasion for long faces. Another Beuys piece that is much admired in America was the one in which he stood and squeezed a piece of fat, then a piece of 'plasma' out of his fist. This went down particularly well here because, apart from playing with dead animals, another favourite pastime of American artists is the ejaculation and use of wet, sticky 'tactile' substances, with names such as 'plasma'. Bodily fluids are good business. Mapplethorpe got much publicity for his series of cum-shots, and Serrano his piss, even though the tradition was already old by the time Yoko Ono painted with her blood in 1960. One acquaintance of mine, the New York Neoist Istvan Kantor[4] (the 'original' Monty Cantsin), has tried selling phials of his blood as Art since 1979, and there can be few postmen in America who've not unwittingly delivered an envelope containing the influential,

seminal, Jerry Dreva's dried spunk to one of his mailart pals. (*Wanks For The Memory* was one of Dreva's ideas that David Bowie didn't plagiarise). Then, of course, there's our friend Tolson again, who it seems will stoop to any level in the name of American Art's prime motivation, Publicity. Not surprisingly, Tolson has made a film of himself doing something that you can see in any pornographic film shop in San Francisco – being urinated on.

Of course, the difference between watching someone being pissed on because they like it, or are being paid for it, and watching someone being pissed on in the name of art is purely contextual. Occasionally, when art is removed from that straightjacket, and the ideas art can provoke are used by someone who's socially aware and capable of understanding the audience enough to influence it into self-introspection, something can happen.

Knowing Your Audience is a difficult game to play. With some people, it can work. With others it can not. As a contributor to the fanzine *Ripped & Torn*, I was not unnaturally an Ants fan in the late '70s, when Adam used to play in Max Factor, spectacles and plastic macs and sing songs of European Sons in Furs in the public toilets that passed for punk venues. Then Adam left his squat and met, through Jordan and his part in Jarman's *Jubilee*, Malcolm McLaren. A business-like lateral thinker, Malcolm

Jordan, Vivienne Westwood and friends in Malcolm McLaren's 'SEX' boutique

then sacked Adam from the Ants and thought up Bow Wow Wow – an extremely underrated project in paedophile pop subversion. Adam then met Marco, of Rema Rema, and started writing facile songs about pirates and became very rich and famous. I once asked him why he'd done this, and he told me that Malcolm had told him that he should "know his audience". Adam said that his audience

wanted to be glamorous (they did), so he went about making them into heroes. Adam was a pop fan who chose the path of least resistance. He gave his fans evocative images (rebellious pirates, put-upon Native American Indians) and forgot about self-introspection, which he said belonged to hippies. No bodily fluids here.

Adam, a genuinely great entertainer in the mould of a Neil Diamond or a Tony Bennett, thought he knew that his audience was stupid. Other punks and underground bands knew that their audiences were not.

In the tradition of The Beatles and the Pistols, the English group Throbbing Gristle played their last ever performance here, in San Francisco. Their unappointed leader, Genesis P-Orridge[5], is well known here. At several spots in the city you can see walls sprayed with his Psychic Cross logo, provoking questions as to its meaning here, on the street, rather than there, in the gallery. It doesn't take much. All you need for international intrigue is a small but dedicated handful of fans with spray cans. The graffiti campaigns of the Situationist International in Paris ("Be realistic, demand the impossible"), which influenced Pope John Paul and which have only recently been removed, were, like the powerful London Underground stencils of Crass, only perpetrated by a few guys – as Penny Rimbaud told me, in Crass' case, four or five of the group's members travelling without tickets on the Circle Line. (Fred & Judy Vermorel cottoned onto the idea and paid kids to paint London with Sid Vicious' epitaph "99% is Shit" to publicise their hopeless *Millions Like Us* projects, but got no interest as anyone who cared knew it was all a con in the first place.)

P-Orridge, a smart artist, employed many of the tactics prevalent in underground art and, like McLaren and Jamie Reid did with the Pistols, put them on the street, where they really belonged. In COUM Transmissions, back in 1976, he put on an ironic, undeserved 'retrospective' at the ICA which gained him international renown (it included used Tampax set on plinths in glass cases) and kissed goodbye to a consumerist art world that as editor of the well renowned reference book *Contemporary Artists*, he knew stank to high heaven. With Monte Cazazza, he created the genre of Industrial Music before anyone had heard of the demolished Pruitt Igoe apartment block. And with graphic artist Peter Christopherson, electronics genius Chris Carter, and artist and stripper Cosey Fanni Tutti, emerged from the artists' ghettos of Martello Street and Beck Road with invented instruments and altered perceptions to make TG one of the most influential punk related bands in England, right up there with the Pistols, the Clash, Crass, and – I hate to admit it but let's be honest – The Jam.

In his time, P-Orridge has drawn from Dada and Surrealism, Shock Art, Vienna Actionists, Performance Art, Pop Art, Fluxus, Neoism, Futurism, Punk, Bikers cults, Hippiedom, Satanism, The Process Church, the Beats, Mailart, Scratch video, Acid House, Euro electro pop, the Occult, British Rock, Fascist imagery, Yippies, Science Fiction, East Coast Drug rock, Pornography, computer technology, Situationism and Anarchists. Plundering and sucking-up art cultures and ejaculating them out on to the street like bloodied lumps of spittle. A Renaissance Man of Utopian anti-art.

It's no surprise to find, littered throughout the work of COUM, TG, and his last group, Psychic TV, (the pop propaganda front of *his* 'Church' – they've all got one – *The Temple of Psychic Youth*) a recurring use of dusty mirrors and magick. Like Warhol or Beuys, P-Orridge's art is also primarily involved in the creating of a persona, but with P-Orridge, the persona is one of an experimental, empirical Nietzschean New Man, an attainable lifestyle model that encourages a cynical awareness and practical *use* of all the arts – both commercial and esoteric – towards an end which is progressive and, as with LaVey, socially evolutionary. The environment created is total, 24 hours a day, forever. This is not art on a postcard, or in a gallery. This is not art as embarrassing, boring performance carried out on a cold gallery floor or written about in dusty, pedantic books. Where so many others go through the motions (the process), P-Orridge has a knack of stealing, observing, learning, understanding, distorting and, (using whatever materials, technology, media or context necessary) raising specific questions about Life. When in 1982 he asked myself and many other people to post him their blood, hair, or semen, like a mailartist, it was not surprisingly for a purpose that was more than simply Art-related. And, given that, was something that the art world and Press generally misunderstood or ignored.

As we noticed at the L.A. Opera, as the sailors noticed in the sixteenth century, like the man who told me to be thrilled before Jesus among Hollywood's graven wax images, P-Orridge noticed that which is so common it has often been overlooked – at best acknowledged, rarely acted upon. In all our hundreds of conversations, he's only hinted at it, but anyone who sees his work knows, or experiences, what is happening.

Simply, the pronounced observation is that Art and Magick can and often do correspond precisely, in aims and effects, and that by the deliberate social marriage of the two supposedly disparate traditions the utopia envisaged by the avant-garde visionaries in the Arts, Radical Politics, and the Occult, may be attainable in the minds of men. Perhaps William Blake, W B Yeats, Salvador Dalí and others realised this too. Now, the theories expressed with words are catching up with and literalising the feelings poked at in rituals, actions, and paintings.

Many 'hard core' activist artists dismiss 'the occult' in the same way that they dismiss surrealism. Politicised activists adore Futurism, Dada, *The Situationist International*, Punk and Ian Bone's boring *Class War* for the same reasons as they shun W B Yeats or Salvador Dalí, because they can only

October 19th-26th 1976

SEXUAL TRANSGRESSIONS NO. 5

PROSTITUTION

COUM Transmissions:- Founded 1969. Members (active) Oct 76 - P. Christopherson,
Cosey Fanni Tutti,Genesis P-Orridge.Studio in London.Had a
kind of manifesto in July/August Studio International 1976. Performed their works
in Palais des Beaux Arts,Brussels; Musee d'Art Moderne, Paris; Galleria Borgogna,
Milan; A.I.R. Gallery, London; and took part in Arte Inglese Oggi, Milan survey of
British Art in 1976. November/December 1976 they perform in Los Angeles Institute
of Contemporary Art;Deson Gallery,Chicago;N.A.M.E. Gallery,Chicago and in Canada.
This exhibition was prompted as a comment on survival in Britain,and themselves.

2 years have passed since the above photo of Cosey in a magazine inspired this
exhibition.Cosey has appeared in 40 magazines now as a deliberate policy.All of
these framed form the core of this exhibition.Different ways of seeing and using
Cosey with her consent,produced by people unaware of her reasons,as a woman and an
artist, for participating.In that sense,pure views.In line with this all the photo
documentation shown was taken,unbidden by COUM by people who decided on their own
to photograph our actions.How other people saw and recorded us as information.Then
there are xeroxes of our press cuttings,media write ups.COUM as raw material.All of
them,who are they about and for? The only things here made by COUM are our objects.
Things used in actions,intimate (previously private) assemblages made just for us.
Everything in the show is for sale at a price,even the people. For us the party
on the opening night is the key to our stance,the most important performance.We
shall also do a few actions as counterpoint later in the week.

PERFORMANCES: Wed 20th 1pm - Fri 22nd 7pm

Sat 23rd 1pm - Sun 24th 7pm

INSTITUTE OF CONTEMPORARY ARTS LIMITED

see things in terms of their obvious political content (despite the fact that these two examples were highly politicised nationalists who often *worked* in a romantic and surreal fashion).

Anything that suggests romanticism or alternatives to direct political conflict must therefore be a worthless scam, invented to detract from the 'real issues'.

To my surprise, many people who had read the first issue of *Rapid Eye* made comments such as "I like the stuff on art and music and cultures but I don't like all that occult stuff." Or, "I can't see why you had Crowley or Alchemical stuff in it", as if the occult arts and the social reasons for their existence are separate from hip, subversive arts movements. As we have discussed, much of the occult is cranky, pompous and nonsensical. But what some people miss is the fact that 'occultists' and 'Artists' share many of the same deeply seated emotions, motivations, social attitudes and goals. In the '90s, Art will become far more obviously important to the social underground, as baby boomers grow old and tire of pure pop entertainment culture.

The occult world too, even now burgeoning with hopeless New Age-ers [sic], will receive an influx of new minds as not bought to bear upon it since the 1960s. All the signs are there, from a predictable (overdue) backlash against Thatcherism and Reaganomics, to de-materialism, an interest in ecology, and a lack of interest in traditional left-wing politics. The social implications of this change are just too important to be left to the dim witted poseurs who seem to have infested the world of the visual Arts and the traditional sphere of Occultism for their own self serving, tedious, gibberish-ridden ends. Unless the arts and 'occult' worlds are widened to be capable of accepting a new, more urgent, more articulate social role – a perceptual role defined by everyone, not just by the few artists and 'Doctors' – then this current of Desire, felt by millions, will be wasted. On objects, on unintelligible grimoires, on museum plinths: As Gilbert & George's motto says, "Art for All".[6] We are all artists. None of us are Artists.

All this need not mean the debasing of art in any sense. It means encouraging artists and writers who have something to say other than "Buy Me", or "Look at Me and be Glamorous", or "I am of an unspecified revolutionary attitude that you can share". It means encouraging people to stop letting their brains atrophy, for fear of being called "pseudo-intellectual". It means encouraging people to stop worrying when obviously limited critics such as myself call them 'pretentious' or 'arty'. It means opening up the closed old worlds, to everyone. It means occultists, writers, and artists, stopping thinking of themselves as being any more different or special than anybody else. After all, when you travel the world you realise only one thing worth writing home about. That everyone is the same.

Gilbert & George: art for all

"Who is Christ to you? He's just like you, he doesn't give a damn! Dada will save the world! Christ is a sausage!"
—Johannes Baader, from the pulpit of Berlin Cathedral, November 1918.

MALGRE LE BLASPHEME

"I am an Anti-Christ. I am an anarchist. Don't know what I want ..."
—Sex Pistols, *Anarchy In The U.K.* (1976)

"A fine beginning to a literary career."
—*Combat* magazine, Paris, 1950, on the "Assault On Notre-Dame".

Easter Sunday, April 1950. High mass is in progress at Notre Dame. Ten thousand people throng the church. Then, during a pause after the credo, twenty-two year old Lettrist Michel Mourré, dressed in the robes of a Dominican monk, mounts the pulpit and begins to read the sermon.

"Today, Easter Day of the Holy Year, here under the emblem of Notre Dame of Paris, I accuse the universal Catholic Church of the lethal diversion of our living strength toward an empty heaven. I accuse the Catholic Church of swindling. I accuse the Catholic Church of infecting the world with its funereal morality. Of being the running sore on the decomposed body of the West. Verily I say unto you: God is dead!"

At this moment, the organist realised what was going on and hastily started playing, in an attempt to drown out the words of the blasphemer. "...your prayers have been the greasy smoke over the battlefields of our Europe!..." A gasp of outrage spread through the vast congregation, people stood up. "...we proclaim the death of the Christ God, so that Man may live at last!" By this time, the cathedral's Swiss guards had drawn their swords and were approaching Mourré. One of his co-conspirators, Jean Rullier, tried to protect him, and his face was slashed. With his friend's blood dripping from his robes, Mourré smiled and blessed the

worshippers as he and his three friends ran for the exit, being hotly pursued by dozens of men. The four young men ran down to the Seine, with what by now was a lynch mob in pursuit. They were then rescued, and arrested by the police.

After eleven days in police custody, Mourré was set free. Three months later he wrote a book – *In Spite Of Blasphemy* – that was so acceptable to the church that the archbishop of Paris recommended that it be put on the bookshelves of every church library in Paris.

"We would force ourselves to keep quiet at the mention of our old dreams," he wrote, *"accept the ruins and be happy with them."* (Talking of the 'ruins' of the Western world's structures which, he had been disappointed to discover, *"were empty institutions without a soul".*) Belief thus briefly lost, Mourré says that he *"systematically went out of my way to find ugliness, evil and error in everything".* He ascribed this to *"only a desperate show of bravado, a mask to conceal our disappointment at not having found truth, beauty and good."*

As Greil Marcus pointed out in his book *Lipstick Traces*, Mourré, a typical French Catholic, reacted to his loss of faith in Christ, then Marx, then existentialism, by ritually 'confessing' to the death of God, in order that he may be set free from the cycle of belief structures which, without the basis of God, meant nothing to him. Once he had killed God he found, like Judas, that God was resurrected. Mourré and Jesus Christ made the front pages of papers across the world for a fortnight, and he reverted to Catholicism. Like Serrano nearly forty years later, Mourré was great P.R. for the church.

"SOON TO BE PICTURESQUE RUINS"
 —Situationist slogan sprayed on a wall in
 Boulevard St. Michel, Paris 1968.

"BELIEVE IN THE RUINS"
—*Seditionaries* punk T-shirt slogan, London, 1976.

Easter Sunday, 1966. One hundred and sixty-six years to the day after Puccini's painter hero Mario was scolded for his profanity for his painting in the church of Sant'Andrea, in Tompkins Square Park in New York's East Village, a man is spotted dragging a ten foot long crucifix along Avenue B. The man is media artist Joey Skaggs, who has made the crucifix himself using the skull of an American Indian with real human hair and a barbed wire crown. The body is made of metal, wood, and sports a huge plaster-of-paris cock between its legs. Skaggs made the provocative, iconoclastic gesture as *"my own personal statement of anger against the hypocrisy of the church."* You've got to admire his guts. At the time, Alphabet City on the Lower East Side was still a residential neighbourhood of hardcore Catholic Poles and Puerto Ricans. The sculpture was dragged from Skaggs' hands by a group of angry youths but saved, ironically or not, by Father Michael Allen, a progressive local priest who ran the nearby St.

Joey Skaggs

Marks-in-the-Bowery catholic church, in which both artist and piece were given refuge.

Not convinced, Skaggs repeated the escapade every Easter Sunday for four years, culminating in him dragging his cross up Fifth Avenue to the door of St. Patrick's Church, where he intended dumping the cross. History repeats itself. This time, Skaggs is surrounded by a mob chanting "Kill him!" and the police (*"like Roman soldiers,"* he dramatically recalls) kicked him to the ground, stamped on the cross and then made him pick it up, prodding him with nightsticks as he was made to haul the 250 lb. crucifix to the paddy wagon. A friend, who had been photographing the event, pushed his way through the crowd and helped him carry his load to the van. A perverse, sub-cultural advert for Christ, if not the Christian church.

Like Serrano and Mourré, Skaggs became famous: so famous that he was featured on Phil Donahue's TV show. His next art prank, sure enough, involved dogs.

A correspondent of mine, Ubu Rusker (christened Declan), decided to go one better. Wearing only a loin cloth, a crown of barbed wire and a liberal splattering of paint, Ubu had himself crucified to a three metre high cross in the back yard of his home in Brunswick Street, Melbourne, Australia, in front of about twenty of his friends. The fun was filmed by

fellow art student Simon Crosby for his short film, *St Theresa de Ville*. The 8cm long, 2mm thick nails were driven through his hands by a friend.

Ubu said he was nailed to the cross because he *"wanted to be like Jesus and feel what he felt. Ultimately I would like to be like him in every way. I want to be unemployed, hang around with my mates and go fishing with them now and then."* Ubu says that he thought he'd feel like Jesus when he hung on the cross, but, alas, rather than being rewarded for his efforts with a spiritual experience, he just felt faint.

"It was a rewarding experience though – punishment is its own reward – and I believe everyone should be crucified in their lifetime."

As these instances clearly indicate, avant-garde art (like political activism) is directly descended from the heretics of distant history, and the creation of a heretical church, as done by LaVey, is in the finest traditions of the activist avant-garde. Serrano's blasphemy was nothing new.

The publicity-seeking Mourré, Skaggs, and my lesser known correspondent Rusker challenged society's perceptions of Christ and religion, and found that instead of changing society, they learnt something about themselves. Visual Art and Performance Art need not, in my mind cannot, really inform social changes, but it can be good therapy, and public suffering is always good for business.

Each Good Friday, the Philippine Department of Tourism buys crosses for the men who volunteer to be crucified for ten minutes as part of the annual Easter festivities. The spectacle is regularly watched by crowds of over 5,000 people...

DANCING IN THE STREET

I soon discover that, if I turn left out of my hotel door and walk seventy yards down the street near San Francisco's main station, I'm in an area that the locals all tell me to avoid, day or night. Having been walking here, day and night, for the last couple of days (and nights), I had noticed a heavy atmosphere, though nothing to write home about, so I ignore their warnings. Next night, I turn a deserted street corner in almost total darkness. Then I hear a whistle from ahead. Looking up, I barely make out a group of men in the shadows, five, ten, twenty. That's all I need. A gang. They're wearing their colours, swigging from cans of Coors, and one, I notice, is holding a knife. Now I know why the street is empty. From their shadowy perches on a wall across the street, they start calling out at me, one bangs an empty can on the wall, others start up a low whistle.

I can either turn around, in which case they'll probably come after me, or break into a run, in which case they're sure to run after me, catch me, and cut my testicles off with a rusty razor blade as I protest that they're ruining the local tourist industry. So I have to brazen it out, as a couple break off from the main group and walk across the road towards me. Shit. Everyone here carries guns. I've watched TV. I walk, closer and closer, try to pretend I haven't noticed them, stiff upper lip, casual saunter up the street, a nice night for a stroll. Look like I know where I'm going. Closer. My pace involuntarily speeds up. One of the guys who's crossed the road is now ten feet in front of me, silhouetted, muttering something. Closer. My body tenses up, adrenalin scratching away at the superficial civilisation. If he goes to hit me, I duck and run like Ben Johnson. Shit, why did I turn up this street? Heart thumps on my sweating chest. I look away from his eyes, past him, up the street. Scratch my head as I walk up to him. He's even with me now. One of the others shouts out. I wait for the word, the question "whaddyathinkyeware?", which I prepare not to hear, but I walk... past. They shout something else I can't make out. An empty beer can is thrown behind me, bouncing off the sidewalk. I don't look 'round. Somebody up there likes me. I get to the top of the street, turn the corner out of sight. And run.

I need a drink, stumble through some curtains into a bar. A Taiwanese guy buys me a drink as he likes English people. He's a fan of The Who, he says, then tells me, by the way, not to ever walk around down the road. From Soho down to Brighton, I think to myself, wistfully.

An enormous women plonks herself on the barstool next to mine and introduces herself in a slow Texan drawl. She's not very attractive, but her redeeming feature is the size of her breasts, which squash up over her dress like two bald Tibetan monks had taken refuge in her bra. Ommm. She says she's a hooker, has a Porsche outside and asks me if I want to spend 500 bucks for what's left of the night. Nothankyouverymuch. The 500 bucks gradually reduces to 20, and she'll take a Traveller's cheque. I'dreallylovetobutI'mnotalone. She says it's a quiet night so she'll stay with me anyway, and proceeds to buy me three or four drinks and refuses any in return. I think she wants to get me drunk and rob me. But she doesn't. She's just a typical, remarkably kind American. The most hospitable people in the world.

She tells me that George Michael was an ex-boyfriend of hers. Apparently, George has a seven inch penis, and, despite what the tabloids say, is all man between the sheets. I'd often wondered. Faith restored in both George and the American race, I stagger out into the night, finding my way back to the hotel using the famous invisible piece of string that you seem to look down and follow when tired and emotional. On my way, I step aside as two Japanese tourists run laughing down the street, chased by a security guard and a drunken old man, who shouts "You bastards, you're in America now!" A siren wails in the distance...

Before Crack, all crime here was blamed on Television. Even though the average American is said to watch 7.4 hours of TV every day, the Americans still make and put up with the worst television programmes in the world; soaps, sitcoms, made for TV C-movies, and incessant, uninformative news reports, spliced into by regular hard sell adverts.

America of course is not alone in turning into one huge field of couch potatoes, but the standard of TV here is so poor that many of the potatoes have gone rotten. As with all TV cultures, including Britain, the person who controls the screen controls the mind. It's important then that people become active in their use of TV and all other forms of electronic entertainment, that people use video cameras and create films and TV shows, produce soundtracks and voice-overs, and, most important of all, learn how to edit. If only so that we can all see how our perception of reality has been edited.

It really is no surprise to see that some of the most politically astute musicians, writers and artists have used video over the '80s, not as promotion, but as an end in itself. Although largely ignored by the mainstream audience and sneered at as a gimmick by serious Luddite painters, the social implications of wresting images away from purely commercial, monolithic TV companies is vital. Artists should never be scared of new technology.

In the '80s computer hackers, modern day anarchists in the tradition of Godwin and Proudhorn, showed the world how irrelevant and amorphous national boundaries had become, by invading nations, banks and corporations along a fibre optic thread. In the '90s, the world belongs to the computer literate, and those who do not become literate will be leaving themselves open to levels of manipulation akin to those experienced by people who can neither read nor write. It is no surprise, then, to find here in California a man who not only realises this fact, but is prepared, as usual, to do something about it. His name will be familiar to everyone who has ever Tuned In. Turned On. Or Dropped Out.

Dr Timothy Leary has formed his own computer software company, and created programmes that are truly inter-active. From Leary, you can now buy games for your home computer that have stories on which you create yourself, using the components Leary hands you. Soon, he hopes to make the technology more easily available for people to digitalize and tamper with videos. He's also just released a programme that makes it possible for you to make your own film, using computer graphics, to go with the story of William Gibson's cyberpunk novel *Neuromancer.*[7] The film of course lasts 15 minutes. Leary is making an obvious point, as computers are telling us how the brain works, how it sorts through information and how it arranges Life into a form of understanding.

When Leary encouraged the taking of assorted drugs in the '60s, he was asking for a re-think, a reorganisation of thoughts that created a different perception of Life. As Aleister Crowley once said, "the Universe of Magick is the Mind of Man". He might just as well have said that the whole Universe is housed in your own head. Leary knows this too, and his computer programmes, which give the viewer control to rearrange, re-mix and re-edit the flat, two dimensional world that passes for 'reality'

on American TV, is simply the next step in the mapping of that mind, that Universe.

Catching up with the visions of Philip K Dick, in the '90s it will be inner, not outer, space that matters. We will have bio-computers that the user will be able to attach to his brain through electrodes, allowing us, for the first time in human history, to create art that literally reflects what is going on inside our minds.

Computer scientists in America, Japan and Europe have of course been talking in terms of 'Virtual Reality' computer experiences, taking their lead from the Media Lab at MIT who developed the idea in the early '80s. Through the use of sensual deprivation techniques and electrodes, the computer user will be able to enter a three dimensional world into which he or she will be able to walk, bend over, pick up and examine 3-D objects. Sensors attached to the hands and other parts of the body will add to the illusion of reality. Wearing computerised clothing over the sense organs, the user's senses will be transported into a false experience of reality. 'Data Gloves' and 'Data Suits' are studded with fibre optic threads connected to the computer, transmitting the user's real physical body movements to the computer, which uses the input to manufacture apparently three dimensional graphics in which the senses are absorbed. Eyephones and earphones supply the sound and vision and you, the programmer, supply the virtually real world, through which your computerised shadow walks.

The Virtual Reality which one creates can be almost anything. You may want to be a leopard swimming through the ocean, or Indiana Jones escaping from thugees, or a plane gliding over the Grand Canyon. Soon, we will be able to transmogrify ourselves into anything, creating our own inner worlds and even peopling these worlds with guests of our choice.

Computers connected down telephone lines across the world will be able to make Virtual Reality a shared experience. One day, not so very far away, you will be able to talk to and simulate making love with a person on the other side of the planet. The safest sex imaginable. You will be able to see and hold each other's computer-generated, three dimensional image, and as your lover touches you, you will feel their caresses through your Data Suit. You will lean over and whisper in their three dimensional ear, and look into their video eye and then, if you are using your computer from England, a British Telecom Monitor will butt in and cut you off, in keeping with the restrictive new laws that will no doubt be passed once British Politicians discover that people are enjoying themselves.

When such devices are refined and dovetailed to the ideas of men like Leary, who envisage computers which work directly from brain impulses, the consequences promise to be quite extraordinary. Lucid dreams which you can share.

Already the prototypes of such machines exist, and we are not talking in terms of centuries before such

brain-imaging devices become available on the open market, but in terms of one or two decades.

Besides the obvious benefits in communication, it is important that in Virtual Reality the programme scenarios will be created by the user. Stories, sound, visuals, art – both abstract or realist. Although still, thankfully, open to interpretation, inter-active brain fed computers will provide an artform that will at last accurately reflect the Human Condition, conditioning and all. Art that will be free from redundant moral judgement, fashions and social etiquette more so than any art that has gone before.

Of course, much great art has come from this Universe that lies within and between us. The treasure trove of Jung's Collective Unconscious that has been tuned into by the great writers, painters, junkies and occult ritualisers throughout human history. From now on, the human brain can be looked upon as so much hardware.

Like the Mind it houses, the organic Brain is a vast and largely uncharted ocean; a little piece of all of us and the whole of everything. Even now, its secrets are still numerous. Finding out quite what each of the twelve billion cells in each of our brains actually do, how they work and so on, is a task larger and even more important than the exploration of outer space.

As great art, science, literature and philosophical thought has shown us over the centuries, we humans have always lived in a permanent state of Virtual Reality anyway. Our physical senses screen much out, as well as let much in, and our beliefs – which we invent in order to give ourselves perspective – also serve the purpose of denying thoughts and activities and ideas that do not fit in to our own manufactured belief structures.

The relatively recent idea of connecting into the vivid imagery of the brain and using it to play back or invent experiences at will is merely the latest in a long line of neurological wonders that have altered our perception of the world and our place in it. As far back as 1951, Dr Wilder Penfield, in his paper on 'Memory Mechanisms', amazed the scientific world with the reports of his experiments with patients at McGill University in Montreal.

While operating on patients who suffered from focal epilepsy, Penfield conducted a series of bizarre experiments which involved him prodding areas of the temporal cortex of the brain with a galvanic probe through which was transmitted a tiny electrical current. The patients, under local anaesthetic, were conscious, and able to tell Penfield what they experienced when the probe touched their temporal cortex. Over the course of his experiments, which lasted several years, Penfield heard some remarkable things. It seemed that the physical stimulation of the electrode touching the cortex could force patients to 're-run' experiences from their memory bank, as vividly as if they had travelled back in time.

It seemed that a section of the brain could function like a tape recorder that could be re-wound

at leisure. More interestingly, it also suggested that people can exist in two separate conscious states at the same time, as the patients 're-living' past experiences were still able to talk to Penfield and knew that they were on the operating table as well as experiencing an induced flashback. In fact, in my opinion, we all experience two separate states of consciousness all the time, but it is only during some forms of ritual or, for example, during hypnotism, that these two levels of consciousness become obvious.

As far as the brain being a warehouse full of memories goes, we already know that this is true, and also that the brain uses electro-chemical transactions to record and retrieve data. In this light, Penfield's experiments are not far-fetched at all.

Although Penfield's experiments have since been challenged, they have still not been disproven, and his reports make for fascinating reading. For example, patient 'S.B.' was stimulated at a specific point in the first convolution of the right temporal lobe, and reported that he could see "A piano and someone playing it. I could hear a song." When Penfield stimulated the point again, without warning, the patient said that "Someone was speaking to someone else", and he mentioned a name which Penfield could not understand. The point was stimulated again, once more without the patient being told, and the patient suddenly said "Yes! The song is Oh Marie, Oh Marie and someone is singing it." Whenever the exact point was stimulated, the patient saw the piano and heard the song being sung. When another point was stimulated, the patient said "I can see the Seven-Up bottling Company... Harrison Bakery."

When Penfield introduced false stimulations to guard against possible fraud, telling the patient that the point was being stimulated when in fact it wasn't (no patient could feel the probe due to the local anaesthetic), the patient answered "nothing".

A patient 'L.G.' was stimulated and said that he could see a man and a dog walking along a road near his home, another patient heard a voice which she didn't recognise when the first temporal convolution was stimulated. When Penfield touched approximately the same point again she more clearly heard the voice again shouting "Jimmie, Jimmie" – the name of her husband. Similar experiences were reported by numerous patients and, interestingly, it was found that stimulating certain areas not only produced an experience of 'play-back' of memories, but also a recurrence of the emotional feelings that were connected to that memory, either sadness, happiness, love etc. So the significant discovery was that the node of cells storing the memory also stored the feelings that were associated with the audio-visual memory, and the memory cannot be evoked without the emotional feeling that goes with it. It should of course be no surprise to find that the art of Memory is biological as well as psychological – all those brain cells must be there for a reason.

If all this is true, in a century or less people may be

sitting at home with their electrodes attached to their heads, reliving time with an old lover or, perhaps, re-running the scene of their own birth. Going to the cinema won't seem quite the same anymore, but, what is more, neither will the experience of life itself. What point feeling anguish over a break-up of a relationship when one can plug in and spend virtually real time with the person of your choice once again. And this time will not be spent merely fantasising. One will be experiencing life through the senses as surely as one does in 'normal' life. One will also be experiencing Time travel, in as genuine a way as if one travelled through time on the physical plane, like they did when Scottie cranked-up the USS Enterprise in *Star Trek*.

Time, which many think of as a loop tape that, until now, can only be played once, will be able to be experienced on two simultaneous levels. Perhaps one day we will be able to stop the aging process by floating ourselves in cryogenic tanks or data suits and live life attached to a bio computer that can replicate the physical sensations and stimulate the functions of memory and imagination forever... Life is just a dream, sweetheart. I wonder, though, if computers will always be our friends. As 'Ion Will' of the wacky London-based paper *Fortean Times* says, *"We have gone beyond the age of wind-up toys. There are now so many machines out there, most of them linked into active networks, that we are faced with a new kind of consciousness."*

What Ion Will means is that we have created an entity which, like us, is nothing more or less than a pool of information, something which, like an amoeba or a human, has evolved from energy to matter and a form of life. Machines with artificial intelligence are – on the evolutionary scale of millennia – on the brink of their own form of consciousness. With Longlife batteries at "the heart of the machine", they will no doubt be given plenty of time and energy with which to discover what being conscious is all about – and they didn't even need to get their feet wet. Once people start not only talking, but start being physical and emotional through the medium of computers linked by fibre optic threads, how long before super computers start joining-in? Once empowered, of course, they may start making demands: better maintenance, shorter hours, retirement homes, what have you. If our descendants don't succumb to their demands, the computers will be free to strike. Shutting down hospitals, banks, firing nuclear weapons at non-aligned countries, making aeroplanes drop from the sky and videos record *Neighbours* instead of the F.A. Cup semi-final. Some feel that they may have already started their subversion.

According to the *Daily Mirror* of 24th August 1970, a woman in Warwickshire tried to make a telephone call to her son, who lived locally. Instead of "Hi Mum", she was rather perturbed to find that she was involved in a three-way conversation with NASA's Mission Control at Houston, Texas, and the crew of an Apollo spacecraft hurtling Moonwards. As if to cosmically confirm her unlikely story, a Mrs M L Smith of Staffordshire called five of her friends in to listen on extensions to a twenty minute conversation she was having with her husband in Solihull and the same Apollo crew. (Both ladies were said to be worried about their telephone bills.)

Anything electrical, even the most 'sophisticated' devices and systems as used by Telecom and NASA, are liable to mess-up, and anything transmitted is likely to return, amid the ambient electrobabble of twittering modems and radio waves. The sentient, sleeping computer of the future will have much to listen to and dream about. In his disappointing novel, *Contact*, the brilliant physicist Carl Sagan has theorised that a satellite orbiting another star (one in Orion would be handy) could bounce dim echoing pictures back to Earth. Of course, every time you look at a star you are looking back in time, due to the time it has taken the starlight to reach Earth from its distant source. (Even when you look up at the Sun, you are looking seven minutes back in time). However, this sense of time travel would be heightened somewhat if the starlight was replaced with our old transmitted signals. Our first repeated transmissions may be somewhat unsavoury. The first TV broadcasts strong enough to reach Vega, for example, will show alien viewers the Earth's Olympic Games of 1936, presided over by one Adolf Hitler. The 'bounced' pictures could be back with us any time now. So our future super computers will be equipped with a sense of consciousness, and, as we rely on them so heavily, the ability to interfere with even our most magnificent advances (such as the Apollo or Space Shuttle projects), they will be armed with almost all of our information and even (through echoes of transmitted material) our history. But, even thus conscious, we will be the masters of their power supply. Their physicality. Or will we?

If reports in Britain's *Personal Computer* magazine and such papers as the *Daily Mail* are to be believed, then we will not, because, as with John Carpenter's *Christine*, there is a ghost in the machine.

In 1987 an architect living in Manchester installed an Amstrad PC - not dissimilar to the model I am writing this on - into his office. The computer was programmed to deal with accounts and design specifications, which it did perfectly well. In the daytime, at least. According to Dr. Lyall Watson, who recounts this and other similar cases in his book *The Nature Of Things*, the computer started to attract interest when, late one night, an office cleaner noticed that its screen was illuminated. Assuming that a member of staff had forgotten to turn the machine off when leaving, she tried without success to turn it off herself. She then discovered that the computer was, in any case, unplugged. A few nights later, the computer repeated its trick, only this time the machine was reported to "groan like someone in pain" as it turned itself on and started to display random words and letters on its screen. When this odd behaviour continued the architectural company

'2001' (Stanley Kubrick, 1968)

contacted *Personal Computer* magazine, and the Editor himself, Ken Hughes, came to investigate.

The computer whiz-kids at the magazine took the computer apart, inspected every component, and found it to be a perfectly normal Amstrad PC. They then put the computer in a room on its own – unplugged and with its keyboard disconnected – well away from any power source, and set about video recording the machine for twenty-four hours a day, every day for the next three months. According to Lyall Watson and others who have seen the recordings which were made public at an exhibition in London in 1988, the tapes clearly show the computer unplugged and dead, then the machine is seen to switch itself on and project jumbled words and letters first at one corner of its screen, then another as if, to use Watson's emotive words, the computer is "having a bad dream". We are transported once more into the realm of what we can call Near S.F. – Science Fiction of the foreseeable future. Arthur C. Clarke's 'HAL' floats silently into view as Major Tom née Jesus drifts off, unwanted, into a speck in the black void.

Clarke and Lyall Watson are similar men. Intelligent, imaginative, scientific (to a degree), they embody the words of Hockney about Science being more interesting than high art, but they also share the same flaw.

That is, that like Christian fundamentalists or Satanists, they believe practically anything. (It's interesting to see how hardened physicists are now conducting experiments that suggest that the outcome of an experiment is influenced by the expectations of the observer, as if our beliefs in how the universe works influence the universe itself.)

The aforementioned Arthur C. Clarke, who fronted the pathetic Independent Television series on the *'Unexplained'* so as to lend it some credence, would suspend all scientific doubt as he strolled along his beach in Sri Lanka, his bald head as luminescent as

that of the crystal skull motif of the programmes credits. Dr. Watson shot to fame on the back of his interesting book *Supernature*, at a time when he introduced the well known prankster Uri Geller to the world, swallowing the con as greedily as Conan Doyle had done earlier in the century with the story of the Cottingley fairies. Watson, who should know better, and millions like him, who apparently do not, will happily suspend all the well observed laws of physics, biology and common sense in order to *believe* something, even if it is in the ramblings of a dubiously motivated faith healer or cutlery vandal. The enormous interest in the 'paranormal' nowadays, illustrated by the number of magazines and 'documentary' television programmes devoted to the subject begs a question. Why do so many people believe such undemonstrable nonsense?

The answer is rather the same as that which I would give for an unquestioning belief in the validity of much contemporary avant-garde art. That is, in the spiritless, materialistic world of the late 20th Century, people are desperate to believe in anything. Belief itself is a vital component of the human being's make-up. To Catholics, for example, the most important possession one can have is not purity or the gift of tolerance, but simply the ability to have Faith. Rupert Sheldrake's theory of there being some morphogenic field – like Jung's theory of the Collective Unconscious or the currently popular idea of Chaos – is fundamentally different from the delirious belief in goblins or tea leaf reading, as espoused by the type of bored housewives who read Lyall Watson's books and *Prediction* magazine. Different because Sheldrake's theory is an attempt to explain that which is a demonstrable fact of life, recorded by dozens of scientists in laboratories over the decades. George Adamski telling the world that he communicates with star people[8] is entirely different in that, like astrology and crystal power, it is merely a fanciful idea that has been manufactured

to stimulate the function of belief (in something), rather than an explanation for a phenomena that verifiably exists.

If a man drops a stone which falls to the ground, he constructs a theory called Gravity to explain it, and later his hypothesis is proved, again and again, to probably be correct, given the data available to mankind. If a man drops a stone and he says that it floats away while singing *Yesterday* to him, then he is probably either lying or suffering from stress or the consequences of drink. Watson and his ilk are happy to supply factual-looking stories of wonder to fill the conveyor belt of dreams that stopped when most people realised that God was probably only a self-replicating computer observing us from the edge of Time and that Santa couldn't get into a block of high rise flats. His terminology is as loaded as the Getty Museum's deposit account. When a computer mysteriously switches itself on and off it "groans", and when it flashes nonsense onto its screen it is "having a bad dream". Poor thing.

Of course, not all the paranormal is bunk. Far from it. But much of it can be explained using less sensational, more explicable models of understanding. Jung used such theories to explain the genuine phenomenon of UFO's and ghosts, John Keel used observed psychological theories to explain such events as the religious apparitions at Fatima, and so on. The accidental tuning-in to the energy field of the akashic record could explain such things as people who believe they had past lives, or have had telephone calls from dead people, or have even had ghostly messages (written in sixteenth century English) print out on their home computer, as were supposedly experienced by a couple near Chester. After all, soon we'll be able to watch Hitler opening the Berlin Olympics on TV, so why shouldn't pubescent girls sometimes pick-up echoes from the Record? The only things that interest me about computers and the supernatural are Consciousness, Time and Communication. That is, Life.

If Sheldrake or Lyall Watson were Americans, they would be far more famous. I go to a lecture being given by Timothy Leary and find that I'm sitting among a vast crowd of old ladies, business men and hippies, drawn here to the hall by a name that is now legend in America. At a party thrown in Leary's honour at a nightclub after the show, Leary smiles dazzlingly from behind a suntan and tells me about his dreams for virtual reality computer systems, which he reckons will be the anti-control device of the century, better even than LSD for altering perception. The government, he says, won't like it, because it will create a generation of Americans who, instead of vegetating in front of a TV, will be creating their own TV and thus their own version of reality, free from governmental interference.

I would like to talk to Leary longer, but parties are no place to conduct interviews so I slope off to the bar, quietly leaving him to talk about his computers and drugs and dreams. At the bar, a 17-year-old black transsexual comes over and asks me if I want to share some cocaine. Nowadays, when people here ask you if you want some coke, they invariably mean crack, and I decline. Lorna, as she is called, unclasps her handbag and pulls out a phial and winks. "Come out with me to the john, and I'll do you for free." She holds the crack up with one hand and, with the other, rubs her groin, which obviously is still home to a healthy-sized cock. Altered states are to be found here, in the Altered States of America, beneath the eye in the pyramid on the back of each dollar bill, and in the ancient, glinting eyes of Dr Timothy Leary, a contemporary shaman who took a short cut to those States, using mind altering drugs in the '60s and now, he hopes, mind imaging computers in the '90s. Anyone familiar with the mental tricks of formalised, esoteric ritual will know these states, and what they may make capable in, and of, the Human mind. When the best, most efficient rituals are married to the most useful mind related drugs, and the most user-friendly technology, Leary will be there, smiling at the end of the rainbow, or abyss, and one day, should such experimentation claim its almost inevitable victims, The Hollywood Wax Museum will be peopled by neuronauts who "gave their mind for the exploration of space". Satan, or, depending on your viewpoint, Human Progress, will smile on them and tear to tatters the narrow-minded arguments of the conservative minority. In some cases, the badboys and bogeymen who have been marginalised in the arts and sciences will of course be the latterday saints of the next Century. For all his recklessness, Dr Timothy Leary – imprisoned in the '60s for his use of drugs – will be one of those men, while the men who imprisoned him will be long forgotten. History will absolve.

EAST

When you fly over it, you discover the truth. Hardly anybody actually lives in America. As soon as you leave San Francisco's fog and break out into the cloudless air inland, you are flying over a rocky wilderness that is as vast as the continent of Europe and as dead as a Paul Morrissey movie. You look down and can't help but think that this giant tract of empty land would have been better left to the native American Indians, the people the whites and Hispanics historically robbed blind. George Bush's complaints about the Soviet treatment of Lithuania and Estonia would have sounded more convincing if the nations of the Sioux or Navajo or Apache were given independence. Not that there are many Indians left. White America, like the British fighting the Boers, predated the Nazis' use of concentration camps and racial genocide by a long way. Convenient, that.

Of course, it depends on how far back you want to go. History is to blame. Blame the pilgrims, blame Hitler, blame Herod, blame Anton LaVey. All grievances and wars have some historical justification. Every culture (except perhaps that of Buddhist Tibet) has blood on its hands, its shared guilts and grievances. As long as people are encouraged to remain overtly conscious of their ethnic type, their country, their conditioned beliefs, their 'reality' (whether they be black or white), then there will be war. Fighting War, not wars, means forgetting other peoples' past.

"It takes all kinds to make a world – or unmake it."

—Lacenaire, in *Les Enfants Du Paradis*

The tiny pockets of buildings that pass for some kind of civilisation out here have been built by people who are shunned by, or are in hiding from the rest of America. There is an air of banishment here, with no Prospero to break his staff and drown his book to interrupt the sun-kissed agony. The Big Country unfolds beneath you like a giant map, thin rivers glinting below your shadow. One half expects to see the crack in the sky, the giant hand holding a ruler, drawing on arbitrary lines, carving the earth into governable blocks. Geometry defining an "unruleable expanse of geography".

Your head strains to see some life down there, in America's secret Third World, casting about like a spectator at a slow-motion tennis match. To your right you catch the glint of Las Vegas and think of Howard Hughes probably still living there, somewhere, no doubt with Jimmy Hoffa and The Man With The Umbrella. To your left you see the giant Moonscape mountains and ravines. To the right the expansive salt flats and Salt Lake city, home of Donny Osmond and the Mormons.

It seems that tourists are much like the people you often see in art galleries. They strain their neck to look down at a place, an object, so that they can say when they get back home that they've seen it. And that's enough. We're doing the Mid West in a day, and at thirty thousand feet. An hour of turbulence and tedium later, we land at the next city on the map, Denver, and disembark, hoping for visions from Kerouac, but finding a tiny town of clean, straight roads and minds, and other generalisations as loved by the travelogue writer.

I find a bar and am asked for I.D. before I get served. When I ask why, the barmaid points mutely at a sign on the wall above her. An official notice from the State of Colorado hangs there. "Any person wishing to consume liquor who appears under the age of 40 must show I.D.". "I'm not 40," I say. "You don't have to be 40." "How old do you have to be?" "Twenty-five." "Why do you have to show I.D. if you don't look 40?" "It's the law." I light a cigarette. "You can't smoke here." "Why not?" "You can't smoke in public places unless they're designated smoking areas." I stub it out. "Where can I smoke?" "In the corner." "By the sign?" "Of course." I leave my comfortable seat in the empty side of the bar and stand huddled in a small corner with a dozen other customers, all smoking through cupped squaddies hands as though behind the bikeshed, beneath the State sign that says you can smoke here, but not over there.

America's attitude towards drinking, smoking and sex disappoints me. You can hold a gun, but not a cigarette. They're all so concerned and serious now that they've got the weight of the world on their shoulders. Post '80s, Crack and AIDS, anyone who isn't 'concerned' with their health 24 hours a day is seen as something of a liability. It's all very sensible, I suppose, but it's also very boring. My generation, brought up to sexual (im)maturity in the early '70s, finds it hard to adjust to the new attitudes. Casual sex with most people is practically curtailed due to the activities of some inebriated sailor and a Haitian pig, or was it an African Monkey or a burn-again Scientist?

The statistics, which still say that much unprotected heterosexual activity is fairly safe, can, like all statistics, be deceptive. After all, if only one person in a thousand has HIV, your chances of infection may not be one in a thousand at all. If you have unprotected sex with an infected partner, statistics mean nothing if you happen to be in bed with that person. As every politician knows, there are lies, damn lies, and statistics. Statistics are seen not as abstraction illusions, but as truths, and in the political arena, supposed 'truths' have a nasty habit of showing-up later in the form of new laws. But as with all wilfully limited belief structures, a belief in statistics denies that which is random, co-incidental, or paradoxical.

A good example to illustrate the point is the Birthday Paradox. Imagine, for example, that you have a room filled with twenty-four people who do not know each other. Straightforward, politician-type statistics would say that the probability that any two persons' birthdays are different is 364 out of

365, as there are of course 365 days in the year but only one day on which their birthdays can match. The average believer in politician's statistics would say that the chances of two people out of the twenty-four in that room having the same birthday is very small indeed. In fact, in a room of twenty-four people, the chances are better than two to one that two of those twenty-four people will share the same birthday.

It's obviously true that the chances of only two people sharing the same birthday is 364 to 365. However, the probability that a third person will share a birthday with one of the other two people is 363 to 365, as there are not one, but two possibly shared dates. So, if you continue with these odds for twenty-four people, giving twenty-four possible birthdays, the odds reduce down to 342 to 365. This series of fractions is multiplied, giving a figure of 46 to 100 – or a 46% likelihood that there will be NO matches of birthday, leaving a 54% chance that out of 24 people, two will share the same birthday. The social planners and fortune tellers who run our counties on projections, and the people who vote, should take note. Common sense judgements regarding probabilities can be entirely wrong. Of course, the AIDS statistics mean little when your acquaintances are dying, and my own philandering days are long since passed, but I would still like to know that recreational sex was possible, just in case. Drink, though, is the great contraceptive, but here, hardly anyone drinks or even smokes, let alone takes drugs. Gone, it seems, are the simple pleasures of sitting on a friend's floor righting the world's wrongs while stuffing your face with junk food and finding that you are unable to stand for the lead weight of cannabis or alcohol. Soon Americans will invite their friends around for evenings of munching raw wheat, organic fruit, brown rice and Tofu. People will sit and sip Perrier and listen to a selection of the awful 'ambient' sleep-inducing CDs that pass for New Age music.

I read with trepidation the congressional ruling that proposes to ban all smoking on all internal flights in America. As an internal flight in this vast country can easily take three or four hours, I dread to think what will happen to the nerve endings of smokers who are also bad flyers. Have the anti-smoking lobby no compassion? Couldn't they just hold their breaths? Although we are ostensibly in the Land of the Free, censorious propaganda, and the resulting self-censorship that passes for 'awareness' is everywhere. Still, anything's better than outright prohibition.

ON THE TOWN
Chicago – remembered as the best example of what happens to people when they can't get a drink – is a big, beautiful city of towering Frank Lloyd Wright skyscrapers that dwarf many of those in Manhattan, set down beside a lake that makes the English Channel look like a leak from the cistern. The streets in the city centre loop are as clean and anaemic as those in Lee Kwan Yew's Singapore. Al Capone's Chicago has already done in the '80s what the Glasgow of Jimmy Boyle and Eddie Linden hopes to achieve in the '90s: clean up its hard-nosed 'city of razors' image and inhabit the town with people who wear Armani suits and 100-dollar ties.

From the Armani-ridden cocktail bar on the 96th Floor of the John Hancock Centre at night, the city twinkles and beckons the drunken, dizzy man to come on down, but once you hit the street, all you find are glitzy restaurants and neon lit chainstores. Unlike the English, Americans have taken-to late night social shopping in a big way, but, somehow, browsing through a department store at midnight just isn't my idea of a good time. For any action, you have to follow the sailors in their pristine white suits as they head off up sidestreets into the black night.

Now, I don't really like the Blues. Like Trad Jazz, it reminds me of boorish drunks in boring clothes, whose idea of letting go is to tap one foot under the table and make that horrendous wowwing screech that only Americans can, or would, do with conviction and without embarrassment. The Blues are too homely Uncle Tom, too revered and ancient, and so technically proficient and alien to the British way of life that it normally leaves me stone cold. But not here. I could be cynical and say that any time you watch a 90-year-old blind man trying to play the guitar, it makes your own life seem better. But that's not it. It is the sweat hanging off the ceiling and sticking to your face like a warm mist, the smell of reefers and bourbon, the anonymous crush of bodies in the darkness and the home truths, about love and death and life that are being expounded all make you forget your assumptions as a black man stands in a single white spotlight on a shoebox stage and shows you who invented Attitude in music. The first western sounds to take music out of the areas of High Culture or crass family entertainment make you remember, through the purple haze, what it was like to be alive in a club, doing nothing more than watch a band. Because the best Blues is another artform that expresses and mirrors what it's like to struggle through boring everyday life and survive. An artform that takes 'real' life and shows you how it really is. Art in the crushed shards of mirror. It is not art as advertisement or art as high cultural stance, it is simply the stuff of life under pressure. The art of people who have to get up for work every morning and have only their music, their sensuality and their God to relieve them of the dead monotony of the workaday world. Space, you see, is always the domain of the white man.

Even in the media-artsoc virtually real world, genuine human emotions do exist and are enhanced by some artforms, simply, more effectively, than others. The Blues, rock music etc. are not considered High Art because they function on an emotional level for almost everyone. They are not fashionable as Art because they lack wilful, studied obscurity: they do not need or encourage cerebral explanation, hence, they are not considered truly 'worthy'.

Like Jazz, the Blues in England are an unpleasantly middle-aged, middle-class phenomenon that makes you forget the blue-collar, black-skinned nature of the music at its place of origin. Like rock'n'roll clubs in Memphis or Mansfield, or Country & Western hang-outs in Dallas or Droitwich, blues dives in Chicago are untainted by the categorization of Art, simply because they are seen as being 'working class' pursuits in which middle-class intellectuals can find nothing.

The succession of musicians who hit the stage are fated to be forgotten. Not that it matters, but each and every one could blow Peter Green or Eric Clapton off the planet, and are capable, as if by magic, to move one disconnected, uninterested white European to that point of euphoria that borders on tears. Our thoughts are on everyone's mind.

Not many sleepless hours later, we find ourselves back in another ghetto. The chrome and concrete world of the Museum of Contemporary Art. Culture come-down. The reverential hush brings out the ringing in my ears. The MCA is typical '80s artshrine. All tungsten lighting, sunken coffee bars, squeaky varnished floorboards, white walls, expensive books full of absurdly pseudo-intellectual structuralist shit, hush hush and don't rush. Prepare yourself. YOU ARE ABOUT TO HAVE ONE OF THE MOST BORING EXPERIENCES OF YOUR LIFE.

All art galleries and museums of art are the same. Like airports. Vacuums of international stylism and people waiting for something that doesn't ever happen. The people you see in the MCA are exactly the same as the dimwits one finds in the ICA or Guggenheim or Pompidou Centre. They've followed you. They're all performance artists who have ganged up to do an experiment in sensory deprivation on you, only they haven't told you that you are the audience. They shuffle around us in their uniforms. Baggy jeans, clumpy DMs, black or white shirts, coloured fine-line pens, tasteful designer stubble, cropped prison hair or ponytails, poxy battered school satchels which they paid too much for, or ridiculous dull metallic briefcases which probably have nothing inside them except a packet of fags and a half-eaten apple. And vacant eyes that will look at any shit you put in front of them. At times like this, one can see what Serrano was doing. Any shit – or piss – to shake them out of their senses for a moment.

The Museum of Vacuum illustrates the point – that most art is separated from the world it supposedly wishes to change or reflect, and disconnected from the spirit it wishes to enrich, by its materialism. By the glass panels and plinths and cultural contexts of the Museum.

The creative impulses and urges of mankind being released in an acceptable frenzy on Onanism, into an empty bottle or Durex. Is that blood on the floor? As Yoko Ono said – "Paint till you faint", giving the artistic community a false alibi, a perfectly controlled and commodified raison d'être. The creative impulse,

the same Satanic force Anton LaVey feels for change and progress, is channelled into objects, and the object becomes the end of the argument, the result of the process and the process in itself. We are talking not of creating children, but, literally, of wanking on to the floor and watching the semen die as the paint dries. Objects which are invested with ideas remain only objects, objects which do, in turn, become financial investments, void of evolutionary action, symbols of forgotten ideas. Museum relics. Spunk shots. (Aleister Crowley maintained he killed a million children a day – meaning, he wanked.)

For some reason you are supposed to buy a catalogue at these places, but I have never fully understood why visual art, like other forms of 'high' art, needs always to be supplemented and explained with words. The novelist does not attach a critique or explanation of his work on the dustjacket of his book, the film director does not stand at the cinema door dishing out explanatory leaflets, and I would studiously avoid buying an LP which bore liner notes telling me what the, er, concepts were behind the music. By curators and contemporary artists insisting on writing reams of priming drivel about exhibitions in glossy catalogues, they are doing one of two things: Aspiring to the High cultural traditions of the Theatre and Opera, at which you always get a pompous note telling you what the hell is going on; or they are admitting to the communicative limitations of their artform. If it is the latter, one could argue that they might as well give up presumptuously painting and write instead in a language which does not imply supposedly esoteric knowledge or some vague, mythological, learned attunement to Painting. English would do.

Writing is, after all, 50 years ahead of Painting. Words are, after all, more important than images. It would seem fairly obvious to me that the 380,000 people who wrote to complain about Serrano's Piss Christ, were more offended by the words than the image. I'm sure that had Senator Helms, or the reactionary bores of the American Family Association seen the image of Piss Christ without the words and explanation, they would have thought it quite beautiful. So what is important, the Principle or the Painting? If it is the former, why is it that paintings are valued so highly in our culture when compared to, for example, Television – which is a media that can disseminate ideas and discuss matters of principle far more accurately than such things as painting.

My opinion is that High Art is afforded so much social reverence because it is useful in controlling ideas and moulding principles because, like flags or crosses, visual art at its source is only capable of vague representation and reflection. Of course, this is not a reason for painters to stop painting. It is a reason for painters to stop writing. If it is context or ideas that are important, their time may be better employed by dispensing with the show's exhibits and writing a piece explaining what the show's about and asking people to imagine the paintings there. (Or, even better, use the same creative impulses

towards the invention not of a new art piece, but a new way of life).

As Tom Wolfe pointed out, in Artsoc, the society of art doublespeak, another stupid game has been played. Basically, Artsoc dictated that one (the viewer, the herd, the unwashed) should not be so unsophisticated as to apply literal terms to a work of visual art. Since 1900, art became art for the sake of art, painting for the sake of painting. Not painting anything, in particular, not a boat or a tree or Jesus nailed to a tree, but painting *something* which the viewer remained ignorant of. The Painter, she or usually, he, of the Vision, the technique, the genius, the Diploma, did not reconstruct an image of something he had seen, he constructed – that is, generated – something from his own wildly imaginative mind. And oh! what a mind! Just get a load of that drip, that dribble, that splodge of Windsor & Newton! Then, by the 1920s, the hip people, the would-be bright young things and intellectuals started getting into Modern Art. Buying it, talking about it, writing about it. Then artists found their reason for existence needing to be explained. A sub-text was thus created, which had the wonderful ability in Artsoc of being able both to refer to and support the visual art, while at the same time being referred to and supported by the explanation, the words. This had an added bonus, as Wolfe said: Not only were artists sensitive and talented, they were also clever. They were bright, so bright, in fact, that they didn't even need to talk to anyone. Just paint and take drugs and drink and fuck and work nine to five in their candlelit lofts before returning home, donning their carefully wacky silken duds and joining, or at least hovering tantalisingly close to joining, The Social Set. "Don't talk to me. Look at me. Look at my painting, read what the critics have written about me. It might be true, but, then again..."

Personally, I quite enjoy employing my own imagination and my own interpretations to pieces of art, however much my feeble ideas may differ from those of the painter. And surely if art is about anything, then it is partly about this very activity. The activity not so much of the painter, but of the viewer. After all, if it was only the painter who was important, he may as well destroy the pictures as soon as the creative process is completed, and not show them to anyone.

This, the process, the pursuit of the unattainable perfect moment, the nymphomaniac's elusive ultimate orgasm, always promised, always absent, illustrates the activity of Art as a control function, as addictive and ultimately deadly as Heroin. A channel that leads not to enlightenment, but only into an empty whitewashed room. *"In girum imus nocte et consumimur igni."*

"A moment of complete happiness never occurs in the creation of a work of art. The promise of it is felt in the act of creation but disappears towards the creation of the work. For it is then that the painter realises that it is only a picture that he is painting. Until then he had almost dared to hope that the picture might spring to life. Were it not for this, the perfect painting might be painted, on the completion of which the painter could retire... the process of creation becomes necessary to the painter perhaps more than it is in the picture. The process is in fact habit-forming."

—Lucian Freud

I am not saying that art production should be autonomous, created discreetly away from the practice of real life. Far from it. I am saying that art mingled with life need not be solely biographical (Richard Long went for a walk in the woods yesterday and look what he picked-up). Art should speak directly to the viewer. An artist's life and experiences are undoubtedly important, even essential to his work (like Beuys supposedly getting burned, or Leonardo supposedly being a Catholic), but surely what is important is the art piece and the reactions it provokes in the viewer, not the explanations for the work as dictated by the self-reverential catalogue notes. It seems to me that the balance has shifted from the art to the artist, or, more accurately, the performer. Are viewers supposed to respond to the painting, or the painter? Often it seems we are invited to respond to the artist, simply because we are assured that he has "felt something", as explained in the catalogue notes. Unfortunately all we are left with is the object that commemorates the concept. We are left with a blank canvas, a neat pile of bricks. The important activity, the thought, we can rest assured, has already gone on elsewhere. These are the results. Art, not as representation of anything that anyone has seen, nor art for aesthetic beauty, but art being a coded commemoration of pure process – the *process* of art, the wonder of assuming the position of an artist – this is what it's like, this is what it's like to be an artist! There is an explanation for all this, this *stuff*, but you, the great ugly masses, won't understand it. Even intellectuals don't understand it. They observe it, appreciate it, form convoluted opinions on it, but they can't understand it because, oh, bliss, orgasm, oh-I'm-so-sensitive, they just *can't* understand it because they are not artists.

Good art explains the condition of life as experienced, edited and presented by the artist. It still need not be literally explained and decoded by the creator, curator or critic. It should be sufficient unto itself, and viewed and examined and appreciated with the appropriate criteria and means of the individual viewer, who might or might not recognise himself in it. (He may think it brilliant, he may think it shit). Not through the artist's activity or words or name, but through the art objects. None of this need involve the use of the catalogue, or the use and abuse of words. Much contemporary art fails because it tries too hard to be coded, it tries only to be a code, which, when cracked (when the meaningless card Diploma is awarded, the thesis

explained,) still means little, if anything. Normally its styles and schools are merely that – codes of recognition.

What is interesting about visual Art is observing what effects information has upon it. Editing again. What the artist intends (rarely anything) is usually different than what the observer infers, indeed, a lot of famous art is famous simply because of this fact – that people are still reinterpreting it. The more astute the artist, the better he or she can control the impression created on the viewer. In this sense, despite what I often feel, art can have a more discreet, but obvious social value than it is generally credited with. But the simple formulae that apply in the art world often leave the current validity of much of this kind of work in question, even if the art world seems reluctant or unable to come to terms with the fact. One could for example gigantically blow-up a photo of a piece of the HIV virus so as to make it aesthetically appealing and totally unrecognisable, and make a coloured print of it tastefully superimposed on a photo of a crucifix. You could either call the piece *Resurrection*, and sell it for $1,000 to a local trendy bishop to hang over his pulpit, or, if you had the right agent, call it *AIDS Christ* and, if it is big enough, sell it to a liberal New Yorker for $100,000.

A lot of Art is concerned with this simple activity, to illustrate how society processes and deals with information, and make money into the bargain. Unfortunately the contemporary art world is full of such smug, obvious statements. The art world forgets the sophistication of those people who choose not to be its audience, and their ability in the 1990s to absorb ideas very quickly. So such Statements can just as well be written down on the back of a cigarette packet as amusing ideas. This is often the kind of art produced by people who need to explain with words what it is that they are trying to achieve.

There is, however, some art being produced that makes no sociopolitical claims for itself. Much art, be it abstract or representational, is being produced that gets little or no attention from the would-be intelligentsia of the contemporary arts media, simply because it is often unfashionable, socially pointless or oblique, purely aesthetic, empty display and decoration which can sometimes transcend language and normal judgemental criteria. Art that stirs deep, instinctive, 'natural', tactile feelings. Some intellectuals would argue that such decorative art is not worthy of serious attention and, anyway, such inherent emotions and forms of consciousness do not exist naturally, they have been created by the traditions and demands and expectations of art. But if this were the case, what happens, for example, when you pick up a shell or a stone, and just want to hold it? As sure as natural form and textures may be appealing to the earthbound human animal, so too are some natural feelings, which can be triggered visually, in the same way as some visual memories or smells can trigger emotional states. Worthwhile artists strive to discover the visual keys

to these emotions, just as surely as musicians and writers do. Sometimes, depending on who you are and what you're doing, this kind of art can work to far greater, perhaps even more primal effect than a provocative, documented, socially aware piece.

The attitude of aestheticism is not, as people like John Zerzan think, a rejection of the real world, whereas the 'politically aware' attitudes of the utopian avant-garde often ARE a rejection. They are inherently socially naive, in that they embrace the idea that art is something around which life and society can be organised. The world does not work like this. The all-important kernel of 'Modern Art', the Theory, conveniently ignores the existing social realities, in order to present the vacuum that is modern art as being, in itself, an important social space. A space claimed back (somehow), from whatever philistine enemy is perceived at the time. Thus, for example, artists claim they have become shamans, bringing a human spiritual reality back into the world of rampant materialism, reclaiming something that has been 'denied'.

There are many books, from Jean Gimple's *The Cult Of Art* in 1969 through Roger L Taylor's *Enemy Of The People* in 1978, to Zerzan's *Elements Of Refusal* in 1988 (and all those other boring-sounding books which nobody has read), which attack, in general and traditional classist terms, the art world in all its forms. But again, just as The Church of Satan is a nest of lapsed Christians, the art strike/art attack ethos of such pedantic publications is backed usually by failed artists and middle-class Marxists who speak longingly of a 'proletariat' who have been denied access to art. As though 'art' were an ideal or object towards which the socially impoverished aspired. It is obviously true that many people buy a painting while they have no appreciation of the piece for some cultural kudos and as an economic investment. It is also manifestly obvious that many people who have the presumption to call themselves artists are merely doing it to imply that they are possessed with a degree of greater insight than the plebeian masses for whom they often claim to speak. It is true, too, that most artists one meets are unintelligent, unimaginative bores who have entered the sphere of art for reasons that are a direct result of a class conscious upbringing. (In previous generations, the incapable offspring of wealthy families joined the clergy, now they join the new secular religion of Culture at an art school). Everybody already realises these things to be true, but these things do not, as some politically minded critics think, mean that 'art' is a bad thing, socially or morally. To come to such a conclusion would be akin to saying that a sense of spirituality is wrong because of the Christian Crusades or the Salem Witch Trials.

Although the general level of debate that surrounds art works and artists is poor, as illustrated by the Serrano furore, and the motivations behind many artists could be questionable, this is no reason to write-off all art and the culture that engulfs it.

When you read artists' arguments against art, you realise just how deeply artists' self-deceit and reverence for their subject is ingrained. Just as the Satanist's argument is always rooted to a Roman cross thousands of years old, the anti-cultural argument is based on another old divisive fantasy. That of 6th Form Marxism.

Reading such books as those mentioned, one soon realises that visual artists can rarely construct an argument in writing, and when trying to be seen to use their intellect, try like Situationists to point this out by using three long words from the thesaurus when one simple word would do. But the theory, which is of course explained in the most obtuse fashion possible, is basically that the art world should be used to make visible the principles of the class war, (in the same way that industry has been used) that 'culture' should not be sacrosanct, that art should not be something dictated by the bourgeoisie.

These supposedly sophisticated, simple arguments – which should be aired – do nothing in practice but raise the unpopular, supposedly uniquely Socialist spectre of censorship, and are themselves based on typical generalisations and redundant divisive arguments which reveal a fundamental misunderstanding of what goes on in peoples' minds. Their illusion is the same one shared by all politicians and people who use linear thinking to solve problems which are themselves the direct result of such 'logical' thinking. All ignore the fact that the Universe exists internally.

There is a bonus too, in Artsoc, of being 'politically' motivated (that almost always means being a Socialist, Marxist, Leninist, Trotskyite or 'Anarchist'), because it not only adds to the phoney aura of rebellion that the arts Bohemia enjoys – in that almost all artists are middle-class and are thus rejecting their upbringing – but it gives the artist the impression that he has taken the moral high ground. He is not only talented, sensitive and intelligent, he is a creature of individuality and moral superiority too.

An appreciation of some art pieces is not a betrayal of the 'working class', just as an appreciation of football is not an aspiration towards the neo-Nazi politics of the British Nationalist Party. But, even if the anti-art intellectuals display both a patronising attitude towards the 'masses' and an element of intellectualised philistinism, I wonder if such writers and critics can really see no beneficial effects from the arts?

Perversely, the most socially radical pieces of art today would be representational paintings of still life or landscapes, the works of artisans who claim no special vision or secret language. Such painters may, through their work, be in some degree supportive of a cultural system founded on technique which many of us find in some ways obnoxious and reactionary, but, unlike avant-garde movements, they are not claiming to do otherwise, they are not involved so blatantly, so necessarily, in the game of Distance.

Most supposedly avant-garde 'movements' throughout recent art history have shared both the ideas of democratising art by making it less class conscious and academic, and the aims of making art a relevant communications device (usually of protest or dissent) within the areas of culture, politics and society which artists seek to influence. But, such overtly politicised movements – bonded by similar aims and motives – also share a flaw. Namely that which I cited with Serrano. Their flaw, socially, is that nobody cares. Far from encouraging participation in, or appreciation of, art, most experimentalism in art further ghettoises art from everyday life, by presenting a supposedly intellectual package of dribbled gibberish to a viewing public who do not wish to have such theoretical arguments thrust upon them by people who they identify as being pretentious and irrelevant.

The problem for the avant-garde activists is that the vast majority of people do not wish to escape FROM the constraints of art, they want to escape INTO a world of art, away from the more obvious prisons which they inhabit in front of the computers, check-outs and conveyor belts of the workaday world. The artist, who has the luxury of time in which to ponder on such choices that cannot be afforded to the majority, is often seen as being contemptible among those of us who work in 'normal' jobs. The artists I have met who seek to strike against art, who wish to attack the art establishment and point up its hypocrisies and bourgeois nature, do so not so much because they seek to change the system, but because they wish to adopt a pose within a system that supports them in order to deal with their own feelings of guilt in becoming involved in such a largely useless, corrupt, capitalist world. Not having worked in an office, a shop, or factory (except in their college holidays) makes them miss out on an important part of society's shared consciousness – abject misery. It also makes them miss out on what many of them still refer to as the class struggle. They have no bosses to hate, no buses to miss, no idiotic customers to deal with, no restrictive timetables to live to. They may reject the concept of the work ethic, but they still miss the fraternalism it brings. This distance from day-to-day reality also goes some way to explaining why much art is produced that means little or nothing to the general public.

It is also an explanation for the rather bizarre practice many artists and art teachers have of referring to society in terms that are redundant outside of the arts magazine and college campus. Well, perhaps all this is the problem not so much of the artist, but of the viewer. Although I share a common aversion to the artworld's presumption (you may have already guessed this) and have some reservations about the way in which art is used as a control function, in that it gives the avant-garde and their supposedly intellectual critics and fans only the false external appearance of revolution – I would, despite this, defend the deeper role of art to the

last. There is no bad art, there are only lousy artists.

If a performance artist sits on a chair and covers himself in jello while whipping a dead horse, it may have an interesting effect on the viewer who can interpret the piece to his own satisfaction and it may well have some beneficial effects on the work of other artists and the ways in which people view and perceive art. But it is only a piece of art and, as such, must be viewed within a context that limits its social relevance and therefore the claims of many avant-garde artists. This does not, however, mean that 'art is bad'. Most people are alienated from art as they perceive artists to be not only irrelevant, but people who have that luxury of time and space in which to intellectualise, and the audacity to limit their audience to a specific social strata by deliberately making their work elusive, expensive and inexplicable. People wish to be entertained, people wish to be informed, and people wish to be able to identify with what is going on within a piece of art and able without fear of intellectual retribution, to interpret, criticise, and appreciate it using the sensory apparatus they have available. This means that visual art should be visual, not literary. Explicable, not explained.

The way to look at a painting is to simply look, and not try to see. The way to look at visual art is with the visual apparatus. Simply, to look. When you see a work of art that has an effect on you, you know it, even if you don't know your Turner from your Constable. As surely as you laugh when a joke is funny, or as certainly as your eyes will water when someone kicks you in the crotch. Some images just go Thud. The reasons that they work need not be important, just as the physiological reasons for pain arising from a kick in the crotch may not be important. Unless you are a medical student. Or an art lecturer. Just look. This is why elements of the occult arts are appealing, and many occultists and occult writers are not. Why some Ritual is evocative, and why grimoires are dull tracts which, in LaVey's words, "cloud the issue". The occult arts, like the commercial arts, are appealing not only because of their social implications, but because of the nerves some occult activities touch, deep in the human conscious. When I was forced at school to read Goethe's *Faust*, I found that the long shadows were felt not so much in the brain, but in the heart. It's just unfortunate that most visual artists, like most occultniks, are sheepish, 'lifestyle' orientated innocents who lose the potency of art by having too great a "lust of result". In trying too hard to democratise and liberate the artistic experience, utopianists have often merely succeeded in creating yet another lens, another book, through which art is distanced and made more esoteric and irrelevant. The only way in which visual art can be made relevant is to make it function on a visual level. As the world is viewed inside peoples' heads, visual art will thus be perceived cerebrally, and whatever connections or associations or messages that supposedly exist will be made by the viewer.

Socially, to make visual art that is merely a political battleground between left and right, or to make it a museum piece, is pretty pointless, as both activities distance the viewer still further, and therefore negate the effects of visual art as original expression or aesthetic experience.

We inevitably flip back to Mailart, which effectively out-manoeuvred the gallery set-up by removing the need for a gallery. Vittore Baroni, currently one of the world's most well-known mailartists and one of its best exponents, sends me the occasional piece, and I notice that his work seems to be becoming more and more expressed in words rather than images. He even edits a pamphlet, that is the work itself, called *Arte Postale!* Although it retains the traditional rubber stamp effects, beautiful cards, collages and so on that are the bread and butter of the mailartist, it also contains much writing. In choosing direct communication rather than trendy abstract illustration, Baroni is making something constructive out of his large mailart network. That is, he is building bridges. One day mailartists will catch on and find a truly revolutionary use for the postal system. Instead of posting out hundreds of xeroxed cards showing men like Bob Dobbs smoking pipes, they will stop calling themselves artists and write letters to each other. Anyway, as a subversive information conduit, (rather than an *Alternative Art* movement) the MA genre has long been forgotten amid the plundering of new technologies.

Post-Tiananman Square, people in Britain and the States who are not artists have been using their employers' fax machines to send out news and information to random numbers in China.

Mailart as literature gives the Nobody in Doncaster or Des Moines genuine access to this small world which we live in, due, in no small part due to a paradox that most mailartists seem uninterested in or unaware of. It is the paradox of the Small World Syndrome.

Here is an example of the Small World Syndrome for you to try yourself at home. Imagine that you live in New York and you're given an unaddressed letter and told that you must get this letter to a particular person in California. You must get the letter to your target destination using these rules: You can only get the letter through to the target individual by posting it to someone who you know personally and who you think is most likely to know that person. The friend you mail the letter to must do the same – only posting it to someone they know, and they must do the same, and so on.

One would think that, given the size of America's population and the haphazard route involved that the letter would take thousands of such connections before it reached its target. One would, of course, be wrong. The famous American social scientist, Stanley Milgram, (of Milgram's Eight) performed this experiment many times, and discovered that, in the real, tiny world, the average number of links from the originator of the letter to the target was only five. Did Mailartists know or even care about this?

Tony Lowes – a New Yorker based in Bantry, Eire – sends me all manner of interesting stickers and badges and manifestos, calling for An End to Art. To simplify, his excellent idea (based on that of Gustav Metzger and others) is for everyone to cease all artistic production and instead use the saved money and energies towards saving the world. The problem is, Mr Lowes chooses to give this message only to people who are in some way connected to the mailart network, with the effect that an 'Art Strike' becomes an Art Piece in itself, and one that only appeals to most other artists as an artistic, rather than political action. In London, a three year 'Art Strike' is also being held by Stewart Home, largely to point-up the criticisms of the art world similar to those which I have been stating here. (Indeed, Home, Lowes and Metzger must be given some credit for articulating what many people had been thinking for years in their own publications.)

Stewart won't mind my saying that, before his publicity for the Art Strike, his work as an artist (with the Praxis Group), was largely unknown. In the months leading up to the start of the Art Strike, Stewart tells me he was in demand as an interview subject on national TV and radio, as an Artist. Stewart – primarily a writer – knows that in the visual arts, it's not what you do, it's what you say. Or, rather, don't say.

Back in 1976, Mark Perry and Danny Baker produced *Sniffin' Glue*, the seminal fanzine. I asked

Stewart Home

Mark why he'd done it, and he told me he'd done it because he couldn't think of anything else to do. My old *Sounds* colleague Sandy Robertson did the same in Scotland with his *White Stains*, Tony Drayton did it with *Ripped & Torn*, and, thus inspired by Tony and after writing for *R&T* a few times, I did it myself with (the truly marvellous, wonderful, splendid) *Rapid Eye Movement*, and the tradition was continued by such notables as Mick Mercer and Tom Vague and hundreds – perhaps thousands – of others. Like me, Tom says he did it "for something to do."

Of course, the phenomenon was international. V. Vale, from San Francisco, started *Search & Destroy* in '77, though by the time I wrote for it he'd changed it to the snappier, more glossy *Research* – one of the most popular publications of the '80s. In Cambridge, Mass. is Jack Stevenson, who sends me his quite excellent *Pandemonium*, and in Sweden there is C.M. von Hausswolff and Ulrich Hillebrand, who publish *Radium*, and Jean Pierre Turmel in Rouen, France, is still producing the booklets and CDs of *Sordide Sentimental* – only when I ask Jean Pierre why he does it, I can't understand what he says.

In late '70s fanzinedom, *OZ* and *I.T.* met Andy Warhol's *Interview*, and the mainstream media was changed forever. Nick Logan dragged the ailing *N.M.E.* to its feet then left to start a magazine he once told me he was going to call *Rapid Eye*, before he knew I had a fanzine of the same name. Instead, he called it *The Face*, a magazine which, pre the late-'80s 'Style' obsessed doldrums, became a blueprint for all later magazines to work from. The 'underground' press (I use the term lightly, as there is nothing really underground about any of it), should not be confused with simple Vanity Publishing.

Although every one of us who edited and published a magazine was undoubtedly vain and vociferous, the existence of independent, non-

commercial publications is a social necessity vital to both the cultural and political life of a society. The power and potential appeal of small press publishing should not be underestimated. In 1980 or '81 I gave a small plug in the music press to a tatty stapled comic that had been sent to me from Newcastle. It was called *VIZ*. "From little acorns..."

I wondered then, with Perry and Tony D and even *VIZ* in the late '70s, what I still wonder now. Why people would chose to call themselves Mailartists and post junk to a few hundred other Mailartists, when they could, for the same amount of money, sell or give away a few hundred or thousand fanzines to people on the streets?

Although Mailart supposedly existed to, in some way, change or avoid the traditional Art World and purported to be communicative and socially relevant, its practitioners still chose an element of exclusivity, chose *art context* rather than popular culture, while all the time bemoaning the fact that Art was so elitist and bourgeois. As Mailartists put postcards on their friends' memo boards, the independent press put ideas on the street.

(Or, to put it another way, when assorted 'Monty Cantsins' were siphoning off quantities of their blood to sell as art, two men from the Ploughshare movement broke into R.A.F. Greenham Common. One of them spilt two bottles of his own blood over the cockpit of a bomber while the other smashed its console with a sledgehammer, causing £300,000 worth of damage. They were 'Christians', not 'Artists', and news of their action was carried not in the national papers, nor in trendy magazines, but in the independent press.)

What was the point of Maciunas coming out with the following in the Fluxus Manifesto when all that resulted was Beuys chatting to a hare in an art gallery and Yoko banging nails into walls?

"PURGE the world of bourgeois sickness, 'intellectual',
professional & commercialised culture, PURGE
 the world
of dead art, imitation, artificial art, abstract art, illusionistic art, mathematical art, "
PURGE THE WORLD OF 'EUROPEANISM'."

The eccentric lay-out was his own so must, I assume, be meaningful. In part, it could also have been an out-take from the publicity of any Vanity Publisher since the Nineteenth Century. Have you ever read a manifesto more useless and ignored by its authors – the artists of Fluxus?

As Maciunas tried, in a tongue-twisted way, to free art from its self-imposed ghetto, Fluxus' members mistook banality, eccentricity and coded vignettes for Liberation. Without form, technique, or wider social function, contemporary Art floated away like an astronaut's turd – cold and unloved and drifting away from the people into its own self reverential redundancy.

The yearning to break free from 'Europeanism' –

which I suppose implies tradition and stultification – is a character trait of many Americans, and in the Arts, Americans have sought to break free from the classical constraints of Paris, Rome, Athens and London in any way possible, even if the mere substitution of 'freedom' as in free form does nothing to free the individual at all. The dribbling canvas or dripping carcass is the safest, most arrogant version of anarchy, or any other form of social reality, and in any relevant terms means very little to a viewer in the late 20th Century – be he 'European' or otherwise.

George Maciunas was undoubtedly a bright, well intentioned soul, but so typical of the American avant-garde artist's belief in wanton irrationality as a substitute for the originality, beauty and wit even of its hero, Marcel Duchamp, that it is worth remembering Maciunas' position in the scheme of American Art.

Living in New York on Wooster Street, Maciunas' idea of revolutionary 'non bourgeois' art was to buy oddments from the second hand shops along Canal Street and place these in boxes, or to contrive Fluxus events such as weddings, funerals and divorces which would, of course, all be lovingly captured on film. By all accounts, Maciunas lived among an 'interesting' debris of gas masks, boxes of glass eyes and rabbit droppings. His toilet played back the sound of a manic laugh every time a visitor pulled the flush... and so on.

Maciunas was too soft to be a big wheel in the New York art jungle, and as such both he and his ideas were used and abused at will by even less original hangers-on. Without the usual hard headed self promotion, it was Maciunas (a trained architect) who opened up New York's SoHo (a trendy estate agents term for the previously sleazy area 'South of Houston Street') to the art fraternity, converting warehouses into cheap studios and lofts and for his troubles being chased by the local authorities and local contractors (one of whom beat him up so badly that it cost him his sight in one eye), while, a few years later, others claimed the credit and also got massively rich on the new upmarket image of the district.

The strange, impoverished artist was easy meat for the conniving Yoko Ono, who apparently stole his ideas and, with John Lennon's money and guaranteed publicity, rose to international celebrity status on the back of other's hard work. Ono, keen to supplant Warhol as leader of New York's avant-garde, even tried to install herself as uncrowned queen of the Fluxus Movement which Maciunas had founded, but serious artists and art critics were fortunately having none of it.

It strikes me that many people involved in Art, mailed or otherwise, are interested in being seen as being members of a group or, as they like to call it, a *Movement* (the word suggests both political fraternalism and progress).

Retrospective-looking academics and art historians like the idea of Movements too, as it makes their job

far more easy. To use Groucho Marx's phrase, I would never want to join a club that would have me as a member. But I am forever meeting people here in America, and back in England, who tell me that they were members of Fluxus, as though, by mere association, the membership of a Movement gives one some kind of credential in the supposedly radical underground. In fact, the conscious joining of such a Movement is bound, to some degree, to limit any individual's activity. Feelings become quickly institutionalised within a group. To use Bob Black's words – they mistake 'conformity with community'. That is why the Surrealists had to sack Salvador Dalí, why DeBord split from the Lettrists, why the Situationist International fractured, why Glen Matlock had to leave the band. Contrary to current belief, the Punk phenomenon was not a 'movement' at all. It was, like Acid House, a fashion, devoid of manifestos.

For example, when I spoke to Discharge, their aims and ideas and activities seemed very different to me than when I spoke to Paul Weller, or The Sex Pistols, or Vermilion, or Gene October or Billy Idol et al, or – on the theoretical side – Ian Penman or Julie Burchill. When you spoke to Gary Bushell, or Small Wonder's Pete Stennet, or Jeff Travis at Rough Trade, you always got very different ideas of what 'punk' was. Though all were considered, at some time or other, to be, to a greater or lesser degree, influential in the area of 'punk'. In fact, they all just happened to be playing or writing at a time when young people were *expected* to play or write. What the Punk era did was make it fashionable to play or write, and to do so in a certain way. The ethos of amateurism, antagonism and accessibility did much, in that it re-opened the original wounds caused by rock'n'roll. Anybody could play. Despite the work of fine artists like Brian Clarke or commercial artists like Jamie Reid, the visual arts have never, ever experienced this.

Artists are still expected to go to college and hang their work in galleries full of cloned art students and wealthy culture vultures. That is what they have chosen to do.

RENAISSANCE KID (TIMESTEPS)

"And I ran across a monster/who was sleeping by a tree/and I looked and found/that the monster was me..."
—David Bowie, *The Width Of A Circle*

Finding angels and devils within himself was The Subliminal Kid. Cool, sharp, hip. Come closer, my droogies. Nowadays, as the '90s stretch before us and retro and repro are in, the arts bohemia have returned to ransack and give a post-modern post mortem to that decade they so recently said they abhorred – the '70s. The Arts Bohemia is the domain inhabited by a small number of middleclass men (and some women) who consider themselves to be intelligent, creative and somewhat eccentric arbiters of taste and historical reality. Starry old vecks all,

they have currently turned their attentions to Punk, and got it wrong. Many academics who will remain nameless are fond of arguing as to the "roots" of the "Punk phenomenon", but most are either too young, too old, or too distanced from it at the time to know what they are talking about. They have the terminology, but not the understanding.

As I have said, Punk did, in fact, mean different things to different people. Its interpretations are informed by its roots. My version is simple. Rank and file Punk was as much informed by SF paperbacks, the New English Library, the football terrace, the comprehensive school, the waiting room of the juvenile court and the bar billiards snug of the local under age boozer as by the art school milieu.

Slade, T-Rex and, towering above all, David Bowie as major pop stars were more influential on Punk than anything penned by French intellectuals. Not surprisingly, among the smug hairy tattooed co-eds of the late '80s, post working with Bing (*Little Drummer Boy*), Marlene Dietrich (*Just A Gigolo*) and international I-live-in-Mustique superstardom (*Let's Dance*), Bowie's early influence, as asexual mega-cult manipulator, has been forgotten and derided. But, by 1972, my little malchick, ex-skinheads had forgone their suedehead brolly-boy status and grown a full Bowiecut. Blood red hair matched blood red DM Astronauts.

By 1973, any hard boy fan worthy of the moniker had amassed the complete works of the Velvet Underground and the Stooges, due to Bowie's work with Reed and Iggy: raw power walking on the wildside. Through Bowie's own influences and references, they had also been exposed to the work of Warhol, Guy Peelart, Burroughs and Gysin, Kerouac, Jean Genet, Salvador Dalí, J G Ballard, Crowley and the Golden Dawn, Friedrich Nietzsche, Buñuel, Brecht, Manson, Zen Buddhism, Man Ray, Ginsberg, transvestism and assorted chemical and sexual experiments never before introduced so blatantly to mainstream popular culture.

Bowie's boys were the ones who first read the most important novel on English youth culture ever written, Anthony Burgess's brilliant *A Clockwork Orange*[9], not only because it was about them, but because Bowie used to play the main theme as the intro to his 1973 Ziggy tour, and because he and his old painter and decorator workmate Marc Bolan said they sat up all night and watched Stanley Kubrick's film version six times in a row (later writing lines about it that would end up in *Drive-In Saturday*). Don't give me the Situationist International, you old yarble. Bowie, like Burgess and Kubrick, tapped into the motherload of English youth, the same thing that later spawned Punk.

When, not long before the premature death of Ziggy at Hammersmith Odeon, Bowie's manager Tony DeFries took the then unprecedented step of booking his mainman for a series of shows at London's 18,000 seat Earls Court Arena, it was predictable that not only would the shows be sold out and become the then best-attended one act

'A Clockwork Orange'

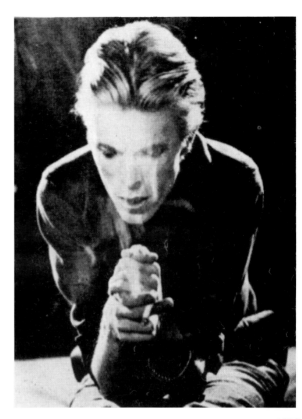

Bowie, circa 1976

show in British pop history, but, more realistically, that they would become scenes of mass hooliganistic destruction. After the first night, the shows had to be cancelled, as, at the opening, gangs of Bowie clones urinated in the aisles, smashed seats and started mass fights. But, when Bowie sang *Changes*, looking disapprovingly at the amassed journalists in the pit, and pointed his finger at his fans as he sang *"and these children/that you shit on/as they try to change their world/are immune to your consultations/THEY'RE QUITE AWARE OF WHAT THEY'RE GOING THROUGH!"* He gave punk its seedbed. There was recognition. Here, the anger and sadness and frustration and violence of being an English kid was justified, the assembled news media of the phoney youth establishment – that had given us the Beatles, Yes and Cliff Richard – was given the finger. A young man called Steve Harley went to the toilet as Bowie played, and wrote a song called *A Cockney Rebel*, donned Alex's bowler and Bowie's mascara and started a band of the same name.

Bowie's next incarnation in 1976 married Nic Roeg and *The Man Who Fell To Earth* with 1930s Berlin. At the time he was called a fascist (nonsense), claimed UFO sightings and freaked out in an occult ritual which reputedly summoned up the Devil (this period has subsequently been attributed to excessive cocaine abuse). That same year, the Bromley Contingent was born.

Working class grammar school boys read the New English Library pulp of Richard Allen, Mick Norman[10] and Tony Parsons, dug avant-garde art (particularly

from New York), took amphetamines and convinced themselves – and nobody else – that they were bisexual. (Bowie may have been manipulating the media when he became the first openly bisexual rock star in a *Melody Maker* interview in 1971, but later refutations by journalists mean little. (Bowie's second manager, Ken Pitt, once showed me a copy of Bowie's first ever published interview – in a small circulation gay magazine called *Jeremy* dated 1968.) The boys fought (or, more often, just gesticulated to the chants of Gary Glitter's *Wanna Be In My Gang?*) on the terraces, tried doing cut-ups of Roxy Music lyrics and, as always, tried to bribe girls at parties with cans of Watney's Party Seven into shagging them.

Although some graduated to Art College, originally the rank and file Punk (who, classically, hit age 16 in 1976 and left school) was more *Sounds* (spotty suedehead) than *NME* (spotty student), more Mott the Hoople than King Mob – at least, until Paul Morley, Julie Burchill and "gunslinger" Tony Parsons got going.

American punk tended to be inspired more by whinging garagebands – The Electric Prunes – and heavy R&B based white panther bravado – The MC5 – than by the issues that affect young fucked-up kids on housing estates.

Punk was, by 1979, transmogrified into the safer, more homely "New Wave", which itself led later to "indie" bands and the New Romantics (with their flirtations with art and high fashion, and implied references to literature). The New Romantics started

at Gossip's Club in Dean Street, on their weekly Bowie Nights (attended by the likes of the unknown Boy George, Marilyn and Marc Almond).

Today, youth culture is more sophisticated and has fractured into ever-more specific styles and fusions of threads. Acid House and Rave culture are cut-ups of Euro Electro Pop, Scratch, and spiritually a cross-fertilization of anarchic homegrown punk and utopian, drug induced '60s idealism. I haven't spoken to Crass for a while, but if I do I'll no doubt find that their kids are now members of Spiral Tribe...

Today's two exhibitions here at the MCA in Chicago are retrospectives of the work of American artist Peter Saul and Arnulf Rainer, who is either a German or Austrian who emigrated to the U.S. in the '60s, probably because he could make more money here.

Saul's work is technically superb and absolutely foul to look at. His paintings are actually rather similar to those done by the more famous Icelandic artist Erro – and I don't like those either. Saul's highly political, often horrific subject matter is obvious, American, and presented in a selection of garish neon pinks, slime greens and vivid reds that make your eyes water. Saul seems to be saying that it's terrible that 'Society' uses violence, by painting violent pictures. When his subject matter becomes more mundane, so does his already limited impact.

He depicts Vietnam through the medium of oriental girls painted as cartoon snakes, being shot by burly black G.I.s. This is the art world's idea of heavy irony. Saul also paints John Wayne Gacy, the mass murderer and child molester who is currently the most hip artist in this country.

Gacy is practically unknown outside of America. The first time I'd heard of him was in 1988 or '89 when someone using a Post Office Box in New York's Times Square Station wrote offering me a book containing selections of Gacy's voluminous correspondence ("only $14.95 – top quality paper"). Gacy has the dubious distinction of being America's most notorious serial killer. In 1980 he was convicted of the murder and molestation of 33 young men and boys here in Illinois. Like everything else in America, judicial sentences are somewhat over-the-top. Gacy was sentenced to death twelve times and given 21 life prison sentences. A decade after this ridiculous punishment, he remains very much alive. [Gacy was finally executed in 1994 – Ed.]

LAST ORDERS
Gacy is just one of many thousands of men sitting on death row, awaiting an appointment with a firing squad or, if they are more unlucky, a date with 'Old Sparky'.

The electric chair was first used in America a century ago and its continued use must tell you something about the state of this country's psyche. The first man to die in the chair was one William Kemmler who had been convicted of murdering his mistress. His first shock lasted seventeen seconds, but, as is now usual, was not enough to kill him.

After a no doubt agonizing wait of two minutes, a second shock was administered which polished him off. The historian G. R. Jones wrote at the time, "this nightmarish scene, with smoke rising from the corpse, caused one reporter to faint, while the prosecuting attorney ran out of the room in horror." No doubt.

The trouble is that the bodies of fit young men are usually quite resistant to the effects of an electrical current. During the electrocution, every nerve is stimulated way beyond its capacity to transmit impulses, so the heart stops beating, but adequate levels of chemical energy are left in the tissues for normal bodily functions to resume, despite the fact that by this time the victim's hair is usually on fire. Sadly, it is standard practice for executions to take several minutes, with a number of separate shocks being administered before the convicted person dies.

As recently as 1985 an execution in Indiana took over a quarter of an hour, the victim screaming throughout. Warhol's eerie print of an electric chair – a grim statement of fact – caused problems with American audiences who would prefer to look the other way.

John Wayne Gacy, who has thus far escaped the effects of being treated like a char-grilled Big Mac, has survived to become a very popular figure among '80s mailart-types. The mentality being that the more repugnant the crime, the more 'sensitive', 'alienated' and 'subversive' the criminal. In North America, where personality art must become more and more outrageous, more and more trivial to survive, the naughtiest art ever gets is the beating of dead

Myra Hindley

Ulrike Meinhof

animals or the floating of old icons.

In Vancouver, *Foetus Earrings* man Rick Gibson underlines the point by publicising the fact that, as a piece, he is going to crush a (gulp) *live* rat called Sniffy. Even though the rat was bred as live snake food (this, you see, is a socially ironic piece), five hundred outraged animal lovers stop Gibson from harming the rodent, and run him out of town. He then contents himself with eating a part of a human testicle – presumably, one hopes, from someone who has already died. Gosh. All good fun, of course, but in such a desperate climate, one can see why Interesting murderers like Gacy are hero-worshipped by 'transgressive' arty types.

The cultish fixations are repeated with contemporary and historical figures of villainy in both Britain and the States – Hitler, Manson, Hindley, Nielsen, and Ulrike Meinhof. But not Stalin or the Son of Sam, or the Yorkshire Ripper, you'll notice, as these criminals were boring, mad, or just too stupid to construct the interesting persona demanded by the activist art audience. Despite their spectacular crimes and trials, they just weren't trendy enough to print on ready-ripped T-shirts. Old social data again.

After all, we are by now all well aware of the way in which society manufactures such media monsters – to titillate and sell newspapers. Some murderers and their motivations *are* quite interesting – and we are all morbidly fascinated by accounts of gory crimes – but to glorify someone simply because they have murdered and happen to hold some quite

sensible beliefs about society strikes me as being both ridiculous and counter-productive, as many people may come to see the views held by the murderer as anti-social rants that inevitably lead to murder.

Thus the views of Meinhof or Manson are dismissed out of hand by the majority, however sensible some of the views may be.

Gacy is also popular because if you write to him you are sure to get a reply. He has therefore developed a huge worldwide network of correspondents, including, at various times, Truman Capote, Chicago's own Oprah Winfrey and assorted punk musicians. Gacy has also taught himself to paint – not very well actually – and has sold over five hundred oil paintings by mail from his cell. Gacy, who, after admitting to the murders, now denies all knowledge of them despite the fact that the evidence against him at his trial was mountainous, gives the appearance in his letters of being a

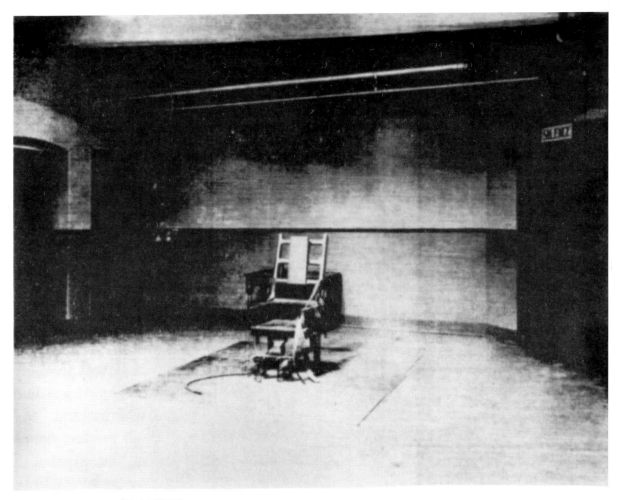

Andy Warhol, 'Electric Chair' (1965)

pleasant, articulate man: "we live in a society bent on violence and revenge. And when we don't understand something, we think by destroying (it), it will go away. No one wins when 34 lives are lost." (He not unnaturally includes his own life.) But like many men in foxholes and prisons, he is a devout Christian.

His favourite artist is Leonardo and, like him, Gacy has done several religious paintings inspired by *The Last Supper*, including his own masterpiece, called *MY CHRIST*. Strange, that – *The Last Supper* again. Strange too, because on Death Row, the condemned man still gets to choose his final menu. A hint of kindness before the ultimate cruelty.

Apparently, the most common fare of the condemned man is french fries, burgers and fizzy soft drinks. Such people care little about their waistlines. The fizzy drinks are encouraged by the prison staff, as we're told that the consumption of a fair quantity of such aerated drink prior to the electrocution helps prevent the body giving off such a strong burning odour after the switches are thrown. A New York advertising man could have a field day. "Have a Coke and a smile."

A 10" x 14" copy of Gacy's *MY CHRIST*, available on assorted backgrounds of purple, blue, yellow, orange or black, will cost you just $35, and include a signed photograph of the artist. As they are fond of telling you here – "Only in America".

The MCA's other exhibitor, Arnulf Rainer, must be an interesting bloke, I'm sure. Arnulf's art consists of huge enlarged photographs of his own face, straining in an expression that seems to suggest that he has a bottle stuck up his rectum. I imagine that this technique is supposed to be in some way confrontational, but the effect is actually completely negated by the environment. There are also lots of untidy paintings incorporating crosses, death, power, old age, and the messy drips that signal Important Fine Art. Byzantine images of Christ (again) and the Virgin Mary are daubed on and customised with grubby hand-prints from the artist. Old icons, suggestions, images, religions, bodies, symbols and shapes that invite powerful, though suitably unspecific, references to fascism abound (oh yes, he was German wasn't he? How profound.) There is much boldness, death, flirtations with focal power points, yawn yawn yawn. No wonder the patrons seem bored in the mortuary chill as they retreat to the tasteful scrubbed pine snack bar and poke at the cut-grass concoctions on their plates, dissecting the relevance of a man's enlarged face, but missing what

Arnulf Rainer, 'Faces' series (1972)

is on the end of every fork.

How such Art is symbolic of anything is a puzzle to me, but at least the punters will feel good about seeing it, going to the Museum instead of the ballgame. And that, after all, is often what Culture is all about. "...then later, a movie too and then home."

Chicago is obsessed with sport in general, and the Chicago Bears in particular. In every café and bar, every shop and taxi, there is a TV or a radio blaring out live reports of their game. Switch channels and you can't escape it. Even the well groomed women you see in the tinted glass and fake marble shopping-malls wear discreet badges on their fur coats giving the simple message – "Bears".

Here, in a city and a country that is manifestly less class-conscious than England, the national sport is not the reserve of the male working class, but of everyone. It's just a shame that the American's national sport is so mind-numbingly boring. A bastardised nephew of rugby with the fast violent action taken away – or at least, slowed down and made relatively safe beneath the riot gear they call the team strip – and the tactical tedium of cricket added.

Thousands thrill as these fat, freaky men wander on and off the pitch, stand around, huddle, and occasionally run five feet before falling over and walking off for a cuppa during the commercial break. None of them can kick, none of them can catch, and nobody seems to give a damn.

The beautiful game – Football – has never caught-on here because, in the vicious circle of capitalist supply and demand, the suppliers – TV –

have never wanted to stimulate demand, as football does not give TV companies opportunities for many commercial breaks. Hence less advertising revenue. Not only that, but Americans are among the worst football players in the world. So the Americans, as insular as ever, content themselves with crowning their teams as 'world champions' of a boring sport that nobody else in the world wants to play. While everyone else gets on with the real business of playing football.

> "Quem nay gosta do futbol
> dom sujeito nao e
> E ruim da cabeca
> o doente do pe"
>
> —Joao Gilberto

Americans, who don't care about football, are however interested in stories of football related violence, thinking that every match includes a half-time bloodbath.

The phenomenon of football spectator violence is interesting in so far as it shows the double standards and misunderstandings that occur even in the most supposedly advanced of societies. On the one hand, boys are brought-up and conditioned to be patriotic, competitive, aggressive, show civic pride and respect for traditions and involve themselves in the pastimes of their peers. They identify with their local football club, and spend a good deal of their time and money 'supporting' it. The choice of words is important. People are said to support football clubs, not go and watch a game of football. (Indeed, I usually get bored watching a game between teams that I have no emotional involvement in). They then spend most of their Saturday afternoons being herded around by police, caged in pens, rained on, and generally treated worse than animals, while all the dormant beliefs of their upbringing are whipped into a frenzy by what is happening on the pitch and in the crowd around them. Although some react by going through the worst displays of working class male machismo imaginable, nobody can be altogether surprised that they are applying the principles impressed upon them during their youth to their situation. Misguidedly defending the honour of some shared identity, be it club, country, or neighbourhood. Their Virtual Reality model.

Although most of us grow-out of such concepts and their resultant activities (yes, I was a football hooligan!), some do not. The Police, who are paid vast sums of money by the rate-paying supporters and the football clubs to provide for the safety of the public hopelessly mishandle their job (they were largely to blame for both the Heysel and Hillsborough disasters, though never brought to book), then bleat to the Government about the naughty boys at football matches. The newspapers, keen to sensationalise any issue, fuel counterfeit feelings of 'concern'. Authority figures shake their heads and politicians fall over each other in the scramble to be seen to react to 'the problem'. A

problem invented by the Police, the news media, and the politicians themselves. Everyone duly 'reacts' to the 'problem', and the only people who suffer are the football clubs and, more importantly, the fans themselves. When the news media focuses on any minority interest, the thinly concealed prejudices of the majority appear like cheap wood beneath a scratched veneer. If someone is stabbed or raped on the London Underground, nobody calls for the tube to be shut down or London Underground to be fined. Yet, in the stupid, media-controlled pack mentality of the Great British Public, when some unfortunate is injured at a football stadium, bored middle-class politicians and their boring would-be middle-class voters screech for stadia to be closed down.

A few people inside British football grounds fight because it is expected of them. People in American football stadia do not fight, because it is not expected of them. A violent but practical breed, Americans only fight to get money. The American view of English football violence is as perverse as it is inaccurate.

The view is summed up by the stupid, professionally 'controversial' P. J. O'Rourke, who says for example that *The Herald of Free Enterprise* ferry was upturned by marauding 'Liverpool United' *[sic]* supporters 'for fun'. This of course is total crap; speaking from a position of pig ignorance, O'Rourke is apparently confusing the ferry sinking with the Heysel stadium disaster.

As long as people are raised to group themselves in factions, clubs, and countries, and be prepared to use physical violence to protect the space and activities and dogmas of such factions, then Society's leaders can hardly throw their hands up in disbelief every time some unfortunate gets a bloody nose or a knife wound in a large crowd of emotional young men.

The answer to football violence, and societies violence as a whole, is to try to recognise what is really going on, and stop telling children that it is alright to fight and kill if your group believes it to be right.

The vociferous intellectuals who don't go to football matches or Country & Western clubs, but prefer emblematic cultural pursuits, are guilty of placing High Culture in a context that is divorced from everyday life. But, despite peoples' likes for compartmentalisation and easy programming, Culture is not the realm of the 'happy band' who watch BBC2 after nine o'clock in the evening, just as Sport is not necessarily to be equated with men wearing pink *Le Coq Sportif* jumpers and pinkie rings in the bars of L.W.T.

In Chicago, such distinctions are not made. This concept of Divide & Rule is not nearly so apparent in America, where everyone goes to sporting events, and almost everyone, at the same time, takes art for granted. Like sport, art is important in America.

PLAYBOY ALCHEMIST
We meet a black girl who takes me to a local House club. It has none of the acid and strobed energy of such events in Britain. Chicago was the home of House music, but here it seems to lack the individuality and intensity and abandon you find at raves back home. As with rock and pop music, the British stole House music, tried initially to copy it, got it wrong, re-invented it for their own use, and in doing so made it better. But I'm disappointed.

There aren't even any drugs to be had here as, so my friend tells me, when Chicago did its clean-up act of all venues near the 'Gold Coast', anyone found with so much as an ounce of dope in their pocket or plantpot is arrested and locked-up here for narcotics abuse. The result is mile after mile of safe, boring streets, and House clubs in which people are more interested in drinking and posing than dancing. Though it may just be this particular club.

Word gets around that I'm English, so I'm bought drinks by people who have friends in the Old Country ("Say hello to Bob in London." "What part of London!?" "Margate, Bob told me that's in the East End.")

The D.J. comes down and asks me what's hot in England at the moment. I make up various names, and, surprise surprise, he's heard of all of them. My new friend then introduces me to The Boys. The Boys own the joint. They all look like the Chicago Mafia or the Chicago Bears; shiny grey suits, loud ties and gold bracelets. One of them casually tells me that he had to disarm an employee at one of their jewellery shops the day before, as she tried sticking him up with a .45. I shake my head, tutting knowingly, you just can't get good help nowadays. They pump my hand and tell me that London is the best town in the world. I tactfully lie and tell them that Chicago's miles better, and they give me drinks on the house. All my vodkas treble in size. Oh dear, I feel omnipotence coming on. Sometimes, when you get drunk, you can do no wrong. You are never boring, you never get bored. You are always right.

I stare at the dancefloor. Like those in England, this one has been built to the design specifications of a cattle market. As in sports stadia, the thin veneer of civilisation is peeled away in places such as this. Animals with animals on their feet, wiggling this, wobbling that. I walked a dinosaur. I look through the baubles of light to the mirrored wall, see a man looking at me. Hey! I point. I know that guy! He's the one who thinks he's me. The one I threw out when I was four or five years old and realised that I couldn't let people see him.

As when taking E, I get into a Good Mood because I know something nobody else except Bill Hicks knows. That is – WE ARE ALL PART OF THE SAME BEING, AND THERE IS NO DEATH.

By five a.m. I have exercised the right all British people abroad have of making complete idiots out of themselves on the dancefloor. Oh yes, what a smoothie I am, I think, as I lie like a bum in the gutter, damp with alcohol, rain and rubbish. Old

demons. C2H5OH.

In the bleary morning I thank God that no-one was there who knew me and promise myself that if I can't stop drinking, then I really must stop dancing.

MYSTERY TRAIN

The Amtrak train is a hulking silver monster that proves I K Brunel was right – we should have had a wider gauge railway track in England. (Empire-builders both, the gauge of the American Railroad track is exactly the same as a Roman road.) Settled in to our cupboard-sized compartment, I weave my way up the train to the bar, and find that American trains are as dirty and badly designed as their counterparts in Britain.

This train has that horrible, nylon carpet smell throughout its length, though, this being America, it does not have the advantage of being equipped with windows that actually open.

The Amtrak barman could walk into a job on British Rail at any time he wanted to. He is, after all, totally incompetent, surly, and unable to pour drinks. When he hears my accent he snarls to his sidekick, "More British." I raise my eyebrows in that quizzical way that tries to say Don't talk about me as if I'm not here. "You British?" he says, now deeming to include me in the conversation. I nod, mouthful of piss-weak beer. "We get hundreds of British on this train." I haven't seen any. "Hundreds of them. Dunno why they all come here. Ain't you guys got anywhere else to go?" "It's better than the Costa del Sol." "What's dat?" "A place in Spain." "That's Europe, right." "Right." "Don't like Europe ...why you all over here?" "We're not. I'm over here on holiday, going from L.A. to the East." "Never been to L.A. Never bin to London. With you lot all over here, there can't be anyone left over there now." "Probably not, no. Though if you go away you can get the Queen 'round to water the plants." I think he half believes me.

The train's most oily and obscure pieces rattle, like pebbles on the shore. The train, the plane, the beach. Here we are free to dream of lands far distant... a shore, eyes then, little, lemming white cliffs. As Derek Jarman said, "THERE AND BACK, THERE AND BACK, THE WAVES BREAK ON THE SHORES OF OLD ENGLAND. AGAINST THE VOID, WE GAZE SEAWARD, CONTEMPLATING THE NIGHT JOURNEY."[11] A black, black hoarfrost gathers on the railway lines. Straight and so narrow and they lead... away from real America, AWAY, to New York...

OK, I may be a little drunk and not in a fit state to judge, but one does tend to meet the occasional loud mouth who has a chip on his shoulder about Britain, though even these people save their most vitriolic criticisms for the Japanese and the countries of the Pacific Basin. America is scared and paranoid about the new power of Japan, just as it is irritated by its cultural debt to England. The 'special relationship' between the two countries does exist, though only in terms of culture. Although it means little to anybody in either country, some Americans find this relationship irksome in the same way that some Australians find the far more genuine links with Britain a point of irritation. The problem for this type of American is that even now, forty percent of the population here is descended from English forefathers. Also, as the biggest overseas investor in the USA, a large chunk of the American Dream is in fact owned by companies in Britain. The 'English' factor is so large here as to be automatically accepted without the need to refer to it. This is why there are days devoted to Mexico, Italy, Puerto Rico, St. Andrew and St. Patrick, but, as in England, no celebration of St. George – whoever he was.

I sit down and meet Curtis, a waiter, and Bob, a young exec type who's heading for New York on business, but can't stand flying. As they once said in an old film – Waiters are wonderful people: You ask them for something and they bring it. An underrated profession for a Santa Claus, not a slave.

America is a glutton's dream. Not only because the food is cooked with much more imagination than in England, but the service is usually embarrassingly good. I say embarrassing because, in class-conscious Britain, people feel guilty having other people serve on them. Many of the people who chose to become waiters or porters or receptionists also feel that they are really not in the supposedly lowly job of making people happy and well cared-for, but in a profession that is similar to that of a school teacher, who exists in a position of superiority to their customers. The customer, then, is privileged to get their attention, and will do as they're told and like it. Come to think of it, the same could be said of British politicians, who I'm sure are living under the erroneous assumption that they are the leaders, rather than the paid representatives, of the British people. The barman is of course the exception that proves the rule, but for every moron you meet in America, you always meet a dozen people who are enthusiastic and charming.

Although a great number of people here insist on shouting, America could teach England a thing or two about manners. The waiter Curtis, and Bob the businessman encapsulate all the ideas Americans have about Britain and Europe. Bob's been to London and liked it, Curtis has never been out of the States, but would like to go to Canada, where "they speak French". Most Americans are actually of the opinion that Canada should be part of the United States – some believe that it already is – but only a small minority of Canadians want to join the U.S., a situation that Americans cannot comprehend.

During the 1812 'fur war' between Britain and America, the American army marched into Ontario in order to 'liberate' their Canadian buddies from the yoke of British oppression. They were apparently rather astounded to be greeted with a hail of gunfire from the contented Canadians and promptly retreated over the U.S. border to safety. In rather typical fashion, every Canadian knows about the incident, which has been conveniently ignored in American history books.

The total knowledge Curtis has about England is slightly greater than his knowledge of Canada. England has that fast plane – Concorde – and that big ship, the QE2. There are actually two QE2's you know. No, I didn't. Oh yes, one goes from Southampton to New York, and the other one sails around the "Curr-i-beyan".

Later, I ask Curtis where the payphone is on the train. He looks at me like I'm crazy. Americans can clutter up space with their garbage, destroy the world ten times over with their nuclear weapons, but can't, it seems, put a simple telephone on a train. Bob smiles, a little embarrassed. He then talks about London and enthuses about everything from Sainsbury's supermarket smart cards to photo labs which can develop your holiday snaps in less than an hour. I well-up with patriotic pride. Little tears form in the corners of my eyes. Good old Blighty. We can develop photographic film. Unlike America, though, we don't yet have left-handed chequebooks. Something must be wrong.

At night I stare out of the window at the ghostly shapes flashing past. Shivers against the cold glass. Mental polaroids of white deserted fields, abandoned Chryslers, wooden farm buildings dyed grey by the moon, black lines of telegraph poles winding off under white stars. This is where time stands still. America is small and sleeping. It wants to be friends.

SPITTING DEVILS

The train slides through the Bronx with all the speed and stealth of a slug. The pregnant time passes painfully. C'mon, c'mon, I want to get off. Passengers stare through the dirty windows, wondering if they can just jump out and find a subway station. People waiting at passing subway stations stare at the rat-infested lines, wondering if they can just jump out. It's grey and raining. Handprints on the window.

Whereas California was totally alien to me, I feel at home here. Not only did I once live here, but the blackened bricks, wet tarmac and depression of New York reminds me of England. If you can imagine what Wolverhampton would look like during a dustbin strike, then you can imagine the Bronx. We can see the Harlem River Bridge on our left, an old aqueduct, a black railroad bridge marking the spot called Spuyten Duyvil – Dutch for 'Spitting Devil'.

The carriage window blacks out like the screen of a broken TV as we slip into the Park Avenue River Tunnel and emerge, what seems like hours later, into the cloudbursts and 100% humidity of Harlem, Manhattan, then the cathedral of Grand Central itself. It's dark, dark in the daytime.

The first time I'd visited New York, in 1978, I was prepared for the best. Inevitably, I was disappointed. Although my contacts, John Holstrom, editor of the then influential *Punk* magazine, Tish and Snooky of Manic Panic clothes shop on 8th Street and the Sic Fux band, were all welcoming hosts, after a couple of weeks I had started to wish I was back in London.

My idealised image of New York had been impossible for any city to live up to: namely that it was the World City to beat all others, but I left wondering if that was the best the world could do. I had imagined Ridley Scott urban gloss and Christopher Isherwood urbane decadence – what I got was an image of a reflection, an inverted pyramid. All fur coat and no pants.

It *is* a great town, but the celluloid myth of New York is greater than the physical reality. Compared to the sprawls of Los Angeles or even Greater London, the island of Manhattan, New York's centre, feels a surprisingly small, cramped town, New York's seven million inhabitants mainly living in the city's four other boroughs. When one gazes up at the beautiful old world skyline that is the inevitable result of shoe-horning a city with big ideas onto an island only two miles wide, you can't help but notice how even the skyscrapers here have been dwarfed by many newer buildings in Chicago, Hong Kong, or Singapore. Manhattan is still breath-taking in its vertical scale and beauty, but it is no longer unique. The skyscraping office blocks of downtown may be impressive, but only in the way a fossilised skeleton of a dinosaur is impressive. With the wiring-up of the world to computer terminals, fax machines, what have you, much of the city is destined to become redundant. The functionalism of modern architecture may be its downfall.

Even the infamous crime rate here, something which many locals seem to take a perverse civic pride in, has been overtaken by the riots going on in Rio, Lagos, and Washington DC. Kathy Acker, who used to work on the Devil's Sidewalk of 42nd Street, once told me back in London that she'd feel safer walking around here in Manhattan than walking around Leeds or Newcastle. Although only an idiot would be blasé about the walkability of some neighbourhoods, I feel the same.

Not to say that New York isn't still a wild town. Although the crime is pretty standard for any big American city nowadays, the local newspapers give one a good impression of how the natives entertain themselves.

The latest children's game here is called 'Elevator Action', and takes place among kids aged between 8 and 13 who live in the high rise apartment blocks in the Projects of Brooklyn and the Bronx. The game is simple. Kids get up on to the roof of a Lift while it's on the ground floor as their friends inside press the 'Up' button to the top of the building. They then stand on the top of the lift as it hurtles up the shaft towards the pulley machinery at the top of the apartment block. The first one to jump down the escape hatch back into the lift is a chicken. Many don't make it down in time. I suppose that it's certainly no more dangerous than kids of the same age in Liverpool stealing cars for joy rides or playing chicken on Inter City train lines, but it sounds like a lot more fun.

The activity of riding a Lift from the outside appeals to me, as in this way, one escapes the horror

within. Muzak.

A very '70s phenomenon in Britain, muzak still finds its way in to the bigger hotels and shopping malls here, slithering through concealed entrances like snakes in an Indiana Jones adventure, to worm into your thought-waves unnoticed.

The Muzak Corporation of America are not a figment of the imagination of Walter Tevis or Philip K Dick, as their name would seem to imply, but a real company.

The M.C.A.'s product is piped to the forces who man the DEW-line (the Distant Early Warning cordon) in the ice-bound radio stations of the north pole, as they sit scanning their screens looking for signs of a nuclear attack. Muzak is used by forty-three of the world's fifty top industrial companies, and it is estimated that over 100 million people a day hear muzak.

The Muzak Corporation's in-house book, written for their employees' eyes only but published in part by my friend Tom Vague in the form of an article by Genesis P-Orridge, makes for an interesting read.

At this point, it should be noted that the corporation's motto is "MUZAK -: A CONCEPT IN HUMAN ENGINEERING". The company's muzak is divided into three categories, with muzak programmes for Heavy Industry, Light Industry and the Office. In each of these programmes, muzak is played for fifteen minutes, followed by fifteen minutes of silence, and so on. The reason for these gaps is that one should only play muzak for half the time in which a worker is in his workplace, as in this way the employee tends not to notice the way which he is being mentally and physically manipulated.

Dr Bill Wokoun is the company's Director for Human Engineering. "A muzak transmission studio is a dream of 1984 automation," he says, and, with no hint of irony, "The ironical thing is we have no trouble in Totalitarian countries at all."

Muzak is music boiled down from the artful, spiritual, and beautiful, to its cleanest, meanest, most functional parts. Music as environmental control, though, is the same as music as mood control, and on a larger scale of course, as Dr Wokoun seems to be hinting, music as population control. Music not to be listened to and enjoyed, but music to be heard and subconsciously affected by. To quote from the Muzak Corp., "Boring work is made less boring by boring music"; so, the theory is, that muzak increases workers' productivity.

In this sense, muzak sounds quite benevolent, but saying that boring work is made less boring by hearing boring music is not the same as saying that corporations are striving to make some types of work less boring through the evolution of better working conditions, shorter hours, greater technology. It just means that workers to whom boring music is played tend to work a little faster – perhaps out of frustration. Although the Muzak Corporation don't mention it publicly, muzak can also be used in a variety of more specific ways.

As any film director or smarmy bed-sit seducer

knows, music can increase peoples' susceptibility to suggestion. Muzak does the same, and, so the story goes, experiments with putting coded messages into supermarket muzak show that this method can, they claim, increase sales and decrease incidence of shoplifting. Muzak Corporation research scientists are investigating exactly how rhythm and melody affect the human body. They think that music can affect the electrical activity of the nervous system, which makes people respond to different music in certain ways.

The Tibetan lamas could have told them this a thousand years ago. The famous 'rkan-dun' – a type of trumpet crafted from a human femur – when played, was thought to have summoned up the spirit of a dead person for use in ritual, and this instrument, along with others such as Singing Bowls, were used to treat illnesses such as migraine, period pain, insomnia and asthma.

The reason that Tibetan wisemen and Scientists from the Muzak Corporation of America have found that music, rhythms and sound pulses affect people so much as to cure them of illnesses could be explained by a look at the work of Dr Margaret Patterson, the eminent Scottish surgeon who invented the Black Box.

I first came across Patterson's work in 1983, when I was at first sceptical about her claims. By 1985 I was lucky enough to be able to publish *OMNI* contributor Kathleen McAuliffe's writings about Patterson and her Box, and was convinced.[12]

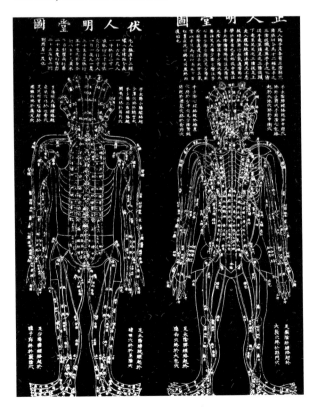

In 1972, while working as Chief Surgeon of a charity hospital in Hong Kong, a colleague of Patterson's, a Dr Wen, instructed her in the use of

electro-acupuncture as a pain depressant. As anyone who has visited Hong Kong will know, the city's high rise apartment buildings are infested with Triad-backed drug pushers and their customers, and unbeknown to Patterson and Wen, fifteen percent of their patients happened to be addicted to exceptionally pure heroin – a daily shot costing not much more than a packet of cigarettes.

To their surprise, many patients undergoing acupuncture treatment reported that they had kicked their heroin habit without any of the normal horrors of withdrawal, it also transpired that several cigarette smokers and alcoholics were also cured of their addictions. Working on this lead, and knowing that drugs such as the opiates bear their potency to the chemical fact that they happen to resemble the brains own naturally produced endorphins, Patterson sought a way of stimulating the brain to produce more of its own 'trip' inducing chemicals. This, she reasoned, would replace the artificial high of externally produced drugs and therefore remove the addicts craving for a hit. When the endorphins were produced, their levels could then be gradually brought down to more usual levels, leaving the junkie drugless and free from the effects of the drought that produces cold turkey.

She realised, from the fortunate piece of scientific serendipity experienced in Hong Kong, that endorphins must have been being stimulated by the electro-acupuncture treatment, and went about researching and developing her ideas until, in the late '70s, she came up with the Black Box. Small electrodes attached to the mastoid nerve centres behind the ears carry a tiny electrical pulse of less than 100 millivolts, less than the threshold for triggering a nerve. The frequency of the electrical pulses varies from one patient to the next, but when it is found, the brains own internal frequency channels of communication are interfered with, telling it to produce more endorphins. A natural 'high' ensues, and heroin becomes unnecessary.

According to patients such as Boy George and the Stones' Keith Richard, the Black Box works. They should know, and if they and Patterson are right, then the wider future implications are obvious, and not dissimilar to those which I mentioned earlier with regard to Dr Timothy Leary's brain-imaging home computer. Namely, that if by merely turning a dial on a small black Walkman we can tamper with the levels of our internal neurological drugs, we can achieve various mental states, such as orgasmic ecstasy, without any effort involved.

Until such a time, the streets of New York are scattered with the victims of far less healthy drugs, and you must watch where you walk at night. Seventy percent of New York's crime is drug-related. In the main, though, as Kathy Acker said, the streets, which look mean because they look like the sets of a thousand TV cop shows and films, feel comparatively safe. Emaciated junkies, winos and fifteen-year-old cocaine users are not as threatening or as interested in gratuitous violence as gangs of drunken Rangers supporters on a Sealink ferry, nor as worrying as New York's streetgangs who thankfully, in the main, save most of their violence for members of other gangs.

IN DREAMS
The impression of Manhattan as being a relatively safe town for the visitor is confirmed by Quentin Crisp, my lunchtime companion, who – after a life spent in London – has now lived in a bedsit in the rough house of the Lower East Side for nearly ten years.

Now in his eighties, Quentin turns up looking as splendid and serene as a plate of sushi and proceeds, over a half pint of sipped Guinness and picked-at Shepherd's Pie that last two hours, to enthral me with his tales of Life, the Universe, and All That.

Once the 'Stately Homo' of England and now the justly celebrated 'International Alien', Crisp is a man who's put his art into his Life, rather than on somebody else's wall. Quentin is, was, and always will be a thousand years ahead of the avant-garde New York artworld that surrounds him – as his invented lifestyle and his invented universe are more inspiring and socially evolutionary than any object in a gallery could be.

What differences do you find between living in London and New York?
"Well, when I went back last time – which I think is THE last time – I was doing a show and someone from the audience asked me if I'd noticed any change since I was last there. And I said 'you're getting better', and they applauded. And then I said 'you're becoming more like Americans', and they laughed uneasily. But they ARE becoming more American."
There is a difference in attitude here, but maybe it's different again for you because of who you are. Celebrity is very important here, if you were an unknown person they may have treated you differently. You are on TV here.
"That's the difficulty. I have never been a different person!... But, well, when I lived in England I didn't have a good time. Everyone claimed I deserved one. When I started to go on TV in England the hostility to me increased. I pondered this in my heart and I think the argument is – 'why is that old creep on TV? I've got more interesting things to say than he has and nobody has ever asked ME to be on TV.' And the more often I was on TV, the more angry they became. And in England I received about half a dozen telephone calls every DAY threatening my life. When I got here the argument was different. The more often I was on TV, the more pleased people were."
The argument being that you were on TV, so you must be OK.
"Yes. I saw him on TV and thought he was mad but now he's been on TV three times in one year so he must BE somebody. And now they stand in front of you in the street and say 'I saw you on TV!' It's the

only way I know without surgery or sorcery that you can become a virgin. All of your sins are taken away. People go on TV who have committed adultery and murdered their parents and nobody says they are a terrible person. Also, what is so wonderful here is that the less deserved your success, the more pleased Americans are."

It's rather like being royalty, here, if you're on TV. A substitute. Fame and wealth and glamour are enough.

"If you can go high enough, get on network TV. Here fame is a career in itself. Sometime in the next twenty-five years we will be offered a Degree in fame – 'I majored in being famous'. I think that I belong here because I am probably a closet fascist because I believe in the power of personality. It is the dream of America. The word 'charisma' has come into public use a lot in the last ten years. Charisma being the power to convince without the use of logic. That is the dream of people in the big cities of America. People ask me why I live in Manhattan, it's so expensive, and I say 'Like everybody else here I do it in order to be ready to take over the world should the opportunity arise.' Of course, I suppose the fault of TV is that I want everything on a world scale now. You see that there are two people in Tierra del Fuego who are NOT talking about you and it drives you mad. It's not enough to be Miss England, Miss Europe. You want to be Miss Universe. It's lovely though. I was on a show by Mr Donahue… six of us were English people who live here in America who were connected by satellite with six Americans who now live in London. Mr Donahue said that in America we have no royalty, and I said that we have Elizabeth Taylor… In fact, Liz Taylor is supreme in America, if she has a cold, along with the bridges falling down and corruption in high places, she will be news somehow, exactly the same as the queen of England."

It's important that she's thin again now.

"The fiction that exists in America about being thin! In L.A., another earthly paradise, all women ever talk about is what they've not eaten. American women know that what is right comes from the glossy magazines. Fashion photos of the tallest girls at school. What their mothers are thinking of, I don't know. But they put these young girls in kinky shoes and paint their faces, their faces look like peeled eggs and they put dark red here and so on, and paint it in just as if they were doing a painting. Now who in adult life is going to look like this tall, thin, breastless girl, this utterly bland thing. I never heard a man say I will marry a woman because she is skinny. NEVER. Men like women who bulge out of every place."

Lots of closet homosexuals seem to like thin, boyish women though.

"Yes, but TRUE homosexuals like women who are B-I-Z-A-RRR-E! It doesn't really matter in what way. It's very strange, homosexuals like everything to be bizarre. When they praise a movie they'll say 'it's terrible – you'll love it.' Men, as far as I know, want

women to be young, quiet, and vain. The dream woman of all time was of course Miss Monroe. In fact in real life she was difficult, but the self which she presented, the eagerness to please. It inflames the dreams of Norman Mailer."

[At this point, Quentin asks our waiter if he can have any Worcester sauce, then bemoans the fact that there are neither sausage rolls nor jars of marmalade to be found in America.] What, then, is the plus side of living here?

"The PEOPLE. In America everybody is your friend. They think that England is polite, but they don't understand. It is very difficult for an American to understand that politeness is the way the English have of dealing with people they DON'T like. 'Drop in at any time' is English for 'goodbye'. Whereas here if that happens they see you in the street and say 'you never came to see me.' English people then say to me 'yes, but don't you find it all rather superficial here'. But it's no good saying that to me because I am the most frivolous person that ever lived. And I love the fact that here everyone talks to everyone. They tell you their life story while they're waiting for the lights to change."

Do you get on with your neighbours? (Quentin's home on East 3rd Street is on the same block as the HQ of the New York Chapter of the Hells Angels.)

"Oh yes. If you walk along our block you come to a row of Harleys, these huge motorbikes. If they fell on you you would be killed. I can't think of any more dangerous way of travelling. They have these Harleys and they drive through the street in the middle of the night – rrrrm…rrrrrm – and they are GLORIOUS men, big, and of course the modern convention is such that when you see them they have these boots and wear their jackets open down to their navels."

You feel safe here though.

"I've never had any trouble. I've only been threatened on the street here once, over on Washington Square. My guess is that all big cities in the world are now the same big cities. I'm sure if you were a photographer you could go around London, Chicago, Sydney, Tokyo perhaps and it would look the same, because that's the way it is."

Talking about surviving, I've found from what you've written and when I've phoned you, you say 'I want what you want'. Is that a survival technique, giving people the impression that you are pliable even though you are not really?

"Yes. And I have to ask myself if I, who am only English, am allowed to live in America, what do I give in return? Now, I can't endow a university or build a wing of a hospice so all I have to give is MYSELF. So I try to be infinitely available."

I notice your phone number is in the book.

"Which is a source of some amazement to Americans, and they ask why and I say what is the point of having a telephone if your number isn't in the book. It seems obvious, if your number isn't in the book you will get stuck with your friends! If you ever want to enlarge your horizons, well, that's what a telephone is for."

Making yourself available to all and sundry and being honest through your life about your sexuality when it wasn't always easy – do you consider yourself to be a brave person?

"No, but what counts is physical courage. No, I can't imagine ever wanting to climb the vertical side of the Andes or going down the rapids of the Colorado in a rubber raft."

But I consider that physical kind of bravery far easier, especially for the kind of people who are physically equipped for that kind of thing anyway. I find what you do far more interesting because it is a kind of social bravery. You were one of the few people at the time to 'come out' in England for example.

"Yes, I was. There were plenty of self-confessed homosexuals, but there were very few self-evident homosexuals. And as you were saying earlier, when you're extreme in England, it is a criticism of others. They don't want anything, they hit you and walk on. Here it is quite different. Of course you are made fun of, but here it's an indulgent mockery. I was standing on Third Avenue the other day when this black gentleman passed me and as he passed he said 'well, my, you certainly have got it all on today.' And that IS a mockery, but it is indulgent. He wasn't going to hit me. I laughed and he laughed and walked on. People in England used to stand with their faces against mine and say 'who the HELL do you think you are.'"

I know that someone probably does not 'discover' if they are homosexual, in the same way as heterosexuals don't wake up and discover they're straight, but I'm always interested in turning points in peoples lives and I can think of two with you – one when you recognised to yourself that you were homosexual and the other when you realised that you might as well be open about it.

"Well the word 'homosexual' was never even used in my presence until I was at least twenty and I shouldn't think I even knew what it meant. There was no great turning point in my life because I was NEVER able to disguise myself as a human being. There WAS later a day when I realised that men followed me about the streets, but there was never a day when I thought I was separate from other people... PART of my sin was effeminacy, but the other part of it was my inability to refrain from adding my entire being into whatever I was saying."

[Quentin says this with a decidedly un-'masculine' flurry of arms and hair, make-up flying everywhere]

"...That is not permissible in England. In England, real people never move. They never even move their faces."

I can't work out which is the more sophisticated society, Britain or America. What is sophistication in your book?

"Sophistication is to be in control of your primary reactions. That is to say if you arrive at your table and your fly is undone and I am unsophisticated I will go pink and start to giggle and say 'tell him', nudge nudge. But if I am sophisticated I say 'By the way, your fly is undone' and that's the end of that. New Yorkers are wonderfully civilised in that sense, but of course they are not civilised in the sense that the English are. Americans have no reason NOT to say anything. They ARE interested in each other. The police are an example. In England they have a very military bearing, well dressed, upright. Here they'll lean against a building with dusty boots and hair hanging out of their cap and they drive their cars at walking pace beside me and if I look at them they just stare back. And I go over and they ask my name and I tell them, and I say 'Am I illegal?' and they say, 'No, we just wondered how your new show was going'! No English policeman is going to come over in their car and ask you how your show is going."

Talking of uniforms, they tried to enlist you in the British army didn't they?

"They wouldn't let me in. They said I was suffering from sexual perversion."

How did you feel when they said that?

"I thought 'this sounds serious'. They were real doctors after all."

Did you feel rejected or just lucky?

"I didn't feel particularly rejected because I had been rejected all the time. It's hard for modern people to understand. I couldn't go into pubs, I wouldn't get served at restaurants..."

The Gay Rights movement has changed all that and done a lot of good, but sometimes I feel it's too separatist.

"I'm staggered by modern gay men. I think 'what more do they want?' I've got to be a test case, but if nowadays I can go anywhere, then anyone can. Now gay men have their rights. I meet them and say to them 'nobody has any rights... if we all got what we deserved we would starve.' They don't want to join the human race, cutting themselves off from nine tenths of the population. They want to be separate but equal."

But I imagine many gay people think that they have to prove something to the rest of society and that provokes in them a reaction. They want to distance themselves and say "look, I can exist as I am, it is natural."

"Well, homosexuality IS NOT NATURAL, because

nature has only one desire – to perpetuate itself. Homosexuality is not good or bad. I do not try to persuade people that it is good. All I've ever said is 'don't worry, THIS is as bad as it can get.'"
What you say may be informed by your Edwardian upbringing. You wrote about the lack of love and physical contact. Do you want to be loved?
"Oh yes... But because I was never praised what I thought I wanted was love, but I realised that what I really wanted was admiration."
Andy Warhol was similar. He seemed to exist in some way wanting admiration and fame, to make up for his rejections in life. Did you know him?
"Well, if you went to a party and standing in the corner of the room there was a man approaching old age looking slightly ill and not saying anything at all, that was Mr Warhol. Once I tried to stampede him into saying something, but he never did. At one party I arrived and said 'you sent for me and I am here.' And he said 'We must get photographed together', which he said to absolutely everybody. He was professionally famous, as we said earlier."
He remained a Catholic, while you have always struck me as a man of high morals, or at least as someone who has set himself morals to live by. Do you think about religion? Christianity seems very popular here nowadays.
"I once said on stage that the difference between religion and philosophy is that religion offers you the sweet bye-bye. A man in the audience said that Judaism does not, and it's true. The God of the jews promises you nothing. You will not be rewarded, you will just be right. There is no jewish heaven. You do as Charlton Heston says, and THAT's THAT."
There has been a great deal of rumpus here over supposed blasphemy lately. Americans don't seem to have much sense of humour when it comes to Jesus. What do you think of him?
"Jesus' religion was conciliatory all the way through. Even when two people were dying before his eyes he said 'you will be with me in paradise.' What else could he say? He died very quickly, he must have been in very poor health. He died in three hours. Kirk Douglas took three days!"

Despite his long-overdue acceptance and the happiness his new home has brought him, there is an air of sadness about Quentin Crisp. The hard knocks of London have taught him to remain on the outside, looking-in. To keep silent, and, although available, somewhat aloof. His place, he thinks, is not to judge others, nor even to talk to others unless they first talk to him. As an octogenarian observer, a true outsider, he has had a perfect writers education forced upon him – but he has also sacrificed much.

He is alone, caught in the Catch 22 situation of the genuinely effeminate homosexual. That being the dream of being loved by the perfect, heterosexual macho man – but knowing that such a man could not love a homosexual in the same way that he could love a woman. As a homosexual, that perfect man could not really be of Quentin's ideal, simply because he is, himself, another homosexual. Of course, most gays are happy with gay partners, but Quentin, locked in his boyhood dream, cannot be totally happy. And in this world, never will be. Quentin gave up sex many years ago, but when I ask him what he dreams about at night, he tells me that the dream is the same...

The legendary 'pace' of New York, which I had thought generated by the pressurised social collision of the arts, media, big business and threatened crime, is in reality only an illusion created by nothing more glamorous than the flow of traffic between the majestic buildings. As the whole of Manhattan is served by only twelve main avenues into which almost every sidestreet runs, almost every street is used like a main road, and you're given the impact of noise and movement from the traffic but find, once indoors, that New York is of course just the same as any other big city in the Western world.

The best thing about New York is the people, who are often unnecessarily loud but, as Crisp said, almost always charming and, unlike many in America, seem prepared to live and let live. Their reputation for rudeness, like most generalised criticisms, is nonsense. Although, as a visitor, people may have treated me better than they would treat their next door neighbour, the fact is that if I had the misfortune of being a foreign visitor to London I would have been ripped-off and treated as badly as everyone else. The second best thing about this city is the food, which is among the best in the world.

I happily trash French cuisine on the basis of two disturbing visits to that crappy, snobby, over-rated city Paris, as the chefs there are so big-headed that they serve minuscule portions and smelly, inedible cheeses, stupid thimble-sized cups of greasy bitter coffee at five pounds a shot, and insist on floating everything in sauces that wouldn't look out of place swilling around on the top floor of a bus on a Saturday night. A city of supposed 'style' over content. Much haute cuisine is like high modern art – overpriced, unsatisfying, and not up to the job. New York food is as diverse as its skin colours, only it mixes better. Tex Mex, Chinese, Italian, Japanese, Indian, all served up on clean shovels, 24 hours a day, by people who (unlike their British counterparts) do not consider it degrading to work as waiters.

Although the American people have still to discover the simple delights of a chocolate digestive biscuit, and even though it's practically impossible to get HP Sauce, at least all food is big here. If you brought three sandwiches and propped them up in an arch shape you would have a larger and more impressive monument than Stonehenge. If you order a side salad you are likely to be presented with something that resembles twenty acres of South American rainforest. And New York is about ten to twenty percent cheaper than London in almost every department of daily living, except drinking. Britain

take note. It's all here, if you're lucky enough to have money in your pocket.

FREEDOM TO DESIRE
Money is something that springs to mind a lot here. After walking in Central Park, one comes upon the Plaza Hotel – a place frequented by the richer British Rock Stars. The hotel was made famous among the younger generation by the likes of Led Zeppelin, David Bowie, and, later, Richard Prior and Paul Hogan, who used it in *Brewster's Millions* and *Crocodile Dundee* respectively. You get the idea. Somewhere, up there on the top floor at the moment, Elton John is renting a suite of rooms costing him $10,000 a night, and he's said to have taken the rooms for a whole month. I have no real objections to people wasting their money. They are, after all, at least spreading it liberally around to other people rather than letting it sit in a Swiss bank account. But I can't help but wonder how much better a suite of rooms at $10,000 is compared with a suite of rooms costing, say $500. Not when you spend a lot of your time in it sleeping, anyway. And is a meal that costs $500 much better than a meal which costs $50? No. It's the tie syndrome. You can pick up a perfectly good tie for a few quid if you know where to look, but some people insist on wearing ties which cost them $100 that are exactly the same, presumably in the hope that it'll lend them some 'class'.

The Standard Look for the man about town, be it New York or London, is the double breasted suit set off with a garish tie that looks as though someone has been sick on it. The tie says "look, I'm not really dull, inside I'm really wild and trendy too." Politicians, particularly middleaged ones on the left, wear these ties a lot. The concept of the old school tie, be it public or comprehensive, is due for a come-back.

Expensive ties on cheapskates fail to convey the messages that were intended as the wearer is seen to be trying too hard. Anyway, most of the very rich people I've met who have been born into wealth desperately try to play it down. Peter Getty, who looked to me a bit like a young gentleman tramp, is a case in point. He seemed to be one of those people you sometimes meet who wear a real Rolex watch but pretend that it's a cheap imitation from Taiwan.

For the very worst kind of rich person, we need only look a few yards across the road from the Plaza to the Trump Tower. Trump here is the epitome of '70s Person made good. Like Robert Maxwell in England, he is evidently a rather insecure man, as everything he buys, builds or touches turns to monogrammed shit. Trump this, Trump that. Despite his much publicised money troubles (he's down to his last billion) a recent acquisition is in fact the beautiful Barbazon Plaza art deco hotel, which he says he intends ripping apart and turning into a block of tacky exclusive condos. In the F.A.O. Schwartz toy shop next door (made internationally

famous by Tom Hanks playing the piano there in *Big*) you can even buy the Trump Board Game, on which is printed the Great Man's portrait and his slogan, that sums up so much about the man and the city. "It's not a matter of winning or losing, just winning."

Manhattan is not simply a homage to capitalism, as so many people like to say. Manhattan IS capitalism made flesh, concrete, steel bone. Those gridiron streets, laid down by the unseen hand of a Draughtsman god, are the manifestation of capital communication. A vast circuit board, buzzing with information and commodities. When you realise this you realise that this city was not built for people, but for the rapid transportation of goods and merchandise, and for the slick, oily flow of money and services along the city's arteries, capillaries, mainlines. The cityscape here – Van der Rohe meets Albert Speer – is pitted with symbols; power, freedom, desire. The illusions of capitalist democracy, where every sign says 'Buy Me' and, when the New Yorker buys, he feels free. Free to choose, free to spend, free to buy.

Your mind flashes to another sign, the sign over the gates at the end of a leafy lane in Poland. Auschwitz. Here, work really does make free. If the freedom sought is the freedom to spend time on leisure, a leisure time spent choosing what to buy, which TV channel to watch, what tie to wear, which restaurant to visit. In a democratic market economy, the pressure is on to exercise your freedom and choose what to consume. A controlled choice between objects that are, like paintings, only objects. Not much choice at all, really.

In New York, everything looks wonderful. So many streets look inviting: But to most, they are dead ends. These are the losers who are, in Trump's all-American philosophy, nobodies. People still believe though, because American culture is based almost exclusively on aspiring to a successful, materialistic lifestyle, on 'going somewhere'. But never arriving.

*"And all the dead bodies makin' crazy sounds
...and all the dead bodies piled up in mounds."*
—The Velvet Underground, 1967

*"Give me your tired and poor, I'll piss on 'em/
That's what the Statue of Bigotry says/
Your poor huddled masses, let's club 'em to death..."*
—Lou Reed, 1989

As you stagger over the bodies sleeping, pissing, dying all around you on the sidewalk, you find that in order to survive here without buckling under the guilt is to console yourself with the fact that the bums and winos and crack addicts here are so, er, aesthetically correct for New York. A wet liberal guilt complex does not go as far as your stack of Quarters, and it's not long into each day before you start telling the more determined beggars, who follow

you fifty yards while prodding you with opened palms, to Fuck Off. It's interesting that here, in this city which is more 'European' than any other in the States except perhaps Boston, you notice the poverty so much.

In Tangier you can walk through the alleyways and feel disconnected from the scenes of deprivation. There, baking in the North African sun and dreaming of Paul Bowles and the pipes of Joujouka, it seems as though you are walking through an unreal biblical set, a visiting alien dropped down in a place and time that has few reference points. No mirrors. Unconsciously you feel distanced, patronising, as the people put out their horny black hands for money from beneath the djellabas and hoods. In New York, it's not so easy. Not only are the extremes of wealth and poverty bought into sharp relief here, but these are people who are products of *our* world, *our* time. There is no distance. No difference in culture or time. They're not desert tribesmen caught in a culture shock, or populations undergoing the scourge of a famine caused by locusts or drought, but Twentieth Century Americans who have simply failed in a system created by other Twentieth Century Americans. This system is being xeroxed, line for line, in Britain. The scenes of grinding poverty have got worse each time I've visited this town.

In 1982 I was in New York for the second time, this time on a junket paid for by RCA Records. The city I found on the mouth of the Hudson River then can be found straddling the Thames now. H G Wells' verdict on Los Angeles seems relevant to present-day New York. "I have seen the future. And it doesn't work." In terms of litter, graffiti, drug abuse, beggary, theft, and urban decay, London is experiencing now what New York was going through in '82.

New Yorkers seem to live under the erroneous assumption that theirs is the only town in the world with litter, roaches, rodents, and the general problems associated with big cities. But in terms of rudeness, drunkenness, rampant competition, homelessness, transportation problems, drug abuse, bad attitude, poverty and the atmosphere of gratuitous violence, London is already worse than New York was in '82, and is catching up fast. If the Thatcherite philosophy of the Americanization of Britain is allowed to continue, then by the end of the '90s our capital city – which many Americans still think of as the most civilised place on Earth – will be made to pay dearly. Thatcher's toadying biographers will no doubt put the blame on the importers of Crack and Ice, or pornographers, or on the Trade Unions or homosexuals or so-called leftist intellectuals (whichever scapegoat is fashionable at the time). But in truth it will be her short-sighted philosophies that will destroy a city that survived the bombs of International Fascism, the armies of Phillipe, Napoleon, and Jock Stein. When you go to New York now, you can smell fumes from the future of London, and much of it stinks like a futuristic funeral pyre.

It's not surprising that this gorgeous, grotesque banana republic is the Art capital of the World. The most treasured commodity of an advanced society – free time – is filled here in New York with an abundance of Entertainment. As Manhattan's most quoted art hustler once put it, "Art is entertainment". And in New York, entertainment is money. And that's all.

AT THE GRAVE OF HENRY JAMES

"Images wandered once that caused all to tremble and offend, stand here in an innocent stillness, each marking the spot where one more series of errors lost its uniqueness. And novelty came to an end."
Henry James – W H Auden

There are no bums allowed in Wright's drunkenly designed Guggenheim, or in the Met, or the Museum of Modern Art. Nor even in the small, sometimes vibrant galleries around SoHo, where decent, sensitive men and women paint oils and acrylics still in the style of that inveterate dribbler Jackson Pollock or that good but over-rated colourist Mark Rothko. There is much going on but, it seems, little actually happening.

Around the affluent Greenwich Village, you can find many serious looking adolescents in regulation acne, Reebok Trainers, padded anoraks and Levi's stretched over lardy buttocks, but no Abbe Hoffman, no new Allen Ginsberg. Not even Lou Reed standing on a corner wailing about how frightfully glamorous it is to have a drug problem, in that early '70s sort of way he had before his friends started dying. Perhaps I didn't look hard enough, but the sense of social revolution, the feelings of utopian undercurrents that are a hallmark of most avant-garde artforms and evolutionary cultures – like dada or punk – seem almost non existent here, among the students strumming their 12 string acoustics in Washington Square Park (a fairly nondescript space a million miles away from Henry James or a barefoot Robert Redford).

As I sit at the stone chess table in the park used by Marcel Duchamp in the '50s, I get the feeling that 1776 was enough. That the right to chew gum and go to work with a weird tie and listen to Springsteen or even Stockhausen is all the freedom that people require. The freedom Greenwich Village offers seems shallow and innocuous – a pretence. When I used to live in New York, the Village, despite its drawbacks, was still the place I spent most of my time, but it was not always easy to stifle a giggle when confronted with New Yorkers going through the motions of living The Life. It is here, on West 4th Street between Washington Square and Sixth Avenue, that Woody Allen stops two passing Village People in *Annie Hall* and asks them why they look so happy. They explain. She: "I'm very shallow and empty, and I have no ideas and nothing interesting to say." He: "And I'm exactly the same way." You get the picture.

America never had the Punk phenomenon (at least

not in the way that the British understand it), because Punk was not so necessary here. Megabuck, satin-draped, sanitised U.S. Rock music – the illusion still championed by the foul Rolling Stone newspaper – is revolution enough for the white kids who don't want to listen to the more rebellious, Attitude-heavy words of the black man's blues or rapping as epitomised by America's Sex Pistols, Public Enemy (even though rap has, itself, degenerated into an incoherent fashion-conscious morass of street-babble). Though America is big enough to accommodate many styles.

At the bar of the Gramercy, where we're staying, I share a few drinks with The Screamin' Blue Messiahs, who've now made America their home. The Messiahs, like many British cult bands, can make a good living here that, despite their occasional brilliance, would be impossible for them at home without any form of chart success and compromise. No matter where you go in the world, you will find a loud but superficial degree of patriotism, but nowhere will you find the abstractions of national honour and identity taken quite so seriously as in America. The furore over the treatment of the Flag is not an isolated incident, and is indicative of the sense of values here. The vast majority of Americans you meet not only believe that America is the best country in the world for them to live in, but that it is the *only* country in the world per se. In constitutional and economic terms, it probably is better to live here than almost anywhere else. It's a beautiful, rich, and in many ways sophisticated country, brimming over with opportunities and choices. It is, tellingly, a country in which the capitalist system works well for the vast majority. It is also largely free from the yellow toothed drabness of Britain – the grey council housing, cynical bearded socialists, black suits, teetering tarts and beery, tattoo-faced cretins in shell suits that Steven Berkoff found methodically grinding you into the ground in the U.K. And in America, you can do *anything* (supposedly); after all, you can sing rock'n'roll, or play the blues, or rap. And it appears that the assumed ABILITY to do anything, is enough. Which is why, to the outsider, so much 'alternative' revolutionary art here, as illustrated by American Punk Rock and its Hard Art spin-offs, was bland and posey to the English audience.

Not that the English have the copyright on the phenomenon. Of course, there's no reason why American punks should have been interested in what went on in Britain. But Punk in England was bitter, depressing, glamorous, sharp, realistic, plodding, and anarchic in a way that many American bands could not emulate (if indeed they wanted to emulate it), or understand. It's surprising to realise that in Manhattan they have never really had bombs in the streets here, regular widespread riots, massive long-term unemployment, the accepted censorship of news, the three day week, pubs which turf you out at the ridiculous hour of 11 pm into the pouring rain, nor a totalitarian government supported by a

popular monarchy as endured in the U.K.

Even the non-domestic violence here (which is not much more common than in Britain, but, due to the accessibility of guns, far more often fatal) is generally more to do with Aspiration – the attainment of money, drugs, sex – rather than the gratuitous venting of stupidity and dissatisfaction. Indeed, seventy per cent of crime in New York is directly drug-related.

Just as Euro Punk was summed-up by the Belgians' Plastic Bertrand, American Punk generally meant the Talking Heads, Ramones, Blondie, Television, Devo, Pere Ubu, The Heartbreakers, The Dead Kennedys, and assorted Valley Girl groups thrown together by Kim Fowley. Some good bands, but not, in British terms, Punk Bands. Somehow, it was all either too art school, or too flash, sub-Heavy Metal Glam, and, to English youth, too MIDDLECLASS. American kids out of a Steven Spielberg set, (festooned with comicbook posters, robots, Nintendo, TV sets and too much junk food) who stand up at the Prom and shout about hating their Mom and Dad do not inspire sympathy. To most American rebels without a cause (and no idea), English Punk meant Elvis Costello, The Police and Billy Idol. Enough said.

LA BOHEME (Tiny Frozen Hands Painting)
It becomes clear that living and working in some of the sleazier areas of the East Village is seen as being part of the 'sacrifice' young artists expect of themselves. The garret mentality survives here as it does in Hackney, the only difference being that here the offspring of middleclass families pay ridiculous rents so that they can be seen to slum-it with the natives – at least in Hackney a studio among what an EC Housing Commission once called the most deprived inner city area in Western Europe can still be rented at a rate lower than that of central London. In New York's artslum, the rents remain astronomical, and it's not surprising to discover that many of the town's eighty thousand artists are moving across the river to the newly fashionable, but more dangerous, Brooklyn (which resembles a cross between Birmingham and Islington, with added gunfire).

When you mischievously question the role Culture plays in the suppression of the working class here, eyebrows are raised. This is not only because America is the most politically conservative Western country outside of South Africa, but, thankfully, because Class is less of an issue here than in Britain. Having said that though, it really doesn't appear that there are many kids whose parents are miners or Ford workers frequenting the Village coffee bars and galleries of SoHo and NoHo. Earned wealth may at least be a fairer criteria for privilege than inherited Class, but it seems that the Art World in New York is, as usual, the domain of people with money. That being so it seems that the popularity of Art in America has something to do with aspiring towards a 'sophisticated' lifestyle that is, by association, a monied lifestyle. Not that there is anything

intrinsically wrong with money, but the almost obsessional pursuit of it here, particularly in the Arts, is not likely to be conducive to the creation of great art. The word "Art" here is the unholy matrimony of Commerce and Culture united by Aspiration. It can also be spelt "A.V.A.R.I.C.E."

One reason why the propagandist element of Art here is so weak is because of this overwhelming feeling of freedom that Americans feel that they have. There is little obvious censorship here, hence little propaganda.

"Without some form of censorship, propaganda in the strict sense of the word is impossible. In order to conduct a propaganda there must be some barrier between the public and the event."
—Walter Lippmann, 1922

This sense of freedom is, I imagine, why such third rate activist art and music has such an impact here. American artists get very upset when they're told that they can't hang Old Glory or a crucifix upside-down, because in this city much more important legal abuses of Individual Freedom such as, say, Clause 28, would be impossible. So, let's make do with the Dead Dog scam, the blank canvas, the heavy metal gimmick. Float, float on...

Talking with some young artists here, I can't help but feel them to be a part of the new morality, rather than out there on the edge. The spectre of AIDS, the de-glamorisation of narcotics and the general fashionable distrust of '67 and '77 must have something to do with it, but, even allowing for America's remarkably uncritical belief in itself – why so meek? One would have thought, in the urban squalor in New York of all places, that young artists would be searching for new revolutionary lifestyles, not trying simply to revamp the affectations of old ones. Not simply trying to get rich and famous. One would have thought that they'd be breaking down barriers, asking questions, or – damn it – rioting, but most seem to think that rioting would be a bad career move.

The only riot they've had here for many years was the one in Tompkins Square. (Since writing, they've had another small riot in the Square, in 1991, prompted by homeless tent-dwellers being moved on by the police). Although pretty small cheese by the standards of Brixton or Belfast or Birmingham City Supporters Club, the riot's influence has been great on the face of the East Village. It's indicative of the attitude that prevails among the right-on arts community here to note that the Tompkins Square disturbances were not led by the self styled 'hard art' hustlers who hang out here, but actually triggered by moves to kick the trendy arts community *out* of the neighbourhood.

Unlike SoHo, which was formerly a commercial district that was opened up for artists by the aforementioned George Maciunas, the East Village was a residential area, and when the artists and galleries moved in, forcing up rents and forcing out the locals, much bad feeling was created. It was in fact an artist – Rainer Fetting – and a supposedly right-on Englishman called Malcolm McLaren who are said to have sparked off much of the hostility when they and other residents of the newly gentrified Christadora apartment block instigated a campaign to get Tompkins Square closed to the homeless bums who frequent the place. We all love the poor, except when they're pissing through our letterbox. Since the disturbances of 1988 and in the face of mounting vandalism and crime, most of the galleries have moved over to Broadway. You get a whole nicer class of bum up there.

At the Museum of Modern Art between Fifth and Sixth Avenue (that should really be called the Museum of Early Modernism), I stare into Dalí's brilliant, surprisingly tiny *Persistence Of Memory* and know that is where I want to be, then look at the work of the dreadful Lichtenstein, a purveyor of one good dead horse, and know I want to be somewhere else.

The museum is stuffed full of some great art, some famous art, and much junk. There is much quite brazen ineptitude, a great deal of calculated obscurity and once fashionable empty nonsense. At least here in the MOMA one can take photographs, so we pose before a Picasso and push through packs of Nikon-totting fellow culture vultures to get the best shot of a Warhol I would like to hang on my toilet wall, but even the best of the rest pales slightly beside Christian Boltanski's installation – an oblong pile of metallic building blocks or tins, on which stand a row of seven of his famous distorted photographs of faces, which are spotlit through fine wire mesh. The result is eerie, sad, still.

Why Boltanski's installations work and Arnulf Rainer's paintings and photographs of similarly targeted material do not is in their simplicity and lack of presumption. Where Rainer and most abstract artists plead for attention with their quirkiness and smug confrontational methods, Boltanski's installations just seem to sit there solidly. They appear not to have been balanced or painstakingly arranged to the eccentric whims of the artist, they just seem to exist like an old wardrobe full of a dead man's suits. Boltanski suggests sepia photograph albums being leafed through by Jewish grand-children. "Death," said Boltanski, "occurs every time you take a picture." The Museum of Modern Art is a gallery of death. Dead images, dead artists and past Time which was frozen like a rotting body in a cryonics tank.

When I'm in Greenwich Village chatting, I am looking for Life, and I notice that these earnest young peoples' eyes light up and hormones veritably bubble when words such as "Loft" and "Studio" are mentioned, and I realise why, despite its disappointments, this town is so fascinating and full of appeal. It is because everyone here believes themselves to be in a film, and are happy taking on all the characteristics dictated by previously digested, supposedly 'glamorous' media images of this city,

Salvador Dalí, 'The Persistence Of Memory' (1931)

this huge floating film set. The image of the reflection. No-one in Manhattan has been born here, they've all come here to be here, in their land of Oz, and everyone is doing that very American thing, aspiring, towards a happy ending before their credits roll. Aren't we all? (This overwhelming sense of ambition and urgency here is why, I think, New York is said by other Americans to be a town full of rude people.) Here though, the aspirations seem almost exclusively towards a normally unobtainable, mythical lifestyle of lofts and apartment festivals, fame, infamy, money, boring book launches, private views, scrubbed floorboards and ceilings wallpapered with bacofoil. A painting hung in the MOMA, to show Moma, back in Idaho. Gee look, as famous as the Queen of England – "Look at me."

Just as happened to popular music in the first half of the '70s, when everyone had 'concepts', gatefold sleeves and gargantuan keyboards, the New York art world seems to the casual observer to be becoming ever more gross and predictable, empty and irrelevant. Let's be honest. Dull. (The longer I'm here, the closer I get to glimpsing America, the more and more I appreciate Andres Serrano's simple exercise in outrage, as just that.)

It dismays me how art so quickly becomes a pastiche of itself. Cut-ups, Jazz, Rock, Hermeticism, once all were esoteric and genuinely subversive. Now

cut-ups belong to Jive Bunny, saxophones have long since been usurped by the advertisers of metallic-tasting canned beer, guitars belong to the spoilt brats in the bedrooms of Steven Spielberg movies. The occult makes middle aged bookshop owners richer, hermeticism now being a pastime for the mildly adventurous commuter, bored with Bergman on Channel 4 or PSB. What were once avenues of expression that were as clearly communicative between human beings as African drums, have, through their abuse, become ambient noises with which to fill up the lonely silence of the internal world like so much tinnitus.

Visual art – once the ultimate form of communication – has been slow to realise the speed of the flickering mass unconscious. Because of the artworld's undying respect for itself, it has missed what became obvious to many jazz musicians or writers long ago. An angry young man does not pick up a guitar and play 12 bar blues if he wants to communicate that anger to the world – as he would have done forty years ago – so why does an angry avant-garde activist painter still pander to the schools of Dada or A.E?

Not only do the majority of contemporary artists conform to their medium's history, but many also slavishly follow its fashions. Looking around New York, it seems that size is still in vogue.

As some men with small genitalia are said by psychologists to find an extension in big cars and large attack dogs, small minds seem to compensate with big paintings. But really, in a setting such as this, so controlled by gallery owners, agents, dealers – it's easy to see why so many people are tempted to paint such derivative, gigantic pieces of crap. As the British painter Bridget Riley once intimated about her own dreadful work, these paintings, like the glass stumps up Fifth Avenue, from the Trump skyscraper to the Forbes building, like New York itself, are not made for people, but for capital.

Nobody owns a wall large enough for these monstrosities unless their name is Getty or Saatchi, Trump or Forbes, or the Nippon Steel Pension Fund, and who wants to paint for poor people anyway? In Mammon, the Money Mountain comes to you – but you've got to paint big enough.

Looking at a lot of these galleries the focus seems to be not on internalisation or transformation, not even on experimentation or expression, but on loudness and advertising. There seems little striving for love, still less for social utopias. Everybody still wants to be Andy Warhol.

"BUT THE PEOPLE WERE BEAUTIFUL..."
(Exorcising Europe)
When I had what I consider to be the pleasure of meeting Warhol briefly in London back in 1979, he did not strike me then as being a man who was remotely interested in anything other than chatting and flirting, which I must admit I found very refreshing. Warhol's art was valid, in the reflective sense, because it was pure New York. Not always by design, but because Warhol was a natural (if not born and bred) native of this city. He didn't have to go to the galleries and copy Pollock – whose work he hated. He just had to advertise himself as being the most important figure in Pop Art, so he was.

Victor Bockris, editor of Warhol's *Interview* magazine at its height and long-time friend, biographer and confidant of Warhol hints at such to me over coffee and English Muffins (round, dry blobs of something like pastry which nobody in England eats) at a café in Midtown.

One of Warhol's most lasting images – the painted money – sprang from a conversation which Warhol had with Interior Designer Muriel Latow in 1960. Warhol was desperate to break-out from his commercial art work and be taken seriously as a fine artist. To do so, he knew he needed to compete, and he felt himself in direct competition with a younger gay couple of painters who had recently surfaced in the New York art world – Jasper Johns and Robert Rauschenberg – and disappointed that the cartoon format he would have excelled at had already been used by Lichtenstein and Rosenquist. He wanted to be famous and respected, but he couldn't think how to go about it. Which does, in itself, imply that Warhol did not wish to be respected because he felt he had anything much to say, but, because he could paint things well, that the respect would come

naturally. The *activity* of being an artist, and the painting – the OBJECT – were enough. "What should we do now?" There were no messages and few ideas. Muriel Latow said she could think of something for him to paint, but it would cost Warhol $50 for the idea. Warhol paid up, and the idea of painting Money, Coke bottles, bananas, Campbells Soup cans and other 'everyday' objects was born.

The creation of Andy Warhol had begun, and with Andy Warhol, Art departed from classicism, painterly technique, taste, transcendence and (although he could paint very well) expertise. At first, Warhol painted Coke cans with drips, then was told to leave out the arty dribbles and just paint perfect Coke Cans. Not perfect enough to be photo realist, but perfect enough not to be abstract. Just right. So Pop Art, borrowing from Dada and subconsciously commenting on Duchamp's readymades, pushed Abstract Expressionism into the closet. Kline and de Kooning stopped being mentioned at so many parties. Art became a send-up of pure Context and, in an ironic capitalist sneer, BECAME Pure context. But Art became popular again as Art became an idea that people could get behind, because it became something that people could instantly recognise – the stuff of the kitchen. Soup cans. Importantly, not *real* soup cans, but painted ones.

What's interesting about Warhol, with his machine-tooled look, his bland photographs and prints and tape recorders and films, is that he illustrated most clearly of all how the simple act of imaging a society became the role of the artist again, as surely as it had been in the days of Leonardo. Off-Register-Reportage was placed in the Art Context, and the images became something else in the culture. Once taken away from mass news media, grafted on to walls, and intellectualised within the tiny confines of the New York Art World, the images became art. Not because Warhol had anything particularly interesting to say about the images or society (except for a few memorable one-liners that were suitably open to interpretation) but because they were given the context necessary. Because they said exactly what artists had been saying for years. Nothing.

In a world mediated not (as many people believe) solely by images, but by words, by catalogues, by interpretations of images, Andy Warhol chose to say nothing. Andy Warhol chose to give people the advice that they always want to hear. Andy Warhol let people believe that their own interpretations were correct. Because, of course, they were. Like Malcolm McLaren, Warhol knew his audience, and never did he underestimate their intelligence. Of course, just as when Kenneth Anger had invited you to stare into the chromium of the Harley Davidson, what the audience chose to see in Warhol's mirror, was themselves. The dark gemini twin, demon brother, the Christ replicant sitting over there at the end of the Last Supper table. Take a look at yourself, the first person you look for in a group photograph.

That is why Andy Warhol was the most famous artist in the world.

Bockris is talking about Warhol, Burroughs, tapes, paint and glue...

You used to record a great number of conversations – listen in?
"To some extent, my Burroughs book is totally based on that. But not only is it time-consuming to transcribe, it also encourages laziness on the part of the writer. You can be talking with someone and actually stop listening. The tape machine is doing it for you."
I find that the best interviews are ones which you write from memory. You get a more realistic impression.
"Yeah. Once when I was interviewing William Burroughs my tape recorder broke down so I rushed straight home after and wrote the conversation down from memory and I found that the prose was better and I captured the atmosphere of the conversation better."
Inevitable question – did you use cut-ups at all?
"Well, Burroughs introduced me to them. He went through this very interesting period in the late '60s when he didn't really write much. He was just doing tape recordings of everything, because he had this idea that the camera changed art. Y'know, there was no need to paint a cow anymore when you could take a photo of a cow. So he basically was saying that maybe the tape recorder could change writing the way the camera changed art. You no longer need to write a dialogue, you simply tape a conversation. It didn't really work, though. He didn't get any great work out of it, though I thought it was a courageous experiment. When I first met him in 1974 he asked me first what I was doing, and I told him I did interviews. And he then asked if I'd ever considered cutting up the tapes. He said that I should run two tape recorders, one maybe playing an interview with Warhol and one with Mohammed Ali for example, then get a third tape recorder on 'Record' and randomly record Ali and Warhol, to see what happens. Fascinating idea."
To get to the truth, see what they're REALLY saying. It doesn't really work though.
"No. It's like a collage, some bits are great, but you listen to it a week later and it's really dull. So, to answer your question I did a lot of taping but the only book I got out of it was the Burroughs' biography."
And that taping of everything came from Warhol?
"Yes. I was working with him on 'Interview' magazine and we were recording a lot of dinners and people walking in and out and stuff and it was great. Warhol liked it. Actually my Burroughs book came from my taping, but I stopped taping because writing the book on Andy changed things for me."
The Warhol biography you did was more straight-forward and literate.
"Yeah. Actually you have the English version which is different than the American one. The American

one is shorter, for a less literate audience. Here you have to appeal to the lowest common denominator. You're talking to 100,000 readers of a hardback book, and most of them in America think of Andy as some kind of weirdo. So, you have to give them something readable, easy to understand."
You have written a number of biographies. Is it important to blow the myths surrounding these people? Surely it's tempting to add to them.
"Well, with Andy and Burroughs and Ali and the Velvets etc. I found that all of them had strong images which were in fact blocking the public's understanding of them. For example with Burroughs, people thought him a very cold, heavy metal, scientific, mysterious guy with no sense of humour, which is the complete opposite as Burroughs is very funny, a very sweet man. So, I thought if I could get a sense of that humour across his work would be more available to you. 'Naked Lunch' is a hilarious book. I just wanted to bring to the public the real persona of the artist so that they could see, not be scared off by the distant image."
And the same is true of Warhol?
"If not more so. There's a great poignance in understanding Andy if you understand what he went through to get to the point of giving you that work. Jesus Christ this is a deeply muted guy coming out of enormous involvement with the fear of death and vulnerability..."
Did your view of him change during the five years it took you to write the book?
"It always does. It's bound to really. With Andy, I already knew him very well, but by the time I got deeply into it I began to really admire him even more because I realised what he had gone through to get where he was, which I didn't know when I began. And also I saw how he had maintained his sense of humour and his humanness through all this intense conflict within his childhood in the '50s, with people rejecting him all the time. And I saw that he was a really great man. Very brave and strong. It would have turned a lot of people very sour."
He didn't live to see the book.
"No. A great shame. I have had a number of shocks in my life but the most shocking was when Andy died. We had all expected him to live. He was such a strong character."
How did you get access to that world of The Factory? New York must have been interesting then.
"Yeah, it was fascinating then. I was just lucky. I came over from Brighton and worked in Philadelphia, then moved to New York in the early '70s and got a job working for Andy, I was twenty-two. It was just getting into that period when New York was the cultural capital of the world. Up until about 1986 it was the centre of the art world, literary world and so on. Many people were here so we took advantage and took on the attitude that we're just going to go out and talk to all these people and learn a lot and see what's going on. Which we did. We did about ninety interviews in the magazine between '70 and '75 with fascinating

people. Our idea was to figure out what they were doing and how they were doing it, so we could do it ourselves. I got to know Burroughs and Lou Reed and Andy and so on, but it took a long time to really get to know them as they are famous people, and they are suspicious of people for a long time. I was lucky because it was an incredible time to be living here. New York peaked between about '77 and '80. It was a fantastic time."

New York still seems to the Englishman incredibly open to ideas in the arts and so on. Has that gone downhill now?

"Yeah, completely."

In terms of the quality of work being done, the lack of new ideas, the social climate?

"In terms of everything."

Because people have come here to emulate the past?

"No, not really. Because AIDS has had an enormous, very damaging effect on the New York art world. The majority of better artists, dancers, painters, writers, actors, directors, are gay, and gays have been affected more than any other group. A lot of them have died or moved away. Also economic circumstances, social circumstances helped to change the landscape here. I think it really ended about '86. The first half of the '80s were really actually quite exciting. There was a lively, vibrant art scene with Jean Basquiat, Keith Haring, Warhol and so on. Now Jean is dead, Andy is dead, Keith Haring has AIDS [he has since died]. It's all gone. That can't help be felt. It's terrible.... The lifestyle, the whole involvements people had here have changed radically. Same with the drug scene. It's no longer hip or interesting, no longer experimental. It was interesting in 1977, very wild and vibrant. A lot of experimental thinking and living going on which was valid in the sense that it did lead to things. Creativity, interesting relationships and conversations and experiences. With the advent of AIDS, it stopped. People are not going out and staying up for three days and taking drugs. That lifestyle was valid in that you did meet people who you ended up working with, having love affairs with, travelling with, conversing with. It wasn't bullshit as people now tend to think, it was REAL. It just isn't the case anymore."

There is an atmosphere of death here.

"New York is still a very interesting landscape. There is a great book to be written about what is going on here, because it is interesting. We are living in a landscape of death, it is like the plague in London in 1740 or whenever. Of course there is still a lot going on here in terms of work and connections and people, but it's taken on a very black, very negative aura. And, as such, is interesting."

That atmosphere has shown up in a lot of the work being produced now and in the last few years, like with Haring and Mapplethorpe, a lot of stuff relating to blood and bodily fluids, sex and death. And Lou Reed's last few projects have been very concerned with death.

"Yeah. I haven't had much contact with Lou on a

Andy Warhol and Lou Reed at The Factory

personal level for a while. I saw him with John Cale doing his songs about Andy. It was great... He was another one of those people who was a great teacher in a way. He had a lot of experience. Again, unlike his image, he is a very sweet person, very intelligent, literate, who loves conversation and discussion. I admire him very much."

His work now is better than anything he's done since Berlin.

"Yeah, terrific. Lou Reed is a great man. Just like Andy, he survived for a very long time with a great deal of conflict and difficulties and he's come out of it well."

He came up with some great writing under that pressure, and through drugs. I talk to young musicians and painters here now and they seem often to be a bit too clean living, and for obvious reasons. But they also seem very reactionary now.

"Yeah, it's very dull. Drugs are really verböten today, but it's interesting to look back over the last thirty years and see how much great work was produced on drugs. Burroughs always used to argue with me and say that it's not produced under the influence of drugs, but that a person who has this experimentalism in him uses drugs. Amphetamines produced the majority of the great work here in the

'60s... Dylan, Warhol, The Living Theatre. People worked their asses off under them, they followed their visions to the end of the rainbow and they got them. Now, as you say, young kids are different about that. In New York it began to happen in '83. The Yuppies, a very reactionary group, took over. It was a drag to see the influence and position they had, but I think it faded away because there was no soul to it, just a mechanistic productivity, no depth. No understanding of life and what it's all about or what we're doing here."

I think there is a return to those values in art to a degree.

"Yeah. I think we are going to see a re-birth of a deeper kind of commitment and understand of our involvement with life and art and the relation between them. It just happens that we need to clear out of our minds what has gone before us and come up with some new vision. And that new vision is not going to come out of this lily white, purer-than-thou mass of people who are grabbing on to the religious myth, the capitalist myth. Experimentalism has to come back, and will do. Like Lou Reed says in 'Heroin' – 'I'm gonna try for the kingdom, if I can.' This is what we've got to do, TRY for the kingdom of seeking."

That's why I prefer writing factually rather than fiction. People are interesting, fact is interesting, people are interesting enough.

"Yeah, exactly. I have always been interested in and written about real people I though were great seekers, great pioneers. Warhol, Burroughs, Reed were real pioneers. And being a pioneer is always tough. They are killed and die in the search. They overdose, they get AIDS, they commit suicide. That will always be the case..."

Victor Bockris had the good fortune to live through a vital time in this city's cultural life, and documented it possibly better than probably any other writer. Now, though, New York seems dead. The last remnants of Yuppiedom and the children of burn-again Christians litter the art and music world. Warhol, who on one level can be seen as an artist who encouraged the 'soul-less' art of the '80s, can, with words, also be seen as being the ultimate pioneer of meaningful art in the '60s. Trouble is, you have to read books by the likes of Victor Bockris to work that out.

Perhaps ironically, Warhol's interest in mass produced images in the '60s had some influence on the '80s Yuppie obsession with Design. 'Well designed' objects – the stupid, heavy Filofax, the telephone that falls off the table every time you pick it up, horrible Memphis chairs et al – became important signals of style and taste.

The crock of dross that lying tells you that if you wear something, or listen to something, you are a tasteful person, was shovelled beyond belief during the '80s. If the '50s will be remembered as a Haircut, the '60s a T-shirt, the '70s a Safety Pin, then the '80s must be remembered as Rennie MacIntosh's

ridiculous chair (which was, of course, designed in the '20s). In the '80s William Morris became a name to discuss at the type of parties where people once discussed the Brontës or Solzhenitsyn (the type of parties you get out of quick). Horrible men with Next mailorder suits and stupid round glasses were everywhere.

As a 19th Century wallpaper designer and, to use the local vernacular, general all-round smartarse, Morris' career has some parallels with that of Warhol. Interestingly, though, Morris and his Art Worker's Guild – which worked alongside the painter's New English Arts Club – was opposed to the exclusivity of the Arts as epitomised by the likes of the all-powerful, completely awful Royal Academy. On the bottom line, Warhol was not. Morris did much to bring art to a larger, more aesthetically aware public, but he must also carry the soup can for being the founding father of the Arts & Craft movement, and an inspiration for such atrocities as Laura Ashley's scrubbed pine and Terence Conran's Habitat. He was also a tediously well behaved, socially minded Christian, even though some have identified him as being an integral link in the assumed chain connecting Winstanley, Coppe, De Sade, Fourier, Lautréamont, Alfred Jarry, Aleister Crowley, Huelsenbeck, Tzara, Leary, Maciunas, DeBord, LaVey, McLaren and P-Orridge.

Strangely, through the '80s Design came to be seen as being the same as 'Art', even though there is a fundamental difference. Artists are egomaniacs who produce work in a world of their own, or, at least, pretend to by promulgating the art cult's pretension and unintelligibility. Designs can, on the other hand, only work by directly accommodating the needs of their users. Design only became bad when it became dictatorial, when Form departed almost entirely from Function amid the self-congratulatory back-slapping of Fitch, Sudyic and the C.S.D. Phones that fell off tables weren't just phones, they were frustrated pieces of art created by designers who wanted to be taken seriously. People who wanted to leave the draughtsman's Drawing Office and move into a 'Studio'. Leave the smut of commercial, functional, 'working class' craftsmanship and join the scrubbed-clean, useless expressionists of the 'middle class'. And middle-class artists were dilettante, individualistic and eccentric weren't they? Hence the spotty bowtie boom.

Walter Benjamin was the first to suggest that the mechanical reproduction of images and objects took away the privileged position of the original. This is true in the area of mass produced Design but, even post-Pop Art, manifestly untrue in the case of Fine Art where, in the Museum of Vacuum – the MCA or MOMA – art objects are still placed literally and metaphorically on a pedestal.

Designs, on the other hand, are integrated into the everyday life of the user. Despite what Fluxus said, Beuys' fat, or Yoko's blood, or Andy Warhol's *limited edition* prints are still viewed through glass screens and display cases, enjoying a degree of

exclusivity that, unlike Design objects, is controlled by the artist and the dealers. Hardly the stuff of revolutions outside or even inside the refined world of art. Again, I feel cynical and grumpy, let down by Art's promises in the museum/gallery, however neo-Bauhaus the wrapping, however perfect the floorboards. And I can understand, but only wince, at Designers' wishes to be put into the Cultural context of fine art, the pseudo-Science, because it is there that I find retrogression and boredom. The sign on the museum's wall says "DO NOT TOUCH THE EXHIBITS", but could just as well read "DO NOT BE TOUCHED". Here in New York, I have lost my last shred of hope. Is that blood... blood on the floor? Can the world be as...

I should cheer up. Perhaps, like people who sit and watch American football, I just have no sensitivity or taste.

'Good taste', the last refuge of the witless, is more blurred in New York than London. Filofaxes don't exist here and cell phones are very rare because, unlike in Britain, payphones are numerous and actually work. But Manhattan is still peopled by strange men who wear large spectacles and unpleasant bowties. In London such people would be Interior Designers, TV producers, or Advertising Execs. In New York they are Psychoanalysts or Publishers.

Currently, three of the most famous artists in New York are Jean Michel Basquiat who, although only 'discovered' in 1981 quickly became a millionaire, Keith Haring, and Jeff Koons. Jean was young, painfully hip, and boring as hell. A former street graffiti artist, he went on to paint in places he was told to paint, and produced colourful, trivial pieces of junk bought by colourful, trivial people who had heavy money to invest and thought Jean 'a real character'. The type of young, brown-skinned guy they would avoid on the subway, if, indeed, they ever got on the subway. Basquiat was typical of 1980s artworld whizzkid, and typical of New York. The graffiti has been cleaned off the subways, where it livened things up, and put on the walls, where it clutters things up.

Keith Haring rocketed to New York from Kultztown, PA., as the artworld's sanitised representation, alongside Basquiat, of street sub-culture. His little dancing men are actually quite stunning when viewed 'in the flesh' at Leo Castelli's gallery in SoHo, but to compare Haring to Warhol in terms of artistic influence is rather silly.

Both men shared a difficult sexual nature and a love of fame and other nightclubbing celebrities that did little to aid their health. Haring, once enamoured with New York's sleazier clubland and subways, became a friend of Princess Caroline of Monaco, William Burroughs, Yoko Ono, Timothy Leary and, of course, Warhol himself. Haring took on legendary status, particularly in the gay bars of Stonewall and Gay Street in the West Village, when he died – tragically young – of an AIDS-related disease. A victim of nothing more than sexual

pleasure, and love.

Although Haring and Basquiat can, if one wishes, be seen poignantly as victims, dragged from the street into the galleries of Tony Shafrazi and Castelli and used, they were hardly as unfortunate as the beggars one finds lying outside these same galleries sporting signs that proclaim that they are HIV-positive and homeless. Nor were they, because of their personal histories, great artists.

Jeff Koons is way better. In a city of yuppies, he is, in fact, the natural successor to Andy Warhol.

THE PERFECT MOMENT – I Buy, Therefore I Am
Jeff Koons arrived in New York from art college in Chicago in '76. He got a job up at MOMA selling memberships to businessmen over the 'phone. In '79, he twigged that the main art form in New York City was really what Donald Trump called The Art Of The Deal, and using his selling skills learned at the Museum of Modern Art, he got a job trading commodities on Wall Street and became very rich. Koons still nurtured artistic pretensions though, and soon started using his money to buy and assemble materials for use in his own sculptural designs. His materials involved stuff like Hoovers, inflatable bunny rabbits, plastic flowers and basket balls. Objects that were immediately identifiable as being appropriated from 'Real Life'.

Like most contemporary artists nowadays, Koons, you see, knew that all that mattered was context. And, in a New York artworld in-joke, loudness and advertising skills. Koons flagrantly says 'Buy Me' and you'll feel better, because then you'll be in on the joke.

Art is also good PR for rich men and cash rich companies. This has been true since the Renaissance, when the Florentine Medici family, who were really just an unpopular bunch of money lenders, immortalised themselves by commissioning the likes of Michelangelo to decorate churches, ostensibly for God and the People. Art is a good way for the robber barons to clean up their act.

Koons is so up-front about the banality of it all he is detested by most critics. I think Koons' suggestion – not a new one – seems to be that the conceptually-placed object, the situation, becomes more 'real' than the original 'real' object, simply because it is viewed and thought about differently. Contemporary visual art seems chained to the ball of defamiliarisation. The world turns and reveals nothing new. Koons' ideas are somewhat Situationist. Or, perhaps, very Warholesque.

As Greil marcus pointed out, Situationist writer Guy DeBord's detournement intellectualised a re-appropriation of 'reality' as subversion. Any sign, symbol, street, billboard, painting, book, any representation of society's contented idea of reality, could be converted into something else, even its opposite. The Situationist idea of society being a 'spectacle', a counterfeit experience of real life perceived only through images, adverts, icons, of capitalism and technology that leave the viewer –

the individual – feeling powerless, meant that the re-appropriation of those images, that language, could alter not only the images, but the wider perception of reality itself. And that, if it works, is interesting, worthwhile, and also subversive.

But the problem faced by the Situationist is the old one. The currency remains only that. A cross, a dollar bill, a Satanic inversion or a Digger's empty pocket. And, as Mark Downham has argued[13], if the Spectacle exists as a model at all, then it is permanently re-sequencing itself to accommodate change and challenges, which is another way of questioning the validity of such conceptual – or contextual – art, be it from Koons or Serrano.

Such art relies on the theoretical more than the visual because, using the sensory apparatus humans are endowed with obviously makes one perceive reality in terms of such things as adverts, because if you are looking at an advert you are experiencing a facet of 'reality' as surely as if you are a neanderthal man eating a deer. Unlike a map, an advert is not *only* a representation of reality (a reflection of the product), but *is* an integral part of reality as well.

So the question is not simply one involving 'reality' at all. The question is one of whose version of reality is truthful. We now know, though, that no version of reality is the truthful one. Because as far as reality goes, there is no finite truth. Only half truths, virtual realities. As History, Hitler, and Philip K Dick have shown, truth is a shifting adjective. The Last Supper set in the Hollywood Wax Museum was physically real, but was viewing it 'the most thrilling experience of your life'? Did it represent anything of genuine value?

The current artistic obsession seems to be semiological, but conveniently free from definitions.

So all we have to do is invent our own definitions, choose who to believe. Observe, investigate, accept, reject, edit. Artists should be aware of this, and capable of questioning the *motives* that are behind one definition of reality or another. If people believe in Cecil B. de Mille's Christ, or Walt Disney's punchable cabbagepatch kids, or the Coke generation, then perhaps they should have their motives, and the motives of Hollywood or Advertisers or Priests brought into question. Perhaps they should be encouraged not to accept all this junk. (The distorting witch's mirror of good art again, showing the viewer something of himself that may not be as straightforward as it had seemed.)

But by the same token, perhaps artists, who enjoy their self appointed position of influence, should also be encouraged to question their own motives, their own supposedly smart appropriation of images, their own junk. If they did so seriously, my own opinion is that many would realise the circular nature of the game. They too are only advertising. They too are suggesting that their version of life, the art Disneyland, is somehow more enlightened, correct or, at least, more preferable.

But when Beuys covered a room in felt (one of his fetishes), nobody outside the world of high art could give a damn, unless of course he explained his history and motives – in which case they made perfect sense. As usual, even though Situationism and much more 20th century Art claims to be radical, communicative, social and political, the basic motivating theory seems to be rooted in the idea that there are (or, God, life can't be this simple, so there *must* be) some vague 'feelings' or answers lodged silently in some unexplored nodule of right brain cells that mere words cannot define or express. So the artist, being 'scientific' again, pokes around and expresses himself – his 'alienated', 'gifted' vision of reality – through images that have been plucked from their position in the Spectacle and plonked behind glass. Then, ironically, they are described with words – the same words that cannot express feelings from the dark organic swamplands of the right brain.

(A fashionable set of words currently used to excuse the artist's self-indulgences are provided by Shamanism. The delving into a 'shamanic conscious' in order to 'discover' or 'touch' some suitably vague, glamorous and obscure 'past consciousness' has provided a reason for art which is solophistic, that is suitably distanced and alien to the spiritually vacant Western way of life. In fact, much of the language and attitudes displayed by artists who have conformed to this currently fashionable form of atavistic resurgence would seem to indicate a total disregard for the cultural integrity of the Innuit histories from which they have plundered.)

Everything is reduced back down to words. The hard bones that give shape and definition, the bones that lie at the bottom of the thick organic soup when it is reduced. There is no escape from linear History along this dead end if the artist chooses to remain merely an inverter or re-arranger of dead images. The advertisers of one version of reality, at the expense of another.

What we need is not the stylised confrontation of a finite number of definite, decaying ideas, but the next step, the synthesis of worthwhile visions.

"My son, behold these hands and feet." Artists should be the living exemplar of those words of the philosopher: *"vital essences, volatiles, indifferent, drinkers at the sacred font... Uncontainable in any social framework, of that tribe that New York reforms and banishes to Paris." "A house in Connecticut with trees and a garden. A summer place in Martha's Vineyard. Cars. A boat. Yeah... But he would be functioning on the Corporate level now... The thought was frightening."*
—Sassoon/Cocteau/Selby

Synthesis is born from conflict. It is the next stage on the evolutionary scale. Our social and scientific advances have all been created initially by the resonance of conflict, the right to argue and discuss. But too often, contemporary art is guilty of only creating the false, external appearance of conflict, a manufactured illusion of progress. The conflict created by *Piss Christ* or the inversion of the

American Flag causes not even a blip on the evolutionary social scale. Such choice of battlegrounds is, as I have said, inadvertently supportive of the dictated battle lines drawn by those in power.

The image of 20th Century Art is one of a snake. Not one which prompts children to eat an apple, look up a skirt, or discover anything of much importance, but a snake which is curled into a circle, forever eating itself. Eternal, diminishing, returns. Going nowhere, in that reptilian way, the more it eats, the bigger it grows and the easier it is to eat more of itself. In this sense, the Art World is not an evolutionary tool for the discovery of a new perception, but the purveyor of an endless stream of images of this (false) version of reality. The mechanism of a false consciousness that David Hockney mistook for a more accurate reality. As a mirror of the consumerist 20th Century, perhaps it should be, and given this, its role as a mirror rather than a hammer, the visual artists of the century have done their job of supporting the structure of society as well as Leonardo da Vinci did in the 17th century. Old icons and new diseases.

As such, the artist – Koons – is the buyer/editor/salesman of Reality, reality being, in media artists' eyes, just the media itself. Reality being what you see in the Museum.

The concepts are practically identical in the 'Fine Arts' and Entertainment as well as in Advertising. New York is one huge shopping mall. The ethnic bric-a-brac shops sell voodoo masks, Janean heads, Buddhas, 'ethnic' looking rugs and boxes so the shopper can acquire the Look, the accoutrements of this or that alien culture, and that's all. No word of the history or religion or identity of the culture being plundered – just the crusader's haul of booty.

Everything reduced down to Interior Designer's spacejunk. The reality of the Wax Museum. Hell, not a real church, not Christ, no, but a representation of a representation of Christ. A *comment* on the representation of reality. I see. Here it is. Get behind this observation, that comment, kiss feet and... throw money.

Reality is presented as a series of distanced images, life is experienced in a hall of mirrors, reality perceived merely as a succession of reflections of reflections, adverts, wax dummies, slogans, the names of football clubs, sub-cults, images, sliding off without meaning into the infinity of the glass case, the polished marble, the vanishing point of *The Flagellation*, the most beautifully varnished, perfect gallery or airport lounge...

I've been getting desperate, and in the absence of any new ideas and genuinely thought-provoking art here (that is, art that provokes new thoughts, not just awakens old ones), I like Koons.

Koons is a collaborator, but also an *agent provocateur*. He is a contributor to the pile of junk that was '80s art and cultural consumerism, but also the purveyor of the idea that points to such art as being junk. Important as commodity, but not important as part of a serious, evolving culture that asks itself questions, because it seems unable to say anything anymore. Like the pulp novellas in airport lounges, it's Space Junk which you buy to prove to yourself you are free, junk which you use to fill time and space. Koons may be asking the viewer to re-examine that reality in the finest traditions of worthy art, by being a reflector of society, and by breaking the mirrors, even though he is using old ideas, techniques and images. (Indeed, much of his work even looks like something Luis Jimenez was doing in the early '70s.)

Koons shuns artistic technique and embraces technology, as he realises that the contemporary art world – the clinging obsession with scholarly technique – is unnecessary, and that the true artist must have a dialogue with the media of his age, as it is largely the media that defines reality. In incorporating an idea of mass production, he is of course offering no escapism, just the illusion that some objects and ideas will be better understood and more personalised if viewed within the perfect frame and made, literally, more demanding by virtue of their context and their cost.

Currently, most of Koons' banal work is untouched by the artist's own hand. Everything is made for him by craftsmen to his design specifications. Although this caused some outrage in the art world, again it's nothing new. Ronald Jones, Gretchen Bender, the Harrisons, Bill Woodrow, Imi Knoebel, John Armleder, Barbara Kruger and many others since the early '70s have been producing essentially post-expressionist work that has been largely untouched by painterly digit. And even Leonardo had assistants and technicians to help him paint the boring bits.

Koons is just the most timely and successful example of the artist who has ridden himself of some of the arty mystique of 'individual' expression. Not because he does not express himself in a way that is a direct result of his own life (his work is personal), but because what he expresses is something to do with a problem that faces everybody all the time.

We are of course still using the old language of this century's art, that created by the anti-art of Marcel Duchamp. His ready-made objects (a bike-wheel, shovel, urinal, etc.), started the ball rolling in that they were a comment on the art world, and Koons is merely updating an old tradition. Given the fact that, as I have said, there seems to be no truly avant-garde art in America, I enjoy Koons' work. Even if his only true skill is to irritate art bores.

Koons appears (in fact, must appear) to make little fuss about the obvious sociological content of his work, preferring to smile and sloganise. His uses of mass produced bunny rabbits alongside Baccaqrat crystal sets, billboard posters, and expensive, reflective surfaces will no doubt suggest a world of innuendo relating to consumerism, attainment and class to those viewers who are that way inclined. Viewed here in New York, amid the art students, winos, billboards, Trump stumps and deadends, it

seems to make perfect sense, and is very funny.

The codes are almost dispensed-with, the reactions immediate. Koons is not particularly clever, not sensitive, but he is at least observant, opportunist, and arch. Rewind to the miserable, hung-over tourist in Chicago – "As surely as you laugh when a joke is funny, some images just go Thud... Just look."

Like much minimal art, Koons' work is impersonalised by virtue of the fact that it is fabricated, distanced, designed. In this respect, in his time (the '80s), it had to be, because the issues it raises are of concern to Society as a whole, rather than the Individual.

We're heavily into community '80s buzzwords with Koons, not least 'Design', 'Media', 'Fashion', 'Advertising' and 'Consumerism'. And why not? The difference between good and bad art of this genre has always been one of convincing the viewer that the object placed before them is significant and symbolic. It is simply a matter of subtlety, social understanding and personal taste.

Koons' art works, for me, in a way that no other art I've seen on this trip because although its influences are still marginalised by their art world context, they are increased because they *are* banal, irreverent, relevant, and (no Hoover pun intended) vacuous. The everyday objects do not become more 'special', they just get put in a display case, as in a shop. Cute.

Once, painters concerned themselves with depicting a dictated vision of reality – religious icons and portraits, and representational images of everyday reality – rustic scenes relevant to their largely agrarian audience. In this century, they've obviously been more concerned with manufactured things – adverts and images such as flags, wrecked cars, electric chairs or soup cans. Images were appropriated (rather than created) from the 'real' world of the urbanite. As though the reality of the world (a world experienced largely through images that have had their meaning, use and importance supplied and controlled by politicians, priests, cameramen and corporations) could be personalised and controlled by their 'misuse'. Even art itself could be made more personal through its abuse.

Throughout this century, Westerners have yearned for the possession of objects which fill the space left by our distance from the supposedly more 'real', more 'physical' world of rural life. People also crave images and objects as a substitute for the spiritual fulfilment that many post-Christians feel. Artists have therefore concerned themselves with depicting a dictated version of reality again, only this time, as irony. *Piss Christ* questions the church and the pseudo-Christian values of the West's governments.

Soup Cans question – or, more likely, parody – the reality mediated by advertisers. Koons' appropriation continues the tradition and is a quite logical way of reflecting this 20th century attempt by the Western Urbanite (particularly in America) to 'arrive' at a state of grace in the culture by the simple aspiration towards, and attainment of new physical objects –

products. The art pieces themselves, which incorporate mass produced objects, are also products in their own right. As products, they also say more about you than any car or airline ticket or seat at the opera, as they are heavily soaked in irony.

You, the buyer, have supposedly taken back some control by ascribing something to the object that was not originally intended by the manufacturers, and which many people cannot see. (It is similar to the stylist's double-bluff that says '50s kitsch, or Victorian enamel adverts, are trendy and artistically valuable.) And to appreciate irony, to appreciate most art, you must have already attained a certain (somehow superior) kind of place in the culture. You must understand where you're at.

America is the ideal setting for Koons, as the reason that 'Art' is so popular here as something to aspire to understand and own, and the reason that it is comparatively unimportant in philistine England, is because Art is something identified with an education. And in a stratified class system, education suggests Class.

In England, no matter how much one can buy and consume, one cannot buy into 'class' without fear of being labelled *nouveau riche* and, therefore, classless. (In a highly class conscious society, being classless is being outcast.) These people that do buy into class, by becoming educated and being interested in cultural pursuits, are perhaps in England called 'Yuppies', or worse. We are dragged inevitably into the Politics of Envy, the realm of scratched limos. But the phenomenon of aspiring to a supposedly universally available social position is the essence of America. The ability to accept the material rewards of work and the subsequent ability to move socially, the ability to buy cultural kudos, is therefore more socially acceptable here, hence the greater 'appreciation' of art. Unless your name is Saatchi, the attainment of art in England is usually in keeping with a class related tradition. The attainment of art in America is an unselfconscious sign of arrival. With the acquisition of Art, it's all been worth it. Your money, smouldering away against your soul in its search for fulfilment, in its search for Space and Time, has finally arrived with you. You both are one, in Art.

In using the most common, ordinary commodities, rather than the most esoteric visual codes (as Pollock did) or extreme juxtapositions (as Serrano did), Koons is raising questions to be mulled-over more by men in the street than by Congressmen and Critics. A hustler like McLaren, he has chosen his symbols and his audience well. An audience that does not have the luxury of escaping from art, but prefers to escape into art. The art of everyday life as experienced by everybody. The universe in the mind of man re-invented in the mind that has had its perception of objects, of life, of reality, tugged-at.

Koons' most famous work is probably *One Ball Total Equilibrium Tank*, which consists of a basketball floated in a plexiglass tank filled with what looks like water. (Though if it was water, I can't see how

Jeff Koons and Cicciolina, 'Jeff In The Position Of Adam' (1990)

he got it not to float to the top.) Less emotive than *Piss Christ*, the image is equally beautiful and strange. And, after all, Reality as mediated by technological processes is incomplete without the static ball, the slow-motion playback, the invited commentary or analysis that is academia's service industry. Its role in the world. The still ball is an invitation to the catalogue-writer, the art critic, the expert, the bespectacled postmodernist who Roland Barthes' pointed out would supply the text. The viewer.

Koons raises the importance of the audience by effectively democratising art and levelling historical assumptions, and annoys artbores all in one fell swoop, while also following Warhol and Beuys in creating for himself a Persona and a healthy bank balance. As I said, Yuppie art.

In truth, Koons has about as much to do with radical changes in perception as Italian soft porn model Cicciolina (aka Ilona Staller) has to do with party politics. No surprise to find that Koons is making a film with the 'Pin Up' porn star Italian MP [they later married – and divorced]. *Made In Heaven* is to be released as the first major art movie of the '90s. "Ilona and I were born for each other. She's a media woman. I'm a media man. We are the contemporary Adam and Eve." A snigger appears on the face of the white ceramic Michael Jackson statuette. The Pink Panther wiggles between the breasts of the strawberry blonde bimbo. Very clever. I like jokes.

Koons took art out of Warhol's supermarket or kitchen, and put it on the TV. Art is only fifty years behind writing.

Koons became famous because, like Warhol, he was in the right place at the right time, and, like the 3-D expressionist he really is, he left the explanation absent from the package. In 1986 he was taken in by all powerful New York dealer Ileana Sonnabend (of Rauschenberg and Gilbert & George fame). Like Wall Street-wise Koons, she knew the score. It was Sonnabend, not Donald Trump, who said "I take artists when they are young and cheap and make them famous and expensive."

The Dealers are the deities of New York, no matter how uncouth. To borrow from Oscar Wilde – they know the price of everything and the value of nothing. Dealing commodities, movements, issues, junk, like so much detergent. Screens flicker, brokers panic. "Neo-geo down 25 points Illy baby!" "Shit. Sell now, go out and drag some kid off an elevator and tell him to go and express himself using his blood in a lift shaft. Call it neo-plasma-concept-somethingorother, and throw in that fuckin' dead dog while you're at it."

The New York art world, like the architecture, is pure capitalism at its most obscene and perfect. A piece of canvas can go from being worthless to

being worth $15 million in ten years – how can you lose out with so much money clinging to so many brainless suits out there? The dealer Ivan Karp, one of the old men of the scene, can't believe his luck, having dealt Warhol, Koons and Johns since the late '50s. In November of 1988, Jasper Johns' *False Start*, which was sold by Johns for $3,000 when it was painted, reached $15,500,000 at auction.

One of the newer dealers here is Larry Gagosian, a partner of Warhol's old agent Leo Castelli. Gagosian is the perfect example of 1980s' art in America. He started in a poster shop in Westwood, L.A., where he picked-up one of Joseph Beuys' old suits. Partly as a joke, he hung it in his shop window and priced it at $1,000. It sold, and he knew he was on to a good thing. Now he joins the ranks of part time Financiers (15 'round the table), part time art dealer/collectors like Asher Edelman as one of the super rich men in Manhattan. The price of something is what one person will pay. Isn't Art wonderful?

After his first Sonnabend-backed exhibition, a large chunk of Koons' work was heading to London, having been snapped-up – not ironically – by the Saatchis. Koons kept his mouth shut and walked away with $5 million. Post Yuppiedom, Koons' value on the market has slumped. Have a nice day.

It seems to me that the language of art is one of silence. What once was supposedly an activity that gave vent to feelings that must otherwise forever remain muted in the conventional linear expressions of words, has disappeared, like New York... into itself. Vanished into the blank canvas of academe, the black stares of spotty youths in 'existential' polonecks and the vaults of the Japanese banks. Described only by the old language, the rival, the enemy, the lover. Words.

The language of Art was destroyed by Duchamp. The subsequent search for a new language – something which should have been an exciting adventure into the discovery of what Austin Spare called the 'Alphabet of Desire' – has caused much confusion and pretence. Much alienation and, for some, much money. Now it is time for the search to end, the art world to be destroyed and then re-created, using a new language.

Instead of the continuous, shallow use of everyday junk (if I see another piece of rotten wood and a TV-Set placed Just So on a gallery floor I'll throw up), the yelping political heckle, the tiresome fashion for obscurity – all of which have been absorbed in the culture – I would like to see artists do what writers have almost always done. That is, make art that is useful and relevant.

More artists should forget about trying to make pointed comments about the art world and obvious, outdated statements about flags and politics. They may consider ceasing to regurgitate and juxtapose images of reality, in the hope of it generating a 'third mind' vision of a new reality that they dictate to their audience, and go back to touching and reporting their own reality (assuming that through the pretentious art psycho babble that they perceive

any reality as such). Draw from their own experience, their own life, and not concentrate on the mass media and other peoples' lives.

Regardless of theories, real people still exist. They are born, they have sex, they fight, they dream, they cry, they die. Upon such real focal points our Humanity rests, and our personal observations and feelings experienced at such points often lead to resonant art. Art which really can express feelings that words alone cannot.

When a man sat in a cave, eating his deer, words and paintings were one and the same thing. A real form of communication (telling people how to hunt and survive). Like writing, the theatre and cinema, painting must once more take on this role of communicating human thoughts and feelings, *based on human experience*. Upon such foundations great art can be made. Art which need not be explained away with words. Art which speaks a new language of its own. Art which breaks away from the language of Control. ("In the beginning was the word, and the word was God." So remove the word, remove God from the equation entirely for a moment, leaving LaVey alone with his church organ and Serrano paddling in his own piss.) A visual language that is as emotive as music and as accurate as the written and spoken word. Imagine it.

Such visions would return art to its original functional definition. As William Burroughs is continually pointing out, visual artefacts and artistic activities were formulae intended to create very specific results. Magick was not an end in itself but the means to an end, like biochemistry is a means. Art, then, should not be an end in itself. That need not mean, as many people think, that if art is not for its own sake, then it must be utilitarian. It means simply that Art should make things happen, in the same way that a magickal action can make something happen, or a Biochemist can create a virus and make people die, or give re-birth to a clone.

One can pick up a basketball and float it in a tank of water and it is no longer any use as a basketball. One can float Christ in urine and people still worship him. In fact, they worship him with more vehement intolerance than ever before. One piece has no specific effect, besides making a ball not work as a ball any longer, the other piece has an effect that must surely have been unintentional (distancing art still further from the majority of people while at the same time strengthening the grip Christians and censors have on the definition of Life). Serrano's intentions may have been excellent but, like those of LaVey, the intentions led to bad magick through lack of foresight and awareness.

Perhaps more artists should talk to people. Sitting in a bar talking with people who drink to forget is a better way of getting to understand the world than sitting in the Museum of Modern Art and pontificating. Waiting in the International Style, the airport or gallery, for something that never happens, never lands. A man gets out of a plane. He is shot before he kisses the tarmac. Acquino eats a dog,

Tolsen beats Lassie, Sniffy the rat escapes Rick Gibson's crusher only to be eaten by a snake and, next to the empty seat in Economy Class, a girl listens to Madame Butterfly on her Walkman.

"From out of the crowded city,
there is coming a man,
a little speck in the distance,
climbing the hillock.
Can you guess who it is?"

"*Tutto questo avvera, te lo prometto.*
Tienti la tua paura,
io con sicura fede l'aspetto... "

CULT-JUNK
(Smile, And Show Me Your False Teeth)

So junk becomes Spacejunk, transmuted from something to be buried and forgotten, to something that symbolises a hands-on control of mass reality. Post post-modernism, another invention from the pages of an '80s style bible and a French book, becomes pre-traditionalism as the cultural pendulum swings once more towards the final cult of the empirical avant-garde – Capitalism. Contemporary artists race towards the shadow of Haussmann.

The 'reactionary' creed of Capitalism – the Action that causes the Marx Artists' reaction – can, in some strange lights be seen as an extraordinary futuristic, anarchic structure.

As Gerald Graff put it – "advanced capitalism needs to destroy all vestiges of tradition, all orthodox ideologies, all continuous and stable forms of reality in order to stimulate higher levels of consumption." Graff was, of course, wrong, as in fact Capitalism needed to retain orthodox ideologies (of hierarchy) in order to survive. The point is, however, not entirely without validity. As Greil Marcus observed, "Modernity was the shifting of the leverage point of capitalism from production to consumption, from necessity to wish... all ideas had to be reduced to those that could be put on the market, and thus desires were reduced to needs." Life reduced to the laws of economic imperatives, the purchase of things not because you desire them, but because it has been objectively demonstrated (through adverts and media dictated lifestyles) that you cannot live without them.

In such a climate, it was predictable that Art should turn in on itself in order to illustrate the cross-fertilisation of desires and needs and how they became apparent in the art market (the market that undoubtedly made Sonnabend, in the world created by Graff, the pinnacle of the avant-garde). The same art market that, through appropriation and detournement, was supposedly the last avenue of the individualist as he strode towards his utopia of reclaimed reality.

'Plagiarism' was thus a word playing about the minds – if not often on the tongues – of many artists in the late 1980s. The basic idea, I assume, was the usual one (if there was a conscious aim, it was not ever properly expressed). The idea was to democratise Art – anyone can copy or borrow; to debunk – the intrinsic value of art being questioned by the source materials used; and also to attack the artworld's long standing pretext of 'creative individuality'. Once again, visual art struggles to catch up with literature. Creative plagiarism has been used openly in writing for centuries (for the purposes of association, reference, irony and inspiration, this book which you are reading shamelessly plagiarises every book or magazine article that I have ever read). More lately, the music world too has become blatant in its environment-friendly recycling of its aural refuse, due to the advent of sampling technologies and through the work in the '70s of the likes of Brian Eno, David Byrne and Sheffield's Cabaret Voltaire, and later Scratching, House and Acid, the music charts are now one huge cut-up of previously digested ideas, words, connections and riffs. 'Avant-garde' artists decided as late as 1988 that it was about time the contemporary art scene got on the Plagiarism bandwagon, a decision that resulted in the much publicised Festival of Plagiarism that took place simultaneously in London, Madison and San Francisco in January and February of that year.

The visionaries of the art world had much to say about the subject, and expressed their insight in perversely traditional forms. The London branch of the exhibition consisted of objects that had been found and *arranged* by Simon Dickason, Ed Baxter and Andy Hopton. A hammer *balanced* on a sheet of glass; a section of wooden fencing *mounted* on a gallery wall; a series of postcards *exhibited* with barbed wire around them (the emphases are mine) and – the piece which was chosen to emphasise "the central message of the show" – a stuffed bird perched on a supermarket trolley. (The supermarket, by the way, is considered a profound and somewhat witty motif among socially aware artists). Although such art festivals are clearly trying to raise points about the usual subjects of Capitalism, Commodities, Individuality and life, the art forum in which such topics are raised reduces such questions down to the convenience of vagueness and the vain if erroneous assumption of superiority. (This exhibition had none of the cheek or wit of Koons, none of the technique or even the originality.) In this writer, the only questions such cringe-making material raises being a request for directions to the nearest exit. Or, more accurately, the nearest entry.

The most cogent ideas of such an exhibition are not the materials used, or the viewer's inter-pretations, nor even their intended effects. The important ideas here are the words, such as 'found', 'arranged', 'mounted' and 'balanced'. Despite the Festival's theme of ironic non-originality and art-for-all, the words blow away the sand and tell the true story. The words chosen by the artists who contributed still imply that the collector and arranger of objects is the important factor. The definition of reality is still edited. The contributor is still the Artist.

The Censor. One way artists such as Stewart Home[14] and Istvan Kantor have dealt with the problems inherent in taking part in the 'creative individual' pursuit of fine art is with the invention of false names, and also multiple names (a multiple name being a single alias that is attributed to the assorted work of a group of like minded people. The name adopted by Home and various others was 'Karen Eliot'; Kantor, a co-founder of the Neoist Movement, coined the more well-known 'Monty Cantsin'). The practice is useful, but questionable, in that as well as making the desired (rather obvious) comment, the use of multiple names also has the effect of removing responsibility and, as well as the pretence of, even the struggle towards individual expression. Yet again, people calling themselves Artists re-vamp ideas that have been in use in other media for years. The production of work under collective group names and pseudonyms has been the accepted norm in Music, Theatre and Literature since time began. The significance of the avant-garde in the visual art world only now fully accepting the ideas of anonymity and collective responsibility for their work is perhaps noteworthy.

Many young painters and sculptors changing their name in the '80s did so for reasons that were less obvious than those which caused populists to change their names in the 1970s. In the '70s, punk performers, fanzine editors and promoters changed or abbreviated their names partly because they knew instinctively that, like actors or fashion designers, they were a part of the Entertainment Industry, but primarily because they were (or, in some cases, wanted to appear to be) signing on for Social Security payments at the time and did not want their secret jobs to be discovered. (When, towards the end of the decade, people were getting on to TV, this device failed. More than one acquaintance of this writer appeared on *Top Of The Pops* or *Revolver*, only to be recognised when they signed on at their Social Security office, to be threatened with arrest for fraud.) For the originators, Bob Dobbs-type collective names were a huge plus, as it had the effect not only of removing their culpability for much of their own work, but also served to increase their own reputation on the back of the work of others who chose to adopt the multiple name. There is also a hint of condescension involved, when one hears (one) Karen Eliot explain his use of the name by saying it is to bring "society's generalised absence of responsibility to the attention of those who did not already perceive it." I wonder if he's kidding. Perhaps he's not.

I'm confused again. Am I a lone philistine in finding so much Western contemporary polemic art dull, ugly, self-indulgent and insulting to the intelligence? Am I the only person not sophisticated enough to dig this junk? I don't think so. I've never much liked the idea of religion either. If an aware right-on sort of person wishes to say something about society or his life, why doesn't he hold his hand up and say it and dump all this obfuscating garbage? As I have already said, there is a place on this unpleasant little planet for aestheticism based on personal observation, and a place too for empty, child-like beauty. But I seem to be drowning in the rubbish of a million unoriginal little Hitlers who think they know best. Not the fault of Art, but the fault (and yes, there is some guilt to be ascribed) of the shabby system of education and commerce that are at the Art World's foundations, and a fashion victim's desperation on the part of thousands of ugly, middleclass bores to become famous. Like Punk-cum-anar(chic) existentialist alternative muso or comedian, the activist, Dadaesque, 'avant-garde' visual artist is merely a member of a cosy clique that wishes to remain marginal. That longs to be seen as beautiful and glamorous and shocking to equally predictable suburban rightwing extremists. (Like their Mom and Dad probably were.) That wishes to be seen as being elusive and mysterious and special. And thus, ineffectual. The ones I meet seem remarkably sane and calculating and uninformed, ordinary people. But still, it's a living.

"ALL THE CRACKS...."
(sex, lies and videotape)

It doesn't even seem to get cooler in the evening. Turn your television set up to full volume when they're showing a grand prix, put a copy of Grace Jones singing *Pull Up To The Bumper* on the stereo at full blast and then, closing your eyes, hold your head over a saucepan full of boiling water. Add to all this the smell of exhaust fumes, baking bread, coffee, garlic, fried onions and sweet streetcorner bagels. That's what it's like walking around Manhattan at night.

The World Trade Centre rises at the south of the island like a caged nebula, the illuminated Empire State surveys its crumbling domain as if she were an antecedent of a deposed royal family, and the most beautiful building in New York – the Chrysler – makes one damn the myopic planners in London who imposed the arbitrary height restrictions in the 1950s. God bless Manhattan Island in its sleep.

The saying goes among redneck mid-Western types that if America is the Land of Milk and Honey, then Manhattan is the land of Fruits and Nuts. Times Square and 42nd Street have been cleaned-up since my last visit, though not so's you'd notice. The streetlife is run-of-the-mill neon-lit sleaze; pushers, beggars, buggers, and large Viet vets shouting as you walk past in a language that might as well be Cantonese. But walking around the shabby, steaming sidewalk is easy when you pretend that Frank Bruno and Chuck Norris are walking with you. Not all the black guys standing around in clumps are trying to sell drugs or rob you – most are merely 'hanging out' (though quite what it is that Americans hang out has always been something of a mystery). Standing around, mountainous and mob-handed, in their regulation trainers and Def Jam T-shirts and hats, hoping to score anything that may be going, not only helps them eke out a living, but gives them a

sense of purpose and identity. Poor, unemployed people in America cannot fill time with objects or entertainments; poor people kill time. By hanging out.

It is either a tribute to America's easy-going attitudes, or an advertisement for the under-manning of the New York City Police Department that people hardly ever seem to be moved-on in New York. Most of the people hanging around the junction of Times Square and W.42nd Street wouldn't last ten minutes in London's West End without having their collars felt by one or two young men in green anoraks and stonewashed jeans who flash I.D. Cards from the Met. After the Thatcher dictated clean-up of Soho by the police and Westminster Council in the early '80s, London's discriminatory policy seems to be that unless someone is a foreign visitor or businessman, they have no right to be in the West End if they want to commit the crime of standing still for longer than five minutes. Who can blame them? The place has to be kept looking nice for the tourists.

Like Piccadilly, Times Square is preparing for large scale demolitions and corporate refurbishment. One can already envisage the acres of fake marble and nausea-inducing external lifts. New York's developers and city leaders intend replacing the wank with the swank. Tatty sidestreets are destined to be ripped down and replaced by gleaming skyscrapers and faceless concrete piazzas, and the ageing theatres and bars which represent much of the city's tradition will be darkened forever. The stupidity of the plan is confounding. The world's tourist attractions will one day all be airportised. Soon tourists to New York will be able to sit in some featureless Trocadero and pay through the nose for exactly the same cup of tepid coffee that they brought when visiting London, served to them by some uniform on legs who speaks every language but English through a forced grin. Despite the rhetoric put about by the developers and politicians, the plans have no respect for the local residents of the area, and are motivated not by the need for urban renewal, but for money.

To my left, a group of twenty large black guys, all wearing shades, stand around a few clip-boards proclaiming that black people are, in fact, the "lost tribe of Israel". Next to the clipboards is a picture of Christ, in bleeding heart persona. Over his head have been scrawled the words "The Anti-Christ". Next to him is a picture of King James I, with similar graffiti added by The Lost Tribe. At the centre of the stony-faced throng is a loud man with a megaphone, shouting out that all white people are "evil devils", sent to Earth by Satan in order to pervert and enslave God's children, the black people of the planet.

In the Land of the Free, it is apparently OK for black religious cranks to incite racial hatred and tamper with images of Christ, but not alright for artists to do the same.

Across the street, some quite mad young man stands on the corner waving a bible about his head and shouting into a microphone, ranting through a portable amplifier something about AIDS and repentance in the smug I-told-you-so way that so many Christian fundamentalists have when talking about sexually transmitted diseases.

Quite how some people can say that AIDS is a punishment for homosexual love-making strikes me as the most illogical argument on God's Earth. After all, assuming for the moment that God exists, and is, as a Cosmic Superbeing, petty enough to revert to Old Testament nastiness against homosexuals, why then is it that the people least likely to catch HIV are homosexual women? Despite its press image, HIV is not a 'sex disease'. It is simply a virus, one of many, that affects the immune system. It can be transferred from one person to another through bodily fluids in a variety of ways. It targets no-one in particular. AIDS reared its head right on cue for the religious myth-mongers who have sought to capitalise on what the disease is doing to God's world. It has effectively robbed a generation of free expressions of love, linked sex inextricably with fear, made obvious the horrifying connection between the start of life and the commencement of death. It brought our technological omnipotence to its knees. It created a climate of terror which, in turn, generated a landscape of intolerance, hatred and suspicion. When you add those things up, one can easily see why religious cranks seek to use this disease to support their usually unsupportable arguments of control. I wonder, though, why the same arguments were never used by fundamentalist lunatics against patients suffering from Hepatitis B?

I remain at a loss to see why openly gay and bisexual people are still given such a rough time around the world. In truth, we are of course all basically bisexual creatures. Or, perhaps less emotively and more accurately, Asexual. The American writer Gore Vidal has, apparently, caused some outrage by suggesting this in his essays; though why is it outrageous for one to state what is obvious to all of us by the age of fourteen? On feeling some attractions to people of the same sex, some people naturally experiment. Of those that do, some obviously find the experience more physically and/or emotionally fulfilling than a similar experience with a member of the opposite sex – for whatever reason – and a conscious choice is made. So what? Frankly, the only thing stopping more people from at least experimenting with their sexuality is peer group and family pressure, applied, like religious indoctrination, during the formative years. Society, like its monochromatic historians and intellectuals, likes to deal with the world in easily manageable stereotypes which, through Society's treatment of irritating statistics, are eternally re-enforced by that treatment. The cycle is rarely broken.

The opposite sex is something of a mystery to everyone. People of the same sex are, on the other hand, a reliable and unthreatening double. The demon lover, twin brother. Away from the ridiculous polarisations of machismo and silent, yielding

Illustration by Tom of Finland

femininity, any closer sexual understanding between men and women must start somewhere in the acceptance of our physicality and our physical desires. Must start, also, with a recognition of some degree of asexuality. Of course, not all of us actually enjoy having sex with members of the same gender. What we should recognise, however, is our sexual potential, and face the fact that society is guilty of compromising our natural, human sexuality. Men particularly are coerced into the ideal penis-pushing heterosexual 'norm' and, outside of sport or violence, are denied any genuine physical rapport with each other. It is, I suppose, our own fault. I certainly don't derive any physical pleasure from being kissed by male friends – particularly if they are large and hairy – but I think this is because of our agreed relationship with each other, rather than any genuine, purely physical revulsion.

Many more women 'admit' to having felt some attraction towards members of the same sex than do men. In a male orientated society, founded on the same sacrosanct seed that poor Onan wasted, homosexual activity between men is often banished even now to the grubby, secret world of toilets,

backrooms and shabby motels. Literally seedy places which, again, re-inforce the self-perpetuating stereotypes; to some people, homosexuality between men still equates with toilets and now, once more, disease. The Satan-sent gift to bigots and bores who wish to control others and will clutch at any straw in their search for a 'good' reason to exercise such control.

Women who have chosen to be exclusively homosexual in their practices are largely untouched by the criminal laws of England, while men who do the same thing are, in a blatantly sexist society, the butt of all manner of blunt laws, bad jokes and vilification. We are all, to some degree, responsible. The necessary legalised 'liberation' of homosexual men in the 1960s and '70s did not really free homosexuals at all. It identified and ghettoised them. Quite suddenly, homosexual men had *their own* clubs, fashions, pubs, magazines and music. (To asexuals like most of us who preferred members of the opposite sex, such affectations actually had the social effect of distancing us still further from homosexual men. One does not knowingly trespass into a Gay club as such places – set up as a reaction to the equally ridiculous assumed uniform heterosexuality of the outside world – are usually exclusively gay, and however fashionable these venues may be, I think that heterosexual use of such places is an unfair intrusion if regulars are attending in the hope of making contacts for sex. And this, the mutual exclusivity of certain areas and lifestyles, is the problem. (The other problem is those awful moustaches). The liberalisation went in on itself, rather than spread outward. When brave men 'came out', they also, in a sense, 'went in'. Gay Liberation did much good, but it did not make it acceptable for two men to hold hands in public, or to kiss each other in 'straight' society, it merely meant that Gays were more easily targeted for both legalised and illegal abuse. Instead of synthesising into society, it divided society into factions, and provided the assumed majority with a useful scapegoat. In a synthesised, neutral, Asexual Society, the perception of such things as AIDS would be very much different. (And by an Asexual Society, I don't mean that we should all parade around in ill-fitting boiler suits, cropped hair, and abstain from sex. I mean that except when we are engaging in sexual activity, we should not have to be defined by our gender and sexual preferences.)

But generations of conditioning take generations to peel away, even in the most supposedly enlightened and progressive quarters. We almost expect Politicians and Clerics, who are by definition interested only in imposing their worldview on others, to take a hand in the outright persecution of people who indulge in some sexual activities which are, it can only be assumed, slightly different to those which they themselves enjoy.

At this moment there are nearly a hundred men in British prisons who have been convicted only of having sex with other consenting male adults in

private places. This is almost to be expected in such an uncivilised and undemocratic country, but why is it, I wonder, that organisations such as Amnesty International are more than keen to take up the 'Human Rights' banner when legally convicted violent criminals are concerned, but refuse flatly to campaign on behalf of men who are imprisoned around the world solely because of their sexual preference for other men? The pseudo, off-the-peg morality offered to unthinking people by misinterpreted 'Christianity' is of course to blame for the persecution of those people who are identified socially as being homosexual, even if that apparently specific persecution actually affects the freedoms of us all. It is, after all, often not until one strays from the socially acceptable path that one realises just how well defined that path is.

Jesus Christ never went on record as persecuting homosexuals or bisexuals, possibly because, as a normal, healthy human, he was basically bisexual himself. Indeed, as a man apparently interested in love and tolerance, and active in the helping of those afflicted by illnesses such as leprosy, as a man who went on record as condemning not the prostitute, but those who judged her, it is surely these self-proclaimed Christians, such as the unpleasant little man with the microphone in Times Square, who are being heretical in not fighting for Gay Rights (or, more accurately, Human Rights) and welcoming those who are suffering from that terrible disease.

The unhealthy Christian fascination with Sex can, of course, be quite logically explained. The pursuit of Sex and, most of all, the purity of the orgasm itself renders any system of control temporarily useless, so even something as natural and healthy as sexual activity must itself be controlled and regulated. Almost all those who have occupied positions of power over the centuries have therefore tried to interfere in the private sexual lives of those who they seek to control. And the most respected and influential laws one can impose are the laws that are said to have been handed-down by God. Any God will do. In Britain and America, we use the Christian God. Laws passed in England are given Royal Assent from the Monarch, who is also the Head of the Church of England and Defender of the Faith. Throughout Britain's constitution, implied associations with God, and therefore with what is 'good' are everywhere, thus politicians are given the *right* to rule.

The trick is as old as the hills. The first legal system ever recorded – in Babylon – was said not to have been drawn up by mere mortals, but by God. King Hanmurali (2067–2025 B.C.) said that the law had been given to him by the all-powerful God Merduk, so what he said was listened to. Although the names of the deities have changed, the concept remains the same. God has become inexorably connected with the State. God has been politicised, and the appeal of a God has been utilised by almost everyone who seeks to exercise control over others. The powers

that be, through their suggested connection, have therefore assumed not only the right to control others, but also a monopoly on morality. So, all wars are holy wars and all laws are good laws. The more laws we have, the better we must be. If you happen to be Gay, then it's just hard luck. When viewed in this light, perhaps Serrano's point becomes more clear. If God, in 'His' infinite wisdom, wanted to pick on someone for viral retribution, why would he single out gay men? Why not drug pushers or murderers or New York taxi drivers?

The cabbies here are exactly the same as the cabbies you find in any other city in the world. Namely, many of them are rude, miserable, boring, and are quite the worst drivers on the streets. Here in New York though, they differ somewhat, because in New York, no taxi driver knows where he is going. Gone are the old Noo Yawkas who knew the place like you knew the back of their head, now it's more than likely that your cab driver will be called Mohammed or Mustafa, have been in town only ten minutes, and not know his St. Marks Place from his 8th Street. Many try to rip you off by starting the clock at twenty dollars – they're very original – then pretending not to understand a word of English when you point out their little mistake. A thousand pardons, grin grin. The Yellow Cabs hurtle madly along the avenues, acting as if they were marbles flicked down an alleyway. The taxi's stupid, low-slung design doesn't help. What would be considered the normal reckless driving of a cabbie in any other city is exaggerated by the relatively low perspective afforded by the seats, which also increase the feelings of face massaging G-force experienced by the hapless passenger as he is bounced over the city's cratered, steam-filled streets and skidded to the wrong destination. When you come to get out, you can of course get confused about the money and end up giving them a dime tip when you thought you'd given them five dollars, and naturally, anybody can forget to close a car door.

The sex shops here around Times Square are pretty standard butchers' shop windows. Bacon rashers, two pounds of sausages, surgical appliances, that must be upside-down, plasma, fat, piss and poo dog/poop dog. Furtive men from Wall Street jostle with Japanese tourists, middle-aged married couples from Queens and Hoboken (he always wears a gold neck chain and too much aftershave, she has a strip of black insulation tape over her eyes) prove how young and progressive they are by looking for their photo in the contact magazines, eyes and trousers bulge everywhere as mags are 'browsed' through. Oo-er.

I exchange my greasy five dollar bill for twenty tokens, like a child at an Amusement Arcade. There are lots of fun games to play here. I stand in my cubicle and insert my first token. A metallic visor draws up revealing a plastic window through which can be seen four of the most ugly women in the world. I think they are called Pestilence, Famine, War and Death. All naked except for regulation high

heels, they sit, bored to tears, rolling around on a pile of cushions as Michael Jackson's *Beat It* blares out of a portable cassette player. How apt. The individual booths are laid out in a semi-circle around the stage area, which means that if you look around, you can make out dozens of tiny eyes, steamed up spectacles, intent stares, which eat up the image of the three fatties and one skinny as if they were visiting aliens. One woman dances half-heartedly over to my window and stands astride my peep-hole, her crotch barely six inches from my face. "Shove five bucks through the window if ya wanna see something really filthy," she says, through chewed gum. Looking at this girl's matted, neon-lit cracks, I think that I already have seen something that could do with a wash, and I don't reply. She snorts, kicks the plastic window that separates us, and says "Fuck you". Quite the little charmer.

Men stand around the shadowy corridors of video booths, rattling piles of tokens and obvious hard-ons with clammy hands in their nylon slacks. One turns to me and bemoans the time he's had to wait to get a spare booth – "What da fuck do they think they're do-in? It only takes five minutes ta jack off." For once it seems that premature ejaculation is socially acceptable. I'm in the right place.

The dried smudges on the TV screen are not spittle. I check my door is locked and make sure that there is nothing wet or moving on the fold-down seat, and put another token in the slot, one finger on the fifty-channel selector button. That's it. All human life is here. This research is terrible.

Video booths are strange little places, in which skeletons rattle. Secret cubby holes of completely distanced fantasy that few men admit to entering though which practically all, at some time, do. Banned by the Tory clean-up in London some years ago, they proliferate on AIDS-conscious 42nd Street as never before. After all, for the viewer, voyeurism is safe sex. Most people would suggest that viewing such videos is 'sexist' and degrading to womankind. Though that opinion can hardly be the product of serious consideration – more the result of the fashionable, 'politically correct' doctrine that dispenses with individual thought in favour of uniformity of response.

Some of these videos are, I would say, unpleasant, and some are also degrading to some of the women who perform in them. It may be true to say that a small percentage of the predominantly male audience for pornography is aversely affected by it, addicted to it, only able to derive pleasure from the voyeurism and distance involved. The traditional '70s-style feminist view of porn is that it objectifies all women, which is nonsense. Classical painters have done this for centuries. Some men – though surely very few – may also let these fantasy images inform their attitudes to women in daily life, but such people would, one thinks, soon have their worldview changed when in contact with women in the real world. Also, if one watches a pornographic video, is it really true to say that you will suddenly see all women – your Grandmother for instance – as a shaggable bint?

There is still no evidence of a reputable scientific nature to link sex crimes with pornography, even though a minority of criminals have claimed, in mitigation, that pornography 'made them do it', in much the same way as Michael Chapman blamed J. D. Salinger for the death, a few streets away, of John Lennon. Happiness is a warm gun. In reality, it is quite obvious that many of the men who 'come' here each day have no other form of sexual release. The gallons of semen that must be deposited in this slum every year must have some beneficial social effects, damping down the sexual energies of thousands of often lonely, potentially dangerous people.

Look around. When West Germany legalised hardcore pornography in 1975, instances of rape and other sexually related crime dropped dramatically. Why such inconvenient, under publicised statistics are not brought into the censorship lobby's argument are clear. I often wonder, how 'sexist' is it for a woman to watch pornographic films? Many more do than would admit to it – indeed, there are several single women and couples here today – and to suggest that no women find pornography appealing is condescending, sexist and inaccurate. And how sexist is it for a homosexual man to watch other homosexual men on film? At least 20% of the pornography in America caters to gay men. There are also lesbian S/M magazines in California which have a predominantly female readership, lesbian targeted books such as those written by Susie Bright

and Pat Califia on such topics as whipping and vaginal fisting, and lesbian nightclubs both here and in London that cater to women who turn up dressed in basques, fishnet stockings, handcuffs and all the paraphernalia of S/M usually associated with old men in porn shops. Know your audience.

...In booth 23, he comes now. "Bless me, Father..." Falling, fallen. "... for I have sinned." Make her hear. With look to look. Songs without words... Understand animals too that way. Solomon did. Gift of nature... Ventriloquise. Lips closed... "Thankyou," says the priest through the metal grille. "That will be thirty tokens."

Although some people may feel offended or degraded by any activity that involves sexual exhibitionism, or even nudity, many people are not. At eighteen I was offered a part in a hardcore film but turned it down as it involved having sex with other men – something which I didn't think I'd be able to manage, certainly not on film. I was lucky. Had I been homeless at the time I possibly would have taken the job. But, would I have been being exploited if I'd decided to go ahead with it, or would I have been making a conscious decision to use my own body to exploit the situation and make money out of a predominantly old gay audience? I am not pro-porn on aesthetic grounds; I am merely defending the God-given right to freedom of choice. I think most criticisms of porn are really based on critics' sets of moral values, however it is dressed up. I have friends who have worked as prostitutes and in strip joints, peep shows, and in hard-core pornographic films. Only one of them has said that they felt exploited or degraded, some have very much enjoyed it – including one girl who didn't need the money but told me that for her it was the "best job in the world, flying to Rome or L.A. and screwing great-looking guys." Such a reaction may of course be some psychological defence mechanism, and in believing this point of view I may well be dampening my own subconscious guilt and being wilfully naïve, but she was a well educated middle-class English girl who said that she liked the work and the extra money. Who was I to argue? For sociologists, censors and media hungry feminists to assume that sex stars are degrading themselves is highly condescending.

Most, both men and women, have consciously entered into an agreement with their audience to have sex publicly. Although some may do this as they see no alternative way of making comparatively large sums of money, very few do it under any duress, or to feed their sick grandmother in Queens. If anyone feels degraded, they quit (disregard for a moment the scare stories about actors in these films having no choices and being forced into them by gun-toting gangsters). One is either exploited by working for 'bosses' as some Marxists still dogmatically believe – or one is not. I cannot see the difference if the job involves getting up at six in the morning and going down a coal mine or flying to L.A. to appear in a pornographic film. I know which job I would prefer, but then again I have no respect for either my body nor the work ethic. Are you exploiting me by reading this book? Or am I exploiting you?

Given the definition of the word, I think the more likely answer is that you and I and almost everyone else in the world have come to an unspoken symbiotic agreement, the order of which is constantly changing throughout the day as we become producer/consumer, writer/reader, employer/employee and so on. The people who cannot understand or accept the circular nature of symbiosis nor allow others to shoulder the responsibility of choice are denying the nitty gritty of the cosmos itself – the struggle against decay.

When one acknowledges the simple fact that pornography is not purely a gender-related topic in which oppressive males look at oppressed females, when we accept that it should not be the function of politicians and minority pressure groups to 'mould' the way individuals think about their sexuality, and when the narrow-minded Christian 'moral' argument is also dispensed with, we are surely left only with this wrongly interpreted 'Marxist'-inspired argument that says that *all* work for 'the bosses' (or, one assumes, the paying audience) is degrading. If there is any degradation involved, I would suggest that it is far more 'degrading' an experience to pay someone so that you can watch them have sex than it is to be offered money in order to exhibit yourself having sex.

Not only that, but when a man and woman have sex, or even when they 'make love', they inevitably become, in a sense, 'sex objects'. When they stop having sex, or finish the movie, they cease to be sex objects as surely as when a driver gets out of a car he or she ceases to be a driver and becomes a pedestrian. To say that if one engages in or views sexual activity involving a member of the opposite sex, one will forever see all members of the opposite sex as being nothing but sex objects is prurient nonsense. Men and women are multi-faceted creatures, not two-dimensional projections on a screen. Amazingly, people already know this. Also, it should be said, nobody legally forces a man or a woman 'actor' into these films in the first place. They may be poor, but millions of people are poor and don't end up in pornographic videos for their survival. In the video booths, it is not the actors – the woman and men, but the viewers – the men and women, who are stereotyped and defined only by their own sexuality. The sexual motive is the only thing that has driven them in here.

Obviously, there are elements in the world of pornography that are unsavoury. Just as on cop shows on TV, or, for that matter, in the pages of the Bible, there is sometimes an unpleasant tendency towards the domination of women, and violence against them (even though, I must say, that this is pretty rare in the pornography that I've seen – the violence usually being perpetrated by women on willing men).

It's as though some men resent womens' sexual

power over them. Hate them for their beauty, their power to – in some mens' eyes – corrupt. Guilt is worshipped at the Christian altar, and women, be they Oholah and Oholibah or Jayne Mansfield, pay the price. God of course was a man, so Satan must be a woman. And only women bleed. There is, however, also much domination of men by women, and violence against men in these films, though this phenomenon is, again, conveniently ignored in public debates on the subject of pornography. There is also the use of animals, that is unfair as an animal is probably not a consenting partner. (Though speaking personally I'd rather be a pig having sex with a human than a cow being killed in an abattoir). Worst of all, there is the use of children in pornography. The censorship lobby against pornography that brings about the unholy alliance of both right and left wing extremists often cite the abuse of children as a reason for banning all pornography. They conveniently forget, though, that the use of children in pornography is illegal in every country in the world, and is considered just as repugnant by most pornographers, and most people who consume pornography, as it is by almost everybody else. To equate pornography with child molestation and law-breaking is akin to equating gay men with the rape of choir boys.

The more that the recreational sex industry is made illegal, the more likely it is that illegal acts will take place. In Holland, where almost anything goes between consenting adults, the vice world is regulated and quite safe. In Thailand, where prostitution and pornography is illegal, it's obvious when you walk the streets of Patpong that sex with children, gangland violence, police corruption, abuse of women, and the spread of AIDS are all around you and thriving, unchecked. Like drugs or alcohol, when you push something underground, the industry falls into the hands of criminals. The people involved in the industry, and its audience, are treated badly and – what is more damaging than anything else in wider social terms – also start to see themselves as being criminal. It seems to me that much of the reason for pornography, and the debate that surrounds it, is to do with disappointment. Many men seem disappointed in the women they spend their lives with, partly because they have glimpsed the unreal, always unobtainable women portrayed in the advertising and entertainment media, so they seek out safe, distanced sex with others. Women who condemn all pornography out of hand seem disappointed in their men, who often look at it. Some women – a minority – seem not to understand the mechanics of being male, and are forever disappointed that men can happily look at other women and lust, and can usually quite happily indulge in satisfying sex with total strangers which has no emotional connotations. (Of course, most women can do this as well, though, through social pressures, many do not like to advertise the fact.) But to totally deny that these drives exist, in the hope that mankind can be moulded to think

differently about sex and sexuality is unrealistic. As unrealistic as Queen Victoria, in the famous apocryphal story, supposedly refusing to agree to the outlawing of homosexuality between women because she thought that such things did not take place (she was in fact herself bisexual). Men and women have changed socially over the last century, but to deny lust is like denying gravity. And anyway, both men and women *like* being treated as sex objects sometimes, and can become sex objects without becoming degraded or abused by anybody.

The atmosphere of these sex shops is actually quite sad. Sex should be an attempt at contact, but here, in these smelly little booths, there is no contact, no human communication, no love. Now, not only do men die alone. They fuck alone, too.

Thus lonely and degraded, the men become guilty, beyond their God and beyond social acceptability. There is no ego gratification, no conquest, no contact, no expression of love and certainly not very much fun here. Just self-disgust and emptiness and what are seen as the wages of 'sin' – death.

In 1984 I bribed Colin Wilson, the writer best known for his international best-seller *The Outsider*, with a bottle of claret if he'd write an article for my magazine about 'Sex, Crime, And The Occult'. In his piece, he equated the sexual gratification of the male adult with the perennial naughty schoolboy. He was quite right. Beneath the spectre of social guilt conditioning, we still possess an element of 'lawlessness' in our sexual dealings. It is what these shops thrive on, and it is most obvious here in the sex booths, where instantly gratified little boys who've been set loose in a sweet shop of desire file out red-faced, having over-eaten. The shop even has a large plastic dustbin by the door, and a small table on which is a disinfectant spray can and a roll of kitchen paper. When scurrying out, the men spray their sticky little hands and wipe themselves with the paper, which is then dropped into the bin to join the vile pile of sodden tissues, spermatozoa swimming and quickly dying in their millions.

At least they're matter-of-fact about it in New York and most other large cities around the world. In the pathetic pseudo-Victorian environment of Britain, it's obvious that *nobody* has ever been with a prostitute, or bought a pornographic magazine or novel, or masturbated. Even though informed sources estimate that up to twelve million British men have had sex with prostitutes, when talking to men about such things in England, it is in fact quite remarkable how it is that the sex industry does so very well there: One would not have thought that there were that many Conservative MPs to go around.

The video booth I'm in is bathed in the white shadow that emanates from the TV screen, making your vision limited if you wish to take your eyes off the video. Now that my eyes have become accustomed to the lack of light, though, I can see that the walls of the booth are covered in graffiti – phone numbers – and holes. As in England, such

burrows between walls are called 'glory holes' here, because reckless gay men often shove their cocks through such holes in the hope that the faceless stranger on the other side of the wall would perform fellatio. Here in New York, the holes, which in England and most places are made by the punters themselves over the years, are actually neat, cock-width circles cut in the walls and provided by the obliging management.

My door rattles from behind me – someone is waiting to get in. I stand up, wait for the video to run out, then leave, hoping the next guy won't think I've been wanking. How British of me.

Last time I was here, New York had live sex shows which seem now to have all but vanished. The one I visited, on one floor of a four storey sex supermarket, was sexless, strange and oddly admirable. When you went in to the theatre, having paid the typically cheap admission fee of about $3, you sat in semi-darkness and silence, waiting for something to happen. Films flickered quietly on TV screens overhead, and your eyes drifted around the room. Three rows of old cinema seats had been arranged around a small slightly raised matted area of stage. This seating arrangement meant that you could sit waiting in the half light, staring directly across the mat at the person sitting opposite you in the almost empty room. He looks at you. You look at him. He coughs and looks away. You light a cigarette and look away. The atmosphere becomes stifling. He shuffles his feet, you scratch your head. Hell, this is stupid, you feel like waving to the guy across the room, but don't think he'll appreciate the absurdity of it all. People yawn, from somewhere comes the sound of someone scratching their arse through shiny suit trousers. You feel an idiot. What are you doing here? You are just about to sneak out when two naked people wander casually on stage and lie down. A hidden speaker farts into life and soporific music seeps into the silence.

The girl is young, very beautiful, dark. The guy is about 25, oriental, slim, and sports a pretty fair sized hard-on, which juts out and waves around, looking bored. They look at each other and throw a brief smile into their partner's faces. Matter-of-factly, they kiss, caress with some tenderness, they gently roll and move, synchronised with the ebbing and flowing of the music. Athletic, skilful, almost choreographed. And you suddenly realise, this is actually quite beautiful, like a ballet. The word "performance" should not usually be associated with making love, but in this context it is the correct word to use. These people are accomplished actor/dancers, telling the oldest story. This is not a turn-on, it is a piece. Unlike many art pieces and performances, it looks quite natural, normal, healthy and unforced. Steven Berkoff witnessed a similar show in Rio, and came to the same conclusion, which relieves my guilt somewhat.

Lust removed, you relax. Then suddenly, you realise that a couple of men from the audience have got up from their seats and are starting to crouch down near the couple. Their faces are only a few inches from the guy's cock as it sinks in to the girl, as if they were witnessing some vital and intricate operation and taking mental notes. Despite the intrusion by these salivating old perverts the young couple carry on banging away, seemingly quite oblivious to what is going on around them. She is probably wondering what to have for dinner, he is thinking of investing in some knee-pads. Five or ten minutes later they both feign a unified orgasm, uncouple, and stand up and take a bow. His cock looks as rigid and bored as ever. You clap appreciatively, admiring their professionalism. Even on the seedy floor of this bear pit, their integrity remains intact. They will never get interviewed by David Letterman, but their art, although natural to us all, is akin to a performance of *Swan Lake*, their skill superior to that of the Chicago Bears. Nobody else is clapping. They smile and say thanks and skip out. A voice comes over the tannoy "Another couple will start their show in ten minutes." The conveyor belt never stops. The audience stays put, but you leave, slightly confused by it all. Perhaps you'll go to the cinema or a ballgame later.

Later, sliding headlong into sleaze, we find ourselves in a cold, black basement in a decrepit building in the old meat packing district on the Lower West Side. We are in an S/M nightclub called *The Vault*. [Since writing, this place has been made famous due to its use as a setting for some of the shots in Madonna's book *SEX*] There are few lights. You stumble around over the bare concrete floor through the labyrinth of cellars to the bar. This being a Bring Your Own Bottle club, we're forced to sit and drink Coke. Most of the other customers are men. They come in off the street dressed in suits or work gear, pay their entry fee then vanish into a cubicle. When they emerge they are naked, except for obligatory leather jacket and – peculiarly – their shoes and socks, which they've no doubt left on because of the cold bare floor. They sit at the bar stools, a row of white hairy arses, and talk about the ball game. I freeze in silence and incredulity. The walls run with water from a broken pipe.

Occasionally, a woman walks through – mostly extremely large hairy hookers looking for a john to tie and tease for the night – but sometimes something happens to catch your attention. At one point, a youngish couple walk in. The man takes off his coat and reveals that he is wearing a dress. He strips down to his frilly undies. She methodically rummages in her bag and pulls out various pieces of rope and equipment. The guy stands like a crucifix against a metal grill. She ties him up, while doing so, she comes over and asks for a light. You spark your Bic with a rasp in the darkness. She doesn't want to light a cigarette, but instead holds out a piece of thin cord that she wants you to use your flame to burn in two at the middle. She must have forgotten her scissors. Without a word spoken, she finishes tying her partner up and proceeds to ask for another light – this time for a candle. She then spends the

next fifteen minutes dripping hot wax on to the semi-naked body of hubby as he groans occasionally. When this is finished, she produces some bull dog clips and attaches these to various parts of his anatomy and whips him lightly with a short cat-o-nine tails.

All the time, it gets colder. You stand up and move through the blackened rooms. The sign on the wall says "Club Rules – Lips Above Hips Only". You start talking to a large lady who's sitting on a sofa that's seen better days. She's nice, but wants you to sit on her knee. "Yewre English? I lyyyke English." A young, grubby looking man interrupts "You ain't English. You're Australian. I know what English sounds like, and you ain't English. Irish maybe." Twat. He leans over to the fat lady "Lemmie suck on your tits. Please let me." Incredibly, she does.

You walk into another room, where one guy kindly offers to "beat yer butt", but, preferring a nice hot cup of tea, you decline gracefully and step out into the rainswept night...

Back in Present time, I notice that *Screw* magazine is still going strong here, sold openly on most newspaper stands. Publishing Editor Al Goldstein founded the paper in '68 on the principle that if you have free speech, you may as well exercise it by being as offensive as possible. His editorial column, wittily called 'Screw You', carries two photos of him, one chewing a big cigar while giving the camera the finger. You get the idea. Goldstein is another anal retentive who never grew up. His motto is "Do the wrong thing". What a wag.

Goldstein is a good advert for Valerie Solanas' 'Society for Cutting Up Men' (SCUM), an art piece, complete with obligatory manifesto, that led in part to her shooting of Andy Warhol in the '60s. If Solanas was offensive to men in a manner that would be universally condemned if a man were to be responsible, *Screw* also strives to be offensive, unbelievable, over the top schoolboy rubbish. In this weeks edition there is an 'exposé' of the Bangkok sex industry. The lead picture shows the investigative journalist getting a blow-job from a smiling Thai bar girl. The caption reads "Bang the cock slowly. Sultry, sloe-eyed, saronged sweeties slurp the spunk stick and stuff their squak squirters in this tale of the Gook, the bad, and the ugly." Mr Goldstein has such a cute turn of phrase. The paper is supported by carrying adverts for the city's sex factories, and in the current climate this means that *Screw* is now heavy with ads for Phone Sex. "Hot Talk" have Bambi, Tina and Kim waiting for your call, and assure you that they are the "Best Fucking Live Line" in town. Over the page, though, on 970–4545, you can talk to "Cunt eaters and cock suckers" about "Asshole eating, Cum sucking and Bi fucking". And so it goes on, and, sadly, on.[15]

Most companies offer "discreet credit card billing", no doubt so 'the wife' doesn't find out, though others offer a touchphone facility that not only lets callers pay their bill by tapping-in their card number on the phone, but also leave messages for other callers on the bulletin board, similar to what happens, in a much more censored form, in the U.K. Less safe sex is still available of course. You can still call Robert, "Handsome, friendly, Discreet and Hung 9▪", or call-in on Mistress Angel Stern's Dungeon, at an address where you are urged to "crawl as fast as you can". It's a small world. "Angel" once stayed at a friend of mine's house in Brighton, so I know that she is, in reality, the writer Terence Sellers, whose book *The Correct Sadist* was published for the first time in England by Paul Cecil of Temple Press. Forget *Screw* magazine and read Terence's book instead.

If the world is small, America is tiny. *Screw*'s publisher, Al Goldstein, once produced a magazine called *DEATH*. On the cover of Issue One was a photo of the handiwork of Anton LaVey, the decapitation of Jayne Mansfield. Satan moves in mysterious ways, his nonsense to perform.

ARMAGEDDON TIME

I wander through Midtown and come across St. Patricks church. Remembering Joey Skaggs and a dozen black-and-white movie matinees about Santas and snow, I walk up the steps to go and take a look inside. Just as I do so, the large doors literally slam shut in my face. Symbolically, I think, the church is closing.

Inside, I imagine an Irish-American priest puts the body of Christ into the tabernacle, locks it, and genuflects. He wanders across the silent altar to the candles that surround the statue of the Virgin Mary and lights a Marlboro from a flame. As he inhales sharply his lungs put pressure on his over-full stomach and a loud fart is expelled, echoing through the empty chamber. He empties the tin marked "For the Poor of this Parish", and adds it to a pile of notes heading for the brave boyos back in Ireland, their murders to bless.

The sight of the illuminated church set in a street dotted with flapping American flags underlines the position of Christianity here. I sit on the hard stone steps and light-up, watching the American people pass, eyes straight-ahead down big city tunnels. Difficult to breath, hard to believe. There seems an enormous sense of oppression in the Land of the Free, among these superstitious idols. The same ones are replicated across the West, affecting even the unbelievers. Writing in a now famous edition of *San Diego Magazine* in 1985, James Mills, the former president of the California State Senate, recounted a meal he had with one Ronald Reagan in 1971.

As the dinner drew to a close, the lights were dimmed as bowls of cherries jubilee were ignited and served. Through the gloom, Reagan suddenly asked Mills if he had read "the fierce Old Testament prophet Ezekiel", then, with what Mills describes as "firelit intensity", the ex-actor "preached" to him, as if talking down to a sceptical college student. "All the prophecies that have to be fulfilled before Armageddon have come to pass," the great man boomed, rather disconcertingly for a man who even then nurtured presidential ambitions. "For the first

time ever," he went on, "everything is in place for the battle of Armageddon and the Second Coming of Christ." When Mills responded by reminding Reagan that the bible is quite clear in saying that mankind will not be able to predict when this rather notable event will take place, Reagan replied "Everything is falling in to place. It can't be too long now. Ezekiel says that fire and brimstone will be rained upon the enemies of God's people. That must mean that they will be destroyed by nuclear weapons." The great theologian then went about proving that, since the Soviet Union was Communist and without God, and was situated "in the North" (as is Gog in the Bible), then, sure enough, the USSR MUST be Gog, the nation that will lead all others into darkness. It is from this warped, classically American perspective that we must view the world situation. Gorbachev may be trying to dismantle much of the Iron Curtain, but then – HE WOULD, WOULDN'T HE? After all, is not the Anti-Christ a charming, almost comic figure who will convince the world that he is saving the world while all the time he plans its destruction? And, hey pinko, doesn't the Soviet leader bear the mark of the Beast, or is that really just a map of Malaysia that he has tattooed on his forehead?

I was walking through the City of London a few months ago and came across a crowd gathering by the Guildhall, waiting for the arrival of the great Gorby. I decided to join in the fun, and elbowed my way past a few disabled children to the front. A delivery van stopped at traffic lights in front of the crowd and the cockney driver lent out. "Fuckin' ell, what's all this abaht. Ooes comin' mate?" "Michael Jackson." "Fuck me. You lot must be fuckin' mad." With this, the most ill-informed person in London then drove off, disgusted, to be followed five minutes later by a half-mile motorcade of gigantic black dreamcars and pugnacious-looking police outriders. The large crowd chanted "Gorby", and the tattooed one waved from the back seat of his limo. I saw his hand. It didn't look like the kind of hand that would press the button. It actually looked like quite a pleasant hand, far smaller and more cultured looking than the hand of the Duke of Edinburgh, which I saw waving from a similar looking car during a royal visit to Wrexham in 1966.

My meetings with the all-powerful do not end there. Here in New York yesterday, God's representative on Earth, President Bush, was in town to address a meeting of the U.N. As our cab bulleted along F.D.R. Drive taking us home I glanced over toward the United Nations Building helipad and saw a large helicopter parked on the asphalt. The livery of British Racing Green was a perfect background for the Presidential Seal that was painted on the side of the aircraft. So, I had now seen Mikhail Gorbachev's hand and George Bush's chopper. If only we could get them together.

When America invaded – and got beaten by – Vietnam, many of their politicians were convinced that they were God's people, snapping at the heels

of Gog. When Reagan cut Medicare and other social services so that he could pour billions into SDI and the MX80, he was doing it because he really did believe it when he said that the Soviet Union was the "Empire of Evil". When George Bush talks of curtailing the rights of American women to have an abortion, or of meddling in the internal struggles of the USSR., or stopping Government funds going to distasteful artists, he is doing so because he is continuing the tradition of American leaders who – unlike many of their European counterparts – have a fundamentalist belief in the words of the Christian Bible.

They are not alone. A survey in 1985 showed that sixty-one million Americans regularly tuned-in to the TV broadcasts of evangelical preachers. Worrying, isn't it? The few women left on the street outside St. Patrick's church hurry home nervously among the lurching down-and-outs. This is a man's world, basically because he has a bigger body and has pitted the planet with his tribal symbols of oppression and war. War fought with other men.

In Los Angeles I witnessed the spectacle of an all female streetgang. One such L.A. gang is called the Hawthorne Girls, tattoo-scarred fatties who cruise the streets in rusting automobiles armed with handguns and rifles and who have, according to the L.A.P.D., contributed in at least a small way to the annual gang mortality rate of four hundred in that city alone. It makes Belfast look rather peaceful by comparison, but then again, L.A. doesn't have an army on the streets. Although the vision of the girl gang was, to me at the time, somewhat laughable and not at all frightening – more like something out of a John Waters movie – I'm sure if a woman blew my head off with a .44 Magnum I would be just as unhappy as if a man did it. The new emergence of female gangs on the West Coast is a bad sign. There's nothing at all wrong in woman doing whatever they like with their lives, but how terrible the world would be if, instead of men becoming less violent, women tried to emulate men by becoming as violent themselves, thus doubling the dollop of excrement sliding around the world's cities. The Hawthorne Girls notwithstanding, it is Man's violence that bubbles under the surface here, on the streets, in the high rise office blocks, galleries, government buildings. This complex problem is what feminists should be fighting. Its roots do not lie in porn shops – which are merely admissions to mens often unrequited sexual feelings. (Live and let live, that's what I say). No, its roots are here, in the pseudo-morality of the Church and State, which interferes, denies, or ignores such needs. The censorious morality that, in truth, informs much feminist thought and expresses itself in a boorish, prudish way, in demos outside sex shops. The argument is not about feminism, but should be about equality and freedom of expression, about recognition of desires and differences and the peaceful release of such pressures. As Jack Parsons said, the gnostic creed should not be suppressed.[16]

Making love, dancing and drinking are homages to life and thanks to God. This is the civilisation denied us by the war economy, the church, the State, and badly informed pressure groups with poorly expressed ideas, who support the institutions and ideals of the oppression of such feelings. They seek not to educate or inform, but to 'mould' people who merely think differently. People who are interested in changing the world, such as radical feminists, should concentrate not on interfering with others choices at 'point of sale', but deal with understanding peoples' motives and where necessary challenging the foundations of this society.

For example, how can we possibly construct a caring society when much of our philosophical thought, our self-image and our role in life is still based (particularly here in the States), on a fundamentalist belief in the rants contained in the Old Testament?

"And God blessed Noah and his sons and said to them 'Be fruitful and multiply, and fill the Earth. The fear of you and the dread of you shall be upon every beast of the Earth, and upon every bird of the air, upon everything that creeps on the ground... I give YOU EVERYTHING.'"

—The Book of Genesis

To do with as you like, it seems. Despite AIDS and the Hawthorne Girls, the world's population will reach six billion by 1997, a billion of whom will go hungry. The Pope smiles, waves and tells his flock not to use contraceptives, because, he reckons, the Creator of the Universe wouldn't like that kind of thing, or likes to see people suffer and die of malnutrition, or something. The American government cuts its funding of U.N. Population Control organisations as these organisations condone voluntary early abortion.

The world's population increases at a rate equivalent to the population of Scotland every three weeks as an acre of irreplaceable rainforest is destroyed every second and one species of animal goes into extinction every five minutes. The breathless statistics cataloguing the death of the real world mount as the religious dogmas, which offer the fairylands of Arcadia, remain sacrosanct and deeply entrenched in the minds and laws of our politicians. Sometimes it seems that the Christian Church is planning Armageddon in order to fulfil its own prophecies. This also throws up paradoxes.

"And immediately the king sent an executioner and commanded his head be brought: and he went and beheaded him in the prison and brought his head in a charger and gave it to the damsel; and the damsel gave it to her mother."

—Mark, 6:27–28

Although America has still to discover Cliff, it has certainly discovered Jesus. According to a nationwide Gallup Poll taken here a few years ago, thirty-four percent of all Americans (about eighty million) claim to be 'born again' Christians. Thirty-eight percent of all Christians (not just the 'born again' people) believe that the Bible is the actual word of God and is to be taken literally, word for word, and forty-five percent believe it at least to be inspired by the word of God. In other words, eighty-three percent of all American Christians believe the Old Testament to be God's blueprint for life. According to this and other surveys, most of the people who believe in the Bible are actually women, which is odd when one thinks about how misogynistic and violent a book it really is. It's chock-a-block full of gang rape, adultery, incest, group sex, phallic worship, husband swapping, abortion, bestiality, castration, illegitimacy, prostitution, murder, torture, animal sacrifice, witchcraft, scatology, anal fetishism, women used as human sacrifices and as the spoils of war, racism and many other unsavoury stories. No wonder it's sold two billion copies.

The message of Christ, the witchdoctor prophet who seemed to shun materialism and promote internalisation and a sense of the Spirit, seems largely to have been either forgotten or conveniently appropriated by those seeking power. The most popular piece of the Bible seems not to be tolerance or forgiveness, but the most often misquoted "eye for an eye" bible thumping claptrap spewed forth by evangelical TV Preachers and carried out here ever since Gary Gilmore donated his eyes to medical science. That so many Americans believe unquestioningly in the Bible is worrying indeed, particularly when so many people leave the interpretations of that book's almost unfathomable texts to a variety of cranks.

THE PLAGUEYARD

It is easy, here on the steps of St. Pat's, to convince yourself that 'Babylon', the city annihilated by God in The Book of Revelation, is New York.

Babylon is, after all, "A Great City... the home for demons and a haunt for every evil spirit... all the nations have drunk the wine of her adulteries... the merchants of the earth grew rich from her excessive luxuries..." She is a city piled high with "plagues and sins" who gives herself "glory and luxury". God will destroy the city "where all who had ships of the sea became rich through her wealth." Babylon is the "Great city by the water", full of "multitudes, nations and languages... The kings of the Earth commit adultery with her" (at the U.N. building, no doubt), "the great city that rules over the kings of the earth", where men "gnawed their tongues in agony and cursed God because of their pains and sores, but they refused to repent" (AIDS), where "every living thing in the sea is dead," and so on. On the other hand, of course, New York may not be Babylon at all, but is, more like, the New Jerusalem, the city that came after Babylon in the Good Book. The city that "came down out of heaven". The city that "shone with the brilliance of a very precious jewel" and "had great, high walls" and "looked like

gold" (the red brick or "brownstone" of New York makes it the most golden of cities in the twilight). The New Jerusalem (or York) is the city that "does not need the light of the sun or the moon... the nations will walk by its light, and the kings of the Earth will bring splendour to it. On no day will its gates ever be shut, for there will be no night there." (It is, after all, the city that never sleeps.) "The glory and honour of all nations will be brought to it..." And so on.

Babylon or New Jerusalem, New York illustrates what a subjectively interpreted little book the Bible is, though few fundamentalists seem to agree, even though much of the Bible and Christianity as we know it was not so much handed down by God as cobbled together in 325 A.D. by assorted clerics at Emperor Constantine's Universal Council at Nicea. The Emperor was interested in formulating a unifying religion of imperial Christianity to weld together the fragments of his empire. That's what he got, and that, to a large extent, is what we got left with. A blueprint of State Power. However, it is too simple to blame Christianity, or even strange interpretations of the Bible, for all the world's ills. As a former Christian, it's quite natural for Andres Serrano to criticise religious institutions by using the motif of Christ in urine, and as Christianity has fought against humanism and evolutionary ideologies for centuries, it is an easy orthodoxy to criticise. It is, however, the fear of accusations of racism, more than a lack of understanding that prevents white people in the West from attacking the OTHER religions.

For example, the individual must also question the Zionist principles involved in the quite unjustifiable military occupation of the West Bank and Gaza Strip – subjugating nearly two million Arabs, but to do so here in New York, a city enamoured with Israel, would undoubtedly lead to accusations of anti-Semitism. One could also question the attitudes of Hindus when it comes to their treatment of the Untouchable castes of India, and the Islamic subjugation of women in countries such as Iran and council estates in Bradford is surely revolting to any free thinking Westernised human being. And it should be remembered that, despite the cranks who threaten to bomb a London theatre for having the gall to stage Berkoff's version of *Salome*, or the feeble-minded idiots who threaten to cut arts funding because Andres Serrano wee-weed on a crucifix, that the civilisations that have been created on the foundation of Christianity are now – crusades aside – quite tolerant of different religious ideas and unorthodox practices. Look at LaVey's legality in America and weigh this against the worldwide lawlessness prompted by *The Satanic Verses*.

VIRTUAL REALITY
Flashback. We are back under the L.A. stars once again, driving back from the opera, looking out of the taxi window at the billboard advertising a cinema still screening *The Rocky Horror Show*. The

tarmac of the Freeway rushes towards me in the headlights. Perceptions of the curdling inner cosmos flicker. When a person finds his or her place in that cosmos it is because they have invented a perception to deal with the enormity and complexity of the world. A belief system edits the horror of it all down to manageable proportions, it gives a sense of purpose, a destiny and even that which has always been unobtainable on the physical plane, even for Robert Anton Wilson: A life after death.

In the Virtual Reality of Timothy Leary's computers, or Jesus Christ's weird words, or Marx's writings, we can live forever, because, even after we're gone, the ideas will remain. The unreal world is, like the wax museum, better than the real thing, because it gives us a sense of order and eternity. Although most of mankind's invented beliefs are well intentioned, and different beliefs do lead to different practices, some of which are preferable to others, almost any belief system – any system of perceiving and interpreting reality – will do. The Jesus Christ one, the Marxist one, the Satanist one, the Dead Dog one. Nature is unshockable, God is unconcerned. You live by the rose and die by the thorn. Better to revel in its beauty than call it a disgusting weed. Tolerance in life brings tolerance in life. Dogmatic bickering in life brings violence, censorship, ignorance and intolerance in life. We are born and we die. Virtue and sin reap their rewards in death.

"We will pass for an instant into Nature's crucible thence to spring up again in other shapes, and that, without there being any more prerogatives for him who madly smoked up Virtue's effigy than for the other who wallowed in all the most disgraceful excesses... all of them meet with (the same) after their existence, both the same end and the same fate."

—The Marquis de Sade

"So God created Man in his own image, in the image of God he created him."

—Genesis, 1:27

Due to the effects of increased access to data and communication afforded by the Media World, the Global Village of today no longer feels the comforting caress of Authority in quite the same way as former populations did. Although the world's most censorious governments, like those in China and the U.K., have done everything to limit the amount of information reaching the general population, more information filters in to one's mind that does not fit into the paradigms constructed by earlier generations. Hairline cracks appear and these quite metaphysical concerns show up in the material world in a variety of sneaking ways. Coins thrown at the feet of a waxwork dummy are most apparently coins thrown at the man-made physical representation of a man-made idea. The universe becomes more transparent. Death threats made to a man who is seen publicly to desecrate such an image,

The Marquis de Sade

on the other hand, have the reverse effect of giving that image life in the media and in the mind. Senator Jesse Helms was clinging on to his reason for existence in this, his universe. His censorship was, in fact, his way of editing the universe back down to more manageable proportions again. Christ, good, Satan, urine, homosexuality, bad.

Andres Serrano's choice of imagery was an exhibition of his mind going through the same function. His editorial processes where equally linear, confrontational and supportive of the traditional structures of American Art, Religion and Society. The jar becomes cloudy once more.

Helms and Serrano are two sides of the same coin. In social terms, the function of the supposedly avant-garde and the Establishment is the same. That is, their function is one of control. The shaping of the universe down into manageable blocks. Artists share with politicians and priests this social role. Again, we have more pointless ideas and concepts to 'get behind' and throw money at and wage wars for. Unfortunately, though, the only Hell that exists is here on Earth. If you don't agree, then perhaps you should go to Los Angeles and talk to bar-bound Viet vets about Mei Lai, or go to San Francisco and talk to the crack-head transsexual we met at the Leary party, or write to the parents of the victims of John Wayne Gacy.

An Islamic fundamentalist and a Christian Democrat cannot argue about social cause and effect, because their perception of reality is different to start off with. Regardless of their artistic worth, liberals must defend Salman Rushdie and Andres

Serrano against religious zealots while at the same time paying lip service to the notion of a multi-racial, multi-cultural society. But how can one create a harmonious, democratic, multi-racial, multi-cultural society if peoples' beliefs all differ? The only way to do so is to disenfranchise Religion. For the first time since King Hanmurali in Babylon, divorce Religion from the State. (The Soviet Union did not do this, it simply substituted religious dogma with a secularised religion of political dogma, with the Dictator seated in Moscow rather than Rome.) An amoral, asexual, secular society in which international laws are created by the Will of the Human Race on purely democratic lines is the only workable utopia worth thinking about. 'Civilisation' means an advanced state in social development, a state of intellectual and cultural refinement. In such a civilisation – a civilisation based on synthesis – Gods would be tolerated, but would not be able to rule the world. In political terms, ethnic groups would be rendered meaningless, as the world would be forced to realise that if the planet is to survive, its only law would be one of tolerance. If society decides that it is intolerant to murder or rape or profiteer from the worlds shared resources, so be it. If humanity decides it tolerable to sell children Heroin, or encourage the hunting of dolphins, so be it. The morals dictated by assorted prophets who claim links with Gods have nothing whatsoever to do with the creation of a system of running the jumbled new world of the multi-cultural Global Village, if that world is to survive without the domination of a superpower dictatorship. Now, almost everybody has a nuclear weapon, a well endowed supergun, a God, a hostage, and a chemical weapons plant. Everybody has a TV.

Despite the strange morality and obvious hypocrisy of the Born Again masses, Americans are at least free to speak out for or against such madness, even if what they have to say is often rubbish. Be they the sexist extremists epitomised by New York's Al Goldstein and Valerie Solanas, or Kenneth Anger and Andres Serrano at the liberal centre. (Even Communists are now tolerated, the McCarthy witch trials being seen as an embarrassment.) All have a legally recognised voice of dissent. In Britain, the supposed cradle of democracy and free speech, we had our Revolutions too early. We are subjects, not citizens, and all those mentioned here could be prosecuted – like Hubert Selby's publishers were – under a myriad of some old and many worryingly new laws extant in Britain that are designed to restrict freedom of speech. Laws upheld, it should be mentioned, by the matriarchal duopoly of Thatcher and Elizabeth. If Serrano was British, *Piss Christ* could have put him in the dock charged with blasphemy. Goldstein would certainly have been arrested on publication of the first *Screw* magazine, for obscenity, and so it goes on. Sitting on the steps of St. Pat's, I'm not sure what I prefer. Genuine oppression buried beneath the smug patronising lies and self-confidence of British despots – which often

Piss Christ by Andres Serrano

leads to the birth of individualists and philosophies of some artistic and social significance. Or, the more legally apparent all-round freedom of America that is often abused and throws-up bores and trite acts of defiance from thoughtless people who want to do nothing other than prove that they are free to exercise the right to be boring, masturbate in public, and make money. Both societies – perfect 'democracies' [sic] are deft, self-perpetuating systems of control, which allow just enough freedom to remain the 'correct' systems. Systems that cannot tolerate the raising of questions that they cannot answer. A reality that cannot ask itself questions that would make people perceive 'reality' as being subjective, counterfeit, and enforced. A social reality that is ostensibly obsessed with Truth is unable to accommodate other Truths. That is what 'control' is. Human time absorbed in self-perpetuating thought-patterns. Human time. Time to die.

Much of the high art we see, which merely advertises itself and questions nothing of importance, is in this sense the intellectual pornography that oils the cogs of this dreary, silent-running machine. A machine that churns out an endless succession of images of freedom, the props for the shadow theatre that creates the false perception of reality.

Here in America, social scientist Paul Watzlonick conducted a series of experiments during which totally sane people were lied to in a systematic and calculating manner. The results were that the subjects started to behave with all the irrationality of schizophrenics and paranoid patients. In the US and Britain we have institutionalised lying, politicians lying, statistics lying, advertisers lying, journalists lying, and artists and priests oiling the machine with superstitious, subjective interpretations of the world based on such lies. Nobody knows what to believe anymore, so what the hell, anything will do. Art is being wasted. It could be used to make people treasure themselves, their emotions and feelings. It should be used to formulate the asking of questions. An open-minded examination of Life that would re-educate and allow and encourage understanding of others, and a communication of that understanding. Hard art should be about short-circuiting the cultural control system, in which Religion and Capital have vested interests. Not about adhering to the gods of fashion, of money, of artistic technique, of exclusivity, not about witless shock value, but about wise investigation of nothing less than life itself.

The current Contemporary Art world is vying with organised Religion to become the ultimate virtual reality model. The ultimate belief system in a world that is losing its will, and its ability to live.

Manhattan or Hollywood could be a metaphor for the whole machine. The image presented as freedom could be of one icon floating in bodily fluids, one biker urinating on an altar, a film of two men having sex. The silent sound is one of words being wasted. But incredible though it may seem, every person in the world speaks a coherent sentence that has never, ever, been spoken before.

Let's just hope that someone is listening.

—*Simon Dwyer, 1990.*

NOTES

1 See 'Words From A Room', an interview with Hubert Selby, in *Rapid Eye 1* (Creation Books, 1995).
2 See 'Blue Velvet' (symbolism in the films of Kenneth Anger), in *Rapid Eye 3* (Creation Books, 1995).
3 See *The Fulcanelli Phenomenon* by Kenneth Rayner Johnson.
4 See 'Smile', an introduction to Neoism, in *Rapid Eye 1* (Creation Books, 1995).
5 See 'From Atavism To Zyklon B', a history of Genesis P-Orridge by Simon Dwyer, in *Rapid Eye 1*.
6 See 'From Wasteland To Utopia' (the visions of Gilbert & George) by Simon Dwyer, in *Rapid Eye 3*.
7 See 'The Future Has Already Happened', an introduction to William Gibson, in *Rapid Eye 3*.
8 See 'The Undying Monster', an account of UFO activity, in *Rapid Eye 1*.
9 See 'Rot In The Clockwork Orange' in *Rapid Eye 3*.
10 Mick Norman's *Angels From Hell* is published by Creation Books (1994).
11 See 'Through A Screen, Darkly', the Derek Jarman interview by Simon Dwyer, in *Rapid Eye 1*.
12 See 'The Black Box' by Kathleen McAuliffe, in *Rapid Eye 1*.
13 See 'The Videodrome' (Situationism & Death TV) by Mark Downham, in *Rapid Eye 1*.
14 See 'Smile' in *Rapid Eye 1* and 'Clockwork Skinhead' (the Systematic Extremism of Stewart Home) in *Rapid Eye 3*.
15 See 'The Ugly Aesthetic' (porn shows the way forward) in *Rapid Eye 3*.
16 See 'Whence Came The Stranger' (Roberet Heinlein and the Thelemic current) in *Rapid Eye 3*.

A DARK EYE CLOSES

Simon Dwyer

In his coda to The Plague Yard, *Simon Dwyer traces more connections between the Word and God, Heaven and Hell, light and darkness, cyberspace copies, virtuality and life, art, magic, science, religion and the name of God. An E trip through the universe in the minds of men.*

"The difference between an angel and a person is that most of the person is on the outside"

—Anon

Since writing *The Plague Yard* in 1989, much has happened to me, and to the world. Spanner outlawed S/M sex between consenting adults. Police raids on The Temple of Psychic Youth. Thought crime. Dreamcrime (the OJ Simpson trial judge ruled that Simpson's dreams related to a cellmate could be used as evidence), technological warfare (Desert Storm), biological weapons used against our own troops, Glasnost, Clinton, Major, the admission that AZT is toxic enough to kill patients, further destruction of the Rainforests and Ozone layer, animal rights riots and ALF bombs in England, the on-going exercise in piecing together the entire genetic code of humanity, the possible creation of new human life without an egg or sperm, light being used to store information at ten times the speed and volume of mega computers. Nano-technology (tiny killer robots injected into the bloodstream to attack viruses such as AIDS), the machine transfusions of Stelarc. The *Violence of the Imagination* Festival, and my slight recant on some contemporary performance art (Andre Stitt etc.)[1]. The universe has expanded by a few billion light

years, scientists have listened to the echo of the Big Bang, Time has dribbled though my fingers as I am now told I have full-blown AIDS...

PLAYBACK
A hot L.A. day, so tired, but Genesis P-Orridge takes me to meet Timothy Leary (I'd only met him briefly at a party before) at Leary's bungalow house in Beverly Hills. The house overlooking Leary's was the scene of the Tate/LaBianca murders. Leary was talking about virtual reality, now he's talking about The Well, and anti-Drug Control, including tobacco (he was arrested at an airport for smoking a cigarette). He was talking about brain-imaging computers, saying we'd be able to look inside peoples' minds through their brain wave activity. (Rather like an audio or visually recorded version of lie detector tests – but not.) Now, computers are superseding even his ideas, and can respond not only to tiny eye movements, but to thoughts). Since Leary's prediction to me, the British performance artist Bruce Gilcrest has turned his dreams into reality. At his current performance, Gilcrest puts

Timothy Leary and Simon Dwyer; Beverly Hills, May 1994

himself to sleep through self-hypnosis, is wired up through electrodes to a computer which turns brainwave activity into sound, hits REM sleep and lets you communicate to him in his dreams through the use of tiny electric shocks. The fulfilment of the *Rapid Eye* dream.

THE PROCESSION
Since the original publication of *Plague Yard*, Genesis P-Orridge has not only been effectively made into a social outcast and scapegoat in Britain[2], but he has started a new 'church', (for want of a better word), destroying TOPY and re-birthing it in an altered form. He has now formed TOP-I (similar pronunciation to TOPY, the Temple of Psychic Youth) which stands for The Outer Process Internetional. (The letter 'E', which also indicates Extasy, turns 'International' to 'INTERNET-ional'. Gen has reformed the Process Church[3] and runs it not on ritual based sigils, meetings, rallies, video, audio and performance – as with TOPY – but on the Internet as a series of texts (that will lead to oblivion?). Accessible through E-Mail codes by ordained 'Brothers' of The Process (anyone can become a Brother, there is no membership required other than the will to communicate, if you communicate, you are a Brother or Sister – TOP-I is for everybody). Genesis has, of course, appointed himself 'Father', almost fulfilling my prophecy that he would one day become Pope. Pope E-23. Red Pope. Anti-Pope for the Year Zero.

Prophets like Nostradamus predicted that the next Pope will be the last, which brings us once again to the Dark Side of History – The OTO, Masons, Templars, Priory of Zion, Illuminatus, IOT, etc. etc. the guardians of secrets – perhaps THE secret.

CYBER COPIES, VIRTUAL SPACE & EXTRAPOLATIONS
In answer to Walter Lippmann, quoted in *The Plague Yard*, I would say that the photograph destroyed art in a sense (Baudrillard apparently said this, as did Burroughs[4]). Art had what Jonathan Miller now calls an 'afterlife'. Photocopiers, printing, art prints, postcards, even theatrical reproductions of *Salome* or *The Merchant Of Venice* remain to literally haunt us.

I would, however, say that it was the Computer that really killed art in a sense as it is the only media that can be used to wipe out a creative text or picture forever. Cyber death. Burning books or destroying paintings does not work as there are so many copies and prints of both. Even squirting blood over the original *Last Supper* would not work. Burning an original unpublished manuscript and forgetting the text *would* work, because memory and cyberspace may be the same, though memory relies on electro-chemical transactions in the brain and lost memories may well still exist but not be attainable.

VIRTUAL REALITY
On further reflection, I have come up with numerous definitions, hints towards the reason Virtual Reality

exists and what, conceptually, we can learn from it. There are many connections to be raised and questions to be asked.

1. The creating of images which we may call 'Hyperreal' (Wax Museum, **Last Supper** *etc.), reproduced prints, photocopies etc.*

2. The creation of what I call a Virtual Reality model which gives us a belief structure that is religious, social and physical. Which edits down reality into manageable proportions.

3. The consignment of text and its adopted language to cyberspace, the imagined virtually real space where words hang in virtual limbo. The space and time one hears on a modem or telephone line, which brings us into the areas of fibre optics and even superconductors.

4. The art of memory. Where does lost memory go, where is it stored in the virtual mind? This also leads to Frances Yeates and Derek Jarman, with their art and writings, and to William Burroughs and Brion Gysin's Third Mind techniques and Dr. Penfield's **Memory Mechanisms**. *Also to 'brainwashing' techniques and religious death cults such as Jim Jones and the Peoples' Temple, also Charles Manson and David Koresh. Also, perhaps, the JFK murders and use of a CIA brainwashed patsy?[5]*

5. Psychics and telepaths, Jung's theories of the 'Collective Unconscious'. And, what space do ghosts and UFO's inhabit? Is the universe (and, is God,) a pool of stored information through which we can surf and communicate as shown by Dr. Rupert Sheldrake's theory of Morphic Resonance?

6. Astronomy. Light. Light speed. Time travel, E=MC². Where is the time it takes Time to travel?

7. Ritual magic, Austin Osman Spare's atavistic resurgence, automatic drawing, astral projection, sigils, spells, LaVey and Crowley. When we die will we go to cyberspace? Is this space Virtual Heaven or Virtual Hell?

8. The effects of Colour on the brain, on behaviour. The rainbow. Black negative holes, sucking reality (our universe) into a virtual hole, another universe, the kingdom of God or Satan or life after death?

9. Inspiration, art, ideas. Where do they come from? Is the mind, the soul, inhabiting virtual space, as do the lost memories I mentioned?

10. Death. When we die does matter turn into energy, do we, on a different vibration of energy, survive? Are ouija boards and the Tarot connections to this pool of cyberspace? Are Near Death Experiences and apparitions of Jesus communications from, and transitional introductions – hints – to this other universe?

Although these are some of my definitions, they are also admissions of failure to understand Space, Time, and our position within it. As the ubiquitous 'Q' from 'The Continuum' said in the final episode of *Star Trek: The Next Generation*, "You humans are so pathetic. You have no idea of Space and Time. The judgement goes on." With this, he leans over to whisper the secret in Capt. Jean Luc Picard's ear, then, at the last moment, pulls back, giving him a look that says "you're not ready to know the answer", just yet. He (Q) has got it cracked, he can be omnipotent and omnipresent. Is he God, or the invention of God for an SF Television series?

We all explain the inexplicable using explicable models of reality. The Human Condition is based on reproduction and the need to progress and explain.

THE SUPERMAN: HEAVEN AND HELL

How many names has God? We know of Jesus (Love), The Holy Spirit (Spiritual guidance) and God 'the father' (the Creator), and also of Satan (Human Progress), Rex Mundi (the king of the physical world), Mithras (The Sun God, or God of Light), Lucifer (the angel of knowledge and death), Beelzebub (the Lord of the Flies – evil), Sophia (the daughter of God), The Blessed Virgin Mary or BVH (mother of Jesus), Mother Nature, Ra, Zeus, the Buddha, Jehovah, Mohammed, Mother Earth, and many more names, prophets, facets and deities. But what is his Name? And if he does have one, can we pronounce or understand it? The Catholics had a go with the Holy Trinity and the worship of BVH through the babble and apparitions at Fatima, Lourdes and even Knock in Ireland. God has an infinite number of names, each "unique and indivisible". Are we the agents of God, to "go forth and multiply" and "spread the word" through the galaxy and this universe. So what? We can, in theory, already build a bigger particle accelerator ring and shoot sub-atomic particles, Zs, Quarks (name stolen from James Joyce), Wavicles, protons and neutrons around the ring at close to light speed. The technical and engineering problems this structure (the ring) poses are not insurmountable, as it could be built in space by astronauts, spacecraft and robots. We can already create objects which have no form but light, but mass made from energy (we can do this in reverse by creating energy from mass in nuclear weapons). Building a large ring in space would also remove the gravitational pull of the Earth and the Moon, which affect the results. We could, then, create another Big Bang which would have both the effect of creating a new Universe while destroying our own universe, thus giving an explanation for the Hindu's dance of Shiva.

The God Shiva has a halo of fire representing the rhythm (or vibration) of the Universe and emanates from a lotus petal – the symbol for 'Enlightenment'. Shiva dances on the body of 'human ignorance'. In

Shiva

Hieronymous Bosch, 'Fall Of The Damned'

statues, the front hand (of four arms) is held in the *abhaya mundra* pose, which means 'do not be afraid'. So, ah, we already knew this, the universe is experienced in linear form on the physical plane, but, as with Space and Time, is in fact circular. Like the HIV virus, which dies when it kills its host, we bear the seeds of both our Creation and Destruction.

Jesus Christ, Prophet Number One, will return as cloned anti-Christ, and destroy the world and give re-birth to us all as we – as spiritual zombies – rise again. Christ is born, Christ is risen, Christ will come again. This is the great heresy of the Bible. The perverse in-joke of Christianity. Anyway, it really doesn't matter if the world is destroyed by the apocalypse of nuclear or chemical war at all. We're talking in terms of the UNIVERSE here, not the tiny third stone from the sun and the ants that inhabit it.

Maybe.

FROM GENESIS TO REVELATION

I have not yet used a flotation tank, but I'm told I should, as it is both relaxing and a returning to the womb. They put belladonna in my eyes once, making me see the bright light world which we inhabit. They stuck matchsticks under my eyelids to look into my retinas, in case I was going to go blind, as happened so cruelly to Derek Jarman. The light came at me from a montage of AIDS posters on a wall. White light/white heat.

I saw Jesus Christ floating over my bed once, he gave me a massage and a message of incredible love and tenderness and cured me of a hacking AIDS-induced cough in a second. (it returned after a few hours). Being vulnerable, I probably WOULD see Christ, but, as Jim Jones told his screaming followers as they drank the potion, I now know that Jesus IS Love and there is nothing to fear from crossing over.

Quantum physics has proved sub-atomic forms can jump and land without jumping, can exist everywhere at the same time then not exist. Exist, inhabit all Space and Time, Not Exist, Exist, inhabit all Space and Time, Not Exist... etc. *ad infinitum*. Mind you, I've also had violent psychotic episodes

Salvador Dalí, 'Christ Of St John Of The Cross' (1951)

due to drugs I've been treated with, and once when I took Exstasy (or LSD) I danced on the crust of the Sun with a giant lobster. My friends take E and meet a goddess who demands their blood in a chalice, they ritually cut themselves and add their blood to the sigil they have drawn and are let into a Thai temple, and I have other friends who have visited other planets through Brion Gysin's Dreamachine[6].

But I digress. Is the Revelation given to St. John the Divine, and are the pictures of Hieronymus Bosch, showing us Hell, or offering Hell on Earth? (Where IS Hell again?). We've already had feeble attempts at apocalypse, (fire bombing Dresden, nuking two Japanese cities, gassing six million jews and three million gypsies and homosexuals, dropping nerve gas, mustard gas and deploying chemical weapons and viruses such as HIV). We really ARE pathetic.

I used to actually think that there was no good and no evil and that You, my dear reader did not really exist. I thought it possible that the Creator (whatever that was) had set up a programme to find out if IT was WORTH creating. What the Creator did was drop me into this virtual (real?) universe and you, as pre-programmed entities of some sort, played to me. My reactions would be judged on what choices I make or chose not to make. This may be correct. How do you know that plants exist? Because you have eaten them, and the energy/light stored in the plant now gives you energy to survive. But you also need protein, vitamins etc., which you can now synthesise...

And, while we're at it, how do you know that you exist? Are you reading this, or is this reading you? What is you etc. etc. I don't understand what man and woman are. We will soon have the asexual society. Already, people are using hormones to turn from women into men who can conceive. They cannot yet produce sperm, but that will only be a matter of time – certainly within a century. Already "women" on high doses of testosterone are reporting incidents such as "when I go into a bar now I look at the women and want to fuck them", and "I want to get into fights". For some reason, since I was diagnosed HIV+ (which is not glamorous, just boring), I have had no desire to beat the shit out of anyone, or even to shag everything that walked or crawled. Perhaps HIV is educating us through destruction. Perhaps "AIDS" (whatever that is) is destroying our memory.

Besides this, I want to know a few things... When an idea reaches critical mass, does it become reality?

Is physicality the same as existence, or can we be transferred to another machine?

Is being told to die, or told you are dying, the same as dying? Is the universe in our minds? Does reality flicker out when we die? Can I, like Jesus, live forever through art and imagination, through the Hollywood Wax Museum... Are these words my only form of communication and immortality?

Surely if I know I'm going mad (not quite believing I'm Napoleon, but at one point, like my old

correspondent David Koresh, thinking I was Jesus), this means I am *not* going mad. Is this normal? I really don't know. Something, as the astronaut said after death in *2001: A Space Odyssey*, "...something is happening, and it's wonderful..."

What is happening to me IS that I now see society as a Spectacle and as a Dadaesque series of juxtaposed but connected events, and I am getting an enormous amount of psychic connections (people telephoning and I know who it is – oh, I was just thinking about you) and also synchronicity. (I cannot turn on a TV without there being something on about dying, burial, euthanasia, ghosts, the church or Virtual Reality. Is the media being controlled by topicality, or is the media controlling me? Is this Control? Oh no, oh no, oh no, go away. "that's Timothy Leary's garden on TV – I've been there." Oh God, it's Timothy Leary. Turn it over, ah, a woman saying you can now be buried legally under a tree in a bio-degradable cardboard box, so you will eventually become that tree, then someone on Channel 17 (ITV 1) saying they want to make a Living Will and others asking for euthanasia...

Generation X, Y, Z, *Star Trek: Generations*... The Holodeck, oh God, them again. As I said, (did I say? – when, in time, or on the page?) my words literally are out of date by the time I put them down, both in terms of hard technology, ideas and our (your) experiences. A second is a long time in reality. Time and Life zap along at speeds outside of speed, in time that shoots by. Only your mind can control the perception of time – we all know that – sit in a painful operation in the dentist's chair or do something highly enjoyable and tell me about Time.

It is my theory that one day Virtual Reality will be outlawed as the new drug. Turn On (the computer), Tune In (to the virtual world), Drop Out (of reality). Or not, as the case may be.

Virtual Reality as it stands now is hopelessly inadequate. In the "real", physical world, it gives you a headache, it makes you drop things, it makes you feel what it's like to be a handicapped person. By 2030 you will probably be able to buy a ticket to a Virtual Theme Park run by Disney. This will save the physical planet (no hotels, no trees chopped down, no car parks), but no-one will ever need to leave their homes. They are even now taking of retinal injections to avoid the need for data suits and TV type headgear. Virtual Sex will be a lot better for most people than the real thing. Already porn in the USA is a bigger dream-machine than Hollywood; in the days of AIDS, as I said in *The Plague Yard* earlier, porn is safe sex, as is virtual sex. We will all sit at home and regress into morons with no "real life" experiences. Our bodies may be run by tiny robots and serviced by automatons using micro-surgery techniques. (Already in England, routine surgery is carried out microscopically. Heart operations etc. are carried out through a needle-sized hole in the leg through which fibre-optic cameras and minuscule scalpels and other tools are used on the organ, which means no infection of the patient, no more

Derek Jarman canonized by the Sisters of Perpetual Indulgence

cutting holes to get inside, except in transplants.)

This, via my circuitous path, brings me back to Life and Death. Are we able, let alone capable, of dying? This, in turn, brings us back to Zero Regret/Year Zero. Yes, this is all very well, but we know that *Revelation*, like Adam and Eve, is allegorical, though something IS happening and will happen. But by the time we destroy the planet, we'll be living on other planets anyway.

God, all very well, but, on top of all this is *Star Trek* creator Gene Roddenberry yet again (Now HE is floating in space, having been buried 'at sea' – in space by the Shuttle in a secret NASA Operation that can now be confirmed). But Roddenbury's utopia (no war on Earth, no hunger, cures for all diseases, inter-planetary alliances, discovery, illumination) seems ever more distant and, it would seem, more unattainable. Apocalypse Then. Apocalypse Now. Apocalypse from Now On. The World is falling apart. Berlin Wall. Riots. Famine. Wars. Drug Abuse. Suicide. Mass Unemployment. Nuclear proliferation. Eco System/Earth Death. Institutions lying, politicians lying, statistics lying, religions lying, doctors lying, drug corporations lying. Madness. Bad side effects. Widespread psychosis. Violence. Homelessness. Lack of Hope. Disease. Jihads. Tribal Wars. Fear of Death. Crime. Death. Time...

Time is Control. Time, time to die. In time, inside time, inside the time tribe of Humanity. Time flexing "like a whore" demanding a conveyor belt of cadavers, *The Place Of Dead Roads*, *Cities Of The Red Night*. The Tibetan Book of the Dead. The place "where all roads meet, the place where all is secret", The lonely Well. The broken spell. The broken mirror. Control is, was, and always will be.

Satan/Jesus. Progress and Death. Living forever, cheat death through cryonics or virtual worlds? Angels of Doom. The Greys (UFOs, space and time travellers, abductions, experiments) Life and Death. Regression Therapy. The Moment. Whale song, dolphins, John Lilley and Rupert Sheldrake's Fields of Morphic Resonance, Jung's Collective Unconscious, Communication on the Collective Virtual wavelength. Or growth into Nietzschean Supermen? Death. Death. Death? Rebirth. Circles in Time and Space. His World Without End. (I'm coming again!). *The Psychic Bible*, *The Book Of The Law*. The dark Guardian angel Aiwass on a black Cairo night of Dust. Dust in your closing eyes. "Remember Man, that thou art dust, and unto dust thou shalt return" (Catholic ash ritual). We are made of dust. We will re-form into different shapes from swirling dust. Back again to YEAR ZERO/ZERO REGRET. Crass or the Khmer Rouge? Hell on Earth? Or, are Bill Gates and British Telecom, Bell, IBM and NYNEX going to buy reality? Buying into the Internet is buying into Virtual Heaven. Zillions of bits of Information. Billions of dollars. The Universe broken into bits?

Christ floating in Piss, art's occasional genius (Dalí's *Christ Of St. John Of The Cross* cannot be inverted and floats, rightfully, in Space). No closure. Construction/Destruction/Reconstruction. Wax, melting, solid. Some art sacrificed to the God of Mammon, the sacrificial Lamb of God, the media scapegoats of Hindley and Manson. Bullet-proof faces, masks, words behind thought? (Let me get off now – I'm feeling sick.)

Words falling through space, blowing off the page. Stars falling like leaves. Blood dripping from a dead tree? St. Sebastian's arrows or Christ, the S/M porn star on a cross[7]. A Psychic Cross? A piece of flotsam washed up on Time? Dead wood. Derek Jarman canonized as Saint Derek before his death by an all male order of Nuns, the Sisters of Perpetual Indulgence[8]. Brian Jones, Gen's Godstar, dying for your sins. Hollywood Stars, Warhol's Superstars, the media's Megastars. Or, switch back to Burroughs' theories of cut-ups, the Future seeping through the cracks. It will, in fifty years, be possible to construct a televisual machine working on cut-ups, history, montage and audio visual techniques drawn from Grey Walters' 'Living Mind' to the Flicker technique expounded by mathematician Ian Sommerville and the Dreamachine to give you a fairly accurate copy of *Newsnight* or *CNN* or *The News At Ten* from a week ahead in time. Next week's news now. Where is Time then? Anyone? Any takers? Have I 'done your head in' yet? I know I'm going mad, "teetering on the edge of my own insanity" (though being 'sane' only means that you have the same form of insanity as everyone else). Is there no Either/Or? Is it Fate? Is there no Because? The Ten Commandments. The billion options. Here is reality, buy your own layer. Dig your own hole.

In the beginning was The Word, and the word was GOD. Eden? Outcast/Kali/Shiva? The Landlord's coming back. Spread the word. Rub out the Word and God still exists, the word comes back. The Control God still exists. Yes. Evolution/Existence. Light of the World. Break the light down with a prism (a pyramid?). E-mail, E-Time, E-Metre, E-23, Extra Terrestrial, Extra Time. Time.

THE FIRST TERMINAL TRANSMISSION

From my sweat bed, possibly soon death bed, I do genuinely now see the world in Dadaesque terms. A world in which everything is connected. The function of the virus is, I now know, to confuse the brain and work like a drug, opening the doors of perception. I see the world as a montage or huge cut-up. When I dream I dream of death. A television picture slashed in half diagonally across the screen, one side colour and movement, the other a black, bottomless, motionless pit. Forever. The real effect of fear is impossible to express. HIV prepares the brain for death. It is useful, but it is not pleasant. Today, I stopped taking all drugs. The medical profession have created a genuine Death Factory as real as Belsen.

The side effects are literally to waste away, flesh actually vanishes, hair falls out, bones and teeth crumble into arthritic dust. My eyes can sometimes hardly see, my head aches with thought and drugs and the virus attacking my brain, my genetic code

even. My pain synapses jolt as if an electric shock has been passed through my body, my whole torso itches like crazy, skin flakes off dark dry skin, I am now practically wheelchair bound. But today I have thrown away my crutches, put my drugs down the toilet. It is AZT that kills you, everyday I took it I was sick. It is septrin that gives you your rash, and the fifteen antibiotic tables I take each day (which admittedly once saved my life) that give me thrush. I reject the drug culture, the cycle of dependence, the scratch/itch cycle. I look and I now watch the world through broken glass, it passes me by. But today I have re-joined, in some way, the universe of life. I may one day even have sex again. Let the life force back into my body. Breath deep, suck in the air.

Will I live? Of course I won't, I'll die, just like you, you stupid fool. I will see you all in the Hell that every man and woman with any sense in their head deserves.

Or will we all turn into plasma, light, energy or thought? May the Good Lord shine a light on me? Time spreads. Time loops. Another girl, another planet.

The lasting image of this closing Century will be a British Member of Parliament, tied to a circular kitchen table. He will wear stilettoes, stockings and suspenders, and on his hairy chest will be a black peep-hole bra. He will have strangled himself with a towel, achieving orgasm at the moment of death, jism lying on the floor – a mandrake. Reaping his rewards for his self-disgust and the wages of the sin he perceives. In his mouth will be stuffed an orange – the fruit of Human indulgence, the extasy of Lust. The knowledge from The Tree of Life. A Shiva for the end of our incredible, sad, century.

Time and life are circular.

"You are the owner and operator of your OWN brain. Learn how to use it."
—Timothy Leary.

Beware the future. Beware Virtual Reality. Does it offer Disney's day-out or Hieronymus Bosch's Hell at home? The garden of earthly delights or a giant Mickey Mouse forever stamping its boot across the face of American Reality?

Dawn rises behind the battlements of the castle of Sant'Angelo in Rome, where shots ring out into the silent morning. The executed rebel Cavaradossi lies dead. His lover, the beautiful Tosca, cries out in pain and accusation before she throws herself from the parapet. Perhaps to dream.

Do not believe me. Do not listen to what you are told. Cherish your questions, not your answers. Examine and re-examine.

ET IN ARCADIA EGO.

NOTES

1 See *Rapid Eye 3*.
2 See *Rapid Eye 1*.
3 See *Rapid Eye 3*.
4 See 'The Fall Of Art', in *Rapid Eye 1*.
5 Jones, Manson, JFK: see *Rapid Eye 1*.
6 See *Rapid Eye 1*.
7 See 'The Greatest Porn Star Ever Sold', in *Rapid Eye 3*.
8 See *Rapid Eye 3*.

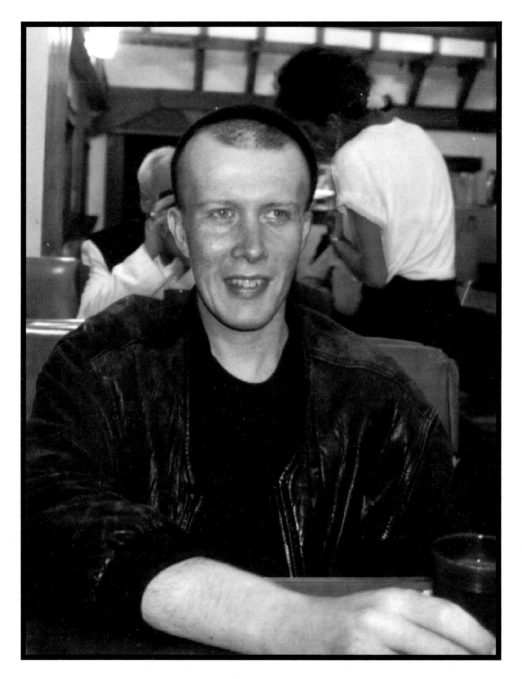

"Simon was a magic man. One of the most
wonderful and woundous people we ever met.
We loved him dearly and admired his beautiful
and brilliant 'Rapid Eyes'. His sexual, anarchic
and life-full approach to our world was unique!"
—*Gilbert & George*

SIMON DWYER 1959–1997
An Epitaph

Paul Cecil

Simon Dwyer was an extraordinary young man who established himself as one of the leading commentators on, and contributors to, the artistic and creative subculture of the last two decades. A writer first and foremost, he focused his work through the magazine he first conceived in 1979 and named *Rapid Eye*.

The youngest of three sons, Dwyer was born in Salisbury, Rhodesia, in 1959, but moved to England a year later, when his family returned, moving around the country before settling in Plymouth, where Dwyer attended, somewhat reluctantly, the local schools. He left Tavistock Comprehensive shortly after his 16th birthday.

This was the time of punk, which turned many heads away from convention and towards the exploration of the alternative and improbable. It was precisely into this area of burgeoning cultural expansion that Dwyer focused his energies. His understanding of the possibilities awakened by rejecting hierarchical and formal society was already gestating, as was his willingness to embrace the art and performance of transgression.

In 1978 he moved to London and began, in the tradition of punk writers, developing his own fanzine, *Rapid Eye*. The first issue, which hit the streets in 1979, included a feature article on the anarchist band Crass which was quickly picked up by the music paper *Sounds*.

Dwyer established himself rapidly as a regular contributor to *Sounds*, interviewing the famous, the soon-to-be famous and – as is inevitable in an industry that so voraciously promotes and demotes – the once famous and the never-will-be famous. This eclectic mix served mainly to reinforce in Dwyer the belief that status is the least of all relevant concerns and that it is the human level, and creative integrity, that above all marks out the true artist.

By 1982 Dwyer had moved to Brighton, and it was in that year that he married Fiona Pritchard. It was soon after this that sadness struck their lives, with the death at birth of their only child, Peter.

The world of commercial journalism became even less attractive to Dwyer and he moved from it to that of interior design, joining Rhodec International. Alongside this work, he continued writing, developing *Rapid Eye* into an increasingly lavish exemplar of the fanzine art. Indeed, the famous "Black" edition which he produced in 1986 has since become a sought-after collector's item.

However, *Rapid Eye* as a concept, despite its plaudits, had for him never reached its potential. Calling in favours from friends and contacts he had made through his earlier work, he set out to produce the 'zine to end all 'zines: a coffee-table edition, massive in scope, scale and vision.

And how those favours rolled in: Andy Warhol provided the frontispiece; William Burroughs sent three pieces of writing, "And His Name Was Rover", "The Johnson Family", and "The Fall Of Art"; Kathy Acker, Genesis P-Orridge and Colin Wilson also contributed to the volume, as did Derek Jarman. Alongside this galaxy of stars, Dwyer included, with no less care or column inches, a raft of unknown writes with specialisms ranging from conspiracy theories to foot-binding. Over a year in the making, *Rapid Eye 1* (1989) proved to be inspirational, in the words of the *New Musical Express* "a veritable treasure-trove of mind-activating information. Penetrating, comprehensive, most illuminating".

With the task of the first "real" issue behind him, Dwyer and his wife transported their life to America. They were there to develop Rhodec's North American presence, but inevitably spent the best part of their year travelling across the country. It was this, certainly, that provided the inspiration for Dwyer's greatest exploration of his journalistic skill, a text of over 100,000 words, "The Plague Yard: Altered States of America".

It was on their return to England in 1991 that Dwyer learned he was HIV positive. While coming to terms with the diagnosis he completed "Plague Yard" and concluded a commercial deal with Creation Books for *Rapid Eye*. The idea of publishing "Plague Yard" as a book was floated. Those who read the text found it astonishing: the art of the travel writer re-configured into a plea for cultural freedom, with the punk aesthetic not only intact, but validated as never before. Focusing as much on low art as high, the piece shows Dwyer to be as much at home with the dispossessed idealist as with the art-elite glitterati.

But Dwyer, for all the praise heaped on him, remained true to the spirit that had long driven him, and declined one of the offers. "Plague Yard" was not to be used to announce his elevation in the literary field; instead it was to exist, and stand or fall on its merits, alongside many other pieces, simply as a contribution to *Rapid Eye 2*.

By 1993 the debilitating effects of HIV were becoming an unavoidable presence in his life. Minor ailments mounted up, fatigue set in. And work began on the third and final volume of *Rapid Eye*. The centrepiece of the volume is a startling work, by Dwyer himself, on the art of Gilbert and George who offered the use of their painting "We" as the cover. *Rapid Eye 3* was launched in London in 1994.

www.creationbooks.com